The
Artist's
Handbook

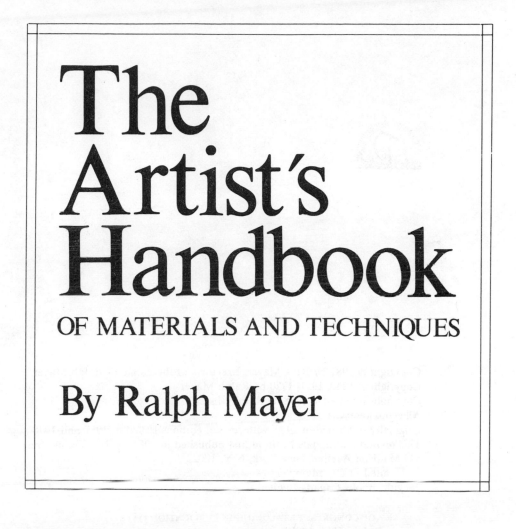

The Artist's Handbook

OF MATERIALS AND TECHNIQUES

By Ralph Mayer

FOURTH EDITION *REVISED AND UPDATED*

THE VIKING PRESS NEW YORK

Originally published in 1940, with revised editions issued in 1957 and 1970
This revised and updated edition first published in 1981 by The Viking Press
625 Madison Avenue, New York, N.Y. 10022
Distributed in Canada by
Penguin Books Canada Limited

LIBRARY OF CONGRESS CATALOGING IN PUBLICATION DATA
Mayer, Ralph, 1895–1980.
The artist's handbook of materials and techniques.
Bibliography: p.
Includes index.
1. Painting—Technique. 2. Artist's materials.
I. Title.
ND1500.M3 1981 750′28 81-50514
ISBN 0-670-13666-2 AACR2

Printed in the United States of America
Book Design by RFS Graphic Design, Inc.
Set in CRT Times Roman

Second printing August 1982

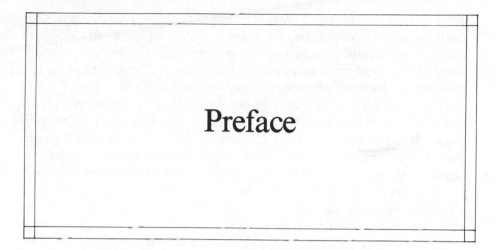

Preface

THIS BOOK HAS been prepared for the purpose of giving the artist a complete and up-to-date account of the materials and methods of his craft. It is based on my experience in the paint, varnish, and pigment industries, where I was engaged for a number of years in chemical research and in the manufacture of most of the basic materials used by painters; and on my experience as a lecturer and consultant to artists and as a painter. It is because the last is my chief interest that I have endeavored to present the subjects from the viewpoint of the artist and to arrange the material in a manner most useful to him.

The artist studies his materials and methods in order to gain the greatest possible control over his manipulations, so that he may bring out the best characteristics of his chosen technique and express or convey his intentions properly, and in order to ensure the permanence of his results. Haphazard departure from approved methods will often involve a sacrifice in one of these directions, but those who have acquired a complete and intelligent grasp of underlying principles are usually able to vary the established procedures successfully, to suit their individual requirements.

At present there are numerous materials and methods the use of which is well established by painters, but which are in an unstandardized state as regards scientifically correct knowledge or procedure. For instance, few modern investigators are in a position to pass judgment on the durability of traditional mural-painting methods under present-day

conditions or to evaluate the merits of newly developed materials as definitely as such decisions may be made in other technical fields, where materials and methods have been more completely studied for their applications to modern requirements. There are still many gaps in our knowledge which well-directed investigation could fill in.

I have included a few notes on matters that are not ordinarily classified with materials and methods but that bear a similar practical relation to the artist's technique. I have also departed from conventional procedure in the rather frequent mention of trademarked names, commercial products, and names of their sellers. These widely available standardized products have in many instances taken the place of the ungraded materials of former times, and they have been referred to here solely from the viewpoint of the retail purchaser, as they are discussed among artists. It seems to me to be just as important to know where one may obtain a raw material and what to ask for as to know the Latin name of the tree from which it comes or how it is dug out of the ground. Because I have found from experience that a fairly large proportion of inquiries deal with obsolete or discredited materials and methods, I have mentioned some subjects that might ordinarily be omitted from a work of this nature. On the other hand, certain subjects of greater concern to the theorist than to the active practitioner have been given less attention than they customarily receive. In reviewing the techniques of the past, I have confined my remarks to periods or schools rather than considered the specific methods and materials of individual masters.

The reader will find fewer instructions on the specific application of materials and methods to plastic and graphic arts than are customary in books on these subjects, because I believe that many such instructions are beyond the scope of a technical work, particularly since they are often open to divergent opinions or criticisms from a purely artistic viewpoint. In each case one must determine just where the discussion leaves the field of technology and enters the field of aesthetics, and I have attempted to confine technical data to their general application to artists' techniques and to avoid either criticism or approval except on technological grounds.

In general, each of the various processes has been presented first in outline form, and then given step-by-step detailed treatment, the degree of completeness varying with the nature and importance of the process. Allusions to chemical and other scientific principles have been subordinated to a clear understanding of the subjects, and the reader has been referred to a separate chapter for the chemical aspects of the various topics. By dividing the material into separate chapters and by using cross-references and a complete index, repetition has been avoided as far as possible Published accounts have been freely used, the source being

mentioned in each instance; those who are interested in following up specialized subjects in greater detail will find selected lists of books on each topic in the bibliography. Many books have been published on certain of the individual subjects covered in this volume, and the titles I have selected should give a good basis for further study in these directions. The book lists were planned and arranged so that they might function as a guide to and a review of the field as well as a reference bibliography.

I owe my introduction to the study of painting materials to Dr. Maximilian Toch, under whose supervision much of my early training and disciplined experience were received. I am especially indebted to Mr. David Smith and to Mr. I. N. Steinberg for suggestions and assistance in the final preparation of my manuscript, and to Mr. Charles Locke and Mr. S. Levinson for similar services. The drawings are by Mr. Steinberg.

PREFACE TO THE SECOND EDITION

During the fifteen years since the first appearance of this book new developments in creative painting have come into wide acceptance, and some new painting materials have been put into circulation. Various older techniques and procedures have also become more popular, thus calling for more detailed treatment. Several topics have been expanded to complete sections or full chapters.

In addition to the inclusion of new material and the revision of some of the original text, there have also been alterations in the arrangement and organization of the book, with the aim of presenting the various topics in a manner more convenient to the reader. Supplementary material has been grouped together in an appendix.

The author has continued to observe the needs of painters, and, as a result of extensive correspondence and personal conversations during this period, has learned much about what points of information are most in demand, and so has been able to make additions to the text that should enhance the usefulness of this volume.

Bibliographies have been brought up to date and some further annotations made, especially to the older literature—a topic the author recommends as an interesting and rewarding branch of the subject and as one that has been neglected by too many students. It is especially valuable to the experimental painter and the innovator to know what has gone before, to recognize old controversies or repetitions of long-buried disputes; it gives an insight into the causes of the survival or decay of old paintings.

Because of changing world conditions, the availability of some of our supplies has been curtailed, and as a result some of the older standard

recommendations are no longer applicable, so that replacements and readjustments have been put to use. Though there has been a continually expanding audience of artists who are conscious of the study of materials and technical procedures, and an ever-growing awareness of the vital importance of this study, the field is still handicapped by a lack of modern scientific data such as could be obtained by a much larger amount of laboratory research done directly in the interests of the practicing creative painter. Consequently the artist must be particularly well versed in the subject in order not to be misled by some very questionable practices.

As in former times, we continue to be presented with novelties—some based upon various modern materials which have recently come into use in industrial fields and others upon new formulations of traditional materials. An evaluation of any of these in order to decide whether it should be accepted as safe and standard procedure is not a matter of opinion; it can be determined only by the long test of time, or by the indications of thorough and scientific laboratory methods. The author continues to advocate and foster, as he has in the past, the establishment of a complete program of organized research exclusively from the artist's viewpoint in order to solve the large number of questions that now perplex the artist and the technical expert alike.

A favorable development in recent years has been the increase in the number of courses on this subject that are now part of the curricula of art schools and colleges throughout the country, especially those that stress basic principles and sound technical knowledge rather than the following of a set of rules or a teacher's personal methods and favorite materials. Another advance has been the successful functioning of the Commercial Standard for Artists' Oil Paints, the proposed draft of which was reprinted in the first edition of this book.

I have been assisted in preparing this edition by my wife, Bena Frank Mayer, who shared much of the thought and work that have gone into it. I also wish to express my appreciation to the John Simon Guggenheim Memorial Foundation, under whose grant for research in painting materials during 1952 and 1953 a considerable amount of the new material on oil painting was made possible.

PREFACE TO THE THIRD EDITION

Since the last revision of this book, there have been unprecedented changes in the technology of artists' materials. The development of new materials, especially in the areas of resins and pigments, in the 1940s and 1950s and their subsequent application to artists' purposes in the 1960s

have necessitated the present rather extensive revision of the *Handbook*. At the same time, the emergence of new art movements and new aesthetic directions has led to demands for materials and techniques whose requirements are not met by traditional materials. However, this point is by no means without precedent, for the history of art and artists' materials is a long record of searches for and adoptions of new means of meeting the changing requirements of art.

In supplying new information and revising obsolete and obsolescent material, it was necessary to make changes in nearly every section of the book, since a number of practices of painters, sculptors, and printmakers have been affected by these developments to some degree.

I am glad to report that some progress has been made toward the organized program of research mentioned in my 1957 preface—the establishment of the Artists Technical Research Institute under my direction. Laboratory investigations are under way in several areas of painting materials.

The technical questions asked by artists and the ever-changing sources of supplies continue to guide the author in the selection of new items of information.

PREFACE TO THE FOURTH EDITION

In the ten years since the last revision of this book, still newer art movements have appeared, necessitating unabated attention to technological development in artists' materials in order to meet these needs. The reader will find that new material has been added in some areas and other areas have been expanded or contracted. In most sections, some new information will be found.

Unusual world conditions have made some of the raw materials difficult to obtain and there have been many changes in the sources of supplies. These lists have been carefully updated, as has the bibliography.

Because I am a painter, I have continued to strive to present this material from the artists' point of view, observing their needs through an ever-widening correspondence and personal conversations with artists, students, teachers, and others in the field. Because of the long and healthy life of this book, perhaps a few lines of statistics and a few words of recapitulation are deserved at this point. Since it first appeared in 1940, it has gone into thirty printings and three revised editions and has proven that what the artist prefers is the absolutely correct objective scientific approach to every aspect of art. I have made every effort to maintain this high standard of information.

There is still much more to be learned. The pioneer investigations of the Artists Technical Research Institute will continue as originally conceived by me.

I wish to thank my wife, Bena Frank Mayer, for her assistance in preparing this edition.

Finally, I wish to thank Mr. Gustav A. Berger and Mr. Herb Aach for their suggestions and assistance in certain areas of the manuscript. Mr. I. N. Steinberg provided six new drawings especially for this edition.

R.M.

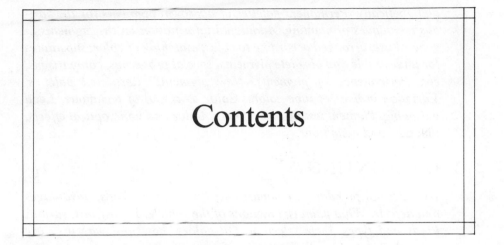

Contents

alphabetically. Permanent palettes of approved pigments for the various techniques of painting. Additional information on the pigments in general use, arranged according to color; matching of color, substitutes for undesirable and obsolete pigments, special properties, comparisons, etc. Permanence of pigments. New pigments. Restricted palettes. Variation in hues of tube colors. Color as a tool of technique. Lead poisoning. Pigment testing and refining. Color and light; optical effects, theories, and definitions.

3. OIL PAINTING

Its universal popularity; comparison with other methods; advantages and defects. What paint is; functions of the vehicle. Drying oils, various kinds and types, their selection. Oil colors, how and why they are ground. Properties, oil absorption of pigments, reactions between pigment and oil, additions of other ingredients. Stabilizers. Hand-ground colors. Fine grinding. Consistency. Painting in oil; coarse textures; mat finish. Structure of paint films. Repellent surfaces. Retarding of drying. Painting over old canvases. Simple rules for permanence. Defects in paintings and their causes. Varnishes, what they are, how made, various types, their uses; home manufacture. Natural resins, descriptions of the various kinds. Synthetic resins. Oleoresins. Mat varnishes. Inspection of oils and varnishes. Driers, their properties, behavior, and use. Glazes and glazing; requirements, uses, formulation, and application. Painting mediums of the past.

4. TEMPERA PAINTING

Definition, description, characteristics, comparison with oil painting. Tempera vehicles, emulsions. Egg tempera, preparation, handling, and brushwork. Egg and oil emulsions. Gum tempera. Wax emulsions. Oil soluble emulsions. Casein emulsions. Tempera techniques; mixed techniques. Ready-made materials.

5. GROUNDS FOR OIL AND TEMPERA PAINTINGS

Grounds and supports. Canvas, oil grounds, their materials, properties, and application. Wooden panels. Various types and brands of wallboards. Gesso grounds, their nature, properties, defects, and methods of manufacture. Emulsion grounds. Colored grounds. Miscellaneous supports and grounds.

*vatives for glues, gums, and other aqueous binders and adhesives.
Waxes: descriptions, properties, and uses of the various types. The essential oils or essences.*

12. THE NEW MATERIALS 400

Colors based on synthetic resins; polymer colors, straight acrylic colors. Toxicity of artists' materials. Synthetic organic pigments; synthetic dyestuffs. Luminescent pigments. New printmaking trends; color woodcuts, the relief print, collagraphs, printing. Collage. Rubbings.

13. CHEMISTRY 421

Part One: Outline of basic theories, laws, explanations, and examples. Uses and behaviors. Organic chemistry. Physical topics. Part Two: Chemical and technological aspects of the various materials and processes used in creative painting, sculpture, and printmaking. Nature of raw materials. Present standards of technology and control. Drying oils. Influence of ground. Litho varnish. Acid number, iodine value, particle size. Driers. Natural and synthetic resins. Synthetic organic colors. Solvents. Water. Tempera emulsions. Glues, gelatin, and casein. Plaster of Paris. Saponification. Lithography. Etching. Ethyl silicate.

14. CONSERVATION OF PICTURES 469

General remarks and rules. Oil paintings. Relining; pressure, non-aqueous adhesives. Transferring. Patches. Cleaning; removal of dirt and old varnish with solvents. Repaints. Cleaning without solvents. Mold, insects. Various methods of filling in lacunae; repainting. Cradling old panels. Varnishing. Keeping photographic records. Framing in relation to conservation. Repair and conservation of pictures on paper; cleaning, bleaching, deacidification.

15. MISCELLANEOUS NOTES 518

The studio, lighting. Enlarging and transferring drawings. Mechanical aids. Brushes; descriptions and general information about the various types and forms of bristle and hair brushes; their functions; care and selection of brushes. Painting and palette knives. Palettes. Inks. Notes on gilding, and various other metallic effects in paintings; gold leaf, gold powder, the various manipulations of gilding with gold and palladium; imitations. Notes on perspective; outline data on the construction

of its effects in painting and drawing. Notes on the graphic arts, the technical aspects and outline descriptions of lithography, etching, engraving, wood-block and linoleum printing, serigraphy. Notes on sculptors' materials—clay, stones, cements, metals, woods. Notes on photography.

The
Artist's
Handbook

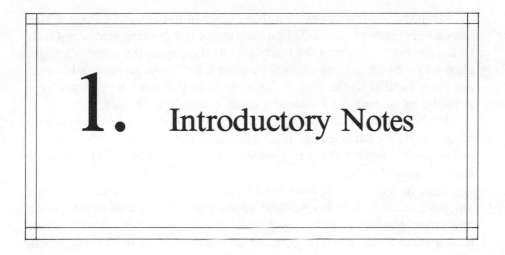

1. Introductory Notes

THE STUDY OF artists' materials and their application to the various techniques of painting covers a number of separate subjects, but they are largely interrelated. This chapter is introductory in the sense that it treats underlying principles and basic points, and includes general remarks that the reader should note before going into further details on the various single topics.

DRAWING

In order to apply pigment to a surface or ground, the first requirement in most cases is that the ground be rough or coarse to some degree. The simplest method of applying color, drawing with a lead pencil, a stick of charcoal, or a crayon, is based on this fact. The surface of uncoated paper is, microscopically, a weblike mass of long fibers; depending upon the degree of coarseness of its finish and upon the hardness of the crayon or pencil, these fibers act as a file: they wear away the pigment particles and hold them within their interstices. Ordinary lead pencils are made of graphite mixed with variable amounts of clay according to the degree of hardness desired; the softest varieties contain little or no clay.

NOTE: A superscript number in the text refers to an item in the bibliographies beginning on page 666.

1

Graphite is a form of carbon that occurs in flat plates or flakes which have a slippery or greasy feel. The pressure of the drawing stroke not only forces these particles into the interstices of the paper, but creates a slight gloss or sheen by causing them to assume a flat, level position with their flat sides parallel to the surface, somewhat in the same way that wax is polished by causing it to assume a level, continuous surface.

Metallic lead has the same properties as graphite; when it is drawn across paper its particles are filed away and held in the mesh of fibers. Subsequent exposure to the impurities in the atmosphere will make these lead drawings blacker.

Thin rods of metallic lead were used as pencils by the ancients, and although graphite was known and applied to various uses much earlier and crude graphite pencils began to be employed as early as the seventeenth century, the modern graphite or lead pencil in its present wood-encased form dates from about the beginning of the nineteenth century.

When metallic silver is drawn across paper that has been coated with a layer of white pigment, small dark particles of the metal are held in the porous or granular surface of the coating in the same way that the other materials are held by the fibers of uncoated paper. Silver-point drawings, which were more popularly esteemed in the past than they are at present, are characterized by a certain delicacy of line. Unless immediately protected by fixative, the lines acquire a tarnish such as forms on all silver surfaces; this color change, however, is usually desired, and the drawings are therefore left unfixed until it occurs. A number of commonly produced industrial coated papers will react with silver (as can be tested by a stroke with any silver article), but these are invariably made with little or no rag content and are of doubtful permanence. If special silver-point paper is not available in the artists' supply shop, it can be made by coating pure, smooth watercolor or drawing paper with a thin layer of Chinese white, using a broad sable or camel-hair brush. The silver point itself may be a sharpened bit of silver wire held in an etching needle holder, or a thicker rod of silver ground to a point at one end and to a chisel edge at the other; both are procurable from a jeweler at small cost. Gold and platinum will make similar drawings of somewhat different color. They do not change by tarnishing.

PAINTING

Surfaces. A paint is made by compounding pigments (powdered colors) with a liquid which is called the vehicle or carrier of the color. As will be seen, many elements contribute to the degree of ease or difficulty with which a paint may be manipulated or controlled; one of these is the na-

ture of the surface or ground to which it is applied. No good paint is made by simply mixing pigment and vehicle; as explained on pages 130 and 145, grinding with strong pressure is essential.

Like pencils and crayons, liquid paints are filed off or taken from the brush in a similar way by the irregularities of the ground (paper, canvas, etc.) and also by absorption, which sometimes acts as an alternative or adjunct to coarseness or tooth. In very smooth grounds, absorbency of the surface acts as an alternative for coarseness, picking up the paint from the brush and causing it to drag in the desired manner. Each technique of painting has its own special requirements as to the degree of tooth and absorbency that will best enhance facility of manipulation as well as permanence of adhesion.

If one draws a loaded brush of oil color across a clean sheet of glass, a highly unsatisfactory effect is produced; normal, direct painting is not possible, and adhesion is imperfect. If ground glass is used, a great improvement is immediately noticed; the tooth of this glass surface takes the color much more satisfactorily. If the same paint is applied to a panel coated with a smooth, polished ground that has been coated with varnish in order to make it nonabsorbent, exactly the same difficulty is encountered. If the ground is completely absorbent, the paint will be taken from the brush and drawn into the absorbent surface so rapidly that another impediment to manipulation is presented: satisfactory painting is hampered by too much drag. If such a ground is treated with a thin coat of size, so that its absorbency is of just the right degree, neither too much nor too little, the oil paint can be applied successfully. If pumice, a coarse, tooth-imparting, inert pigment, has been added to the ground, or if the ground has been scored or imprinted with a texture, oil paint is well taken from the brush, even if the ground is otherwise too nonabsorbent to take it by absorption alone. Watercolor and tempera paints require a full degree of absorbency for their proper functioning, but the surfaces of their grounds do not have to be particularly rough. The coarseness of very rough watercolor paper is for the purpose of imparting the desirable granular appearance or sparkle and has not much to do with brushing or adherence; smooth watercolor paper will hold the color particles as well.

Occasionally painting on a smooth, nonabsorbent surface—such as glass or a metal sheet—is required, but these processes are not in general use, and the resultant coating is seldom expected to last very long.

Binders in Paints. There are several types of binding action, and the materials that depend upon one action should not be expected to produce either the visual effects or the physical properties of the others. A dried oil film encloses pigment particles in a continuous, glassy, solid substance.

The film of a resinous varnish acts in the same way; it is even glassier, and is so impervious to atmospheric conditions that a thin layer of clear varnish will produce a durable film without any pigment.

Tempera paint films are adequately strong and durable, but when dry the volume of binder in relation to the volume of pigment is less than that of oil paints. This is so because the bulk of tempera (and also of all other aqueous paints) is water, and when the paint has dried, a relatively small volume of solid matter remains to bind the pigment particles together, whereas a film of pure oil paint loses nothing by evaporation and normally has a surplus of oil beyond the amount necessary to bind the paint. The pigment particles are surrounded by the binder, but unlike the condition in the glossy oil film there is little or no surplus medium; the surface has a mat or semimat finish, and the layer is porous.

Simple solutions of gum, glue, casein, etc., are more powerful adhesives than oils and resins; they will bind the pigment particles into a mass and attach them to the ground, but they do not form very durable films by themselves. When such paints are thinned to a brushing consistency, the pigments will be well bound but not locked in by a continuous level film, and so their surfaces will not be glossy. Glossy and mat (lusterless) surfaces are discussed on pages 153–57 and 173.

Binders such as the lime in fresco painting fall into another class. They act merely as cementing materials; they hold the particles of pigment or sand to each other but give no protection against outside influences. The surface is porous and any resistance against external attacks it may have is due to its own inert nature and that of the pigments. In the language of the technologist they would be called cementitious rather than pellicular; the latter term refers to an enveloping film.

Fixatives, such as are employed to bind the pigment of pastel and charcoal pictures, are very weak solutions. They are expected to be absorbed by the surface and they supply only enough superficial binding action to reduce the fragility of the picture so that it can be handled with somewhat more freedom.

Adhesion of Paints to Surfaces. In the discussion of the role of oil as a paint vehicle on page 120, a distinction is made between its function as a *binder* of the pigment particles into a continuous film and its function as an *adhesive* in securing or anchoring the coating to the surface to which it is applied. Each vehicle that has been handed down to us from the past is a survivor of the test of time and a vast amount of experience gained through trial and error; the same properties that make it a successful paint binder also make for good adhesion and usually, if ingredients are properly compounded and applied, for facility in manipulation.

The ability of a paint film to remain securely attached to its ground is, of course, one of the basic considerations of permanence. Several properties contribute toward permanent adhesion; these include the natural adherence or glueyness of the fluid material, the nature of the surface to which it is applied, the elasticity of the dried layer in following the movements of expansion and contraction, its toughness, its impermeability and resistance to chemical attacks, and its ability to retain such characteristics with a minimum of deterioration upon aging or exposure to external forces. In the wet stage of the painting, adhesion can be promoted by the use of fresh materials which will behave in the way in which they are supposed to function, by proper application, and in the selection of faultless grounds with the correct degree of absorbency and tooth.

Fresh Paint. A common cause of simple lack of adhesion lies in the use of paint from which some or most of its adherent or gluing-on power has been lost. When the usual coating material begins to dry on exposure to air, it passes through a sticky, tacky, or viscous stage, after which it jells and then becomes solid. If the paint passes through this *entire* viscous

stage while it is in contact with the ground, it will adhere. If it has already passed into this stage before application to the painting, it obviously cannot be expected to perform so well.

Paints such as oil, egg tempera, casein, and ethyl silicate, whose binding actions are due to chemical reactions, will always lose adhesive power to some degree if they are allowed to enter the adherent stage before they get put where they belong, on the canvas, panel, or wall. In the case of fresco, where the wall plays the adhesive role, this principle is accepted as an unquestionable part of the technique; no fresco painter will attempt to apply further strokes after the fresh cementitious character of the surface begins to pass and the wall ceases to imbibe the color. But painters frequently lose sight of this basic principle, and as a result their oil paintings may blister or flake off and their temperas and caseins crumble or dust away. The adherence of polymer colors is discussed on pages 402–403.

Some other coatings, for example watercolors, gouache paints, and simple solution varnishes such as pure damar, dry by simple evaporation of their solvents and so do not come under the restriction of this observation, for no chemical change is involved and they can be reconditioned so that they will go through the tacky stage once more. Watercolor and gouache can usually be remoistened or ground in water; more turpentine may be added to thickened damar. Another exception is encaustic color, which remains perennially thermoplastic; the difference between the fluid color and the solid painting is solely one of temperature. But no amount of thinner will reverse the oxidation or polymerization of oils or the denaturing of proteins. Technologists classify the film formers into two groups: *thermoplastic* or *convertible*. The former remains unchanged on drying; the latter undergoes an irreversible reaction and becomes a new substance. The term "thermoplastic" is here used in a somewhat different sense from its general meaning as used on page 194.

Larger volumes of paints, varnishes, and enamels such as fluid materials in cans, where a thin skin has formed on the surface on short aging, particularly when a volatile solvent is present, may frequently be utilized by removal of the skin and, if necessary, replacement of some of the evaporated solvent. However, the relatively small volumes or dabs of tube paint aged on a palette are more likely to have become affected throughout the mass, even when the interior seems more fluid than the outer crust. According to this principle, on the resumption of painting from a palette that was laid aside, only those oil colors that appear as soft as those fresh from the tube are worth taking chances on, and those that would require thinning to use should be discarded. The subject of paint

films is discussed further in Chapter 3, pages 157ff, and on pages 159–60 where methods to delay hardening are noted.

Balanced Formulas. In the formulation of a liquid paint or the establishment of a painting technique, there is another fundamental consideration which may be called the "balance of solubility." A certain balance or relation must be maintained between the resistance of the coating, the solvent action of subsequent brush strokes, and the solvent or dispersing power of the liquid used. For instance, the gum binder of watercolor is completely soluble in water, yet the dry paint layer is sufficiently resistant that it is possible to apply subsequent brush strokes without disturbing it; on the other hand, the paint is not so resistant that it cannot be softened or run into when the painter so desires. The wet paint itself may be instantly diluted or thinned with its normal solvent, water. A poorly made watercolor paint, or one which could be called unbalanced in this respect, might be picked up and completely removed at the touch of a wet brush or it might dry too resistant to water to be worked into when desired. The best watercolor paints are perfectly balanced and adjusted to the normal watercolor techniques.

In the oil-painting technique the turpentine or mineral spirit has sufficient solvent action to function as a thinner for the wet paint and also to dissolve the freshly applied or recently dried coating if scrubbed into it, yet a freshly dried surface will not be picked up, spread, or dissolved away if overpainted in the correct manner. Oil paint can be freely mixed and blended if desired, it can be made to set quickly enough to withstand the solvent action of further strokes without running in with them, or it can be made to remain plastic long enough for most normal working procedures. If a glaze or overpainting contains acetone or some other powerful solvent the underpainting might be picked up or it might spread. To artists one of the principal disadvantages of many of the modern lacquers and synthetic resins in painting is that they are insoluble in all but the most powerfully solvent and highly volatile liquids, thus creating obstacles to controlled manipulations.

Some of our traditional techniques are less flexible and their manipulations do not involve the same degree of solubility of recently applied color—for example, fresco and egg tempera, in which the brush strokes if correctly applied are not altered by overpainting and where such effects as gradations of color, tone, or shade are normally achieved by hatching or by applying separate strokes. Other techniques demand various degrees of solubility in their materials, and the standards for paint formulas and ingredients, brushes, grounds, and manipulations used in each vary

widely according to its requirements. The fulfillment of all such requirements demands a balance of proportion in formulation or design and correct compounding of ingredients.

Color Stability. One of the prime requirements of a permanent painting technique for artists' use is color stability—the ability of a final dry paint coating to retain its original color effect and the relationship between its colors without any fading, darkening, or change in hue. From the earliest days of painting as a highly developed craft, this matter has been one of the major concerns of painters; it is of fundamental importance in the practice of creative art.

Permanence. The subject of permanence, one of the all-important considerations in the creations of works of art, has many aspects, and it will be found emphasized throughout all rational discussions of artists' materials and techniques.

Permanence has a different meaning to the artist from the one it has when applied to industrial paints or to raw materials originally made or designed for purposes other than easel or mural painting. To the artist it means infinite longevity; his painting or sculpture is supposed to remain in good condition as long as possible, when properly cared for under the conditions that are normally given to works of art. Industrial or architectural paints, varnishes, enamels, and lacquers are not expected to last forever; they are considered acceptably permanent if they survive under the conditions they are designed to withstand for relatively brief periods; when applied to durable surfaces they are intended to be replaced or renewed periodically. Such products, no matter how successful or reputable they may be when applied to the purposes for which they are intended, should never be applied to permanent easel or mural purposes. Also, their raw materials (pigments, resins, oils, etc.) should not be used in artists' paints or mediums unless they have been proven to meet the artists' requirements for permanence by the test of time or by other tests made from the artist's standpoint; they should not be adopted just because they may have been successful in some other field, such as house paints, printing inks, or plastics. (See also pages 98–101 and 188–90.)

When the paint on a work of art soon cracks, peels off, or disintegrates in any way, we call it a failure. In discussions of industrial paints, the same condition would be referred to as a *premature* failure.

The Artist's Responsibility. In the preceding and following remarks about the quality of painting materials it must be understood that the reli-

ability of the paints and grounds is by itself no guarantee of infallible permanence and effectiveness of results. Just as many failures and just as many disappointing effects are caused by improper use of materials as by the use of faulty paints.

Paint is not a finished product. It comes nicely labeled and put up in neat little packages, yet it is only a raw material; the finished "product" is the picture—the dried paint layer on a canvas, panel, paper, or wall, and for the "production" of this, the artist must share an equal responsibility with the paint maker. Hence the use of the right material for the right purpose, the proper selection of materials and implements, and their correct application are of equal importance.

HOMEMADE MATERIALS

The artist's home manufacture of painting materials has been criticized and defended on various grounds by twentieth-century commentators. The modern painter who makes or refines his own materials does so because the particular quality or variety he desires cannot be purchased, because his process demands certain operations that must be performed immediately before use, for reasons of economy, or because he enjoys it as an enlightening avocation. Well-directed experience in this activity is obviously one of the most valuable means of acquiring knowledge that leads to control of materials. But note exceptions under synthetic resins, pages 188–90.

A chronological study of the old manuscript treatises that were written for painters, rather than for those primarily concerned with producing materials in commercial quantities, shows that one by one, with the advance of time, recipes for pigments and mediums are omitted or accompanied by remarks to the effect that their preparation is not worth the trouble and risk of failure, since they can be purchased ready-made.

The development of our modern industrial system based on an economy of mass production makes it quite understandable why it is impossible for the producer of a raw material that is sold daily in freight-car lots to turn out with scrupulous care the insignificantly few barrels of his product that the artists of the world consume annually. One of the contributory causes of the decline of standards for materials at the same time that advances in technology and knowledge made it possible to improve quality was the development of the paint and color industry from one which produced materials largely used for decorative purposes to one whose products are primarily used for large-scale industrial or protective purposes. Pigments, oils, and other products, highly satisfactory for in-

dustrial purposes but of a quality inferior to that demanded for artists' use, are made in enormous quantities. The superlative grades are produced on a much smaller scale and are not so widely available.

The painter, sculptor, or graphic artist who is well acquainted with the properties of his materials is often able to improvise quite acceptable materials when for various reasons his normal supplies are unobtainable or when he is confronted by the numerous minor emergencies which arise in the progress of his work. (For an example of a hastily improvised watercolor, see page 288.) However, the writer or instructor who is intent upon conveying the most correct and approved ways of achieving good results does not ordinarily concern himself with possible remoteness from sources of supply and similar considerations. Hiler[54] mentions some interesting emergency methods for the preparation of materials when the proper ingredients and ready-made supplies are not to be had; other books, including this one, also note such procedures occasionally. It must be understood that no one recommends these expedients as regular procedure, and that the artist should have sufficient experience to judge for himself whether makeshift materials are suitable for his permanent work or whether their use should be confined to notes and sketches, or when the situation is such that the only choice is to use available inferior supplies or not to paint at all. The shortcomings of common oils, decorators' pigments, homemade curd paints, etc., are all well known to the careful student of materials.

Inferior paints and supplies have always existed, and past generations of painters have always had to learn how to choose between the permanent and the impermanent, the good and the bad.

Perhaps the greatest reward to the artist or student who has gone through the training and education of making his own paints is the insight into their control and behavior, which is invaluable in the practice of painting and the discriminating selection of supplies.

QUALITY IN READY-MADE ARTISTS' SUPPLIES

While the use of student-grade materials may be justified on economic grounds for the beginner in his very early stage, it is a question whether this practice is not carried too far. If, as soon as the student has completed his very early attempts and has begun to think and act for himself, he continues his training with the best professional materials he can possibly afford, he should be on the road to a much better control of his materials and methods than if he is introduced to the sorts of materials that "make all the difference in the world" after he has already established his tech-

nique, or the background for his future technique, on a basis of inferior materials. A great number of our younger professional artists, whose works are well circulated, tend to continue the use of inferior materials beyond the need for strict economy.

The development of easel and mural painting has been based on the use of superlative grades of materials; artists in past generations have always realized that no degree of perfection was too small to be overlooked in their preparation or choice. They were held to be products that stood in a class beyond that of the common goods of trade. On the other hand, the extreme preciousness that existed during some past periods has been eliminated, and on the whole our own best grades of supplies are within reasonable limits, as good as we can desire, according to our current knowledge and beliefs. However, because of the numerically greater demand for nonprofessional materials (the kind sold for less exacting purposes—for school work, for commercial applications, for amateurs, etc.), the smaller supply shops and departments of other stores are frequently found lacking in the better grades of canvas, paper, colors, and brushes.

An apprentice in any of the manual or mechanical trades soon learns all about the quality of his tools, and acquires high-grade professional ones early in his career. An ordinary house painter engaged in the most commonplace sort of work would scorn to use a brush comparable in quality and condition to some of the artists' brushes with which paintings are done. Artists should know that the use of cheap materials not only affects the quality of their work, but is often not economical; a pure, strong color will go farther than a weakened one, and a good brush will outlast several poor ones. The one way a student can learn to judge such materials, having been given all the available information regarding their selection, requirements, characteristics, etc., is to be allowed to work with them. Possibly some of the lack of interest in this subject is due to an overreliance on the truism that no amount of opulence in materials will make a good painter, and that a good painter can turn out surprisingly good things under adverse conditions.

There is no longer so much cause to quarrel with the manufacturers of good artists' materials on the score of their prices; it is reasonable to agree that considerable expense is involved in the care and technical skill required to select the highest-grade materials and to compound them properly. Furthermore, the maintenance of stocks and the distribution of the finished products will result in a higher percentage of cost in such products than in those consumed in greater quantities. In fact, most of the higher-grade materials that go into artists' paints are produced in quantities that are insignificant in comparison with quantities of similar prod-

ucts made for mass production. Cadmium red, for example, sold for about $4.00 per tube when it was first introduced in 1919, and was used principally as an artists' color. When it was found that it would be a valuable color for industrial lacquers and other products, the dry color immediately dropped to a considerably lower price, owing to mass production, and the best grades of tube colors now sell for half what they cost when this pigment was exclusively an artists' color.

However, the artists' color trade is like every other in that there is always the possibility that unscrupulous firms will trade on the reputation of fine materials and substitute inferior grades under the same name; the maintenance of high quality is entirely up to the conscience of the maker; because the majority of manufacturers have or can easily obtain technical data, there are few secrets in modern industry.

Ordinary house paints and varnishes are of three grades: first, the best possible products that can be turned out with reasonable allowance for the availability of supplies and restrictions of distribution; second, the best possible material that can be made within a limited or competitive price range; and third, the cheapest sort of rubbish that looks and smells like paint. If a responsible manufacturer makes second-grade products, he will be careful to indicate the fact, but there have been firms, particularly jobbers and sales organizations that did not maintain their own factories, which sold second- and even third-grade paint advertised to compete with first-class products. It is possible that something of the same sort could also occur in the artists' supply trade. However, conditions at present are much improved, and the standards of quality, even among the cheaper grades, are higher than they were in the recent past. A few years ago I had occasion to examine three tubes of artists' white, of a brand happily no longer on the market, that were sold at a low price but with no intimation that they were of student grade or otherwise inferior to the best, and found that the three—zinc white, flake white, and Cremnitz white—apparently came out of the same tub. They were identical mixtures of lithopone, a little zinc oxide, and nearly 20 percent barytes ground in an oil that contained materials to give the colors an acceptable buttery consistency.

Because there are no secrets or mysteries in modern paint technology, every firm sooner or later can compete with a new product. Although the manufacturer has every reason to refrain from divulging the exact recipes and means by which he can make his product excel that of his competitors, in this era of enlightened technical interest it seems rather shortsighted to withhold the identity of the principal ingredient or the basic nature of his product and put it in the "patent medicine" class. The artist today wants to know all about such things; keeping them secret puts the

manufacturer under suspicion of using improper materials and deprives him of the credit for use of good ones.

Standard Specifications for Artists' Materials. In the past, selection of prepared artists' materials has rested upon the experience and judgment of the user, substantiated by simple tests that he or she has been able to make, such as exposure to daylight and a rough strength test, as outlined in this book. No satisfactory, practical standards were established for the control of artists' materials, for there was no agency where such an activity could be guided by modern technicians whose judgment would be largely based on the artists' viewpoint with reasonable allowances for the manufacturers' problems.

In the case of oil colors, this situation was improved tremendously in 1942 by the adoption of a set of specifications voluntarily agreed upon between the manufacturers and the artist-consumers, under the auspices of the United States Department of Commerce, entitled *Commercial Standard CS98–62* and commonly called the Paint Standard.* This important step established a minimum standard by which artists' oil colors can be evaluated; those products that conform to or exceed its requirements are considered satisfactory for professional use in fine-arts painting. The Standard lists a series of performance and physical-property tests and an "official" nomenclature, which is now being observed by most makers and has greatly benefited the artist. Paints whose labels guarantee that they conform to or exceed CS98–62 (or T-51) are of as high quality as modern methods and present-day knowledge can produce. Those not bearing this number may well be substandard in some way, regardless of their advertising claims.

The Need for Scientific Research. The study of artists' materials and techniques is hampered by the lack of systematic data of an authentic nature based on modern scientific laboratory investigations with which to supplement our present knowledge—the accumulation of the practical experience of past centuries, necessarily quite full of principles which rest on the shaky foundations of conjecture and consensus. In the two parallel fields of museum conservation and industrial paint chemistry, much valuable work has been accomplished along these lines, but because its aims, criteria, and requirements are so divergent, the field of the practicing creative artist gleans only crumbs of knowledge from these sources; proven data have accumulated slowly and lag far behind our needs. We await the day when a sustained activity, directed from the viewpoint of

* Reprinted on pages 651–65. The standard is now being revised and is referred to by number T-51.

the artist, will supply us with more of the benefits of modern science and technology. In general, it can be said that our criteria of excellence in materials and techniques are still not far beyond those of 1840 and that our oil-painting methods and materials are not substantially far removed from those of Rembrandt.

What Are the Best Brands of Tube Colors? A vast amount of expensive laboratory work and a perpetual vigilance would have to be involved before an impartial judge could vouch for the quality of any brand of prepared artists' materials. So far as the top-grade lines of professional artists' paints are concerned, this much can be said: in general, those put out by the prominent, well-established manufacturers are more or less on a par. Each one makes a conscientious effort to do the best he can, to make the finest oil color, watercolor, casein, or gouache in competition with the others; his top grade is a prestige item. As just remarked, there are few if any secrets in paint-making. There is, however, some choice or range in color or pigment differences (see *Hue Tolerance,* page 102) and in the maker's idea of what constitutes the best criteria for a good tube color, so that the question is up to the user himself—the artist may prefer one firm's blue, another's red, and so on, or he may favor a complete set of one brand. Personally, I lean toward the American brands of oil colors, for it seems to me that in recent years their oil-pigment ratios have had a better balance, less surplus or free oil as compared with most imported makes. Conformance with the Standard is another factor. It would not be feasible for an impartial specialist to recommend specific brands, for to do so would require the maintenance of a consumer's testing laboratory, continually checking every color in every line every season.

HISTORICAL NOTES

The earliest works of art of which we have definite knowledge are prehistoric, that is, they were produced during periods antedating the times for which we possess contemporary records and of which our knowledge is definite or accurate. The word "prehistoric" is here used in a narrow sense, relating directly to art, and does not necessarily imply that we have no definite, accurate knowledge of other aspects of the cultures that produced these works of art. Of some countries—for example, ancient Greece—we have a good knowledge of the civilization, the literature, architecture, ceramics, etc., but only a vague idea of the materials and methods of mural and easel painting.

Our information concerning the methods and materials of these peri-

ods is derived from relics, archaeological discoveries, and the writings of the earliest historians. Considerable time separated these writers from the periods in question, and although much of value has been learned from them, their writings also contain much that is legendary, vague, and inaccurate; some processes are described correctly in accordance with methods that have survived or developed along similar lines down to the present day, while other statements are the weirdest sorts of fantasy. Sometimes, important archaeological discoveries such as those of Troy and Knossos have substantiated historical or epic legends that previously had been considered unfounded on actual fact. The most valuable aid in reconstructing an old painting method and arriving at a definite conclusion is an intimate knowledge of the behaviors and properties of painting materials and the results that may be obtained by various manipulations, gained through first-hand painting experience and experiment.

All the raw materials used in art techniques, with the exception of some few new products or improved grades introduced during the recent age of industrial and scientific development, are of far greater antiquity than is popularly supposed. The materials that were considered improvements during the introduction of various techniques from the thirteenth century on were well known to the ancients. The principal literary sources that mention painting materials and methods of the classical period and upon which investigators have based many deductions are Vitruvius and Pliny, with lesser accounts by Theophrastus and Dioscorides. (See pages 668–73.)

Interesting examples of the different sorts of records that have come down to us may be found in Pliny's *Natural History*. For instance, he describes the manufacture of white lead in just the same way as it is made by the "old Dutch process" today, 1900 years later. Then in the same vein he relates the source of dragon's blood (a vegetable product from the fruit of an Asiatic tree), which he tells us is not the simple blood of dragons, but is produced when dragons and elephants meet in mutually mortal combat, the dragon crushing the elephant in its coils and in turn being crushed by the weight of the dying elephant. The product, he says, is a thick matter that issues from the dragon, mixed with the commingled blood of both beasts. He states that it is the only color that in painting gives a proper representation of blood; elsewhere he remarks on how the men of former days, the Greeks with their simple mineral palettes, produced work superior to those of his own day even though they now had such resources as "the slime of India's rivers [indigo] and the blood of her dragons and elephants."

Modern investigators have exhaustively studied all the known

sources and references to painting materials of the past—not only the more complete accounts but also the isolated references and clues in poetry, the Scriptures, and other nontechnical writings.

The development of art in general proceeded along distinctly separate channels in the various countries, but always was governed by the culture and type of civilization and the available supply of raw materials, choice or selection of which was strongly influenced by climate conditions and the uses to which the works of art were put.

Egypt. The preservation of Egyptian relics because of the perfectly dry atmosphere of the country and the precautions taken to ensure the safety of mortuary deposits is well known, and students of Egyptian civilization have given us a very thorough understanding of the painting methods employed. The history of these methods constitutes a remarkable record of the survival of a technique that remained essentially unchanged for a period of about 3000 years. Although the art and culture of the Egyptian civilization underwent changes during this period, these changes occurred within fairly limited bounds, and the following two processes served from the date of the earliest existing specimens (about 4700 B.C.) down to the time of the Ptolemies:

1. Mud-plaster walls were decorated with a simple watercolor paint.
2. Designs were engraved or cut in stone walls and gone over with watercolor washes.

Minor, isolated examples of other variations have also been found.

The precise nature of the binder in the Egyptian watercolor is uncertain; gum, size, or some similar material was used, or perhaps all of them, and the colors were applied with crude fiber brushes. It is usually assumed that gum arabic was in greatest use. These watercolor paintings on mud-plaster walls which have survived so well in the dry climate and sealed tombs of Egypt may be entirely destroyed by passing a damp sponge across the surface. The work of the later periods was technically more refined, better and finer brushes and pigments were used, but the process remained the same. Lime plaster was not used prior to the Roman influence.

Greece. The Minoan and other pre-Hellenic Greek civilizations developed a fresco process virtually identical with the *buon fresco* of Renaissance Italy; it is described in Chapter 9, "Mural Painting." The two principal Greek methods of painting easel pictures—according to Pliny, Vitruvius, and other writers—were encaustic and a mysteriously vague second process variously supposed by modern writers to have been oil,

egg tempera, or dissolved or emulsified wax. No conclusive evidence has so far been established on this point, but the methods, materials, and implements of encaustic painting are well known. A large amount of the tradition and legend concerning the highly praised early Greek painters is probably apocryphal and of small value in the study of their techniques. No authentic Greek paintings of the classical period are known to exist; the Pompeian relics have in the past been considered typical of them, but more modern students find that they throw little light on the subject. The Greeks seem to have had a complete unconcern for any sort of recorded data and, unlike the Egyptians, no regard for the preservation of works of art beyond their immediate functions; few statements about their mural or easel painting methods or materials are entirely free from conjecture. The principal source of our knowledge of the artistic as distinguished from the technical nature of Greek pictorial art is the study of the decorated pottery and a few other relics that happen to have survived because of their durability. The Roman materials are somewhat better known to us through contemporary records. Other references to early techniques are mentioned in Chapter 8, "Encaustic Painting," and under *Historical Notes* and *Mosaic* in Chapter 9, "Mural Painting."

Medieval Europe. The period that follows, i.e., the early Christian or medieval era, supplies us with a somewhat larger number of surviving examples of painting, and also with written accounts of a more definite character in all countries. These include manuscripts written by contemporary craftsmen and specialists for the purpose of disseminating their knowledge, records of expenditures for materials, and letters of painters.

Much of our knowledge and evidence concerning techniques of the past is based on the study and careful interpretation of the early manuscripts. A long list of such documents could be made; some of them are well known to students, and others have received little attention. Most of them have been translated into English and critically interpreted by experts, and those interested in referring to them may find them among the books listed in the bibliography for this section. A good bibliography of early manuscripts and books is listed by Laurie,[39] although it is to be noted that some of the translations mentioned in it have been superseded by more modern ones.

The Orient. As with the earliest European painters, permanence was regarded by the Chinese and Japanese as an essential requirement in a work of art. The Japanese have carried on this tradition and today they use the same twenty or so pigments that they used centuries ago (see page 75). Although most colors on the list are of natural mineral origin, one

(indigo) is derived from a plant and another (cochineal) from an insect.[261] However, it must be understood that in general, the paintings created by oriental artists are not as continuously exposed to light as are western works of art. Their paintings are rolled up and stored in individual wooden boxes after a brief showing.

The Chinese were well acquainted with several kinds of drying oils for many centuries and employed them for various technical purposes, but their pictorial art was confined to ink and watercolor tints on paper. A drying oil was used as a medium for the vermilion seal that was impressed by the artist on each painting. Their fundamental conceptions of pictorial art were exactly served by the materials they used, and although in later days they may have absorbed Western influences and ideas, the Chinese have always rejected Western materials.

The Renaissance. The painting methods and materials of the Italian Renaissance are well documented and the technology of its various schools and individuals fairly well established: fresco, egg tempera, and oils. Those of the Northern painters are somewhat less well established; their early records are less often in as complete or treatiselike form; the members of their guilds were less restricted by a single, established mode of procedure, and they seem to have done more toward the development of new materials and processes.

Another example of the proper interpretation and study of old writings has become a classic. Among the statements in Vasari's *Lives of the Painters* are to be found several that other evidence has since contradicted, including the credit he gives to Jan van Eyck for the invention of oil painting. As early as 1781 this was disproved, and the use of oil painting has long since been traced to a gradual development with far earlier beginnings. Yet so strongly did this legend impress people's minds, strengthened by the writings of Flemish and Dutch historians *after* Vasari's first edition, that it still passes for truth in some quarters today. On the other hand, writing not in the chatty vein of the *Lives,* or as a sixteenth-century historian depicting household events in far-off Flanders 150 years before his time, but in his technical chapters, writing as a practicing artist who lived in the circle of Michelangelo and other Renaissance masters, Vasari gives a perfectly simple and straightforward account of the materials and techniques of his own day; the sections 84 and 85 have frequently been used to confute the theories of those who seek the "secrets of the old masters." For some reason or other, his technical chapters are invariably omitted from English translations of the *Lives;* they can be consulted in *Vasari on Technique.*[11]

There is further mention of this subject throughout this chapter, on pages 211–12, and in the annotations on the books listed on pages 667–73.

I know that few painters are vitally interested in these matters, but I have quoted the above as examples of the sort of complexities that are involved when one attempts to exhume discarded working recipes from their tombs and treat them as "lost secrets."

Tempera Painting. From crude beginnings in Byzantine and early Christian art and, as some early writers suggest, but without definite proof, from the ancient Greeks, a traditional tempera process came into general use throughout Italy. The pure egg-yolk technique was described by Cennino Cennini[8] in a treatise on painting as it was practiced at least as early as the fourteenth century; it was well established in his day, and his knowledge and training in it came to him in a direct line from the studio of his idol, Giotto. Egg tempera continued to be the principal medium used for easel painting in Europe until the development of artistic oil painting.

As Eastlake[28] expresses it, the early Italian painters, though taking great care to produce durable works, made no attempt to lessen executive difficulties, tending rather to overcome such difficulties by superior skill. The Flemish and other Northern painters departed from the early Italian methods, using new materials, aiming at ease of manipulation, and producing works technically excellent to a degree impossible to duplicate by strict adherence to the egg technique of Cennini. These methods and materials are supposed to have been initiated about the year 1400 in Flanders and thereafter introduced into Venice. The period from the beginning of the fifteenth century to about the middle of the sixteenth century produced tempera paintings of a high degree of technical excellence, which serve as models for the tempera techniques of today.

At the same time (beginning about 1400), new materials began to be discovered or perfected. A commercial renaissance began, a result of which was the wide distribution and availability of raw materials. Traders brought supplies from the Orient, and the manufacture of finished goods on a larger scale improved quality and gave uniformity to materials in common use.

Linseed oil had been known and used for ordinary decorative and protective coatings from the earliest recorded periods of European history, but it was a crude, mucilaginous product unlike the well-made material we know now as raw linseed oil; however, thinners such as turpentine were virtually unknown. Processes for the purification of linseed oil in the modern sense began to be published about the year 1400.

Distillation was known to writers of the third century A.D., but it was not practiced commercially until the fifteenth, at which time its products, alcohol and other volatile solvents for varnishes and paints, began to be widely available.

The aim and taste of the artist and his public should be taken into consideration when a study of these changes in techniques is made. Vasari and other writers who lived in a day when tempera was becoming obsolete, and when the novel effects produced by oils were widely acclaimed, were often prone to condemn the tempera technique from the viewpoint of the tastes, fashions, and styles of their day. Tempera painting was condemned by them as inferior to oil because of the very qualities which make it appeal to its present-day users.

During the sixteenth and seventeenth centuries, some tempera paintings were done on canvas, which had been introduced with the oil painting technique, by that time in full swing. Tempera as a universally used medium in a high state of technical development may be considered to have become obsolete by the end of the sixteenth century.

In following out any recipes or instructions of former times, even up to nineteenth-century methods, it is important to remember that the quality, character, and nomenclature of many raw materials have undergone changes, and to be familiar with the artistic or pictorial aims of the period for which the methods were intended.

The statement, made in accordance with general opinion, that tempera painting became obsolete more than 300 years prior to its present revival, is true only so far as its wide general usage is concerned. Examples and records of isolated works done with the older materials can be cited for almost every age, but these individual experiments had little influence either on the general practice among painters of the time or on the major part of the painter's own works. The present revival of tempera owes its extent to the adaptation of the technique to the requirements of modern taste, since it makes possible effects particularly well suited to certain modern artistic aims which did not exist in the recent past. In the early part of the present century it seems to have received its greatest impetus in Germany, although isolated groups of English and American painters also pioneered in its use.

Some partial use of tempera materials by American painters of the early nineteenth century is recorded. Sully[30] recommended that colors be ground in skim milk (crude casein). A ground made from skim milk and white lead was one of his favorites, and he also mentioned the use of colors ground in skim milk for underpaintings, carrying this work as far toward completion as possible, then finishing with transparent oil and

varnish glazes. An emulsion of flour paste and Venice turpentine is also mentioned.

Oil Painting. All references to the so-called discovery of oil painting by one man or one school of painters in an attempt to find a method that would revolutionize art have long been held to be fallacious. The drying properties of linseed, poppy, walnut, and hempseed oil were known to some of the earliest writers, and instances of their application to paint are found quite frequently in early records and in accounts of expenditures for materials. The use of such paint, however, was confined to common-place or simple decorative purposes; no traditional methods for work of purely artistic pretensions were established until later times. From an examination of the old expense records, oil paint is seen to have been widely used in England for decorative purposes at least as early as the thirteenth century. Eastlake[28] collected many of these records.

Tempera painting was eminently successful in meeting the demands of the fourteenth- and fifteenth-century painters, but during the fifteenth century, when the demand and preference arose for a new type of easel painting that could not be produced by using the pure egg-yolk technique, or any other method then in use, the new materials and improved grades of older materials were at hand and were applied to produce these effects. Changes or innovations in techniques are more often attributable to changes in times and circumstances and the demands of changing art forms than to deliberate individual creative departures.

The fifteenth- and sixteenth-century paintings of the kind innovated by Flemish artists soon after 1400 and referred to by Vasari and other older writers as oil paintings were, for the most part, precisely the sort of works we call tempera paintings today when referring to tempera in the highest stage of its development, and some were produced by employing alternate coats of tempera and oily or resinous mediums as in the accepted tempera variations.

During the sixteenth century, the materials and technical procedures of oil painting had become sufficiently developed so that the masters of Italian painting were able to exploit its effect to good advantage, and during the seventeenth century it was in universal use. Various individual masters of the sixteenth and seventeenth centuries have been cited as being the first to show the complete adoption of this procedure, but it is hardly reasonable to believe that such definite statements are accurate when applied to a technique which has had a long and gradual development. However, during the seventeenth century, the practice of painting pictures entirely with oils and varnishes increased and finally became

common. At first the gesso grounds of tempera were used, and, according to most modern investigators, resinous varnishes such as are classified as glaze mediums in this book were largely mixed with and used in alternate layers with oil paints. After 1600, oil grounds and straight oil colors were in almost universal use. Some painters, believing in the superior luminosity of gesso as a ground for oils, have continued to use it down to the present day. Although one of the advantages of the oil technique is that it can be used on oil-primed canvases of light weight, the more cumbersome wood panels were never entirely discarded; some artists have always preferred their smooth surfaces or superior rigidity.

The early linseed oil referred to in the preceding remarks on tempera was pressed from flaxseed and purified by heating and sometimes by the action of sunlight. The two principal improvements of the fifteenth century are generally considered to have been the adoption of methods of purification by mixing the crude oil with water, which removes the impurities and produces a superior raw oil, and the wider availability and use of volatile thinners.

Drying oils of the early type had been used from very early times as occasional minor additions to painting techniques and for protective and simple decorative purposes. They are mentioned by Galen, a medical writer of the second century, and on through the medieval recipe books and treatises as well as in records and accounts of various decorative projects, but at none of these times were there established any standard methods of oil painting as applied to purely artistic work. Stand oil has a long history and it is believed by most investigators that it was widely used by artists of the Dutch school during the seventeenth century.*

Studies of the materials and methods used by the individual painters of various periods may be found in the works of Eastlake,[28] Laurie,[36, 39, 40, 51] Doerner,[55] and others. The first-mentioned contains the most complete references to early writings; the more modern writers combine the data accumulated by earlier historians with material developed by themselves and others through studies along more progressive lines.

Some of the successful and durable effects produced by the great painters of the early days of oil painting have been attributed to the use of resins mixed into the oil paint. It is my opinion, both from experience and from the results of other investigations on these materials, that when resins or resin varnishes were so used, the most successful examples probably employed the simple solution or liquid balsam type rather than the type of resin that requires cooking in oil with driers and other chemicals. Most of the early recipes for the use of resins that will not dissolve with-

* My own story of the development of oil painting is given in the entry "Oil painting, development of" in my *Dictionary of Art Terms and Techniques*. (See bibliography, page 667.)

out being cooked in oil will generally produce solutions that are inferior in permanence to the modern cooked oil and resin varnishes, none of which is considered permanent enough for use in artistic painting.

In general, the experience of the past has been that any considerable addition of resinous materials to oil paints increases their brittleness and that coatings containing large amounts are definitely inferior to straight oil paints in this respect. Resins obtained from living trees and the so-called fossil resins dug from the ground, as well as modern synthetic resins, are discussed in the section on oil painting beginning on page 183.

Later Periods. During the eighteenth century, and more completely during the nineteenth, the knowledge and intelligent study of the methods and materials of painting fell into a sort of dark age, from which our contemporary painters have by no means entirely emerged. Good craftsmanship and a thorough knowledge of materials and methods continued to be the concern of some painters, but they were exceptions to the general trend.

The beginnings of the era of great industrial and scientific development released artists from a number of details of labor indirectly essential to their work, so that they began to concentrate their efforts entirely on the plan, design, and execution of the work, leaving the preparation of materials and other auxiliary work to specialists, upon whom they eventually became thoroughly dependent. The first effect this development had on painting technique was to end the necessity of the artist's learning thoroughly the laborious hand or small-scale methods of manufacturing his materials. Instead of giving the art student some degree of organized training in the principles underlying the properties and uses of materials as a substitute for the practical experience stressed in former times, the entire subject was eventually ignored.

Traditions relative to handling painting materials survived for some time, but inasmuch as these were passed on in terms of effect or "how," without regard for cause or "why," they soon degenerated to a set of fixed rules, and by the end of the nineteenth century we find few painters equipped with an intelligent understanding of the craft.

It was a short step from this attitude to the conviction that too great a concern with the fundamentals of technically correct practice would interfere with or hamper the free expression of artistic intentions. The bulk of the work produced by men of this belief has become generally, in all artistic circles, the least valued from a technical viewpoint.

"The Secrets of the Old Masters." One of the first results of this decadence was the general acceptance during the 1700s of the theory that the

great masters of the past had mysteriously and closely guarded secrets through which they obtained their effects and the permanence of their works. Many artists of the eighteenth and early nineteenth centuries seriously attempted to improve their craftsmanship by continual independent study and experiment, and they worked on their mediums until they attained fine control and the exact expression of their artistic intentions, but failed to secure permanent results; a great many of these pictures have deteriorated within a comparatively short time. This can be attributed to their misguided effort in the search for the "secrets of the old masters."

Eastlake[28] suggests that the word "secrets" as used in the medieval recipe books was not employed in the sense that such information was always jealously withheld. There is much evidence that such information was as freely circulated among members of the craft as it is today, and that it was not until more recent times, when this resurrected knowledge not possessed by the majority had a direct commercial or competitive value, that it was more jealously guarded.

The Artist's Contol of His Technique. Almost every writer on the technology of painting points out the fallacy of the belief of some painters of the recent past that any close attention to the technical details of their craft would interfere with the free expression of their intentions, and that by concerning themselves as little as possible with such matters their creative efforts are left untrammeled. In one way or another, students of technique have shown that the work of the preeminent masters of the past was produced under conditions of the most highly developed craftsmanship; that the artists of the Renaissance made little distinction, if any, between their craftsmanship and their artistic intentions, and showed little concern for aesthetics entirely divorced from craftsmanship; that a firsthand knowledge of sound technique is of enormous assistance to the painter in enabling him to express his intentions with accuracy; and that the knowledge that he has utilized the best possible means to attain his ends and to ensure permanence brings an increase of confidence.

I have no doubt that the abandonment of rational studies of materials during the past century had an effect on the development of art forms; such a point of view was bound to contribute certain elements to the nature of the art produced, and many of the more dominant personalities who subscribed to it were led into methods of applying paint which, though unsound from the viewpoint of earlier, more accomplished painters, produced certain novel effects that could be used to support new artistic or aesthetic aims. However, much of the work produced under these

circumstances is considered to be of little merit by most present-day schools of painting.

The electric light removed another restriction that tended to keep oil painting within the bounds of correct and safe practice. Mention is made in this and other books of the ill effects on permanence of excessively thick, pasty layers of oil paint sometimes studded by still heavier areas of almost modeled impasto. Such paintings would have been impossible in the era preceding our present controlled illumination; only by manipulation of individual lighting can they be made to stand out with all the dash and sparkle intended by the painter. When one views a collection of historical portraits in ordinary general illumination, the older ones done in an age of lamps or gaslight, whatever their aesthetic value as pictures, are clearly and successfully visible, whereas the type painted in spectacular impasto strokes will display annoying blobs of color and glare. Not until scientifically adjusted lighting is switched on do these more modern works take their place as paintings worthy of comparison with the others. This is also true of another type of work where glossy retouch varnish has been used for a final touching up in spots, to bring out or secure certain proper tonal relationships, thus obtaining color values by manipulation of refraction, absorption, and reflection of light from smooth and rough surfaces, instead of by the use of pigment. Such effects are never very permanent. Close examination of the type of painting that piles great blobs of color over thick pasty undercoats reveals thirty-year-old works so badly cracked that they seem headed for oblivion. No criticism of the artistic value of these works is intended; but their effects, whether one considers them admirable or deplorable, could have been achieved by sounder methods.

In America there were scarcely any new contributions or developments in the field of painting materials and methods, for in the beginning our tradition was entirely English and thereafter followed the techniques of various European schools very closely.

That tempera and other departures from the standard direct oil technique were known to some early American painters is evident; researches among the voluminous biographies, letters, and records of these painters of the early nineteenth century would undoubtedly disclose many interesting accounts of their painting materials and methods, but they have been ignored because of the low esteem in which the mass of early nineteenth-century painters have been held, even though some of them show a degree of craftsmanship far surpassing the usual level of their time. Dipping into these records here and there, we find observations on the relative merits of solid painting and the use of glazes; we see portraits of

the 1840s in which glaze effects were successfully used both in backgrounds and in faces. This apparently became something of a lost art in the second half of the century, for the works of that period reveal much less success in the attainment of these effects. Some of the earlier American uses of tempera and oil-resin glazes are mentioned on page 20.

In the past, the discovery, or rather the widespread application, of new and improved raw materials and technical methods, almost always coincided with the introduction of new art forms. This statement is not meant to imply that such material innovations were the deciding factor in the genesis of new art forms, but that such materials and methods are ultimately put to the uses for which they are inherently best suited. This occurs in the present day, when new developments not only in artists' materials but in all other fields of activity are often first applied as imitations of older forms, and are not utilized to their fullest extent until a new demand or a new conception of their value arises.

The chart on page 27,* which shows the influences of various schools of art upon one another, is also a guide to the study of the development and interchange of materials and methods used in painting. Modern conditions have brought art to a sort of international era in which the works of all schools, regions, and historical periods are available as influences upon current developments. This has brought about an appreciation and valuation of forms and philosophies foreign to our own, and, in a similar way, there are no known methods or materials used by any other school, age, or country that we cannot employ if we choose to.

Relation of Early Methods to Modern Practice. The artist's interest in techniques of the past is neither that of the antiquarian nor that of the scientist, nor are artists very often concerned with the precise duplication of the technical effects of early painters in order to produce works that will exactly imitate their results. They are primarily concerned with learning as much as they can about their materials and methods so that their opinions as to the durability of works of art may be based on a knowledge of how different types of work have stood the test of centuries under all sorts of conditions. In analyzing the procedures of past ages, which were employed to create effects often entirely at variance with current artistic standards, we are interested in adapting them or their principles to our

* Chronological relationships and geographical arrangement are now shown on this chart. The importance of each period as an influence is indicated by the weight of the outline. A dotted arrow indicates traces; a single arrow, definite but slight influence; a double arrow strong; and a triple arrow such influence as to be a dominant factor in the period. Arrows running both ways indicate reciprocal influences. In general, the terms used are in their broadest interpretations; thus, "Romanesque" covers Carolingian as well. (Adapted from the *Encyclopaedia Britannica*, 14th ed., Vol. 17, p. 526, and reproduced here by permission.)

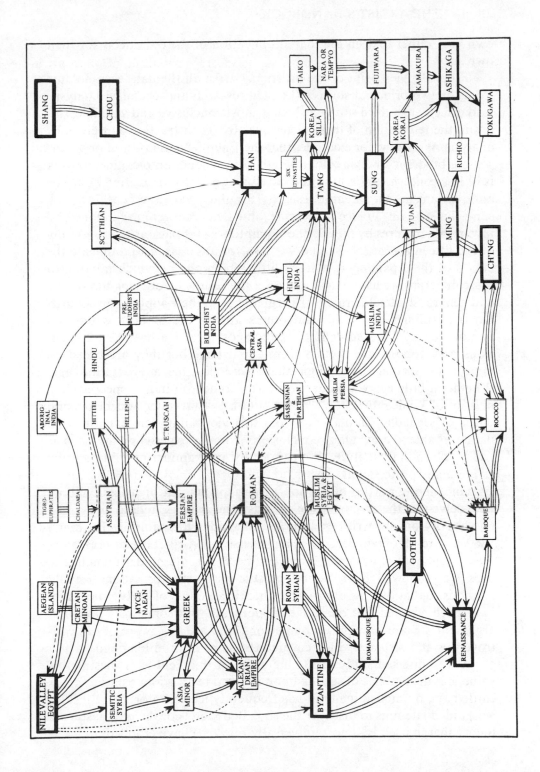

own uses rather than in the mere duplication of the old effects for their own sake.

From the viewpoint of the practicing artist all the data accumulated from the two principal sources (literary research and chemical analysis) lead directly to a third source, which is most conclusive and valuable; this lies in the re-creation of these techniques by reconstruction as well as by analysis. We know, for example, that the Egyptians used a size or water-soluble binder with their colors; whether it was gum arabic, glue, or milk is of less concern, and a long and careful study into the matter would be antiquarianism, not valuable research. Similarly we know that stand oil, sun-thickened oil, Venice turpentine, and sandarac were used alone and in varying mixtures by the Northern painters as far back as the beginning of the fifteenth century. Should we wish for any reason to duplicate the effects of these painters it matters little which one or which mixture of these materials we use so long as we get the results by obeying the simple and generously flexible rules for permanence in their application. Laurie, Doerner, Eibner, De Wild, and others among the modern writers on painting have expressed definite opinions on these matters; their conclusions may oppose one another in minor details, but they are based on more solid factual foundations than were possible a generation ago. Whether a little egg was added to sun-thickened oil in any specific case, or a lot of Venice turpentine, resins, and oil of lavender added to stand oil, is of secondary importance from this viewpoint. The experimental painter is able to draw many conclusions from his experience, and is in as good a position to analyze old methods by an examination of a painting as are many professional experts.

Once more, a word of caution is perhaps not out of place for those who delve into the documents of the past; the artist is advised not to rely too heavily on old writings as practical guides for painting. By about 1860, as a result of two decades of an intensive revival of literary research, the ancient books and manuscripts had been put into modern languages. This was followed by a period of study and interpretations on old methods so that by now our most authentic accounts of early procedures have been adapted and related to modern use. But sometimes points of argument are still brought up by persons who are not aware of old controversies and disputes which covered the same ground long ago.

A well-directed study of the literature of this field is of inestimable value, but the practice of seizing upon isolated recipes and exhuming discarded and outmoded material has frequently led to unfortunate results. Misguided attempts to discover the so-called secrets of the old masters (a theory that in itself is almost universally rejected) have cropped up inter-

mittently from Sir Joshua Reynolds down to the present day; fresh use of old matters requires an authentic knowledge of the field.

Rather than resume the 200-year-old search for the legendary "secrets" once used by painters, we should try to develop the very best medium we can create, regardless of whether it utilizes ancient materials or the synthetic products of our own age. We know quite a bit about the properties that our paint must have for good brush manipulation and to survive the test of time, and we will know still more as we obtain further modern laboratory results of research done specifically for the benefit of artists.

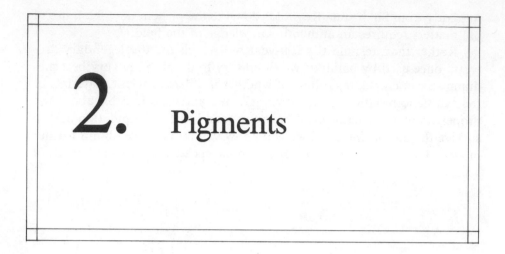

2. Pigments

A PIGMENT IS a finely divided, colored substance that imparts its color effect to another material either when mixed intimately with it or when applied over its surface in a thin layer. When a pigment is mixed or ground in a liquid vehicle to form a paint, it does not dissolve but remains dispersed or suspended in the liquid. Colored substances that dissolve in liquids and impart their color effects to materials by staining or being absorbed are classified as dyes.

Materials used as artists' pigments have requirements other than color; the term "pigment properties" is used in this book to refer to structural and other physical properties apart from color. Powdered materials that become colorless or virtually colorless in paints are called "inert pigments"—a technical term or classification that has no reference to chemical inertness or stability.

The various methods of painting—oils, watercolor, etc.—differ from one another in the material with which the color is applied and attached to the ground; the pigments used are the same in all, except that a pigment suitable for one purpose does not always meet the requirements for another.

BODY COLOR AND GLAZE

Two systems of coloring may be distinguished in our painting methods. One employs comparatively heavy layers of opaque paint or pigment, and obtains its white and pale shades by the admixture of white pigments. This is generally called body color. The other employs transparent colors, and for whites and pale shades utilizes the white of the ground as in watercolors, or glazes for some effects, as in oils.

No strict line can be drawn between the two, for the materials and methods in general use are not entirely one or the other. Transparent painting usually shows some of the body color effect, and opaque painting often contains some of the other. The two systems may be used together in the same painting whenever the physical nature of the technique permits, but they cannot be mixed indiscriminately, and it must be borne in mind that they are two distinct methods of producing color effects. There are few technical procedures other than in the use of artist's paints where opaque and transparent color effects are manipulated or where their differences are so significant.

REQUIREMENTS FOR A PAINT PIGMENT

1. Should be a smooth, finely divided powder.
2. Should be insoluble in the medium in which it is used.
3. Should withstand the action of sunlight without changing color, under conditions to which the painting might normally be exposed.
4. Should not exert a harmful chemical action upon the medium or upon other pigments with which it is to be mixed.
5. Should be chemically inert and unaffected by materials with which it is to be mixed or by the atmosphere.
6. Should have the proper degree of opacity or transparency to suit the purpose for which it is intended.
7. Should be of full strength and contain no added inert or loading ingredients.
8. Should conform to accepted standards of color and color quality and exhibit all the desirable characteristics of its type.
9. Should be purchased from a reliable house that understands and tests its colors, selects them from worldwide sources, and can furnish information as to origin, details of quality, etc.

CLASSIFICATION OF PIGMENTS

Pigments may be classified according to color, use, permanence, etc. It is customary, however, to classify them according to origin, as follows:

A. Inorganic (mineral)
 1. Native earths: ochre, raw umber, etc.
 2. Calcined native earths: burnt umber, burnt sienna, etc.
 3. Artificially prepared mineral colors: cadmium yellow, zinc oxide, etc.
B. Organic
 1. Vegetable: gamboge, indigo, madder, etc.
 2. Animal: cochineal, Indian yellow, etc.
 3. Synthetic organic pigments.

General Characteristics of These Groups. Artificial mineral colors made with the aid of strong heat are generally of the greatest permanence for all uses, while those requiring delicate or very accurately balanced processing are less so. The artificial counterparts of the red and yellow earths are more brilliant and, if well prepared, superior in all other respects to the native products. In general, pigments derived from natural sources are less permanent than the average synthetic color. The synthetic organic pigments are characterized by a great brilliance and intensity. Some of them are remarkably permanent, but many others, particularly the older ones, are fugitive and have the defect of bleeding in oils. Many require the addition of inert bases during manufacture.

The native earths used as pigments occur all over the world, but there is always some special locality where each is found in superlative form or where conditions have been established which permit of its being purified to a greater or more uniform extent than is economically possible elsewhere. Substitutes for French ochre, Italian sienna, etc., are offered for reasons other than the purpose of supplying the best available product.

The natural impurities in some red earths are of such a character as to be harmful; therefore the artificial red oxides are preferred to them. The impurities or noncoloring constituents of the highest grades of ochre and the other permanent earth colors seldom present the same disadvantages.

The artificially prepared colors of American makes are equal if not superior to any others. Cobalt yellow, cerulean blue, cobalt green, and Naples yellow are made in very limited amounts almost entirely for artists' use and are therefore not produced in this country for economic reasons. European books still describe defects in pigments that have long since been overcome by American manufacturers.

There is some doubt as to the antiquity of the practice of refining, calcining, or otherwise treating the native earth pigments. Under the name of artificial or manufactured cinnabar, Theophrastus[1] described the purification and improvement of a fine variety of native red iron oxide and noted that it was a recent innovation, only ninety years old (fourth century B.C.). All the more complete records from Roman times on show that the procedures of calcination and levigation of the native earths was common practice. The identification of pigments found in ancient relics is not particularly difficult for the experienced technician and many studies have been made of them.

Lakes. A lake is a pigment made by precipitating or fixing a dye upon an inert pigment or lake base. The process may be compared to that of dyeing cloth, and a high degree of skill is required to produce good results. Lakes are made in a great range of hues and strengths. A *toner* is an organic pigment in its most concentrated form, containing no inert pigment; for satisfactory performance in artists' colors it often requires added inert pigment to contribute bulk to the paint and to decrease excessive tinctorial power. Alumina hydrate is the usual base for clear, transparent lakes such as are used as glazing colors, in printing inks, etc.; while blanc fixe is the best base for those to be used in heavy paints and for similar purposes where more body or opacity is required. Cheaper lakes, less clear in tone, are made on clay, barytes, etc. Green earth is valuable as a base for green lakes, as it is a species of clay which has a strong power of absorption for dyes. A lake is also occasionally made with a colored pigment as a base; for example, Tuscan red, a pigment made for industrial use, is made with alizarin on an Indian red base.

The dyestuffs used are synthetic products, although a few of the older extracts of vegetable and animal origin still survive for some special purposes—usually only because of their low cost, for lakes made from modern organic colors are greatly superior in every paint requirement to those obtained from the natural coloring extracts. Prior to the eighteenth century, lake usually meant red lake only. The term comes from the Indian *lac,* which is described under shellac. Scum or sediment from the dyers' vats, called *lacca* and consisting of dyed particles of shreds, fibers, dust, and other impurities, was collected and used as a pigment in Italy in early times.

Reduced or Let-down Colors. Commercial pigments are supplied for some industrial purposes in grades known as reduced or let-down colors. As a general rule they are condemned for use in artists' paints; none but

the purest, most concentrated grades available should be selected for use in permanent painting.

A reduced pigment is not ordinarily diluted with inert filler by the simple admixture of dry powders, but the inert material is usually introduced during the "striking" of a batch in the wet stage, thereby producing such an intimate mixture that the product has a brighter and less muddy tone than it would have had if the filler had been merely sifted into or ground together with the finished dry color. A reduced color is often marketed under the name of the color followed by the percentage of its pure pigment content, and pure pigment color of a type that is also largely used in let-down form (such as Prussian blue) is often labeled "C.P." (not meaning chemically pure in this case, but merely denoting full strength), an improvement over the former use of fancy names for various grades.

Mass Tone and Undertone.　The full-strength surface color of a pigment viewed by reflected light is called its mass or top tone; its color effect when it is spread out thinly is called its undertone. The undertone is discerned when a transparent color is spread out on glass and viewed by transmitted light or when an opaque color is used as a tinting color, diluted with much white. Some pigments have undertones which are distinctly different from their top tones; this is apparent in the average alizarin when it is viewed in a thin layer on glass held up to the light, or drawn out on paper as described on pages 111–12. Some synthetic organic reds used as industrial printing-ink colors have such bluish undertones that they can be used to produce two-toned effects. Other pigments display little or no differences between their top tones and their undertones. The paint chemists generally use the term "mass color" instead of "mass tone."

Composition of Pigments.　It should be noted that the chemical purity of pigments varies greatly; some are simple, almost pure compounds as described; others of equally high quality contain minor components either as natural impurities or as the result of ingredients added during manufacture to modify color or pigment properties.

Nomenclature　Pigments are named for their resemblances to objects in nature, for their inventors, their places of origin, the purposes for which they are used, and for their chemical compositions or derivations.

For centuries the nomenclature of pigments was confusing and unsystematic. The principal cause of confusion was the labeling of colors with fancy names by manufacturers and others, often for an ulterior mo-

tive. This has caused a single color to be known by a dozen different names and two or more entirely different colors to be known by the same name. Proposed systems of rational color nomenclature never made any great headway until the 1940s when the situation was clarified in the United States by the adoption of the Paint Standard described on page 651, now being revised.

As a general rule, the manufacturer of a prepared or mixed color or similar material sold under a trademarked name or under some indefinite designation such as "permanent green" or "primrose yellow" is not at all bashful about revealing its true composition when it is made of high-grade, approved ingredients, because he thereby gets credit for the use of correct or expensive raw materials. Products whose composition is kept secret have the disadvantage of being under suspicion. The artist who is concerned with the permanence of his work is advised to select only those colors whose pigment origin is clearly indicated by name, and, for the maintenance of our rational nomenclature, to reject colors whose no-menclature does not conform to that of the Paint Standard.

LIST OF PIGMENTS

Explanations. The following catalogue of pigments with their descrip-tions is a complete list for reference purposes, arranged in alphabetical order. Pigments are included whether or not they are fit for artists' use, because many inquiries refer to obscure and little-used colors; this list is followed by a section of approved pigments for the different techniques of painting, which in turn is followed by additional miscellaneous data on the pigments in common use, arranged according to color. The artist is advised to select only those colors whose pigment names conform to those of the Paint Standard and to help maintain our rational nomencla-ture by rejecting non-standard names. A standard nomenclature for art-ist's pigments has also been established in Great Britain.

The dates attributed to the older colors have been arrived at by a study and comparison of the literature on the subject. Some references are mentioned where the dates are obscure. Most of the dates of the more modern colors (eighteenth to twentieth century) have been obtained directly from original sources such as contemporary chemical and tech-nical publications. There is ordinarily an appreciable lapse of time between the discovery of a material and its introduction to the artist's pal-ette. Lists of dates showing the pigments in use in artistic painting during various eras have been published in the works of Laurie,[40] De Wild,[211] Eibner, and others, but none is exhaustive.

The name most generally used and accepted by artists and by color makers has been employed in the following list to head the description of the color, regardless of its derivation, and all synonyms have been made to refer to it. The nomenclature of the permanent pigments on the approved list conforms to the regulations of the above-mentioned Standard.

Where a name is purely a synonym and the colors are identical, it is entered thus:

GUIGNET'S GREEN. Viridian.

Where the color is basically the same but is either made by a different method or possesses somewhat different properties, it is listed thus:

CASALI'S GREEN. A variety of viridian.

Where the variation is sufficiently important to receive specific mention, it is either described in its place or mentioned under the main heading and listed as:

SCHEELE'S GREEN. See emerald green.

The general arrangement of the items in this list is as follows: name of the pigment, its chemical identification, description of its color, estimate of its value in permanent painting, and data on its discovery and introduction to the artist's palette. Details of manufacturing processes are more or less ignored except where they are a significant factor in the description or identification of a pigment. The reader may be referred, in italics, to a following discussion in this chapter, such as *Red Pigments* on pages 85–88.

ACADEMY BLUE. A mixed color, made of ultramarine and viridian.

ACETYLENE BLACK. See carbon black.

ACRA RED. A proprietary name for quinacridone red.

ACRIDONE RED. See pages 408–10.

ACRILAMIDE MAROON, MEDIUM.*

ACYLAMINO YELLOW.*

* Modern pigments of outstanding fade resistance are entirely acceptable for use in easel painting, and some of them have already been marketed by artists' color firms. I would not hesitate to use the ones whose color and pigment properties appealed to me. It should be noted that these pigments run from five to twenty times more lightfast than alizarin crimson, our oldest synthetic organic pigment (1876), which has always been included in lists of color approved for easel painting. Some specialists on pigments will object to their wholesale acceptance until their individual pigment properties have been investigated from the artist's viewpoint, and properties other than fade resistance, such as bleeding or solubility in oils and solvents, have been determined.

It is to be noted that the names of organic pigments are entered in a volume called the *Color Index* and are precise designations for specific chemical compounds. Variants with different letters or shade designations have different color and pigment properties and different degrees of permanence.

ALEXANDRIAN BLUE. Egyptian blue.

ALIZARIN BLUE. ALIZARIN GREEN. Clear, transparent, brilliant lakes ranging from an indigo blue to an emerald green. These colors are not to be used for permanent painting, although they are employed in printing inks and for other semipermanent uses. They are similar to alizarin red and violet in composition and will not fade readily, but they turn very dark, almost black, on continued exposure to light.

ALIZARIN BROWN. A rather dull but transparent brown. Its properties are identical with those of alizarin red. The brown may be produced as the result of an occasional off-color batch of red. Also called madder brown or brown madder. Permanent. See the following.

ALIZARIN CRIMSON. ALIZARIN LAKE. ALIZARIN RED. ALIZARIN SCAR- LET. Made by developing alizarin, an organic product made from an- thracene, a coal tar derivative. It is permanent, being the only synthetic organic pigment universally approved for artists' use from its intro- duction in 1868 to the late 1930s. Made in a rather limited range of shades from a rosy scarlet to a maroon, alizarins have a characteristic bluish undertone and are clear and transparent. They absorb much oil and are slow driers. Will not fade on long exposure to normal daylight but some samples show a tendency to become deeper in shade. Unlike the older madders, the modern high-grade alizarins may be mixed indiscriminately with all the other permanent colors. See madder lake and *Red Pigments*.

ALIZARIN CRIMSON, GOLDEN. A variant in which the usual bluish under- tone is absent. Preferred by some painters for flesh tones.

ALIZARIN VIOLET. A clear transparent purple lake made from purpurin, which along with alizarin is one of the ingredients of madder lake. Not sufficiently permanent for artists' use.

ALIZARIN YELLOW. A dull, rather brownish, but transparent yellow. Its pigment properties are the same as those of alizarin red, except that it is not so reliably permanent because grades of highest quality are rare on the market.

ALUMINA HYDRATE. Aluminum hydroxide, artificially produced. A white, fluffy, lightweight powder which becomes virtually colorless and transparent when it is ground in oil. It is widely employed as an inert base for lakes, particularly those used in printing inks, and with cetain pig- ments in artists' colors. Permanent. Objection to its indiscriminate use in artists' oil colors is based on its high oil absorption and the fact that be- cause of its transparency it does not mask or hide the color of the oil or the subsequent changes such as darkening of oil. It is often considered by manufacturers to be a necessary addition to some heavy oil pigments for artists' use, because it imparts desirable brushing consistency and stabil-

ity to tube colors. Alumina is the common name for aluminum oxide, not used as a pigment. See *Inert Pigments.*

AMERICAN VERMILION. A heavy, opaque lake pigment, usually made from eosine or scarlet dye on a red lead, orange mineral, or chrome red base. Not permanent. There is great variation of behavior in different specimens.

ANILINE COLORS. This term, as well as the term "coal tar colors," was used in the recent past to denote all synthetic organic pigments. It was principally used in disparagement, for, before the introduction of the newer superbrilliant, intense pigments of remarkable permanence in the mid-twentieth century, all such pigments (with the exception of alizarin and the phthalocyanines, which are not derived from aniline) were impermanent, ranging from very fugitive to semi- or fairly permanent. Aniline is but one of a large number of intermediates from which synthetic organic compounds are made, but it was used in many of the Basic and other early dyes and became a symbol for impermanent pigments. See pages 408 ff.

ANTHRAPYRIMIDINE YELLOW. See pages 408–10.

ANTIMONY ORANGE. ANTIMONY VERMILION. Antimony trisulphide. Bright colors, permanent to light and other conditions, but having the fault of blackening the lead pigments on account of the free sulphur most specimens contain. The orange is light and bulky, the vermilion somewhat heavier; they are rather dull powders in the dry state but bright when mixed with mediums. Obsolete for artists' use; replaced by cadmiums. Patented 1847 by Murdock, Scotland.

ANTIMONY WHITE. Antimony oxide plus about 70 percent blanc fixe. Preparation and properties similar to those of titanium white; similar claims made for it by the manufacturers. British trademark: Timonox. Introduced in 1920. Permanent, but slightly affected and darkened by sulphur fumes. Unnecessary for artists' use.

ANTIMONY YELLOW. Naples yellow.

ANTWERP BLUE. A pale variety of Prussian blue made by reducing pure Prussian blue with 75 percent of an inert pigment, usually alumina hydrate; sometimes contains zinc salts. Similar in properties but inferior to pure Prussian blue. Not for permanent painting.

ANTWERP RED. Light red.

ARMENIAN BOLE. A native red earth; see Venetian red.

ARNAUDON'S GREEN. A variety of chromium oxide green.

ARSENIC ORANGE. ARSENIC YELLOW. See realgar and King's yellow.

ARTIFICIAL ULTRAMARINE. See ultramarine.

ASBESTINE. A species of talc (hydrated magnesium silicate) mined in northern New York and used as an inert pigment in certain mixed paints.

Its physical structure causes it to float or remain in suspension unusually long, and when mixed with heavy pigments it tends to prevent rapid settling and caking in liquid paints. Permanent, but not usually used in artists' paints. Not the same as asbestos, a silicate of different structure.

ASPHALTUM. Not a true pigment color. A blackish brown solution of an asphalt in oil or turpentine. At one period it was extensively used as a glazing color. Dries badly, causes wrinkling and cracking, and develops almost every fault of oil colors, particularly if mixed with other oils and colors. Used for scumbling decorative work to simulate age, but not for permanent painting. Easily imitated by mixtures of permanent colors. Some asphalts are described on page 572. They have been used for protective coatings since prehistoric times; their use in artistic painting began with the rise of oil painting in the seventeenth century.

ATRAMENTUM. Roman name for blacks and black inks made of carbon.

AUREOLIN. Cobalt yellow.

AURIPIGMENTUM. King's yellow.

AURORA YELLOW. A variety of cadmium yellow, introduced by Winsor and Newton, England, in 1889.

AURUM MUSSIVUM. Mosaic gold.

AZURE BLUE. Smalt. Azure was a very early general term for blue. Modern meaning is usually a sky-blue shade of any composition.

AZURE COBALT. A variety of cobalt blue.

AZURITE. Native basic copper carbonate. Rare. Replaced by ultramarine, cobalt, and cerulean blues. Clear, deep blue. Permanent, but often contains malachite as an impurity. Its use as a pigment dates from Roman times. Works very poorly with oil; was used primarily in aqueous mediums.

AZZURO DELLA MAGNA. Azurite

AZZURO OLTREMARINO. (Blue from beyond the sea.) Ultramarine blue.

BARIUM YELLOW. Barium chromate. A very pale sulphur-colored yellow with a greenish tone. Somewhat transparent in oil but more opaque than zinc or strontium yellows. Compared with zinc and strontium yellows, the average barium yellow is very low in tinctorial power, and in appearance is like zinc yellow reduced with about 75 percent of white pigment. Insoluble in water. For all permanent painting. Probably first made soon after chrome yellow in the first quarter of the nineteenth century. See *Yellow Pigments*.

BARYTA GREEN. Manganese green. The term "baryta" is an obsolete form of barium.

BARYTA WHITE. Blanc fixe.

BARYTES. Native barite or heavy spar (barium sulphate), finely ground, washed, and bleached. A white powder with no coloring power and prac-

tically transparent in oil, where it tends to impart muddy tones. Used as an adulterant and inert pigment in cheap paints and colors. Very heavy. Use in paints probably began in the eighteenth century. See blanc fixe.

BENZOL BLACK. See carbon black.

BERLIN BLUE. Prussian blue; term used especially in France.

BIACCA. White lead.

BIANCO SANGIOVANNI. Calcium hydroxide plus calcium carbonate. A fresco white, described on page 327.

BICE. See Bremen blue.

BISMUTH WHITE. Bismuth nitrate. Obsolete since the introduction of zinc white. Had a brief and limited use during the early nineteenth century as a less poisonous substitute for white lead. It is more sensitive than white lead to the darkening action of sulphur fumes.

BISTRE. Yellowish brown soot containing wood tar, made by charring beech wood. Used only as a watercolor wash. Common variety soon fades; better grades fade more slowly, but it is never a reliable, permanent color. Dates from the middle of the eighteenth century. See *Brown Pigments*.

BITUMEN. Asphaltum.

BLACK LEAD. Graphite

BLACK OXIDE OF COBALT. A rather coarse black powder; properties are similar to those of black oxide of iron, but it is not now in use as a paint pigment. Used in ceramic glazes, where it imparts a deep blue color upon being fired.

BLACK OXIDE OF IRON. Mars black. Ferrosoferric oxide, approximately $1FeO$ plus $3 Fe_2O_3$. A dense, opaque, heavy color, absolutely permanent for all uses. A native variety also exists, but it is coarse and not suitable for artists' use. It is comparatively brownish in undertone, wets easily, and is nongreasy. Useful to replace the carbon blacks when these qualities are required. Attracted by magnet. The modern product is a twentieth-century development. See Mars colors, also *Black Pigments*.

BLACK OXIDE OF MANGANESE. Native manganese dioxide. Seldom produced in a finely ground form suitable for pigment use. Its properties are somewhat like those of black iron oxide except that it is still more brownish and is a powerful drier in oil; its principal use in paints and varnishes is as a raw material to prepare driers and drying oils. The native ore, pyrolusite, was, however, used as a pigment in early civilizations. Artificial manganese oxide is described under manganese black.

BLADDER GREEN. Sap green.

BLANC FIXE. Artificial barium sulphate, very much finer and fluffier than native barytes; they have the same chemical composition but are entirely different in pigment qualities. Used as a base for the more opaque lakes

and as an inert pigment in house paints, etc., where, if added in proper proportions (generally 10 percent), it is not considered an adulterant, as it imparts good weathering qualities. Almost transparent in oil, it is of no use in permanent oil painting, but has been recommended as a watercolor and fresco white, in which mediums it retains its white color and is permanent. Introduced in the early or middle nineteenth century in France.

BLEU CELESTE. Cerulean blue.

BLUE ASHES. See Bremen blue.

BLUE BICE. See Bremen blue.

BLUE BLACK. See vine black.

BLUE MALACHITE. Azurite.

BLUE VERDITER. See Bremen blue.

BOHEMIAN EARTH. Green earth.

BOLE. Various native red oxides of iron or clays colored with iron.

BOLOGNA CHALK. Slaked plaster of Paris.

BOLOGNA STONE. Barytes.

BONE BLACK. Made by charring bones. Contains only about 15 to 20 percent carbon, about 60 percent calcium phosphate, and about 20 percent calcium sulphate and other impurities, some of which are water-soluble. It should not be used in fresco or for mortar or cement coloring, as it causes efflorescence. Rather fine, light, and fluffy, but somewhat heavier and more compact than lampblack. Very slow drier in oil; stands up fairly well, but the use of a purer grade (ivory black) is wiser. Has a brownish undertone as compared to the vine black series. Probably dates from Roman times. See *Black Pigments*.

BONE BROWN. Similar to bone black. Made by partially charring bones, it contains incompletely carbonized animal matter. Not permanent.

BOUGIVAL WHITE. Bismuth white.

BRAZILWOOD LAKE. Brazilwood yields a blood-red extract which has been used to make dyes and lakes from very early times. It is less permanent than the synthetic pigments which have superseded it except for some few purposes where its lower cost is a prime consideration. The South American country was named after this product, which had long been an article of commercial importance in Europe.

BREMEN BLUE. Copper hydroxide plus copper carbonate. Produced in a number of shades of blue and greenish blue: some delicate and pale; some fairly deep, all semiopaque. Poisonous. There are a great many variations in the manufacture of this type of copper blue, each product bearing a separate name. Their properties are so similar, however, that in this list they have all been referred to this heading. Not intended for permanent painting, but semipermanent for other purposes. They have been superseded by the cheaper grades of ultramarine for most industrial uses. Prob-

ably first made early in the eighteenth century, they were widely used in the middle of the nineteenth, and continued in diminishing use until the twentieth century.

BREMEN GREEN. Greenish varieties and green shades of Bremen blue.

BRILLIANT SCARLET. See iodine scarlet.

BRILLIANT YELLOW. Naples yellow.

BRONZE BLUE. Prussian blue, especially that with a bronzy sheen.

BROMINATED ANTHANTHRONE ORANGE. See pages 408–10.

BROWN LAMPBLACK. Bistre.

BROWN MADDER. Alizarin brown.

BROWN OCHRE. A dull variety of ochre.

BROWN PINK. A brownish yellow lake of vegetable origin similar to Dutch pink.

BRUNSWICK BLUE. A let-down variety of Prussian blue. Large amounts of barytes are added during manufacture. Sometimes contains a little ultramarine. The name refers to the quality rather than to the exact shade. Not for permanent painting.

BRUNSWICK GREEN. Chrome green made from Brunswick blue and reduced chrome yellow.

BURGUNDY VIOLET. Manganese violet.

BURNT CARMINE. Roasted carmine, deep and dark. Fugitive.

BURNT GREEN EARTH. Deep, transparent brown, permanent and useful. Supplies of the dry pigment vary in shade.

BURNT OCHRE. Ochre that has been heated in a furnace until it has become brick red. Permanent, but weak in color compared with the red oxides. See light red.

BURNT SIENNA. Raw sienna that has been calcined or roasted in a furnace. Compared with the other earth colors, native or artificial, it has the most brilliant, clear, fiery, transparent undertone, and its red-brown top tone is least chalky in mixtures. Permanent. One of the most useful pigments in all techniques. See *Brown Pigments*.

BURNT UMBER. Made by calcining raw umber. Compared with raw umber it is much warmer, being reddish rather than greenish in tone, darker, and somewhat more transparent. Otherwise the remarks under raw umber apply to it.

BYZANTIUM PURPLE. See Tyrian purple.

CADMIUM COLORS. Cadmium orange and yellows are cadmium sulphide; cadmium red is three parts cadmium sulphide plus two parts of cadmium selenide. (Selenium is an element whose compounds resemble those of sulphur.) These pigments are made in a variety of shades, all bright, very opaque, and permanent. Most modern cadmiums are made by a method similar to that used for making lithopone and contain barium sulphate

(cadmium being a metal closely allied to zinc, the two enter into similar chemical combinations). These cadmium-barium colors or cadmium lithopones are superior in most pigment qualities to the older straight cadmium sulphides, and all the shades are permanent to light. Typical examples of the palest yellow shades contain 62 percent, and the deepest maroon 52 percent, blanc fixe (not as an adulterant; see lithopone). The cadmium-barium reds are obtainable in a variety of shades, from a close match for vermilion to a deep maroon. Cadmium red is one of the more recent of the inorganic colors; introduced by de Haen in Germany in 1907, it came into use in America in 1919. The yellows were introduced commercially in England in 1846, but it was some years before they were widely adopted, because of the former scarcity of the metal. There is some record of their use in France at least fifteen years earlier, in Germany in 1829, and are listed in New York art supply catalogs as early as 1842. The salt was discovered in 1817. See *Yellow Pigments; Red Pigments.*

CAERULEUM. See cerulean blue.

CALEDONIAN BROWN. A native earth, resembling burnt sienna but inferior.

CALEDONIAN WHITE. Lead chloro-sulphite. Obsolete.

CAPPAGH BROWN. Native Irish earth similar in shade but inferior to umber. Permanent.

CAPUT MORTUUM. Obsolete name for a very bluish red oxide of iron.

CARBAZOLE DIOXAZINE VIOLET. A modern synthetic organic pigment of good permanence but in a class below those listed on page 410.

CARBON BLACK. Pure carbon made by burning natural gas. An intense, velvety, black pigment, blacker than most of the other forms of carbon such as lampblack, ivory black, etc. A permanent pigment used in industrial black coatings. It is not in general use by artists or used as a tinting color because it tends to show in black streaks even after considerable mixing or rubbing with other colors. Acetylene and benzol blacks are more intense, softer, bluer varieties than can be made by burning natural gas. Invented in America in 1864, carbon black came into wide use about 1884. Lampblack, ivory black, and all the other varieties of carbon are sometimes grouped and referred to as carbon blacks. See *Black Pigments.*

CARMINE. A fugitive lake made from cochineal, a dyestuff extracted from a Central American insect. European use of the name dates from the middle of the sixteenth century. Recipes for its manufacture were published as early as 1656. See *Red Pigments.*

CARTHAME. Safflower.

CASALI'S GREEN. A variety of viridian.

CASHEW LAKE. Mahogany lake.

CASSEL EARTH. A native earth containing organic matter, similar to Vandyke brown. Not permanent.

CASSEL GREEN. Manganese green.

CASSEL YELLOW. See Turner's yellow.

CELADON GREEN. Green earth. This pigment contains the mineral celadonite, an iron silicate. Celadon means a pale or grayish green color. The Chinese celadon porcelain was named for its resemblance to this general shade.

CELESTIAL BLUE. A variety of Prussian blue, similar to Brunswick blue.

CERULEAN BLUE. Cobaltous stannate, a compound of cobalt and tin oxides. A bright sky blue, quite opaque. Permanent for all uses. Known as early as 1805. Introduced by George Rowney, England, in 1870 under the name Coeruleum, derived from *caeruleum,* Latin for sky-blue pigment, applied by the Romans mainly to Egyptian blue.

CERUSE. Obsolete name for white lead. From the Latin *cerussa.*

CHALK. Artificially prepared calcium carbonate in its whitest, finest, and purest form, usually called precipitated chalk. Of no use as a white pigment in oil, but when used in glue and other aqueous mediums as a ground for oil and tempera paintings, it retains its brilliant white color. It is the basis of most pastels. Has the same chemical composition as limestone, whiting, and marble, but contains no impurities, and is much whiter, being one of the whitest substances in use. Its wide use is apparently recent, dating from the nineteenth century. Older references to chalk are to native chalk (whiting).

CHAMOIS. Obsolete name for ochre.

CHARCOAL. Vine, willow, and other twigs charred for use as crayons. When powdered, charcoal has poor paint pigment qualities. See vine black.

CHARCOAL GRAY. Obsolete gray-black powder made from charcoal. Not suitable for pigment use.

CHESSYLITE. Azurite.

CHESTNUT BROWN. Umber.

CHINA CLAY. Native hydrated aluminum silicate. So called because it is used to make chinaware. As an inert pigment it has a variety of uses; in colors it serves chiefly as an adulterant. Lakes made on a clay base tend to be muddy. Kaolin is a very pure China clay.

CHINESE BLUE. A variety of Prussian blue. Highest quality.

CHINESE INK. India ink.

CHINESE RED. Chrome red.

CHINESE VERMILION. Genuine vermilion made in China.

CHINESE WHITE. Zinc white prepared for watercolor use, introduced by Winsor and Newton, England, 1834.

CHINESE YELLOW. King's yellow. The name has also been applied to bright ochres.

CHROME GREEN. Intimate mixture of Prussian blue and chrome yellow. The blue is made in a tank that contains the yellow, the yellow being used as a base. As there are many varieties of each of these two pigments, a great variety of greens may be produced. Their properties in general are the same as those of the chrome yellows, plus the defects of Prussian blue. Never used for permanent painting.

CHROME ORANGE. CHROME RED. CHROME YELLOW. Lead chromates. A large variety of shades, from a pale primrose yellow to a deep orange-scarlet, are produced by variations of the process of manufacture. They are opaque, work well with oil, and are used in large quantities in cheap paints. Even the best grades are not permanent, turning dark or greenish. They may also react with some of the other colors. Replaced perfectly by cadmiums for artists' use. Introduced in 1797.

CHROMIUM OXIDE GREEN. Chromium oxide. An opaque, cool, rather pale willow green. Not very strong in tinting power. A very heavy powder. Absolutely permanent for all purposes and conditions, including high temperatures. Known since 1809. Introduced commercially as an artists' pigment in 1862.

CHRYSOCOLLA. A native green copper silicate. Like malachite, it was used as a pigment in early civilizations. It was replaced by Egyptian green.

CINNABAR. Native vermilion, much inferior to the manufactured product. European use of ore from Spanish mines dates from an early Greek period. Theophrastus[1] says it was obtained from inaccessible cliffs by shooting arrows to dislodge it. Also found in relics of Assyrian and other early cultures. Obsolete.

CITRON YELLOW. Zinc yellow. This term is also applied to any pale greenish yellow. See remarks under primrose yellow.

COBALT BLACK. See black oxide of cobalt.

COBALT BLUE. Compound of cobalt oxide, aluminum oxide, and phosphoric acid. (Imitation cobalt blue, universally used in cheap paints, is a variety of ultramarine.) Bright, clear, nearly transparent, somewhat similar to ultramarine, but never so deep or intense, and with a comparatively greenish undertone. Permanent for all uses. Discovered by Thénard, France, 1802; introduced as an artists' color 1820–30.

COBALT GREEN. Compound of cobalt zincate and zinc oxide. A fairly bright green, not very powerful, but quite opaque. Has a bluish undertone, is permanent for all uses, and is made in a limited range of shades. Not in wide use. Discovered by Rinman, Sweden, about 1780; introduced as a pigment in 1835.

COBALT ULTRAMARINE. Gahn's blue. A somewhat outmoded variety of true cobalt blue made without phosphoric acid, generally considered inferior to Thénard's blue. Appears violet under artificial light. Permanent transparent, clear. This name has more recently been applied to the imitation cobalt blue, mentioned under ultramarine.

COBALT VIOLET. Cobalt arsenite or cobalt phosphate, the latter variety to be preferred as nonpoisonous. A clear, semiopaque pigment made in a variety of shades, bluish and reddish. It was originally prepared early in the nineteenth century, from a semirare native ore yielding a reddish pigment; later it was made artificially and the process was gradually improved until a real violet was developed. The two most available varieties sold in tube colors are the dark or deep, which is a blue-violet, and the light, which is a comparatively reddish and more subtle shade. Because some cobalt violets contain arsenic it should be handled with caution as a poisonous substance. Permanent. In use since about 1860.

COBALT YELLOW. (Aureolin.) Colbalt potassium nitrite. A bright, transparent yellow, permanent for watercolor, tempera, and oil, especially in glazes and for tinting; as a body color, its top tone is rather dull, muddy, and greenish. Supersedes gamboge. Compound discovered by N. W. Fischer, Breslau, 1830; first introduced in the form of paint pigment by Saint-Evre, Paris, 1852; introduced in England and the United States about 1860.

COELIN. Cerulean blue.

COERULEUM. English trade name for cerulean blue.

COKE BLACK. See vine black.

COLCOTHAR. Pure red oxide; obsolete term.

COLOGNE EARTH. Cassel earth.

CONSTANT WHITE. Blanc fixe.

COPPER BLUE. COPPER GREEN. See Bremen blue.

COPPER MAROON, R592-D. A modern revival of Vandyke red, developed by E. I. DuPont de Nemours & Company for use in automotive finishes and for blending with synthetic organic pigments to lower their cost while maintaining good properties.

CORK BLACK. See vine black and Spanish black.

CREMNITZ WHITE. High-quality corroded white lead made by a nineteenth-century variation of the Dutch process, litharge being used as a basic raw material instead of metallic lead. See *White Pigments*.

CRIMSON LAKE. See page 86.

CYANINE BLUE. A mixture of cobalt and Prussian blues; also the name of an organic dye.

CYPRUS UMBER. See raw umber.

DAVY'S GRAY. Powdered slate.

DERBY RED. Chrome red.

DEVONSHIRE CLAY. China clay.

DIAMOND BLACK. Carbon black.

DIATOMACEOUS EARTH. A form of silica or clay, light, fluffy, and absorbent. The particles are the remains of plant life and under a microscope some varieties exhibit lacy designs which are the skeletons of their original forms. In use as an inert filler.

DINGLER'S GREEN. A variety of chromium oxide green.

DRAGON'S BLOOD. A transparent resin of a blood-red hue; not a true pigment color. It will dissolve in alcohol, benzol, and some other solvents, but is practically insoluble in turpentine. Not permanent. Used in Europe at least as early as the first century. See *Colored Resins*, also pages 15 and 86.

DROP BLACK. Burnt grapevines. See *Black Pigments*.

DUTCH PINK. A fugitive yellow lake made from buckthorn (Avignon or Persian) berries; never intended to be used for permanent painting. Made for decorative purposes, its other names are brown pink, English pink, and *stil-de-grain*.

DUTCH WHITE. China clay; also Dutch process white lead.

EGYPTIAN BLUE. Mixture of copper silicates. Egyptian blue is one of the earliest artificial pigments, dating in Egypt from about 3000 B.C. The Cretans of the late Minoan period either imported the material or learned the process, and later it was used by the Romans (see Pozzuoli blue). It has long been replaced for paint use by smalt (the process of manufacture being analogous), which in turn has been replaced by the modern cobalt blues. For further description see frit. The true material in improved pigment form, originating in France or Germany and sold under the names of Italian and Pompeian blues, is not ordinarily obtainable here, and the bright blue color of Egyptian faïence may be found imitated by mixed pigments or organic lakes under these names.

EGYPTIAN BROWN. Mummy.

EGYPTIAN GREEN. A green variety or greenish shade of Egyptian blue.

EMERALD CHROMIUM OXIDE. Viridian.

EMERALD GREEN. Copper aceto-arsenite. The most brilliant of greens, very difficult to match, called Schweinfurt green in Europe. It is a bad pigment now universally rejected because some common varieties are not lightproof, because it is a dangerous poison, and because mixtures of emerald green with several other pigments will darken on short exposure. Sold as an insecticide under the name of Paris green. Before our nomenclature was standardized, viridian was frequently sold in America under its French name, vert émeraude, and confused with emerald green. Discovered by Scheele, Sweden, 1877. The color called Scheele's green, how-

ever, was copper arsenite, an inferior variation, discovered in 1778 and replaced by the industrial production of emerald green during the early years of the nineteenth century. The commercial process for emerald green was introduced in 1814 in Austria. See *Green Pigments* and *Brown Pigments*.

EMERAUDE GREEN. Viridian.

ENAMEL WHITE. Blanc fixe.

ENGLISH PINK. Dutch pink.

ENGLISH RED. Light red.

ENGLISH VERMILION. Genuine vermilion made in England.

ENGLISH WHITE. Whiting.

ESCHEL. A variety of smalt.

EUCHROME. Burnt umber.

FAWN BROWN. Mixture of raw or burnt umber with dark ochre.

FERRITE. FERROX. Trade names for Mars yellow.

FIRE RED. Not a specific pigment. Toluidine red, cadmium red, and others have been so labeled.

FLAKE WHITE. Basic lead carbonate. The best variety of corroded white lead is made by the so-called old Dutch process. A fine white color; works well in oil, with which it forms a smooth unctuous mixture. Its defects are its poisonous action if taken internally and its property of turning brown when exposed to sulphur fumes. Very opaque; absorbs less oil than any other heavy white pigment. Suitable for artists' use only if well protected by oil, varnish, or overpainting; under these conditions it is absolutely permanent. It should not be used in other mediums. The best quality is not darkened by mixture in oil with other well-made permanent colors. In use since the prehistoric Greek period, generally recognized as one of the earliest artificial pigments, it was the only white oil color widely available to artists until about the middle of the nineteenth century. Its use was not greatly diminished by substitution of newer whites until about 1910. See *White Pigments*.

FLAME BLACK. Made by burning coal tar, mineral oils, etc., by a process which produces a grade of carbon inferior to lampblack. Rather brownish, likely to contain oily impurities.

FLAVANTHRONE YELLOW.*

FLEMISH WHITE. White lead.

FLORENTINE BROWN. See Vandyke red.

FLORENTINE LAKE. Crimson lake.

FOLIUM. An ancient mulberry color of various vegetable origins. The term was superseded by more exact names of specific lake colors.

* See footnote on page 36.

FRANKFORT BLACK. Drop black.

FRENCH BLUE. Artificial ultramarine.

FRENCH CHALK. Talc is commonly sold under this name in America. French chalk is neither precipitated chalk nor Paris white, as might be suggested by its confusing name.

FRENCH ULTRAMARINE. Artificial ultramarine.

FRENCH VERONESE GREEN. Viridian.

FRENCH WHITE. Silver white. Unstandardized term.

FRIT. A vitreous substance, such as the blue or greenish blue glaze on Egyptian faïence, made by melting or fluxing siliceous materials with copper and other metallic salts which impart color to the mass. The hue of Egyptian blue frits may be imitated in paints by viridian plus cerulean and cobalt blues. The green phase was probably the result of overburning the blue. The term "frit" more correctly refers to any melted or fluxed ceramic glaze and may be white or colorless, but in reference to paint pigments it is usually applied to the above material. See Egyptian blue.

FULLER'S EARTH. A form of diatomaceous earth.

GAHN'S BLUE. Cobalt ultramarine.

GALLIOLINO. Naples yellow.

GALLSTONE. Variety of Dutch pink, said to have been made from oxgall; more often it was a yellow lake prepared from quercitron.

GAMBOGE. A native yellow gum from Thailand. Transparent. Not a true pigment color. Not reliably permanent. In use from medieval times to the nineteenth century. Superseded by cobalt yellow for permanent painting. See Colored Resins.

GARANCE. Madder lake.

GAS BLACK. Carbon black.

GELLERT GREEN. Variety of cobalt green.

GERANIUM LAKE. A vivid but impermanent synthetic organic pigment.

GERMAN BLACK. Drop black.

GIALLORINO. Obsolete and rather obscure term for an opaque, lead yellow. The one mentioned by Cennini may have been Naples yellow; other Italian writers referred to massicot as giallorino, giallolino, and giallolino di Fiandra. See Naples yellow.

GMELIN'S BLUE. Artificial ultramarine.

GOLDEN OCHRE. Ochre brightened by the addition of chrome yellow. Not permanent. See ochre.

GRAPE BLACK. Vine black.

GRAPHITE. An allotropic form of pure carbon. Principal uses: lead pencils, stove polish, anticorrosive paint, lubricant. Grayish black, semicrystalline, flaky, greasy. Permanent but seldom used as an artists' pigment in fluid paints.

GRECIAN PURPLE. Tyrian purple.

GREEN BICE. Green earth; also Bremen green.

GREEN EARTH. A native clay colored by small amounts of iron and manganese. Occurs in many localities, the best varieties being found in small deposits or pockets. The best European grades are known as Bohemian (pure green tone), Cyprian (yellowish), Verona (bluish), and Tyrolean (similarly bluish, but dull). These distinctions are seldom used in America, where no standard shades are recognized. Several American varieties are also on the market. The supply of the finest kinds is irregular. It is quite transparent and of extremely low hiding and tinctorial power; therefore, it is of slight value as a body color in opaque oil painting, but is used in glazes and as a watercolor wash. It was popular in Italy from the earliest recorded times, especially in tempera and fresco painting. It has a peculiarly good absorption for dyes and has therefore been used as a base for some green lakes. Permanent.

GREEN GOLD. A yellow pigment discussed on pages 408–10.

GREEN ULTRAMARINE. See ultramarine blue.

GREEN VERDITER. A greenish variety of the copper pigment described under Bremen blue.

GRISAILLE. A pigment consisting of a mixture of burnt umber, red lead, and quartz, used in stained glass. The term has also been used to describe a technique of painting. See page 628.

GUIGNET'S GREEN. Viridian.

GULF RED. Persian Gulf oxide.

GYPSUM. Native calcium sulphate, an inert pigment of little value in oil paints, except as an adulterant. Very white and sufficiently permanent in water vehicles to be used extensively in the paper and textile finishing trades and sometimes to prepare painting grounds. Its presence (either in native or artificial form) in pigments for permanent oil painting is not generally approved, as it is somewhat water-soluble, generally contains alkaline impurities, and imparts a brittle hardness to oil firms.

HAARLEM BLUE. Antwerp blue.

HANSA YELLOW. A bright pale yellow made from the modern synthetic dyestuff Pigment Yellow. Transparent or semitransparent, it is permanent in all easel-painting techniques. The name was originally a German trademark. See *Yellow Pigments*.

HARRISON RED. A trade name applied to several bright cherry reds of the lithol and para red class (azo). When first made, it was recommended because it was an advance in permanence over the older aniline lakes, but it is not sufficiently lightproof to be used for permanent painting. See page 99.

HATCHETT'S BROWN. See Vandyke red.

HEAVY SPAR. Barytes.

HOLLY GREEN. Green earth.

HOOKER'S GREEN. A mixture of Prussian blue and gamboge. Sold in two shades, yellowish and bluish, both of which are rather olive in tone. Not permanent, but a modern replacement made of phthalocyanine blue and cadmium yellow is perfectly acceptable when contents are specifically identified on the label.

HORACE VERNET GREEN. Copper green.

HUNGARIAN GREEN. Malachite.

IMPERIAL GREEN. Emerald green, reduced with inert pigment.

INDANTHRONE BLUE. See pages 408–10.

INDIA INK. American term for black drawing inks, carefully made of lampblack with aqueous binders. Various kinds contain additions to improve color and working properties. Permanent. See *Inks*.

INDIAN BLUE. Indigo.

INDIAN LAKE. Lac.

INDIAN RED. See red oxide. Formerly this name was applied to a very pure native red oxide from India. It is now the standard name of the best grade of manufactured pure iron oxide, bluish shade. Early American painters also used the term to describe a color typical of an earth used by the Indians. See *Red Pigments*.

INDIAN YELLOW. An obsolete lake of euxanthic acid made in India by heating the urine of cows fed on mango leaves. It was a fairly bright, transparent yellow of average tinctorial power, nonpoisonous, and was approved by most nineteenth-century investigators as a permanent pigment. However, because few of the Indian yellows were genuine and many of the semipermanent aniline colors were sold under this name, it fell into disrepute. The color has had a long history in India. It seems to have appeared in England about the beginning of the nineteenth century as a material of unknown origin, and its curious method of production did not become known until the eighties. Although its chemical composition was known before that, the pigment has never been reproduced or synthesized on a commercial scale. True Indian yellow has been absent from the market for some time; its production is said to have been prohibited in 1908. At any rate, reliable dealers and manufacturers have replaced it with the more desirable modern light-resisting lakes such as Hansa yellow or by cobalt yellow. Cheap colors labeled Indian yellow are synthetic products of varying degrees of permanence.

INDIGO. A deep, transparent blue originally obtained from plants cultivated in India. A better grade has been made synthetically from coal tar

since the end of the nineteenth century. It is not entirely lightproof and has long been discarded as a permanent artists' color. It was used in Europe from very early times, principally as a dyestuff.

INFUSORIAL EARTH. Diatomaceous earth.

INTENSE BLUE. Variety of indigo lake. Recently applied also to phthalocyanine blue.

IODINE SCARLET. Mercuric iodide. A vivid geranium red, like a synthetic color in brilliance and purity of tone, but much less permanent, fading rapidly to a pale yellow on exposure to light. Extremely poisonous. Useless as a pigment.

IRIS GREEN. Sap green. Originally the name of an obsolete lake made from the juice of iris flowers.

IRON BLACK. Precipitated metallic antimony, not in use as a pigment. Also see black oxide of iron.

IRON BLUE. Prussian blue.

IRON BROWN. Prussian brown.

IRON YELLOW. Yellow oxide of iron.

ISO VIOLANTHRONE BLUE. See pages 408–10.

ITALIAN BLUE. Egyptian or Pozzuoli blue. Name also used for imitations made from lakes or for special shades of Bremen blue.

ITALIAN EARTH. Sienna.

ITALIAN PINK. Variety of Dutch pink.

IVORY BLACK. Impure carbon. The black most widely used by artists. Most (and probably all) ivory black on the market is really high-grade bone black. Permanent. True ivory black, carbon made by burning ivory scraps, has the same properties as bone black, but is finer, more intense, and of a higher carbon content—probably because it is made with greater care on account of the value of the raw material. See bone black and *Black Pigments.*

JACARANTA BROWN. Burnt umber.

JAUNE BRILLANT. Naples yellow.

JAUNE D'ANTIMOINE. Naples yellow.

KAOLIN. A pure clay, sometimes used as a filler; very similar to and often the same as the material sold as China clay or pipe clay.

KASSLER YELLOW. Turner's yellow.

KERMES. An obsolete crimson lake made from a dyestuff of insect origin. Used in Roman and medieval times. See page 86.

KERNEL BLACK. Vine black.

KIESELGUHR. A variety of diatomaceous earth.

KING'S BLUE. Cobalt blue; formerly smalt.

KING'S YELLOW. Arsenic trisulphide artificially made. Originally it was made by powdering the native mineral orpiment. Very bright yellow;

opaque; works well in oil. Very poisonous. Not reliably permanent. The native orpiment is said not to be poisonous, or at least not dangerously so, and was freely used in the earliest civilizations. These materials, extensively used throughout the history of art, have become obsolete since the introduction of the cadmium yellows. The artificial varieties were probably introduced in the early eighteenth century.

KREMS WHITE. Cremnitz white.

LAC. Not a true pigment. A resin with a deep, transparent, brownish red color. Not permanent. Obsolete, having been replaced by alizarin. Used since early medieval times. Described under shellac.

LAKE BASE. Both blanc fixe and alumina hydrate are given this name. See page 33. See also definition of base on page 626.

LAMPBLACK. Pure carbon. A fine, light, fluffy powder obtained by collecting the soot from burning oils, fats, etc. The most familiar and widely used of the pure carbon black group. Permanent for all paint purposes. In use since prehistoric times. See *Black Pigments.*

LAPIS LAZULI. See ultramarine.

LAZULINE BLUE. Native ultramarine.

LEAF GREEN. Chrome green.

LEEK GREEN. Chrome green.

LEIPZIG YELLOW. Chrome yellow.

LEITHNER BLUE. Variety of cobalt blue.

LEMON YELLOW. Barium yellow. Also a general term in common use for a pale yellow shade, rather than a designation for a pigment of any particular composition, and often applied indiscriminately to pale chrome, zinc, or cadmium yellows and others. See remarks under primrose yellow.

LEYDEN BLUE. Variety of cobalt blue.

LIGHT RED. This term is now applied to the more intense pure oxides of the Mars or English red type, but originally it was intended to describe a good grade of burnt ochre of a shade between Indian red and Venetian red; these are permanent, but not so desirable as the pure red oxides, which are cleaner and more powerful. See *Red Pigments.*

LIME BLUE. See Bremen blue.

LITHARGE. Lead monoxide. A heavy, yellowish powder, obsolete as a paint pigment, used as a drier in varnish cooking.

LITHOL RED. A bright synthetic organic lake pigment of the azo class, with a bluish undertone. Used in printing ink and industrial paints; it is not sufficiently fade-resistant for artists' use.

LITHOPONE. Zinc sulphide 30 percent, barium sulphate (blanc fixe) 70 percent, intimately combined by chemical means, the blanc fixe being coalesced with and becoming an integral part of the pigment, not an adulterant. Greater proportions of zinc sulphide do not always improve

it. A fine, white, opaque pigment which has largely replaced zinc oxide for interior house paints because of its good structural properties and its lower cost. Originally lithopones had the defect of turning dark on one day's exposure to sunlight, becoming bright again after a night's darkness. Modern methods of manufacture have minimized this photogenic property, but lithopone is not used as an artists' pigment, although generally approved for use in grounds. Sometimes added to zinc white to impart opacity. Lithopones came into wide industrial use early in the twentieth century. Their development was gradual; the first patent (Orr's white) was issued in 1874.

MADDER BROWN, OR BROWN MADDER. Same as alizarin brown.

MADDER LAKE, ROSE MADDER. Madder, made from the root of the madder plant (*Rubia tinctorium*), was used as a textile dye in ancient Egypt, Greece, and Rome, being the most permanent of the maroon or ruby colors of natural dyestuff origin. Said to have been introduced into Italy by the Crusaders, it was cultivated in Europe from the thirteenth century on, but it does not seem to have been very widely used, if at all, in lake pigments, in either medieval or Renaissance painting. Chemists gradually improved its manufacturing process in the second half of the eighteenth century, and in 1826 its coloring principles, alizarin and purpurin, were identified by Robiquet and Colin in France, who treated the root with sulphuric acid and sold the extract as *garancin*. This superior product established madder lake in wide use for more than fifty years, until it was superseded toward the end of the nineteenth century by alizarin crimson.

MAGENTA. A fugitive lake made from one of the earliest synthetic dyes, named for the site of a battle in Italy in 1859. Also the standard color name for a deep violet red. See page 115.

MAGNESIA WHITE. An unstandardized name for artificial or native magnesium carbonate.

MAGNESITE. Native magnesium carbonate used occasionally as an inert pigment. Permanent. Properties similar to those of whiting. Calcined magnesite is an entirely different material; see page 596.

MAGNESIUM CARBONATE. Artificially made. Probably the very whitest inert pigment. Sold in two forms: heavy, which has properties similar to those of precipitated chalk; and light, which is an extremely bulky, light, fluffy powder of the same chemical composition.

MAHOGANY LAKE. A red or brown lake made on a burnt sienna base, not reliably permanent. Burnt umber and the deeper shades of burnt sienna are sometimes used as mahogany oil stains, and hence sometimes go by the name of mahogany brown.

MALACHITE. Native basic carbonate of copper. Fine, clear, yellowish

green. Used as a pigment by earliest civilizations. Not reliably perma-
nent. Also made artificially; see Bremen blue.

MANGANESE BLACK. MANGANESE BROWN. Manganese dioxide, prepared
artificially. Permanent. Extremely powerful drier in oil. Not in common
use. Patented as a pigment by Rowan, England, 1871. The native variety
is listed under black oxide of manganese.

MANGANESE BLUE. Barium manganate. A brilliant, clear, greenish,
transparent, permanent azure color, its mass tone is a fairly close match
to the opaque cerulean blue. Barium-manganese compounds of this type
have been known to chemists and color makers since the nineteenth cen-
tury, but they have been freely available to artists only since the mid-
twentieth century. See page 83.

MANGANESE DIOXIDE. Manganese black.

MANGANESE GREEN. A green variety of manganese blue; has also been
known as Cassel or Rosenstiehl's green. Not ordinarily available.

MANGANESE VIOLET. Made by combining manganese chloride, phos-
phoric acid, and ammonium carbonate. A permanent violet color resem-
bling the deep or bluish variety of cobalt violet and having the same
general properties. Introduced in Germany in 1868. See *Violet Pigments*.

MAPICO COLORS. Trademarked name of a series of permanent Mars
colors. Introduced by Fireman, Alexandria, Virginia, about 1900.

MARBLE DUST. Native calcium and/or magnesium carbonate, described
on page 328.

MARC BLACK. Vine black.

MARS COLORS. Artificial oxides of iron. The variation in shades and hues
is due to processes of manufacture. All are absolutely permanent and
have the same general properties as the pure red oxides. Mars brown
contains some manganese. Mars black is described under black oxide of
iron, Mars yellow under yellow oxide. The Mars reds are sold in a num-
ber of shades from a bright scarlet to a very bluish variety known as Mars
violet, described under *Violet Pigments*.

MASSICOT. An obsolete yellow oxide of lead, similar to litharge; usually
deeper or more pinkish in hue. Never was considered permanent.

MAUVE. A fugitive synthetic organic lake pigment. A variety of brilliant
mauve pigments is made in two types, reddish and bluish. Mauve or Per-
kin's Violet, discovered by Sir William Perkin, England, 1856, was the
first commercial pigment made from coal tar intermediates.

MERCURY YELLOW. Basic sulphate of mercury. Obsolete. See turpeth
mineral.

MICA. An inert pigment made from a complex silicate that occurs in
transparent laminated form, which can split into very thin layers or
sheets.

The white powder has a brilliant sparkle; it has been used in industrial water paints to impart this quality to them and also because its flat, flaky particles help to prevent rapid settling of fluid paints and improve their structural properties. Its use in permanent artists' materials is considered unwise because of the liability of future cleavage and splitting of the particles. Micronized mica, a modern development, is an extremely fine powder also used to improve structural properties and is said to be suitable for more permanent uses. See page 352.

MILORI BLUE. Prussian blue. The term is usually applied to the purest and highest quality grades.

MINERAL BLACK. A name variously applied to graphite, native black iron oxide, vine black, and artificial black oxide.

MINERAL BLUE. Azurite. Antwerp blue and manganese blue have also been sold under this name.

MINERAL BROWN. Burnt umber.

MINERAL GRAY. Ultramarine ash.

MINERAL GREEN. Malachite. Also Bremen green.

MINERAL LAKE. Obsolete. A yellow tin (stannic) chromate or combined chromate and oxide calcined with potassium nitrate. Name has also been applied to potter's pink.

MINERAL TURBITH. Turpeth mineral.

MINERAL VIOLET. Ultramarine violet. Also manganese violet.

MINERAL WHITE. Gypsum.

MINERAL YELLOW. Turner's yellow.

MINETTE. Ochre.

MINIUM. Red lead. Term used during the Middle Ages; earlier, the Romans had applied it to their native vermilion, cinnabar, and to a lesser extent, to a refined red oxide. Perhaps because cinnabar was often adulterated with red lead the term "minimum" was gradually more specifically applied to this mixture, and eventually to straight red lead. The word "miniature" derives from its use in illuminated manuscripts.

MITTIS GREEN. Copper arsenate, a variant of Scheele's green.

MITTLER'S GREEN. A variety of viridian.

MONASTRAL COLORS. Trademark name for phthalocyanine colors.

MONOLITE YELLOW. Trademark name for Hansa yellow.

MONTPELIER GREEN. Verdigris.

MONTPELIER YELLOW. Turner's yellow.

MORELLE SALT. Old name for manufactured red oxide.

MOSAIC GOLD. Metallic powder of complex composition, principally bisulphide of tin. Formerly used as a cheap substitute for powdered gold. Replaced by modern bronze powders.

MOSS GREEN. Chrome green.

MOUNTAIN BLUE. Azurite; also Bremen blue.

MOUNTAIN GREEN. See Bremen blue. The name was also formerly applied to native malachite.

MUMMY. Bone ash and asphaltum, obtained by grinding up Egyptian mummies. Not permanent. Its use was suddenly discontinued in the nineteenth century when its grisly composition became generally known to artists.

MUNICH LAKE. Carmine.

MYRTLE GREEN. Chrome green.

NACARAT CARMINE. Best grade of carmine. Obsolete.

NAPLES YELLOW. Lead antimoniate made by calcining litharge with antimony trioxide. A heavy, semiopaque yellow, made commercially in limited amounts in about six shades, from a greenish yellow to a comparatively pinkish orange yellow. Made artificially since at least the fifteenth century. Its early history is rather obscure and some of the synonyms referred to in this list are not well established as being identical. Cennini supposed it to be a native volcanic earth from Vesuvius. Similar antimony yellows have been found in Babylon tiles dating back to the fifth century B.C. Permanent, except that the usual precautions for the use of lead pigments apply to it. Often imitated in tube colors, by mixtures such as zinc oxide, cadmium yellow, and ochre, but see *Yellow Pigments.* Also see giallorino.

NATIVE GREEN. Native chromium oxide. Obsolete.

NEUTRAL ORANGE. A blended or mixed color. If pure, should be composed of cadmiums and red oxide.

NEUTRAL TINT. A grayish violet prepared watercolor made of India ink, phthalocyanine blue, and a small amount of alizarin.

NEW BLUE. Name applied originally to a variety of cobalt blue which contains chromium, but special shades of ultramarine were also sold under this name.

NICKEL-AZO YELLOW. Green gold.

NITRATE GREEN. A modern blue-toned variety of chrome green.

OCHRE. Widely called yellow ochre, a clay colored by iron and produced in a number of dull yellow shades. Opaque. Absolutely permanent. The best, most carefully washed and refined grades come from France. Its use dates from prehistoric times. Golden ochre is ochre brightened by the addition of chrome yellow and is therefore not a permanent color. Transparent gold ochre is a name used by some artists' material makers for a permanent color which is either ochre mixed with alumina hydrate or a rather rare dark native ochre which is naturally transparent. See *Yellow Pigments.*

OIL BLACK. Lampblack.

OIL GREEN. Bremen green; also a variety of chrome green.

OLEUM WHITE. Lithopone.

OLIVE GREEN. A designation that may be in use for any one of many mixtures. Applied principally to certain chrome greens. Use of such unstandardized terms should be discouraged.

ORANGE MINERAL. A lead oxide, very similar to red lead, but more yellowish, paler, and not quite so heavy. Less reactive in oil and more suitable for industrial pigment color use than red lead but not used in prepared artists' colors.

ORANGE VERMILION. A variety of real vermilion.

ORIENT YELLOW. A variety of deep cadmium yellow.

ORPIMENT. See King's yellow.

OSTRUM. Roman name for Tyrian purple.

PAYNE'S GRAY. A mixture of ultramarine, black, and ochre, usually sold only as a prepared watercolor. See page 74.

PANNETIER'S GREEN. Viridian.

PARA RED. Paranitraniline toner or lake. A bright cherry red, fairly permanent for industrial use. Bleeds in oil. Its undertone is bluish and less clear than those of other reds. It is not used in permanent painting.

PARIS BLACK. An inferior grade of ivory black.

PARIS BLUE. A general term for Prussian blues, term used especially in Germany.

PARIS GREEN. Common name for emerald green, generally applied when the powder is used for purposes other than pigment—for instance, as an insecticide.

PARIS WHITE. See whiting.

PARIS YELLOW. Chrome yellow.

PASTE BLUE. Prussian blue.

PATENT YELLOW. Turner's yellow.

PERMALBA. Trade name for a prepared artists' white, F. Weber, United States, 1920.

PERMANENT BLUE. Not an acceptable term. Usually applied to ultramarine blue, but sometimes to an organic pigment.

PERMANENT CARMINE. A modern synthetic organic pigment of good permanence but in a class below those listed on pages 408–10.

PERMANENT GREEN. When prepared by a reliable manufacturer, this is a mixture of various permanent greens and yellows in oil or watercolor. The artist can easily mix these pigments himself, and products sold under such an unstandardized name may be inferior. However, manufacturers who use such names usually state the composition on their labels, and many artists value the convenience of ready-mixed shades. Victoria green is sometimes called permanent green.

PERMANENT RED.*

PERMANENT VIOLET. Manganese violet.

PERMANENT WHITE. Blanc fixe.

PERMANENT YELLOW. Barium yellow. The name permanent yellow is not widely accepted as a specific term and is no certain guarantee that barium yellow is meant; it may refer to some of the semipermanent synthetic pigments. See primrose yellow.

PERSIAN GULF OXIDE. A variety of native red oxide of iron, usually containing 25 percent silica.

PERSIAN ORANGE. An impermanent, opaque lake color.

PERSIAN RED. Light red. Also a variety of chrome red.

PERYLENE MAROON.*

PHOSPHO-TUNGSTIC PIGMENTS. Discussed on page 412.

PHTHALOCYANINE BLUE. Copper phthalocyanine. A deep, intense cyan or greenish blue whose pigment properties and color effects are identical with those of Prussian blue, including its coppery bronze and great tinctorial power when in concentrated form. It is completely permanent in all painting techniques and has replaced the less reliable Prussian blue on the artist's palette. Invented in England in 1935, it was first marketed in 1936. See *Blue Pigments*.

PHTHALOCYANINE GREEN. Chlorinated copper phthalocyanine. A green phase of phthalocyanine blue, equally permanent and with identical pigment properties. Its hue resembles that of viridian except that it has a more intense and cleaner color effect. Introduced in 1938. See *Green Pigments*.

PIGMENT GREEN B.*

PIGMENT YELLOW. See Hansa yellow.

PINE SOOT BLACK. A Chinese lampblack, pure carbon.

PLESSY'S GREEN. A variety of chromium oxide green.

PLUMBAGO. Graphite.

POLIMENT. Bole, native red oxide.

POMPEIAN RED. A variety of Indian red.

POTTER'S PINK. Stannic (tin) oxide roasted with various other metallic oxides to produce several variations of pure, but not very intense, pink color. Used in ceramics and of interest to fresco painters, who may welcome it on account of their limited palette. Permanent but not of sufficient tinctorial power to be worth using in other techniques. Not ordinarily available. See remarks on ceramic colors.

POZZUOLI BLUE. Egyptian blue. According to Vitruvius, the process was brought from Egypt to Pozzuoli (Puteoli) in Italy, via Alexandria.

POZZUOLI RED. This name is applied by fresco painters to a red earth

* See footnote on page 36.

originally produced at Pozzuoli—a species of clay or natural cement capable of setting to a hard plasterlike mass when mixed with water. Both the high-grade artificial red oxides and a native earth of a peculiar rosy shade have been sold under this name. The modern fresco painter is more interested in the hue of Pozzuoli red than in its setting properties, which in fresco might be a defect rather than an advantage. See page 82.

PRIMROSE YELLOW. The name primrose is generally used to designate the very lightest or palest shade of yellow and is indiscriminately applied to chrome yellows, zinc yellows, cobalt yellow, etc. The continued use of names of this type adds to the confusion of pigment nomenclature, and should be discouraged at all times. Paints that are labeled with odd names cannot be sold under the guarantee of the Paint Standard (see page 35).

PRUSSIAN BLUE. Ferric-ferrocyanide. A deep, intense cyan or greenish blue; transparent and of extremely high tinctorial power. A great variety of shades exist, depending on variations in manufacture. The concentrated color has a bronze sheen. Large quantities of the cheaper grades are used in commerce. The finest grades, which are rare on the market, are fairly permanent except when used in thin coats and glazes, or excessively diluted with white. As regards absolute permanence, Prussian blue is one of the "borderline" colors; in permanent painting it is now replaced by phthalocyanine blue. A large number of names are given the various shades and grades; the most generally accepted names for the best qualities in America and England are Chinese blue and Milori blue. Discovered by Diesbach, Berlin, 1704; introduced as a pigment about twenty years later; process first made public by Woodward, England, 1724. See *Blue Pigments.*

PRUSSIAN BROWN. Iron (ferrous) hydroxide (Indian red in its raw or unburned state). Formerly made by burning Prussian blue. Opaque, permanent, but not ordinarily used as a pigment. Is a powerful drier and is so used in the preparation of patent leather and oilcloth oils, where it has desirable properties.

PRUSSIAN GREEN. Brunswick green.

PRUSSIAN RED. Light red.

PUMICE. Powdered volcanic rock. A grayish inert pigment and abrasive often used to impart tooth to grounds. See Index.

PURE SCARLET. Iodine scarlet.

PUREE (PWREE). Crude Indian yellow.

PURPLE OF THE ANCIENTS. See Tyrian purple.

PYRANTHRONE RED. See pages 408–10.

QUINACRIDONE PIGMENTS. See pages 408–10, 412, 658.

RAW SIENNA. A native clay which contains iron and manganese. Best

grades come from Italy. Absolutely permanent. Color similar to that of a dark ochre but more delicate and less opaque. See *Yellow Pigments*.

RAW UMBER. A native earth. Its composition is similar to that of sienna but it contains more manganese. A dark brown, its tones vary from greenish or yellowish to violet-brown. Not entirely opaque. Absolutely permanent. Good grades come from Italy; the best grade (Turkey umber) comes from Cyprus. See burnt umber and *Brown Pigments*.

REALGAR. Native arsenic disulphide; reddish orange; poisonous. It occurs in small deposits in all parts of the world and was used in very early times; has been found in relics of most of the primitive civilizations. An artificial variety similar to King's yellow was also made. Survived until the late nineteenth century; now obsolete, replaced by cadmiums. See King's yellow.

RED LAKER. (Copper complex)*

RED LEAD. Composed of lead monoxide and lead peroxide. A very opaque, heavy, brilliant scarlet red. Its color darkens on exposure; in oil it brushes out poorly. No longer in wide use as an artistic or decorative pigment. Industrially, it is widely employed for its physical and chemical properties; it is used in oil as a priming coat for steel and is valued as a powerful drier. Was made by the Greeks and Romans; one of the early artificial pigments.

RED OCHRE. Native red clay containing oxide of iron. See Venetian red.

RED OXIDE. Manufactured iron (ferric) oxide, Fe_2O_3. Many shades, all brighter, stronger, finer, and more permanent than the native products described under Benetian red. They replace the native iron oxides for most uses. Very opaque, absolutely permanent. The best-grade bluish shades are called Indian red; the yellowish or scarlet shades, light red. A very bluish or purplish oxide, known as Mars violet, is also made. Formerly there was much confusion in the nomenclature of the red oxides; the terms given in this list are those specified in the Paint Standard. See *Red Pigments*.

RINMAN'S GREEN. Cobalt green.

RISALGALLO. Realgar.

ROMAN OCHRE. Variety of ochre.

ROSE MADDER. Term applied to a grade of madder or alizarin lake very much weaker than the color sold as alizarin crimson or madder lake.

ROSE PINK. Weak, fugitive lake made from brazilwood.

ROSENSTIEHL'S GREEN. Manganese green.

ROUGE. Artificial red oxide of iron, very finest and smoothest grain, any shade. Polishing rouges may often be brownish off-shades, unsuitable for pigment use.

* See footnote on page 36.

ROYAL BLUE. A "fancy" name variously applied to smalt, to a variety of artificial ultramarine, and to numerous synthetic organic lakes.

ROYAL GREEN. Chrome green.

ROYAL RED. A bright lake, made from eosin. Fades rapidly.

ROYAL YELLOW. King's yellow.

RUBENS BROWN. A variety of Vandyke brown.

RUBENS MADDER. An alizarin red with a bright, clean, brownish orange tone. See alizarin brown.

SAFFLOWER. A fugitive red lake made from dried flower petals of the safflower plant (*Carthamus tinctorius*). This name was also a distortion of zaffer.

SAFFRON. An obsolete bright yellow color obtained from the dried petals of *Crocus sativus.* Fades badly in daylight. Used in Roman times.

SANDARACA. Some confusion surrounds the early history of this term, which was used by the Greeks and Romans to describe orpiment, realgar, and also sometimes cinnabar, the red earths, and a lead oxide yellow. Since medieval times, however, the term "sandarac" has been applied exclusively to a varnish resin.

SAP GREEN. A lake made from unripe buckthorn berries. Fades rapidly.

SATIN WHITE. A mixture of alumina hydrate and gypsum, used in the manufacture of coated paper.

SATURNINE RED. Red lead.

SAXON BLUE. Smalt.

SCARLET LAKE. The old scarlet lakes were semitransparent compounds of cochineal lakes and vermilion; the modern ones are colors made from dyestuffs of the same name. Not permanent.

SCARLET VERMILION. Vermilion.

SCHEELE'S GREEN. A poisonous copper green discovered in Sweden in 1778 by the German chemist C. W. Scheele. Color is inferior to emerald green.

SCHNITZER'S GREEN. A variety of chromium oxide green.

SCHWEINFURT GREEN. Emerald green.

SELENIUM RED. Cadmium red.

SEPIA. Prepared from the ink sacs of various cephalopodous animals, principally the cuttlefish. Semitransparent, very dark brown, powerful; may be diluted to a variety of tones and shades. Used only as a watercolor or ink. Not entirely permanent to light. See *Brown Pigments.*

SHALE. See slate black.

SICILIAN BROWN. Raw umber.

SIENNA. See raw sienna and burnt sienna.

SIGNAL RED. A variety of para red.

SIL. Roman name for ochre. Their finest grade was Attic sil from Greece.

SILEX. Silica.

SILICA. Native silicon dioxide; powdered quartz. An inert pigment, coarse texture, no coloring power. Permanent, but not ordinarily employed in artistic painting. Used in grounds and in industrial mixed paints to impart tooth and as an adulterant. Sold in many degrees of coarseness. See Index.

SILVER WHITE. A nonstandard term that has been used for both flake and zinc whites. In French, *blanc d'argent* means flake white.

SINOPIA. (Also sinope, sinoper.) The ancient Roman name for native red iron oxide. By extension, the red preliminary outline painted on fresco plaster before applying the intonaco. See pages 332–33.

SKY BLUE. Pale artificial ultramarine.

SLATE BLACK. Powdered slate or shale, one of the earliest black pigments used in water mediums. A rather grayish black with poor opacity and low tinting power compared with the carbon and iron blacks. It is still obtainable, being used for some industrial purposes, but is always very coarse and has poor physical properties. Its hardness destroys the surfaces of grinding mills; it is, therefore, never ground very fine. Red, green, and gray slate powders are also made. Permanent, but of small value as a pigment. A shale black containing 15 percent of carbon is made by calcining bituminous shale.

SMALT. A kind of cobalt blue glass or frit, made by roasting a cobalt ore with other ingredients, much as the Egyptian blue frit was made; in fact, historically, it is considered a direct continuation of the Egyptian color, the improvement being the substitution of cobalt for the more poisonous and less desirable copper. Cobalt has been found as an ingredient in various ancient blue ceramics, and as an impurity in copper blues, but pigments derived from cobalt ores are usually held to be a Northern innovation. During the height of its importance, before the introduction of artificial ultramarine, smalt was most carefully made in a number of standard grades, but today it finds only a limited use in ceramics and as a signpainter's material. Its faults were its coarseness, its lack of tinctorial power, and the presence of alkaline impurities. It was first made in Saxony in the seventeenth century.

SMARAGD GREEN. Viridian.

SNOW WHITE. Zinc white.

SOLFERINO. A fugitive red-mauve lake made from magenta and, like it, named for the site of a battle in Italy in 1859.

SOLUBLE BLUE. A variety of Prussian blue that dissolves in water. Used for ruling lines on writing paper and as a laundry blue.

SPANISH BLACK. Charcoal made from cork; also slate black.

SPANISH BROWN. Burnt umber.

SPANISH RED. See Venetian red.

SPANISH WHITE. Paris white in lump form. This name was also formerly applied to the now obsolete bismuth white.

STEEL BLUE. Prussian blue.

STIL-DE-GRAIN. Dutch pink.

STONE GREEN. Green earth.

STRONTIUM WHITE. Both artificial and native strontium sulphates have the same properties as blanc fixe and barytes, strontium being an element closely resembling barium. Entirely superseded by the barium whites, which are much less expensive.

STRONTIUM YELLOW. Strontium chromate. A pale, bright yellow with a rather greenish tone. Permanent. Although the compound has been known since 1836, its application to pigment use is rather recent. See *Yellow Pigments.*

SUBLIMED WHITE LEAD. A basic lead sulphate that contains zinc. A dense white with many of the characteristics of flake white but inferior as regards low oil absorption, brushing qualities, color, and stability in mixtures with other pigments. It surpasses flake white in opacity, is not so poisonous, and turns dark less readily on exposure to sulphur fumes. See *White Pigments.*

SUNPROOF COLORS. The word "sunproof" indicates a modern synthetic pigment and indicates that it is of superior resistance to fading. However, it is a manufacturers' descriptive term rather than the name of a specific pigment and does not necessarily assure permanence for artists' use.

SWEDISH GREEN. See cobalt green.

TALC. A native magnesium silicate used for its slippery or soapy effect and as a filler for various industrial purposes.

TERRA ALBA. Gypsum.

TERRA COTTA. A mixed pigment composed of burnt umber, red oxide, and chalk, in varying proportions; barytes, zinc oxide, or lithopone may replace the chalk; the color is intended to imitate the natural reddish color of terra cotta clay.

TERRA MERITA. Fugitive yellow lake made from saffron or curcuma root. Obsolete.

TERRA OMBRE. Raw umber.

TERRA ROSA. Venetian red.

TERRE VERTE. Green earth.

THALO BLUE AND GREEN. Proprietary names for phthalocyanine blue and phthalocyanine green.

THALO RED ROSE. A proprietary name for quinacridone red of the "scarlet" or yellowish shade.

THENARD'S BLUE. True cobalt blue.

THIO VIOLET. (Thio indigo red-violet B.) An intense and brilliant synthetic organic pigment whose very good resistance to accelerated fading tests indicates that it is a desirable pigment for use in artists' paints. See pages 408–10.

TIMONOX. See antimony white.

TIN WHITE. Stannic (tin) oxide, used to produce an opaque white in ceramics; not a paint pigment.

TITANIUM GREEN. A dark green, analogous to Prussian blue, made with titanium or a mixture of iron and titanium compounds instead of with pure iron salts. Not in use; probably never made commercially.

TITANIUM OXIDE. Titanium dioxide. An extremely dense, powerful opaque white of high refractive index and great hiding power. Absolutely inert, permanent. Properties known since 1870 or earlier, but not successfully produced in a pure white grade until 1919 in Norway and America. See *White Pigments*.

TITANIUM PIGMENT. Titanium dioxide 25 percent, blanc fixe or other inert pigment 75 percent. Composition similar to that of lithopone. Opaque, permanent. See *White Pigments*.

TITANOLITH. Trademarked name for a composite pigment, titanium white plus lithopone. Suitable for use in grounds.

TITANOX. Trademarked name for titanium whites.

TOLUIDINE RED. Paratoluidine toner. Brilliant, rather yellowish fire-red. A semipermanent synthetic pigment of the azo class used in industrial products but not in permanent painting.

TRANSPARENT BROWN. Burnt green earth.

TRANSPARENT COPPER GREEN. An obsolete fused copper resinate used in medieval times. See page 185.

TRANSPARENT GOLD OCHRE. See ochre.

TRANSPARENT OXIDE OF CHROMIUM. Viridian.

TURBITH. Turpeth mineral.

TURKEY BROWN. Raw umber

TURKEY RED. Native red oxide. (Also applied to madder-dyed textiles.)

TURNBULL'S BLUE. Potassium ferrous ferricyanide. A pale blue color produced as an intermediate stage of one process of Prussian blue manufacture. Not in pigment use.

TURNER'S YELLOW. Lead oxychloride. Obsolete. A variety of shades from bright yellow to orange were formerly made. Judging by the attention given to it in books of the early nineteenth century and by its large number of synonyms, it was used to a considerable extent. Not permanent; turns black. Patented by James Turner, England, 1781.

TURPETH MINERAL. Basic sulphate of mercury. Bright yellow. Not permanent; turns black. Highly poisonous. Not in use.

TURQUOISE GREEN. Compound of aluminum, chromium, and cobalt oxides. A rather pale, clear green of very bluish tone. Permanent for all uses. Quite rare and expensive; imitated by colors which do not resemble it very closely. Finds a small use in ceramics.

TUSCAN RED. A rich maroon lake made on a red oxide base. When expressly stated to be composed of alizarin and Indian red it is permanent; otherwise may contain impermanent colors and inferior earths. This pigment is employed principally for industrial purposes.

TYRIAN PURPLE. The celebrated imperial purple of the Romans and that used by the Greeks and other ancient peoples was prepared from the shellfish *Murex trunculis* and *Murex brandaris*. In 1908, Friedlaender discovered that the coloring matter of the ancient purple was identical with a purple coal tar color that had been introduced in 1904. Neither this particular synthetic color nor murex purple is in use today because other purples superior in every respect can be made at lower cost. According to Pliny, the most desirable shades of murex purple varied from the reddish or pinkish to the bluish or violet, according to the fashion of the times, and pigments made from it were used principally as glazing colors. The bluish shade was also known as Byzantium purple.

ULTRAMARINE ASH. A delicate blue-gray pigment of slight tinting power. Consists of lapis lazuli mixed with the grayish rock with which it is found in nature. Permanent, but of limited value.

ULTRAMARINE BLUE. Originally this color was made by grinding a semi-precious stone, lapis lazuli, and purifying it by a complex and difficult process, thus removing all the gray rock with which it is usually associated. Genuine or lapis ultramarine is a rich, deep "true blue" of practically uniform hue. It has been found in Assyrian and Babylonian relics but only as a decorative or precious stone. Its European use as a pigment began in the twelfth century; it has always been one of the costliest and most precious of painting materials. Lapis lazuli occurs in Persia, Afghanistan, China, Chile, and a few other countries; it is more often found in the form of blue particles and veins scattered through a gray rock than in the solid pieces which are used in jewelry and ornaments. Investigators believe that lapis is the sapphire of the Bible and other early writings, including those of Theophrastus and Pliny.

Since 1828, the ultramarine of commerce has been an artificial product made by heating clay, soda, sulphur, and coal in furnaces; the color of the resulting compound is attributed to colloidal sulphur. Best-grade American ultramarines are produced in a wide variety of shades, from

that of the true ultramarine blue to imitation cobalt and turquoise shades which are comparatively greenish. The pigment called green ultramarine is a rather dull color with properties the same as those of ultramarine blue; it is produced during the manufacture of the blue, and may be considered unfinished ultramarine blue; it is not widely used. All pure ultramarine pigments and variations are equally permanent, but many inferior and reduced grades are made for industrial uses. Ultramarine is semitransparent; it works poorly in oil, where it tends to yield stringy instead of buttery pastes. It is entirely permanent for most uses, including high temperature processes, but is easily affected and bleached by very weak acids and acid vapors; the same is true of the native lapis. After several independent discoveries concerning the nature of the product and the method of its manufacture, it was first produced commercially in France by Guimet in 1828, and the pigment was used by artists in Paris. In the same year the process was published by Gmelin in Germany. See *Blue Pigments.*

ULTRAMARINE GREEN, RED, VIOLET, YELLOW, ETC. By variations in the ingredients and process, ultramarine pigments of many hues can be produced. They all are very pale and of slight tinctorial power, and although they equal the blue in permanence and resistance to heat, they find far fewer applications in painting processes. The red and violet are pinkish and lavender colors, their use in oil limited to glazes and pale tints, in aqueous mediums they are somewhat more useful. Their physical, chemical, and pigment properties are similar to those of the blue. Barium yellow was formerly misnamed yellow ultramarine.

UMBER. See raw umber and burnt umber.

URANIUM YELLOW. Uranium oxide. A permanent, expensive color; prior to the use of uranium in atomic fission it was employed to some extent in ceramics. Obsolete in paint use. The typical uranium color is a transparent yellow with a green fluorescence, as in the well-known vaseline glass.

VANDYKE BROWN. Native earth, composed of clay, iron oxide, decomposed vegetation (humus), and bitumen. Fairly transparent. Deep-toned and less chalky than umbers in mixtures. One of the worst driers in oil. Some specimens fade, and in oil this pigment always turns dark, cracks, and causes wrinkling, exhibiting the same defects as asphaltum, but to a somewhat lesser degree. Not for permanent oil painting. Some of the lightproof grades may be used in watercolor and pastel. Dates from the seventeenth century.

VANDYKE RED. Copper (cupric) ferrocyanide. A poisonous color with a composition similar to that of Prussian blue, copper replacing the iron. It is fast to light, but blackens when exposed to sulphur fumes. Brownish

red, reddish violet, or reddish brown shades can be made. Not in very wide use. The brown shades are known as Hatchett's or Florentine brown. See also copper maroon pigment.

VAT ORANGE G R.*

VEGETABLE VIOLET. Bright violet lake made from logwood. Very fugitive.

VELVET BROWN. See fawn brown.

VENETIAN RED. Originally a native earth containing 15 to 40 percent iron oxide, the present commercial material is artifically produced like the pure red oxides, but from 60 to 85 percent calcium sulphate is added during its manufacture. Although fairly satisfactory as a permanent color, the calcium sulphate it contains is liable to cause trouble in oil, and for artists' use it is best replaced by light red, which is purer, stronger, and brighter. A bluish shade of native iron oxide, comparable in hue to Indian red, is known as Spanish red. Venetian red is an average drier in oil, but produces a very hard and brittle film. See *Red Pigments.*

VENICE RED. Venetian red.

VERDEAZZURO. Malachite.

VERDERAME. Verdigris.

VERDET. Brilliant, dark green crystals of copper acetate; soluble in water; poisonous; formerly made in the south of France and used in watercolor painting. Permanence doubtful.

VERDETTA. Green earth.

VERDE VESSIE. Sap green.

VERDIGRIS. Hydrated copper acetate. Light, bluish green, permanent to light, but unreliable for painting. Reacts with some other pigments and is affected by them and by the atmosphere. Obsolete. Dates from Roman times; one of the early artificial pigments. Was still used to a limited extent during the nineteenth century.

VERMILION. Mercuric sulphide. A very opaque bright, pure red which works well in oil. It is the heaviest pigment in use. Erratically permanent, some grades are liable to turn black. This change is a reversion to a black form of mercuric sulphide, the cause of which is still a mystery after years of study. Best grades are made in England, France, and China. In oil painting it will not react with other permanent colors, including white lead. Recently largely supplanted by cadmium red. Vermilion was used in China at an early date. Earliest European date is about the eighth century; prior to that time, the inferior native ore, cinnabar, was used.

VERNALIS. Name given by the Society of Tempera Painters to a ceramic pigment formerly sold as Victoria green. Made by heating chalk and viridian. Permanent. Not ordinarily available.

* See footnote on page 36.

VERNET GREEN. Bremen green.

VERONA BROWN. Burnt green earth.

VERONA GREEN. See green earth.

VERONESE GREEN. Because this term has been so loosely applied to emerald green, Verona green earth, viridian, and chrome green by tube color manufacturers, it has little meaning. The color of the usual material sold under this name resembles a rather pale viridian.

VERT ANTIQUE. Copper carbonate. Pale green. Permanent only if used alone and well bound in oil or varnish. Its principal use is for stippling over a brown undercoat to imitate the patina of copper and bronze, with which it is chemically identical.

VERT EMERAUDE. Viridian.

VESTORIAN BLUE. Egyptian blue.

VICTORIA GREEN. A mixture of 80 parts of viridian, 40 parts of zinc yellow, and 10 parts of barytes, gypsum, lithopone, or zinc oxide. The cheaper grades are likely to contain inferior colors and additional filler. The name is not a reliable designation. See vernalis and permanent green.

VIENNA BLUE. A variety of cobalt blue.

VIENNA GREEN. Mittis green.

VIENNA LAKE. Carmine.

VIENNA WHITE. Chalk made by air-slaking lime, as in the production of bianco sangiovanni. Used more as a polishing powder than as a pigment.

VINE BLACK. Made by calcining selected wood and other vegetable products. This pigment and the other blacks referred to it are members of a group of rather impure forms of carbon made by burning selected, but rather second-rate materials of vegetable, animal, and petroleum origins. They all have bluish undertones, and when mixed with whites will produce blue-grays. They are inferior to the lampblack group in intensity and pigment properties. While these materials are probably permanent enough for most practical uses, it is wiser to select one of the purer forms of carbon as listed under *Black Pigments*. The vine black group should not be used in fresco or to mix with cement, mortar, etc., because of efflorescence from the water-soluble impurities which they always contain.

VIOLET CARMINE. A lake made from the coloring extract of a tropical wood. Fairly clear, very reddish, transparent violet. Very fugitive, it first turns brown, then colorless.

VIOLET MADDER LAKE. Alizarin violet.

VIOLET ULTRAMARINE. Ultramarine violet.

VIRIDE AERIS. Verdigris.

VIRIDIAN. Hydrated chromium hydroxide. Very bright, clear, transparent, cool emerald shade; absolutely permanent except when roasted to more than a dull red heat, when it is converted into the anhydrous chro-

mium oxide green. First made by Pannetier and Binet, Paris, 1838, as a secret product; introduced to artists, and the process first published by Guignet, Paris, 1859; available in England, 1862.

WELD. An obsolete yellow vegetable color (luteolin) obtained from dyer's rocket (*Reseda luteola*).

WHITE EARTH. A pure white clay whose general composition and physical characteristics are the same as those of green earth. Not the same material as terra alba. It is highly absorbent to dyestuffs and therefore finds a limited use as a base for certain lakes.

WHITE LEAD. See flake white, also Index.

WHITING. Native calcium carbonate, ground, washed, and refined. An inert pigment of considerable bulk, of use in oil painting only as an extender or adulterant. When ground in oil to a stiff paste, it does not retain its white or creamy white color, but the paste is yellowish brown and forms the familiar plastic cement known as putty. When used with aqueous mediums and glue sizes it retains its whiteness; it is valuable for such products as gesso, etc. The best grade is known as Paris white; the second best (usual paint-store variety) is called "Extra gilder's"; and a third grade, used mainly for putty, is called "Commercial." See chalk.

WINSOR BLUE. Proprietary name for phthalocyanine blue.

WOAD. Blue woad dyes were made from a plant cultivated in England from very early times, and the color was used as a pigment to some extent until it was replaced by the more satisfactory indigo.

YEAST BLACK. See vine black.

YELLOW CARMINE. A yellow lake of vegetable origin; olive tone, transparent; very fugitive. See Dutch pink.

YELLOW LAKE. An unstandardized term used for a number of transparent pigments. Cobalt and Hansa yellow are reliable substitutes.

YELLOW OCHRE. Described under ochre.

YELLOW OXIDE OF IRON. Mars yellow. Artificially produced by patented processes, this pigment is permanent for all uses except at high furnace temperatures, when it is likely to be converted into red oxide. It is made in a limited variety of shades corresponding to those of the natural ochres which it replaces, but it is always more brilliant than ochre, and has much greater timing power. See Mars colors.

YELLOW ULTRAMARINE. Obsolete name for barium yellow.

ZAFFER OR ZAFFRE. Partially finished smalt; smalt in a stage before its final process.

ZINC CHROME. Zinc yellow.

ZINC GREEN. Cobalt green. Also a mixture of zinc yellow, Prussian blue (steel or Milori, not the reddish shades), and barytes.

ZINC OXIDE. Zinc white.

ZINC WHITE. Artists' name for pure zinc oxide. This material is used in painting because it does not have the two defects of flake white (it is not poisonous and it does not darken on exposure to sulphur fumes). It has much less hiding power than white lead, being only slightly better than semiopaque. First made and sold in France toward the end of the eighteenth century; introduced commercially in America during the first quarter of the nineteenth century; successfully made in a large-scale industrial manner in 1845; began to be accepted as a general industrial pigment around 1860; but not very widely adopted by artists as an oil color until the twentieth century. However, under the name of Chinese white it was almost immediately put into use as an artists' watercolor; one English firm has had it on the market as a prepared watercolor white since 1834. See *White Pigments.*

ZINC YELLOW. Zinc chromate. A pale, semiopaque yellow with a greenish tone. Permanent, but best grades are rare. Rather poisonous. Somewhat soluble in water; therefore generally considered to be not so good as barium and strontium yellows for artists' use. Some of the best and palest primrose shades contain much zinc oxide; few are the pure chromate. Introduced by Murdock, Scotland, 1847. See *Yellow Pigments.*

ZINNOBER. Vermilion. When the term "zinnober" is applied to any other color—for instance, to chrome green—it is being used merely as a fancy name for an inferior product.

ZIRCON WHITE. Zirconium oxide. Used to impart whiteness and opacity to ceramic glazes; not in use as a paint pigment.

PERMANENT PALETTES FOR VARIOUS TECHNIQUES

Although any and all of the pigments in the following lists may be used, many will be found to be superfluous on a working palette. While a painter will naturally have his preferences for specific pigments, some pigments, although definitely separate colors with varying properties, are so closely related to each other that more than one will seldom be required in the same picture. These families or groups have been printed on the same line. An asterisk (*) denotes lesser-used pigments.

PIGMENTS FOR OIL PAINTING

White	Zinc white.
	Flake white. Cremnitz white.
	Titanium oxide. Titanium pigment.
Black	Ivory black. Mars black. Lampblack.

Red	Cadmium, light.
	Alizarin red.
	Light red. Indian red. Mars red.
	*Cadmium, deep. Cadmium maroon.
Blue	Ultramarine blue (all shades).
	Cobalt blue.
	Cerulean blue. Manganese blue.
	Phthalocyanine blue.
Green	Viridian.
	Chromium oxide.
	Phthalocyanine green.
	*Green earth.
	*Cobalt green.
	*Ultramarine green.
Yellow	Cadmium, pale.
	Cadmium, medium. Cadmium, deep.
	Cadmium orange.
	Naples yellow.
	Mars yellow. Ochre.* Transparent ochre. Raw sienna.
	Cobalt yellow. Hansa yellow.
	Strontium yellow.
Violet	Cobalt violet. Manganese violet.
	Mars violet.
Brown	Raw umber.
	Burnt umber.
	Burnt sienna.
	Burnt green earth.
	*Brown madder.

The left-hand column lists eight hue designations, but on an average normal working palette the artist usually requires about twelve or fourteen pigments (see page 101).

Pigments such as green earth and ultramarine green, red, or violet, which have low tinctorial power, are valued more as glazing colors than as opaque body colors; several other permanent but very weak pigments have been omitted. The imitation cobalt blues and turquoise greens, which are special shades of ultramarine, are just as permanent and have the same physical properties as ultramarine blue. Special cleanliness must be observed in handling flake white and Naples yellow in order to prevent lead poisoning. When well-made lead pigments of high quality are used they may be freely mixed with the rest of the permanent palette; sulphur-bearing pigments, such as the cadmiums and ultramarine blue, will cause them to darken in oil mixtures only when poor or badly washed materials are used. Flake white and Naples yellow have such

highly desirable qualities that they are widely used despite this disadvantage.

The pure iron oxide reds are referred to under *Red Pigments.* Indian red has a bluish or rose undertone, and light red, a comparatively yellowish or salmon undertone. In oil paints these two products should be used in preference to the native earth reds and also the artificial product, Venetian red, all of which are inferior. For the same reason vermilion, zinc yellow, and vine black, which are perhaps durable enough for the majority of uses, should not be used, when they can be replaced by more trustworthy pigments of equal color value.

PIGMENTS FOR WATERCOLOR

None of the pigments that contain lead or other substances that are chemically affected by exposure to the atmosphere may be used. Arrangement of the following list is the same as explained on page 71.

White	Chinese white (zinc white).
	Titanium oxide. Titanium pigment.
Black	Ivory black. Lampblack. Mars black.
Red	Cadmium light.
	Alizarin crimson.
	Pure iron oxides. (Indian red, light red, Mars red.)
	*Cadmium medium, deep, and maroon.
Yellow	Cadmium, pale.
	Cadmium, medium. Cadmium, deep.
	Cadmium orange.
	Mars yellow. Ochre.* Transparent ochre. Raw sienna.
	Cobalt yellow. Hansa yellow.
	Strontium yellow.
Blue	Ultramarine blue (all shades).
	Cobalt blue.
	Cerulean blue. Manganese blue.
	Phthalocyanine blue.
Green	Viridian.
	Chromium oxide.
	Green earth.
	Phthalocyanine green.
	*Cobalt, turquoise, and ultramarine greens.
Violet	Cobalt violet. Manganese violet.
	Mars violet.
Brown	Raw umber.
	Burnt umber.
	Burnt sienna.
	*Brown madder
	Burnt green earth.

The weak or low tinctorial permanent colors, such as green earth, ultramarine ash, ultramarine violet, etc., are more useful in watercolor than they are in oil, and some painters make continual use of them; but they are held to be unnecessary by the greater number of watercolor painters.

Some of the highest grades of Vandyke brown are lightfast; these may be used in watercolor painting where the bad properties of this color which cause its failures in oil have no significance.

Payne's gray, in the high-grade prepared watercolors, is a permanent pigment valued as a useful and convenient color by some painters, but considered unnecessary by others who prefer to make such mixtures on the palette.

For gouache (opaque or impasto watercolor) the same palette is in use, but when used full strength the transparent pigments will function as body colors and exhibit their top tones. Their undertones will be brought out when they are mixed with a considerable amount of whites, but the color effects of several will be different from those they exhibit in transparent watercolor.

Cobalt violet often contains arsenic and should be considered poisonous; some of the other chemical colors are not without harmful effect. In working with watercolor one must not moisten brushes with the mouth. Special care should be taken in the selection of pigments for children's use.

PIGMENTS FOR TEMPERA PAINTING

The list of pigments for tempera painting is the same as that for oil painting except that no pigments containing lead may be used if the painting is to be completely tempera without oil or varnish glazes. When it is to be thoroughly varnished or glazed and varnished, flake white and Naples yellow may be used.

In most tempera mediums titanium has better brushing qualities than either lead or zinc, and it displays none of the faults that it sometimes may exhibit in oil. The extremely powerful tinting strength of the pure oxide is sometimes awkward, and in most instances the barium composite variety will be preferable. The titanium pigments replace white lead in tempera more satisfactorily than they do in oil.

There are no chemical reactions as to the various permanent colors which may or may not be used in underpaintings, as even when oil is a constituent of a correctly balanced emulsion, the variation in the flexibility of the films due to a variation in oil absorption by pigments is negligible. The remarks on colors for glazing oil paintings are applicable to colors for glazing tempera.

PIGMENTS FOR PASTEL

All the poisonous and the sulphur-sensitive pigments, such as Naples yellow, white lead, arsenic cobalt violet, emerald green, etc., are eliminated from the pastel palette. When making one's own crayons only the strongest, highest-grade colors should be selected, and in all tests particular attention should be paid to their bright appearance in the dry state. The only white usually necessary or desirable is precipitated chalk. French chalk (talc) has been recommended by some writers as an addition to pastel crayons on account of its peculiarly smooth or soapy texture. If it seems advisable for any reason to use one of the more opaque or heavy whites, no more than a 10 percent addition of titanium to the chalk should be used.

Some pigments which are often rejected for use in other mediums on account of their slight solubility in water may be used in pastel where this property is of no importance; also some of the colors which bleed in oil can be employed if thoroughly lightproof. This makes more of the new synthetic pigment products available. Some of the best grades of Vandyke brown are lightproof and have permanence in pastel in spite of their bad behavior in oil. Some of the borderline colors have been recommended on the theory that the relative thickness of the pastel coating and the absence of medium reduce the likelihood of failure to a minimum, but as in any other technique it is safest to use only the most lightproof pigments.

With the exception of the poisonous and sulphur-sensitive pigments, all the permanent watercolor and tempera colors can be used, but, as in gouache, the transparent or glaze pigments will function as body colors. Emerald green, all the lead colors, and arsenic cobalt violet are considered too poisonous because of the dusting of the crayons during use.

One must avoid the continuous inhalation of the dusty powder that is likely to rise during the normal application of pastels to paper, as well as from rubbing or manipulating the crayons. It is well known that no dusty powders (ordinary talcum powder, for example) should be inhaled. Harmless though their nature may be, the continued breathing of any powder is injurious to health. Pastels are therefore not ideal for individuals who may be sensitive or allergic to such powders.

Japanese Pigments

These pastel pigments, as discussed on page 17, have remained unchanged for many centuries. The finely powdered minerals differ in shade from the same minerals more coarsely powdered.

White	Ground quartz crystal (*sui sho matsu*). Ground calcite (*hokai matsu*). Shell white (*go fun*). Mica (*unmo*). The whites have various textural and reflective characteristics.
Blue	Powdered azurite (*gunjo*). Very finely powdered azurite (*byankugun*). Japanese indigo (*ai*).
Green	Malachite (*byaku roku*).
Bluish green	Azurite and malachite mixture. Malachite rich (*shin sha*). Burnt azurite and malachite. Azurite rich (*yakigunroku*).
Red	Pure vermilion. "Red" (*hon shu goku akakuchi*). Cochineal red (*enji*). Cochineal crimson. Red lead (*tan*). Red earth color (*benigara*). Yellow earth (*odo*).

PIGMENTS FOR FRESCO PAINTING

Remarks have been made elsewhere about the lack of modern scientific and technical studies directly relating to artists' materials; much carefully controlled research remains to be done to bring our data on fresco colors up to date.

The fresco palette is more restricted than any of the others; the pigments must not only be absolutely lightproof, but must resist the alkaline action of the lime plaster and the acid action of polluted air. Pigments must be free from soluble salts and any impurities that are likely to react with acids or alkalis. When selecting pigments, attention should be given to the brilliance and purity of tone in the dry state, which is approximately if not exactly the same as the finished fresco effect. Notes on the further refinement of impure pigments will be found on pages 108–109.

EGYPTIAN MURAL PALETTE[42]

Black	Carbon (lampblack).
Blue	Azurite and Egyptian blue frit.
Brown	Various native earths.

Green	Malachite and crysocolla.
Red	Native red oxides.
White	Chalk and gypsum.
Yellow	Ochre and native orpiment.

MINOAN FRESCO PALETTE[36]

White	Lime putty.
Black	Powdered slate.
Red	Native red oxide.
Blue	Egyptian blue frit.
Green	Mixtures of blue, black, and yellow.
Yellow	Ochre.

ROMAN FRESCO PALETTE[2]

Black	Lampblack, possibly also bone black.
Blue	Egyptian blue, possibly copper ores.
Brown	Native earths.
Green	Egyptian green, green earth.
White	Lime.
Yellow	Ochres.
Red	Native oxides, Pozzuoli red, etc.

Probably refined, washed, and burnt earths were used. The method of making Egyptian blue and green was brought from Egypt to Pozzuoli.

TRADITIONAL ITALIAN FRESCO PALETTE

White	Bianco sangiovanni.
Black	Lampblack.
Red	Native Venetian red or Spanish red. Pozzuoli red and other native red oxides.
	Burnt sienna.
	Vermilion applied *secco*.
Blue	Egyptian blue. Azurite. Smalt.
	Native ultramarine applied *secco*.
Green	Green earth.
	Mixtures of blue and yellow.
Yellow	Ochre. Raw sienna.
Brown	Raw umber.
	Burnt umber.
	Burnt green earth.

Refined, washed, and burnt native oxides and ochres were well known.

MODERN FRESCO PALETTE

White	Slaked lime putty.
	Bianco sangiovanni.
	Neutral blanc fixe.
Black	Mars black.
	Lampblack.
Red	Several shades of pure artificial red oxides: Mars red, Indian red, light red, etc.
	Burnt sienna.
Blue	True cobalt blue.
	Cerulean blue.
Green	Viridian.
	Chromium oxide.
	Cobalt green.
	Green earth.
Yellow	Mars yellow. French ochre. Italian raw sienna.
Violet	Cobalt violet.
	Mars violet.
Brown	Raw Turkey umber.
	Burnt Turkey umber.
	Burnt green earth.

SELECTED FRESCO PALETTE FOR PERMANENT FRESCOES

As noted in the section on *Fresco Painting* (page 317), this palette is suggested as being especially resistant to the corrosive action of polluted air. All the pigments must be neutral, free from soluble salts and other impurities.

White	Blanc fixe.
Black	Mars black.
Red	Indian red. Light red.
Blue	Cobalt blue. Cerulean blue.
Green	Chromium oxide. Viridian.
Yellow	Mars yellow.
Violet	Mars violet.

It has been the practice of fresco painters from an early date to plaster a test panel and subject all their colors to a test of the suitability of their materials for the circumstances of the job in hand. Six months' exposure is considered adequate to determine whether or not a new color or a pigment from a new source is limeproof.

Many colors not universally adopted or at present disputed, such as the cadmium lithopones, phthalocyanine blue, Hansa yellow lakes, and co-

balt yellow, have been proposed as fresco colors. Some have shown promise in tests, but so far, data have been insufficient to form the bases for definite opinions. Painters who add lime or limewater to their colors favor pure slaked lime as a white; those who depend solely on the capillary penetration of their pigments into the surface of the wall prefer a more inert, nonbinding white. It is doubtful whether the Pozzuoli red mentioned by some writers is always the authentic cementitious material; its color, however, is usually a highly desirable rosy shade of red. As remarked under *Fresco Painting* in Chapter 4, the cementing property of this substance is of doubtful or negative value. A number of perfectly suitable fresco colors, such as true turquoise green, potter's pink, and Egyptian blues, are not ordinarily available on the American market. The cadmiums have been generally rejected for three reasons: there is doubt as to their permanent resistance to the alkaline lime, their color effects in the dry state are very brilliant and usually out of key with the rest of the fresco palette, and they are all sulphides and therefore among those compounds most sensitive to disintegration by minute amounts of mineral acids in the air. The cobalt violets now on the market vary considerably in color and chemical properties and some which are lightproof in other mediums will fade when exposed in contact with lime; untried specimens should be tested under fresco conditions before adoption. Colors sold for enameling and other ceramic uses have bad paint-pigment properties and always contain added fluxing and refractory ingredients.

I know of no artists' tests that have been made, but from the results of their industrial use, manganese violet, manganese blue, and phthalocyanine blue should prove to be limeproof.

PROPERTIES OF PIGMENTS IN COMMON USE

The following section includes further details on the properties and uses of pigments, comparisons and data on matching colors, and substitutions for undesirable, obsolete, or rare pigments. Pigments are arranged by color.

Matching Colors. While in most cases an approximate match for a specific color may be made by using a mixture of a composition different from that of the original paint, and while such mixtures may be entirely adequate for the actual application in view, a study of color theory reveals the difficulty of securing precise, accurate effects unless the proper pigment is employed. The variation in physical and optical properties of

pigments of varying chemical or physical structure will result in differences, even when a general similarity of color, shade, or tone seems apparent.

In general, mixtures of two colors are invariably duller or less clear than single pigments of good quality; the addition of a third color is accompanied by a further reduction in clarity. However, we do not ordinarily paint with pure or raw color, but usually depend upon mixed or broken tones for our effects; control of their effectiveness can be attained only by experience and a knowledge of the behavior of the various individual pigments in mixtures. The statement that the presence of fillers or inert materials, as in student grade or other cheap colors, does not alter their properties for pictorial or decorative effects is not quite accurate; a pure color has more clarity of tone and will give superior effects all around.

The exact matches necessary in careful restorations, in alterations, and in additions to finished works require careful, precise mixing and sometimes a viewing in bright, direct sunlight—procedures seldom called for in the practice of creative painting.

BLUE PIGMENTS

Ultramarine is the standard blue color in artistic use. The best quality ultramarines as made since 1826 are identical with the native lapis lazuli for all practical purposes. They have the same chemical reactions and are distinguishable from it only upon microscopic examination, when the difference in crystalline structure is immediately apparent. The principal defect to be taken into account in the use of ultramarine is its extreme susceptibility to bleaching by even minute amounts of mineral acids; hence it has never been used in the fresco palette. Like most other high-temperature furnace products it is otherwise of great permanence. When ground in oil, ultramarine normally has one of the worst painting consistencies of any of the pigments and tends to make paints of erratic and usually stringy nature; it is therefore much diluted with waxes and other stabilizers by some makers of tube colors who require all their paints to have the same buttery plasticity. Artists who grind their own oil colors, however, find that they are able to paint with colors which are not quite up to this standard. Furthermore, ultramarine in oil is of a hue which is seldom employed full strength; it is almost always used as a tinting color in admixture with whites, yellows, etc., which tend to impart a normal consistency to the mixtures.

As mentioned on page 66, ultramarine was the most precious of artists' materials from the Middle Ages up to the early nineteenth century.

Although azurite, blue verditer, and the other unsatisfactory blues were augmented by smalt in the seventeenth century and Prussian blue in the eighteenth, the invention of artificial ultramarine was one of the major events in the history of artists' materials. Its invention was the result of intensive chemical research following the accidental observation of a mysterious blue color encrusted as an impurity in the furnaces where soda ash was made; since then it has become a moderately priced article of large-scale use.

True cobalt blue (Thénard's blue) is one of the more expensive colors and in cheaper paints it is universally replaced by a cobalt shade of ultramarine. This imitation is satisfactory for many practical painting purposes and need give the artist no concern, as it is as reliably permanent a pigment as can be desired except in the case of fresco painting, where the genuine Thénard's blue must be insisted upon because of the previously mentioned effect of atmospheric acid on the color of the imitation cobalt. The color of the imitation or ultramarine cobalt, however, is never an exact match for the true cobalt blue, especially in undertone; it is an approximation rather than a close match. The pigment listed as cobalt ultramarine (Gahn's blue) is not always available and its name may be used to designate ordinary imitation cobalt blue.

Prussian blue has been replaced by phthalocyanine blue so recently that it still requires some additional remarks to clarify its uses. It was the most disputed member of the blue group as regards permanence; it might be said that it was placed in a class by itself, as a borderline pigment. Its color is unlike that of the other blues; it was particularly useful in mixtures. For the past seventy-five years or so it has been alternately approved and condemned. There is a great difference in clarity and beauty of color as well as in permanence between the common varieties of Prussian blue and the very best, well-washed grades, such as the pure Chinese and Milori blues. Some samples will eventually turn brownish when used in oil, or will fade out appreciably when used in thin layers or in extremely weak tints with zinc white in watercolor and tempera. Prussian blue is destroyed by alkalis and therefore cannot be used in fresco.

Laurie[51] recognizes it as a borderline color; he is of the opinion that the practical evidence is in its favor as a reliably permanent color in oil, but that because it is transparent, absorbs much oil, and will not mask the yellowing of oil, it should be used only in thin glazes and as a tinting color with much white, in contradiction to the foregoing statement which is based on some laboratory evidence. He believes it should not be used in watercolor. Ostwald[46] recommends its use as a nearly indispensable color, especially in pastel, where he says that conditions which affect it in oil and place it in the borderline class are not present. Doerner[55] declares

that it is permanent in all techniques except fresco but warns against its lavish use in oil paintings on optical grounds (it gives the painting a lower key than when ultramarine or cobalt is used); he also mentions a tendency for it to fade when mixed with large amounts of zinc white and exposed to light, recovering its color again in the dark.

The variation in quality of Prussian blue from various sources accounts for some of its variable behavior as observed by these investigators; another factor, no doubt, is the variation in methods of testing and the different standards used. A Prussian blue will fade or become discolored when it is exposed to a moist atmosphere or outdoor conditions over a period of time; the same specimen may survive indefinitely when exposed to normal indoor conditions such as those under which works of art are usually preserved. The consensus was that it is best avoided, but that when a painter believes he needs it to obtain desired color effects, he is justified in risking its occasional sparing use in middle tones and mixed colors. It was seldom desired in full strength because the better grades have a pronounced bronze. In fresco or any other alkaline substance it would fail immediately. Although its particle formation is extremely fine, when ground in oil it tends to agglomerate and form a somewhat granular paste; this is less marked in the better grades. In mixtures of dark colors—greens, olives, browns, etc.—it has the property of making rather deep, full-toned shades less dead or chalky than those of the other blues.

Prussian blue is historically notable as the first or earliest synthetic pigment whose development and introduction are completely documented (see page 60). It was discovered by a German color maker who stumbled upon it when he was given the wrong material during some experiments on a red pigment.

Phthalocyanine blue is the modern, reliable replacement for Prussian blue, which it resembles very closely in color and pigment properties. Both of these pigments have so much greater tinctorial strength than the average pigment that their use on the artist's palette is frequently awkward unless the manufacturer has made them more convenient by adding from 50 to 75 percent of alumina hydrate or blanc fixe. This reduction also benefits the color in other respects. It tends to eliminate the bronzy or coppery sheen and to improve general structural or pigment properties which are not particularly good in either of these two materials. See page 78.

In a manner reminiscent of the invention of synthetic ultramarine blue a century previous, the development of phthalocyanine blue began in Scotland with the observation of a dark-colored substance formed as an impurity in a vessel in which a dye intermediate was being made, the

vitreous lining of the vessel having become cracked so that the intermediate (phthalamide) came in contact with the metal.

Cerulean blue has greater opacity than the other blues whose hiding power is due to their deep, dark tones. Its full-strength shade is a rather pale sky blue with a greenish tone. It is a very good drier and its general pigment properties are good. It has been considered low in oil absorption, and so it is, on a basis of weight, but the current prevailing grade shows a very high oil index by volume (see page 625). Because it is one of the more expensive pigments, never employed in industrial paints but only produced in small quantities for artistic and ceramic use, the cheaper and less reputable brands are likely to contain either imitations, or weak mixtures of the true material with extenders or inert substances. It can be replaced by the more brilliant manganese blue, which is of approximately the same hue but is transparent.

When the blue pigments are reduced with white and compared with each other, it will be seen that ultramarine has the most reddish (violet) undertone and the rest are more greenish in undertone, in the following order: cobalt, cerulean, manganese, phthalocyanine.

Ultramarine, cobalt, and phthalocyanine (or Prussian) blues have some properties in common: they all have a transparent or semitransparent, deep, dark hue when ground in oil; they absorb much oil; and they are difficult to grind into pastes of desirable plasticity. The depth and intensity of Prussian and phthalocyanine blues give them hiding power so that at full strength they function as opaque colors.

GREEN PIGMENTS

If it becomes necessary to secure an exact match for a green paint, it will be found that the greens are very difficult to duplicate by the use of materials other than those identical with the ones which composed the original paint. Greens are toned down or brought toward the olive, if too brilliant, by the addition of a clear red or reddish pigment: burnt sienna for the warmer shades, cadmium red or alizarin for the cooler ones. The character of a mixed green made with a lemon or pale yellow is totally different from that of one made with a golden (medium or deep) yellow.

Chrome greens are universally taboo in artistic painting; their color stability is less than that of either of their single ingredients; usually the Prussian blue fades first; the green becomes yellowish or brownish and then lighter as the chrome yellow changes. Chrome greens may be matched or closely approximated by mixing phthalocyanine blue with the various permanent yellows.

Sap greens resemble mixtures of phthalocyanine blue and either transparent ochre or cobalt yellow dulled with a touch of burnt sienna.

Hooker's green may be matched by a mixture of phthalocyanine green and cobalt yellow dulled with a touch of burnt sienna.

Most greens made with Prussian blue cannot be duplicated without its use or that of phthalocyanine blue; if the latter is not available, a mixture of Prussian blue and a permanent yellow is far preferable to one in which such definitely fugitive yellow pigments as gamboge, lakes from buckthorn berries, etc., are used.

Verdigris and similar copper greens are rather easily imitated by using viridian as a starting point. The great variety of shades in which these colors were made make it impractical to mention the additional pigments specifically.

Chromium oxide green is one of the most inert and permanent pigments in use, but it finds a smaller application in artistic painting than do other greens on account of its low tinctorial power and its limited color effect. Still it is well liked among artists for its pleasing hue. Cobalt greens, light and dark, are also opaque, permanent pigments with relatively low tinting power and with similarly pleasing color properties; they are definitely bluish greens by comparison with chromium oxide, which in comparison seems warm and yellowish.

Viridian, which is equally durable for all artistic and industrial pigment purposes, except in high-temperature work, is a valuable artists' color. The inferior grades sometimes contain impurities in the form of complex mixtures of chromates and borates; while these are water-soluble, they are quite difficult for the manufacturers to wash out. Their presence is highly undesirable, and therefore only viridian of the highest quality should be used. The best American dry color is usually cleaner and cooler in shade than the European product, which, by comparison, tends toward yellowish or muddy tones; it should, therefore, be preferred by fresco painters. When viewed under the microscope, viridian resembles small broken fragments of emeralds. Its color effect when used in transparent films is just this brilliant transparent green, but when it is used full strength in thick pasty layers it will exhibit a duller, more blackish body color or mass tone because of the building up of a thick layer of pigment particles which impede and absorb the transmitted light rays, thus producing an opaque coating.

Phthalocyanine green is a more intense clear tinting color than viridian, and will produce somewhat different shades in mixtures with other pigments. Some artists prefer it to viridian; others consider it too raw or garish and prefer the somewhat more subtle effect of the older color.

Many sea-green hues as well as clear, deep olive greens ranging from intense darks to pale tints were produced by the older painters with mixtures of Vandyke brown and Prussian blue, sometimes toned with a little yellow. By substituting the more reliable burnt sienna and phthalocyanine blue as a starting point, a whole series of unique hues is added to the palette of the artist whose previous experience has been limited to the mixtures available with ultramarine and cobalt. Phthalocyanine green will not give the same results.

Emerald green is a highly poisonous substance which will turn black when mixed with any of several other pigments, when in contact with metals, and when exposed to the air; its use should be avoided. It is the most vivid and brilliant of greens and could not be matched by mixtures—this is the sole reason for this dangerous pigment's survival. But close approximation can now be had by mixing phthalocyanine green with the modern synthetic yellows such as Hansa yellow, green gold, etc. (see page 411). There is no longer any necessity for its use in any kind of paint. Formerly, some painters who realized that its indiscriminate use led to darkening and other bad results believed it was safe if used straight or mixed only with the most inert, nonreactive pigments and well locked in with oil and varnish, and they made occasional use of it; for example, a brilliant starboard light can be depicted by a touch of emerald green with a highlight of titanium on it. Emerald green must never be used in pastel or watercolor. Perhaps our common expression for a raw, garish color, "a poisonous green," comes through association with Paris green.

RED PIGMENTS

The wide range of effects that may easily be obtained with the permanent reds and mixtures of them makes it simple to match reds or reddish colors. For nearly all purposes, vermilion is perfectly replaced by the light cadmium reds; if these are too cold or chalky in comparison with it, a touch of whatever toning color may be necessary is added. Alizarin will substitute for all the obsolete transparent lakes. The brilliant geranium reds, magentas, and rose pinks of the past were synthetic organic pigments of poor fade-resistance and were employed for illustration and other work done for reproduction rather than for creative easel painting. Today such hues are available in pigments with greater permanence. See page 408.

The earth reds (Venetian red, etc.) should be replaced whenever possible by their artificial counterparts, the Mars colors and the bright red oxides. Except in fresco painting, however, this is not a seriously impor-

tant precaution; and it is fortunate, since the old nomenclature for these colors was such as to bewilder persons not thoroughly familiar with their properties.

In the color trade the impure native oxide of bluish tone is known mainly as Spanish red, and the scarlet shade as Venetian red. The pure varieties are called Indian red (bluish shade) and light red or bright red oxide. However, special trade names or numbers for various grades are widely used in the paint industry, thereby eliminating much of the confusion.

The principal distinction to be made is that one branch of the family, of which Indian red is typical, has a deep bluish tone, and when reduced with white produces rosy pinks; the other branch, of which light red is typical, is brighter and more scarlet in mass tone, and when reduced with white produces salmon pinks. Mars violets and highly burned Indian reds produce lavenders when reduced with white.

Confusion in the nomenclature of American red oxide artist's colors has now been eliminated by applying the following terms: Indian red for the bluish pure red oxide; light red for the scarlet type and for the special shades, Mars red or Mars scarlet, maroon, etc.; reserving the older meaningless names for the natives or impure oxides. The Mars colors are all artificial iron oxides of great permanence, some of them varying only slightly in color, composition, and method of manufacture from the pure Indian red and light red. Pure red oxides can be made by calcining iron hydroxide made by precipitating iron (ferrous) sulphate or waste solutions from the steel industry with soda ash, or by the direct roasting of ferrous sulphate.

The ancient and medieval crimson lakes had animal or vegetable origins: kermes, grain, madder, dragon's blood, brazilwood, and, later, cochineal or carmine. Alizarin replaces all of them, sometimes with a small amount of dulling or toning if exact matches are required. None of these older red lakes was used for any special quality it may have shown in comparison with another; the optimum was considered to be a transparent ruby or blood red which produced a pure rose pink when diluted with white; the most brilliant, most reliable, and most available one was selected.

Although inferior grades are common, since the 1920s alizarin crimsons have been produced in a superlative quality which is permanent under conditions that cause older or inferior varieties to fail. The highest-grade American product has a brilliant rosy tone in the dry state; it is perfectly clear and transparent, will not liver with pure oils, and may be freely mixed with earth colors. Alumina hydrate is employed in its man-

ufacture, but in a small proportion and as much for its chemical function as for its use as a base or inert material, so that the best grades are almost toners, compared with the usual lake color. Alizarin, like other organic pigments that are permanent in easel painting, is not in the same class of absolute permanence as are the inorganic pigments.

The manufacture of a perfect alizarin requires great skill on the part of the color maker. One of several important points is that while it is being made the material must be kept absolutely free from the contamination of iron, which destroys its character. This is probably the reason so many writers go to such extremes to warn painters against its admixture with and even its overpainting upon earth colors that contain iron. I find that with a best-grade alizarin such warnings are unnecessary, for in its finished state it is not sensitive to iron to an extent that would make these procedures dangerous. According to tests, it can be freely mixed with any of the other approved pigments without bad effect. Alizarin is not of absolute fastness to light in the same sense in which the inorganic colors are lightfast. It can be broken down under accelerated tests; however, it is adequately permanent for use under normal conditions of all accepted artistic painting techniques except fresco. The longevity of alizarin might well be taken as a yardstick with which to measure the degree of color stability acceptable for artists' normal pigment requirements.

In common with other pigments of very high oil content and low specific gravity, dried films of straight alizarin oil color are structurally inferior to those of denser, more highly pigmented coating, and certain precautions should be observed in their use. The fine allover crackle which sometimes occurs on areas painted with straight alizarin oil color is discussed on pages 163–64.

Alizarin comes in the form of an extremely fluffy lightweight powder, one pound of which will almost fill a half-gallon can. A pound of vermilion will go into a four-ounce jar. Both vermilion and alizarin happen to be substances which repel water to such an extent that they are difficult to mix into aqueous mediums, especially when one attempts to stir them into the medium in a container. A round rod should be used for this purpose instead of a flat palette knife. With a little patience, they will mix in. Colors that repel either oil or water will go into suspension more easily on a slab, under a muller or spatula. If alcohol is used to start the wetting before the oil is added, the anhydrous grade is preferable, and it should be well mulled or the mixture should be allowed to remain on the slab long enough for the alcohol to evaporate.

The true madder root lakes made by the older process, especially those of good quality, are now very rarely found on the market. They can

be obtained from only the most reliable sources. Alizarin red is many times more powerful in tinting strength than the madders, which are usually very weak.

YELLOW PIGMENTS

Chrome yellows and oranges are perfectly replaced by the cadmiums for all artists' purposes. Formerly there was some doubt as to the lightproof qualities of some cadmium shades, especially the palest yellows, but I find that all the modern cadmium-barium yellows are of equal permanence under severe accelerated test conditions and are entirely suitable for permanent artistic painting. They have less tinctorial power than all the older pure sulphide yellows possess, but they are acceptably strong and compare favorably with the average artists' color in this respect. Most specimens are finely divided and soft, and work well in oil. The term "cadmium lithopone" does not mean that the color has any of the undesirable features of lithopone white, but merely refers to its method of manufacture in order to distinguish it from the pure sulphide pigments.

Cobalt yellow (aureolin), sometimes toned with another color, will replace the obsolete transparent yellows—gamboge, Indian yellow, etc. It is not used in opaque or body-color painting because its mass tone is a dull and undistinguished mustard hue that can easily be duplicated with less expensive pigments, but it is invaluable for transparent glazes and for the precise matching of delicate or very pale colors and off-whites. Cobalt yellow is an extremely rapid drier in oil; hence one should guard against waste by not putting too much on the palette.

Hansa yellow, a modern synthetic organic pigment adopted by the Paint Standard in 1962, creates brilliant effects alone or in mixtures, quite different from the more golden tones that cobalt yellow produces. Mars yellow can serve as a starting point to duplicate most of the ochres and raw siennas if desired, but it should be considered an addition to this family of colors rather than a substitute for any of them.

The use of the European term "transparent gold ochre" by some makers of oil colors to describe an ochre which contains a large percentage of transparent material is unfortunate, as the term "golden ochre" has long been employed in the American and English color trade to describe an inferior product containing chrome yellow. The best transparent ochre is refined from a rather scarce native ore which contains a smaller percentage of iron than the average; other grades (which are perhaps just as desirable) may be made by mixing alumina hydrate with a deep-toned native ochre. The color is a useful one and it is doubtful whether its great transparency and high inert pigment content will promote change

in tone by revealing the yellowing of oil, as its hue is very close to that of a rather deep-colored oil. Because of the industrial unimportance and limited production of this native transparent ochre, the material sold as a dry color is likely to be the chrome mixture, and therefore it should be purchased from only the most reliable sources.

Strontium yellow is seldom included in elementary or simplified palettes, but it should not be overlooked when very light, clear yellows, chartreuses, or light greens are needed, or when a variety of greens is sought after. It does not have the density of cadmium yellow and is rated as semiopaque. Strontium yellow is the preferred member of a family of three pigments of identical hue; the other two are zinc yellow, which is somewhat water-soluble and has a tendency to become greenish, and barium yellow, which is permanent but much less intense in color.

Naples yellow seems to have been the most disputed yellow pigment among nineteenth-century painters and commentators; some claimed that it was indispensable and others that its color might easily be duplicated by mixtures of white with other yellows. The true product, lead antimoniate, was for a period somewhat unstandardized; it was even claimed that no such pigment had ever been in general use and that any pigment combination of similar superficial hue or top tone could be sold under its label. This was because it has never had any industrial significance, and has never been made in other than small quantities as an artists' color and for ceramic use. The precautions for the use of lead-bearing pigments apply to it; it has the same defects as white lead. True Naples yellow in oil has the peculiar property of turning a muddy green when the paste is rubbed with a steel palette knife. This does not occur when a stainless steel blade is used. Older books recommend spatulas with horn or hard rubber blades.

Genuine Naples yellow is produced in limited amounts in about six shades, from a greenish yellow to a comparatively pinkish orange yellow. These shades are not very widely different, and the usual material available on the market as a dry color seldom offers a choice of more than two shades, generally called light and dark. Because of its permanence to light and the general all-around excellence of its pigment properties, which closely resemble those of flake white, Naples yellow is well-liked by painters. There is scarcely any advantage in buying imitation Naples yellow made with mixed pigments, because it will not duplicate the unique pigment properties of the original, and furthermore such approximations can easily be made on the palette. Nevertheless, most Naples yellow oil colors are now these mixtures; when based on zinc oxide they will not have the special brushing characteristics for which the true Naples yellow was noted and which was a large factor in its survival. Made with flake

white, such mixtures would undoubtedly be a closer approximation to the original.

Ochres occur in all parts of the world, but the finest ones, in fact the best ones suitable for artists' colors, are mined in France, where they are most carefully washed, refined, and placed on the market as recognized uniform grades designated by a series of letters established by long use. For example, one of the most desirable ochres is called J.F.L.S. which stands for *jaune, fin, lavé, surfin*. Mars yellow is much more brilliant and powerful than the ochres and raw siennas; theoretically it should supplant them, especially because of its purity, but most artists continue to prefer the more delicate and subtle tones of the native earth.

BROWN PIGMENTS

Vandyke brown was employed not so much for its general hue, which might have been matched by a mixture of black, red oxide, and a little ochre or sienna, but for its rich, deep tones against which the umbers seem chalky. Old oil paintings in which it was employed are frequently found to be deteriorated into a mass of wide traction fissures.

Burnt sienna is one of the most valuable pigments for producing mixed or broken hues of depth and clarity. Like the other earths it is sold in a great variety of top-tones, but the undertones are fairly uniform. In oil colors the deepest and darker mahogany shades are the most useful, and will yield the least chalky results in mixtures; further mention of some of these mixtures will be found under *Green Pigments*. Burnt sienna is classified sometimes as a brown and sometimes as a red. In a very restricted or simplified oil palette (see page 101) it can be used as a red; in some opaque mediums (like pastel, gouache, and tempera) the color effect of its top-tone is so close to those of Indian or light reds that the latter are frequently considered unnecessary.

Raw and burnt umbers are the most widely used browns; they have a pronounced siccative effect on oil, and tend to produce tough, flexible, leathery films. Their oil content is so high that when used full strength in undercoats they have a tendency to produce cracking of the top coat, as noted in Chapter 3. To be on the safe side, they should not be used in underpaintings in greater concentration than a 40 percent admixture with pigments of low or medium oil absorption; up to this amount they may be added to undercoats in order to secure quick drying and uniform, durable oil paint films.

Sepia and bistre, used exclusively in watercolors and wash drawings, are not so commonly employed as they were in the past. Sepia is rated as a semipermanent or borderline color, bistre as definitely not perma-

nent. Bistre is a rather cool, greenish brown compared with sepia; the difference between them is analogous to that between raw and burnt umbers, but their tones are more subtle and delicate than those of the umbers. Bistre is now very rare.

Both sepia and bistre were valued for their versatility in producing watercolor washes of great variation in tone or "color," depending on their dilution with water; therefore, in the case of a substitute color used to replace one of their hues, a diluted or more highly concentrated mixture will not necessarily match the diluted or more highly concentrated original.

VIOLET PIGMENTS

The use of violet pigments in painting is generally limited; many painters prefer the broken violets produced by mixtures of blues and reds, because they fall into the average color scheme better than the pure, clear violet pigments, which, as a rule, tend to produce cold or harsh effects. When a bright, clean violet color is desired, cobalt violet is usually found suitable by most painters. Manganese violet can replace the bluish shade or dark cobalt violet but not the light. (See the main list for precautions on the poisonous nature of some cobalt violets.) Compared with the bright cobalt and manganese violets, Mars violet is dull and subdued, but when used straight or in mixtures on the average picture of low intensity it serves well to produce the majority of purple and lavender colors ordinarily required. See also the new violet pigments listed on page 410.

BLACK PIGMENTS

The common black pigments—ivory, bone, lamp, vine, and drop black—all consist of carbon obtained by burning various materials. They are very fluffy and of low specific gravity—25 pounds of some grades of lampblack will fill a sugar barrel; the same barrel will often hold 300 pounds of a pigment of average density. They absorb a considerable amount of oil in terms of weight; however, when computed by volume it is not so much as the weight figures indicate. The carbon blacks are all very poor driers in oil and will retard the drying of a normal film unless mixed with a siccative pigment, such as umber. The soluble salts in the impure members of this group (and in some of the purer ones also) will effloresce when the pigment is used as a mortar color or in fresco; also the fluffy and water-repelling nature of this group makes them less desirable than Mars black for most water-medium uses. The material specifically called carbon black is the most intense in color and tinctorial power of

any of this family but is not used as an artists' pigment for reasons noted in the general list.

These nonmineral blacks may be grouped as follows:

Pure Carbon
 Carbon black, lampblack.
Impure Carbon
 Animal sources: ivory black, bone black.
 Vegetable sources: vine black, charcoal black.

Frankfort or drop black is made from a great variety of vegetable and animal materials. From the manufacturer's point of view the difference between lampblack and carbon black is that lampblack is soot or carbon collected by the smudge process, and carbon black is soot made by direct impingement of flames with a metal plate. The inferior grades of lampblack contain small amounts of greasy materials.

Ivory black is the most widely used artists' black and serves well as an all-around black and tinting color. It is the only member of the impure carbon group that is recommended as a permanent artists' color. However, it is one of the worst pigments to use full-strength or nearly full-strength as an undercoat in oil paintings: a film of any other pigment laid over straight ivory black is extremely likely to crack, as noted on pages 163–64.

Black iron oxide or Mars black is a thoroughly trustworthy pigment. Its introduction to the artist's palette is rather recent. The native magnetic oxide and the blacks made of ground shale or slate are too coarse for average pigment use, but they are used industrially to some extent in water pastes as mortar colors, etc.

Some of the black or blackish effects produced by mixtures of other colors are mentioned under *Green Pigments*. Very exact matching of blacks on old paintings requires the direct rays of sunlight rather than diffused north light.

Most of the lines of artists' colors now offer but three choices—ivory black, lampblack, and Mars black.

WHITE PIGMENTS

Some classifications of white pigments include several of the materials grouped separately in this chapter under the heading of *Inert Pigments*. Under the present heading only those pigments which retain their color and opacity when ground in oil are listed.

White lead is one of the earliest artificially manufactured pigments recorded; it was employed in China as far back as we have any history of

the materials of Chinese painting, and was used in the earliest periods of European civilization. It has very desirable properties when ground in oil: it has the lowest oil absorption of all white pigments; it unites with oil to form a buttery paste which has fine brushing qualities, and it is noted for its opacity or hiding power and its pleasing tonal characteristics. It produces paint films of great durability. Its two defects are its toxic nature (see pages 104, 406) and the fact that the surface of white lead paint films is liable to turn dark brown when acted upon by air that is polluted with sulphur fumes. The latter defect is of slight consequence in oil paintings, where the pigment is usually well protected and locked in by oils and varnishes, or in varnished tempera paintings, or in undercoats; but it definitely precludes the use of white lead in all the other artistic painting media. Anyway, white lead brushes out poorly in most water mediums. Should an oil painting be affected by sulphur as described above, the remedy is quite simple; it is mentioned on page 473. However, the only conditions under which this darkening would be likely to occur would be such as are found in kitchens, stables, industrial or factory buildings, and outdoors in localities where soft coal is burned. Artistic oil paintings are not usually exposed to such conditions. Under the conditions which prevail in easel painting, the best white leads in oil will not react with any of the approved permanent pigments, even those which contain combined sulphur, provided these are of high quality.

The best grade of white lead is usually known to artists as flake white, a corroded basic lead carbonate made by what is known as the old Dutch process, though essentially this process is the same as that described by Theophrastus[1] and used in ancient Rome and Greece. The number of modern lead compounds made and used industrially under the name of white lead is large. All are inferior to flake white; basic sulfate and silicate white leads are used because of their lower cost. Cremnitz white, a nineteenth-century development, is made by a modification of the process, which allows it to be more carefully controlled; it is a somewhat purer, more brilliant white, but it has less opacity. Various authorities rate one slightly above the other; for artists' use both are superior to the rest of the industrial white lead pigments. The basic raw material of Dutch process or flake white is metallic lead; that of Cremnitz white is litharge. Fortunately all these distinctions are extremely minor, for it is doubtful whether much if any true Cremnitz white has been sold to artists in the United States in recent times, despite the continued use of this name. Either flake or Cremnitz white can be taken to mean highest quality basic lead carbonate for artists' use. The Commercial Standard (page 651) now omits the name Cremnitz white.

It is also doubtful whether any American manufacturers make a dis-

tinction between the various kinds of white lead in artists' oil colors; the differences are small enough that if a pure basic lead carbonate with the best pigment properties is selected, the product will be satisfactory. Much white lead in oil is made by blending more than one variety.

White lead has always been the basis or principal pigment for oil painting. Its properties in oil, as regards grinding, drying, brushing, and other manipulations, and its opacity, flexibility, and durability are so superior to those of other whites—and in fact most other pigments—that it is not only a standard of comparison by which the physical properties of other pigments are judged, but it is beyond some of the rules and restrictions which govern the correct application of colors. Old portraits which have been thinly painted except in the faces, where a heavier coat of paint consisting principally of flake white has been used, are often found to have disintegrated except for the faces, which are in perfect condition; and it is not uncommon to find other old paintings in which white lead areas, thin or thick, have outlived both impasto and very thin coats of other colors.

The success of the oil painting technique as a standard easel painting process for several hundred years has been based largely upon the use of this pigment, and its exclusion from many latter-day palettes has resulted in a lowering of some of the good qualities of the technique. Because of these points and because none of our other whites is entirely perfect in oil, flake white still remains in use as a pigment for oil painting, despite the claims of zinc and titanium whites.

Zinc white is a term peculiar to the artists' material trade, where it is intended to describe zinc oxide of the highest degree of purity. The manufacture and sale of artists' colors is an insignificant branch of the color industry, and other white pigments, such as lithopone, contain zinc, and in the past, because of the disorganized system of nomenclature, were frequently sold as zinc white. The best grades of domestic dry zinc oxide are sold under the trade name of Florence French Process zinc oxides. There are three varieties, all of which are more than 99 percent pure and any one of which may be employed, as the differences between them are not great. White Seal is the finest-grained and the fluffiest; Green Seal is just as white but denser and less bulky; Red Seal is slightly inferior in whiteness and fineness of grain to the others. A grade of still higher chemical purity is also available under the name of U.S.P. zinc oxide, but this is made for pharmaceutical preparations and has inferior paint pigment or physical qualities. Green Seal is generally considered best suited for artists' paints.

Zinc white as a paint pigment is free from the two defects of flake

white. It is not poisonous, and since zinc sulphide is white, any action that sulphur fumes might have on zinc oxide in a painting will not alter its color. Flake white in oil is adequately white, as is evidenced by its brilliant effects on many old paintings when they are in good, clean condition, but zinc is still whiter. If flake white is called milk white, then zinc could be called snow white. In oil it has a harsher, colder, or bluer effect, and is very much less opaque. It is employed in oil only where its lack of great opacity is either desirable or of no detriment; if a more opaque white is required, flake white or a mixture of 50 percent titanium with zinc white may be used.

Zinc white is a reactive pigment in oil (see pages 134 ff), and unites with it but not in the same way as flake white does. It tends to make a brittle, hard film in comparison with the tough, flexible film of white lead. Its film has none of the desirable paint qualities described under flake white, it brushes out poorly, and it is an exceptionally bad drier. Its particle structure is rather finer than that of the average pigment. Poppy-oil films are definitely less permanent with zinc than with flake white.

Under severe weathering conditions such as those to which outside house paints are subjected (and which may be taken, in a measure, as accelerated or exaggerated indications of the conditions an artistic painting may undergo over a long period of years), white lead films decay by becoming soft and powdery, zinc films by becoming brittle, cracking and flaking; in the average climate, mixtures of the two, containing not more than 60 percent of either, are more resistant to decay than is zinc or lead alone. An addition of 10 percent of blanc fixe increases the durability of such outdoor paints, evidently by reinforcing the structural strength of the film.

Although zinc oxide is a very slow drier in linseed oil, and remains rather soft and flexible for some time, the oxidation of the oil is merely retarded; the drying action will continue until the film has reached its characteristic hard, brittle condition. Hence, zinc oxide is not so good a material as flake or Cremnitz white for use in underpaintings; it is liable to be the cause of cracking on account of the shrinkage in volume accompanying the slow drying of the film. This danger is increased by its finely divided particle size and it is more likely to take place when poppy oil is used. In general, zinc white, especially when ground in poppy oil, may be considered of greatest value as a top coat, or in simple, direct, one-sitting painting. Oil grounds made with zinc oxide should be aged for at least six months before use.

In all aqueous mediums zinc white is free from defects and gives very good results. It has long been used as a watercolor under the name of

Chinese white, and when thus employed its opacity is usually satisfactory. Where it has insufficient hiding power, as in work done for photographic reproduction, titanium should be substituted.

Lithopone is used in enormous quantities for interior wall paints, but despite the modern improvements made in its properties, it is universally condemned as an artists' white. In oil paints it is considerably inferior in color and color stability to zinc oxide. However, it has good opacity, and its structural or film-forming properties are excellent; therefore it is generally considered acceptable for use in grounds, either in water or oil mixtures. Its fineness of grain may cause trouble when used with poppy oil. Lithopone has a structural advantage over zinc oxide in oil grounds and underpaintings because its film tends to dry more completely and thoroughly within a comparatively short time, and to be less brittle.

Titanium whites are extremely inert and are unaffected by all conditions which pigments are likely to undergo, including temperatures up to about 1500° F. When first introduced they were expected to replace lead and zinc whites both for this reason and because of their greater opacity and covering power; but although they are valuable additions to the list of pigments and find a continued wide use, they have certain properties which limit their application when they are ground in oil. When exposed to severe tests, their films have a tendency to become both soft and chalky; hence they are most successful as pigments for oil painting when zinc oxide, which tends to form hard, brittle films, is added in amounts varying from 20 to 50 percent, as is done in white house paints and enamels. In colored or tinted mixed paints, 40 to 50 percent of zinc is used, and for oil grounds on canvas 50 to 60 percent of zinc is probably the best proportion. When ground in oil as an artists' color and compared with zinc and flake whites, the titanium whites may occasionally turn more yellowish upon short aging. The pigment itself does not change; the yellowing is apparently a surface effect of the oil. The reason for it is possibly that because the pigment is so inert or nonreactive it does not form the same combination with the oil that the more reactive zinc and lead do, and therefore favors a more pronounced or thicker continuous oil layer in the upper part of the film, somewhat like that in the glossy-paint diagram on page 153. This yellowing is not extremely bad; it is scarcely apparent when tinting colors are used with the white. The titanium whites are rather poor driers in oil, although more rapid than zinc white; titanium and mixed zinc and titanium oil grounds must be well aged before use.

In aqueous mediums, titanium is entirely satisfactory. In tempera mediums the difference between it and flake white is reversed. In tem-

pera, flake white usually brushes out with difficulty; titanium brushes well. Pure, dry titanium dioxide is sold by one maker under the trade name of Titanox A; the product described in the list of pigments as titanium pigment (made with barium sulphate) is sold as Titanox B. Equivalent grades with other trademarks as well as other kinds of less value in artistic painting are also produced. The pigment made with barium is the one in common use; the pure oxide is somewhat more expensive (but still in the low price class) and, in industry, is employed less often—usually only when extreme opacity or hiding power is required. Some painters dislike it in tempera and prefer the barium composite because the pure oxide is so very powerful that it is difficult to wash out of the brush. The American titanium products are pure, uniform, and well made. According to Toch,[213] the material as ground in refined linseed oil for artists' use shows none of the defects enumerated above, and under the conditions of artistic oil painting is a thoroughly satisfactory and reliable pigment. The physical properties of those American pigments which are made in large-scale production are continually being improved, and the current titanium pigments are superior to those of a few years ago.

The titanium pigments have the greatest opacity and the highest tinctorial power of any of the whites. If a gray is made by mixing one part of black with 10 parts of Titanox A, by volume, approximately 25 parts of Titanox B will be required to produce a gray of equal intensity; using white lead, 40 parts will be required, and using zinc oxide, 60 parts. The grays produced by mixing black with white lead appear neutral or warm in comparison with the cooler, more bluish grays of zinc and titanium.

It will be seen that although neither of the defects of flake white is present in zinc and titanium, and although flake white has none of their defects, we have no entirely perfect white for universal pigment use.

INERT PIGMENTS

The inert fillers or extenders are, as has been mentioned elsewhere, white or nearly white pigments that have low refractive indices and therefore, when ground in oil in the manner of the usual artists' color, have little or no opacity or tinctorial effect. They are used as cheapeners or adulterants, and to impart to oil paints various properties such as bulk, tooth, reinforcement of the film, hardness, softness, etc.

When mixed with aqueous binders or mediums, they are less transparent, and in some cases, as in the chalk-glue gesso mixture, several of them will produce brilliant, white, and adequately opaque coatings. When chalk is mixed with oil, it will form a muddy, translucent paste

more intense in color than the oil itself. Colored pigments which have been reduced or let down with inert materials are ordinarily muddier as well as weaker than pure pigments.

However, there are exceptions, and in some instances the correct use of inert pigments may result in definite improvements in the quality or handling of paints. In a few cases, notably with phthalocyanine blue, the pigment's tinting power is so enormous compared with the rest of the pigments on the palette that an addition of alumina hydrate or blanc fixe will result in an improvement in quality and ease of manipulation. Another legitimate use for inert pigments is in gouache paints where several pigments (for example, Indian red and viridian) are improved by being rendered more brilliant and smoother-working by additions of precipitated chalk or other inert pigments during manufacture. Silica of various degrees of fineness is sometimes used to impart tooth or coarseness to grounds and occasionally to certain paints. Special grades of mica and asbestine will retard the settling of some liquid paints and improve their structural stability. In such cases the inert pigments function as valuable modifying ingredients rather than as adulterants.

The following are the more important commercially available inert pigments. Their properties are described in the list of pigments.

Alumina hydrate	Magnesium carbonate
Asbestine	Marble dust
Barytes	Mica
Blanc fixe	Pumice
Chalk	Silica
China clay	Talc
Gypsum	Whiting
Infusorial earth	

Alumina hydrate is the best and most widely used material for extending transparent pigments, and blanc fixe for the heavy, opaque ones. Precipitated chalk is used to make gesso and pastels and to brighten or extend gouache colors.

Calcium carbonate, chalk, whiting, marble, and limestone have the same chemical composition, and differ only in crystalline structure, density, or degree of purity.

PERMANENCE OF PIGMENTS; NEW PIGMENTS

Permanence in an artists' pigment means that the color will not be altered during the life of the work of art in which it is used, by any condition which it is likely to encounter. Some colors may be altered or destroyed by subjecting them to strong heat or to the action of chemicals, but since

works of art are not normally expected to endure such conditions, the term "absolutely permanent" means that a color complies with all of the normal requirements for pigments as listed on page 31.

Pigments are tested for resistance to fading by subjecting them to concentrated ultraviolet light with laboratory apparatus, whereby the effect of months of exposure to direct sunlight is duplicated in a relatively short time. The action of an ultraviolet lamp is not exerted to the same degree as that of direct sunlight; that is, x number of hours under ultraviolet light cannot be calculated as a reciprocal of y number of hours under direct or diffuse sunlight to obtain a time relationship. But it does supply an accurate indication of the relative degree of resistance to fading, as well as to age embrittlement (see page 446), that is exhibited by various materials, and its results conform closely to the tests described in detail on page 661, paragraph 6.4. Industrial pigments are tested by outdoor weathering.

In the past, new discoveries in artificially made pigments were introduced in various ways. Sometimes a valuable color was allowed to remain in obscurity or as a laboratory curiosity for many years until circumstances caused or allowed its introduction to the palette. At other times, novelties were immediately introduced and later discarded when artists found them to be impermanent or otherwise unsatisfactory. When the organic colors appeared during the second half of the nineteenth century, painters and others concerned with the permanence of pigments envied the brilliance and variety of these colors but realized that few of them could be utilized for purposes requiring any degree of permanence. In the early twentieth century, pigments of greatly improved light resistance began to appear on the market and were adopted by makers of decorative paints, printing inks, and other industrial products. Because they were so much more lightproof than the earlier colors, some of them, such as Harrison red, were introduced to the artist's palette, but none was sufficiently lightproof to have warranted their adoption; the degree of their improvement over the older coal tar colors was responsible for the optimism with which they were received. Sometimes new colors that belong to the same chemical family as a successful older one, and that theoretically should share the older color's desirable characteristics, fail under actual test.

We now have organic pigments of far greater permanence than those of a few years ago. (See pages 410 ff.) In the laboratory, some will test three or four times as resistant to exposure as madder lake. Yet we are proceeding very slowly toward their adoption, and today we await the results of very exhaustive tests before including such colors in our permanent palettes because of the earlier premature adoption of improved colors. As recently as the 1950s, only three synthetic organic pigments were universally approved for use in artists' permanent paints: alizarin

crimson, phthalocyanine blue, and phthalocyanine green. Since that time the Paint Standard has adopted Hansa yellow and given a strong recommendation to quinacridone red (yellowish shade). The words "coal tar colors" or "aniline colors," which were formerly used pejoratively, need no longer be used in that way, since so many of the newer pigments are permanent.

Alizarin, or madder lake, which is universally accepted as a necessary and permanent color for easel paintings, provided they are kept under the normal conditions of preservation of works of art, might well be adopted as a standard of permanence for such pigments. They would then be required to equal it in all respects when subjected to tests.

Many printing ink and industrial paint pigments have the word "permanent" included in their names, and they are permanent in so far as their uses are concerned. A brilliant red which will maintain its general hue on a shop sign under severe outdoor conditions as long as the paint film will last (three or four years) has a right to be called permanent for this use; the same pigment used as an artists' paint may fade, at least enough to destroy pictorial or decorative effects, after five or six years in daylight—even in diffused, indoor daylight.

The fading of a pigment or dye on exposure to daylight is not an evanescence, or the disappearance of the substance itself into thin air, but is actually the result of a chemical change: the ultraviolet wavelengths in the light reacting with the substance or triggering a reaction, sometimes with the combination of air and/or moisture, the pigment changing over to a colorless or less highly colored compound. Color stability is therefore linked with chemical stability.

Not only as regards pigments, but also in connection with paints and varnishes, the artist should remember that his requirements are different from those of the industrial consumer, and that products which are in all sincerity labeled permanent are not always permanent for his purposes. No one expects the paints which are used in ordinary wall decoration to last fifteen years, still less the paints which have to withstand more severe conditions, such as those used on houses, store signs, and boats; yet a material which displayed defects in a work of art after twenty-five or fifty years would certainly be considered a failure by artists.

Bleeding. An obstacle in the way of the adoption of organic colors of really superior permanence to light is that many of them have the property of bleeding or striking through when used with oil or oily mediums. If a coat of white paint is applied over a coat of red that has this property of bleeding, even if the red is thoroughly dry and hard, the color will eventually be observed coming through the white—apparently dissolving

into the film of white paint, running through it in a streaky or spotty manner, or occasionally imparting a uniform pink tint to it. Some so-called nonbleeding colors are really semibleeding, the defect manifesting itself only after a period of years. Bleeding will never occur when insoluble inorganic colors are used and the undercoat is perfectly dry, no matter how finely the pigment has been ground. Any lightproof pigment, regardless of its bleeding or other faults when mixed with oil, may be used in pastel, where such defects are of no significance.

Many thoroughly permanent inorganic colors which have been known for years have never gone beyond the laboratory stage because of economic reasons. With the development of new industrial processes, such as the coloring of lacquers and plastics, mass production of some of these becomes feasible, and occasionally a pigment of known reliability is thus made available to artists for the first time.*

LIMITED OR RESTRICTED PALETTES

Although it is possible to produce a fairly useful range of hues with mixtures of black, white, and the three primary pigment colors—red, yellow, and blue—we find that, owing to the various qualities of the substances we use as pigments, there are many specific color effects which can be obtained only by employing a multiplicity of pigments. Depending upon the desired color key or tonal harmony of the painting as a whole, a complete range of colors can sometimes be effected with a very limited palette, but usually a free choice of pigments is required. Whether the desired result be harmony, contrast, monotony, harsh brilliance, or softness, it is not obtained by merely matching the local colors of nature, but by translating, transposing, or manipulating the tones and colors within the chosen key. A spot of color which in one painting is garish and brilliant might be a dull blight on another picture.

The choice of pigments is entirely a matter of the individual's purpose and intentions. It may be guided by the requirements of the school of painting to which he adheres, but it must be controlled by an understanding of the properties and potentialities of the pigments, each of which requires some study and experience.

If a painter limits himself to one red and chooses light cadmium, he will be able to approximate the tones of the duller earth reds with mix-

* An example of this sort is manganese blue, which was barely noted in the first edition of this book and which ten years later came into wide general use. Others are cobalt violet and cobalt blue, formerly imported from Europe, which are now in domestic production when government restrictions on cobalt permit. Many past examples of the lag between the discovery or development of a pigment and its introduction to artists will be found in the general pigment list.

tures, but he must forgo the tints and glazes that alizarin will produce. If he has both light cadmium red and alizarin he can match the deeper cadmium reds, but if he has only a medium or deep cadmium red he cannot produce the bright vermilion shades, and mixtures with yellow will produce only muddy approximations. The number of greens, both vivid and subdued, that can be made by utilizing all the permanent green, blue, and yellow pigments is unlimited; no painter could possibly want all of them in a single landscape. Yet an arbitrary limitation to too few pigments—for example, to one yellow instead of two—will obviously handicap him in most instances.

A pale or lemon yellow pigment (such as light cadmium yellow or strontium yellow) is so different from the golden yellows (like cadmium yellow medium or deep) that on a working palette they behave like two different pigments rather than two shades of the same color, especially when they are used in mixtures to create greens, oranges, etc. The average palette, therefore, usually requires two bright yellows instead of one. The differences between the medium and the deep cadmium yellows, however, are not nearly so significant; indeed, the medium of some brands is the same or nearly the same as the deep of others, and so these two could be much more accurately considered as different shades of the same color.

Some printers attach great importance to the convenience of having a range or scale of hues with no wide areas in between, so that clear, brilliant, ready-for-use colors are available; others prefer to work with as few colors as possible. The artist is guided, in this respect, by the nature of the work at hand.

Hue Tolerance. On page 14 reference is made to the rating or quality of the various brands of artists' colors on the market. Among the best grades of paints, we find definite variations in color effects; for example, the burnt sienna of one manufacturer will be a deep translucent mahogany hue, and another, equally fine and pure, may be distinctly paler and more opaque. In establishing the Paint Standard (see page 651) the committee studied the question of establishing a set of hue limitations for each pigment but finally did not include such restrictions in the Standard, because the judgment of the manufacturer on what constitutes a medium or deep cadmium yellow or the difference between a "good" or "bad" raw umber, for example, is based on his experience and also upon its acceptance by his customers, for artists always have their individual preferences in these matters. Furthermore, the colorimetric specifications for tinting strength act as controls, because if the pigment is too far from a true example of its prototype, it will not meet the performance of this test.

Aside from the easy portability of a minimum color-note outfit, the most legitimate technical reason for the limitation of a palette is that painting with too great an assortment of ready-made color effects results in a defect similar to that produced by overmanipulation or by the use of tiny, "picky" brushwork, referred to elsewhere. Students are taught to work with few colors as a method of discipline, just as they are taught to work with large brushes, but the arbitrary elimination of useful colors is an unnecessary handicap to mature painters.

Investigators have studied the palettes of noted painters of the past and present; in some cases painters have produced works of sufficient range of color for their purposes with as few as two or three pigments. Among others, the books of Church,[47] Fischer,[52] and Hiler[54] contain lists of various painters' palettes.

An average normal working palette for use on an individual painting would consist of twelve to fourteen colors. I should say that less than a dozen would be a simplified palette and more than fourteen can be called an elaborate palette.

Color as a Tool of Technique. A full complement of pigments is not only useful for local colors but is equally valuable in extending the range of effects by playing one tone against another or by utilizing the contrasts between the color properties of pigment other than those of hue. On the other hand, the deliberate exclusion of a specific hue or the deliberate emphasis of a specific color in a painting can influence the total effect to such an extent that it can create qualities which may actually contribute toward the content of the painting itself.

Some schools of painting have placed a taboo on the use of certain colors; in the recent past there was a prohibition against brown. This was the result of the revulsion of painters against its universal use in the nineteenth century. The lavish use of black to obtain variations of shade and tone throughout a picture gives a certain unmistakable character to the work. Some painters desire this effect; others abhor it to such an extent that they exclude black pigments from their palettes. The discovery that some effects of an admired painter can be duplicated by utilizing certain pigments in a definite way has caused entire groups of painters to allow all their work to be dominated by that method, whether or not it is best suited to their particular case.

In the remarks on perspective (pages 546–47) it is noted that an illusion of recession or the third dimension may be produced by analyzing and translating to the picture the effects of atmosphere and light on the colors of objects in nature. Whether the treatment of a picture is realistic, objective, or abstract, forms are depicted through the mediums of line

and of color masses. The development of Western art has established a general feeling that they are of equal importance in a painting, and usually the terms, rules, criticisms, and evaluations applied to the line in a picture can also be applied to the color.

This is one of the contributory reasons for the selection of the various techniques of painting—oil, watercolor, tempera, pastel, etc.—by artists or schools of painting, for each method has its own properties which make it especially suitable for specific effects. The linear type of painting, in which the line dominates, or the tonal type, in which fields or splotches of color dominate, or the type in which line and color masses are combined or balanced, is each best served by the proper medium; within this selection, the choice of pigments plays an important role. If a painting is considered in the abstract, without any regard to its artistic or pictorial content, its forms may be seen to be influenced to a considerable extent by the artist's choice of pigments.

LEAD POISONING

The use of flake white and other compounds that contain lead has been given considerable attention; most published discussions include warnings regarding their toxic effects. These materials may be handled with perfect safety if the hands and fingernails are well cleaned after using them, and if one is careful not to breathe or swallow the dust. Lead is a cumulative poison; that is, if small amounts are absorbed into the system there is no apparent effect; the toxic effect is built up by added quantities. Workers in factories that produce these products, and house painters who use them, do not contract lead poisoning if conditions are such as to permit the usual precautions. White lead is poisonous only if swallowed or inhaled; on the whole its hazard has been somewhat exaggerated. Ordinarily the artist uses flake white only as an oil color. It should never be handled in dry powder form. See page 406.

TESTING OF PIGMENTS

Paint manufacturers and other industrial consumers subject their pigments to certain routine examinations and tests, the simplest of which are noted here and described rather fully. They may be further simplified under certain circumstances.

It must be understood that positive, accurate data from tests can be secured only by experienced technicians; also that modern industrial requirements often call for more accuracy in tests and more elaborate equipment than can be obtained by these simpler methods.

These tests are comparative; a newly received sample of a color is compared with a standard color kept by the consumer for the purpose.

As a matter of routine, a record of all tests should be preserved in a notebook in full detail.

Color Rub-outs. A weighed amount of the standard pigment is placed on a slab of plate glass or smooth stone, and sufficient linseed oil is added to produce a stiff paste when rubbed with a steel spatula or palette knife. The oil is added drop by drop, the number of drops being noted. Care is taken to gather the paste neatly into a small area of the slab, and to rub not more than is necessary to secure a smooth, uniform paste. The paste is then rubbed with a glass muller (page 142), using a uniform, slight pressure and a back-and-forth, somewhat circular motion, the idea being to grind over the entire amount of paste with each complete rub as much as possible, rather than to spread it over the slab. After twenty-five rubs, the paste is scraped from the muller and slab, gathered into a pile, and given twenty-five more rubs.

Using the new sample, the procedure is repeated, the same amount of oil being added regardless of the consistency that results. The two rub-outs are spread on a strip of thin, clear glass, their edges just touching each other, and are viewed by daylight. A good many variations of this procedure as adopted by various chemists, as well as more complex tests, are to be found in Gardner's book.[205]

Pigments for use in water or varnish mediums, etc., may be tested by rubbing them in those mediums instead of in oil.

Strength (*Tinctorial Power*). One-tenth of a gram of the pigment is rubbed up with two grams of a standard pure zinc oxide, as described above. For the very powerful colors—e.g., phthalocyanine blue and the blacks—the proportion is made 50 to 1 instead of 20 to 1. For testing whites and pale yellows a standard phthalocyanine blue is used. The figures are given merely as a guide and are varied according to the requirements and preferences of the user. The reductions should be enough to disclose all the tone qualities and to allow slight differences in strength to be easily perceptible, but they should not be carried to the point where weaker colors become so pale that an estimate of their relative strengths is difficult. Strength rub-outs are always thoroughly mulled, and if there is any streaking they are given further mulling until the color is uniform and thoroughly developed.

Draw-outs. Another method for comparing the relative color and strength of artists' oil colors, which may be used on prepared tube colors

as well as on dry pigments, is the one that is used by the printing ink trade, which values pigments for their transparent undertones as well as for their top-tones or body color. The dry color is weighed out and rubbed up with oil as in the previous account, or samples may be squeezed out of two tubes of prepared oil colors and placed side by side at the end of a wide, flexible wall scraper (described on page 532).

The handle is grasped in such a manner that when the blade, loaded at the tip with the two dabs of color, is drawn across a pad of white bond paper, pressure can be controlled. The first part of the stroke is light, and a thick layer is thereby transferred to paper; after one-half to one inch of this has been applied, the knife is held vertically, and with a firm, scraping pressure it is drawn across the paper with a rather rapid stroke, which will produce a thin staining of the paper. By holding this draw-out against the light, comparison of the two samples is easy, and minute differences in color, clarity, strength, hiding power, etc., may be almost quantitatively estimated. Try this with an alizarin lake oil color of known high quality and a student grade color made of genuine pigment let down with inert material. An experienced technician can judge the percentage of difference or variation quite accurately.

Volumetric Method. As mentioned on pages 138–39, the evaluation of artists' paints on a basis of weight does not seem to me to be rational. The painter uses his materials by volume rather than by weight and a direct volumetric method of comparing the relative tinctorial strengths of pigments is better suited to his purposes. Also, he will more often wish to

compare ready-made oil colors than dry pigments. Paragraph 6.7 on page 662 describes a standard method for determining the relative tinctorial strengths of oil colors by volume. Simpler but less precise methods using less precise devices such as kitchen measuring spoons can be devised. The ratio should be 10 parts to 1 part white oil color, and for the very powerful colors, 20 to 1.

Dry Color. Dry pigments are compared by placing small piles side by side, covering them with paper or cellophane, and pressing the paper down firmly and smoothly with a palette knife. When the flattened surface of the combined piles of color is viewed by daylight, the line of demarcation and any differences in shade are easily seen. A drop of turpentine placed where the pigments join will bring out the variation in tone with white or inert pigments.

Fading. Artists' oil colors are tested for color stability in direct outdoor sunlight as described in paragraph 6.4, page 661. Tints do not resist this severe accelerated test to the same degree as do straight pigments, so the original Paint Standard tests were run in 85 percent reductions with zinc white as well as in full strength. But since the properties of the accepted pigments are well known, and since any samples that pass the full-strength test would be acceptable and would not be expected to fade indoors in any reduction, full-strength tests alone were deemed adequate. (See paragraph 5.1, page 653.) Watercolors on rag paper may be exposed in a photographer's printing frame in an unobstructed south window, with a strip of black paper or cardboard protecting part of the painted paper for comparison. All such accelerated tests are extremely stringent and provide a wide, safe margin over centuries of actual indoor exposure to diffused daylight and artificial light.

Yellowing. The accelerated test described on page 99 is used.

Dyes and Lakes. No paint pigments should be soluble in oil, water, or the volatile solvents. To test for insolubility, dust or blow a small amount on wet white blotting paper. Any solution will be immediately apparent. The same filter-paper test is used with soluble dyestuffs to distinguish between single dyes and mixtures of dyes.

Lighting. Color comparisons should be viewed by daylight; most of the artificial daylight lamps are unsatisfactory substitutes. Although an even north light is preferable in the greater number of cases, direct bright sunlight is sometimes useful in examining blacks and other very dark colors.

FURTHER REFINEMENT OF PIGMENTS

The following outline is intended for the use of painters or groups of painters who may have occasion to use pigments free from water-soluble impurities in sufficient quantity to warrant the trouble of washing pigments which are otherwise of high quality. These instructions are not given as recommendations for common use.

The impossibility of the average color manufacturer's producing pigments especially for artists' use has been mentioned previously. Some of our permanent pigments contain small percentages of impurities which do not detract from their utility in common industrial applications or even in the ordinary artistic techniques, but which are undesirable in some cases where requirements are more exacting—for instance, in fresco painting.

The usual impurities will be small amounts of water-soluble salts, acids, or alkalis, which can be removed by subjecting the pigments to a few additional washings in hot water, using such simple inexpensive apparatus as is employed in the laboratories of the color makers for their small-scale experimental batches. The manufacture of pigments in general does not require very complex equipment (except in the case of special furnaces for those pigments which are made at high temperatures), and jars, beakers, little tubs, and filters may be considered as miniature color factories. The actual manufacture of pigments from their raw materials, however, calls for a high degree of skill and much specialized experience—an inexperienced person cannot expect to manufacture small batches of color that will equal the commercial pigments either in purity of color or in pigment properties.

The dry pigments are mixed with water, preferably distilled water, boiled, allowed to settle, the clear water poured off, and the procedure repeated until all of the impurity is dissolved and washed away; then the mixture is filtered and the pigment dried and pulverized. The washing may be done in laboratory beakers of 500 to 1000 ml capacity, depending on the quantity of color needed, and an ordinary large glass funnel and folded filter paper may be used for the filtering. A more satisfactory filter, however, is one assembled from a common laboratory vacuum (aspirator) pump, which is a simple affair made to be attached to a water faucet, and connected by a rubber tube to a suction flask with a rubber stopper into which is fitted a Buchner funnel. The funnel and suction flask come in various sizes; the funnel is made of porcelain, and has a flat, perforated surface within it, upon which is laid a sheet of coarse filter paper. After the pigment has been boiled with several changes of water, it is poured onto the filter, and, preferably just before the pump has extracted all the

water (at which time the remaining filter-cake becomes cracked and the noise of suction changes), it is washed again by pouring boiling water upon it. Then, after the pigment has been sucked free of superfluous water, the funnel is disconnected and the pigment turned out on a piece of paper and allowed to dry at ordinary room temperature or with mild steam heat; strong heat may make it cake too hard. The washing vessel should be large enough that the settled pigment occupies only one-fourth to one-third of its capacity, and the suction flask should be large enough that it does not have to be emptied too often, which is inconvenient.

All of this equipment is of the commonest kind and is available at any laboratory supply store. If beakers are used they should not be heated over a direct flame but should rest on the usual asbestos disks. If enameled pots are used, they should be of best-quality acid-proof white enamel.

It is best to know the nature and extent of the probable impurities so that the wash water can be tested for their presence, by simple qualitative methods; acids and alkalis are detected by the use of litmus, phenol phthalein, or other indicators; and the presence of salts by adding a few drops of the usual test solutions.

Dryness. In large-scale factory procedure, after the washings, the moist pulp color from the filter press is broken up and spread out on open trays of screening or lath and either air-dried, steam-heated, or put through a mechanical dryer, according to the nature of the pigment. It is then pulverized and packed in bags or barrels; so long as it is a fine smooth powder with no tendency to form hard cakes, it is universally considered bone dry for practical purposes and is within the range of tolerance for any normal painting technique. Some artists preserve their pigments in glass jars with ground glass stoppers in order to exclude atmospheric moisture (see page 139) but for all practical purposes the less expensive screw-cap jars and friction-top cans will serve as well. In reasonable well-conditioned rooms, they may even be stored in paper bags. When absolute dryness is required for very special cases, the pigment must be desiccated by chemists' methods. A harmful or abnormally high moisture content would be apparent by a tendency of the pigment to form into firm cakes or lumps.

COLOR AND LIGHT

The color of a pigment is not one of its definite, inherent properties; it is rather the effect on the eye produced by that particular substance under

certain circumstances. Many conditions can alter the color effect of a material, and two examples of the same pigment will not match each other exactly unless they are seen under exactly the same conditions.

When a dry pigment is mixed with a liquid its color is changed to a darker or deeper tone. This is an optical effect, which may be explained in the following manner.

The materials used as pigments differ widely in certain properties from the liquids used as mediums. One of these properties is the amount of light a substance reflects and absorbs. All solids and liquids vary from each other in this respect and each one has been measured and tagged with a number which is called its *refractive index.*

A sheet of glass is a transparent substance; when a ray of light strikes it at an angle, there is a varying amount of surface or mirror-like reflection, depending on conditions; however, the greater part of the light passes through its continuous uniform structure and emerges refracted or bent, at an angle different from that at which it entered. The refractive index is computed from this change in angle, which depends in each case on the substance's power to impede light rays.

When two substances of varying refractive indices meet, the greater the difference in their refractive indices, the greater will be the proportion of light reflected at the point where they meet. When a pigment with a refractive index of 2.00 is dry, each particle is surrounded by air, the index of which is 1.00, and a certain amount of white light is reflected. When the pigment is moistened with linseed oil, which has a refractive index of 1.48, much less light is reflected, more is absorbed, and the pigment appears darker or more intense in hue.

When transparent glass is pulverized, the powder appears white. Water in the form of ice is transparent; in the form of snow it is white and opaque. The reason for this is that while light rays are easily transmitted through the uniform continuous mediums of the ice and the sheet of glass, when they strike the powdered glass and the snow they are reflected in all directions from the myriads of tiny facets of the particles surrounded by air, and are bent from one tiny particle to another until they become entirely diffused. When such broken planes and irregular facets exist only on the surface, as when a sheet of glass has been rubbed with an abrasive to produce a ground-glass or nontransparent effect, the light is broken up and reflected on the surface, creating a whitish or frosted appearance. However, since the light-dispersing particles lie only on the surface in a thin layer, the rays are not entirely impeded, and continue on through the glass, which is now translucent instead of transparent.

A flat or mat effect on a paint or varnish film is always due to the fact that the surface consists of a thin layer of such irregular construction.

When such a surface is moistened its opacity is temporarily diminished. In the same way, alumina hydrate, a white, opaque powder when dry, will become colorless and transparent when wet with benzol because the particles are then surrounded by a medium which has a refractive index very close to their own. The effect of liquids upon the color and opacity of pigments varies greatly in each case, depending upon the difference between the two refractive indices concerned.

If a pigment that appears transparent or translucent in a thinly applied layer is piled up or applied to a surface in a thick layer, it appears more opaque because the light then travels through a great number of separate particles, each one of which impedes its progress by refracting it; also because there is more reflection of light from the points where the pigment particles and their surrounding medium meet, and because more particles absorb more light. Intensity of color also decreases the transparency or increases the hiding power of a pigment.

Pigments vary in transparency in direct ratio to their refractive indices, but all of them are transparent to some extent. If the proper medium is selected, laboratory tests can be made which will show that the most opaque colors, even flake white, appear transparent under certain conditions. The liquids used in such laboratory experiments are not suitable for paint medium purposes, but the effect produced clearly demonstrates that hiding power or opacity in a paint film can be lost through a change in the conditions which surround the pigment that has been used. In an actual oil painting, this does not occur at once; but in galleries one may frequently find a picture in which, by reason of changes wrought by time, oxidation, etc., the refractive index of the oil film has changed, and a thin coat of paint that originally sufficed to form an opaque film has become sufficiently transparent to allow underpainting or drawing to show through. The effect is called *pentimento*. (See Glossary, page 626.) Though all opaque pigments have this property, the whites possess it to a greater degree than do the others; pentimento in old pictures usually appears where white or colors reduced with much white have been used. The fact that all dried films of oil paint tend to become more transparent with age is well established.

It will be seen, then, that when light impinges upon an object it is either transmitted, reflected, or absorbed, depending on the nature of the object; in the case of most paints it performs all three of these actions, in varying degrees.

The practical lesson that oil and tempera painters of the present day have learned from this is that the ground and underpainting always have some effect on the final painting, even when it is not apparent, and that pictures must be built up carefully with this point in mind.

Correct procedure calls for keeping the ground and underpainting as white or pale as possible, superimposing darks over lights (so far as the nature of the work allows), and whenever possible, scraping down or removing any substantial thick or dark areas when these are to be over-painted or obliterated for the purpose of making corrections. If two pictures were identical except for the fact that one was painted upon a brilliant white ground and one upon a black ground, the difference be-tween them would be apparent; any departure from the pure white ground or from strictly necessary underpainting will produce an effect which tends toward that of the black ground. It is especially important to use the whitest sort of ground and pale underpaintings when glazes and veils are employed.

There are few activities other than the use of artists' paints where opaque and transparent color effects are manipulated and where their differences are so significant.

There are many aspects of color and light, each of which is a study or field in itself, such as color harmony, color classification or notation, and color considered from aesthetic, psychological, or scientific viewpoints. These are important studies, and the works listed in the Bibliography under "Color" on page 694 are recommended to those who have need of them. The present account is simply an outline of the physical and optical considerations which are relevant to the technology of painting materials and methods. Some of these considerations are explained at greater length by Ostwald[46] and by Laurie.[51]

COLOR EFFECTS

Each paint pigment owes its color to the kind of light rays it absorbs and reflects. White light (daylight) is composed of a number of waves or im-pulses of various dimensions or wavelengths, any single one of which, if isolated, would have the property of producing a specific color sensation on the eye. When a ray of white light falls upon a pigment, the pigment absorbs certain waves and reflects others; this determines its color effect. Vermilion, for example, will absorb the waves which produce the effect of blue and most of the waves which produce yellow, and it will reflect or throw back the red waves. Ultramarine absorbs almost all but the blue waves; pale cadmium absorbs all but the yellow. Whites absorb little or no light; black pigments absorb most of the light and reflect little. Upon being absorbed, the energy of light waves is converted into heat. We take advantage of this in the summer when we wear white or light-colored clothing.

None of the pigments in use, however, produces a pure color sensa-

Refraction of light. A light ray passing through a sheet of glass or other transparent substance bends (is refracted) and takes a shortcut. The angle of refraction varies with each substance and increases according to the power of each material to impede light rays.

Transmission and reflection of light. Under average conditions a certain amount of light is also reflected from the surface of clear glass as from a mirror. The proportions of light reflected and transmitted vary according to the nature of the substance, the surrounding conditions, and, in many cases, the angle from which the surface is viewed.

Absorption of light. Thin, translucent milk glass or other semi-opaque material transmits less light than does a transparent material. In this instance, some of the ray is reflected, and some absorbed. The more the light is impeded and absorbed, the greater the opacity.

Dark surfaces. The greatest amount of absorption of light, accompanied by the least reflection, occurs when light impinges on a dead mat, intense black surface. Other considerations being equal, a brilliant white surface will reflect the most light, and as it is tinted the amount of reflection will decrease according to the depth of color.

These diagrams show one application of the foregoing principles to painting. When a layer of paint composed of pigment particles and binder is coated on a white ground the resulting reflection of light contributes brilliance and luminosity, which are altogether lack-

ing when the painting is done on a black ground. Any coloration of the white ground will tend to lessen the amount of reflection, and the more translucent the coating is or becomes, the more the brightness will be affected.

tion; we can consider them faulty or impure in this respect. Vermilion reflects a certain amount of yellow along with the red; alizarin reflects some blue with the red; therefore we call vermilion a yellowish red, and alizarin a bluish red.

Another reason why body colors do not give a pure color sensation is that they reflect from their surfaces, as from a mirror, a certain amount of white light, which dilutes the intensity of the color to a variable degree, depending on the nature of the surrounding medium, as previously explained.

The three colors mentioned so far are called primaries; when any one is mixed with another a secondary color effect is produced: green, violet, or orange. This system of color mixing is known as the subtractive process, because the second color subtracts or absorbs still more waves from the white light than the first color did. When three or several more pigments of different color are mixed, tertiary or broken hues are obtained. Because of the "impure" nature of the color effects of our pigments (each one reflecting some waves of a length different from the dominant one) all mixtures will contain blends of minor components, and the effect of any mixture of two colors is invariably duller, less brilliant, or muddier than that of a single pigment. Viridian is a clear, bright emerald green of pure tone compared with any imitation which could be made by mixing a blue with a yellow, because it reflects none of the red waves that such a mixture would reflect. Similarly, painters realize that mixtures of three colors will be still more "broken." A complementary color is one which will absorb the entire portion of white light reflected by another. Red and green, blue and orange, yellow and violet, are the three simple pairs of complementaries. The color circle on page 117 shows complementary pairs.

Light waves have often been compared with sound waves; two different musical notes may be played on two different instruments so as to blend into one clear, simple effect. But if we take two different chords, orchestrate each, and play the orchestrations simultaneously, the result will be complex, if not confused. Laurie[218] suggests an analogy between light waves and radio waves: pigments are substances which have the property of tuning in on certain light waves.

When a transparent pigment is mixed with a white for tinting purposes it does not function entirely as though it were a body color by imparting to the mixture the color effect of its surface color to the mass, but its transparency has much to do with the clarity of tone produced by the mixture. Tints or mixtures of opaque colors are usually duller. When two opaque pigments are mixed, the tiny particles of each, when viewed under the microscope, will appear intermingled, lying next to one an-

other. Rays of light will be reflected from each; the amount of white light reflected from the surface will be the sum of that reflected from all the particles of both pigments. When a transparent pigment, such as alizarin, is used to tint a white paint, the effect is as if each particle of white were surrounded by an envelope of the transparent red; light will pass through the transparent particles, the amount of reflection of light from the surface will be less than when two opaque pigments are used, and what reflection there is will tend to come mostly from one source—the opaque pigment. Fischer[52] points out this property of tinting colors.

Occasionally upon the drying of a paint there will be a color change which is an exception to some general physical or optical rule. This is always because of some peculiar physical or chemical property of the materials involved. For instance, painters who use aqueous mediums in opaque techniques, such as gouache or casein, will note that grays or other mixtures containing black pigments sometimes dry darker instead of lighter. This may be explained by the fact that, because of the relative density and fineness of the various pigment particles or because of some other physical properties, a movement of the dispersed particles has occurred while the film was still wet, and the black has floated toward the surface. Paint behavior is not ordinarily erratic; under similar painting conditions, similar results may be expected; and the painter who has learned the characteristics of each of his pigments is able to control their effects.

Additive Colors. When white light passes through a prism it is broken up into its component parts and the rays emerge in the familiar rainbow or spectrum arrangement, the rays at the red end having the longest wavelength and those at the violet end the shortest. The angle at which the rays are bent, or refracted, is greatest at the violet end and least at the red end. The infrared and ultraviolet rays are invisible under ordinary conditions.

By recombining colored rays, we can mix colored light as we would mix body color; but in this case a magenta, a cyan blue, and a medium yellow are the three primaries, and the system is called additive because the mixed hues are obtained by adding light rays instead of absorbing or subtracting them. The effects of transparent or glaze paints (as opposed to opaque or body color paints) are a little like that of additive colors, because transparent pigments reflect less white light from their surfaces than do opaque pigments.

The followers of the French Impressionist school have been said to have utilized the additive process by substituting the juxtaposition of small spots of pure color for mixtures of colors. When viewed from an adequate distance the light rays reflected from these adjacent colors

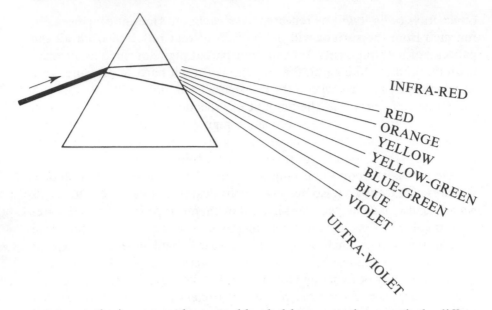

merge, producing upon the eye a blended hue sometimes entirely different from that which would have been produced had the colors been mixed on the palette. The effect is clear and has a peculiarly vibrant, luminous quality. A similar effect, as all painters know, is produced when mixed colors are not too thoroughly blended on the palette but are rather loosely scrambled on the canvas. This additive behavior of light rays explains many peculiarities and tendencies in color mixtures, though it plays a minor role in our painting methods, which, for all practical purposes, conform entirely to the rules for subtractive mixtures. The additive system of color mixing is principally involved in working with the effects of colored lights rather than with paints, and it is basic in colorimetry and in color photography.

Diffraction Colors. A color effect which has little to do with painting but which often occurs in nature, or which may be produced by manipulations of certain materials, is that caused by the refraction of light in all directions without the use of pigmentation. The brilliant colors of certain plumage and minerals are caused by the diffraction of light from surfaces that have structures equivalent to myriads of tiny lenses or prisms. The iridescent colors in soap bubbles or oil films on water are explained by the fact that very thin films will display iridescence when surrounded by two mediums of different refractive index. In the case of the oil film, the two mediums are air and water. These effects are characterized by an intensity, a brilliance, and often a hue of almost metallic quality, which can be only approximated in paint.

*Variation in Color Effect.** The principal ways in which the color effect of a pigment in a painting can be altered as described in the foregoing section, may be summarized as follows: (1) the nature of the surrounding medium, (2) its degree of gloss, (3) quality and intensity of illumination, (4) juxtaposition, or the effect of the surrounding areas of color.

* Further remarks on the color effects of pigments and their variation are to be found in the author's *The Painter's Craft.* (See Bibliography, page 676.)

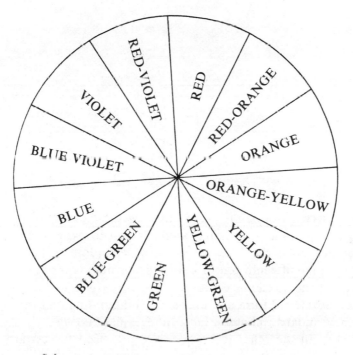

Color circle. Each hue is opposite its complementary.

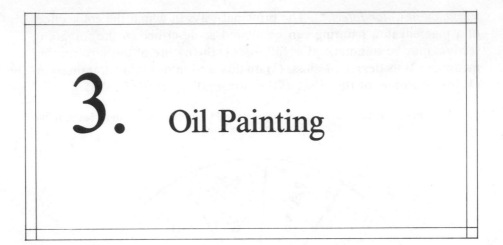

3. Oil Painting

WHILE THE HISTORY of paints made from vegetable drying oils goes back to the Middle Ages and oil paints were known to painters of the fourteenth century and earlier, they were not widely adopted for use in easel painting until the fifteenth century, for reasons noted on pages 21–22. By the middle of the sixteenth century, the method was in full swing in a rather well-developed form and ever since, oil painting on canvas has remained the standard technique for artists' easel painting.

Although all the other techniques are practiced for certain advantages they have over oil painting, the latter remains standard because the majority of painters consider that its advantages outweigh its defects and that in scope and flexibility it surpasses watercolor, tempera, fresco, and pastel.

From the viewpoint of permanence, however, all these accepted and time-tested methods of painting may be considered to be of equal merit. They all possess certain inherent defects which the careful painter does his best to minimize, and each presents peculiar difficulties which he must overcome. Materials for each must be carefully selected; oil paint, tempera, and fresco must be correctly manipulated and applied if they are not to deteriorate; and the fragility of watercolors and pastels requires that they be carefully preserved.

In the recent past, oil painting dominated the field to such an extent that from the standpoint of public acceptance, the other methods of

painting were relegated to the status of minor techniques. With the development of art, and especially in modern practice with so many facets of art being appreciated in the same era, there is now not so wide a gulf between the leadership of oil painting and the secondary use of other techniques, and some of our greatly admired artists create their major works in techniques other than oil.

The basic points of the oil technique's superiority over the other accepted methods of permanent painting are:

Its great flexibility* and ease of manipulation, and the wide range of varied effects that can be produced.

The artist's freedom to combine transparent and opaque effects, glaze and body color, in full range in the same painting.

The fact that the colors do not change to any great extent on drying; the color the artist puts down is, with very slight variation, the color he or she wants.

The dispatch with which a number of effects can be obtained by a direct, simple technique.

The fact that large pictures may be done on lightweight, easily transportable linen canvases.

The universal acceptance of oil painting by artists and the public, which has resulted in a universal availability of supplies, highly refined, developed, and standardized.

Its principal defects are the eventual darkening or yellowing of the oil, and the possible disintegration of the paint film by cracking, flaking off, etc. The former may be eliminated or reduced to an acceptable minimum by correct selection and use of materials, and the latter by correct handling of the technique.

PAINT

Paint consists of finely divided pigment particles evenly dispersed in a liquid medium or vehicle; it has the property of drying to form a continuous, adherent film when applied to a surface for decorative or protective purposes.

As noted in the first chapter, surfaces may be colored or decorated by

* Some painting methods and materials must be more carefully or precisely applied than others. With some, the range of variation or modification is small, and standard procedure must be closely followed; others are more flexible and a considerable degree of latitude is permitted within the bounds of sound practice. The word "flexible" used in this rather abstract sense to describe technique in general, as in its more literal meaning as applied to a physical property of materials, does not signify an infinite degree of elasticity; it must always be understood that there are definite limits to such a range.

applying the pigment directly; in pastel painting the protective function may be supplied by a fixative, the application of which is separate from the decorative or color application; and in fresco the ground itself supplies the adhesive or binding property. However, paint, in the commonly accepted meaning of the term, usually implies a material which combines these functions—as the typical oil or tempera paint.

When a drying oil is used as a medium for painting, it performs the following four functions, the first three of which were discussed in Chapter 1:

1. *Executive.* It allows the colors to be applied and spread out.

2. *Binding.* It locks the pigment particles into a film, protecting them from atmospheric or accidental mechanical forces and from being disturbed by the application of subsequent coats of paint.

3. *Adhesive.* It dries and acts as an adhesive, attaching the colors to the ground.

4. *Optical.* It has an optical effect, bringing out the depth and tone of the pigment, and giving it a quality different from that which it possessed in the dry state, as discussed in the section on *Color and Light* (see page 109).

DRYING OILS

A number of vegetable oils have the property of drying to form tough, adhesive films either by themselves or when assisted by the action of added ingredients. These oils do not "dry up" in the ordinary sense of the evaporation of a volatile ingredient, but they dry by oxidation or absorption of oxygen from the air. The drying process is accompanied by a series of other complex chemical reactions, and the dried oil film is a new substance which differs in physical and chemical properties from the original liquid oil; it is a dry, solid material which cannot be brought back to its original state by any means.

The increase in weight or volume of the oil through the absorption of oxygen is compensated for to a variable degree by the loss caused by the passing off in gaseous form of certain by-products of the reaction. These changes may be measured in the laboratory and from such figures we gain considerable knowledge of the properties of our oils. This subject is given further mention on pages 440 ff.

LINSEED OIL

Linseed oil is pressed from the seeds of the flax plant which is grown in all temperate or cold climates. The seed from each flax-growing region has

its own characteristics and is rated in quality accordingly. The impurity that is principally responsible for variations in quality is foreign or weed seed. This is true of any commercial vegetable oil. Sometimes foreign seeds are added deliberately.

The production of linseed oil in America is a highly developed modern industry in which considerable scientific work is constantly being done to promote economic efficiency and the uniform production of oils which will have the best properties for the various uses to which they are applied. Because of the relative insignificance of the quantities that are used for artists' materials, scarcely any of the results of this research work are directly applicable to our purposes.

The seed is crushed and the oil is extracted from it by pressing it in special machinery, usually with the aid of steam. The use of steam is necessary to secure the most economical results, but the quality of the oil thus produced is very definitely inferior to that extracted by cold pressing, especially from the artist's viewpoint. The hot pressing extracts a larger percentage of substances from the seed; and despite any subsequent refining to which the oil is subjected, the oil's resistance to embrittlement on aging, as compared to cold-pressed oil, is definitely reduced. From their introduction in the 1800s to the 1930s, the steam-pressed oils have always been considered inferior to cold-pressed oil and were never used in the best artists' colors. But because there is no longer any sufficiently large-scale commercial demand for it, cold-pressed linseed oil has not been available from American sources since 1938, and the oil producers have supplied artists' material manufacturers with the best grades of pale, alkali-refined oil (see page 123) as substitutes, claiming that they are superior in uniformity and all-around properties to the cold-pressed oil. On the other hand, some artists, notably in England,* have claimed that modern oil colors are vastly inferior to the older colors that were made with cold-pressed oil, not only in resistance to embrittlement but also in plastic flow and other working qualities, including their pronounced "suede effect"—that is, a definite difference in color between vertical and horizontal brush strokes on an area of flat color, a property that is also called dichroism (see page 626). We can expect this controversy to be resolved in the near future. Cold-pressed oil is now available in art-supply stores. (See *Sources of Materials.*)

Linseed oil is also produced by a third process, extracting the oil from crushed seeds with benzine or other solvents. Extracted oil is unfit for artists' use.

* Gluck, (Miss H.). "The Impermanence of Painting in Relation to Artist's Materials." *Journal of the Royal Society of Arts,* Vol. CXII, April 1964, pp. 335–352.
Gluck. "The Dilemma of the Painter and Conservator in the Synthetic Age." *The Museum's Journal,* September 1954.

Raw Linseed Oil. The usual procedure is to warm the crude oil slightly and allow it to stand in tanks for some time (up to two years), during which period a considerable amount of solid mucilaginous sediment or foots settles out and falls to the bottom of the tank. Oil from some seeds will soon purify itself to a great degree in this manner, but some varieties will throw down foots indefinitely.

After some partial purification the steam-pressed oil is fairly clear but of a rather dark yellowish brown color, sometimes with a pronounced greenish tinge, and it is sold as raw linseed oil. It is not used in this form in artistic painting or to any great extent in the better interior commercial paints and varnishes, as it is inferior in nearly every respect to oil that has been further refined, with the possible exception of its durability under extreme weather conditions when employed in an outside house paint.

Cold-pressed oil properly aged and filtered has a medium or pale golden color and is used for pigment-grinding purposes without further refinement. Its paint films retain their flexibility better or embrittle less rapidly than do those made with steam-pressed oils.

Refined Linseed Oil. For most paint purposes steam-pressed linseed oil requires further refining, and the usual commercial treatment is to mix it with sulphuric acid and water, which removes the bulk of the undesirable impurities and improves its color. This procedure is carried out on a large scale with special equipment, and the best grades are subsequently purified of all traces of water and acid. Many variations of this method are in use, employing a number of bleaching agents and other chemicals. The refined paint-grinding oils range in color from pale straw to golden or golden amber.

As a general rule, I am inclined to favor the use of paint-grinding linseed oils which have been refined to a golden or light amber color rather than those which have been bleached to a very pale straw color, because many of the latter have a tendency to revert to a deeper tone on aging (see page 125). However, some of the best grades of modern pale oils are processed without chemicals by the use of superheated steam, refrigeration, and other mechanical means, which greatly increase their color stability.

Varnish Linseed Oil. The refined oils discussed above meet the requirements for materials used in ordinary painting or paint grinding. Another class of refined oils is produced commercially for use in clear varnishes, etc. The first requirement for a varnish oil is that it should be free from "break." When linseed oil is heated rapidly to 500° F and a flocculent mass, or cloud of particles, forms in the oil, it is said to break; oil which remains clear is acceptable as nonbreak oil. This break contains a large

percentage of phosphorus and is not to be confused with the foots which the oil precipitates spontaneously as it ages.

Another specification is that varnish oil should have a low acid number (see page 451), whereas for maximum wettability and dispersion of pigments, paint-grinding oil should have a relatively high acid number. The common method of refining varnish oils is to use alkali instead of acid in the treatment, but some of the best grades are also processed by mechanical methods. Despite the fact that such oils are held to be less desirable than the paint-grinding oils for use in the production of industrial paints, artists' color manufacturers will usually select this type because of the all-important attribute of color stability. This is the type most likely to be on sale in bottles in the artists' supply shops; in the absence of cold-pressed oil, alkali-refined oil is the best for all-around use.

Stand Oil. When linseed oil is heated to 525–575° F and held at that temperature for a number of hours, an internal change takes place, and the physical and mechanical properties of the resulting product, stand oil, are not the same as those of raw oil. The change is a molecular one, polymerization; nothing is added to the oil and nothing is lost. Stand oil is a heavy, viscous material of about the consistency of honey; it may be thinned to a painting consistency by mixing it with several parts of turpentine, the mixture being paler in color than other linseed oils. Owing to its viscosity and its low acid value, it is not so suitable as a vehicle with which to grind pigments, but when diluted with a thinner it is one of the most useful ingredients of glazing or painting mediums, as an addition to oil paints or tempera emulsions and as an ingredient in varnishes. Stand oil turns very much less yellow with age than raw oil does, and when it is diluted or mixed with other ingredients to a usable consistency, the resulting medium is practically nonyellowing.

One of the most striking characteristics of stand oil is its leveling property, that is, its tendency to dry to a smooth, enamel-like film, free from brush marks, and its ability to impart this tendency to paints and mediums when it is added to them. For satisfactory results, stand oil can be made only by large-scale industrial methods from selected varnish-type oil. High-quality pale stand oils are now made by heating the oil in special equipment, under high vacuum or in an atmosphere of carbon dioxide. Formerly, stand oil was made in open kettles and heated for as long as eighteen hours or more; the resulting products were dark, not uniform, and were partially oxidized. The modern light-colored polymerized linseed oils have great color stability and, unlike the oils refined by other processes, are not so liable to revert to darker colors.

The product specifically called stand oil is made to conform to a

standard range of viscosity. Some polymerized oils are made in lighter grades and some in very heavy consistencies, so heavy that they can scarcely be poured. Lithograph varnishes are very similar to stand oil, but in general it is not a good practice to substitute them for the latter because they are usually made by variations of the high temperature process which are designed to impart special properties for use in the preparation of printing inks. Even when thinned with turpentine to the same consistencies as those in which the true stand oils are used, these varieties have working properties considerably different from those of stand oil.

So far as the painter is concerned, there does not seem to be any precise or critical viscosity to which stand oils must conform; there is some range of viscosity among the stand oils sold as such to artists, but all of them appear to give characteristic results. The heavier ones obviously require the addition of a little more turpentine and perhaps a bit more varnish in the preparation of painting mediums; some carefully controlled laboratory work would be required if the exact limits for a good stand oil were to be determined. Mixed and diluted to desirable working consistencies, the end products show little differences.

Blown Oil, Bodied Oil, and Boiled Oil. Linseed and other drying oils may also be thickened or bodied by an entirely different change, oxidation or combining with oxygen. This is the same process by which the oil dries when exposed to the air, and it results in a product far inferior to stand oil, although resembling it in superficial properties. Oxidized oil is produced by blowing air through the oil; heavy, viscous blown oils are prepared commercially in large quantities. They should not be confused with stand oil. Boiled oil is a misnomer; the oil commonly sold under this name is not boiled but heated with driers until very slightly thickened. A good deal of the boiled oil of commerce is raw oil to which liquid driers have been added; such oil is derisively called bunghole boiled oil to distinguish it from heat-treated or kettle-treated oil. Neither should be used for permanent painting.

Sun-Refined or Sun-Bleached Oil. An older process of refining artists' oils, which dates from the fourteenth century or earlier and which usually produces a more rapidly drying product, consists in shaking up the oil with about an equal amount of water, sometimes salt water, and exposing it, in glass jars or trays, to outdoor sunlight for a few weeks. The vessels are loosely covered in such a manner as to exclude soot and dust but admit air, and the oil and water must be thoroughly mixed every day for the first week. It is not possible to name any definite length of time for the exposure of the oil, since the time required varies according to the pur-

pose for which the oil is intended, the consistency and color desired, the actinic power of the sun in the particular locality and season, the type of oil used, and the size of the container. Gelatinous or albuminous matter is removed by filtering the oil through coarse filter paper or fine cloths; if a little clean sand is put into the jar at the start, it will help the settling of such impurities. At the end of the treatment the oil is most easily separated from the water by the use of a separatory funnel (see page 633).

The action of the sun and air is threefold: it partly oxidizes, partly polymerizes, and effectively bleaches the oil. Although this oil has been used with good results by past generations of painters, there is considerable opinion that the oxidation part of the process robs it of a good deal of its life, and that it will eventually behave in the same manner as a blown oil or one in which oxidation is begun by the addition of driers; certainly its superficial properties resemble those of a blown oil. If the free access of air is permitted, the oil will thicken to a considerable extent; this action may be retarded by using a narrow-mouthed jug or otherwise limiting the amount of air. Allowing the oil to bleach to the palest possible shade, as mentioned on page 122, is not always recommended, as there is an optimum degree of permanent bleaching to which any given sample of a vegetable oil may be carried; beyond that point, it may, upon aging, revert to a deeper color, a common fault in some commercial bleached oils. The usual correctly sun-refined linseed oil is a light golden or pale amber hue, rather than an extremely pale straw color.

In common with other treatments which increase the viscosity of oil, sun-thickening decreases its wetting power, pigment dispersion, acid number, and free brushing quality, but increases its speed of drying and its leveling and protective qualities. It is therefore more suitable for clear varnish, or glaze and painting medium purposes, than as a vehicle in which to grind pigments.

Sun refining is the only oil treatment which can be carried on successfully by home methods; as noted in connection with the cooking of varnishes, no heat-treating can be well done by other than large-scale industrial methods, and only the most antiquated recipes call for home boiling of oils.

POPPY AND WALNUT OILS

Oils pressed from the seeds of the poppy and from mature, rather stale kernels of the common or English walnut have been known and used as drying oils from the earliest recorded times down to the present day. The history of walnut oil is coeval with that of linseed, and that of poppy oil nearly so, but it is interesting to note that these two oils have always

occupied a position inferior to that of linseed oil in popularity among painters.

Poppy oil is a naturally colorless to straw-colored oil with none of the characteristic golden or amber color of linseed. Whites and pale colors ground in it present a somewhat clearer and more brilliant appearance than when they are ground in linseed oil, and the dried, clear poppy oil film has less tendency than the linseed oil film to turn yellowish. However, because it will turn yellow to some extent under the same test conditions, and because in pale colors even slight changes are apparent, its superiority over linseed oil in this respect is not so great as is popularly supposed. Manufacturers of oil colors are prone to use it for whites in place of linseed oil because it gives their product a more brilliant appearance as it comes from the tube, because the pastes can be stored in bulk or in finished packages more satisfactorily, and because a buttery consistency is more easily produced.

The serious defects of poppy oil are the frequency with which its paint films will crack upon aging, and its slow drying rate.

It owes its property of yellowing less than linseed oil to the smaller percentage of linolenic acid it contains, but it is just this difference in composition that causes it to form weaker films. Compared with linseed oil, it drives very much more slowly, its film tends to be softer, spongier, and more likely to crack, particularly when painted in successive coats and especially when the undercoats contain reactive pigments (see page 135) or when the top coat contains very finely divided pigments. In all-around paint qualities I should rate poppy oil as a fair artists' material but distinctly inferior to linseed, and as one which requires a more careful and precise observance of the laws governing the correct technique of oil painting. This matter is dealt with further in Chapter 13, "Chemistry."

Perhaps the best use to which poppyseed oil can be put is as a modifying ingredient in linseed oil colors (see page 141). Poppy oil colors have frequently been recommended for use in direct, simple or *alla prima* painting, but not for use in mixed techniques or those which call for complex or multiple layers of underpainting or overpainting.

Walnut oil is similarly inferior to linseed oil in all-around paint qualities; some investigators rate it above, and some below, poppy oil. In the past its cost has precluded its wide use for industrial paints; therefore, little modern scientific research has been done on it. It dries more rapidly than poppy oil, being nearly the equal of linseed in this respect.

The finest grades of both walnut and poppy oil are cold-pressed; they may be further refined, bleached, or bodied by the processes used with linseed oil; however, sun- or heat-thickened poppy or walnut oil is not ordinarily in use, because both of these oils are employed primarily as

paint-grinding vehicles, where a normal oil consistency is required. Linseed oil is always the choice for clear painting mediums because of its greater durability. Poppy oil has very little odor or taste and is used in France as an edible or salad oil; walnut oil will grow rancid on storage and develop a strong odor, as is common with other nut oils; its properties as a paint medium are believed to be thereby impaired. Fine grades of cold-pressed poppy and walnut oils are made in the United States, the former being pressed from imported seeds.

At present the average American manufacturer of oil colors uses linseed oil as a basis, and mixes in or substitutes poppy oil, according to his judgment and experience with the various pigments. Since the nineteenth century poppy oil has been used to some extent in hand-ground colors, but it is not ordinarily employed as the sole vehicle in artists' colors.

Controversies over the merits of poppy and linseed oils have by no means come to an end, especially as applied to various specific techniques, and some of the foregoing opinions are disputed by other writers.

So far as is known, pure linseed, poppy, and walnut oils may be mixed with one another in any proportion without any special ill effects. A tube of poppy oil color can be immediately identified by smelling it; linseed oil has a definite characteristic odor while the poppy oil color is completely odorless.

OTHER DRYING OILS

A number of other oils of vegetable origin have drying or semidrying properties, and some are used in the paint and varnish industry. For the most part they are inferior to linseed oil and are employed as cheap substitutes for it.

Soya bean oil is a widely used industrial substitute for linseed oil, but is distinctly inferior to it. It may be bleached to a very pale color, but it always requires driers. Processed with alkyd resins, it has long been an ingredient of some of the best industrial nonyellowing varnishes and white enamels.

Perilla oil, obtained from crop-grown plants in Manchuria, Japan, and India, has been used in industrial varnishes and enamels to impart hardness and toughness. It is not cheap, and is rated as a first-class drying oil rather than as a substitute for linseed, but it cannot be used in artists' paints on account of its strong tendency to turn yellow.

Tung oil (China wood oil) is pressed from the nuts of *Aleurites fordii* and *A. montana,* trees indigenous to China. The Chinese oil, from wild trees, was imported into the United States as early as the 1890s; by the 1920s its use had grown to large proportions and because of widespread

adulteration and shortages, the tree began to be cultivated in the south-eastern United States. Tung oil is highly valued as an ingredient of industrial varnishes, where it produces tough, durable coatings. It has little value as a paint binder, and it requires expert thermal processing with driers, resins, and other ingredients to perform well in varnishes. No tung oil product is suitable for use in artists' materials. Tung oil culture and production have been developing for many years in the southeastern states of this country, and it has become an important agricultural and commercial product.

Oiticica oil is a Brazilian product of similar properties. The fatty acids and the drying reactions of both of these oils are quite different from most of the other drying oils. Pronounced "wahti-*seek*-ah."

Lumbang oil (candlenut oil) is obtained from widely distributed tropical sources, principally from the Philippines. When economic conditions make it profitable, it is sometimes used as a substitute for linseed oil.

Sunflower seed oil and hempseed oil have properties resembling those of poppy oil, and have been used in Europe as linseed oil substitutes. The drying properties of hempseed oil were known to some of the early writers. They are, however, inferior to those of poppy oil, according to modern investigators.

Safflower oil is obtained from the seeds of *Carthamus tinctorius* and *C. oxyacantha,* plants which have long been extensively cultivated, principally in India, but also in East Africa, Egypt, Turkey, and elsewhere, for the sake of the safflower dye which is obtained from their blossoms. It has been used in India in textile decoration and in a sort of linoleum. After some years of research into growing the seed in the United States, it is now in large-scale industrial production and is used both as an edible oil and a paint oil, especially in the manufacture of nonyellowing alkyd resins. Such investigations as have been made indicate that it is a fair replacement for linseed oil in artists' colors but its resistance to age—embrittlement—is not expected to equal that of linseed oil. One firm has had safflower white oil colors on the market since 1960, under the trade name Everwhite.

Stillingia oil (tallowseed oil) is obtained from a tree cultivated in China and is widely used for many purposes in that country. It has good drying properties and probably is the traditional material used by Chinese artists to grind the vermilion for the seals which are impressed on their paintings. It was formerly encountered here chiefly as an adulterant in Chinese tung oil.

Tobacco seed oil has a high linolenic acid content and has been applied to the production of synthetic products such as oil-modified alkyd resins, which are of excellent color retention, as are safflower and soya

bean oils. More attention to tobacco seed oil has been shown in Great Britain than in America. The seed is gathered in southern India principally from wild plants because tobacco cultivated for the leaf is harvested before the flowers develop.

Minor drying oils: About fifty other drying oils are known, but most of them are of minor importance because they are not available in sufficient quantities or because no work has been done on the development of their application to paint purposes. Their sources include the seeds of some of our most common domestic berries as well as seeds from remote parts of the world.

Semidrying oils: A large number of oils which are or could be extracted from seeds, grains, etc., will dry alone with extreme slowness but may be more rapidly dried by the addition of driers, by heat treatment, or by admixture with rapidly drying paints. They are occasionally used to adulterate cheap paints, and sometimes to prevent the settling or caking of heavy pigments in mixed paints. Cottonseed oil and corn (maize) oil are familiar members of this group. Their use always decreases the durability of oil paint.

Nondrying oils: Another large group of vegetable oils is altogether nondrying. In some rapidly drying, rather brittle paints or varnishes, it is occasionally possible to add a nondrying substance, the drying action of the coating as a whole being powerful enough to carry the nondrier along with it and produce a finish which is, to all appearances and purposes, perfectly dry. For example, castor oil, a member of this group, may be added to shellac and lacquers to impart flexibility (see page 397).

No animal oils are employed in artistic painting; but for outdoor use, especially on smokestacks, fish oils have been used in industrial paints.

SELECTION OF OILS

Any artists' oil should be a genuine cold-pressed oil obtained from seeds of high quality and purity, and should be properly aged. The following suggestions are made in descending order of desirability.

For Paint Grinding: Oil of a relatively high acid number.
1. Cold-pressed linseed oil, either raw or refined by mechanical means without chemicals.
2. The best grades of alkali-refined linseed oil, or of sun-refined oil which has not been exposed to the point where thickening is pronounced.
3. Poppy oil, inferior to linseed; to be avoided in underpaintings, it has proven more successful in simple, direct work. Up to about 15 percent (oil content), its use is permissible as a modifying ingredient in linseed oil colors. A mixture of 50 percent linseed with poppy oil tends to neu-

tralize defects of poppy oil but it is inferior to straight linseed oil. (See page 141.)

For Glaze Mediums, Clear Varnishes, and Emulsions: Linseed oil of a relatively low acid number.

1. Stand oil, or stand oil and turpentine.
2. Sun-refined cold-pressed oil.
3. If an oil of ordinary viscosity is required, a high-grade industrial varnish oil, either alkali-refined or refined mechanically rather than by chemical means.

A few brands of oils are listed on pages 643–44.

OIL COLORS

The artists' oil colors that are sold in tubes are made by first mixing oil and dry pigment in a revolving can in which paddles revolve in opposite directions; the product is stiff, rather dry paste of approximately the consistency and smoothness of peanut butter.

This paste is then run through mills which are usually of the steel-roller type, although some makers may still use the old flat-stone type. The complete and thorough grinding which artists' colors receive may exert a little pulverizing action on the pigment particles themselves, but for the most part modern pigments are produced in a sufficiently fine state of subdivision, and the action of the mills in dispersing or wetting the individual pigment particles is more important than any comminution accomplished. (See pages 145–46.)

The usual modern paint mill has three steel rollers mounted horizontally; each roller is cooled by a stream of water which runs through its center. The first roller is geared to run less rapidly than the middle roller, and the third one runs more rapidly. The color paste is placed between the first roller and the second, to which it clings, then passing between it and the third roller. End plates keep it from running out of the mill. A horizontal scraper or doctor blade removes if from the third roller and it slides down an apron into the containers. The five-roller mill (with rollers mounted vertically) exerts a double amount of grinding and is an efficient saver of time, space, and labor. Colors frequently require more than one passage through the three-roller mill for complete dispersion.

After the average pigment has been given its first mixing, the particles* will tend to agglomerate and become surrounded by oil somewhat in the following manner:

* The diagrams in this book which represent pigment particles are not intended to be pictures of single round grains; each individual pigment has a definite structural appearance and par-

After a thorough mulling or grinding through a correctly adjusted mill, the agglomerates are broken up, and each particle should be surrounded by the medium, thus:

This produces a truly dispersed paint.

The original agglomerates of pigment particles tend to enclose air within their voids; should the dispersed particles in a well-mulled paint settle and come together again to form clumps, their interstices would then contain oil. The instability of a film containing occlusions of air or of dry particles is obvious, and the plasticity or consistency of a poorly mulled paint will differ from that of one in which the individual particles are as well dispersed as possible. A great many physical properties of paints are the result of complex physicochemical reactions which are directly related to the intimate mixture or dispersion of pigments in oil. The diagrams also have a bearing on the explanation of oil absorption, the various pigments requiring various amounts of oil to surround each particle. These intricacies of physical chemistry are, or should be, taken into consideration by modern manufacturers; for the artist who grinds his or her own colors by hand the only concern is to see that the paints are most thoroughly and completely mulled.

The operation of mixing pigment and oil on a slab with a sturdy palette knife or spatula represents the manufacturer's power mixing; the subsequent careful mulling is the artist's counterpart of grinding or mulling. Hand grinding or mulling of paints is described on pages 141 ff.

The advantages and benefits of grinding one's own colors by hand

ticle size when viewed under the microscope; often the particles exist only in the form of clusters. The round shapes in the diagrams represent primary particles; in the case of some pigments these may be individual single grains of various shapes and in other cases the nearest approach to the single grain in which these pigments normally occur.

have been mentioned on pages 9–10 and elsewhere; they are almost entirely of a nontechnical nature, and involve such considerations as economy, assurance of purity, training in the nature of materials, etc. From a strictly technological viewpoint the product of hand grinding cannot compare with the superior results obtained by the well-controlled use of modern power mills, especially as to the physical requirements of a well-made color as outlined above. Any qualities produced by hand grinding which are different from those encountered in the usual machine-made product could be duplicated on roller mills, were they desired.

ABSORPTION OF OIL BY PIGMENT

In order to grind dry pigments in oil to a usable consistency, an amount of oil beyond that needed to bind and hold the pigment to the painting surface is required. This amount varies markedly with each pigment, and there is also considerable variation between different grades of the same pigment. The grade of oil used is also a factor in the variation.

The normal amount of oil required by each color includes what it absorbs plus enough extra, not only to give the proper degree of plasticity, but also to produce the kind of oil film which will correctly lock in and protect the pigment particles. But because oil in excess of this normal required amount is one of the major causes of the yellowing of oil paint and because it is also a factor in some of the structural failures of paint films, the careful maker attempts to keep the oil volume down to an acceptable minimum.

Measurement of Oil Absorption. Paint manufacturers and chemists have worked out oil absorption figures for the various pigments, expressed either in terms of percentages of oil and dry pigment by weight, or in terms of pounds of oil per 100 pounds of pigment. Due to variations in materials from different sources and variations in grinding methods, these figures are not valuable as accurate statements; the methods by which they have been established do not always take into account all the elements which enter into the grinding of colors particularly in relation to artists' requirements; but they serve as a rough guide to manufacturers in the formulation of their products. The relation between the weight and bulk of the pigments is generally overlooked; the artist is more interested in the percentage by volume than by weight; he does not apply his color by weight, but in films of a particular thickness, that is, by volume.

OIL INDEX

For the purposes of this chapter I have adopted the term "oil index" for a rating of the various pigments as to the relative volumes of linseed oil necessary to grind them to average paste consistencies. The figures serve to indicate whether the paste will contain much or little oil, and how the volume of its oil content compares with that of other pigment pastes. Pigments whose oil indices fall below 75 are low in oil absorption; 75 to 90, medium; 90 to 150, high; over 150, extremely high. Two figures for one pigment indicate that variations encountered in samples of the pigment are so great that there may be said to be more than one grade as regards oil requirements.

Figures of this kind are useful for various purposes; for example, as discussed under *Painting in Oil,* it is not safe to apply a layer of low or medium oil content on top of a continuous film of high or very high oil content. The list that begins on this page will serve as a guide.

Low

Aluminum stearate	29	Cobalt green*	65
Emerald green	47	Cobalt violet*	66
Venetian red	54	Zinc white	71
Flake white	56	Zinc yellow	72
Spanish red*	63	Phthalocyanine blue	73
Chromium oxide green	64		

Medium

Yellow ochre*	76	Cadmium-barium maroon	79
Cadmium-barium yellow, light	76	Naples yellow	82
Cadmium-barium yellow, medium (golden)	76	Indian red	83
		Mars violet	83
Cadmium-barium red, light	79	Ultramarine blue	85
		Titanium dioxide (low oil type)	87

High

Cadmium orange	92	Raw sienna*	118
Prussian blue	96	Mars yellow	119
Cadmium-barium orange	97	Mars black	128
Alizarin red	100	Burnt sienna*	129
Ivory black	101	Burnt umber*	136
Raw umber*	103	Green earth	144
Cerulean blue*	112		

* Asterisk indicates imported pigments. Further details concerning this list will be found in the Appendix, on page 640.

Very High

Cobalt yellow*	174	Manganese violet	205
Cobalt blue, domestic	180	Viridian	233
Lampblack	164–194	Cobalt blue*	270
Carbon black	164–284		

In recent years, the previously mentioned importance of physico-chemical reactions as they affect the physical character and behavior of liquid paints has been realized by makers of industrial paints, and a demand has arisen for pigments treated to meet various specifications, including oil absorption. Specially treated lithopones and other pigments are regularly made with a wide range of physical properties, and if artists' pigments were used in sufficient quantities, no doubt some of them could be turned out to meet uniform requirements as to oil absorption and other properties. For low oil absorption, the pigment is ordinarily treated with a 2 percent solution of aluminum stearate in benzine, which coats its particles and alters its properties. The amount of aluminum stearate thus introduced into the final paint is negligible. Pigments will absorb varying amounts of stearate, corresponding roughly to their oil absorption figures.

It must be understood that the average pastes which result from grinding colors by hand with a muller will contain considerably more oil than those ground by power mills, and that the texture, wettability, and degree of resistance to dispersion or tendency to form agglomerates may vary enough from the corresponding properties in mill-ground paints to alter some of the relationships indicated by the figures above.

Insufficient Oil in Colors. When the amount of pigment in a normal paste color is raised above the normal quantity, it is liable to cause the condition known as overpigmentation, where the color may become too stiff and firm to be easily manipulated on the palette and brush. In such cases the danger of introducing insufficient binder and the likelihood of the paints' hardening in the tubes during storage should be considered. However, this condition can easily be avoided, as its existence should be apparent to both maker and user.

INFLUENCE OF PIGMENTS ON OIL

When an oil paint dries it undergoes changes which are the result of chemical and physical reactions occurring between the pigments and the

* Asterisk indicates imported pigments. Further details concerning this list will be found in the Appendix, on page 640.

oil, as well as changes brought about by the oxidation of the oil. The total effect of these interrelated and complex reactions varies in the case of each pigment. Among the properties of the paint which are influenced by the pigment to a variable degree are consistency, drying speed, and extent of oxidation, and the flexibility, hardness, durability, and color stability of the resultant paint film.

Examples of some of the most strongly reactive* pigments are white lead, burnt umber, zinc oxide, whiting, and red lead, whose special properties in oil are mentioned in Chapter 2, "Pigments." Some pigments have a beneficial or reinforcing effect upon the paint film; others will tend to impart undesirable characteristics to it. As a general rule, when pigments with opposite properties are mixed they will tend to neutralize each other's defects or to impart their own distinctive properties to a greater or lesser degree. When used in small amounts as tinting colors, their effects are proportionally minimized. Those pigments which are definitely rejected for permanent painting, however, will sometimes confer their defects upon mixtures out of all proportion to the amount used.

The oil absorption figures can be used as a guide to the various degrees of flexibility that may ordinarily be expected of layers of paint containing different pigments; in the following lists the pigments are grouped according to other properties they will impart to paints. They are arranged in the order of their degrees of drying activity; the most active member of each group heads its list.

In these lists to an even greater degree than in the oil index grouping, variable conditions of practice and differences among raw materials make it difficult to gauge relative values with scientific accuracy, or to assign even rough index numbers to them. When poppy oil is used, the action of the siccative pigments will be diminished; those toward the end of the list will have little effect; the retarding pigments will produce a more exaggerated effect; films described as hard and brittle will be softer but not necessarily tougher or more flexible, and those described as soft will in that respect be dangerously near, if not beyond, the line of sound permanent painting.

The oil absorption figures in the preceding section were based on dry colors of the highest type, such as are most likely to be found on the American market and used for the best artists' colors. The following list is based on the average behavior of prepared artists' tube colors of several of the better makes, domestic and European. As stated above, the list is a

* The word "reactive" is not here used in a strictly scientific sense; it merely denotes that some action takes place—something happens. For instance, the exaggerated defects produced by Vandyke brown when it is added to other pigments, even in small amounts, are probably more of a mechanical action, as if a very weak and nonpermanent resin were added to the paint.

PIGMENT	FILM CHARACTERISTICS

Rapid Driers

Umbers	tough, flexible
Prussian blue	hard
Phthalocyanine blue	hard
Flake or Cremnitz white	tough, flexible
Cobalt yellow	hard, erratic
Burnt sienna	hard, fairly strong

Average Driers

Raw sienna	tough, fairly strong
Cobalt blue	rather brittle
Cobalt violet	rather brittle
Red iron oxide (pure)	strong
Black iron oxide	strong
Yellow iron oxide	strong
Cobalt green	flexible, fairly hard
Chromium oxide	flexible, fairly hard
Viridian	flexible, fairly hard
Naples yellow	strong
Zinc, strontium, barium yellows	hard, rather brittle
Some native red oxides	usually brittle

Slow Driers

Other native red oxides	usually brittle
Green earth	soft, flexible
Cerulean blue	soft, nonelastic
Ultramarine	fairly hard, somewhat brittle
Yellow ochre	fairly strong
Alizarin crimson	soft

Very Slow Driers

Ivory black	soft
Emerald green	fairly hard
Cadmiums	fairly strong
Vermilion	strong
Alumina hydrate	hard and brittle
Zinc oxide	hard and brittle
Lampblack	soft
Carbon black	soft
Vandyke brown	soft and weak

rough indication of the relative activity of the colors rather than an exact rating.

Adjustment of Drying Rates in Tube Colors. In order to meet the average painter's requirements for prepared artists' oil paints, the manufacturer usually adjusts the drying rates of various colors so that his entire line will dry within limits that are not so extreme as they would be if the action of each pigment were allowed to proceed normally. In controlled amounts, driers (see pages 202–203) are added to the slow-drying colors, and slow-drying poppy oil to the rapidly drying colors. The careful manufacturer will resort to a minimum of this sort of adjustment. There has been some controversy on this point; because driers are of no benefit to the ultimate paint film but are likely to lessen its durability, because they may not be compatible with mediums subsequently added by the artist, and because some painters wish to control their own materials entirely, it has been suggested that control by the manufacturer should be omitted. On the other hand, the manufacturers point out that they are in a position to choose and compound the materials more exactly and correctly than the artist can, and that a set of colors of extremely diverse drying actions would not only present executive difficulties but would cause paint films of faulty structure in the work of the average painter, who has neither the knowledge nor the inclination to regulate his colors in this respect.

STABILIZERS[*]

Materials other than pure coloring matter and oil are often added to colors by manufacturers in order to keep the pigment in suspension and the oil from separating during the period the tubes lie on the dealers' shelves, as well as to impart the desirable short (buttery) consistency to those pigments which normally produce long (stringy) pastes. Because none of these materials contributes any ultimate beneficial quality to the paint film, and because their use or rather their uncontrolled use is apt to have a deleterious effect, there has been some discussion as to whether or not they are to be classed as adulterants.

For a long time painters have been accustomed to expect all colors to come out of their tubes with precisely the same uniform, buttery consistency, and to be capable of being brushed out with more or less identical manipulations. The watercolor painter, however, realizes that certain pigments have poor working qualities in that medium, and learns to ma-

* This term was borrowed from the field of emulsion chemistry in the first printing of this book, and since then it seems to have been adopted as the usual designation for a material added to an artists' paint for the purpose of preserving its uniformity and consistency.

nipulate them with sufficient skill to overcome these faults. Those painters in oil who have prepared their own colors also find that they are able to manipulate the less tractable colors and to make allowances for their various behaviors. Some of the stringiest pastes, such as ultramarine, are colors which are seldom required in the pure, full-toned state but are more often used in small amounts as tinting colors, where this lack of easy brushing quality has little importance. There are, of course, limits to what is acceptable—no painter wants to use very stringy or very liquid colors—but some tolerance can be applied to certain colors, and an exactly uniform consistency should not be required if it means the distortion of other desirable qualities of a pigment. Some further comment on the ideal consistency of oil colors will be found on page 148.

The three classes of materials used as stabilizers for oil colors are (1) waxes or waxlike materials, which produce a colloidal or gelatinous condition in the oil/pigment system; (2) water or aqueous solutions, which produce the same effect by emulsifying the oil; and (3) certain inert pigments, such as alumina hydrate, which produce very short pastes.

The addition of beeswax, or of aluminum and zinc stearates or palmitates, will result in good buttery pastes, and when these are used in very small amounts there is probably little danger of any harmful effect on the structural strength of the resulting oil film. Such materials, however, always have a definite particle structure, which places them in the solid rather than in the liquid class; hence they do not take the place of some of the oil, but replace some of the pigment volume, thereby diluting the tinctorial strength of the paste just as if an inert loading pigment had been added; for this reason the color will require a larger percentage of oil.

If used in sufficient quantity, the metallic soaps will tend to cause the oil film to become spongy and to get brittle with age. They are also suspected of becoming yellow or promoting the yellowing of oil. To a careless manufacturer, they would present a simple solution of all the problems of color-grinding, and because they have great bulk and are comparatively inexpensive, they are well suited for use as deliberate adulterants or cheapeners. Judging from the low tinctorial strength of some of the poorer colors which contain aluminum stearate, their uniform consistency, the comparatively low cost of some of the rarer colors, and the fact that the aluminum stearate is used indiscriminately in all pigments, one would suspect that it is sometimes used in greater amounts than the manufacturers would have us imagine. Two percent by volume in the total amount of oil color is usually considered permissible.

The difference between percentage by weight and percentage by vol-

ume, as mentioned in the section on oil absorption, must be considered in this connection, because aluminum stearate is such a light, bulky material. Its specific gravity is 1.01, and one pound ground in an oil paint will bulk about 0.118 gallon, which is over 15 ounces by volume. American chromium oxide, a heavy pigment, has a specific gravity of 5.09, and in paint one pound will bulk 0.0236 gallon, which is only about 3 ounces by volume. This means that if a comparatively small percentage by weight of aluminum stearate, say 5 percent, is added to chromium oxide, the pigment in the resulting paint will contain about 21 percent by volume of this nonpigment material. The weight figures are of importance only to the manufacturer and the analyst as a basis for computing the significant or volume figures. The same weight percentage of aluminum stearate mixed with a pigment of below-average specific gravity, such as ultramarine blue (specific gravity 2.34; one pound bulks 0.0513 gallon, or about 6 volume ounces), would produce a mixture containing more than 11 percent of aluminum stearate, by volume. This point is brought out in the oil absorption table, where I have included aluminum stearate among the pigments, and it ranks first, or lowest in volume percentage; it would be twenty-third if the table were arranged in order of percentage by weight.

When waxy materials are used as stabilizers, their action is partially a surrounding or coating of the pigment particles and their agglomerates with a layer which increases the wettability of the pigment and also serves as a sort of lubricant or cushion for the particles within the plastic paste. The use of waxes in colors results in greatly increased oil absorption; for example, cadmium yellow, which occupies thirteenth place on the oil absorption list, is not greatly altered when 1 or 2 percent of beeswax is added to it, but when it contains 10 percent it requires so much oil that it would be placed in the "very high" group.

When it is desirable to use a stabilizer in homemade colors beeswax is to be preferred. Aluminum stearate and other metallic soaps are produced in many grades and variations; their application involves much expert care; manufacturers prefer them to beeswax for their own purposes and use wax only occasionally, as a plasticizer rather than a stabilizer.

The use of any appreciable amount of water, with or without soap or emulsion-forming material, is definitely to be condemned, as the resulting films are spongy and will certainly turn more yellow than will the films of water-free paints. According to Toch,[139] 0.5 to 1 percent of water may be added to artists' tube colors without detrimental effect. Few of the ordinary dry materials that surround us and are in daily use are entirely desiccated or free from all traces of moisture—least of all the finely di-

vided pigments, the surfaces of the particles of which expose a large area to the atmosphere. A fairly appreciable amount of "innocent" moisture may therefore be ground into a paint, depending upon the moisture content of the pigment.

Separation of oil from the pigment is annoying, but unless it occurs to so great an extent that it leaves the pigment in a hard, dry, unusable mass, it is not one of the very worst defects an oil color can have; it might even be taken as evidence that not too much stabilizer has been used. However, it is more often an indication of improper selection, formulation, or grinding of materials. When a little excess oil has separated from the paste, it may be removed by spreading the paste out on paper, which will absorb it. If a manufacturer is conscientious in his selection of materials, in his adjustment of proportions, and in his methods of grinding, etc., he will need to use only a minimum of stabilizer.

Student-grade colors are often loaded with considerable amounts of such inert pigments as alumina hydrate, which give them very desirable buttery consistencies but which practically ensure their eventual lowering in tone, as the transparent nature of such materials does not mask the yellowing of oil films.

The diagram of the tree tubes indicates how the relationship of oil to pigment in pure color is altered, and the tinctorial strength of the color weakened, by large additions of extenders.

Livering. Oil paint which turns to an insoluble rubbery mass in the tube or can is said to liver. This is invariably the result of the action of low-grade or impure pigments on mediums, or of the action of poorly formulated materials on each other. Pure, high-grade pigments correctly ground in the proper oils will not liver.

HAND GRINDING OF OIL COLORS

The grinding of oil colors by hand does not call for particular techniques other than those outlined in Chapter 2, under *Color Rub-outs*. The pigment should first be mixed with oil on the slab to a stiff, uniform paste with a sturdy, yet flexible, palette knife or spatula. The straight, rather blunt kind, at least four inches in length, is more useful for this purpose than the slender, tapered kind generally used by artists. The paste is then ground with a muller, much as described under *Color Rub-outs;* care must be taken, especially at the beginning of the grind, to gather the paint by scraping it from the sides and bottom of the muller as well as from the slab, and this should be done very frequently during the grinding. In the case of most pigments, a more liquid consistency will develop after some mulling, at which time a little more pigment may be worked in with the spatula if desired. Although the volume of oil is to be kept at a minimum, it will be found, as previously stated, that in order to grind and disperse the pigment particles thoroughly, more oil will be needed than is required to mix the pigment to the stiffest sort of paste.

If it has been decided to add wax to any of the colors, put 4 fluid ounces of oil in a measuring glass and add white beeswax, which has been broken into conveniently small pieces, until the level of the oil rises to 4½ ounces. Transfer it to a tin can or other suitable vessel and warm it on a stove until the wax melts. Be careful not to overheat or boil. This mixture will contain a little over 11 percent of wax by volume, and should be diluted with 3 or 4 parts of pure oil for average color-grinding use. If greater accuracy is desired, the following table shows how many parts by volume of pure oil should be added to each part of this wax-oil mixture to produce paints of various wax percentages. The mixture may become semisolid on cooling, but at room temperature will always mix into oil and color easily. It should be kept in a tightly covered wide-mouthed jar or can.

As mentioned under its own heading and in the chapter on chemistry, poppy oil is generally less desirable than linseed oil as a painting medium. However, pigments which produce poor consistencies in linseed oil will often behave much better when they are ground in poppy oil, which tends to make more buttery pastes and to hold the pigments in suspension more effectively during long storage. In many cases, notably with such pigments as ultramarine, viridian, and certain artificial iron oxides, a small percentage of poppy oil added to the linseed oil will produce shorter and more stable pastes. The minimum amount that will produce this improvement varies with each pigment and must be determined by experience; 25 percent of poppy oil is as much as can be used without its imparting its undesirable effects; a lesser volume, 10 to 15 percent, is bet-

ter if it will give the desired results. Over 25 percent poppy oil will result in a mixture that will display the bad characteristics of the oil—namely, slow drying and the formation of weak films liable to crack.

Percentage of wax desired	Oil index of pigments				
	50–75	75–100	100–125	125–150	over 150
1	8	6	4	2	1
1½	6	4½	3	1½	¾
2	4	3	2	1	½
3	3	2	1	½	¼
4	2	1	½	¼	0

Muller and Slab. Glass mullers are obtainable in some supply stores; the average convenient size has a face or grinding surface of 3½ to 4 inches in diameter and weighs three pounds or more. They may be had in various sizes from ¾ inch to 6 inches in diameter; 2½ inches is about the smallest useful size. These solid lumps of hard glass are handmade; one must avoid those that have bubbles dangerously close to the grinding face because of the possibility of their wearing through. Formerly some of the older painters used cone-shaped lumps of porphyry or other hard stone and were concerned that impurities from softer stone or glass might be ground into the paint, but the glass muller and ground-glass slab of heavy plate glass have been standard for many years. Marble slabs or tabletops are also in frequent use.

The design of the curve at the bottom edge of the muller is regarded as being important because it should create a wedgelike entrance into the grinding surface. In order to increase the weight of a large muller for some uses, its handle may be encased in a collar of lead; this can be made of strips of sheet lead. Both muller and slab should have a grain or tooth, which may be produced or increased by grinding carborundum or some other abrasive powder with turpentine or water on the slab with the muller. Plate glass is the usually preferred grinding slab; white marble or a lithograph stone is occasionally used. The back of a glass slab may be painted white, white paper may be placed under it, or it may be made of opaque white glass.

Grinding should be continued until the paint is acceptably smooth-textured and glossy. Some of the pigments will be found to offer more difficulties than others; these must receive additional mulling. Because of the larger quantity of paint involved, a larger area of the slab will naturally be covered than in the rub-out tests previously described. The proportions of dry color and oil required in each case may be noted as a guide for future work with the same materials.

Some Notes on Various Pigments. Viridian acts as if it were a kind of powdered glass when first mixed with oil, and it requires more grinding than the average pigment to make a smooth paste; persistent grinding will usually give the desired results; wax is not often necessary. If viridian is used in too coarse a state, it tends to give a blackish appearance. Zinc oxide is one of the colors to which some manufacturers insist upon adding wax to improve the flexibility, to correct the natural tendency to form pastes of a stringy consistency, and to prevent their settling and hardening in the tube. Wax is added to Prussian blue, cobalt green, and cobalt yellow to overcome a granular texture and to such heavy pigments as chromium oxide, vermilion, and titanium white in order to minimize settling or separation of pigment and oil. Ultramarine is perhaps the worst pigment to grind into a buttery paste on account of its stringiness and thixotropic properties; much ultramarine ground in oil and sold in tubes contains so much stabilizer that the difference between it and a home-made color is obvious. Some of the long or stringy pastes may be somewhat improved merely by grinding manipulations.

Tempera colors are similarly ground in water or tempera mediums, and are more conveniently stored in small screw-cap jars than in tubes. Watercolors must be ground very fine; a prolonged grinding with pressure is necessary to obtain the correct texture, as mentioned under "Watercolor and Gouache." Fresco colors must be equally well ground. Gouache colors should be well dispersed and smoothly, but not necessar-

ily finely, ground. Some pigments repel water (e.g., alizarin) and they require a wetting agent to start the first mixing efficiently. Moistening the pigment with a little alcohol will permit rapid wetting in such cases; the alcohol should evaporate during the mulling.

Tubes. Collapsible tubes may be had from the druggist, from some artists' supply stores, and from wholesale drug houses. The usual "studio size" is 1 x 4 inches. Pure tin tubes were formerly the only acceptable kind for the best artists' colors; they are the most satisfactory in all respects, preserving the paint and not staining or otherwise affecting the contents. The shortages of tin tubes which have occurred since 1941 have forced artists' color manufacturers to use lead, aluminum, alloy, and tin-coated tubes; at the present writing government restrictions do not permit the use of tin tubes for paints; the artist must use whatever is available.

The tubes are filled with a palette knife, and enough room should be left at the bottom so they can be closed conveniently and neatly. If one attempts to cause the paint to settle into the head of the tube without enclosing air bubbles, by tapping the capped end on the slab, the shoulder of the tube is certain to be bent or dented. To avoid this, the tube is grasped lightly in the hand so that the cap is protected from contact with the table, and the fist is pounded on the table. The open end of the filled tube is then squeezed together lightly, the tube laid on the slab, and a palette knife pressed down firmly on its end (covering about ⅛ inch of the tube). The tube is then picked up by its cap with the other hand and folded over the blade; this folding is repeated once or twice. The end may then be crimped more securely with a pair of stretching pliers if desired. Do not fill the tubes too completely or they will leak or burst open. About 1½ inches of a studio-size tube must be left empty to allow for proper closure.

"Studio size" tubes of artists' oil colors and large tubes (one pound) of white are in regular use; smaller sizes are convenient for portable sketching boxes, but less economical.

To prevent the cap from sticking and to prevent the oil color from hardening in the neck of the tube, wipe away excess color with a rag and replace the cap immediately after use. If a cap gets stuck too tightly to unscrew *easily* with the fingers, try pliers *gently;* don't twist the cap too hard or the tube may burst. A stuck tube will almost always open if its cap is held in the flame of a match, then grasped with a cloth. Professional painters keep their tubes clean and neat; keeping them from becoming battered or misshapen pays off in avoiding leakage and waste. Always fold them neatly at the bottom as paint is used.

During the eighteenth and early nineteenth centuries, when prepared

Student Studio Pound

oil colors began to be an article of commerce and before tin tubes were invented, the colors were kept tied in small bladders which were punctured with a bone or ivory pin in order to squeeze out the color. The pins had large heads and were replaced in the puncture to seal it again. Later, a refillable brass tube with a piston arrangement, like a miniature grease gun, was in use for a short period.

Fine Grinding. Considerable differences of opinion formerly existed as to the proper degree of fineness to which pigment particles should be ground, but most investigators now seem to agree with Ostwald[46] that there is an optimum degree, which varies with each pigment. Doerner[55] warns against overgrinding by commercial makers, and says that the character of the color is often lost thereby.

I am of the opinion that altogether too much concern is felt for the supposed overgrinding of pigments by the manufacturers of tube colors. In the first place, very little crushing or grinding down of pigment particles occurs in paste or fluid mills; the action is dispersion, and an over-

ground paint is rather one which is overdispersed. The experienced manufacturer is well aware of the optimum degree of grinding compatible with the most brilliant appearance of his product, and he is not going to allow his colors to suffer in comparison with those of his competitors because of being overground. Furthermore, it is expensive to grind colors fine—the material must be run through the mills several times with a comparatively slow-flowing output. Finally, brilliance, the desired short or buttery quality, and stability of the dispersion are best arrived at by grinding accurately to an optimum point, which varies with each color but which ordinarily will not be fine enough to injure the physical properties of the color. Those pigments which are liable to cause structural defects in the film by being too finely divided have seldom been reduced to that condition by the mills; more often it is simply one of their natural characteristics. (See page 131.)

The particles of ancient pigments, especially those which were made from native ores, are often many times larger than those of modern pigments of the same composition. When viewed under a microscope, these coarser pigment particles always appear so much more brilliant and colorful, so definitely characteristic of their type, that on that basis one would choose them as more beautiful. However, when each pigment has been ground in an oil medium it is doubtful whether any difference in color quality can be discerned; the better structural effect upon the film of

Powder into Paint

the uniformly screened, modern pigment would be a deciding factor in choice. The older color makers manufactured their pigments in as fine a powder as they were able to in practical production, and they would have produced or pulverized them more finely and uniformly had their equipment been equal to the task.

Some investigators believe that in the grinding of oil colors as it is actually practiced, irregularities due to coarse particles are a more likely source of failures and weak points in the film than is overgrinding. All are agreed that uniformity of particle size is most desirable.

Extremely coarse particles of material are occasionally called for as additions to finished paints in some techniques; for example, powdered pumice is sometimes added to grounds to increase tooth, and sand or other coarse materials in order to achieve textural effects. Inasmuch as these materials may be considered to remain outside of the regular pigment/oil dispersed system, it is a question whether or not they have any effect upon the structure and permanence of the paint coating, by either weakening or reinforcing it; they are generally used in comparatively sparse amounts. Coarsely textured surfaces on oil paintings are discussed on pages 151 ff.

An oil color for artists' use should be dispersed enough to show a smooth, glossy, nongranular surface as it comes from the tube; and when it is diluted to a thin glaze film and applied to a white or transparent surface, no pronounced color particles or clumps should be apparent on close examination. The discussion concerning fine grinding applies only beyond this point, and artists who grind their own color should realize that with the means at their control there is little danger of their going too far; they should grind their colors as fine as they can. With care and attention they should be able to turn out an acceptable product but they should also realize that these colors will not equal those produced by the power mill, in regard to either complete dispersion or low oil content. The paints will contain from 15 to 50 percent more oils than those made in power mills, and a much lower proportion of completely dispersed, or primary, pigment particles.

The time-honored method of comparing textures, used by the workers who tend paint factory mills, is to rub small bits of the pastes between the thumbnails, whereby slight differences in coarseness or grittiness are perceived with great sensitivity. Coarse particles are easily discerned when a thin layer of paint is smeared on a sheet of glass and held to the light.

The simple mixing of dry color and oil without mulling is never recommended, as the resulting product is by definition a paste, not a paint; it will contain a large excess of oil, will tend to have poor plasticity, and will

not make films of durable structure. The pigment will be neither evenly dispersed and wetted, nor completely locked in with binder. If a painter who has become accustomed to mixing pigments and oil lightly with a palette knife will take some of his product and give it a thorough and complete mulling, he will find that he can usually introduce much additional pigment into the mixture without changing its original consistency. This is ample proof of the presence of excess oil in the first product. When silica or pumice is added to an oil ground for the purpose of imparting texture or tooth, it should be lightly mulled into some of the mixture and not merely stirred in. Aqueous *grounds* (gesso) do not usually require grinding, because of their wetting and binding properties and the peculiar structure of their dried coatings; but aqueous *paints* require careful and complete grinding.

Ideal Consistency of Tube Colors. Our present standards of what constitutes the best consistency for oil colors demand a smooth, "short" or buttery paste that will stand up or stay put without flowing of its own accord, and that has no tacky, stringy or "long" characteristics. These standards go back at least as far as 1840, and probably became exactly set and uniform as they are today—a few decades thereafter—with the adoption of the collapsible tube and the mechanical improvements of paint-grinding machinery. This period coincides roughly with the developing of artistic forms and styles for which a paint of such consistency is eminently suitable, leading into the Impressionist and the Postimpressionist schools; certainly it is an ideal material to "push about with spade-like brights bristle brushes" (Laurie[53]) and with palette knives.

Consistency of Oil Paints. If everybody were satisfied at all times with the consistency of our oil colors just as they come from the tubes, many of our problems concerning defective paintings would be simpler, because history and the laboratory teach us that straight oil paint, plus a little turpentine when needed, will produce the most permanent kind of pictures on canvas. But only about half of us are satisfied with this; versatile and flexible as oil paint is, it is not sufficiently versatile to serve all of the manipulations and effects we desire—especially when we want to emulate the effects of some of the old masters (whose paint was generally more fluid than ours), or to use it for newer aims and purposes beyond those of the painters for whom our present materials were developed. In order to modify the tube colors for these purposes, and for facility in securing other special effects, such as glazes and free-flowing applications, they must be diluted with a medium.

In other words, after the manufacturer has taken so many pains to "build in" certain plastic qualities, we must destroy these by adding a painting medium.

At first glance, adding a fluid medium to tube colors to overcome properties which have deliberately been built into them might seem to be an irrational way of arranging things; but a certain balance or combination of consistency characteristics is necessary for each purpose or for each individual's requirements: a certain amount of mobility or flowability for free brush manipulation, a certain degree of plasticity or ability to set up and stay put. The most feasible way for the artist to obtain this is to have his colors made with a pronounced gel or short, buttery consistency, and to have a fluid diluent or medium with which to increase its flow to variable degrees. A ready-to-use thin paint with all its volatile solvent and its free-flowing, drying and resinous film-forming properties would not keep well in containers, and it could not be adjusted to meet various contingencies.

Consistency from the standpoint of physics is outlined on page 438

PAINTING IN OIL

There are obviously nearly as many techniques and combinations of techniques in oil painting as there are schools of artistic thought, but the rules which govern the correct application of the oil-painting materials are the same in all cases. Within their general restrictions there is ample leeway for adapting them to individual requirements and to the requirements of the various types of work. It must therefore be understood that in these remarks, as in most published accounts of painting processes, examples which have been chosen are broad enough to cover most of the variations, and have been selected as the clearest or simplest means to demonstrate the principles involved.

The simplest example of oil painting is the production of a plain two- or three-coat system such as is applied to walls by house painters. When paint is applied to a canvas, a panel, or a wall for pictorial or decorative purposes, it will act in accordance with the same rules that govern the actions of the common wall paint, and the basic principles of correct application are the same in both cases.

One of the first considerations is that no moisture should be present in the ground, and precautions must be taken to prevent moisture from permeating the film from the rear. Another is that the degree of absor-

bency of the surface should be uniform. House painters therefore give porous wood and plaster a good "drink" of very thin shellac or glue size—not enough to create a nonabsorbent, slick surface, but sufficient to penetrate and size or seal the pores.

If a perfectly impervious and solid surface, such as a metal, is to be painted, it is roughened mechanically in order to give it a tooth or key, and the priming coat is composed of materials that have strong adhesive properties and that give a surface so coarse that even when sanded to a smooth finish it will still have considerable tooth. Wood or plaster surfaces which have previously been painted must, if their surfaces are smooth or glossy, be roughened with coarse sandpaper or steel wool, so that the ground will have sufficient grain both to take the paint from the brush and to make it adhere well. A slick, nonabsorbent surface is frequently the cause of nonadhesion of top coats; paints which will give perfect results under the normal conditions of surfaces in easel painting may display lack of adhesion when applied to abnormally smooth coatings.

In a three-coat system, the first coat should be coarsest in texture, the second of a finer grain, and the third, finest. Likewise, a superimposed coat must be as flexible and susceptible to expansion and contraction as the undercoats. It may be somewhat more so, but on no account should it be less flexible than the undercoat, or cracking, flaking off, and peeling will certainly occur. An exaggerated illustration of this principle would be to grasp a sheet of rubber that had been painted and stretch it; the paint would immediately crack. This most important rule of gradation of layers, which applies to all methods of artistic painting, is referred to under *Fresco Painting* in Chapter 9; it was known to craftsmen of prehistoric times.

The oil index figures (pages 133 ff) indicate the general order in which oil films containing various pigments may safely be superimposed. There is, of course, no definite, precise line to be drawn, particularly among pigments of the same class, and the precautions apply only to pure colors, or to mixtures in which these colors predominate. A good rule to follow is that pigments in the high or very high groups should never be used full-strength or nearly full-strength as underpaintings for those of lower oil absorption. (See pages 161–62.)

Thinning. The free use of turpentine or its equivalent as a thinner or diluent is a necessary part of the process in the majority of oil and oleoresinous painting techniques, and with experience the painter learns to introduce just the right amount to make his manipulations easy and bring the thickness of his paint layer under control without impairing the structural strength and durabililty of the film. It should be clearly understood

that the sole purpose of thinners is manipulative and that none of them have any reactive effect on the paint. (See page 364.)

Glazes and Painting Mediums. The addition of oleoresinous painting mediums to tube colors is a rather complex and involved subject and so it is treated under a separate heading at the end of this section (page 203) after the properties of their ingredients have been discussed.

COARSE-TEXTURED EFFECTS

In the past, some painters and schools of painting have aimed at rugged, textured effects rather than smooth appearances, and those who carefully followed traditional procedures and kept their heavy impasto strokes within the bounds of what has been considered good practice have achieved these results by skillful handling and the selection of appropriate technical measures. More recently, experimental painters have been producing very coarse textures, gross exaggerations of these methods, by piling huge blobs of oil paint on canvases or by stirring into the paint extremely large and coarse particles of foreign matter, such as coarse-grained sand.

Materials of doubtful stability have also been used for this purpose—sawdust, coffee grounds, tobacco, and the like—and sometimes one sees extremely thick impasto paint manipulated into sculptural effects and accidental textures, produced by the addition of larger impurities like palette scrapings and coarse bits and chips of various materials. One of the great disadvantages of all of this sort of painting is the well-nigh impossible task of future cleaning, and the necessity for its careful handling in general. Not all paintings are given museum care after they leave the artists' hands; not many of these textural effects can be expected to resist some of the mistreatment by handling and exposure which more soundly constructed works frequently survive.

The overloading of a painting with great gobs of impasto, to a degree that would never have been attempted by careful craftsmen of former periods, has been condemned by specialists in the technology of paints and painting ever since such practices have been in use. Ever since its adoption, the oil-painting technique has followed rules developed over the centuries as artists have learned about the survival of paintings, and such departures from accepted practices involve too many unknown factors to be considered safe. The earlier painters were capable of creating an effect of robust and rugged textures without actually overloading their canvases with exaggerated thicknesses of paint, and if some of the current or future forms of painting actually require this kind of handling, some newer ma-

terials or techniques must be developed to meet them. One of the several reasons for the current revival of encaustic painting and one of the attractions of polymer colors is that any reasonable degree of full, rich impasto can be applied with safety.

Another method of obtaining textures is the strewing or sprinkling of ground glass, silica, pumice, and other dry powders over a wet painting—a procedure that is like making sandpaper—sometimes in underpaintings and sometimes on surfaces. Thompson[70] would refer to this as the "tar-and-feathers" system. Because it is a procedure of some antiquity (see Eastlake[28]) some painters accord it the sanction which we are prone to accept form traditional methods. However, it must be remembered that few of these older operations employ coarse materials and none of them omitted a final protective fixation or varnishing; the result was a strong, reasonably smooth surface which permits cleaning and general preservation.

Varied crumbly, irregular, and accidental textural effects can also be created by the process known as lifting, in which a sheet of paper or textile is pressed to a wet paint surface and removed, thus carrying away or lifting parts of the coating in a characteristic manner. When applied to small or limited areas in a painting, these effects can often be controlled and made less accidental.

Special White for Crisp Touches. Painters have frequently noted in their efforts to re-create certain effects observed in old paintings, particularly those of the seventeenth-century Dutch and Flemish masters, a crisp outstanding quality in some of the whites and pale-colored touches or heightenings which cannot be duplicated by using the simple oil colors obviously employed in the rest of the picture. Many explanations have been offered on this point; one of the most successful means of achieving these effects has been the use of a special white made by mixing flake white oil color with an equal part of flake white, ground to the same consistency in whole egg. This mixture, handled like an oil color, will produce impasto strokes that will retain their sharpness and crispness without shrinking or flowing. The egg is thoroughly mixed with a few drops of water and strained, the flake white ground into it with the muller to the same consistency as the oil color and then mixed into the oil color with a palette knife on a glass slab or on a palette. The resulting water-in-oil emulsion has a mat effect; it thins nicely with turpentine or mineral spirit and it dries quite rapidly—that is, it promptly sets up dry to touch or to overpaint but does not dry to complete hardness any sooner than the rest of the painting.

According to Doerner,[55] the addition of tempera colors to oil colors in

this manner was revived by painters in the 1920s after being out of use for forty years. He recommends such additions of tempera to oil colors on the basis that making them "leaner" is better than making a tempera too "fat" by adding oil. In speculating upon the materials used by old masters to create outstanding loaded whites and pale colors or in methods by which heightening with lights can be done fluently, Laurie[51] suggests re-creating these effects by the use of a similar combination of egg yolk and stand oil to produce a turpentine-soluble (water-in-oil) emulsion, in which flake white will produce a crisp and nonflowing quality.

I know of no earlier references to this oil-plus-egg material nor of any tests that give information as to its longevity, but would suggest that it be reserved for occasional use in oil paintings in separate brush strokes or in limited spots where such effects are wanted, rather than that it be used freely over large areas, so that the painting will retain the advantages of being primarily a straight oil painting. If its use is confined to outstanding strokes, crisp facile touches, and crisp impasto touches, it seems to be safe enough, but if it is freely employed over large areas it might develop defects. Flake white should be replaced by titanium in egg.

From my own experience, three parts of the tube flake white to one of titanium egg white yields a tougher, more elastic, and more adherent coating than the usually recommended equal parts.

In recent years, special ready-made white paints in tubes have been offered for similar purposes, but so far, the formulation of none of these has been published. (See page 650.)

MAT OR FLAT FINISH

The manufacture of glossy and flat liquid paints may normally be regulated by varying the proportions of turpentine and fixed oil varnish binder, care and precision being required.

In the formulation of a glossy mixed paint, when the nonvolatile binder (film former) has greater bulk than the pigment, the dried film produced may be approximately represented by the following diagram, in which the surplus medium has leveled out to a smooth, even surface above the pigment particles.

If a larger amount of turpentine or other volatile solvent be added to the vehicle, so that all the oils or resins which form the dried film are of lesser bulk in proportion to the same amount of pigment, still sufficient in quantity to surround the particles and lock them in but not present in large enough proportion to flow out, a rougher surface is produced, and the light, instead of being reflected from a smooth mirrorlike surface, is broken up and reflected in all directions, resulting in a flat (mat) effect, thus:

If an intermediate proportion of binder is present, a semiflat or eggshell finish is produced, thus:

The four formulas for wall paints on pages 339–40 illustrate these principles.

In actual industrial practice, these flat and semiflat effects are sometimes obtained by the use of materials such as aluminum stearate, wax, etc., which cause the vehicle to assume a microscopically wrinkled, porous, or otherwise rough surface; or by the use of inert pigments whose structures are irregular, containing particles in the forms of flat plates, needlelike crystal, etc., which will extend up into the surface film, preventing it from flowing, thus:

If a mat finish is attempted by diluting a ready-made paint excessively with turpentine, the effect may be mat, but the film may also be

weakened to such an extent that the pigment is liable to chalk off eventually, or the film to crack or display other defects. The diagram in such a case would show pigment particles surrounded by a layer so thin and porous as to offer them slight protection against being rubbed off or picked up by subsequent coats.

When normally glossy pure oil colors are applied over grounds that are considerably more absorbent than the average prepared artists' canvas, usually enough of the excess oil is absorbed into the ground to produce a mat surface on the painting; but it is not always possible to rely upon such action to produce finished paintings which will present a uniformly mat finish. A fairly exact degree of absorbency must be worked out for the ground if it is not to have the disadvantages of being too absorbent or too impervious as mentioned in Chapter 5 on grounds; it is not always possible to prepare either grounds or paint layers of such uniform quality and thickness that there will not eventually be dull and glossy spots in the picture; the first or direct painting on the absorbent ground will act as a priming coat, upon which subsequent brush strokes will appear more glossy. If the paint or medium contains resins, or is otherwise more glossy than normal oil color, irregular glossy spots will be still more likely to form. Some painters, however, particularly those whose techniques may be for the most part classified as simple and direct, have succeeded in applying this system of mat oil painting with fair visual results. The use of a final varnish or treatment, after a painting has become dry, to produce a flat finish, is mentioned under *Mat Varnishes* on pages 197 ff.

Some of the older accounts of painting methods recommend the addition of ground glass to oil colors in order to achieve a mat finish and to speed the drying.

Mat Oil Painting Not Recommended. However, the typical well-painted example of permanent oil painting does not have a mat finish, and paint technologists agree in declaring that durability or nonyellowing properties are sacrificed by attempting to imitate the qualities of tempera, fresco, or casein paints, qualities which do not normally belong to the oil medium. Until comparatively recent years, especially with the popularity of the "blonde" type of picture, paintings in oil were expected to be lustrous, and historically, the natural gloss of oil paint was one of the desirable points that led to the adoption of oil paints for artists' use. Those who seek completely lusterless effects in fine-arts painting are advised to turn to the methods which employ the powerfully adhesive water-soluble binders.

The oils and varnishes used in the technique of oil painting produce

adequately tough, durable films that are permanent under normal circumstances, but they do not give armor-plate protection, nor are they particularly notable for their adhesive or gluelike properties. Conditions and circumstances therefore do not have to be removed very far from the normal to cause abnormal results. This is well known in the instance of those industrial coatings that are subjected to hard wear or exposure, and where it is the common experience that a pronounced decrease in durability always results in direct ratio to the increase in mat or dull effect. A sort of human perversity can be observed among painters who seek ways of painting dull surfaces in oil, and then, when working with casein paints, seek ways of making them look glossy to imitate oil paints. (See pages 388–90.)

Dead flat and semiflat coatings are obtainable in industrial and house paints, and artists have for years experimented with recipes whereby lusterless effects can be achieved, but so far no acceptably permanent results have been obtained.

Addition of Dry Powders. One way of producing a mat finish which at first glance seems to offer a desirable surface for use in grounds and also for use as an "underpainting white" is to mix dry white pigment or an inert pigment (e.g., silica) into a paint. This mixture of unground particles into a properly dispersed paint would theoretically confer upon the mixture all of the disadvantages of a poorly milled coating. Also, upon further reflection, one can remark that if the resulting product is of a quick-drying, absorbent nature on the surface, might not its underface, where it lies on the panel, likewise have the same dry properties, thereby increasing the danger of poor adhesion and eventual cleavage upon aging? The consequent decrease in adhesive power or anchorage might be similar to that noted under *Fresh Paint* on pages 5 and 8. On the other hand, I have some oil paintings done over white industrial lacquer into which dry zinc white and silica were stirred before it was sprayed on wallboard panels. They worked well and so far have survived twenty-five years' aging under good care.

The entire subject of mixing dry ingredients into artists' paints has not been sufficiently investigated to yield definite facts on the expected longevity of such films.

Mat Effect of Aqueous Binders. As a general rule the aqueous mediums, such as are employed in watercolor and tempera, contain more powerful adhesives than do oil mediums, and once the correct proportion of pigment and binder is established they may be diluted with their volatile solvent (water) as freely as desired, without the dangers mentioned above (see diagrams on pages 4–5). Watercolor in particular may be thinned

down to the faintest wash without impairing its permanence; the open-textured paper will still hold the pigment particles in its interstices, trapping the pigment in the surface. With aqueous binders, the mat finish is a function of the pigment; the clear medium, if used alone, may dry to a glossy finish when applied to a nonabsorbent surface. This may be observed occasionally when there is too high a proportion of binder to pigment in the composition of a water paint and the dried material or the dry painting in which it was used exhibits an undesirable hardness or glitter.

THE STRUCTURE OF PAINTINGS

A painting is a laminated structure; its support, its ground, and its layers of color in varying degrees of complexity must be built up in accordance with the simple physical and chemical laws that determine its stability. Among these, the rule of gradation of layers, referred to on pages 149–50, is of great importance; a layer of finely divided particles should overlie one composed of coarser particles; a layer should never overlie one of greater elasticity, and a less flexible layer should lie below the one with greater flexibility. Likewise (and this is especially important in the case of water-soluble coatings), coats that have a greater degree of binding power should not be applied over those which contain weaker binders. Coatings which are equal in texture, flexibility, and strength, however, may safely be placed over one another. A rather crude or exaggerated analogy concerning the brittle over the flexible (or "lean over fat" as the Germans express it) would be a casein painting on a sheet of rubber; upon stretching the rubber, the dried paint would fly off the surface in a thousand pieces. Similarly, where dry oil paint is less flexible than its underlayer, it is liable, because of some degree of embrittlement with age and the continual flexion or movement of the canvas in handling, or because of a microscopic expansion and contraction through temperature changes or the absorption and discharge of atmospheric moisture, to suffer microscopic hairline cracking which could become a full-scale defect.

Sometimes artists scrape fresh or fairly fresh layers of paint away from a surface with a palette knife. This is generally considered to produce an excellent foundation for further layers of paint and to enhance the adhesion or anchorage of the overpainting. It is also a good way to reduce overthick layers of paint.

Lack of adhesion between the ground and the linen seldom occurs except when an exceptionally heavy glue or gesso has been applied instead of the more desirable thin glue size recommended on page 243. Moisture from the rear or seeping through cracks on the surface can easily cause separation at this point. In the case of picture cleaning, this can

be a serious matter; hence the general admonition usually given to inexperienced persons not to use water and particularly soapy water in picture cleaning. Heavily sized canvases will crack and peel when hung on damp walls, especially when the ground and paint layers depart from the conventional straight oil techniques and contain ingredients which are affected by moisture.

Lack of adhesion between paint and ground or between layers of paint is more common; it is discussed later under *Defects in Oil Painting*.

The diagram "Anatomy of an oil painting" on page 474 may be referred to in connection with the structure of paint films.

An artistic oil painting with its broken areas of separate brush strokes has a large advantage in durability over ordinary wall paint with its continuous film of uniform thickness. Occasional heavy impasto strokes may safely be used in combination with thinner painting; expansion and contraction due to atmospheric changes or to the flexing of a canvas will not readily cause cracking in such cases. Uniformly thick, pasty painting over wide areas, however, soon leads to cracking because the resulting film acts as a unit in expansion and contraction. The life of house paints, whose formulas sacrifice the extreme permanence of artists' paints for other considerations, is greatly prolonged by correct application. One of the first rules for applying continuous films of industrial paints and varnishes is to keep the layers thin; several thin coats always are preferred to one heavy pasty coat of equal thickness. Coatings applied in this manner are less likely to become defective.

Theoretically, and in the results of laboratory tests, the application of a coat of oil paint over a recently dried layer does not produce such a desirable structural effect as its application over a completely dry film, or over one that has not quite set to dryness. However, this is not a seriously important point in practice, especially when pure linseed oil is used in normal techniques. All other conditions being satisfactory, oil paint may safely be overpainted at any stage, so long as its surface is sufficiently firm to resist being picked up, and so long as it has sufficient tooth or absorbency to hold the new paint.

The spontaneous volume changes and movements involved in the drying of oil films are somewhat different in type from the movements which may occur in dried or aged films. It should be remembered that the former actions are temporary, that is, they take place only once, at the time of drying, during a period when the flexibility of all elements of the paint structure is greater and more uniform than it will be in the finally dried painting.

The movements that affect the permanence of a dried painting and

are induced by external forces—temperature and humidity fluctuations and the like—are permanent hazards. A well-painted picture is designed to withstand these forces when they occur in average normal degree; when they occur in extreme severity they may exert their destructive effects at any time during the life of the painting; cracking, peeling, and other such defects are liable to be the result of faulty practice at any time after the various layers of the painting structure have dried and assumed the greater part of their final characteristics.

As a general rule, defects that are a direct result of the application of overpainting while the underpainting is not in the ideal stage to receive it should occur within six months. The choice of materials and methods for building up a structure that will withstand age and variable external conditions is a more important consideration than the order of painting on newly dried surfaces.

Repellent Surfaces. When a dried painting presents a slick or waxy surface upon which fresh paint does not take well, and when it seems necessary to make some provision for the permanent adherence of the new coat, it is better to do so by roughening the surface slightly than by coating it with some foreign material which will add another element to the structure and introduce an additional danger. This includes such antiquated methods as rubbing the surface with a slice of raw potato or with buttermilk. Roughening the paint surface to supply a key or tooth for further paint may be done by rubbing it gently with a mild abrasive, such as finely powdered pumice, bread, a rubber eraser, or Artgum; in the case of delicate films and glazes, care must be taken not to destroy more paint surface than is intended. Freshly dried surfaces that have become soiled by handling are best cleaned with balls of soft bread. A good retouch varnish can safely be used to bring out dull spots during painting, provided it is kept to a thin layer.

Retarding the Drying of Oil Paints. Although the contemporary painter is more frequently concerned with the acceleration of drying and the use of quick-drying materials, there are also circumstances where he or she wants to retard or delay the initial setting or drying of the paints in order to be able to resume work into wet paint on the following day. This is particularly desirable in the case of styles of painting which call for extensive merging or gradations of color areas into one another, and in the case of portrait painting where it is necessary to work from life with intermittent sittings from day to day.

Of all the procedures recommended for this purpose, the one that

seems to give the best results is the addition of a few drops of oil of cloves to the oil colors. Oil of cloves is one of the slowest-drying of the essential oils; when spread out by itself it takes over a month to dry or evaporate.

Other diluents that will retard drying by reason of their own slow rates of evaporation are lavender and rosemary oils, which together with clove oil are classed as *essential oils* (see page 398); pine oil, a product of the turpentine industry, used in bulk in industrial work; and butyl lactate, a volatile solvent or diluent used in lacquer compounding. Pine oil is a very useful material to add to paints, glazes, retouch varnish, etc. for delaying the initial or first stage of drying, by reason of its slow rate of evaporation, when it is desired to prolong the wet stage for manipulations over a single long working period. But for carrying the work over to the next day or days, oil of cloves has not yet been improved upon.

No exact recipe can be given to control the amount of retardant to be added, as this depends on several variable conditions, such as the nature and thickness of the wet film, the dilution or thinning of the paint, and the climate. Few studies have been made to determine what degree of harm, if any, might result from the consequent interference with the normal drying reactions of linseed oil in artists' colors through the use of retarders. Subjects of this kind are discussed in the section that begins on page 440, and particularly on page 448.

Painting Over Old Canvases Not Recommended. The practice of painting over an old picture is certain to lead to unwanted effects; if it is necessary to utilize old canvases for the sake of economy, it is best to remove the entire old painting and ground. If the canvas is soaked in a tub of water overnight, the entire ground and painting can sometimes be scraped off the following day, leaving few traces. If this does not work, it is best to discard the canvas. Fresh paint, as previously mentioned, can be scraped off with a putty knife, and the surface thus exposed usually presents an excellent foundation for repainting. Removal of old paint from easel paintings or walls in a wholesale manner with paint remover is not to be recommended; paint remover contains paraffin wax which will be left embedded in the surface; aside from this, the action of the solvent is likely to leave remnants of the ground or underpainting in a weakened condition. Alkaline or acid solutions will also leave injurious substances in the surface.

Old paintings will always show through newer painting eventually, on account of the increasing transparency of the aging paint film (pages 111–12). When the brush work of the first picture contains impasto strokes or brush marks even slightly thicker than a thin flatness, ghosts of the original work will show up in a disconcerting manner. The

presence in the original painting of reactive materials, especially zinc and poppy oil, and variations in the original film's consistency and thickness all present elements of danger to the final work. Isolation of the old painting with a layer of casein or other material that is dissimilar to the paint introduces an additional element of complexity and is not in accordance with the rules for the correct gradation of layers.

Historically, few if any important paintings on second-hand canvases have survived in good condition. The texture and brush stroking of the directional lines of the old composition will always be at variance with those of the new, and it is not unusual to see the contour of a hill appearing across the face of a portrait, or the ghost of a head coming out in a background. (See pentimento, page 111.) Coating the surface with a new ground of white paint will serve for students' exercises that are to be discarded, but a new picture over an old oil painting will not produce permanent, satisfactory results.

SIMPLE RULES FOR PERMANENCE

The following is a résumé of the more important points to be observed in painting a permanent picture in the simple straight oil technique:

1. Select a support that is stable in itself and sufficiently durable to withstand the conditions under which it is expected to last. Canvas must be securely and permanently fastened to its stretcher and panels must be correctly braced or framed.

2. The ground must possess absorbency, porosity, roughness, or a combination of these properties to a definite degree depending on the requirements of the work and sufficient to create the proper mechanical bond between the surface and the coating. The ground must be as white as possible and, if it is homemade, a thin glue size should isolate the oil paint coating from the linen.

3. The common procedure (subject to numerous variations) is to sketch or trace a preliminary drawing on the ground with charcoal or pencil. The drawing lines are then usually gone over with very fluid oil paint, containing at least 50 percent thinner. On gesso-type grounds, thin watercolor or ink may be used. Before applying oil paint over charcoal or chalk, the excess particles should be dusted off by flicking lightly with a cloth. Some painters like to secure the drawing by spraying on a tiny amount of charcoal fixative.

4. If more than one layer of paint is to be applied, the first coat should be kept thin and even, as far as the nature of the work permits. Pigments in the high or very high oil absorption lists on page 134 should never be used full-strength in underpaintings; they should be mixed with at least

40 percent of pigments of lower oil absorption if they are to be over-painted with average colors. Paint must not be applied to completely dried, glassy, nonabsorbent underpaintings because of the poor adhesion between such surfaces and fresh paint. Overpainting during the period of from one week to two or three months after oil paint has dried is considered dangerous by some workers, as the paint undergoes shrinkage, but with the possible exception of a complete set of colors all ground in poppy oil this is not an important precaution. In all further applications of paint, no pigment of low oil absorption should be placed over one of appreciably higher oil content. Thinning with turpentine, especially in upper coats and with thicker films, must be done with care so as not to weaken the resulting film or make it too brittle. Heavy impasto strokes have good durability only when broken or scattered. Continuous thick, pasty layers are extremely liable to crack.

5. The fresher the paint, the better the chances for permanent adhesion of the painting to the ground and the lesser the chances that it will peel, flake, or dust away. Avoid the use of old oil colors that have been exposed to air on the palette for too long a time, especially those that require the addition of fluids to bring them back to their normal consistency. This does not apply to paints that have been diluted with thinners or mixed with a varnish or resinous painting medium and have become viscous during the same day by simple evaporation of turpentine, for they can be reconditioned by replacing the turpentine during the same sitting.

6. For fluent operations with the brush and free manipulations, the oil colors are thinned by mixing with just the right amount of turpentine or mineral spirit—not too little, not too much. For manipulations that require still greater facility, further desirable properties can be given to the paint by a sparing addition of a good painting or glaze medium such as the one described on page 215. Avoid the use of complex mediums or plain linseed oil.

7. To bring out the full color effect on dry or sunken-in areas, to produce a uniform wet appearance in order to match colors on the resumption of painting, apply a thin coat of retouch varnish with a soft brush.

Retouch varnish is specially formulated to be used in extremely thin layers, the usual ready-made variety sometimes requiring the addition of a little extra turpentine. It is undesirable for retouch varnish to produce a really continuous film or layer of appreciable thickness, because then it would add a complicating element to the physical structure of the painting. It must be absolutely dry before overpainting or the paint may stay tacky for a long time. Some areas may require more than one application; the varnish should be used until the desired effect is produced, but not beyond that point. If necessary it may be applied again and again, provided

one avoids building up a heavy varnishy layer. The gloss produced by the well-applied retouch varnish is not necessarily permanent; it needs to last only during the paint manipulations. A good retouch varnish should, at the most, act as a sizing to lessen the absorbency of the surface. The difference between a material that acts as a size and one that creates a continuous film or layer is an important point, as noted on page 250.

8. Depending upon the thickness of the paint film, the painting should receive a thin but adequate coating of final picture varnish after the oil paint has dried so completely that all appreciable expansion or contraction in its volume has ceased. In the case of a picture of common or average thickness the drying time will be from three to six months. Very heavy paint may take longer, very thin paint less than three months. Extremely thin layers and glazes may be varnished as soon as they have become completely dry to the touch. No oil paintings should be left unvarnished for more than a year, unless they are very carefully stored.

The premature varnishing of a painting of normal or less than normal thickness is not such a serious matter as some painters have been led to believe; the strict admonition to wait a year is a holdover from the old days when a heavy, glassy layer of mastic was practically flowed over a painting, rather than the more thinly brushed-out coatings in general use at present, and it is my experience that it is better to varnish a painting too soon than to run the greater danger of subjecting an unvarnished oil painting to exposure for too long a period. Picture varnish is discussed on page 172, professional methods of varnishing paintings on pages 501–503.

DEFECTS IN OIL PAINTINGS

Cracking. 1. Coats of paint less flexible than underlying coats. This condition can exist when the underpainting contains considerably more oil than the overpainting, when it contains a vehicle of entirely different and less brittle composition, or when the top layer of paint was overdiluted with turpentine. The cracking usually appears as an "alligator" design of fine lines with sharp edges, occasionally quite deep, but more often a surface effect. Cracks from this cause are liable to occur soon after the drying of the paint.

Full-strength oil colors of high oil absorption, such as lampblack or ivory black, should not be overpainted with whites or other pigments of much lower oil content (see pages 133–34). When it is necessary to work freely without deliberate planning and to intersperse different colors during the composition of a painting, Mars black will probably give better results. Cracking frequently occurs within a short period when zinc white,

which dries to one of the least elastic of oil films, is applied over an underlayer of ivory black, umber, or viridian, which, having high oil content, dry to more elastic films.

2. Painting over a glossy, smooth, hard surface on which the flexible paint will creep or crawl. Usually the effect is worst when the top coat is thick; it will then display wide fissures with irregular edges, the hard or nonabsorbent uncracked ground underneath being clearly visible. The technical terms for this defect are traction or cissing.

3. The use of materials that have the constitutive or inherent property of cracking, either alone or when mixed with certain other ingredients (asphaltum, copal, Vandyke brown, etc.).

A few of our permanent pigments (notably alizarin and lampblack) are light, fluffy powders of high oil absorption which, when used full strength, will occasionally develop a fine hairline, allover crackle, apparently because the oil film is not reinforced as it would be with a denser, more granular pigment. Some properly directed laboratory studies should be able to teach us how to avoid this shortcoming of alizarin, one of our necessary pigments.

4. Extreme changes of temperature, especially extreme cold. Storage in unheated buildings during severe winters causes a characteristic design of cracks in concentric circles; the cracking usually goes all the way through the ground. Copal and other mixing varnishes are particularly susceptible. House paints, which ordinarily do not crack in this circular design, will do so when painted on cloth and exposed to use. The rapid disintegration of old European paintings when brought into steam-heated apartments is well known; panels suffer more than canvases in this respect.

5. Too much drier. The cracks are similar to those described under No. 1, but are usually wider (see *Driers*).

Poppy oil will crack in the same manner as linseed under all the above conditions; it is generally agreed, however, that its cracking will be more exaggerated and that it will begin to crack under less extreme conditions than will linseed oil. The typical poppy oil crackle under normal painting conditions is likely to result in an elongated alligator pattern with ragged edges along the short sides of the pattern; the fissures are usually wide enough to reveal the ground underneath.

These descriptions of the various types of crackle are not to be taken as infallible; they merely indicate the most usual or likely manifestations. As everyone experienced with the failures of paint films knows, almost any variation of crackle effect may appear as the result of a slight variation in the conditions under which the principal cause operates. Where a crackle effect in oil coatings is deliberately sought after (as in some of the

industrial decorative crystallizing finishes) by the addition of certain materials or by the manipulation of oven temperatures, exact conditions must be maintained or the effect will be erratic or unsuccessful.

6. Lack of rigidity of support; continual flexing of canvas, or warping of panel. Cracks from such causes are liable to curl up at the edges, and particles will become detached if the paint is brittle. Cracks on panels are long and straight, parallel to the grain of the wood; on canvas, they are fine and crumbly. This is a common form of cracking, particularly in the case of canvases that have been rolled, improperly stretched or stretched too tight, or expanded (keyed) too frequently after the ground has become brittle. Canvases that have been tightly rolled for a considerable length of time will crack through the ground in long, closely branched veins parallel to the axis of the roll. An ideal rule is that paintings on canvas should never be rolled; when circumstances make it necessary, they should be rolled face out, on cylinders of the largest possible diameter.

7. Faulty grounds. This cause can be detected easily. Gesso over improperly selected wood will crack along the grain of the wood; when cloth is glued to the wood as a backing for the gesso, weblike cracks will appear if it has not been securely glued down.

Lack of Adhesion. Cleavage (any separation of the paint from the ground) or flaking (detachment of numerous small pieces of the paint film). Such defects may occur alone or in connection with other defects, or as an aftermath of cracking or other blemishes.

1. Moisture penetrating canvas from rear.

2. See *Cracking*, second paragraph. Inflexible or brittle paint will flake off instead of creeping.

3. Faulty, brittle canvas, especially the cheaper commercial grades. Small flakes of the paint film will become detached, even though the ground itself cracks in larger areas.

4. Variations in humidity. The resulting expansion and contraction of the ground or support will cause brittle paint to become detached.

5. Paint that has passed into or completed the adhesive stage before application. See *Fresh Paint*, pages 5–6.

6. Cleavage caused by minor accidental blows, scrapes, or flexion in weak, brittle, or poorly adhering films, where normally tough, strong films would survive.

Wrinkling. 1. Excess of medium; not enough pigment to reinforce film. More frequently on thick areas; underpigmented coatings are not so prone to wrinkle when thinly applied. Also common when industrial

paints and enamels are used in artists' free techniques instead of in the layers of controlled, uniform thickness for which they were designed.

2. If in varnish film only, too heavy application.

3. Compression caused by concave warping of panel or by reversed (face inward) rolling of canvas.

4. Use of materials that wrinkle inherently (asphaltum, megilp, too much drier, etc.).

Crumbling or Powdering. Too much thinning or dilution of the paint; too little binding medium; disintegration of binding material. See *Fresh Paint,* pages 5–6.

Blisters. There are two kinds: some are formed by the paint film separating from the ground or undercoat, others by the entire paint film and ground separating from the support. Causes of blisters of the latter type are:

1. Moisture attacking the canvas from the back.

2. Lack of adhesion of the paint film or ground in spots. This may be due to any one of several circumstances: the canvas or ground may have been damp or oily when painted over; the ground may have been too slick or nonabsorbent; the difference in composition and physical properties between the two layers may be too great.

Blisters in only the top film of paint and not in the underpainting are difficult to explain. They are usually due to accidental conditions and rarely occur. They may be caused by a lack of tooth in the underpainting or by the presence of small oily or nonabsorbent spots.

Darkening or Excessive Yellowing. The use of an excess of linseed oil; the use of copal varnish or interior oils; the action of sulphur fumes on lead and copper pigments; the normal yellowing of, and absorption of dirt by, varnish on old paintings; the old practice of "oiling out" or rubbing a picture with linseed or other oil repeatedly, instead of varnishing it. An experienced person can usually determine the cause of a specific case of yellowing.

A normal oil painting requires an average, normal amount of daylight (not direct sun rays) during the time of its drying and for a few weeks thereafter. If the painting dries in a dark or dimly lighted place it is liable to turn dark; should this occur it can be brought back to normal by a week or so of exposure to north daylight. An abnormally humid atmosphere also promotes yellowing during the drying period.

Streamlines. The surface defect resembling drops of water running down a window pane is variously known by painters and paint techni-

cians as frilling, curtains, runs, or tears. When these occur in the varnish film they have usually been caused by applying the varnish while the painting was in a vertical position, the varnish having then set while it was flowing down the surface. The same may occur when lavish, over-abundant, or very fluid glazes are applied. The remedy for this is to work on a table instead of an easel, and allow the coating to remain in a horizontal position for fifteen minutes or until it begins to set up. If the blemishes are in the paint itself, there was too much medium in proportion to the pigment—the paint was too fluid. Picture varnish is intended to be applied while a picture is in a level, horizontal position. When paintings must by reason of certain circumstances be varnished *in situ,* they may sometimes be treated successfully by methods referred to on pages 507–508.

Photochemical Embrittlement. If organic coating materials remained completely inert and stable, that is, if they retained their original properties the way glass or ceramic glaze does, some of our problems with proper binding media would be solved. As oil paints age, they gradually lose elasticity and become brittle; this process is more rapid when the coating contains resins. The primary cause is the gradual and cumulative effect of exposure to the oxygen of the air and the ultraviolet in daylight. So far as is known from the experience of the past, well-applied pure oil paints are sufficiently strong, tough, and leathery to survive these changes in good condition while those composed of faulty materials or too high a percentage of resins or incorrectly applied will exhibit defects as the result of such embrittlement. There is a further section on this subject on pages 445–47.

Precise Conformance with Correct Principles. One of the reasons for the persistence of the popularity of oil painting is the flexibility of the rules which govern its correct application and the leeway one has between the ideal of perfection and the normal practice of painting. Despite the many rules with which one must become familiar, and certain ills to which badly painted pictures are prone, the painter must not look on such matters as bugaboos or worries that will interfere with his free expression.

If oil painting required a very strict and precise conformance with these rules, with meticulous attention paid to the utmost perfection in each operation, it is doubtful that its popularity would have continued; one of its great advantages is the absence of a good deal of the preciousness and precision that are required to paint successfully in some of the other mediums. One has a great deal of leeway in the application of oil paint; the general rule is to follow and carry out the principles of cor-

rect procedure with judgment and common sense, but, at the same time, not to stray too far from the correct line. For example, one is warned not to overload one's canvases with solid layers of thick, pasty painting throughout, yet a good "juicy" paint quality and the free use of impasto strokes are among the most pleasing attributes of many styles of painting; one must merely be conscious that there is a point where the departure from the technical ideal becomes dangerous. Another example is the warning against free use of mixtures and touches of relatively flexible and inflexible strokes, one over the other, without much concern; only in definite, extreme cases, such as a layer of zinc white over an area of pure raw umber, or some other very blatant infraction of the rule of "fat over lean," is it likely that the longevity of a painting will be endangered on this score.

VARNISHES

A varnish is a liquid that, when coated over a solid surface, dries to a transparent film of varying degrees of gloss, toughness, flexibility, and protection, depending upon its composition. Varnishes may be divided into several groups:

1. Simple Solutions of Resins in Solvents. Examples: damar varnish, a solution of damar resin in turpentine; shellac varnish, a solution of refined shellac in alcohol. These varnishes dry by complete evaporation of the solvent, which leaves a thin, transparent coating of the pure resin. They can be made at home successfully. They have been frequently called "spirit varnishes," but this term applies more accurately to those in which alcohol is the only solvent.

2. Cooked Oil and Resin Varnishes. Solutions of resins either natural or synthetic, which are made by cooking them with oils and then thinning with turpentine or its equivalent; driers always added. Example, linseed oil—copal varnish. The drying action is complex; first the turpentine evaporates completely, then the oil solidifies (oxidizes). These varnishes cannot be successfully prepared by other than large-scale industrial methods, attended by expert manipulation. With few exceptions they cannot be mixed with other varnishes and oils without disintegration. The terms "long oil" and "short oil" refer to the relative proportions of oil and resin in various types.

3. Modern Pyroxylin (Cellulose) Lacquers. These products, made of nitrocellulose, cellulose acetate, viscose, celluloid scrap, and other forms of

cellulose, are industrially important, but they are of small value in permanent artistic painting as their durability is extremely questionable. Their compositions are so varied that it is unwise to use them without first applying tests, especially in regard to darkening on exposure to light. They are generally applied by spraying. The finished products for industrial and household use are sold under many trade names. One of the most widely known is Duco; an equivalent trademark of German origin is Zapon. Cellulosic materials are discussed also on pages 190–91.

The cellulose materials used do not dissolve in drying oils, turpentine, or alcohol, and the lacquers are made by dissolving them in special solvents, such as acetone, ethyl acetate, butyl alcohol, amyl acetate, etc.

Tinting colors for lacquers are sometimes ground in castor oil, which generally mixes well with lacquers and also acts as a plasticizer. It is often employed for that purpose alone or together with a miscellaneous list of other substances, most of which have a bad effect on the life of the lacquer. Lacquers, particularly those containing such additions, have delicately balanced formulas, and require expert, experienced care in their manufacture and application.

These modern lacquers have good qualities which have been factors in their supplanting the older finishes for coating industrial products; but their principal advantage in this use is their high drying speed, which makes them particularly adaptable to the mass production system. This is notably true in the automobile industry, where they have entirely replaced the older types of coach varnishes. No successful application of these materials to thoroughly permanent artistic painting has so far been accomplished. They have undesirable qualities when used as picture varnishes or as isolating mediums.

The durability of modern lacquers was first improved by adding alkyd resin and more recently further improved by using acrylic resin. Cellulose nitrate, the original lacquer material, is relatively a tough, strong-wearing product during its life span, but with age turns yellow and tends to crack and lose adhesion. Cellulose acetate film is less inflammable and has somewhat less tendency to crack and turn yellow. Disastrous lack of adhesion, cracking, and darkening have been the fate of easel paintings in which cellulosic coatings have been used. Pigmented lacquers usually begin to show signs of disintegration after exposure to daylight for fifteen years.

4. *Enamels.* These industrial paints or pigmented coatings are based on varnishes or varnish-and-oil mixtures rather than straight oil vehicles. An enamel made of cellulose lacquer is sometimes known as a lacquer enamel, as distinguished from a clear or unpigmented lacquer or

from an enamel made with other varnishes, but is more frequently referred to simply as a lacquer. Because of their rapid rate of evaporation, the pigmented lacquers must be ground in ball mills. (See page 349.) When the ultimate in durability and resistance to severe or difficult conditions is required, especially where the product is to be baked at high temperatures, the alkyds and other high-grade synthetic resin enamels are used instead of lacquers.

Industrial and household enamels will wrinkle, crack, and exhibit other faults unless they are brushed or sprayed with the proper smoothness and uniformity of film thickness for which they were designed. Their use in the free and miscellaneous brush stroking of artists' work invariably leads to defective results. As a general rule their life on canvas is shorter than on more rigid supports. There is little point in mentioning the trade names under which these commercial paints and enamels are sold; the number is very large, and regardless of whether they are of high quality or are substandard, their unsuitability for permanent painting is equal. Furthermore, their composition is continually changed by reason of the usual developments, improvements, and other changes that industrial products undergo. Frequently inquiries are made about a material called Ripolin, which is simply a household enamel of widespread European distribution.

5. *Oriental Natural Lacquers.* These exude from trees in a liquid state. They include the original Ning-Po lacquer of China, the industrially important Japanese lacquer, and the lacquers of India, Ceylon, and Burma. None of these varnishes is exported, but each is used for the manufacture of lacquer ware locally.

6. *Synthetic-resin Varnishes.* A number of clear varnishes for industrial purposes and a few for artists' use are made from synthetic resins. The latter are discussed in Chapter 14, page 506.

HOMEMADE VARNISHES

The simple-solution varnishes are of the most interest to the artist and, with few exceptions, are the only ones he should use.

The rate of solution of any solid increases when the surface exposed to the liquid is increased; this is ordinarily accomplished by crushing or grinding the solid into fine particles. In the case of adhesive substances such as resins and gums, however, this attempt is defeated by the rejoining of the particles or small lumps with each other, the partially dissolved or softened material forming a solid lump. There are three ways of over-

coming this: (1) enclosing the resin in a suspended mesh bag or box, which will allow the heavy solution to sink to the bottom of the container, keeping the crushed pieces exposed to the action of the solvent; (2) mixing clean, coarse sand with the powdered material and thus interfering with the adhesion of the particles; (3) continuously agitating the batch with a power device. The first is the simplest and most efficient for occasional home use; the last is the method used in industrial production.

To make simple-solution varnishes, place the resin on cheesecloth, tie or sew the cloth together in the form of a bag, and suspend it in a container of the solvent overnight. Strain the solution through a cloth and allow it to settle a few days. The wide-mouthed glass jar, crock, or tin can used should be of such shape and capacity as to allow the bag to be completely submerged in the liquid without touching the bottom or sides of the vessel. The careful worker will regulate the shape of the cheesecloth bag to this end. To prevent too much evaporation of the solvent and also to keep out dust, the vessel may be covered. Sometimes it is possible to rig up a tightly covered jar, the bag suspended by a cord fixed to the cover. The bag may also be tied to a flat stick resting on the edges of the vessel, and solution may sometimes be expedited by lifting it occasionally, allowing the heavier solution to drain out of the bag.

If one has sufficient experience to judge the consistency of varnish without depending on exact formula measurements, or if the purpose for which the varnish is to be employed does not demand accurate measurements, a rapid method is to use an excess of resin, by which means a sufficiently heavy solution can be made in a few hours, the balance of the resin to be dissolved in fresh solvent at one's leisure. Under ordinary conditions from twenty-four to thirty-six hours are required to make a varnish of the usual concentrations; but this varies according to such factors as temperature, type of resin used, and the size of the batch.

On a larger scale, in factories, the resin is vigorously and continuously shaken up with the solvent in a revolving barrel or other agitating device until completely dissolved, and then it is clarified by being run through a centrifugal machine—a much more rapid procedure. If a solution is attempted by placing the resin in the solvent directly without the cheesecloth, unless it is constantly and vigorously agitated it will form a compact mass and dissolve very slowly. Small-scale shaking or agitating devices operated by small electric motors can be improvised when circumstances warrant their use. Acceleration of the solvent action by the application of heat almost always darkens or otherwise alters the resulting product. A fire risk is also involved.

Simple solutions of resins in solvents, made without oils and driers, are known in the varnish industry as "cold-cut" varnishes, even though

steam heat is occasionally used to accelerate the solution. The various concentrations are known as 5-pound cut, 8-pound cut, etc., the figure referring to the number of pounds of resin added to each gallon of solvent.

KINDS OF VARNISHES

Varnishes are used by painters for the following purposes, each one of which demands a product that conforms to certain requirements, as listed under the respective headings:

1. Picture Varnish. A final coating for oil or tempera paintings, both for protective purposes and to produce a desired uniform finish.

2. Retouch Varnish. For bringing out the full wet appearance of oil painting on a dry canvas before resuming painting.

3. Mixing Varnish. As an ingredient in painting or glaze mediums intended to be added to tube colors for various techniques of oil painting, and as an ingredient in tempera emulsions.

4. Isolating Varnish. A solution of a resin that is insoluble in turpentine and mineral spirits, used as an intermediate sizing between coats of paint. See page 174.

Picture Varnish

The following ideal specifications for a picture varnish were drawn up by the committee on the restoration of paintings and the use of varnish of the International Conference for the Study of Scientific Methods for Examination and Preservation of Works of Art, Rome, October 1930:

1. It should protect the painting from atmospheric impurities.
2. Its cohesion and elasticity should be such as to allow for all ordinary changes in atmospheric conditions and temperature.
3. The elasticity of the paint film and tissues under the varnish should be preserved.
4. It should be transparent and colorless.
5. It should be capable of being applied thinly.
6. It should not bloom.
7. It should be easily removable.
8. It should not be glossy.*

The author reports that the committee did not know of any varnish that met these requirements.

* Gettens, Rutherford J., "Chemical Problems in the Fine Arts." *Journal of Chemical Education*, November, 1934.

Our three most generally approved picture varnishes that most nearly approach the ideal requirements are (1) a pure solution of damar in turpentine, (2) a pure solution of acrylic (methacrylate) resin in petroleum solvent (or a blend with turpentine), and (3) a pure solution of mastic in turpentine. In recent years, mastic has gone down in favor as distinctly inferior to the other two, but still better than other resins on the list. It turns quite yellow with age and fails to meet specifications 6 and 8. Damar, when pure and carefully made, will meet number 6. Pure methacrylate or acrylic solution has been accepted by museums and technical specialists since the early 1930s. It is colorless and dries to a dull satiny finish, often preferred to the higher gloss of damar. Although it does not dry to complete hardness any faster than damar, it will dry dust-free or to the touch in considerably less than an hour and thus the painting may be framed and transported sooner. It is the easiest of varnishes to remove from a painting with mineral spirits because it is so freely soluble, but this property also makes it more difficult to brush on for a second or third coat without picking up the undercoat than is the case with damar, which if well dried is more easily gone over again with another coat. It is very much lower in gloss than damar; if thinly applied, both damar and methacrylate will produce a lower gloss than the old-fashioned mastic or copal varnishes that tend to give the high gloss or glassy finishes popular in the nineteenth century. Thinly applied damar or methacrylate will come more closely to the average gloss of normal oil painting which is what is usually desired nowadays. When a bright, substantial coat of varnish is occasionally wanted, as in an old, dark portrait, damar freely applied with a full brush will usually suffice.

In comparison to damar, the pure methacrylate may become a little softer in extremely hot weather. Also, it is suspected (my own observation without proof by controlled tests) to be more receptive or magnetic to rapid accumulation of dust and so it may require more frequent cleaning or replacement. It is about on a par with damar in overall value; choice between the two is mainly a matter of the type of finish desired.

The most successful nonglossy or mat varnish, as described in this chapter, leaves much to be desired, but as I have noted, gloss is a natural characteristic of the oil and varnish process and no dead mat finish can equal the durability of a gloss finish. This is true of any kind of painting that employs a binder that locks in the particles or that produces a clear coating in a level continuous film.

Retouch Varnish

The proper use of retouch is discussed in number 7 on page 162. Retouch varnish is generally composed of a single nonyellowing resin such

as damar or a synthetic resin; it is similar to picture varnish except that it contains a much larger percentage of turpentine, so that when carefully applied, either with brush or spray, it will not form an appreciable skin or layer and will not contribute a permanent high gloss. The standard, traditional methods of painting do not normally call for the use of retouch varnish for any purposes other than the ones for which it is designed.

Mixing Varnish

For use in glaze and painting mediums that contain stand oil or sun-thickened oil, the total resin content of the final dry binder excluding the turpentine but including the approximately 50 percent (by volume) oil content of the original tube colors should be not much more than 15 percent resin; a higher percentage may ultimately weaken or embrittle the film.

Damar varnish is now perhaps the most widely used resinous ingredient employed in oleoresinous mediums. Mastic, copal, and most of the synthetic resins have faults or shortcomings and are not recommended. The subject is dealt with at greater length in the section on *Glazes and Glazing*.

Isolating Varnish

A thin spray of isolating varnish over recently dried oil paint permits free manipulation of an overpainting without picking up the underpainting, and permits the correction of false strokes or imperfect results by swabbing them away. It is especially useful in the application of delicate or precise details (see pages 495, 503, 649–50). Isolating varnish is used with the straight acrylic colors (pages 405–406). It is also employed in the mixed technique and other multilayer methods in oil and tempera painting.

Old Varnishes

A great number of recipes for varnishes are to be found in old books and manuscripts. None of these should be followed blindly as practical guides; varnishes used prior to the recent decades of the present century are in the same class as the old mediums discussed on pages 211 ff.

RESINS

The natural resins are hardened exudations from trees. Those that exude or are extracted from living trees are sometimes called "recent resins" to distinguish them from the "fossil resins," which are dug from the earth or recovered from the beds of streams where they have been deposited by

vegetation of former times. Some of these fossil resins are identical with or analogous to resins obtained from living trees in the same locality; others are the remains of completely extinct vegetation. A third group, the synthetic resins, is comprised of a number of man-made compounds which have resinous properties. (See page 188.)

Resins are insoluble in water, but will dissolve wholly or partially in such liquids as oils, alcohol, turpentine, etc. In the varnish industry, resins are commonly known as gums—damar gum, kauri gum, gum copal, etc.—but when they are considered for artistic or scientific discussion the precise term "resin" is always used, and the term "gum" is applied only to water-soluble substances. As the varnish industry is little concerned with the true gums, it uses this term without much confusion.

Resins vary greatly in properties such as odor, shape, hardness, solubility, color, and color stability, and specimens of the various kinds and varieties are easily distinguished from one another. Many resins bear the names of localities; these sometimes represent their places of origin, but more often the ports from which they are shipped. The various species come on the market in more or less well-standardized grades or qualities, each with its own system of grading and designation. The terms "bold" and "sorts" both indicate that the grade is largely or entirely composed of clean pieces of the largest size. Grades of resins which consist of small fragments or powder always contain large amounts of impurities and usually considerable low-grade resin. Adulteration with cheaper resins is possible only in these grades; adulterants would be detected immediately among the large pieces of the better grades.

Films of pure resins, as formed by simple-solution varnishes, have a considerably higher resistance to permeation by water vapor than oil films have, but they are less durable in other respects.

DAMAR

Damar is gathered from forest trees, numerous varieties of *Shorea* and *Hopea*. It comes from Malaya, Borneo, Java, and Sumatra. There are many grades on the market; large, clean, colorless or pale straw-colored lumps should be selected if possible. The two principal varieties usually available are Singapore and Batavia, named for their concentration and shipping points. No. 1 Singapore is preferred by many for picture varnishes, although Grade A Batavia is more expensive and is considered better by industrial consumers. Sometimes various inferior and less standardized varieties, such as Pedang and East India, are available. These are rather fine points, as the average retail buyer may often have little or no choice. Many fine "selected" or "fancy" grades are no longer available

Making Damar Varnish

on the American market, and some superior varieties mentioned in European books, such as the superlative Mata Kuching (cat's eye) damar, are unknown here. No. 1 Singapore damar comes on the market in whole and broken pebbles and short stalactitic pieces, bright, clear, and transparent, ranging in color from water-white to deep straw. The whole pieces appear somewhat opaque, due to a powdery dust of the resin, but the fractured facets are clear. The largest lumps are about 1½ inches in diameter, but the average piece is considerably smaller. Grade A Batavia comes in considerably larger pieces, mostly rounded lumps. Damar resin has a faint characteristic odor.

Although Grade A Batavia is more expensive, No. 1 Singapore is more suitable for artists' simple-solution varnishes; its film is harder and it seems to have less tendency to bloom. One may select his own special grade by picking out the cleanest and most colorless pieces, choosing, say, the best two pounds out of a five-pound lot. When such selected grades were on the market their prices were very high, not only on account of the labor involved but also because more than half of the original material would no longer be No. 1 grade, and had to be sold at low prices for less exacting purposes.

Turpentine is the solvent for damar varnish. While alcohol will attack and destroy a dry film of the varnish, it is not suitable to use as a solvent

for damar varnish as the resin is very imperfectly soluble in it. Ordinary mineral spirits will not dissolve the resin cold, nor will it mix with the varnish without impairing its properties, except in the case of rather dilute solutions. Many of the more powerful special solvents will dissolve damar, but are not ordinarily employed for this purpose.

Damar varnish retains its colorless appearance longer than any other common varnish, because the resin itself contains little or no coloring matter, its slightly yellowish tone being caused mainly by leaves, bark, and other impurities. Fresh damar yields a more colorless solution, the impurities apparently becoming more soluble with age.

Proportions. The customary average formula for damar varnish is a 5-pound cut, or 5 pounds to each gallon of turpentine; this is the varnish referred to as standard damar in this book. For use as a picture varnish it must be thinned with pure turpentine to a usable brushing or spraying consistency, according to the requirements and nature of the work and the judgment of the individual; about four parts of this varnish to one part of turpentine will meet the majority of brushing requirements. Some of the ready-made grades are a scant 4-pound cut. In the case of such mixtures as tempera and glaze mediums it is added full-strength as called for in the formulas. In some instances it is convenient to have it slightly heavier—6½ pounds to the gallon—and in this proportion it is the varnish referred to as damar of heavier than average consistency. When a heavy, viscous solution is desired, an 8-pound cut is made. There is ordinarily some waste of resin in preparing varnishes, especially in home methods; this may be compensated for by the addition of a corresponding amount of resin, according to the judgment and experience of the worker—roughly, a little less than an ounce for each pound.

To make approximately one pint of these various concentrations, dissolve the following amounts of damar in 10 fluid ounces of turpentine:

5-pound cut—6¼ ounces
6½-pound cut—8¼ ounces
8-pound cut—10 ounces

Allowing for the average waste and the loss from impurities, one pound of No. 1 Singapore damar resin when dissolved will bulk approximately 14½ fluid ounces; or one ounce will bulk 0.9 fluid ounce.

While modern practice quite properly lays stress upon accurate control of formulas, an experienced person can judge the viscosity of varnishes by examining the way they flow from a brush or stirring rod. (See also page 207.) Until comparatively recent years, varnishes were seldom made by a strict adherence to standard formulas, but were altered

during manufacture according to the judgment of the expert worker, which accounts for the rather vague proportions given in some of the earlier recipes. Because of variations in supplies and circumstances, some painters prefer to depend on experience and the "feel" of the varnish in thinning it for use, rather than to adhere strictly to exact recipes; they make a heavy cut by placing an excess of resin in the solvent, a procedure more rapid than waiting for all of a given amount to dissolve.

When of the highest quality, damar varnish is straw-colored and clear or nearly so. A slight cloudiness is unobjectionable, being caused by waxes which are imperfectly soluble in turpentine, but which are clear and transparent when dry. To clarify the damar varnish made according to the method previously mentioned, add a little acetone, anhydrous alcohol, or methanol in very small portions until the varnish is clear (shaking or stirring vigorously after each addition). When the clarifier is first added, a white, curdy precipitate of wax forms; but it redissolves at once upon shaking.

Partial clarification of the varnish improves its appearance in the bottle and seems to help in preventing bloom; however, the addition of too much clarifier might have a destructive solvent action on underpainting.

De-waxing. If the addition of these solvents is continued beyond the point where the solution becomes clear, the wax will separate permanently and must be removed by filtration or settling. Removal of wax from damar is not recommended for average varnish purposes, as the durability of the varnish is likely to be impaired. De-waxing is a practice borrowed from the lacquer industry which uses damar resin in certain types of coatings where the presence of these waxes is undesirable. Few experts would recommend the de-waxing of resins for use in artists' varnishes, and many would advise against clarification. When the best Singapore damar resin is stored in a warm, dry place, or carefully warmed to ensure the absence of absorbed moisture, any cloudiness due to this cause will be eliminated.

Impurities in the form of a reddish powder will often settle out of freshly prepared damar varnish. These may be removed by allowing the varnish to settle for a week or so, then straining it through cotton sheeting or other cloth. These impurities are bark or wood dust, and in some cases their amount may be decreased by washing the resin in water, being very careful to dry it thoroughly before putting it into the turpentine. Commercially prepared damar varnish is sometimes cheapened by substituting the offensively odorous steam-distilled turpentine, or by using up to 50 percent mineral spirit. The former will not affect the quality of the

varnish, but the latter may make it dark and turbid. Clear damar varnish sold in cans for industrial finishes is almost always "improved" by the addition of oils and other varnishes; only those brands made expressly for artists' use and sold by reliable firms should be purchased.

Damar varnish, when properly made and applied, has less tendency to bloom than the other picture varnishes. There is no truly nonblooming surface; even a sheet of glass will bloom. If bloom forms on correctly applied damar it will generally be only a surface effect, easily wiped away. (See page 509.) This worst sort of persistent bloom, that which apparently lies below the surface of the varnish, is undoubtedly caused by moisture in the ingredients or by the condensation of moisture on the surface during its drying. The molecular action involved in the evaporation of a wet-film ingredient increases its temperature, and minute amounts of moisture are thereby condensed on the surface. This theory has been advanced to explain why some materials have a greater tendency to bloom than others.

The recorded history of damar is not long, but there are many early-nineteenth-century references to its use as a well-known, accepted resin, and it is likely that prior to the extensive development of the trade in lands of its origin, the material circulated in Europe under the name of some resin of similar appearance. Early references call for "Damas, or common white resin," "Gum de Mar," etc. According to Barry,[166] the Malayan word "damar" is not a specific term for the resin, but means torch; flares or torches for local use are made from the trees.

MASTIC*

Mastic resin is obtained from *Pistachia lentiscus,* a tree that grows in all countries bordering on the Mediterranean. The resin comes on the market in the form of rounded drops or tears, about ¼ inch or less in diameter. It has a clear, rather bright yellowish color which turns deeper and duller on aging. It is somewhat brittle but softens at a low temperature; some of the finest and largest pieces are used locally as a chewing gum, hence its name. The finest grade is called Chios mastic; it has been known and used since the earliest recorded times.

Fresh mastic dissolves into a perfectly clear varnish with alcohol, turpentine, and most of the more powerful solvents, but it is not soluble in mineral spirit. As a picture varnish, made with turpentine, mastic brushes and flows out to a clear, glassy coating and can be manipulated more easily than damar, but its greater tendency to bloom, and its property of yel-

* Another meaning is attached to the word "mastic," which has nothing to do with mastic resin; Webster's Dictionary has it: "any of various pasty cements." See page 360.

lowing or turning to a dark brownish-yellow or greenish-brown with age, have made it a second choice for this purpose during the present century. The yellowing, however, is not so bad as that of copal or other cooked oil-resin varnishes.

When linseed oil and mastic varnish are mixed,* a jellylike mass is formed which is called megilp (Macgilp, McGuilp, etc.). This material was introduced to the artist's palette in the eighteenth century and it was employed extensively during the nineteenth. Although it was soon realized by intelligent craftsmen that the use of a mastic and linseed oil mixture was disastrous to the life of paintings, it continued in popularity for years, and the failure of many nineteenth-century pictures can be traced to its use as a painting medium. When mixed with oil colors, megilp imparts a marvelous unctuous, buttery working consistency to them, but the picture, after drying, is extremely liable to exhibit all sorts of erratic defects, such as cracking, blistering, turning brown, etc. An old film containing megilp is so sensitive and soluble that it can be cleaned with solvents only by the most delicate and expert manipulations. For this reason, mastic should not be added to oily glaze mediums, tempera, etc. Its only safe use is in simple-solution picture varnishes that contain no linseed, poppy, or other drying oils.

A pure, straight mastic varnish is made in the same manner as damar; the usual proportions are 6 to 7 pounds to a gallon of turpentine. This solution is heavy enough for practically any use, and requires thinning with turpentine for average varnishing purposes. In alcohol the proportion is usually 2½ pounds to the gallon.

Mastic versus Damar. A summing up of the comparative merits of damar and mastic shows damar to be superior in hardness and wearing qualities, in nonyellowing and nonblooming. Mastic is more easily brushed and leveled to a smooth, even film, and it is perhaps more easily removed or cleaned from an old picture; but damar's disadvantages in these two respects may be overcome by skillful manipulations.

Some writers state that damar has more tendency to bloom than has mastic; this may be true of inferior grades of damar, but my experience has been the opposite. Repeated tests over a period of many years with a Singapore damar picture varnish containing a little anhydrous alcohol and toluol and up to 5 percent stand oil have shown it to be superior varnish for general purposes. This small amount of stand oil does not interfere with any of the regular requirements of a picture varnish, and it improves its brushing and leveling properties. A recommended formula is

* The mastic varnish must be of a very heavy consistency and the oil must be strong drying oil cooked with lead, or else the gelatinous effect will not be produced.

2 ounces of a 1:1 mixture of stand oil and toluol to 20 ounces of damar varnish.* However, it is standard practice to use the straight, pure damar solution as a picture varnish. A further improvement of these properties may be achieved by using some of the solvents which have slow rates of evaporation, as listed in Chapter 10, "Solvents and Thinners" (see pages 375–76). Damar can be mixed with linseed oil to make permanent mediums; mastic reacts with oil and is not used in such mixtures.

SANDARAC

Sandarac is a resin that exudes from the *Calitris quadrivalis* or alerce tree grown in North Africa. It was widely employed for making protective and decorative coatings as well as artists' mediums from very early times, but has for many years been replaced by other resins. It is quite hard and extremely brittle, qualities which it retains and imparts to the varnishes made from it. It comes on the market in the form of yellowish, opaque tears and broken cylindrical pieces. It is soluble in alcohol and the stronger solvents, and partially soluble in turpentine, mineral spirit, and benzol. It may also be dissolved in oil to make cooked varnishes. Many recipes call for it in varying amounts, usually to impart hardness to mixtures of other resins or oils. In some of the earlier references to sandarac, it is erroneously called gum juniper, pine gum, or white pine resin. Sandarac and mastic, so far as we know, were the principal hard resins widely used by artists in the early days of oil painting. Some investigators suspect that sandarac is the amber mentioned in some of the medieval recipes. For many years it has had little or no industrial significance as compared with the natural and synthetic products that have replaced it. Although simple-solution varnishes made from sandarac will not yellow very badly compared with copal and the other cooked varnishes, they are generally held to be inferior to mastic in this respect.

Damar or mastic can be substituted for sandarac in most old recipes, and if the result lacks the brittle hardness of the original, so much the better in most cases. Sandarac varnishes of the past needed considerable addition of plasticizing ingredients to ensure their durability; when damar is used in mediums in combination with stand oil, it seldom requires much oil to produce a desirable, flexible film, and such doubtful plasticizers as nondrying oils, camphor, and the like are unnecessary. Examples of widely used sandarac varnishes of the past are to be found in nineteenth-century recipe books.

SHELLAC

Shellac is obtained from the branches and twigs of several species of trees in India, where it is deposited by insects which feed on the sap of the trees. The crude material or stick-lac is refined into a number of grades for various purposes. The best two available on the market are orange shellac, which comes in the form of thin, translucent orange-brown flakes, and bleached or white shellac, which looks like pulled molasses candy. The less refined grades (seed-lac, garnet-lac, and button-lac) are a deep blood red; formerly this lac was used to make a red dye, and before synthetic dyes superseded it this was the principal object of its cultivation, shellac for varnish being a by-product. (See pages 34, 54.)

Both white and orange shellac are entirely insoluble in turpentine and mineral spirit, but yield cloudy solutions in alcohol. The cloudiness is due to waxes that are imperfectly soluble in the alcohol but become clear after the varnish film has dried. Many of the more powerful solvents will also dissolve shellac but are not commonly so used.

As a varnish, shellac dries rapidly to a hard, tough, flexible film, and is useful for varnishing floors and furniture. The surface under normal brush application shows a characteristic slightly rough or orange-peel effect. Shellac is not used extensively in permanent painting on account of its tendency to turn dark with age; some investigators also report severe cracking after five or ten years when it is used as a final picture varnish. However, when it has been diluted with pure alcohol to an extremely thin solution, its yellowing is not of much significance, and it may be used as a sizing for porous surfaces and as an isolating layer between films of paint in certain techniques (especially in tempera painting); it has even been sold as a cheap fixative for charcoal and other drawings.

This solution, however, is not to be employed as a retouch varnish or in any clear coating over a painting, for in such uses its yellowing would soon be apparent. Shellac in any work of art must always be well covered by pigmented layers. Its complete insolubility in mineral spirit and turpentine makes it valuable as a size in ordinary wall or decorative painting. Although dry shellac is mixed or melted with other resins and miscellaneous materials to make sealing wax, phonograph records, and other industrial products, the varnish is generally not improved by admixture with other resins and oils. Good grades of the varnish are sold in cans and bottles by reliable makers who state the contents and weight of cut on the label. A specially refined, de-waxed shellac cut with pure alcohol, and quite clear, was formerly called French varnish; but this name now has little meaning. Many inferior shellac substitutes are commonly sold; some of these contain materials added to imitate the cloudi-

ness of true shellac; they are to be avoided, even for household use.

Fresh bleached shellac is soluble in water solutions of mild alkalis; borax is the usual material used for this purpose. These solutions are used as sizes and stiffeners in industry, and for paper, cloth, straw, etc. If shellac varnish purchased in a can is only partially used, the remainder is best stored in a glass bottle, as it is liable to darken if kept for any length of time in a metal can which has been opened. Shellac that has been thinned often becomes nondrying on storage and is best discarded. Dry white shellac becomes insoluble on long storage; fresh stock should be used.

OTHER SOLUBLE RESINS

There are a few other resins that are or have been used in the preparation of simple-solution varnishes, but they have been more or less completely superseded by other materials for both artistic and industrial use.

Elemi: The best is obtained from a tree that grows on the island of Luzon; it is shipped from Manila and is generally called Manila elemi to distinguish it from inferior varieties from Brazil, Mexico, and Yucatán. The purest grade is white, granular, and soft when fresh, but it darkens and becomes harder when aged. Many nineteenth-century recipes call for it to impart toughness and flexibility to coatings for various uses, but it is doubtful whether it is durable or stable enough for use in artists' materials. It dissolves in alcohol, benzol, and the more powerful solvents, and will dissolve with some difficulty in hot turpentine, but this solution is not stable. It has a very low melting or softening point; harder resins, such as sandarac, were usually mixed with it for best results.

Manila copal or spirit-soluble copal is a term for a number of variations of a resin obtained from trees in the Philippines and the most easterly islands of the Malay archipelago. They vary in hardness and degree of solubility in alcohol. They are not to be confused with the other resins called copals or true copals, and are generally rather inferior for any purpose, being used principally for the cheapest grades of shellac substitutes and for industrial dipping enamels. Manila copal has also been used in fixatives for charcoal drawings.

Benzoin, a resin produced in Thailand and also in Sumatra and other neighboring islands, is occasionally called for in some of the old varnish recipes where it evidently was employed for its odor, as it has small value as a varnish ingredient. Gum Benjamin is an old name for it.

COLORED RESINS

Colored resins were formerly employed not only to impart color to varnishes, but actually as paint pigments. Colored varnishes are now made

with oil- or alcohol-soluble coal tar dyes, and those resins formerly used as transparent paint colors have long been replaced by more permanent colors, as noted in the lists of pigments. Chief among them are:

Lac: see shellac.

Gamboge: a resin obtained from trees in Thailand. It comes on the market in cylindrical pieces made by melting the resin and molding it in bamboo. It is soluble in alcohol. Its clear, bright, transparent yellow was for a long time the only satisfactory yellow for glazing, but cobalt yellow now replaces it. Gamboge fades rapidly in bright sunlight but is semipermanent in diffused light.

Dragon's blood: a resin obtained from the fruit of an Asiatic tree and shipped principally from Singapore and Batavia in the form of long, thin, cylindrical sticks. Other varieties are occasionally sent from other parts of the world. It is soluble in alcohol, benzol, mineral spirit, and some of the other solvents, but only partially soluble in turpentine. Dragon's blood has been employed for coloring spirit-varnishes a ruby red. Its use as a paint pigment dates from Roman times. (See page 15.) It furnished a fairly lightproof color, but one not to be compared to alizarin or to any of the other modern lightfast synthetic organic red pigments.

Gum accroïdes (Xanthorrhoea; black-boy gum; Botany Bay gum): an Australian resin occurring in two principal groups; one has a ruby-red and the other a golden-yellow color. The resin is used today to a small extent in industrial colored varnishes, as the color is satisfactory and quite permanent for certain industrial uses. It has some value as a varnish resin; its film is rather like that of shellac.

Turmeric (curcuma): prepared from the roots of several varieties of an Asiatic plant. This resin was formerly used to some extent as a yellow dyestuff, and *Aloes,* a resinous material from the juice of a great many varieties of a plant obtained from a number of tropical regions, was used as deep brown. Both of these products were fairly permanent as varnish colorings, but less so than the better modern synthetic dyes.

Oil-soluble dyes: The modern transparent colorings for industrial varnishes, oils, etc., are the oil-soluble dyestuffs. One group of these products are coal tar colors of comparatively good permanence but rather dull and limited in color range; these are chiefly the unsulphonated azo dyestuffs, which are insoluble in water but soluble in oils, resins, waxes, and most of the volatile solvents. A more brilliant and varied but considerably less lightproof series can be made by dissolving some of the regular water-soluble dyestuffs and precipitating them together with a resinate or resin soap.

Metallic soaps: The commercial metallic resinates or insoluble resin soaps are of two kinds: fused and precipitated. The first is made by sifting

metallic salts into molten resin and maintaining a constant temperature until the salt is entirely taken up by the rosin. The second method, which produces a more concentrated product, is to cook rosin with alkalis, and after the rosin soap has been formed, to add solutions of metallic salts, when the insoluble resinate will be precipitated. The driers used in paints and varnishes are carefully and expertly made by these same processes; a linoleate is made with linseed oil instead of rosin, a tungate with tung oil, and a stearate with stearic acid.

Some of the metals will produce highly colored materials. Cobalt compounds of this nature are a deep rose color; those of nickel and copper are bright green. Zinc and aluminum do not impart color to their resinates, stearates, etc. According to Laurie,[40] a transparent green of resinous composition was widely used as a pigment in illuminated manuscripts from the eighth to the fifteenth centuries; this would correspond to a modern fused copper resinate. The earliest recipe he has traced for this material (De Mayerne MS, seventeenth century) calls for verdigris dissolved in Venice turpentine. (See item 32 on page 673.)

RESINS USED WITH OIL

As previously mentioned, cooked oil and resin varnishes are not adapted to home manufacture. Aside from the fact that any operation requiring the application of heat to inflammable materials entails a serious fire hazard (fires are of frequent occurrence even in the best-regulated varnish factories and laboratories where provision is made for their immediate control), it has been my experience that the quality of a batch smaller than 5 or 10 gallons is always inferior to that of the usual 50- to 250-gallon batch, even when made in a modern varnish laboratory by expert technicians. The following resins are the principal materials employed for artists' varnishes of the past.

Amber. Amber is a fossil resin occurring in beds in the ground; the principal supply comes from East Prussia along the shores of the Baltic Sea, but minor deposits are found elsewhere. It is the hardest natural resin. It has been known from the earliest times, and the Persians and Greeks were aware of its property of attracting straws when rubbed. Amber varnish has a traditional reputation as the varnish par excellence, but it is doubtful whether any such product was ever in very wide use. Amber is an extremely insoluble and intractable substance and, as all varnish makers know, most of the old recipes calling for it are unworkable, being either versions garbled through much copying or deliberate frauds. At high temperatures a little amber can be worked into a cooked

oil varnish, such as copal or kauri; the product is very dark, usually black. If any amber varnish offered for sale actually contains amber, it will be in only a very small proportion to the oil and other resins. It has often been suggested that some other resin, especially sandarac, was confused with amber by some of the medieval writers, and so called by them in their recipe books. The term "amber" was probably more descriptive than specific and may have referred to any currently available hard, transparent resin.

The various early words for amber and varnish have been the subject of much etymological research and conjecture. Beginning with the medieval Greek name Bernice or Berenice, the B of which was altered to a V sound, many names have been used: vernice, verenice, vernition, and vernix. The German for amber is *Bernstein* or Bernice's stone. The term *vernice* or *vernice liquida* is employed in early writings, and refers to a thick, heavy varnish composed of cooked oil and resins, which was rubbed into panel paintings warm, the picture then being exposed to the direct rays of the sun until dried. The old recipes represent numerous variants of a cooked linseed oil–sandarac–Venice turpentine mixture; few of them are applicable to painting methods in use since the sixteenth century.

Copal Varnishes. To the artist, copal varnish is the most familiar example of the oil-resin type of varnish. The artist who has any concern for the permanence of his work will never, under any circumstances, use copal varnish in paintings or grounds.

The term "copal varnish" as applied to one specific material means practically nothing. In the current market reports of the varnish industry, a dozen distinct species of varnish resins from many parts of the world, having widely varied properties, are all legitimately listed as copals. Furthermore, from three to ten or more grades of each are regularly on the market.

A varnish that contains a small percentage of any one of these copal resins plus large percentages of rosin and oil is always called copal varnish. Kauri, an expensive fossil resin from New Zealand, was at one time called copal and was highly esteemed, as were other copals now absent or rare on the market.

The better kinds of copal are expensive, require the most expert manipulation, and probably never find their way into artists' varnishes. Few manufacturers of artists' materials maintain their own varnish works, and many compounders of paints are ignorant of the composition of the varnishes they buy.

Copal varnishes are made by melting the resin at high temperatures,

adding linseed or tung oil and lead or manganese driers, cooking until the drier is thoroughly incorporated, and thinning with turpentine substitute.

These varnishes will always turn dark and are extremely liable to crack with age, particularly if mixed with colors, driers, oils, or other varnishes. The easily obtainable grades of fossil copals and of kauri and other natural resins, which are imported from various parts of the world, may be found listed in the weekly market reports of the periodicals that serve the varnish industry. Complete descriptions of them will be found in the books listed in the bibliography. They range from very hard, clear, amber-like lumps to soft, opaque, or dirty materials.

The distillation or "running" of resins was a standard procedure and a highly developed art among the nineteenth-century industrial varnish firms, generally based on the personality of the varnish maker, who, more often than not, had learned his trade from his father and grandfather before him. Operated for years into the twentieth century by empirical methods, the industry began to introduce scientific procedures based on studies of the chemistry of oils and resins and as a result, the quality and uniformity of varnishes were on their way to improvement when the introduction of synthetic resins largely replaced, and rendered obsolete, both the older methods and the natural resins by producing industrial coating materials of superior quality and uniformity. Consequently, some of the natural resins have suffered a decline in industrial importance.

Rosin. Rosin is the resin obtained from gum thus, the exudation from plantation or crop-grown pines of the southern United States and from similar pines in various parts of the world. It is the residue left in the stills after the turpentine has been extracted from the crude exudation. (See pages 194–95, 366.)

Rosin is a clear, transparent, brittle material; it is rather sticky to the touch and it melts at about the boiling point of water. It dissolves in practically all the volatile solvents and oils used in paints and varnish practice. Paints and varnishes which contain rosin are weak, not durable; they will always turn dark and crack and are so generally inferior that although rosin is used in large quantities for cheaper products, it is considered an adulterant in the better industrial paint and varnish finishes. It has no place whatever in paints and varnishes for artists' purposes. Large quantities of it go into mixtures and compounds for uses other than paint and varnish coatings. Rosin is sold in fifteen grades on the basis of color and dirt content, as established by the Naval Stores Act; X, W.W. (water white), and W.G. (window glass) are the palest, being light straw-colored, and are followed by a series of amber and darker shades designated by various letters of the alphabet in reverse order. Colophony is an obsolete

name for rosin, from Colophon, a city in Ionia, but some say it means "sound glue," an allusion to the use of rosin on violin bows. Another old name for it is Greek pitch. Rosin contains a very high percentage of a substance called abietic acid.

Rosin can be hardened, bleached, neutralized, and otherwise refined for industrial use by chemical and mechanical means; the principal grade of this type is called ester gum. Although improved for certain industrial uses, it still retains most of the defects which make rosin unsuitable for use in permanent painting materials.

Asphalts. The properties of some asphalts are noted on page 572. Asphalts have been used on a large scale from prehistoric times to the present for their durability and their water-, acid-, and alkali-resisting qualities in various protective and other technical applications. They cannot be used in any artistic or decorative paints because of the complex surface defects which develop soon after the film sets. These defects are especially marked when asphalts are mixed with linseed oil or other paint mediums.

SYNTHETIC RESINS

The synthetic resins that have been in wide use since the 1930s to produce the great majority of the industrial, architectural, and household paints, varnishes, and enamels are complex organic products of considerably varied composition. Each member of the numerous groups or families of these materials has its valuable qualities that it imparts to the mixture in which it is used; each one has its points of superiority or inferiority for specific applications. They have revolutionized the coating materials industry by replacing materials of natural origin that had been standard basic ingredients of paints and varnishes for centuries and by making possible the introduction of products of superior performance characteristics.

It has been said that the development of synthetic resins could have occurred seventy-five years earlier if organic chemists had known what to look for and if their reports had not often stated, "The experiment ended in failure, producing a useless resinous mass."

The coating materials industry is by no means their only consumer; huge amounts go into the manufacture of solid plastics, textiles, and other products.

The experimental painter for whose special requirements none of the traditional painting materials seem to be ideal longs to explore this field,

and before such products were made expressly for artists, he sometimes turned to the industrial paints on the market, such as the Duco-type lacquers, the bright household enamels, and the mat finish interior wall paints—excellent products, but all foredoomed to failure because they are not intended for artists' use. They are carefully formulated with "built-in" qualities that perfect them for the purposes for which they *are* intended—such as long life in cans on the dealers' shelves, ease of application by amateur house painters, competitive brilliance of color, and competitive sales prices. Manufacturers try to make them as durable and permanent as possible, within these requirements, but industrial and house paints are definitely not supposed to last forever; the very measures taken to enhance their desirable industrial properties almost always detract from, or may be a compromise with, longevity as the artist understands it. Some of these ready-made products are disqualified by the powerful and obnoxious solvents necessary for their solution, others by their awkward and unmanageable brushing qualities.

The pigments used in industrial coatings are not selected with artists' requirements in mind. Many, if not most of them, would be rejected by artists' material manufacturers as being impermanent. The painter who is concerned with the longevity of his work does not use ready-mixed paint products that are not made by artists' material specialists.

Many (but by no means all) of the traditional paints, varnishes, and other media used by artists can be made by the artist in his own studio. Some of these can be of excellent quality, and others, although not quite equal to factory-produced materials, are usually adequate. (See page 9.) But the resins, plastics, and their modifiers that have dominated the industrial paint field since the mid-twentieth century are technologically in a different class from the older raw materials. The older ingredients are natural products, or the products of simple processing or of uncomplicated chemical reactions; they merely need to be combined in such a way as to take the fullest advantage of their desirable properties or to overcome their shortcomings according to rules based on long experience. But the new materials, produced by the complex and sophisticated processes of modern synthetic chemistry, are designed to meet very precise and definite specifications. They have reached the stage where they are produced in great variety with built-in properties to suit specific industrial purposes. One of the significant elements in the whole scheme of a synthetic medium is the skill and experience of the technologists who direct their use under efficient factory control that assures the uniformity of the product and guards the health of its workers. The raw materials of synthetic media (with a few exceptions) were not designed to be sold freely to the general public.

The manufacturer of artists' materials is a knowledgeable specialist. He is constantly alert to take advantage of new, nontoxic resins of superior performance and reasonably low cost. But over the past thirty years in which synthetic resins have been marketed, he has rejected all but a very few. The painter or sculptor who experiments with resins to "discover" a new medium that will work better or that will be cheaper is not only somewhat presumptuous—he takes a chance on the longevity of his work and also in some instances with his health. (See pages 9–10.)

The following account outlines the nature of principal synthetic resins that are used as raw materials in the coating materials and plastic molding industries, some of which have been successfully adapted to painters' and sculptors' use. Finished artists' materials based on synthetic resins are discussed in Chapter 12.

Cellulosic Materials. The earliest synthetic coating materials are those made from cellulose fibers. Up to the present time none of the cellulose polymers have been acceptably developed for use in creative art because of a drawback that outweighs their desirable qualities—the degradation of flexibility of thin films on relatively short aging, which is still more rapid in the presence of daylight. But because nitrocellulose-based lacquers have been, and to some extent still are, the subject of some experimental uses by painters, some of their historical and technical points are noted here.

The first American synthetic plastic, introduced by John Hyatt in 1869 under the trade name Celluloid, was made of cellulose nitrate (also known as nitrocellulose and pyroxylin), plasticized with camphor. It became popular immediately as an economical substitute for ivory and tortoise shell and was applied to the manufacture of photographic film in the late 1880s and in solutions, for clear, colored, and pigmented lacquers and as adhesive cements. Its inflammability is a deterrent to many uses, but this has been reduced to some extent by the use of modern ingredients, and in film and plastics it has been overcome by substituting another less dangerous member of its family, cellulose acetate. It is interesting to note that, for decades, its fabricators went to great trouble and considerable ingenuity to imitate the striated grain of natural ivory and the mottled design of tortoise shell (or, as has been said, to copy the defects of nature) rather than take advantage of the inherent qualities of plastics and utilize them for their own excellences.

On the technical side, it is also noteworthy that, a century later, cellulose nitrate is still the principal lacquer ingredient, that camphor still is one of its best plasticizers, and that despite the number and variety of modern plastics now employed, the cellulose plastics still have their uses.

Although one may say that nitrocellulose and the other cellulosic compounds are not, strictly speaking, synthetic resins because they are polymers of a processed natural substance, it is accepted practice to classify and discuss them together with the plastics and synthetic resins. Modern cellulose-based lacquers are discussed on pages 168–69.

Alkyd Resins. These resins cover a considerable range of variations and modifications of a basic synthetic product made by a special reaction between two classes of materials (the esterfication of polyhydric alcohol with a polybasic acid). Many varieties are now "tailor-made" to suit different requirements. At first they were named "alcid" to indicate the composition of mixed alcohols and acids. The present spelling is said to be "a euphonious rendition" of this. One of the first such materials used as a resin in varnishes and electrical coatings was glycerol phthalate. R. H. Kienle is credited with getting the idea of combining the drying oils with alkyds in 1921. He was granted a U.S. patent in 1927, which was later rescinded.

Initially, a typical alkyd was composed of a glycerol and a phthalicanhydride. Recent developments, especially in the production of a material of superior flexibility and color stability, favor the use of pentaerythritol to replace glycerol. This type of alkyd resin used in formulating coating materials is known as an oil-modified alkyd and has a percentage of oil in it; that is, during the formation it is combined with a drying oil or with the separated constituents of a drying oil (fatty acid). This produces a sort of ready-for-use oleoresinous product. The principal ingredients of both the long-oil or the short-oil kinds of oil-modified alkyds are: pentacrythratol, phthalicanhydride, xylol, and mineral spirits which are solvents and *tall* oil. The latter is a by-product of the sulphate process of making paper from wood pulp. It is not called "tall" because of size. Its name comes from the Swedish word meaning pine oil, a different material than what is called pine oil in this country.

Oil-modified alkyd resins have for many years enjoyed a very high reputation in the industrial paint field. This is especially true of house paints made with alkyds; they outlast and otherwise outperform all of the many other materials that are available for this purpose. The "oil-modified" part of their names does not refer to added oils or oil colors, as in the cooked-oil and tree-resin varnishes of the old days, but to the drying oil (linseed, safflower, or tobacco-seed) that is combined in its manufacture as an integral part of the resin molecule.

As a general rule, the alkyds made with linseed oil are the most durable and weather-resistant while the other two are usually of a paler color, but all of them are adaptable for artists' use. The development of these

resins for this purpose has been slow, although experiments as early as the 1930s were conducted in trying to produce a practical set of alkyd colors for artists' use. More recently there has been a rising tide of alkyd successes and they have appeared on the marketplace. One of the major advantages of alkyds over oil colors is the advanced speed of drying, uniform for the whole palette. Some painters may, however, be disconcerted by the accelerated drying speed and also find it difficult to adjust to the different way the materials handle from the oil colors they have been accustomed to.

Acrylic Resins. An important family of synthetic resins, first made in the laboratory by Otto Röhm in Germany in 1901 and produced commercially in America by Röhm & Haas and by E. I. DuPont de Nemours since the 1930s. The acrylic "family" is perhaps the most popular and admired of all the plastics for excellent properties which make them suitable for a wide range of uses. In solid form, the plastics are marketed under the trade names of Plexiglas and Lucite, which are water-white, fairly hard, tough, durable, and sparklingly clear. One of the series, a methyl methacrylate, is soluble in mineral spirits and turpentine and is sold under the names Acryloid F-10 and Lucite 44; this is the type used in the acrylic picture varnish and straight acrylic colors described in this book. Another grade, Acryloid B-72, is insoluble in artists' solvents but soluble in toluol.

Another important product is made by polymerizing the acrylic monomer by emulsification, thus dispersing the resin into minute droplets suspended in water. This is the milky fluid which is used as the base for compounding polymer colors (page 402). The principal if not the only grade in use is called Rhoplex AC234.

Acrylic resin solutions, such as clear acrylic picture varnish or the straight, concentrated solutions of Acryloid F-10 and Lucite 44, have been used by some experimental painters as oil-painting mediums. Some writers have called these resins oil-compatible. However, according to the paint technologists, mixtures of acrylic resins and drying oils do not produce stable films; none would combine them in an industrial formula.

If a painter wishes to experiment with a synthetic resin as an ingredient of an oil-painting medium, one of the nonyellowing alkyd solutions or varnishes would be a wiser choice.

Vinyl Resins. A group or family of synthetic resins, the polymers and copolymers of vinyl acetate, vinyl chloride, and vinylidine chloride, are used industrially in coating materials, plastics, and sheetings for innumerable purposes. The vinyl group includes clear, water-white products

similar to the acrylic resins, but because none of them are soluble in artists' safe solvents, they have had few applications for use in paintings. Polyvinyl acetate has long been used in various applications for the repair and restoration of museum objects, but has largely been replaced by acrylic and other materials for such purposes.

Polyester. This is a kind of synthetic resin closely similar to the alkyd resins except that it is insoluble in artists' safe solvents and so cannot be used in liquid coatings. It has excellent properties for molding and impregnating, and has been so used by experimental sculptors in various applications. Since the solvents used in polyester resin such as MEK (methyl ethyl ketone) are highly toxic and its accelerators, hardness, or other additives may attack the skin, it must be handled only under safe conditions with professional equipment, and therefore is not eligible for ordinary or casual studio use. Polyester resins have many industrial applications including the manufacture of Dacron textile fibers.

Epoxy Resins. A group of thermosetting resins, some of which are employed in industrial molded products and in baking enamels. Epoxy resins are most familiar through their use in cements and adhesives, especially the kind that is sold in two tubes to be mixed just prior to use; one contains the resin and the other its hardener, which creates its cementing action. Epoxy resins have also been used in experimental sculpture techniques molded with fillers, fiberglass, and pigments. (See page 639.)

Plastics. When marketed in solid forms such as sheets, rods, blocks, etc., or compounded, processed, molded, or formed, either clear or colored with the more permanent pigments, these synthetic products are known as plastics—and some paints have been given this title to inform the consumer that they are made of the same ingredient in liquid form. The plastics have been accepted to some extent as modern miracles, so well do they serve so many functional and decorative purposes, and their high reputation has sometimes carried them over into the field of artists' paints, for which their qualifications do not necessarily fit them, as I have just pointed out.

Foamed Plastics. Durable, lightweight plastics containing air or gas-filled cells. They are used by sculptors for solid forms and for making molds in various casting procedures. The usual foamed plastic is made from polystyrene (Styrofoam), but several other resins are also employed. See Bibliography, numbers 287, 290, and 296.

A plastic is a synthetic material that has been prepared so that it is malleable or susceptible of being shaped or molded, after which it retains or can be made to retain its new shape. According to this, we might even call linseed oil a "plastic" (although it is a natural material); when exposed to a chemical reaction (oxidation and polymerization) it is converted from a mobile or a plastic state to a solid or deplasticized form. Wax as used in encaustic painting could be called a plastic, and so could glass, which is flexible and can be deformed when hot, retaining its new shape when cold.

Heat is one of the principal forces used to form plastics, and the various kinds are classified into two groups depending on whether they are:

1. Thermoplastic, that is, rendered workable, plasticized, or malleable when hot, becoming solid or deplasticized when cold.

2. Thermosetting, that is, rendered permanently homogeneous, set, and hard by the action of heat.

The various synthetic resins and plastics go by trade names as much as they do by chemical designations; for example, the acrylic (methacrylate) plastic is sold as Lucite and Plexiglas, the various polyvinyl resins are known as Vinylite, followed by code letters, and the alkyds are manufactured by many companies in a variety of modifications, each with its distinctive trade name and a numerical designation. Some of these are Rezyl, Falkyd, Glyptal, Aroplex, Duraflex.

OLEORESINS OR BALSAMS

The thick, viscous liquids that exude from certain trees, mainly conifers, are called oleoresins or balsams. They are nonmiscible with water, but are miscible with the oils and solvents commonly used in paints and varnishes. While the best of them may be incorporated into liquids which will dry to form hard films when spread out thinly, they will not readily harden in their original state, but will remain liquid indefinitely when kept in closed containers.

The nomenclature of these products, some of which are called turpentines, is explained under *Turpentine* on page 366. The designation oleoresins may be slightly misleading; the liquid ingredients of these materials are entirely volatile, like turpentine, and are not film formers like linseed or the other drying oils, and what remains in the dried paint or varnish film is purely resinous.

The various grades and types of crude and refined natural products have highly individual characteristics. Although the sources from which they are obtained may be closely related, and although from the view-

point of general classification they may be very similar, variants of natural products are usually limited to specific purposes. This is common knowledge in the case of such materials as tobacco, coffee, grains, animal products, and earth colors, where minute differences in chemical composition, in local climatic conditions, or in species will result in marked differences in grade. The natural resins, oils, and balsams are no exception to the rule, and the various exudations of the pine family differ in their properties as much as do the more familiar products of forest, mine, and farm.

Gum Thus. This is the exudation from American turpentine pines of the southeastern states, which are principally the long-leaf yellow pine, *Pinus palustris.* It is also obtained from the Cuban pine, *Pinus caribaea,* and the loblolly pine, *Pinus taeda.* It is never used in painting, as it is much inferior to the two products next listed. It is the source of turpentine and rosin; its defects are similar to those of rosin.

Venice Turpentine. Exudation from the Austrian larch, *Larix decidua.* A heavy, thick, resinous liquid with a characteristic odor combining those of pine wood and pine needle. It has a long history and has been used extensively by artists in glaze mediums, varnishes, adhesives, and plastics.

Strasbourg Turpentine (Olio d'Abezzo). Exudation from the silver fir of the Tyrol, *Abies pectinata.* A product very similar to Venice turpentine. Seventeenth-century compilers of recipes were unanimous in preferring Strasbourg turpentine.

According to Barry, [166] Strasbourg turpentine was widely used during the sixteenth century and was preferred to Venice turpentine on account of its better color and odor. Venice turpentine became of great commercial importance about the middle of the eighteenth century. It has always been used more widely than Strasbourg turpentine by artists in America, because it is cheaper and perhaps because supplies of the authentic material are more available. Neither of these products has had much industrial importance for some time. They are valuable in painting mediums because they have the property of drying into desirable films when mixed with drying oils, etc.; because they enter into stable emulsions with the accepted constituents of tempera mediums; because, compared with the customary oils and varnishes, they are acceptably permanent, nonyellowing, and durable; and because they tend to impart more flexibility and life to the films than do most resins. When Venice or Strasbourg turpentine is mixed with stand oil, the resulting varnish is superior for artists' mediums

to the cooked oil-resin varnish group; and when liquid driers are added, the resulting product is superior to those varnishes into which driers have been cooked.

Burgundy Turpentine. Obtained from *Pinus maritimus,* the tree that is the source of the French turpentine and rosin industry. A slightly purified and solidified grade known as Burgundy pitch is obtainable in America; it is called for in some antiquated recipes, principally in medicine; it has no value in painting mediums and few properties for technical uses that cannot be duplicated by the two products just mentioned.

Jura Turpentine. Exudation from the red pine of the Vosges, *Picea vulgaris.* Apparently very similar to the above; not known on the American market.

Canada Balsam. Obtained from the familiar balsam fir, *Abies balsamea,* of the eastern United States and Canada. Widely available in clean grades, as it has some commercial importance as an adhesive used in various industries. Because the tree from which Strasbourg turpentine is gathered is said to be very similar to the American balsam, this domestic material has often been suggested as a possible substitute for Venice and Strasbourg turpentines, but little work on adapting it to such uses has been published. Its higher cost would probably be a deterrent.

Copaiba Balsam. An exudation from a South American tree. The product comes in a number of variations bearing the name of localities, and some publications describe details of the many grades apparently available on the European market. For practical purposes there is probably very little difference between them. The reliable supply houses select this material mainly for the properties that make it valuable in the few limited uses mentioned here and in connection with conservation regardless of source or variety. (See pages 494–95.) Most of what is imported here is known either as Para (from Brazil) or Maracaibo (from Venezuela). In general, the Para contains more volatile and less solid ingredients. All varieties have the same characteristic odor.

Copaiba balsam is a very slow-drying material and has poor properties as an ingredient in painting mediums or emulsions; it should never be used for such purposes. When it is diluted with at least an equal amount of turpentine to a free-flowing consistency, it may be rubbed or brushed over dried oil films in very thin layers where it has the property of bringing out the full tones of dry, sunken-in color and is said to combine with or penetrate slightly into the surface of the film. When so applied it can

be overpainted or varnished with any of the accepted oil painting materials, without any apparent harm to the picture. It is even popularly supposed to be beneficial to the life of the film, acting as a plasticizer or, in the case of old, brittle films, as a regenerator, but its value in these respects is probably overrated. It is employed in several details of restoring technique, but is of doubtful value for general use by the painter. Most proprietary regeneration and restoring nostrums employ it as an important ingredient.

FLAT- OR MAT-FINISH VARNISHES

A flat- or mat-finish varnish is produced by adding a flatting material to a varnish of the type needed in any particular instance. The most successful flat varnishes are those produced for industrial use—the cooked oil-resin, long oil type, such as spar varnish. Flat picture varnishes are much more difficult to make. All flat varnishes have an opaque, cloudy appearance in the container, and require thorough stirring before use.

As noted on pages 110–11 and 153–57, a flat finish is one whose surface is microscopically rough and irregular as compared with the smooth, glassy nature of a gloss finish.

The rough surface may be secured by the use of wax or waxlike materials which, as noted elsewhere, retain their definite semicrystalline structure when dissolved or suspended in oils and varnishes. Another and older method is to introduce a finely divided inert pigment such as magnesium carbonate (light) which, besides being translucent and also transparent in oils and varnishes, will tend to produce this rough or mat effect. This material is ordinarily used only to produce a nontransparent but translucent coating, such as an imitation of ground glass for windows, etc., but it sometimes may be added in very small amounts to a wax-finish varnish to improve its flat quality, usually at the expense of some of its transparency. The antiquated method of applying milk or buttermilk to the surface of a painting simply coats and obscures it with a thin film of impure casein and butter fat, and it is not to be recommended. It is sometimes used for a temporary effect, since the film is easily removed with a damp cloth. On oil or resin surfaces of any delicacy, however, such materials must be cautiously tested, for they are quite likely to cause permanent blemishes by faintly attacking the surface, particularly when they form drops or runs.

Wax will make an oil varnish flat, and to a less satisfactory extent will reduce the gloss of a simple-solution resin varnish, but the dried films will be tender and susceptible to polishing. A typical recipe is four ounces of

molten wax, preferably white beeswax, thinned with ten fluid ounces of damar varnish (5-pound cut) and two fluid ounces of turpentine. Most waxy flatting agents must be used in approximately the same proportions, and for best results the waxy material should be used in amounts just sufficient to produce the desired effect. It is usually necessary to alter formulas for this type of material by making trials, in order to obtain the best results in each case.

Aluminum stearate, a bulky, waxy substance mentioned under *Stabilizers,* is a better material for this purpose and it gives very satisfactory results when used in a long-oil varnish. With a simple solution of damar or mastic, however, or even with a short-oil industrial varnish, the mat effect is not always so well produced, and is easily destroyed by such light rubbing as ordinary cleaning or dusting with a cloth. Wax is employed in furniture polishes because its particles have the property of coalescing and forming a smooth, lustrous, continuous surface when friction is applied; most of these mat varnishes tend to act like wax polishes when rubbed.

A gelatinous material known as zinc tungate produces a flat varnish when expertly combined with damar; it consists of zinc oxide expertly cooked with tung oil. When it is combined with the correct amount of damar varnish and turpentine, nonpolishing flat varnishes of satisfactory toughness and transparency are obtained. But although it was for a while accepted by restorers and museums, it was discarded because of eventual yellowing and the difficulty of its removal; its use is now more or less confined to decorators' purposes. It is a very rapid drier; its color in the bottle is quite yellow and it has a waxy turbidity.

Until further improvements and complete aging tests have been made, it would seem best to use all such materials sparingly and only when a flat finish is absolutely requisite, and to continue with the time-tested clear damar and mastic as much as possible, especially in the case of recent works of permanent artistic value. Semimat or satin finishes may be obtained by mixing clear and flat damar varnishes in various proportions. A flat finish takes better on a pale or "blond" painting than on a dark or deep-toned one; considerable black or near-black areas, such as those in many old portraits, are liable to be made grayish or streaky by a mat varnish. Many paintings, particularly dark ones and those with very rough or impasto surfaces, require a varnish with a bright gloss to bring out their full values.

As mentioned on page 155, a dead mat quality is not a natural characteristic of the oil-painting technique and any method used to obtain it entails a deliberate sacrifice of some good quality—durability, nonyellowing, etc.

INSPECTION OF OILS AND VARNISHES

When oils or other transparent liquids are examined to determine their color in the liquid state, the *volume* of liquid which is being observed must be considered, and no comparisons are of any value unless the samples are viewed side by side against the light in bottles or tubes of exactly the same dimensions.

An oil or varnish of heavy consistency will naturally be darker than the same kind of product with turpentine or other solvent added. An approximate method for comparing the viscosity of heavy oils and varnishes is to fill two identical tall bottles to the same level (nearly full) with the materials to be compared. Cork tightly and invert suddenly at the same time. If the materials are havy enough for the bubbles to travel slowly, any difference in consistency will be apparent from the relative speed with which the bubbles rise. Simple but accurate special equipment for this test is described by Gardner.[205] Experienced persons can judge approximate consistency and body* by dipping a palette knife into the liquid and allowing it to flow off the blade held at an angle of about forty-five degrees. For more accurate measurement of density, the hydrometer (page 621) is simple and easy to use. The artist may easily test the comparative yellowing of oils and varnish films by methods noted in the section on the *Testing of Pigments,* page 104. An accelerated yellowing test may also be made by coating a piece of white canvas with the clear oil or varnish and allowing it to remain in a dark box or cupboard face down over an open container of water. If the box can be kept warm, the test will be more severe. Materials that contain drying oils will yellow rapidly when allowed to dry in a warm humid atmosphere without daylight. These are simple tests for the guidance of users of oils and varnishes; data of absolute accuracy in these and other tests can be obtained only by skilled technicians. The laboratory method is to coat pieces of white milk glass by means of an apparatus that lays down a uniform coating of controlled thickness to 0.0005-inch accuracy and place them together with a dish of water in a desiccator in a thermostatically controlled oven at 78° F for three days. The extent of yellowing is determined by colorimeter or reflectometer measurements made before and after.

More information on viscosity of liquids and the consistency of pastes

* The term "body," when applied to oils, varnishes, and other mediums for paint purposes, means a little more than just the consistency or thickness; good body implies a certain optimum direct relation between the degree of viscosity and the specific gravity, as in the case of raw linseed oil or a conventional standard varnish. A medium which has a thick-flowing consistency unaccompanied by the proportional heavy weight to which users have become accustomed—in other words, one which has high viscosity and relatively low specific gravity—is said to possess "false body."

will be found under "Chemistry" on page 438 and other test methods in the Paint Standard on page 661, paragraph 6.5.

Adulterants in Varnishes. Rosin, which is probably the cheapest substance used as a paint material, is the most common adulterant in all types of varnish.

Simple-solution varnishes intended for general industrial use are often "improved" by the addition of linseed, tung, or castor oils, copal varnish, etc., to give special qualities. For artists' use, such products must be considered adulterated, and only varnishes made by reputable artists' material specialists, or at home from pure resins, should be used.

DRIERS

In order to accelerate the drying of mixed house paints, varnishes, and other compounds of drying or semidrying oils, reactive materials are added, which have the power of starting, accelerating, or forcing the absorption of oxygen by the paint film, or of overcoming conditions which inhibit drying.

Driers or siccatives are metallic salts combined with materials such as oils or resins which mix with the usual paint and varnish ingredients. They are diluted with solvents for convenience in using. Their chemical and physical reactions are not fully established. (See page 452.)

As a general rule, driers detract from the life of paint and varnish films and are to be considered undesirable additions to oil paints and varnishes for permanent painting, especially when used indiscriminately. However, when sparingly applied with judgment by experienced painters, a good drier can be used with safety and in some instances, as in glaze manipulations, may be essential. Driers have been in use as long as drying oils.

Some pigments act as driers; the rapid driers are listed on page 136 in the order of the accelerating effect they exert on drying oils. Whenever a drier is desired, these pigments will act in that capacity with no bad results, provided they fit into the desired color effect.

The most common driers available to artists in the recent past have been *siccatif de Haarlem* and *siccatif de Courtrai.* These materials contain lead and manganese resinates cooked in oil. Practically every one of their ingredients has the property of turning dark eventually. Furthermore, they are progressive driers; that is, a pronounced action continues long after the film has dried to the touch. This leads to brittleness and cracking.

Inasmuch as the oils and resins take up a very small percentage of metallic salts, driers are composed largely of inert materials. Only a comparatively minute amount of active drying ingredient is required to give a strong siccative effect. Lead, manganese, and cobalt are the chief metals whose compounds are used as driers in paints and varnishes; each has its own special function, but cobalt is the only one now considered suitable for artists' materials.

Cobalt linoleate, which is made by cooking cobalt salts in linseed oil, is the best (or rather least harmful) drier for permanent painting. It is less progressive than other driers—that is, it seems to act mainly while it is still in a liquid state—and less likely to cause excessive darkening with age. It is put up in small bottles by several artists' supply firms. Cobalt naphthenate also can be used; it is a more recent development, used in industrial coatings; sometimes it has a sharp, disagreeable odor, but the newest type is odorless.

The earliest use of cobalt driers I have been able to trace was in Belgium in 1852, when driers identical with materials in use today were described*; so far as I know, the earliest American reference[154] to the same materials was in 1874, but they were not widely used in America until the early days of the twentieth century, probably because they were not believed sufficiently superior to the manganese driers to warrant their higher cost. They were thoroughly approved and adopted throughout the paint industry long before they became artists' materials; in fact, the traditional siccatif de Haarlem and siccatif de Courtrai survive to this day, although most authorities condemn them.

Driers must not be used in thick, pasty paintings nor in underpainting. Ostwald[46] says that a thick painting done with lavish use of driers is "an old man on the surface while it is still a youth within," the drying action being more rapid on the surface when the painting is in contact with air.

Driers are of value mainly in glazes and thinly painted pictures where the entire mass of paint can dry thoroughly in a short time. Such pictures may receive a thin final coat of protective varnish, applied soon after the painting is, in the opinion of the painter, thoroughly dry, instead of several months later, as is customary when no driers are used.

The most important rule to observe in adding siccatives to glazes or painting mediums is to test the drying action of the mixture before using it. Mix one of the pigments of average drying properties (page 136) with some of the medium to which the drier has been added, noting for future guidance the number of drops of drier to an ounce of medium. Paint it

* *Description des Brevets d'Invention,* Vol. 24 (2e série), p. 319.

out under exactly the same conditions that will attend its later use, and allow it to dry overnight or for a longer time if desired. After this, regulate the amount of drier so that just enough is used to produce the required siccative effect, the object of the test being to keep the amount at a minimum. The figure will be an approximate guide for future use; it varies according to the humidity and temperature in different seasons of the year and is different with materials from different sources.

The addition of drier to prepared, ready-made liquid painting mediums often leads to cracking and other failures, because these mediums usually contain driers, copal varnish (which is always made with drier), and other materials which are not compatible with the siccatives added by the artist.

Driers were used by the ancients. Litharge made by roasting lead ore was described by Dioscorides, Pliny, and Galen; white lead was described by Galen and others. During the fifteenth century, white vitriol (zinc sulphate) was employed, but because zinc is not a drier it is generally believed that its drying action was due to manganese which probably occurred in it as an impurity. In Spain and Italy during the sixteenth and seventeenth centuries, verdigris was in common use as a drier for oil, and the Spanish masters considered it the best of all driers. All the thin glazes of the early masters of oil painting seem to contain metallic driers.

As the records and instructions for the use of drying oils increase in medieval times, we find many new substances listed, so that by the time oil painting was adopted a number of driers were available for use. These driers were dissolved in the oil medium during the cooking process, as in the case of most factory-made oil mediums today. However, according to various investigations which have been made, if driers must be used, the advantages of adding them in liquid form to the finished paint or varnish are numerous: one may control the amount more accurately and hold it to the minimum required for the purpose, thereby prolonging the life of the film; the instability of some mixtures or oils and driers on storage is obviated by adding the drier as required. It is also my own opinion from observation and experience that films so produced seem to be less likely to crack or turn yellow than those whose oil contains drier cooked into it.

Poppy oil is best excluded from the list of glazing materials and from mixtures that contain driers because of its tendency to crack when mixed with reactive substances and because its range of safe uses is limited, extending little beyond the simplest manipulations of ordinary direct oil painting.

A very small percentage of active metallic ingredient is present in the most concentrated prepared liquid driers. For example, the powerful, concentrated cobalt linoleate contains 3 to 6 percent, depending on its

form; any usable liquid would contain 4 percent at the most; the commercial product put up for artists' use probably contains considerably less. The rest of the contents in the case of pure cobalt linoleate is linseed oil and thinners; in other commercial liquid driers it is likely to be almost any compound of oils, resin, or synthetic materials. Prepared driers are useless to manufacturers of industrial paints unless their exact metallic content is given. The material referred to as cobalt linoleate drier in this book is made by mixing 2½ fluid ounces of turpentine or mineral spirit with 8 fluid ounces of the syrupy 6 percent pure cobalt linoleate.

As noted on page 137, most of the artists' oil colors on the market contain driers, and some of them may contain materials which retard the normal drying action of certain pigments. If the user of homemade colors finds that a drier is necessary to bring the drying rate of a certain color closer to the average rate of the rest of his palette, it should be added in the same cautious manner recommended above in the case of glaze mediums. The aim should be to improve the pigment's drying rate to an acceptable degree, not necessarily to make it equal to that of the fast-drying pigments.

In common technical usage a drier is a chemical substance. The spelling "dryer" is used to designate a machine, device, or apparatus for the drying of materials.

GLAZES AND GLAZING

Glazes are mixtures of mediums and transparent oil colors that are applied over dried oil or tempera underpaintings. The color of the undercoat blends with that of the transparent glaze; because it is not mixed with it as in direct oil or body-color painting, the nature of the resulting color or optical effect differs from that of body-color and may be more or less identified with the second system of color blending mentioned on page 31. A rough illustration is the effect obtained by superimposing a sheet of colored cellophane over another color.

Minute amounts of opaque or semiopaque pigments are often added to transparent glazes, the slight thickness of the film allowing the color of the underpainting to remain effective. This is recommended for the purpose of toning down overbrilliance or lack of solidity.

Requirements for a Glaze Medium. 1. It must brush out well and allow the desired manipulations to be carried out easily. For this requirement it should be neither too oily nor too tacky, but balanced according to the preferences of the user.

2. It must be composed of time-tested permanent materials.

3. It should dry within a convenient length of time. Overnight is generally considered desirable.

4. It should not exert a solvent action upon or pick up the underpainting.

5. It should resist the solvent action of subsequent coats of glaze or varnish.

6. It should not run down or flow when applied in a reasonably skilled manner to a painting in a vertical position, as on an easel. However, the more precise glazing manipulations are usually carried out with the picture in a horizontal position.

7. The flexibility or elasticity of the dried paint film should not be less than that of the original oil color.

From the foregoing, it will be seen that no single oil or varnish meets the specifications and that carefully balanced mixtures must be used.

Many prepared painting mediums are sold, but few are to be recommended to careful artists, as the composition of such products is seldom made public. When these mediums require additions to adjust their properties, it is impossible to foresee the result as regards permanence; some of them are made according to antiquated formulas which contain miscellaneous unstable ingredients such as lead and manganese driers, copal or rosin varnishes, raw or oxidized oil, and synthetic resins.

I refer to the oleoresinous mixtures as glaze mediums rather than painting mediums in order to minimize the importance of adding a medium to all oil paints, and in accordance with my remarks that the most durable and permanent types of oil painting are those which do not depend on such mediums. The experienced painter will be able to sense just to what extent he can add these resinous materials in thicker painting that goes beyond the description of glazing, but the term "painting medium" leads to the inference that all oil paint requires mediums.

Scumbling. This term refers to the use of thinly applied *opaque* colors instead of transparent glaze colors. It is a somewhat vague term usually applied to the rather wholesale daubing of an entire painting, or considerable areas of it, with a thin coating of color in any medium, while the term "glazing" always implies carefully controlled placing of a thin transparent layer of more definite composition. Scumbling is done over a coat of paint that has become dry to the touch or over an isolating varnish, with either glaze medium or straight opaque oil color. The paint may be applied with a brush and the surplus wiped off with a rag, leaving a uniform coating of the desired tone, or it may be stippled or rubbed on with a brush, dabber, rag, or with the fingers.

Manipulations. Glazing may be done by applying thin, transparent paint with the brush, by stippling the color on with the tip of a more or less blunt brush, by using a blender or badger-hair brush, or by the use of a pad, tamper, or dabber. Choice of method of application depends entirely upon the artist's painting technique and the type of effect desired. For very clean, unbroken, mechanically perfect results, a different handling is naturally required than for more casual effects. Most of the remarks in this section are made with the more smooth, perfectly blended type of picture in view; their application to freer or more casual use is a simple matter, and the average painter who employs glaze methods in a looser technique may extract from the complete method such points as are useful in his or her work.

Large areas in which tones are imperceptibly graduated from light to dark or from one hue to another, such as skies, plain backgrounds, etc., are best glazed by carefully mixing each color before beginning. If the glaze medium contains driers, one must work with dispatch; otherwise the material will begin to set before it is used. In most instances there is ample time to apply it if there is no unnecessary delay.

Care must be taken to make the color mixtures smooth, homogeneous, and free from particles of paint skin, lint, or other impurities. Saucers are convenient to use, the material may also be poured into screw-cap jars if desired. Usually a beginner will find that about twice the expected number of separate tones or shades are required to obtain a smooth gradation of colors. The consistency may vary from that of a heavy flowing syrup to that of a soft paste, according to preferences and requirements. Blendings between two colors must ordinarily be made before the first one has set, the two wet glazes being worked into each other. Sometimes for pictorial reasons the lighter shade is best worked into the darker, or vice versa, but if one (usually the darker) contains more liquid and less pigment than the other it is likely to have more picking-up tendency because of its greater solvent action; therefore, unless other considerations are more important, the darker color is best applied first in blendings.

As a general rule, the medium and the oil color should be mixed to a well-pigmented, semifluid or soft paste consistency and made into a thin layer by its method of application or manipulation after it is on the surface, rather than by making it up to a thin-flowing underpigmented wash which will drip, go on unevenly, and have an unsightly paint quality. The deposit of glaze color on the canvas is reduced to the desired thinness by stippling or tamping it with clean, dry brushes or dabbers, or, on a coarser scale, by deftly wiping it partially away. In other words, glazing is best done by application of a very thin layer of well-balanced soft paint instead of a full, direct brush coating of a faintly tinted, varnishy fluid.

Glazing with a Dabber

It will be found impossible to create clean edges around an unglazed area if the glaze is allowed to run over the edge and then is wiped off with turpentine, for the solvent will run back into the glaze and destroy the edge. If the nature of the work is such that the glaze cannot be wiped off sufficiently clean with dry cotton or cloth, edges are best glazed by the precise use of fine brushes.

If dabbers or tampers are used, they may be made entirely of cheescloth, care being taken to fold it so that a flat, unwrinkled surface is produced; or cheesecloth may be filled with absorbent cotton. Well-washed or old cotton sheeting, silk, fine or coarse cloth, knit or stocking material, leather—any one of a number of materials may be used, each producing a different effect. The dabber should be lightly loaded with paint, which should be applied by tapping or pouncing only, not by smearing. A separate brush or dabber must be ready for each color, and the brushes must be perfectly dry; they cannot be used long before they become too full of paint for further use. I find that a convenient way of quickly cleaning and drying a brush for this use is to rinse it in turpentine, wipe it off, then remove the slow-drying turpentine by rinsing the brush in a cup of acetone, or other rapidly evaporating solvent. If the brush is again wiped off and its handle twirled between the palms or flicked on a cloth, it will dry at

once. This procedure is useful in other methods of painting as well as in stippling glazes. Small areas, naturally, must be glazed only with brushes; stippling and blending with various types of brushes will create various surface effects and textures.

The very best brush for stippling glazes, and also for imperceptible blendings in more solid painting techniques, is the badger-hair blender (page 528). It is used dry and clean, by tapping it directly on the painted surface after the colors have first been blended roughly with other brushes. Best results are to be had by working with the painting laid flat on a table and the brush held perpendicular to the surface. If a brush is continually revolved between the thumb and fingers while tamping, one can avoid an undesirable imprint of the brush pattern or shape that is sometimes produced when stippling is done over an extensive area.

The general rules are to keep the glazes thin, to apply darker tones over lighter, and to apply several thin coats rather than one heavy one.

One danger in overreliance upon smooth glazing is that glaze effects in the general run of contemporary artistic painting are likely to lead to undesirable halftones, lack of forcefulness, or mechanical textures, especially if they are overdone. These, however, are not strictly technical points, but rather matters for the individual painter's consideration. Glazing should be intelligently used as a tool or instrument; when so employed, no sound objection can be made to it on technical or optical grounds. Although the separation of layers of different color coats will produce a certain luminosity of tone, especially when painted over a white ground, the finished painting in which glazes have been much used will absorb a great amount of light, and it is best exhibited in a very well-lighted position

Formulation of Glaze Mediums. Because the film of glaze is so thin, a little more latitude in the selection of its raw materials is allowed than in the case of body-color paints, and well-selected driers and varnishes may be mixed with oil. These materials themselves, however, must be of the very highest quality and not liable to turn yellow with age.

In the formulation of a glazing liquid to be applied either to recently dried or rather well-dried layers of oil or tempera paint, consideration must be given to the rule of gradation of coats, as explained in the section on *Painting in Oil.* The glaze film should not be coarser in physical structure or less flexible than the underlying layers, and the properties of the materials which compose it should not be too foreign to those contained in the undercoat. In a glaze, the proportion of the binder to pigment is ordinarily greater than in the case of a body-color. Good working qualities and the exclusion of materials which may yellow or promote yellowing

are prime considerations, and careful attention to the balance of solubility is most important.

The glaze and oil-painting medium that I recommend as the best for general, all-around purposes is the following:

> Damar varnish (5-pound cut)—1 fluid ounce
> Stand oil—1 fluid ounce
> Pure gum turpentine—5 fluid ounces
> Cobalt drier—about 15 drops

The proportion of varnish and oil may be varied somewhat to suit the preference and requirements of the user; a little less varnish will make the results more oily in handling, a little more varnish or a 6½-pound cut instead of the 5-pound cut will make it tackier. Up to two additional ounces of turpentine can be added when circumstances require a thinner medium. The stand oil content is designed to reinforce the elasticity of the paint film, thus compensating for any tendency toward brittleness that might be caused by the resin, and also to maintain its resistance to solvents. In order to employ a minimum of drier it is best not to adhere to any set quantity, but to test the amount required each time by the method described on pages 201–202. Whenever the medium is used, pour the liquid off without disturbing any sediment which may have formed. Mediums containing liquid driers should not be expected to keep for more than a few months without some precipitation. This medium is designed to be used with tube oil colors, either as they come from the tube or after they have been spread out on bond paper for a while to remove some of the surplus oil. It works well in the glazing of oil paintings, and also in glazing gum tempera of the type for which a formula is given in the chapter on tempera painting, because it contains the same ingredients. (See page 214.)

The damar resin content of the average glaze made by thinning tube oil color with this medium is well below the limit which might make it vulnerable to varnishing, overpainting, or cleaning. I have removed coats of damar and acrylic varnish from a picture and revarnished it four times; where this mixture, in the form of thin lines, had been applied to the painting in very fluid consistency with a draftsman's ruling pen, these gray lines representing guy wires against a pale sky did not suffer the slightest damage. (Reasonable care must always be taken in the removal of old varnish, as described under *Removal of Old Varnish* on page 490.)

An example of a variation of this medium is a retouch varnish which may be made of the same ingredients by mixing them in the following proportions and order. By volume:

5 ounces damar varnish (5-pound cut)
1 ounce stand oil
½ ounce toluol
¼ ounce anhydrous alcohol or acetone

Stir or shake until clear and add

13 ounces turpentine

The use of retouch varnish is mentioned on pages 162–63. This varnish is acceptably nonyellowing and performs much like the well-known and generally respected Vibert varnish. The current Vibert brand contains 75 percent of volatile solvent (a highly refined petroleum spirit), and 25 percent of a clear resin which by test shows no trace of damar or pine resins. It is probably a synthetic. Maroger's medium originally called for grinding the pigments with "yellow varnish," made by melting damar resin into hot linseed oil, then mixing them with a water-in-oil emulsion paste made by lightly whipping a gum arabic solution into the same varnish. During the painting the colors were freely diluted with "black oil," using the brush. Black oil is linseed oil saturated with lead by cooking it with litharge or white lead. The current Maroger's medium is a mixture of the black oil with mastic varnish. As frequently mentioned in this book under megilp and other topics, I do not advise the use of materials of this type.

According to Church,[47] Bell's medium contains blown linseed oil thinned with spike oil, and Roberson's medium may be duplicated with a mixture of copal varnish, poppy oil, and white wax. These are nineteenth-century English mediums still on the market.

In addition to the stand oil–damar glaze or painting medium I described on page 208, and which is the one to which I refer throughout this book as a standard or simple medium, I quote the following recipe which is in general American circulation, but which contains higher percentages of resin:

9 parts damar varnish (5-pound cut)
9 parts turpentine
4 parts stand oil
2 parts Venice turpentine

This material is preferred by some painters to the first recipe for use on egg/oil tempera. It may be utilized for the dilution of tube oil colors or for the grinding of dry pigments. For use in the so-called mixed technique, careful painters add a drop or two more of stand oil when mixing colors for overpainting, in order to ensure the greater flexibility of the layer as compared with the one which lies beneath.

Sun-thickened oil has long been a favorite ingredient in glaze mediums because it has a rapid drying rate. One recipe is:

4 parts damar varnish (5-pound cut)
2 parts sun-thickened linseed oil
1 part Venice turpentine
4 parts turpentine

Sun-thickened linseed oil dries faster than stand oil; this recipe needs little or no drier. The combination of sun-thickened linseed oil and Venice turpentine is best suited for use in glazing egg/oil emulsions, and in general gives good results when dry colors are ground directly in it. Additional turpentine should be added according to the judgment of the user to compensate for the evaporation during such grinding, and when the resulting paint is used in successive coatings each upper layer may be made more flexible by the addition of a drop or so of sun-thickened oil.

The above two mixtures are not recommended for glazing gum tempera or straight casein paints; their adhesion, range of expansion and contraction, etc., are not so suitable for these uses as the corresponding qualities of the damar–stand oil mixture; on the other hand, that mixture is perhaps less suitable for use in the egg/oil tempera techniques.

Neither of the above two mediums has the all-around advantages of the first one recommended by me on page 208; both contain higher proportions of resin.

Straight egg tempera may be, and often was in the earlier days, glazed with dry colors ground in diluted egg yolk. This procedure is followed by some tempera painters today and its results are quite luminous and high in key. Some practice and experiment is necessary to control this procedure; the usual technical danger, as with all pure egg-yolk techniques, is that the inexperienced painter will not dilute his paint with enough water. An objection on optical grounds to such entirely pure egg-yolk techniques is that the results are likely to be thin, unsubstantial or watercolorish. This, however, is more often the fault of handling or manipulation than of any inherent defect in the process. Some painters desire this quality and do not consider it to be a fault.

The mixture of linseed oils of various degrees of refinement is a procedure of considerable antiquity; it was adopted by craftsmen of the past who, although they would have been at a loss to explain the reason, were very well aware of the fact that such mixtures had properties entirely different from those of a single oil refined to approximately the same viscosity, color, and body (see page 450). A small amount of a linseed oil of ordinary consistency added to stand oil will impart a certain

hardness, body, or solidity approaching that produced by a resin; some of the old effects which may be approximated by the use of Venice turpentine and oxidized oil may also be duplicated by the above mixture, particularly as regards manipulations and brush stroking. Oxidized oils will impart a still harder or more brittle nature to stand oil. The prepared painting mediums on the market, particularly the older brands that originated in times when practical industrial varnish makers were constantly formulating and producing such mixtures, probably contain more than one type of linseed oil. It would of course be impossible for a chemist to duplicate such formulas by purely analytical means.

One of the principal differences between a glaze medium and a picture varnish is that the latter must be easily removable by a simple solvent which does not act on the painting, whereas the glaze film must be capable of resisting the action of cleansing and picture varnish solvents.

Should it become necessary or desirable to remove glazes and overpaintings without disturbing the underpainting, this can usually be accomplished by various means, depending upon the nature and age of the paint. Films of any appreciable thickness are best removed by gentle scraping with sharp blades as described on pages 495–97; if an isolating varnish has been used, the procedure is easier. Oil glazes and overpaintings on tempera pictures are rather easily removed by this method; they can also be taken off with acetone or certain other solvents if these are applied by careful picture-restoring methods. Very slight or delicate oil glazes of recent application can often be removed or taken down with Artgum, rubber erasers, or other mild abrasive.

EXHUMING DISCARDED MEDIUMS

Various complex oil painting mediums have been proposed as the solution to the problem of those who seek the "lost secrets of the old masters." However, throughout the history of European oil painting and the history of materials which parallels it, there runs a main current of the traditional use of straight oil paints. Documentation and evidence point to the fact that most works of the past were painted with something very close to our own fine colors in tubes. These colors were used with round brushes, both pointed and blunt, of superlative quality, and they were thinned judiciously with a little turpentine or its equivalent. One notes, too, the occasional and sparing use of a simple oleoresinous glaze medium when some special effect was desired—one containing a heavy-bodied oil plus a small amount of simple varnish, such as the one on page 208.

Apart from this trend, we have a confused and miscellaneous collection of recipes for more complex painting materials: varnishes, mediums, trade or coach painters' expedients, and vehicles for fluent decorations and embellishments which were never intended to be used for permanent works of artistic pretensions. In the past, of course, artists made experiments, gathered recipes from obscure manuscripts and books, and sometimes entered them in their own notebooks. But such practices were originally developed in relation to problems, to confusions, and—even as far back as 200 years ago—to searches after "lost secrets." Earlier and more authentic writings give perfectly clear accounts of the simple mediums of the older painters. The complex mediums almost always contain materials that have been condemned by chemists and technicians, and almost all of these "ancient" materials date from the late eighteenth century—for example, megilp and its variants.

Every competent painter in the past had the same temptations: unctuous painting mediums such as megilp, and dozens of fugitive and impermanent pigments of vegetable and animal origin were in use for decorative purposes. He chose the permanent ones and rejected the bad ones, just as the painter of today rejects the brilliant but fugitive aniline colors. My belief is that the top-ranking masters did not use complex mediums, particularly in works that have come down to us in good condition, any more than the serious painter today uses every new proprietary medium that is offered. The painter is interested in new materials, he will try them out and experiment with them, but will cling to the tried and tested for major works. Any museum restorer knows that the cleaning and rehabilitation of the average painting is routine (if that word can be applied to any aspect of such an intricate craft), but that the troublesome picture is the unusual one, generally the one that has a great deal of resin (hard or soft) in its makeup. I am not certain as to whether the disastrous aftereffects of megilp are entirely due to its chemical instability or whether any unpigmented gel medium would not produce at least part of such defects by reason of the physical structure or weakness of the final underpigmented film even when such a gel is composed of more acceptable ingredients. Another and more familiar objection to underpigmented coatings is that any yellowing of the vehicle is not masked by pigment.

In the oil paintings of the admired artists of the past there are very few technical effects which cannot be duplicated out of the average paint box, even where a more fluent or fluid effect is wanted. I do not recall any results from the complex mediums that have been offered to painters which have been better than simpler means in skillful hands.

Says A. P. Laurie, "It is a common mistake ... to make up for

the want of manipulative skill on the part of the modern painter, by inventing complex mediums which the painter of old is supposed to have used."* Synthetic resins in oil-painting mediums are discussed on page 192.

* *Technical Studies in the Field of the Fine Arts,* Vol. VI, No. 1, July 1937, p. 18.

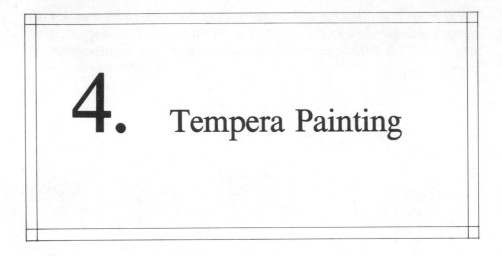

4. Tempera Painting

IN THE MODERN usage of the term, tempera painting is painting that employs a medium that may be freely diluted with water but upon drying becomes sufficiently insoluble to allow overpainting with more tempera or with oil and varnish mediums. Remarks on the derivation of the word "tempera" will be found under *Temper* on pages 630–31. Tempera paintings are best executed on rigid panels coated with absorbent gesso.

Tempera paintings are characterized by a brilliant, luminous crispness that is never exactly duplicated by the use of oil or other mediums. Although its materials are applied in many distinct variations of technique, tempera paintings may usually be identified as such without much doubt. When left unglazed they have a pleasing flat or faintly glossy finish. When carefully glazed and worked up, they are capable of presenting a highly developed appearance.

In tempera the fourth or optical function of the medium (see page 120) scarcely exists, and when the paint is dry the colors resemble their original dry state more than do the deep-toned oil colors. Depth of tone, if desired, must be brought out by a final application of varnish or transparent glazes.

This separation of the optical properties from the mechanical properties of the medium is not to be considered a complete disadvantage, because it contributes largely to the tempera effect and allows a controllable, systematic method of working which appeals to many painters.

214

The dried paint film does not become yellow or darken with age as faulty oil paintings may do, because the medium itself is nonyellowing compared with oil, and there is considerably less excess of binder in the finished painting. The bulk of the liquid (water) evaporates completely from the film.

Many of the conditions that cause cracking and other failures in oil painting are not present in tempera. Correctly painted tempera pictures are less likely to crack with age than are oil paintings; if there has been any fault in the preparation or execution of the painting or ground that might result in cracking or other failure, such failure will almost certainly show up soon after the picture is dry. This is a general statement to which there are occasional exceptions, but it is fairly safe to assume that if a tempera picture has not exhibited traces of cracking by the time it has become thoroughly dry, it will not crack at a later date.

However, tempera mediums are not foolproof; if improperly formulated or applied, they may be subject to as many defects as oil mediums. As a general rule, the tempera techniques are not well suited to casual or spontaneous styles and for the most part require serious consideration and a familiarity gained through intelligent understanding of their principles. Tempera paintings of extreme age (several hundred years old), especially those few which have survived on canvas, are very often covered with a characteristic allover crackle of small size, which ordinarily has no effect on the adhesion of the paint.

Work may be resumed on, or additions made to, an egg tempera painting for some time, but at a certain point (somewhere around eight months) the fresh egg colors seem not to take or coalesce with the old work. They tend to lie on the surface with the unwanted color effects of opaque gouache; the egg medium apparently enters into a final inert and permanent stage. This is my own observation; I am not aware of any published information on this point.

When compared with oil painting, tempera has certain limitations and disadvantages as well as the advantages just listed. It is more limited in its range of effects, and the inflexibility of its film makes it unsuitable for painting on canvas, although aged tempera films are not greatly inferior in flexibility to very old oil films. The chief manipulative advantages of oil over tempera are its greater fluidity, the ease with which its colors may be gradated or blended, its conveniently slow rate of drying, and the absence of color change caused by evaporation of the medium on drying. Oil is a more convenient, flexible, and available technique.

TEMPERA VEHICLES

Tempera vehicles owe their distinctive characteristics to the fact that they are emulsions. An emulsion is a stable mixture of an aqueous liquid with an oily, fatty, waxy, or resinous substance. Milk is an example of an emulsion, the butterfat which is suspended in minute drops being the water-insoluble ingredient. Tempera emulsions dry to form transparent films; their milky appearance when wet is caused by the refraction and dispersion of light from the countless tiny globules of oil, in the manner noted on pages 109–11. Polymer vehicles and mediums are emulsions.

The principal early type of tempera emulsion was a natural one— pure egg yolk. The yolks of hen's eggs contain a water solution of a gummy substance, albumen, a nondrying oil called egg oil, and lecithin, a lipoid or fatlike substance which is one of nature's most efficient emulsifiers or stabilizers. Albumen itself is a good emulsifier. The subject of emulsions is dealt with further in both parts of Chapter 13, "Chemistry."

Egg yolk is an example of a paint vehicle that contains a nondrying or semidrying substance mixed with a quick-drying substance, the whole mixture drying successfully. There are also other substances where varying amounts of nondrying or semidrying substances may be added to a paint or varnish whose drying properties are strong enough to carry it along, in order to impart favorable properties to the product.

Albumen belongs to a class of proteins that have the property of being coagulated by heat, as demonstrated by a cooked egg. The same effect is obtained when it is diluted, spread out in a thin layer, and exposed to daylight. The pure egg-yolk film becomes adequately insoluble, tough, leathery, and permanent, and as a film it serves as a standard by which to judge the artificial tempera emulsions. Artificial or compounded tempera emulsions are employed more for their improved executive or working properties than for any superiority in the quality of their films.

Tempera paintings are called insoluble here and in other descriptions, but this does not mean that they are absolutely waterproof or scrubbable; they may often be softened or disturbed enough by the deliberate or accidental application of water to ruin their effects. Well-dried tempera paintings may usually be cleaned with a little acetone or anyhydrous alcohol if these are applied very cautiously as in the regular restoring technique. Tempera and gesso can be completely and quickly removed from panels by rubbing with soap or ammonia solutions.

They are insoluble to the extent that they are not picked up by overpainting, and when completely dry they are adequately water-resistant under all normal conditions. Neither tempera nor gesso is intended to withstand such treatment as harsh scrubbing with a bristle brush or care-

less application of water. Only a very slight disturbance of the color effect is enough to ruin an artistic painting even though the paint film may be virtually unaffected from a mechanical viewpoint.

When thoroughly dry, most tempera paints will assume a satiny semi-gloss finish if polished with a soft cloth or wad of absorbent cotton. This is done by some painters before applying oil or varnish glazes, especially in the case of gum tempera, on the theory that such surfaces will become more resistant or more uniformly absorbent to the superimposed mediums.

The choice of pigments to underlie each other is not as important in tempera painting as it is in oil where their variations in oil absorption and reactivity are factors, but the rule of gradation of layers still holds—that is, no coat should be less flexible than its underlying coat. A similar general rule to be followed in the case of aqueous mediums is that no coat should have appreciably stronger binding or adhesive power than the layer under it. Should this be the condition, the contraction of the stronger layer is liable to cause it to crack away and to pull off the weaker layer. When this occurs, it usually takes place at the time of drying or shortly thereafter at the first appreciable climatic change, as mentioned on pages 258–60 under *Defects of Gesso Panels*.

The term *oily ingredient* as used in the discussion of tempera emulsions refers to any of the nonaqueous ingredients whether or not any oil is present, and includes waxes, resins, varnishes, and oils. The varnishes or solutions of oily materials may contain turpentine or its petroleum substitute but not alcohol, which may be incompatible with the aqueous ingredients used in tempera emulsions.

PAINTING WITH EGG YOLK

A number of instructions for the use of egg tempera have come down to us from all periods of European art. The traditional pure egg-yolk technique proceeds in the following way.

The yolk is first separated from the white. Some painters are extremely careful to keep it free from any traces of white; others are less particular; but a pure yolk, free from white, is the standard material. The white is practically pure albumen and water, and there is enough albumen in the yolk alone for a well-balanced tempera emulsion. An excess would not injure the dried tempera film so much as it would increase the speed of drying and cause difficulties in manipulations or brushing. After the yolk has been separated from the white by the usual method of pouring it back and forth in the half shells, or better, by the use of an aluminum egg separator, it is rolled briefly on a paper towel to dry off the layer of clinging egg white and most of the chalaza, then transferred to the

flatly held (not cupped) palm of the hand, picked up by the thumb and forefinger of the other hand gently, so as not to break the skin, and suspended over a jar or cup. The skin is then punctured at the bottom by stabbing it with a knife or other sharp point, and, if desired, after most of the yolk has flowed out, the little that remains can be squeezed from the skin on the slab with a finger. Instead of rolling the yolk on the paper towel, some painters roll it from one hand to the other, the hands being alternately wiped on a towel or apron, until the skin of the yolk is dry. Sometimes painters merely break the eggs into a coarse strainer, and after the white has drained off, puncture the yolks and allow them to run into a container. If this is done it is well to strain the yolk again through muslin, but the result will not be so pure a yolk as that separated with greater care. For ease in the straining and handling of egg yolk, a small amount of water may be mixed with it; so much water is used in the painting that it will not matter. However, if the yolk is being prepared for use in some exact recipe, this addition should be taken into consideration.

The pigments are well ground in distilled water with the muller, and placed in small screw-cap jars where they will keep indefinitely. Just prior to use, equal volumes of this color paste (about the consistency of tube oil colors) and egg yolk are mixed. Some painters add a little water to the egg—$\frac{1}{6}$ to $\frac{1}{8}$ of the volume. A set of kitchen measuring spoons is handy

to use in measuring proportional amounts of both dry and liquid substances.

There is no technical objection to grinding the colors directly into the egg or into a mixture of egg and water, which some painters prefer to do, especially with pigments that do not grind easily in water alone; but keeping them in the form of a water paste and adding the egg just prior to use ordinarily saves much labor because the pigment-and-water paste keeps indefinitely, whereas colors made by grinding pigments directly in egg yolk will have to be thrown out at the end of the day's work.

While the painting is being done the main supply of the egg-tempera paint may be kept in little covered jars or cups instead of on the open palette where it will harden more quickly. If these containers have no screw caps they may be covered with a damp cloth during painting operations. A piece of moistened filter or blotting paper inserted in the cap of a jar will produce a humidor effect and retard setting or skinning of the surface, but in warm weather will tend to encourage decomposition or mold.

Pure egg tempera is best applied to the absorbent gesso panel without previous coating; if it is desired to have the panel somewhat less absorbent, a very dilute gelatin size may be employed. Some painters, especially those who put down a very accurate and careful drawing on the gesso before painting, use the size as a fixative for their drawings. It is better not to color the first size and use it as a veil, because of its penetration into the pure white gesso; but a colored veil or size may be applied as a second coat. Other materials suitable for a first sizing of the gesso are very much thinned down shellac varnish, egg water made by mixing a teaspoonful of egg yolk in a full glass (6 ounces or more) of water, and a much diluted casein size. The unsized gesso surface is, however, most desirable in the average case. Its absorption of the tempera medium is not usually sufficient to destroy its whiteness, but it is not considered advisable to use very heavy, thick strokes at first, before thinner coats of paint have reduced absorptive action. The theory is that too much absorption of binder by a ground will leave the pigment of a thick layer insufficiently bound. The gesso surface can be made less soluble by spraying it with a 4-percent solution of formaldehyde (page 463), but this is seldom necessary. Pure egg yolk is primarily suited for smooth painting; it is not useful for heavy impasto like gum or egg/oil tempera.

It is better not to use preservatives in egg, and most painters prefer not to use them. The egg alone or in mixture with colors will keep in a dark, cool place for three or four days; if it becomes necessary to keep it longer, a 10 percent pheonol solution (carbolic acid) may be added in minute amounts, or 1 percent or less of a 3-percent solution of acetic acid, vinegar being the traditional egg preservative. Most vinegars contain

from 3 to 5 percent of acetic acid. Acid solutions will attack chalk or whiting grounds, ultramarine blue, and the cadmiums. It is doubtful whether many present-day painters use acid or other preservatives in egg. The decomposition of tempera paints and similar materials can be delayed by refrigeration, but freezing will destroy their properties. The section on *Fresh Paint,* pages 5–7, is particularly applicable to egg-yolk paints.

Cennini[8] refers more than once to the use of fig-tree sap, either added directly to the whole egg to make a wall size, or introduced by beating the egg with cuttings of the young shoots to produce a medium for secco painting. Every possible explanation has been offered for these procedures by various writers; fig-tree sap has been said to be a preservative, to add toughness and flexibility (the juice is similar to latex, the milky sap of the rubber tree), and to make the paint more brushable. There is no record of its use in modern times. Most investigators have considered it to be an unimportant point and it is generally omitted in present-day reconstructions of the technique. Some laboratory research would be necessary to answer the questions that this matter involves. The so-called fig-milk of German origin is an artificial product, a complete tempera emulsion in itself.

It is always advisable to use the freshest eggs obtainable; the medium will then stay in condition for the longest possible time, and the paint will be superior in every respect. Storage and preserved eggs are suspected of forming weak or impermanent films. The yolk is useless as a medium after it has commenced to decompose. The yellow color has very little effect on the paint, especially when the yolk is well diluted with water and mixed with pigments. Daylight is said to bleach it permanently soon after it dries. Cennini recommended town eggs as being paler than country eggs; some types of white eggs have very pale yolks, but the practical difference between the lightest and the darkest is very slight.

Handling the Paint

When painting with egg, plenty of water should be used, and the brush should be dipped into water frequently. When the amount of egg is in proper relation to that of pigment, a large amount of water may be added to the paint; inexperienced painters often have difficulty in handling the tempera medium through not introducing enough water. When too much egg is used, the paint will dry too rapidly and brush out with difficulty; when not enough egg is used in relation to the amount of pigment, the resulting film will be weak and powdery. To test the paint film it should be brushed out and allowed to dry on a sheet of glass. If it can

be peeled off in a continuous, tough film with a knife, there is enough egg to bind it; if it powders or flakes off there is not enough. Some pigments, as will be found by experience, require a little more egg than others. This procedure does not, however, afford a fair test of the paint film's time of drying, brushing properties, etc., because the conditions are too far removed from those of actual painting on a gesso ground.

Brushwork Instructions. In working the paint on a fully absorbent gesso panel, the following three points must be observed.

1. Use the very finest quality pure red sable watercolor brushes. For some parts of the work, blunt red sables such as the single-stroke (see *Brushes,* page 522) can also be employed; when this shape is used, some painters prefer the second quality (red sable mixed with ox hair) because it has more springy resistance. For general use, the best round, pointed watercolor brush is essential.

2. Mix some of the egg color with water to the desired consistency on the palette, dip in the brush, loading it fully, then squeeze half of the charge out between the left thumb and forefinger (if you are squeamish use a tissue). A bit of experience is necessary before one gets to control the exact charge; the purposes are to produce a uniform *translucent* stroke and to avoid that unwanted drop or drip at the end of the stroke. If the paint is not applied in some such manner, it will not have the tempera effect; if overloaded it will produce an opaque, pasty film for which one might as well use gouache.

3. Use *single* strokes in one direction, not back and forth. Do not go over the same spot twice rapidly; if you wish to go over it, wait a short time (three to five seconds) for it to set up a bit, whereupon it can be gone over in the same or any other direction without danger of its being picked up to expose the white gesso or to produce muddy, clogged effects.

The traditional handling of egg tempera is in light, hatching strokes, but wide strokes and thin washes are not forbidden. Build up a thickness of paint and (if desired) a hiding of underpainting by several coats; keep each layer translucent, even in the whites and flesh tones which normally have a greater degree of opacity than the darks. Despite the hiding power of this build-up, the ground and underlayers will still contribute their effects to the result even when apparently obscured. A translucency can sometimes be recovered by overpainting a clogged or opaque spot with thin or transparent layers.

This kind of tempera painting is definitely not an ideal method for beginners or for those who prefer an impulsive or extemporaneous style; it is favored by those whose scheme of work is deliberate and planned.

The early painters traced an outline of their very complete drawings on the panel, then referred to the original drawing during the execution of the work, even when the model remained present. To follow this procedure, the original drawing should reach the same stage of complete development as is planned for the final picture. Every single problem of design, modeling, and content should be worked out in this drawing or cartoon; thus the artist is free to concentrate his entire attention on color problems, the technique, and the paint quality. The method is eminently suitable and appropriate to linear styles (see page 104) and particularly effective for the so-called blond painting.

The foregoing account of tempera painting is intended to be an outline of the pure or classic method as practiced in Italy from before the fourteenth century until oil techniques took over in the fifteenth. All other tempera procedures stem from it. The painter who has mastered this method is well equipped to control, adjust, and experiment with the modern innovations. Because of overlapping and the survival of older forms under various circumstances, it is impossible to ascribe the various tempera developments to specific dates and names of individual artists, but the works of Giotto are examples of the early perfection of this technique and those of Botticelli, its culmination or highest development.

An intermediate or transitional stage of development followed the pure egg-yolk technique, in which oily, resinous, or waxy materials were introduced into the process in some manner. This in turn was followed by the jewellike glazed tempera paintings as exemplified by those of Antonello da Messina and the fifteenth-century Flemish painters. Finally this gave way to pictures painted throughout with oil colors, and the older tempera methods became dead techniques until their revival in the recent past.

EMULSIONS OF EGG AND OIL

The addition of stand oil, sun-thickened oil, Venice turpentine, and cold-pressed linseed oil of normal viscosity to egg yolk and whole egg has been mentioned in early writings, but there is little record of the establishment of any standard, traditional technique or of any exact formulas; all recipes in present-day use are of comparatively recent origin.

Addition of oil to egg changes the latter's qualities, and without entirely losing its tempera character, the medium tends to acquire some of the oil characteristics. It becomes somewhat easier to handle and is more adaptable to a wider range of effects, especially when used by an artist whose training and experience have been principally confined to oils; it

piles up a little more satisfactorily than pure egg yolk; that is, sharply textured or semi-impasto strokes stay put. For really heavy impasto spots, such as those produced by the early painters in making small spots stand out in bold relief, it can be used to much better advantage than the pure egg yolk, but still not so well as gum tempera. For the technique which paints tempera into wet oil-medium color as described farther on in this section, an egg/oil emulsion seems to be the most desirable.

Egg/oil mixtures have several disadvantages: their tendency to lean somewhat toward the oil painting characteristics sometimes brings their optical effect toward that of oil and away from the pure egg tempera appearance; the emulsions must be accurately and rather delicately balanced in order to work successfully; and their behavior is likely to be erratic and influenced by very slight variations in conditions. Every once in a while an egg/oil emulsion refuses to dry and becomes gummy and intractable under the brush. This behavior is usually accompanied by a separation of oil from the emulsion in rather large, visible globules, and occasionally traction fissures will occur in the film. The cause of this condition is not always easy to analyze. The oil may have become separated from the emulsion because of the presence of impurities such as soluble salts; the emulsion may have gone over to the water-in-oil type which is described on pages 437 and 457; the emulsion may not be combined properly, some of the oil remaining in superficial mixture rather than being completely dispersed or emulsified; or sufficient water may not have been used. Stale eggs may also be the cause. In an egg/oil emulsion the limits within which proportions may vary are rather narrow, and not too much deviation from a successful recipe may be made.

These remarks on the defects of egg/oil emulsions are to be taken as warnings or precautions rather than as condemnations of the medium, for many painters make use of it with complete success, and its properties and effects exactly suit the technical and artistic requirements of a number of styles or schools of painting.

Most of the published formulas for egg/oil emulsions are apparently of German origin. Perhaps the most universally successful mediums of this type are those formulated from the starting point of equal parts of whole egg and oily ingredient, to which are always added at least two parts of water. Doerner[55] says that such emulsions need not be mixed with special equipment nor for very long, and recommends only a brief shaking in a tall bottle. This is not quite in accordance with the approved methods of making stable emulsions of this type as established in scientific and industrial practice, where care is taken to agitate the mixture long enough to break the oil into globules of the smallest possible size

and to make sure that none of the oil remains unemulsified. Such mixtures are agitated by shaking them in a tall container or by stirring them with a propeller; there is some disagreement as to which method is better. However, these procedures have not been investigated for their application to tempera paints. Some experimental emulsion methods require two short stages of shaking with a few minutes' rest in between. Mechanical agitating devices are mentioned under *Gum Tempera*.

The oily ingredients in approved general use are oils, thickened oils, simple-solution varnishes, Venice turpentine, and mixtures of these, such as half stand oil and half damar varnish, three-fourths oil and one-fourth varnish. Laurie[51] says that if a little turpentine is present (as it would be in the case of damar varnish), the emulsification of heavy oils, such as stand oil, is assisted. Together with the majority of writers, he is of the opinion that pure egg yolk is the best tempera emulsion.

A number of American painters use the following egg/oil emulsion as a standard recipe, varying the composition of the oil ingredient according to individual preferences.

2 parts whole egg
4 parts water

1 part stand oil
1 part damar varnish

When oil and varnish glazes or overpaintings are used with such emulsions it is well to use the same or similar oily ingredients in both, and with any technique which employs alternate complex or multiple layers of paint, careful painters sometimes add an extra drop or so of oil to each succeeding glaze or paint coat in order to produce a correct gradation of flexibility.

Egg/oil emulsions which employ the separated yolk rather than the whole egg are much more likely to exhibit the defects previously enumerated. The following recipe is an example of one of the countless variations which may be made.

3 parts egg yolk
1½ parts water

1 part stand oil
1 part damar varnish

In the *Papers of the Society of Mural Decorators and Painters in Tempera*, Vol. II,[58] Hart gives the following recipe for egg-yolk/oil tempera, and accompanies it with very detailed instructions which are briefly outlined below.

Yolk of 1 egg
10 drops of oil of lavender
Washed and sun-clarified linseed oil equal
 in volume to the egg yolk
Twice this volume of water

Very careful precautions are taken to keep the white out of the yolk, including rolling the yolk from one hand to the other and wiping each hand after the yolk leaves it. The reason given is that excess albumen would encourage cracking in this formula.

The yolk is emulsified with the oil of lavender by the mayonnaise system, one drop of oil at a time rubbed in thoroughly with the muller on the slab. The egg should become somewhat paler and thicker. It is put in a jar, covered with a damp cloth, and a portion of it returned to the slab where the linseed oil is worked into it in the same way with the muller. After four drops have been emulsified, more egg mixture is worked in, and the procedure is repeated, the oil being added in gradually increasing amounts after each addition of egg. When it is finished the emulsion should be stiff "mayonnaise." The two volumes of water are apparently to be added at the end, small portions at a time.

This medium is used in the same way as the other egg/oil temperas, but its author recommends that an additional part of a special varnish be emulsified with it for use with ultramarine, cobalt blue, and the cadmiums. The varnish is one part of hard copal dissolved in tetrachlorethane, a powerful chloroformlike solvent, and then mixed with one half its (copal?) volume of raw linseed oil. The volatile solvent is allowed to evaporate completely (without boiling) before the varnish is used in the emulsion formula. According to its author, the resulting product is not to be confused with the undesirable cooked copal varnishes. (Note precaution on page 373 concerning this dangerous solvent.)

The careful and meticulous instructions for emulsions given by Hart and other writers may be considered by many practical painters to contain unnecessary overrefinements, but the concern over a complete and thorough emulsification of the oil is not unfounded. In the case of the above formula, if care be taken to ensure complete dispersion of the oil the results will be superior to those produced by a casual shaking. The small amount of lavender oil assists in the emulsification and the formation of an oil-in-water type of emulsion; it is more or less evaporated during the subsequent mulling.

Studies on the commercial production of emulsions of very similar composition show that the beating in of a very slow and steady stream of oil will in many cases produce a more stable emulsion than can be made

by adding successive portions. Mixing the above formula with a high-speed mixer or beater, pouring the oil into the egg in a very slow stream, should give results at least equal to those produced by the mulling method described, but about three times the amounts of the original recipe would be required for the efficient use of such equipment.

Friedlein[68] gives a recipe for egg/oil emulsions: 30 grams separated egg yolk (about 2 yolks), 20 grams of oil, and after these are thoroughly mixed, 20 grams of water shaken in, in small successive portions. His favorite formula contains ingredients of doubtful value: 150 parts of separated egg yolk (10 yolks) emulsified with a mortar and pestle with 75 parts of poppy oil, then thinned with 20 parts of water and 10 of glycerin. I have made many experiments with separated egg yolk emulsified with the usually approved oily ingredients, but have not succeeded in improving upon the all-around results of straight egg yolk, gum emulsion, or whole egg/oil tempera. Apparently, the well-balanced emulsion medium requires the presence of the albumen in the egg white to emulsify with the added oil.

Experiments with tempera emulsions call for careful, accurate measurements and preparations, and a record of the formulas should be preserved in a notebook. Samples should be painted out on glass and also mixed with pigments and painted out on paper or gesso-coated paper, and observed for drying, flexibility, brushing qualities, yellowing, binding, and adherence.

Egg-White Mediums. Egg white, or glair, has been used to a minor extent in painting techniques from early times, especially in the application of colors to illuminated manuscripts, but its poor brushing properties limit its use for techniques which demand any degree of flexibility or variation in manipulations. It is virtually a pure colloidal solution of albumen; it has comparatively weak film-forming and binding qualities; but it reacts in the same way as the other substances of its class in that it becomes denatured (coagulated) when exposed in thin layers to air and sunlight; and its consistency is altered by agitation or beating. Its dried film is a little more soluble in water than some of the others; like a gelatin or glue film, it may be hardened with formaldehyde. Medieval recipes call for beating it to a frothy liquid; sometimes it was used to bind very pale or very reactive colors which gave less desirable effects when mixed with egg yolk. Its sole desirable use in modern tempera painting is as a constituent of those egg/oil emulsions in which the whole egg is used instead of the separated egg yolk, as in the traditional pure egg tempera method. It appears to contribute a stability to such emulsions, probably because the additional colloidal solution of albumen overcomes any ten-

dencies on the part of the other ingredients to form undesirable or unstable types of emulsions. When egg white is employed on a commercial scale, as it is in various industrial processes, a dried material is used. This is available on the market in a form resembling crushed gum arabic, and is called egg albumen. Egg white is used more successfully as a size for attaching gold leaf to gesso, picture frames, and leather than for painting purposes. A popular conception is that, because it is colorless in comparison with the yolk, egg white was extensively used in early paint mediums, but it was never used to any extent in standard, well-developed easel-painting techniques. Its mention in this connection is an example of the type of inaccuracy that finds its way into compilations and accounts written or translated without first-hand knowledge of the subjects.

GUM TEMPERA

Emulsions made from gum arabic produce satisfactory tempera paints, and when glazed or overpainted with thin oil and varnish mediums they can be used to duplicate some of the luminous qualities seen in the later Flemish and Italian glazed tempera works. Because gum arabic does not alter in process of drying as do egg yolk, casein, and albumen, but merely deposits a mechanical film by evaporation, its film is not quite so water-resistant as those of the other temperas, and greater care must be taken to avoid the picking up of the underpainting when a second coat is applied, especially when the underpainting is freshly dried.

Gum solutions, however, will combine with a large number of oils and resins without turning dark, and if the brush stroking is carefully done, they may be overpainted in much the same way as the others. Gum arabic has been used as a painters' material from the earliest times; it is generally considered that it was employed along with improved oils and varnishes during the early period of improvement of the tempera technique. The less-soluble variety, gum Senegal, should be used whenever it is obtainable.

Gum emulsion mediums are permanent, they are a little easier to manipulate than egg emulsions as they can be made to dry more slowly, and they are capable of producing a great number of effects; either smooth, thin painting or heavy impasto may be produced by them. Their most important advantage is that their formulas may be more widely varied within the bounds of sound practice than those of the other emulsions. They are therefore more adaptable to the requirements of the individual.

Gum arabic is dissolved to a heavy, syrupy consistency, and the oily ingredient is stirred into it slowly. Emulsification takes place immediately; the mixture has a milky appearance. But the rule for making per-

fect emulsions of this type demands that the mixing or shaking be continued vigorously for some time.

A convenient mixer for preparing emulsions is an inexpensive egg beater and a glass jar to fit, procurable in kitchenware departments. A better piece of equipment, which also finds many other uses in the studio workshop, is a small household electric mixer; the kind that can be held in the hand as well as set in its support is most convenient. Three to five minutes' mixing with this produces emulsions that, if properly formulated, will not separate on long standing.

Typical gum tempera emulsion (parts by volume):

5 gum solution

1 stand oil
1 damar varnish

¾ glycerin

The gum solution is made by pouring 5 fluid ounces of hot water on 2 ounces of crushed or powdered gum arabic (2 ounces of finely pulverized gum arabic will equal approximately 2½ ounces by volume—it will be slightly less). The damar varnish is the usual 5-pound cut mentioned under varnishes.

The oily mixture is added to the gum solution in a slow stream with constant agitation, which is continued until the mixture is a thick white liquid, homogeneous, and free from large globules or drops of oil. If no mixer is available, the emulsion may be made by shaking the ingredients together in a tall bottle no more than three-fourths full. The glycerin is to be mixed in thoroughly after emulsification of the gum solution with the oily ingredients. This recipe may be used as a starting point by painters who wish to develop a medium to suit their particular needs. Variations in the proportions of oily and aqueous ingredients will change its film characteristics. Increase in the amount of glycerin will improve its brushing qualities but will also increase its solubility.

In addition to the advantages previously listed, this type of tempera emulsion uses only permanent, time-tested materials, and has oily ingredients the same as those that go to make up some of the most approved glazes, thus producing glazed pictures of correct physical structure.

Solutions of gum arabic decompose upon standing, but to a much lesser extent than do those of casein or egg. Gum tempera medium will keep in tightly sealed bottles for over a year; but if the bottles are imperfectly corked so that a little air can get in, it will soon develop mold on the surface. Glycerin has a definite preservative effect and helps somewhat to retard decomposition. Generally speaking, it is not worthwhile to com-

plicate this easily prepared and long-lasting emulsion by the addition of preservatives, but should the occasion require it, either sodium ortho-phenyl phenate, described on page 393, or a 10-percent solution of phenol (carbolic acid) may be used; with the latter, an addition of 1 percent of the volume of the emulsion is generally sufficient. A small amount of pine oil added to the oily ingredient will act as a mild preservative and will also improve the odor of a gum emulsion. The properties of glycerin and gum arabic are mentioned further in Chapter 11. The emulsion itself holds together well in storage; if it does not contain too much water there will be a definite creaming, but the emulsion can be homogenized again by a little shaking. Gum arabic and oil can also be emulsified by another method; a formula of Friedlein's[68] is as follows: 100 parts of pulverized gum arabic are well ground with a mortar and pestle until free from lumps. Measure 150 parts of poppy oil and 120 parts of water into a wide-mouthed glass, dump this into the gum arabic in the mortar, and rub continuously until emulsification is complete. This will take only a short time. Then add 20 parts of water in small successive portions.

Cherry gum has been used successfully in tempera and may be sub-stituted for gum arabic in the above formulas. Some tempera specialists believe that it is superior to gum arabic. Its use dates from very early times and it may be a more authentic material than gum arabic for du-plicating some of the older temperas. It is described further on pages 378–79.

A typical or starting-point formula is the following (proportions given by volume):

> 12 parts cherry gum solution
> (2 ounces gum and 6 fluid ounces water)
> 4 parts stand oil
> 4 parts damar varnish
> 1 part glycerin

WAX EMULSIONS

Tempera paints made with wax emulsions have many good qualities. They are quite resistant to external moisture and their color effect is bril-liant; if the paintings are burnished or polished with a soft cloth or absor-bent cotton, a lacquerlike effect will be achieved without varnishing. However, unless it is important or highly desirable to retain the original finish, it is perhaps safest to varnish them as one would an oil painting.

In order to employ beeswax in tempera emulsions, it is first necessary to saponify it; that is, make it into a soap by heating it with an alkali so-lution. If the formula is not accurately compounded and an excess of al-

kali is present, free alkali will remain in the emulsion and the resulting medium will turn yellow.

The use of saponified beeswax in painting mediums is of great antiquity; references are to be found in the earliest writings and in the records of most later periods, but there are few if any standard, complete techniques established in modern practice. Some investigators believe that one of the means the ancient painters had for making a fluid paint before the days of turpentine and other volatile solvents was the use of a waxy medium that could be thinned with water. At present its use is confined to painters who adapt it as a result of independent experiment.

Wax soap is best prepared by boiling 1 ounce of white beeswax with 5 fluid ounces of water and after it has melted pouring in slowly, with stirring, ½ ounce or a little less of ammonium carbonate that has been mixed to a creamy consistency with a little water. A teaspoonful of half-strength ammonia water may be substituted for the ammonium carbonate if desired. Continue the heating until all the ammonia gas is driven off and allow the mixture to cool, stirring occasionally. This wax soap will be pasty and usually must be warmed before use; if a creamier consistency is required, increase the original amount of water. At this point the saponified wax is not a good paint vehicle; it is an ingredient to mix with other materials, both aqueous and oily. Emulsification with oily ingredients is assisted if an ounce or so of turpentine is added before putting in the alkali. If the wax soap is emulsified with egg or some other aqueous medium, the resulting mixture may be freely thinned with water.

Among the materials most recommended as ingredients of wax emulsions are simple-solution varnishes, oleoresins, casein, glue, and gum solutions; as plasticizers, glycerin and castor oil. The drying oils are generally condemned on account of their tendency to cause such emulsions to turn yellow, but stand oil and some of the modern varnish linseed oils may possibly be suitable. Further uses of beeswax are noted in Chapter 11 under *Waxes* and in Chapter 8, "Encaustic Painting."

Wax soap must be entirely free from uncombined alkali if it is to be mixed with resins or oils; otherwise soaps of these latter materials will be formed. Careful users will warm the wax solution until all ammonia odor has disappeared or until the mixture no longer turns red litmus test paper blue.

Tempera mediums that contain wax are not easily managed or controlled and must be accurately made and well tested to guard against erratic behavior. In the hands of an experienced painter they are capable of being applied to work of great delicacy. Very few of the published wax tempera recipes can be used directly without some experimental adjustment.

Friedlein[68] gives the following recipe for a different sort of wax preparation to be used in emulsions: melt equal parts of white wax in castor oil; remove from the stove and thin with 5 parts of turpentine; keep in a tightly closed can, and use by emulsifying with egg, casein, gum, etc. Typical formulas for such emulsions are: 15 parts of wax mixture to 10 parts of gum solution; 100 parts casein solution, 60 parts wax mixture, and 50 parts water. This wax preparation, unlike the saponified wax, is purely an oily ingredient and is meant to be emulsified with hot aqueous solutions.

Wax emulsion painting is not to be confused with the encaustic or hot wax technique, nor with the experimental use of wax compounds added to oil colors.

OIL TEMPERA

Under *Emulsions* on page 437, mention is made of a water-in-oil or reverse type of emulsion in which the water is dispersed in minute globules in the oil. A familiar example is butter, in which the aqueous constituents are suspended in minute globules in the butterfat. Such emulsions may be thinned only with turpentine or other oil-miscible solvents and not with water, and so if it is desired to add a little more water to such mixtures than that which naturally comprises half of the yolk, it must be mixed with the egg before the emulsification.

Egg yolk carefully separated from the white and mixed in the proper way with no less than twice its volume of stand oil will result in a medium that has very interesting properties. Laurie[51] suggests that it may have been used in the fifteenth-century Flemish method. (The usual reconstruction of this method employs painting wet into wet with aqueous tempera and oil-resin mediums.) The definition of tempera given at the beginning of this chapter does not cover this type of emulsion; yet from the point of view of its use, behavior, and effect, it is classed among the tempera mediums.

A few drops of egg yolk or egg yolk and water mulled into a tablespoon of stand oil, other oil, or a mixture of damar and oil like the third recipe on page 225, but with the omission of the oil of spike or other volatile solvent, will produce a medium which can be diluted with turpentine instead of water and which has working properties different from those of any of its ingredients and from those of aqueous tempera. Its film will not usually dry faster than its oily ingredients alone, nor will it be more resistant to the action of solvents. The properties of the medium will change as more drops of egg are added and when the volume of egg or egg solution passes one-third of the total, the mixture will change over or revert to the

oil-in-water type, which is miscible with water. Another experimental oily painting medium of a stiff, buttery consistency and glossy effect can be made by lightly whipping a little gum arabic solution into linseed oil in which damar resin has been dissolved by heat (1 part by weight of damar to 2 parts of oil).

These emulsions have been employed by experimental painters, but because no standard tradition has been established they must be closely observed and tested before being used, to make certain that they are homogeneous mixtures miscible with solvent and that they will dry well. The presence of finely divided pigments is helpful in the formation of water-in-oil emulsions; tube oil colors can be used in their preparation.

The presence of much turpentine in an emulsion recipe definitely favors the formation of the regular, or oil-in-water type; on the other hand, formation of the water-in-oil type can be aided by omitting all volatile solvent from the mixture. I find that whole egg gives results far superior to those of egg yolk, in every respect.

The principal drawback to the wide acceptance of these materials has been our lack of data regarding the permanence of paints made with them. Experimental painters have been attracted to them because of their distinctive textural effects and manipulative or brushing qualities.

There is an impression among some that if the ingredients are properly balanced, an emulsion can be made which may be diluted with either water or turpentine. This is not a correct statement; it is not in accordance with the present theory of emulsions, and such a condition would be of doubtful value in any case. However, when the outer phase or surrounding medium contains an emulsifier or a readily emulsifiable material, an addition of turpentine or oil can be made to enter a further emulsion with it, and in some cases may go into the original emulsion as easily as though it were a simple thinning or dilution. True emulsions of either type, however, can be thinned only with their appropriate solvents, and it usually requires additional shaking or mulling to incorporate more oil into an oil-in-water emulsion. The structure of all such mixtures is likely to be quite complex. See dual emulsions and the inversion of emulsions, pages 437–38.

Balance of properties for all-around use is more difficult to achieve in water/oil emulsions than in oil/water emulsions; the film usually has many of the characteristics of the oily ingredient, especially its solubility. One part of egg yolk emulsified with 1 to 2 parts of heavy damar (8-pound cut) and thinned with 1 part of turpentine gives a nonyellowing painting medium which handles well but which is as soluble in turpentine as is straight damar varnish. This emulsion keeps for a long time in bottles.

CASEIN TEMPERA

Emulsions of casein solutions with oils are easily made. They have good structural or film-forming qualities and are quite stable, but they invariably have the unfortunate property of turning yellow or brownish yellow with great rapidity. Casein-oil tempera should never be used for permanent work, and oil should never be used in casein grounds if their brilliance or whiteness is to be preserved. Although prepared tempera colors made with casein have been sold in tubes, there have been no standard methods or formulas in common use, and artists who wish to employ casein emulsions must do their own testing. Nonyellowing emulsions of casein may be made with saponified wax, Venice turpentine, damar varnish, etc.; any tendency of the medium to turn yellow will soon be disclosed if it is ground with zinc white, painted out, and exposed to sunlight in the way in which pigments are tested for fading (page 107) or coatings for yellowing (page 99). Simple casein solutions for use as painting mediums cannot strictly be classed as temperas, because they are not emulsions. (See page 199.) Painting with straight casein colors is described on pages 388–90.

TECHNIQUES OF TEMPERA PAINTING

In addition to the outline of procedures for the pure egg-yolk tempera on pages 217–22, the following remarks include some points which apply to all variations of the medium.

The oil-painting process came into use and largely supplanted tempera as an entirely different technique that could produce entirely different effects; watercolor painting is used for the same reason; and tempera owes its present popularity mostly to the fact that it produces paintings of a character different from that of oil or watercolor work. There is, therefore, little reason to attempt the imitation of oil or watercolor effects in tempera; if these are desired, one had better use the appropriate medium.

Long experience has acquainted us with the advantages of each medium, we have become accustomed to certain ideas of how each one should look, and we are usually prone to be rather critical when the effects of a medium do not comply with our notions of what is fitting. Before beginning work the artist has a visualization of the final results, and decides the details of the technique to be used on the basis of personal preferences and experience.

The traditional tempera techniques are all based on deliberate, me-

thodical, well-planned procedure—particularly those which employ oil or oil-resin glazes, where, as has been mentioned previously, the optical effect depends upon built-up elements or layers rather than upon the inherent properties of a single direct medium as in oil painting. However, within limitations tempera is also applicable to more spontaneous or direct methods of painting, and it is beyond the province of any commentator or instructor to determine the limits on technical grounds, although he or she may justifiably criticize the results of an inappropriate application of materials. Some painters are personally or temperamentally able to use the tempera medium successfully in a much more direct manner than others; the majority of those who favor tempera, however, prefer the methodical step-by-step construction.

The usual or standard procedure, based on the traditional pure egg-yolk technique, is to make a complete drawing and trace it upon a gesso panel which has been brought to a smooth, ivorylike finish, as described in Chapter 5. The artist has a clear idea of the final effect desired and, according to preference, may either trace the drawing in detail or merely outline the significant or guiding points. If the drawing is made directly on the gesso with a lead pencil, care must be taken not to clog the white surface with too many soft smudgy pencil marks or mar it with the scratches of too hard a pencil. Pencil lines or tracings are strengthened by going over them with a pointed watercolor brush, using diluted watercolor or ink of any shade; however, if the tempera painting is to be thin and rather translucent, these lines should not be so strong in color as to show through and produce an aquarelle or unsubstantial effect, which is generally not in keeping with the more opaque tempera effects. The painting is done thinly with much dilution of the color, achieved by dipping the brush in water, and color gradations are made with fine strokes or hatches rather than by the oil technique of blending or scumbling. Red sable brushes are used more often than bristle brushes, but this is again a personal matter. As noted on page 221, however, the classic or traditional pure egg tempera painting of any degree of delicacy demands the use of nothing but the very finest quality red sable watercolor brushes. Most experienced painters prefer that the brilliant white ground be covered up immediately with at least a thin veil; its luminous effect will always be there, but its actual appearance is not in accordance with the best traditions.

If the painting is not to be glazed, full, deep-toned colors are used from the first in its execution; if it is to receive glazes, the undercoat is ordinarily kept very pale or chalky, resembling the tones popularly called pastel shades. The actual hues and shades used in underpaintings are a

matter of preference based on experience; usually the final color reduced with white will suffice, but for some effects there is an advantage in using a cooler or a warmer shade of the same hue, or an entirely different color. The brilliant red draperies of some old paintings were often made by applying a glaze of some lake such as madder over a rather strong tint of vermilion. Blue skies were underpainted with a pale yellow or pink; flesh tones with a variety of transparent colors. Sometimes the flesh was completely modeled in cool monotone and then given a warm, lifelike, transparent glaze; sometimes green earth and white were used in such underpainting and sometimes a full range of very pale colors. One method of painting the earth in a landscape was to model it completely with burnt sienna and white, overpainting local hues with both opaque and transparent colors. All of these procedures and modifications of them are in use. If the technique and methods of a painter have been established through oil painting or watercolor, he or she will find that obvious adjustments of those methods must be made but that control of the medium will usually come after a little practice.

Those who wish to emulate the exact effects of the early Italian tempera painters will find in the treatise of Cennini[8] routine instructions on how the various elements of a picture are handled—the figures, the flesh tones, the draperies, landscape, etc.; these have also been gathered and put into practical form by V. and R. Borradaile.[9] Most present-day users of egg tempera, however, use these traditional materials and manipulations according to their customary modern methods of painting, rather than adhering too closely to the palette and the restricted and thoroughly disciplined forms in art as practiced by Cennini.

Wet-into-Wet or Mixed Technique

When colors that have been mixed with an oily glaze medium are glazed or not too heavily painted over a tempera underpainting or directly upon a sized gesso panel, and the work is continued by painting with aqueous tempera into this oily layer while it is still wet, a sort of crisp contrast in textural and optical values is achieved. The effects are sufficiently different from those of other methods to be placed by some painters in a definite class by themselves.

Many of the effects produced by variations and extensions of this method cannot be duplicated satisfactorily by other means, and investigators have long attributed to this procedure certain results obtained by the early schools of painting, especially by the fifteenth- and early-sixteenth-century Flemish and German painters; the method is also

thought to have been used during the transition period prior to the adoption of straight oil and oil-resin techniques; statements in early writings substantiate both of these contentions.

Two entirely different effects produced by wet-into-wet painting are the depiction of very fine crisp lines (such as hair in portraits), generally done with the point of a small brush, and in the loose, free, rather draggy opaque areas of pale color or white surrounded by or covered with transparent glazes of deeper, darker tones. In the latter case various effects are produced by playing the opaque tempera and the transparent or translucent glazes against one another and by confining the cool or the warm side of the palette to one or the other.

The principle is subject to considerable variation on the part of individual painters, and if they find it suitable to their requirements they are most likely to use it in a personal or individual manner. It may be employed throughout a picture or for occasional effects. As remarked in the section on watercolor painting, any picture which combines opaque and transparent effects must be either well planned in advance or executed by an experienced hand in order to avoid unpleasant optical results.

If painting into wet layers is confined to separate brush strokes rather than covering broad flat areas, if there is a close connection between the ingredients of the oily and aqueous mediums, and if the layers of oily medium are kept very thin, cracking does not occur. Use of tempera and oily mediums of too widely divergent properties and use of extensive areas of tempera over thick oily layers should be avoided.

Thick or impasto tempera should be used only in the first layers; if repeated alternate coats are required, then the additional tempera as well as the oily paint should be kept very thin.

The most popular and successful materials in use for this sort of painting today are (1) a whole egg/oil emulsion used in conjunction with a glaze medium made from ingredients which are the same or have the same properties as those of the oil or resin content of the emulsion; (2) a gum solution/stand oil–damar emulsion used with the stand–damar glaze medium. Final glazing coats, especially if they are to cover the entire picture or are to be used on considerable continuous areas, should contain a little extra oil in order to assure the proper structural flexibility, and if drier must be used anywhere in the picture it should be kept to an absolute minimum. The addition of cooked varnishes such as copal and other commercial types is likely to cause rapid checking of glazes in an "alligator" pattern. In some techniques, particularly with the gum-tempera procedure outlined above and for final glaze coats, regular tube oil colors, drained by spreading them out on paper for a while, may be mixed

with the oily or resinous medium to a glaze consistency instead of grinding dry pigments directly into it. As a general rule, if paintings executed in the mixed technique are going to fail by cracking, this defect will display itself immediately after they become completely dry, or within a very few weeks thereafter; if no such early failures occur, work of this type may be considered to be as durable as any other form of tempera painting.

READY-MADE TEMPERA MATERIALS

Most of the materials necessary for painting in tempera may be had ready-made, but, in order to secure perfect control of the technique so that it may be adapted to their individual requirements and also for reasons of economy, many painters prefer to make their own. Although excellent results as to both durability and satisfactory application may be secured by the use of prepared materials, it is generally conceded that some first-hand experience and knowledge of their composition and preparation is necessary for their proper use and selection. Such experience enables a painter to identify the general nature of the prepared materials and, if necessary, to adjust them to his or her requirements.

In America, poster or show-card colors sold in jars are sometimes labeled tempera, and the term has some circulation (but inaccurately) in the commercial art field as a designation for any opaque aqueous paint as distinguished from oil paint or transparent watercolor. There is also, occasionally, some confusion with the term "distemper" (see page 626). Correctly, these colors, which are mostly of the simple gum-water or glue-size type, should be known as poster colors, also called show-card colors. Use of the word "tempera" by some makers is apparently prompted by the need for a name to distinguish the finer grades of poster colors from the inferior kinds. True tempera paints are never sold in jars, but in tubes; their use was highly developed in Germany, where all sorts and varieties were made—good, bad, and indifferent. I am well acquainted with only one brand of prepared tempera (Rowney's from England); these are said to be carefully made from an egg emulsion and they have been used with success by many painters; others prefer the working qualities and effects of their own particular mixtures.

The evaluation of prepared tempera paints is, in general, quite simple, at least for the artist who has made his own and is familiar with their requirements; the principal test is whether they will perform in the desired manner when subjected to his manipulations. The yellowing of im-

properly combined mixtures, such as casein with linseed oil, usually shows up after a month or two of testing by exposure to sunlight in the usual manner.

Laurie[51] suggests that prepared tempera paints be tested for alkalinity with litmus paper, and that a lump of the color as well as a brushed film be placed on glass and allowed to dry for a month. At the end of this time it should not have cracked, and if left to stew in hot (not boiling) water for several hours it should neither disintegrate nor separate from the glass. As mentioned in connection with prepared painting materials in general, the reliability of the maker is also an important consideration.

Gesso panels on plywood and cradled Presdwood may be had ready-made or made to order; the process and its principles are simple enough to lend themselves to commercial production without any difficulties, and there is little reason for the substitution of inferior materials. The artist may quite easily judge for himself by an examination of their workmanship and surface properties whether or not they are of high quality.

Prepared tempera emulsions of secret composition are best shunned, unless they are sold as being the same medium as that employed by the firm in question to make prepared tube colors which the artist has selected as suitable for use. Other liquids for tempera painting, such as glazing mediums, varnishes, etc., present the same problems as do similar products for oil painting; very few of them are sold with a complete, unequivocal analysis of their exact percentage composition.

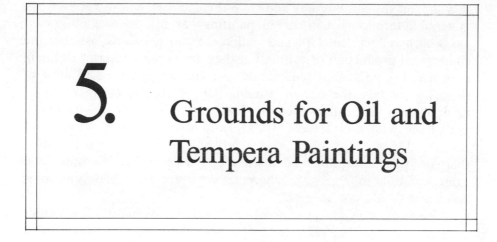

5. Grounds for Oil and Tempera Paintings

THE MATERIAL UPON which an oil or tempera painting is executed is divided into two parts, namely, the actual surface or ground, and the support which is the foundation, backing, or carrier for this surface.

The three chief grounds in general use are oil grounds, gesso grounds, and emulsion grounds, which are a mixture of the first two. A number of other grounds enjoy less popular use.

The principal supports in use are textile fabrics stretched on wooden frames, wooden or composition-board panels, and, rarely, thin sheets of metal.

CANVAS

The word "canvas" does not refer to any specific material in the field of textile fabrics, but is applied to a number of closely woven materials of relatively coarse fiber, such as are used for sails, tents, awnings, etc. In painting, the term "canvas" generally implies a coated fabric, ready for use; the word is also employed by commentators to mean a finished oil painting.

Practically every closely woven textile has been utilized at some time as a support for paintings. Legend tells us that linen canvas stretched on wooden frames was first used for paintings of religious subjects to be carried through the streets in processions, especially in Italy. However, cloth

239

as a support for painting was known to the ancients, and it was a logical material to turn to when artistic oil painting was introduced. Cotton canvases, such as duck, sailcloth, and twill, came into occasional use after the commercial production of cotton, but they are entirely inferior to linen; they stretch poorly, they tend to give an inferior surface, and most of them do not take the size or priming well. Only the cheaper sort of ready-made artists' canvas is cotton. The best material is a closely woven pure linen with the threads of warp and woof equal in weight and strength. Linen-cotton mixtures are probably worse than pure cotton; their unequal absorption and discharge of atmospheric moisture will cause variations in tension. Jute becomes very brittle and lifeless on short aging and should not be used.

Linen canvas is distinguished from cotton by its natural linen color (cotton is white or very pale) and by the bold character of its weave effect which persists through layers of paint—desirable in both fine and coarse textures. Prepared or primed cotton canvas presents a flat and flimsy surface; it could really be called an imitation of the original, and its use is justified only in the cases of extreme economy, shortage of supply, or for art school and practice sketches. On the wall, and especially in the company of linen canvases, paintings done on cotton can usually be identified at a glance.

The cost of pure linen is a major item to the canvas maker and this encourages him to do a good job on the priming, and not to lower its value for the sake of the small difference in cost of the coating. On the other hand, with the cheap cotton canvas and its low competitive selling price, the quality of the priming is likely to be skimped; thus the average cotton canvas usually is a low-quality product all around.

Ready-made canvas has the advantage of being prepared in shops that are in continuous operation and are well equipped and manned by skillful workers so that a flawless, even product is made. On the better grades, the priming has just the right degree of absorption and flexibility and is well attached to the linen by being forced into the weave, using a minimum amount of material. The homemade product also has its own advantages; the materials can be selected solely on the basis of the artist's criteria of permanence, suitability, etc., unhampered by certain considerations that must be taken into account in commercial manufacture, storage, and distribution.

During the early nineteenth century a smooth canvas with a diagonal or twill weave was in wide favor, especially for portraits. The work of several of our most prominent early American painters can be recognized because they habitually used a canvas of a particular weave. Prior to the introduction of mechanically produced close weaves, a handloomed

square weave of coarse single strands was used; this was sometimes a very open weave and required a filling of thick glue.

Prepared artists' canvas is sold in two grades, "single-primed" and "double-primed," and the controversy as to which is the more desirable seems to be unending. Double-primed is more expensive and more rigid and hence to the majority is considered better. Some painters, however, believe that the single-primed has greater longevity because it is more pliable and limber; old canvases with a thin coating of paint are frequently found to be much more supple and less subject to cracking when handled than those on which the coatings are thicker.

Priming Oil Canvas. Stretch the linen as directed on pages 245 ff and impregnate it with size as described in that section; on drying it should become somewhat tighter and free from folds and wrinkles. Some careful workers will first drench it with water as an extra shrinking or tightening operation and then do some restretching if it is not tight enough to suit them.

Size is considered an absolute necessity; oil paint should never come into direct contact with the fiber or the canvas will "rot," that is, eventually become weak, brittle, and crumbly. This has been known to artists for hundreds of years, and some of the earliest examples of oil paint on canvas are found to be thoroughly sized with aqueous glue.

When the size has dried, apply the white priming with a brush in an even coat, as thinly as possible; sometimes a painter will go over the first coat of a double-primed canvas lightly with a wall scraper (page 532) to ensure its being very thin.

A high-quality priming can be made by mixing one pound of stiff white lead in oil with three fluid ounces of turpentine. (See flake white, page 48.) This will not have the free-flowing consistency of the customary house paint but it brushes nicely and may be applied in a level, uniform manner. Brush it well into the weave of the canvas with a back-and-forth wrist motion in all directions; then finish with a long, straight smoothing stroke absolutely in line with the canvas weave so that the brush marks will not be apparent. This should dry in three days or so, after which it should be lightly sandpapered with the sandpaper loosely held, the idea being not to take down any of the coating at all but to shave off the stiffened fuzz of the canvas. This difference of surface can be immediately discerned by stroking the unshaven and the finished areas with the palm of the hand. Then apply a second identical coat, allow it to dry, and it is finished.

White lead and flake white are different names for the pigment *basic lead carbonate;* they are also used at times to describe different products,

for instance flake white as oil color in tubes, white lead as oil ground for priming. Consequently, their compoundings are based upon different formulas, taking into account their different purposes. Flake white as paint in tubes is thinner, containing more oil, hence virtually ready for use, though lending itself to reduction. White lead, as heavy paste in cans, is solely intended for priming purposes. There is currently a scarcity of white lead paste in the marketplace. Flake white may be substituted for white lead priming provided the flake white is ground in linseed oil, but substituting flake white ground in poppy oil is not recommended. It is to be hoped that potential manufacturers of white lead paste will someday bring back this important material, employed for over five centuries, for discriminating use by artists, who can control its toxicity.

The commercial paint-store white lead in oil (Dutch Boy or equivalent good-quality brand) is fine for this use, but do not attempt to use it for final painting because it is not good enough for that purpose. It must be exposed to daylight during its period of drying in order to avoid excessive yellowing. If linseed oil is added to such priming it may give the paint a free-flowing consistency, but it is generally believed to produce a coating less in accordance with the "fat-over-lean" principle (see page 157). Canvas of this type can be used soon after it has been made, but some authorities recommend aging it from one to six months—the point has never been settled by scientifically controlled tests.

Addition of oil also may produce a surface that is too nonabsorbent and perhaps too glossy. Too much turpentine will result in absorbency, porosity, and lack of toughness and durability. The above recipe is designed to give the average desired semimat, slightly absorbent finish. Note the precautions for handling white lead (page 104); it is not dangerous if normal cleanliness is observed. Any bristle brush may be used; the cutter described on page 529 is ideal.

Much modern prepared canvas is made with titanium or zinc, but good grades of these in oil are not available to the retail consumer except in the expensive tube colors. Their sole advantage is their snowy whiteness; structurally white lead is superior. Various mixtures of zinc and titanium based on their performance in house paints are also in use, ranging from 40 to 60 percent of either. Note the properties of the various whites on pages 92 ff. Both zinc and titanium dry to form much more brittle films than those produced with white lead.

When additional tooth or coarseness is desired, a coarse, inert reinforcing pigment, such as silica or pumice, may be ground into the paint up to 10 percent. No dry pigments should be merely mixed with oil for priming purposes; they must be ground—**not necessarily** finely ground

but mulled enough to ensure wetting of the individual particles and uniformity of the paint film. When coats of different composition are used, it is always better to apply the coarser one first and always absolutely necessary to apply the more flexible one last. Most commercial primings are tinted slightly grayish to overcome a tendency toward yellowing.

The usual preferred sizing material is hide glue, dissolved according to the procedure described under preparation of gesso on page 261, but diluted with water so that it forms the weakest sort of semijelly on cooling. Casein has been recommended for this purpose, because when dry it is much more water-resistant than glue or gelatin; but glue is far superior because casein is too brittle. The moisture resistance in both cases is greatly increased by the use of formaldehyde, as explained on page 462. After the glue or casein size has dried, both sides of the canvas may be sprayed or brushed with the 4-percent formaldehyde solution.

A size is not a coating; it is a penetrating liquid employed to fill pores, to isolate coatings, or to make surfaces suitable to receive coatings; it is not intended to form a continuous, level film. This is an important distinction, and one not always realized. It is difficult to give any strictly measured or weighed formulas, due to the variation in glues, but about 1½ ounces of rabbitskin glue to a quart of water will not be far from the correct amount. Its gel has the consistency of applesauce.

Direct application of oil to linen, definite and inevitable as its rotting effect may be, is no more ruinous to an oil painting (and is usually more amenable to conservation treatments) than a heavy film-forming coat of glue or casein, such as is sometimes found underlying an oil ground, particularly in eighteenth-century paintings. Glue, unreinforced by pigment as in gesso, or by starch or dextrin as in relining and industrial techniques, has little stability as a continuous film of appreciable thickness, especially under several coats of oil paint. The movement caused by its continual absorption and discharge of atmospheric moisture often results in a complete and heavy scaling of the entire picture, a condition that can be repaired only by transferring the paint film and removing the size, one of the most exacting and laborious of restoring techniques.

As remarked elsewhere, linseed oil is not a strong adhesive, and the film of an oil ground should be allowed to get some sort of hold in the interstices of the canvas, which should be isolated from chemical action but not from a mechanical bond with the oil ground. The anatomy of an oil painting and similar matters discussed in Chapter 14, "Conservation of Pictures," may be referred to in this connection.

The ground is not merely a first coat of paint over the support; for permanent wearing qualities it should not be dispensed with by painting

the picture directly on the support. Besides supplying the necessary white color, uniform texture, degree of absorbency, etc., it furnishes an intermediate structural layer between the support and the painting layers.

The sizing of canvas with a solution of cellulose has been suggested on the theory that it will not rot the cloth, will not absorb and discharge atmospheric moisture, and will be chemically the same substance as the fibers. To this suggestion I would add the precaution that care should be taken to use this material sufficiently dilute to be a size which merely seals the absorbency of the fibers, and not an actual film; cellulose coatings will form continuous films even when quite dilute, and such films would present a rather precarious bond for the oil paint. Any one of the pure solutions of cellulose or pyroxylin lacquers may be used together with any convenient solvent, and because of the present novelty of the procedure and its experimental nature, it would be well to make a permanent notation of the combination on the back of the canvas. These materials produce films which are totally foreign in composition and properties to the usual painting materials; this feature may be of greater significance than the fact that they are related in composition to the textile fibers. Glue size leaves little to be desired from a functional viewpoint; its incomplete resistance to moisture, or its hygroscopicity, is its only fault, and this can be overcome to a large extent by tanning the back of the canvas with formaldehyde and by protecting the rear with cardboard (pages 249–50).

Circumstances sometimes make it necessary to roll finished pictures, but they should preferably never be rolled. When it is unavoidable, they should be rolled around a cylinder of as large a diameter as is convenient. Canvases should always be rolled face out; the tension produced is less injurious than the compression caused by rolling them with the painted side inward; also when they are unrolled, the strains of tension are relieved and the danger of cracking diminished rather than intensified, as would be the case had they been rolled face in. The practice of placing paper over the painted surface is generally not a good one; it is likely to cause more damage by adhering tenaciously than the canvas causes by rubbing. Glassine paper sticks least. Gesso or semigesso grounds on canvas will usually begin to crack immediately when rolled.

A much better way to preserve unstretched paintings, especially old ones, is to thumbtack them face down to sheets of wallboard, so they lie flat. For shipping purposes they may then be covered with another piece of wallboard and tied securely with twine.

Well-made modern linen canvases should give permanent service; the best firms have apparently profited by the experience of past generations of canvas makers, with the possible exception of their tendency to use linen that is too thin or lightweight. The disintegration of old canvases

around the edges of the stretcher frame is common. Early nineteenth-century English and American pictures on commercially prepared linen canvas are often found intact after more than a hundred years of storage under average circumstances, but a large majority of them require relining or reinforcement at the edges from seventy-five to one hundred years after being painted, even though the face of the picture is intact, particularly when the canvas was primed after the stretching and the folds and margins were not sized and protected by the priming. Few, if any, eighteenth-century oil paintings of value in collections have survived intact without being treated by restorers.

The cloth is obviously the weakest point in the survival of a well-made picture; but previously mentioned advantages, including the important fact that defective paintings on canvas can be repaired or conserved more satisfactorily than those on other supports, have caused linen to retain its position as first choice as a support material ever since it came into general use. Of the painters who use oil grounds on panels, the majority do so because they prefer the smooth, textureless surface rather than for any advantages resulting from the rigidity.

Gesso on Canvas. In view of the incomplete scientific data on which we can base opinions, I do not wish to be dogmatic on the subject, but strongly recommend that canvas on stretchers should be used only for oil painting on oil grounds, polymer painting on polymer grounds, and the classic or hot-wax type of encaustic painting. Canvas was originally developed as a support for oil paintings. The defective results I have seen when gesso grounds, emulsion grounds, tempera and casein paints, and other coatings of inferior flexibility have been applied to canvas bear this out. Some of the advanced or complex "mixed techniques," which combine oil painting with minor additions of an egg-in-oil tempera medium, are sometimes applied to canvas, but it is pretty generally agreed by students with past experience that casein, gouache, and other paints with aqueous binders do not have sufficient flexibility to withstand the movements that canvas undergoes, and that canvas does not give gesso grounds sufficient protection against penetration of moisture from the rear.

Stretchers. The universally used stretcher bars of the tongue-and-groove type, with mitered corners and beveled sides, are made by automatic machinery and are superior to the older kinds and to most of those used in Europe. They are generally made of selected pine or ash, kiln-dried. The ordinary dimensions of those carried in stock in artists' supply stores are: 1¾ inches wide, about ⅞ inch thick, and from 6 to 60 inches long. Lengths in fractions of an inch can be ordered, as well as a chassis

with the highly desirable crossbar. A chassis is an assembled stretcher frame.

Much more rigid and durable stretchers are those 2½ inches wide, beveled on one side only; they are not kept in stock but are made to order by the same firms that make the stock stretchers. These heavy stretchers should be used on large pictures and in the conservation of old or relined paintings of any size. If crossbars are ordered on these stretchers they will usually be keyable; those on the common-weight stock will not be, unless so specified. Stretchers are usually made about ¼ inch short to allow for keying; if exact length is required of made-to-order strips, that fact should be specified. This is sometimes important when the painting must fit an old frame or when European canvases are to be restretched.

Both the ready-made and the made-to-order stretchers of the shops are of acceptably good quality but when high precision and the utmost in perfection are desired, as in museum work, custom-made 2½- or 3-inch stretchers are obtained from a cabinetmaker or specialist. See further remarks about stretchers on pages 472–73 and 644–45.

In France the dimensions of canvases and frames are standardized into fifty-seven numbered sizes, nineteen each of three shapes called *figure, paysage,* and *marine.* This system is advantageous in that a large selection of both canvases and frames in conventionally pleasing shapes constitute stock items that can be ordered by number. A common notion is that the system has been arranged according to some mathematical law of proportion or symmetry, but more probably it was arranged by dealers and artists to afford the greatest possible number of choices with a minimum of stock.

Stretching Canvas. There are a number of satisfactory systems to follow in tacking the canvas to the chassis. I find the following method satisfactory. Make sure the chassis is perfectly true by pushing its corners firmly into a corner of a door jamb to align it and by measuring both dimensions at the center with a steel tape. A piece of canvas 3 inches longer in each dimension is cut from the roll and placed face down on the table or floor. The chassis is centered on the back of the canvas. After the strips have been aligned with the vertical and horizontal weave of the canvas as nearly as possible, there will be a margin of more than an inch all around. Drive in a tack at the center of each strip, using the stretching pliers with strong tension. The canvas will then have a diamond-shaped wrinkle. Drive in tacks at regular intervals on a long side starting at the center and working up to where the tongue and groove begins, leaving the corners untacked. Use the stretching pliers with strong tension but not so strong

as to wrinkle the canvas between the tacks. Before placing each tack, tug the canvas with your other hand to make it taut horizontally. When the corner is reached, turn the canvas over to the opposite long side and tack the diagonally corresponding half; then complete both long sides before tacking the short sides in the same manner. Finally, tack the corners, being careful to place the tacks at the right-hand ends on the lower portion of the edge and those at the left-hand ends on its upper portion (right and left when facing the rear of the canvas). A glance at the construction of a chassis will explain why this is important: The lower part of the right-hand end and the upper part of the left-hand end are wide and solid enough to receive centrally placed tacks without splitting. The corners are finished by tucking in the canvas over the right-hand ends as in drawing A, not by folding them over as in drawing B. They will then be neat and trim. They will fit into a picture frame better, and have no exposed tab that may be caught accidentally and damaged. In stretching, the aim should be to make the canvas sufficiently smooth and taut without resorting to expansion of the corners, so that the keys or wedges are kept in reserve to tighten the canvas should any subsequent slackening occur. When used, the keys should be driven in uniformly by counting the number of hammer blows. Before using a hammer, be sure to slip a piece of cardboard between canvas and chassis at the corners to guard against accidental swipes of the hammer, a not uncommon cause of subsequent cracks occurring in the paint film near the corners. Nail a small brad into the inner edge of the stretcher strip, alongside and parallel to the end of each key, to keep it from falling out of its slot. Stretchers with expansible crossbars should have one key (not two) at the end of each crossbar, parallel to the sidepiece opposite that into which the key at the other end is driven.

It is advisable to leave an inch or more of surplus canvas and fasten it down to the rear of the chassis instead of trimming it off at the back edge of the chassis; this permits the canvas to be restretched if necessary. The surplus may be stapled down or pasted with rubber cement, after which

A B

its irregularities or the unwanted surplus, if any, may be trimmed by ruling with a razor blade. Note that rubber cement, useful for this purpose, is not an approved material for use in permanent techniques.

Regular number 4 steel carpet tacks are recommended for stretching; number 6 or larger may be necessary at the corners, where the tack must penetrate more than one canvas layer, or on heavy stretchers. I have found that one may guard against distortion of the chassis by the force of the stretching pliers, with four much larger tacks (such as number 14 or 16), driving one into the *back* of each strip at a point in the middle of the area where a tongue is sandwiched in the groove of the other strip, before starting to stretch the canvas. This helps maintain the shape of the chassis during stretching, after which these four tacks must be lifted with a screwdriver or tack puller.

Some painters fear the result of rusting iron and use copper or aluminum tacks, but these do not hold well in wood. Thoroughly rusted tacks hold well for centuries; perhaps secure, permanent holding of the canvas is a function of the rusting. With the easy availability of lightweight stapling machines after World War II, the staple began to replace the tack, expediting the job of stretching, but in every other respect thin staples are vastly inferior to tacks; if the edge of the canvas is pulled slightly when they are new, they come out easily, and the rusting of such thin wire can be a serious flaw. One artist told me he solved this problem by using a heavy industrial stapling gun with heavier, substantial staples. This may be true; I have not investigated it. Lightweight staples are handy for temporary use when placing the canvas on the chassis. They should subsequently be replaced by or fortified with tacks.

Protection of Canvases from the Rear. Eastlake[28] notes the extremely sound and careful set of precautions in the interest of durability established by the craftsmen of early days and mentions the fact that protection of the back of the canvas or panel was the single safeguard completely overlooked by them. He does not consider the possibility of their having had a definitely adverse opinion of this procedure. The most obvious method, application of a coat of paint or varnish, is not a good one for several reasons.

American nineteenth-century canvases carefully painted on the back have been found in bad condition; this, however, is by no means certain proof that the procedure has no value; we seldom know how or when the paint was applied or just what its composition was. An important objection is that unless the film applied is of almost mechanically uniform thickness, the variations in brush strokes will soon impart their effect to

the surface of the picture in the form of lumps and depressions because of unequal tension on the threads of the linen. Another objection has been the interference of such coatings with future repairs to a damaged picture.

Among some of the recommended methods for protecting the back of a canvas are giving it a brush coat of red lead or white lead in oil, coating the linen with tinfoil attached with gold size, impregnating the back with a solution of tannin or formaldehyde to make the size more resistant to moisture, and stretching an extra layer of canvas under the picture.

An examination of large numbers of American paintings on canvases commercially prepared from 1830 to 1870, and bearing the stenciled trademarks of makers in various American and European cities, shows that, instead of the practice of selling prepared canvas in rolls, canvases were most often coated after stretching, leaving the margin which is tacked to the stretcher frame uncoated. Almost all such canvases, even when the face of the picture is in excellent condition, become rotted around the edges, often to such an extent that the cloth may be rubbed to a powder between the fingers, and the intact face of the picture is sometimes found entirely separated from the uncoated margin. When linen that is mounted on its final stretcher is being prepared, the sides and corners should also be sized and painted.

When a sheet of cardboard is tacked to the back of the stretcher or picture frame so that some circulation of air is possible but the canvas is well insulated, the protection is great. Changes of temperature and humidity will affect the canvas more slowly and to a lesser extent than they would without this device, and the covering can always be removed for periodic dusting. An airtight seal would be less beneficial because canvases protected in this manner seem to rot and become brittle even more rapidly than exposed canvases.

Examination of decayed canvases of great age, of early American canvases, and also of those of 1890–1910 (which may be considered equivalent to those in current use), shows almost invariably that the portions of a canvas over the stretcher bars and crosspieces are in a better state of preservation than the rest of the picture; in the majority of cases, unless disintegration was due to abnormal circumstances, the preservation of these areas is perfect. This has been observed by Ostwald[46] and others, and it shows the efficacy of an independent layer of material back of the canvas, even when the protection is only partial.

According to Sully,[30] a beeswax preparation was used to protect the backs of some early American canvases, but pictures so treated do not appear to have survived in any better condition than untreated canvases of the same period. Stretching the linen double is a procedure of some an-

tiquity, but canvases stretched in this manner disintegrate as badly as any others. Possibly the principal advantage of applying paint or other coating to the back of a canvas is the additional rigidity imparted to the picture; when a gesso ground is coated on the back of a piece of prepared oil canvas the gesso resists cracking to a greater extent than when applied to plain linen.

To sum up the methods of protecting canvases from the rear, in order of their relative value:

1. Spray or brush the back with a 4-percent solution of formaldehyde (see page 463) after the size has been applied and preferably before the priming coat is laid on.
2. Attach a sheet of cardboard, wallboard, coated fabric, or heavy paper to the back of the framed picture in such a manner that the canvas is not hermetically sealed against all access of air but is well protected against accumulation of dust and dirt, direct drafts of air, and accidental pressure.
3. Leave the picture entirely untreated.

Of lesser or doubtful value:

4. Stretch a double canvas.
5. Seal the rear tightly so that all air is excluded as far as possible.
6. Coat the linen with wax or wax-resin mixture, metal leaf, or tinfoil.
7. Coat with oil paint, varnish, or lacquer.

As to the selection of prepared canvas, Laurie[51] recommends that it be tested by working it vigorously between the hands to see whether the priming is firmly attached; also that the yellowing of any particular brand be tested by cutting a sample in two pieces and allowing them to age for three months, one in the daylight and one in the dark; the brand that yellows least should be chosen. Insufficient attention to the quality and condition of prepared canvas is a common failing among painters, and inferior grades or pieces upon which crackling or flaking of the ground has already occurred are often used, when a careful examination before accepting them would reveal their shortcomings and thus preclude rapid and early failures.

Laurie also recommends that all canvas should be kept six months before use, in order to ensure thorough drying of the oil; presumably this means first stretching the canvas, then allowing it to age on the stretcher. Old, thoroughly dry canvas will sometimes crack when stretched, especially the end of a roll where it has been tightly compressed. Any ground on cloth can be made to crack when folded or sharply bent, but the comparative strength of coatings and their degree of adhesion can be estimated by a vigorous folding.

WOODEN PANELS

The wood selected by the early Italians for their panels was mostly poplar; that used by the Northern painters was oak. Eighteenth- and nineteenth-century Northern panels are usually mahogany. The Italian panels were generally very thick, the others much thinner. In England well-aged boards from old paneling or furniture were often used. Modern painters often seek such well-aged panels, and when they can be obtained, prefer them to new boards or plywood of recent manufacture. It is general knowledge among investigators and experienced craftsmen that well-made, properly designed panels composed of several plies of wood cemented or glued together are much more resistant to warping and splitting than are solid, one-piece panels. All fine furniture or cabinetwork is veneer or plywood.

The regular plywood universally available from the plywood dealers is five-ply birch, 13/16 inch thick; it is constructed with a thick lumber core (usually poplar or gumwood) to each face of which two thin plies of birch have been glued, with their grains running at right angles to the core. Such panels are also made with maple, walnut, mahogany, and other facings, and in a number of fancy grainings, none of which have any particular relation to the purpose; but the face should be free from such blemishes as are undesirable. The outer ply should be, so far as the size permits, of one piece; the purpose for which it is to be employed should be mentioned to the dealer; otherwise, a piece with a joint that would make a very beautiful grain effect in furniture work might be considered by him to be better than a plain panel whose face is one single sheet of wood.

Die Boards. Perhaps the best of the readily available plywoods are the die boards, made for technical use rather than as decorative woods; they are built of five plies of maple of equal or approximately equal thicknesses and so are probably more durable than the thick-core thin-veneer type. They are available in several dimensions; typical sizes are 24 x 36 inches and 36 x 48 inches in ½-, ⅝-, $^{11}/_{16}$-, and ¾-inch thicknesses.

Plywood is customarily sold as "good one side" or "good two sides," the latter being more expensive and unnecessary for our purposes. The "good" refers to unblemished surface effect. It is not recommended that any of this material be cut with a handsaw, as the outer plies are liable to be loosened and broken away at the edges; a circular saw is better, because the teeth go in one direction only; a band saw is still better. Finer plywoods of similar weight and thickness can be secured at greater expense from specialists who make them to order according to their judg-

ment as to the best kind of wood and the most desirable thickness for each ply. This general type of panel, although heavy and cumbersome, is much more durable and satisfactory than the thinner three- and five-ply panels (approximately ¼ inch thick) which are sometimes used for paintings.

The lumber core of correctly made plywood is composed of strips a few inches wide, sawn from planks and assorted so that they do not present a uniform, continuously grained structure; if the core were one plank, or pieces assembled from the same plank, there would be more likelihood of concerted warping and splitting. For the last fifty years or so the outer plies or veneers have for the most part been made by soaking and steaming the logs and then putting them through a machine which peels the thin veneer from them with a knife blade in a rotary manner. Some veneers are made by slicing through a halved or quartered longitudinal section of the log. The usual furniture veneer is made $\frac{1}{28}$ inch thick, but for technical purposes thicker plies are often made. Although the sliced and peeled veneers are dried and delivered in a flat condition, they tend to revert toward a curved shape when made wet again. For this reason, some careful panel makers insist upon using plywood in which all the plies have been made of sawn wood only. The fine, expensive furniture veneers, especially those with rare grainings, are commonly cut or sliced because sawing will waste too much wood; more sawdust than veneer is produced. Panels for painting, however, do not require any rare or finely grained effects, and plywood made with sawn wood of commonplace grain is often obtainable at a fraction of the cost of such furniture panels.

In localities where there are no plywood companies, a good lumber-yard can obtain the various commercial types on order.

In the majority of instances Presdwood is superior to wooden panels, and I believe that under the average modern American conditions it offers the best panel support available, at least for pictures of ordinary easel-painting size. Its properties are described more completely and compared with those of other wallboards in the following pages. Woods vary widely in their properties, but all of them are highly complex structures of cellular and laminated arrangement, subject to a number of defects and stresses which are absent from the denser varieties of wallboard.

WALLBOARD

Wallboard of one kind or another has been in use for light construction for more than a hundred years. The types available on the market can be grouped into several classes. They are all sold at lumberyards.

1. *Laminated boards,* made mostly from paper waste and wood pulp. These are really heavy cardboard, and when cut or broken they may be seen to be constructed of papery material in layers. There are a great many trademarked brands on the market—Beaver Board, Upson Board, etc.—all of approximately equal value. This material grows brittle very rapidly, and is altogether too fragile for use in any sort of support for durable painting. On account of its very low cost it is sometimes utilized for students' class work in oil painting; for this use it is coated with a thin shellac size followed by a coat or two of flat wall paint. The easiest way to cut this material is to rule a line on both sides with a sharp knife and break it smartly over the edge of a table. When it is desired to split and separate the two sides of a piece of such board, as when sketches have been made on both sides, this can be done with a large, pointed bread knife, the edge of which has been made somewhat sharper and smoother than is usually customary. Compo-board is a rather outmoded material made of a thin sheet of lightweight splintery wood faced on either side with sheets of brownish-red cardboard.

2. *Cellular* or *porous boards,* made in one homogeneous thickness. These materials are bulky and loose in texture compared with the other boards; one of their functions is to serve as an insulating material in construction. They do not offer sufficient resistance against average wear and tear to serve as supports for permanent painting; furthermore, they are subject to much internal expansion and contraction, and they tend to become brittle on aging. The most open-textured is *Celotex,* a familiar gray insulating board composed of cellulose fibers (from sugar cane) which have been rather loosely compressed and matted together by pressure alone. Celotex is said to contain no added binding material. Although it presents an interesting rough texture for some types of painting, experience proves that its structure is not nearly dense or rigid enough for durability; furthermore, the material tends to become discolored and brittle with age. Its weblike structure resembles that of a piece of paper viewed under the microscope.

3. *Compact boards,* a most important group, consist of boards which are similarly pressed from fibers into one homogeneous layer, but which are of such close, compact texture that they are satisfactory substitutes for wood. The varieties selected here as durable are believed to be permanent; they have passed all tests except the one of actual time. They have not been available long enough for us to have absolute confirmation of the results of tests, but because they are superior to wood in withstanding accelerated test conditions, we accept them as permanent.

Presdwood, the most highly recommended board of this type, is a brown building board ⅛ inch thick, perfectly smooth on one side, criss-

crossed with the marks of a wire screen on the other. Standard Presd-
wood, once made by the Masonite Corporation of Chicago, is no longer
produced here but is imported in limited quantities from England by
Arthur Brown and Brother (2 West 46 Street, New York, New York
10036).

This material contains no binder, but is made by exploding wood
fiber under a steam pressure of 1000 pounds per square inch, and pressing
the refined pulp with heat. The fibers interlock and form a permanent
hard mass, evidently bound by natural lignins or other ingredients of the
wood.* During the process the fibers are impregnated with a very small
amount of sizing compound made of paraffin, which imparts a water-
proof quality to them; the finished boards are moisture-resistant to a high
degree and will not warp readily. Large pieces will, of course, curve and
bend by their own weight if left standing on edge, but this does not occur
when they are properly framed or braced, and it usually does not occur at
all in the case of unframed pieces shorter than 24 inches. Presdwood is
sold at lumberyards in sheets 4 feet wide and in several lengths up to 16
feet. Additional details of its properties and uses will be encountered in
the following pages where the application of grounds to panels is dis-
cussed. I have used this material since its introduction; along with many
other painters, I have come to regard it as an entirely reliable material
and, under the average American conditions, superior to wood as a sup-
port for easel paintings.

Other products of this company that are not recommended for the
same purposes, but may be used for other purposes according to
the judgment of the user, are $3/16$-, $1/4$-, and $5/16$-inch Presdwood: the same
material in thicker forms, useful for small panels that are not intended to
be cradled. They are rather unnecessarily heavy and clumsy for most of
the other purposes mentioned in this book; they have little advantage
over the $1/8$-inch variety when that is properly backed and framed. A
thinner grade ($1/10$ inch thick) is also made.

If the artist plans to use this material for the purposes for which it is
recommended in this book it is important to get the Standard Masonite
Presdwood because the same company manufactures other types of
boards, which, good as they may be for the purposes for which they are
intended, are unsatisfactory in these cases.

Not to be used is Tempered Presdwood, sold in the same thicknesses
as the Standard Presdwood, and made in two colors, a brown darker than
that of the Standard, and a black. It is impregnated with an oil that makes

* Boehm, R. M., "The Masonite Process." *Industrial and Engineering Chemistry,* Vol. 22, No.
5, May 1930, p. 493.

it very tough and resistant to wear but is to be avoided for use in gesso panels, as the permanence of adhesion with such an oily base as well as the permanence of the oily material itself is doubtful. Among the same company's other products is Panelwood, which is not sufficiently dense or strong. Competitive boards, especially imported ones, seem not to take aqueous coatings as well as Standard Presdwood.

4. *Other boards:* Numerous other types of boards used in construction work are of less interest to the painter; gypsum or plaster boards are made of a layer of plaster faced with cardboard or paper layers, and rather heavy boards are made of asbestos fiber bound with cement and pressed for compactness. The usual mixture contains about 80 percent Portland cement. Asbestos boards are painted with oil paint in industrial practice, but for permanent results they are too alkaline to be used for oil or tempera; however, they are suitable for casein and other mural purposes. Flat Transite, made by the Johns Manville Company, New York, is widely available; it is a durable, dense, strong product of a light gray color and smooth surface. It comes in various sizes, from 3 x 4 feet to 4 x 8 feet, and in more than a dozen thicknesses, from ⅛ to 4 inches. A similar material called Flexboard, made under less pressure and consequently less dense, is also obtainable in 4 x 8 foot sheets ⅛ and $^3/_{16}$ inches thick. This material can be sawn and nailed more easily than Transite but is less durable. A buff-colored, thicker, but less dense material called Marinite, which contains plaster, is much favored in marine interior construction. There are several other competitive brands of asbestos board which seem to be of equal value.

The literature of the industrial wallboard field is scant, and most of the information we have on these products is supplied by the makers. The other competitive close-grained homogeneous materials are believed to be made with added oily, aqueous, or resinous binders, and although some of them may be equal in value to those mentioned here, I do not know of enough practical artists' tests over a sufficient period of time to recommend them.

Most of the wallboards can be obtained at lumberyards from stock or on short order; a well-established firm can supply information on materials not carried in stock and can secure them easily. The makers usually issue descriptive literature.

Cradling of Wallboard Panels. The cradling of panels by attaching wooden strips to their backs with strong adhesives is designed to increase their strength, rigidity, and durability, to counteract their tendency to warp, curl, or split, and to rectify such defects in the case of old paintings. The term is perhaps more accurately applied to the specific crisscross

method of conserving wooden panels described on pages 504–505, but it has recently come into general use in reference to any method of bracing panels by fastening wooden or metal strips at the rear.

Panels made of Presdwood or similar material, which, unlike wood panels, neither split nor become permanently warped, are ordinarily made rigid by gluing the cradling on all around without any provision for loose strips. The usual backing is wood of the same approximate size and quality as the heavy stretcher strips used for canvases; a rectangular frame with two crossbars, horizontal and vertical, is generally employed for the sizes up to 25 x 30 inches. Larger sizes usually need more bracing; the cross-members of a very large support are often made as close as 12 inches apart, but the spacing may vary and is a matter for individual judgment. Strips 2½ inches wide should be used on large panels.

The use of regular canvas stretcher-strips with the beveled edges planed down is a makeshift; much better panels are made if the frame or cradling is specially constructed for the purpose. The corners should be mitered and the joints may be dovetailed or doweled by any of the regular methods. The ends of the crossbars should be square butt joined to the sides. Any good carpenter, amateur or professional, can make such frames from selected, well-dried lumber.

After the cradling is completed the edges of the Presdwood, which usually are somewhat ragged from the sawing and subsequent handling, may be made neater by finishing them off with a coarse file or rasp and sandpaper. The ground is less likely to chip off at the edges if they are beveled or rounded. Small Presdwood panels, up to 24 inches long, are sometimes coated with gesso on one or both sides and left uncradled, especially for sketching and other temporary purposes; but for the very best permanent painting cradling is recommended, even for the smallest sizes.

It is useless to attempt the cradling of panels without employing strong cabinetmakers' clamps or a press of some sort; the piling on of weights is a makeshift and an unreliable method. Unless the panel is firmly clamped to the wooden strips so that they are in contact at all points and the glue is under pressure during the time it is settling, bad warping, separation of the panel from the cradling, or some movement which cracks the ground usually occurs. The best and most convenient adhesive is the prepared casein cement described on pages 387–88.

The use of nails and screws is a doubtful expedient. They may be utilized in repairs or to reinforce suspiciously weak spots, but their general tendency (according to my experience with defective panels of my own, with those made by pupils, and with commercially made products) is to give way or pull out erratically, thus subjecting the panel to a twisting

warp, with disastrous results to the ground. It is a simple matter to countersink the screw and nail heads and fill the spots flush with the surface with a plastic material; but it is almost an impossibility to keep these spots permanently invisible. Iron and steel will rust, and copper and brass will corrode by electrochemical action, thus discoloring the gesso, and it is extremely difficult to prevent this by any means. The plugs will shrink, swell, crack, or fall out—at any rate they remain weak spots. The greatest danger from the use of nails and screws, however, is the unequal tension produced on various parts of the painting.

Pictures on wooden or wallboard panels should be well braced and supported by their frames in order to resist warping, but no panel should be so tightly held by a picture frame that expansion will produce buckling. See *Framing Pictures,* pages 510–11.

GESSO GROUNDS

After the selection and preparation of a support for the panel, the next operation is to coat the panel with several layers of white gesso. Gesso is a plastic or liquid material applied as a coating to surfaces in order to give them the correct properties for receiving painting, gilding, or other decoration. It is made by mixing an inert white pigment such as chalk, whiting, or slaked plaster of Paris, with an aqueous binder such as a solution of glue, gelatin, or casein (see Chapter 11). Gesso may also be built up, molded or modeled into relief designs, or carved. Aside from its use in preparing flat surfaces or grounds for painting, it is employed in the decoration of picture frames and furniture, and to a lesser extent as a medium for modeling. When finally dry, its surface is normally sandpapered to a smooth, ivorylike finish. See warning on ready-made gesso, page 404—polymer primer is not really gesso.

Although gesso sometimes has been applied to canvas, especially to the back of prepared oil canvases by some painters, its lack of flexibility makes the survival of such grounds extremely doubtful. When the gesso is carefully applied in two thin coats, the first one scraped down wet as in the preparation of an oil canvas, it will adhere well and seem to be quite stable but will often develop a fine, allover crackle within a comparatively short time.

Ancient paintings on gesso grounds over canvas supports are often covered with a dense, allover pattern of fine crackle; provided that pieces have not become loosened or flaked off, this is seldom considered a bad defect but is accepted as the normal effect of age. Such crackle on a recently painted picture, however, is entirely undesirable, and the use of gesso or some of the absorbent semigesso or emulsion grounds on canvas

entails this risk; it is not unusual for aqueous grounds on canvas to show signs of crackle soon after completion and to exhibit serious cracking within a comparatively short time after the painting has been completed. Rigid panels are the best support for gesso grounds.

As any artist who has become adept by the repeated preparation of gesso grounds knows, the unerring production of perfect gesso surfaces requires careful workmanship and a painstaking attention to detail. Because of the narrow limits of the required properties, recipes for gesso are rather delicately balanced, and for this reason complete instructions for its mixing and application seem complex, although gesso itself is simple both in principle and in substance. The common variations encountered in different samples of glues and casein (because of differences in age, atmospheric conditions, and sources), as well as variations in the properties of the pigment used, are not infrequently sufficient to throw published recipes off balance and make the coats prepared according to them too hard or too soft and the liquid too heavy or too thin. The experienced worker is careful to observe such variations, especially when changing his source of supplies, will regulate hardness and brushing quality in his mixtures, and will apply simple tests or trials to the materials as he goes along.

DEFECTS OF GESSO PANELS

Pinholes are caused by minute air bubbles which appear while the gesso is drying. They usually develop in the first coat; once started, they persist throughout subsequent coats. Tempera or oil colors applied over a surface pitted with pinholes will magnify their effect rather than conceal them. One of the reasons for the development of pinholes in an otherwise well-made gesso panel is the way in which the first coat is applied—often the gesso has not wet the support thoroughly because of dust, temperature variations, or high surface tension in the gesso mixture. Careful application of the first coat, as described in the following methods of procedure, will ordinarily eliminate this defect. Pinholes may often be the result of or may accompany other defects caused by application in cold or damp rooms, as mentioned later.

Pinholes will develop if the glue solution is too dilute, and may sometimes also develop if it is too concentrated. Undue beating or whipping just prior to use will obviously cause air bubbles or foaming, especially in hot glue gesso. The surface tension of the gesso may be reduced and the formation of pinholes made less likely by the addition of alcohol, but this is by no means a safe procedure when the gesso is to be used on panels, as it may lead to other defects; it is recommended by some craftsmen for

picture-frame gesso, especially in cold weather, but is not generally approved for panels used in permanent painting. Alcohol should never be added to casein gesso. The addition of oxgall or a modern wetting agent to subsequent coats will often eliminate or minimize pinholes which have started in the first coat; this is apparently a safer method.

Any cracking, peeling, or blistering of the gesso will generally occur as soon as the coating is thoroughly dry; one of the generally accepted statements on the advantages of correctly made gesso panels (and tempera paintings as well) is to the effect that if the thoroughly dried coating shows no evidences of the development of these defects within two weeks, it is a pretty safe conclusion that such defects will not occur. However, it may be added that should any slight evidences of cracking be discerned it is practically certain that these will eventually develop into complete cracks.

Cracking and peeling away of the gesso is commonly caused by too concentrated a glue solution, by too much variation in the strength or composition of the several layers (especially by strong gesso over weak), or by highly unfavorable atmospheric conditions. Although this last cause is a frequent one, I do not recollect seeing it mentioned in published accounts. It has been shown by experience and experiment and research that those oil films which have the most rapid and uniform rate of drying are the most durable, the toughest, and the least likely to crack; it is in this respect that linseed oil is superior to poppy and other drying oils. The same rule seems to govern the drying of gesso. In poorly heated places in the winter, and in cool, exceptionally damp places such as basements, rooms with freshly plastered walls, etc., where drying is greatly retarded, I have seen examples of completely ruinous cracking of gesso panels which had been otherwise well made by experienced practitioners who had no such failures when their panels were made in reasonably dry and normally warm surroundings.

When the glue solution is too dilute it will produce a weak, soft gesso, as undesirable as the overhard surface produced by too concentrated a glue solution, but such a surface will not ordinarily crack. However, if the solution has been very greatly overdiluted, a mottled crackle will appear, usually not in the form of open fissures.

As in the application of any ground or paint coating, there must obviously be a good bond between the coating and the surface to be coated; the support must be sufficiently coarse-textured or absorbent to afford an adequate key for mechanical bonding of the gesso, and it must be free from all traces of oil or grease. The cracking and separation of gesso due to lack of proper qualities in the support is easily identified by a clean parting of the ground layer from the support.

Cracking after coatings have been applied to the finished gesso surface is sometimes attributable to the use of too concentrated a glue, casein, or varnish size, which has penetrated the gesso and upon drying has contracted with enough power to crack the gesso and cause it to separate from the support. This is more likely to occur when the binder used in the gesso is too far outside the limits of correct practice (too dilute or too concentrated), or when adhesion to the support is insufficient. It seems to occur more frequently with casein glues than with hide or skin glues, and after such panels have been subjected to their first appreciable climatic change.

PREPARATION OF GESSO

The Ingredients. The best record of the early European methods of making gesso is contained in the treatise of Cennino Cennini,[8] which describes the making of a glue from parchment scraps and its combination with an inert white pigment; the latter was made by thoroughly slaking plaster of Paris in water until its cementing or setting properties (definitely undesirable in this case) had disappeared, the resulting product being an inert white powder (see page 464).

Today the best glues are sold under the names of rabbitskin and calfskin glues. Glues are made from the skins and bones of animals; skin or hide glues are very much more suitable than bone glues for our purposes, the optimum being a glue which will set to the strongest jelly, for with this kind the amount of organic material in the gesso is kept to a minimum.

The highest-grade gelatin made from the skins, hoofs, and bones of calves is a pure, comparatively uniform product which has been much used in gesso, especially in preparing foundations for gilded picture frames and for furniture. Edible gelatin such as the powdered material sold in grocery stores has a yellow color and is comparatively weak in jelly strength. The kind which is made for laboratory and technical use is obtainable in very pure water-white grades mostly imported from France and Belgium.

The ingredients of gelatin are not present in the same proportions as they are in glue, and gelatin is usually considered by experts second choice to high-grade skin glues for gesso panels, although it is most useful for gilders' work and for making the weak sizes used as isolating layers in tempera painting. This is one of the many instances we find in the study of painting materials where correct balance of properties is the requirement, and where overemphasis on one property entails a sacrifice of an equally important quality.

Glue and gelatin are hygroscopic and are extremely variable products. Because of their variability, especially in connection with the wide range of inert materials, supports, methods of application, and atmospheric and other conditions which accompany their use, it is quite impossible to quote precise formulas which will give universally successful results. Whatever figures and amounts are given here should therefore be used with intelligent allowances for small variations.

Partly for these reasons, and partly to avoid repetition elsewhere, the following instructions have been made rather complete and detailed. Some further remarks on glue and gelatin will be found on pages 390–91, 461–64, and under *Sources of Materials*.

Procedure. Place 2¾ ounces of rabbitskin glue in a glue pot, can, or enameled saucepan, with a quart of cold water. If the French variety is used, the sheets must first be broken into small pieces; a cloth wrapped around it will prevent its flying about. A few extra pieces of glue should be soaked separately in another vessel in order to have them available for addition to the batch in case they should subsequently be required. After the glue has soaked overnight, it will be found to have absorbed water and to have swollen to about three times its dry volume; in the case of the French variety its color will be an opaque greenish gray. If the pot is too shallow, some parts of the glue pieces may not be covered with water; if it is too narrow the glue may be confined so that some of the pieces adhere to each other in such a way as to prevent parts of them from becoming thoroughly swollen. In these cases, such pieces will be readily recognized by their yellowish brown color and thin, hard, or tough rubbery consistency as compared with the softened grayish appearance of the bulk of the glue. These pieces should never be used in this condition, but must be separated from each other, immersed in the water, and allowed to continue soaking until they have swollen thoroughly. When other brands or grades of skin or hide glue are used, the color may vary, but the same precautions must be taken and the same inspection of the swollen glue made before continuing the procedure. The American rabbitskin glue referred to under *Sources of Materials* is of approximately the same strength as the French variety, and may be used in the same proportions; the best calfskin glues have a higher jelly strength and a lesser amount can be used, as determined by making a comparative test.

Melting Glue. The pot containing the glue and water is then heated until the glue is dissolved. Glue must never boil, especially for use in such an accurately balanced composition as gesso; the color darkens and the strength is immediately altered in an erratic way. To ensure against this,

a glue pot or water bath (double boiler) may be used, although direct heating on an electric hot plate or gas stove covered by a metal sheet is perfectly suitable, provided that the glue is carefully watched and occasionally stirred so that it does not stick to the pot and so that no boiling takes place. This latter method is employed by persons who melt an occasional batch of glue; electric glue pots are used in shops and by those who employ glue continually. Possible further accuracy in the proportions of water and glue may be had by soaking 2¼ ounces of glue in 26 fluid ounces of water, melting it, pouring it into a quart measure, and making the volume up to a quart by adding hot water—thus eliminating error due to evaporation of water during soaking.

The traditional method of testing the strength of the glue at this point is to allow it to cool to normal room temperature in the pot, when it should assume the form of a firm but not tough jelly. Downward pressure is applied to the jelly with the thumb and forefinger, spreading them at the same time so that the jelly is broken apart. By the feel of the strength of the jelly, its degree of resistance to fracture, and most of all by the nature of the fissure produced, one can tell very accurately the strength of the glue. The side walls of the crack should be rough or granular; if they are smooth, the glue is too strong.

Although this empirical method of testing seems to be one which must be learned by direct instruction, it is so definite that it can be employed to considerable advantage by those who learn it independently. If such a test is made and the behavior of the resulting gesso remembered and compared with that of subsequent batches for which the glue has likewise been tested, the experimenter will soon learn the best glue consistency for a gesso of the properties most desirable for his or her own purposes and preferences.

The testing of glue solutions is by no means a completely standardized procedure even in the chemical laboratories of glue and gelatin manufacturers, and each one has its own methods and system of measurements, expressing the results by a variety of numerical designations. A finger test similar to that described above is still in general use and considered to be the most satisfactory. The laboratory worker presses the surfaces of the samples of glue jelly with the fourth finger of his left hand (which is supposed to be most sensitive) and grades the glue according to his experience and judgment.

One method of controlling the strength of glues with simple and inexpensive apparatus is by the use of hydrometer (see page 621); one made especially for the purpose is sold by laboratory supply houses. This glue hydrometer or "glueometer" is graduated from 1 to 12 degrees Baumé and calibrated for use at 150° F. It requires a glass cylinder of about

250 ml capacity and a thermometer. The glue solution is poured into the cylinder at 150° F and the hydrometer carefully immersed in it, the reading simply noted. The jelly strength, however, is more significant than the viscosity.

If the solution is found to be too dilute, melt into it some of the extra pieces of soaked glue; if it is too concentrated, add hot water. A quick checkup can be made by mixing a little of the glue solution with chalk or whiting and brushing it out on a scrap of wood or Presdwood; its drying may be hastened by warming if desired. After this, a few rubs with No. 2/0 sandpaper will indicate the hardness or softness of the gesso. If the sandpaper fills up too rapidly and takes down the gesso too easily, the gesso is too soft; if the sandpaper works with too much difficulty, the gesso is too hard.

The glue solution of correct strength is then heated as hot as possible without boiling, and poured gradually into a pot or can containing the chalk or whiting. The mixture is stirred constantly during the pouring to produce a small paste. Further smoothness is attained by straining the mixture through a fine sieve or through cheesecloth (which may be squeezed), thus breaking up agglomerations of particles and removing coarse impurities. The hot gesso should be about the consistency of the average light coffee cream. The amount of pigment will vary according to the materials used.

The Pigment. The pigment used in gesso by Cennini was slaked plaster of Paris, but whiting and chalk have largely replaced this material, as noted on page 464. The technical advantages of whiting over gypsum are greater hiding power or opacity, fineness and uniformity of grain, insolubility in water, and greater bulking power, whiting being noted and valued for its bulk in all paint uses. Precipitated chalk is an artificial whiting, cleaner, purer, more uniform, and usually whiter; it produces a gesso of a finer grain, but of the same type of texture, and is therefore preferred by many gesso makers. Further remarks on these materials will be found elsewhere in this book under their own headings.

There seem to be no chemical or structural objections to the use of highest-quality silica, barytes, blanc fixe, or magnesium carbonate as added ingredients, if they are found desirable, but the texture produced by the use of whiting or precipitated chalk is the standard.

Talc (French chalk), mica, and asbestine are of doubtful stability in gesso and best avoided.

The opaque or heavy white pigments which have greater hiding power than chalk or the other inert pigments such as zinc oxide, lithopone, and titanium oxide did not exist in the early days of the develop-

ment of tempera painting, and for the most part they are not necessary; indeed, any considerable amount added to the gesso formulas will result in a product differing in texture and structural strength from that made with whiting. However, a small addition of opaque pigment—for example, the replacement of 1 to 10 percent of the whiting with pure titanium or zinc oxide—is a definite improvement, as the hiding power of the gesso is greatly increased, and such impurities as black specks or particles of dirt, wood splinters, etc., are thereby more completely masked.

Chalk, whiting, slaked plaster of Paris, and some other inert pigments will mix with aqueous binders to make uniformly dispersed mixtures of the proper structural characteristics without the mulling or grinding required in the case of oil grounds. The heavier opaque pigments by themselves do not disperse so well into aqueous solutions, but they can be used if they are mixed with enough chalk. They should be rubbed to a smooth paste with some of the gesso before being stirred into the main batch.

Casein Gesso. Many painters prefer casein to glue for use as a binder in the preparation of gesso panels. Its principal advantage is that it is applied at normal room temperature, thus doing away with one of the troublesome factors in the control of successful coatings of glue gesso. Casein gesso may therefore be applied to panels by spraying through a pressure spray gun, a procedure which is practical when very large surfaces are to be coated or when continual production is required. For this purpose a large amount of water is added to the formula; the panels must lie flat and level, and the gun should be of sufficient power to handle the material adequately, delivering a fan-shaped spray at a continuous, uniform rate.

When casein gesso is brushed out, its consistency should be about the same as that recommended for glue gesso, although thinner consistencies may safely be used if desired. Brushing manipulations are somewhat easier with casein gesso, as the brush stroking, especially on the later coats, may be continued for a longer time before the material begins to set. Otherwise, the instructions given for brushing out the glue gesso apply here.

Casein has much in common with glue: its lack of definite formula, its nonuniformity, the lack of well-established chemical knowledge concerning it, and the lack of satisfactory methods of testing it; but in each of these respects it is somewhat of an improvement over glue. It is described on pages 380–81.

Although casein is a thoroughly accepted and approved material and has been used in some form since the earliest days, and although there are no objections to its use from the viewpoint of chemistry, most painters rank casein gesso second to glue gesso in quality. This is true especially of

those artists who are sticklers for perfection down to the last degree. They maintain that the quality of the surface of casein gesso, the behavior of the tempera on it during painting, and its response to painting manipulations are definitely inferior to the corresponding features of glue gesso. It is more brittle than glue gesso.

Casein is more amenable to exact formulation than is glue, and recipes for its use in gesso grounds are figured on a basis of percentages of casein and pigment, allowing the amount of water to vary as necessary to produce the desired consistency—a much more satisfactory method than that employed in the glue gesso formulas. About an ounce of casein is required to bind a pound of precipitated chalk.

The casein is dissolved as described under *Casein Solutions* on pages 381–88, where reference is made to its use in gesso. The most easily and quickly made gesso of all is the one made with the solution described under *Soluble Casein* on pages 384–85.

APPLICATION OF GESSO

The original Italian gesso as described by Cennini[8] and subsequent writers was made in two different textures: *gesso grosso,* coarse gesso, and *gesso sottile,* fine or finishing gesso. The *gesso sottile* was applied in thin coats over a heavy coat of *gesso grosso* which had been allowed to become thoroughly hard (the *gesso grosso* was regular unslaked plaster of Paris mixed with a solution of parchment glue); this was in accord with the sound and logical rule of gradation of layers as referred to in the discussion of plastering under *Fresco Painting* in Chapter 9.

This procedure is generally considered by modern painters to be an unnecessary refinement; indeed, Cennini's treatise is usually interpreted to mean that the *gesso grosso* was used only on heavy, ornate, and elaborately carved structures where greater strength was required, and that for simple, flat panels the *gesso sottile* was used alone.

Cennini and other early writers have occasionally recommended that strips of linen be glued to wood panels before the *gesso grosso* is applied. More modern painters have covered panels completely with a sheet of muslin, fastening the muslin by soaking it in glue, applying glue liberally to the panel, and stretching the wet cloth over the wood, tacking it to the edges of the panel while it is drying. The main object of this is to isolate the gesso from the wood so that if cracks develop in the wood they will not affect the gesso. The result does not seem to be worth the effort; very minor hair cracks developing in the grain of the wood often transmit themselves through to the gesso despite such precautions. If one wishes to use cloth, an open-weave linen carefully attached to the panel with strong

glue is better. Cloth, however, adds an additional element to the anatomy of the picture with additional risks of such defects as blistering, etc. The number of points at which failure may occur is increased, and the additional layer of variable flexibility sometimes causes trouble on short aging. But when a restorer has a decrepit, old panel to repair, the presence of a cloth backing is a great advantage.

Before gesso is applied to wood panels, the surface is given a good coat of glue or casein size and, if necessary, lightly sandpapered first to remove wood fibers or fuzz. When Presdwood is used, some painters apply gesso grounds to its rough side because it seems to offer a better key than the smooth, rather water-repellent side; but the smooth side really offers a more satisfactory foundation and is the better side to use. The rough side is somewhat wavy and unsuited to the production of a level finish; for such a finish, additional coats of gesso and additional labor are required. If irregularities of finish are desired, they are easy enough to obtain without resorting to the rather mechanical effect of the board. The crisscross marks are not very successful as an imitation of canvas weave. There is, however, no objection from a purely technical viewpoint to the use of the rough side of Presdwood if its visual effect is desirable. The smooth surface requires a little treatment to ensure a proper bond between it and the ground, either for gesso or for an oil ground. It may be scrubbed well with any of the volatile solvents or mixtures of solvents, including ammonia; an efficient mixture is 2 parts of denatured alcohol and 1 part ammonia water. After this has evaporated completely, the repellent surface will be found to be receptive to a ground coat. If the result is doubtful and one wishes to be thoroughly certain, the board can be made receptive by sandpapering it completely. The makers' explanation of the nonabsorbency of the surface is that their processing brings a very thin coating of the natural resins or lignin of the wood to the surface. The adhesion of gesso to any such surface may be tested by coating a small piece and after the coating has set, attempting to break or chip it off. If it comes away from the support completely and cleanly there is insufficient adhesion; if it takes traces of the fibers of the support with it, it is satisfactory. The brownish color of the wood fiber removed by scrubbing the surface with solvents has led some painters to fear that this color might work its way or bleed into the ground, but this never occurs; the brown coloration is actually in the form of fine particles and is insoluble.

If gesso is applied in equal coats to both the front and back of a small Presdwood panel there will be little chance of the panel's warping or twisting because of unequal tension. Some painters have prepared panels in this way, especially in the smaller sizes, and left them unbacked by

wooden frames, sometimes protecting the edges with thin chromium or copper channel strips.

If hide glue has been used in the preparation of the gesso, the mixture must be kept hot throughout the application, but as previously mentioned, it should never be allowed to come to a boil. Continued heating for many hours will naturally cause some evaporation, and a little water may have to be added occasionally, according to the experience and judgment of the user. Casein gesso has an advantage in this respect, as it is applied at normal room temperature. Both kinds must be stirred continually so that the chalk will not settle to the bottom. The brushing consistency should be that of a smooth, *thin* cream.

The first coat can be scrubbed into the support very hot, with a stiff nail brush or a rag, but the best way is to brush it on and then immediately to go all over it lightly with the fingers in circular or back-and-forth motions, inspecting closely for air bubbles. Disregard the irregularities; this first coat will be thin and completely hidden by the next. The aim is to produce a uniform, fairly smooth coating free from air bubbles. Each subsequent coat is applied as soon as the surface has become sufficiently dry to withstand its application and not be picked up by the friction of the brush. The first coat will dry in a few minutes, but each succeeding coat will require a longer time—toward the end, a half hour or even an hour. It is therefore best to start early in the day (a half-dozen or so panels of average size can be prepared at the same time); allowing the work to run over into the next day is by no means forbidden, but one is more likely to secure uniformity of layers if the work can be completed in one day.

The second coat (really the first good, substantial coat) is applied in even brush strokes parallel with and beginning along one edge of the panel; the gesso may first be applied and evenly distributed with a few short back-and-forth strokes, but all the leveling or smoothing strokes of the brush must be made in one direction only. As soon as the gesso stops flowing and begins to set or the brush begins to drag, stop the stroking and apply fresh gesso over the next area. The third coat must be applied in strokes at right angles to those of the second coat, parallel to the other edges of the panel; the fourth coat, at right angles to the third, and so on. There is no rule as to the number of coats, but enough thickness must be built up so that all the brush marks on the final surface may be sandpapered down, still leaving enough coating to cover the support with an even, opaque layer of gesso. Four brush coats are usually necessary, five or six not unusual; an expert, experienced worker can sometimes get good results with as few as three.

A wide, flat varnishing brush is most convenient to use, and one that

is thin seems to be more serviceable than one with a full thickness of bristles—it will deposit less gesso at the edges of the strokes and so produce fewer heavy laps. A 2½- to 3-inch "sign-writer's cutter" of highest quality is especially recommended. A regular artists' flat bristle brush, if a wide enough one can be obtained, also gives good results. A high-quality, wide calcimine or whitewash brush with long bristles is favored by some workers, especially to cover large surfaces with casein gesso, which may be diluted to a somewhat thinner consistency than glue gesso. For applying casein gesso with a spray gun, a powerful pressure-type gun is required, but the first coat is best rubbed in with a rag or the fingertips.

Finishing of Gesso Panels. After the last coat of gesso has become thoroughly dry, the panel is finally brought to a perfectly smooth finish with fine sandpaper, several varieties of which may be used for the purpose. Some of the more common grades act slowly on gesso of the correct hardness, and some will discolor the gesso; the most satisfactory one is fine garnet paper, grain 4/0 to 6/0. The variety called cabinet paper has a dense grain; the other variety, finishing paper, has a sparser distribution of abrasive on the paper. Garnet seems to be the best abrasive for use on wood, gesso, plaster, etc., and when it is employed in fine grains for a smooth effect it appears to have a more powerful cutting action than any other abrasive, including the artificial ones. A small block may be used to hold the paper to a level surface, but most painters simply hold it with the fingers; the slight irregularity of surface thereby obtained has traditionally been preferred. When a number of panels are made at one time to be kept for future use, the final sanding may, if desired, be postponed until the panel is to be used. Artificially textured gesso such as is produced by stippling the last coat with a stiff brush, by imprinting a cloth weave on the nearly dried surface, or by spattering with a spray gun, may also be sandpapered in the same manner as smooth gesso; the result will be a surface smooth enough for ease in painting, yet with the textural effect retained.

Among the other abrasives which may be used on gesso are corundum, a native alumina (aluminum oxide), Alundum (fused alumina), and Carborundum (silicon carbide).

Finally, the smooth, ivorylike perfection is achieved and the scratches removed by rubbing with a wet pad. Use a pad of well-washed, soft old cotton sheeting, thoroughly wrung out in water, and folded smoothly; apply with a firm but not too heavy pressure in a small circular rubbing motion. Have the cloth uniformly damp, and keep it moving along continually; too much scrubbing in one spot may take off too much gesso and go through to the support. The water is supposed to dissolve a surface

layer and spread it out, not to dig too deeply into the gesso. When the gesso dries, it will usually be found to have become much harder, more resistant to sandpaper, and sometimes less absorbent, the glue or casein having apparently become more concentrated on the surface. This procedure is effective when employed to reduce minor irregularities. One must bear down rather firmly in tight little circles but keep moving continually and avoid rubbing too long in one spot. When it has been completely gone over, hold the panel flat, at eye level, and sight along the surface, aiming directly toward a light source. The effect should be a brilliant polish, although when viewed in a normal way the panel will be perfectly mat.

If finely powdered pumice is used in this operation, the gesso will be ground down more rapidly and part of the pumice will be embedded in the surface, imparting to it some degree of tooth. If a piece of lump pumice or a pumice block with a smooth, flat surface is used instead of the cloth, however, a smooth, ivorylike polish will be produced. This type of finish is liked by some painters; if it is painted upon thinly with oil or tempera and the paint, when dry, is polished by rubbing with cotton, a very fine lacquerlike finish may be obtained.

Some authorities recommend painting not only the backs but also the edges of all wooden picture panels with a protective coating of paint or varnish in order to exclude moisture and thereby minimize the possibility of warping and other defects; others contend that the two edges that go across the grain should be left unpainted in order to permit access of air as a precaution against dry rot. All unframed panels should be stored lying flat, especially those of large size.

Both glue and casein surfaces may be made more resistant to the action of water by spraying them with a 4-percent solution of formaldehyde, as described on page 463. This treatment also has a definite tanning or toughening action on the coatings. Although the effect is to increase moisture resistance to a certain degree, it must be remembered that the surface never becomes waterproof, and that although its resistance may be sufficient for the purpose intended, it still may be disturbed or destroyed by intentional or accidental application of water. It is uncertain how deeply below the surface glue or casein is affected by the formaldehyde treatment, especially in the case of thick coatings, and therefore all smoothing or polishing operations should be finished before applying it. In tempera painting, the standard or usual procedure is to apply the tempera paints directly on the untreated, absorbent gesso.

Smooth gesso panels make an excellent background for some kinds of photography because of their grainless surfaces. They cannot be tinted for this purpose by adding pigments to the white gesso; colored panels for

textureless backgrounds must be made from one pigment and not a mixture of pigments.

Ready-made gesso mixtures in dry powder or paste form have appeared on the market from time to time, and are, in general, quite satisfactory, especially those put out by well-known artists' material firms. There is no technical reason why a prepared gesso mixture could not be soundly made from well-selected ingredients. See the caution on page 257.

Pastiglia. Medieval and Renaissance painters and craftsmen used gesso to create build-up, carved, relieved or repoussé effects, not only in moldings, ornaments, and decoration, but also as fundamental elements of design. Comparatively simple elements, such as the jewels on costumes and the halos around the heads of saints, were modeled in the gesso before applying the paint or gold leaf, and very elaborate work was also done in which the entire composition was in relief.

Gesso can be built up by applying it with a brush and by various smoothing, carving, and modeling operations which will occur to the artist. If gold leaf is to be applied over these surfaces, they must be smoothed or burnished to receive it properly. Modern painters whose plans call for heavily textured or raised effects have sometimes solved their problems by a division of technique, obtaining the textural element by building it up in gesso on the panel and then applying the color coat in a normal paint thickness. By this means one may avoid the dangers that go with overabundant or exaggerated impasto of those paints that were traditionally developed for use in a limited thickness, and that suffer from various defects when applied in a manner in which they were never intended to be used. Work of this type should always be done on panels and not on canvas.

EMULSION GROUNDS

If a glue gesso is made with half chalk and half zinc oxide and emulsified by pouring into it (with constant stirring and beating) linseed oil to the amount of 25 to 50 percent of its volume, the resulting ground will have properties midway between those of a gesso and those of an oil ground. Emulsion grounds do not have quite the complete absorbency or the brilliant, permanent whiteness of gesso grounds, but they are considerably less brittle, especially when new. Although they are not so flexible as straight oil grounds, they have been applied to canvas, particularly to linen which has been sized and stretched on its permanent stretcher. Application to linen must be made with some care; it should be remembered

that even the average oil-primed canvas is none too flexible and will withstand little enough bending, rolling, and pulling; an emulsion ground on linen must receive even greater care. It is my opinion that the superiority of an emulsion ground over a true gesso ground in this respect is due merely to the fact that the softer, more spongy or crumbly coating will withstand rolling and flexion a little better than will the more rigid, brittle gesso coating. After some aging, a picture painted on an emulsion-primed canvas is apt to become equally brittle, as a slice of bread will lose its ability to bend.

It should be remembered that flexibility and brittleness are not the only two terms of description for the degree of elasticity in a coating. A film may have a crumbly or spongy quality, appear much more flexible than a harder film, and yet upon being put into use may display the defects of a brittle coating to a considerable degree.

Some modern painters prefer emulsion grounds for the manner in which they respond to their personal techniques and for the effects that can be produced on them, but others feel that from the viewpoint of precise, careful attention to the rules of permanent painting, they are less durable, and that gesso should be used on panels and oil grounds on canvas. Emulsion grounds are, in practice, as susceptible to permeation by moisture as are straight gesso grounds, and they are extremely sensitive to the action of atmospheric moisture or of any liquid on the rear of a canvas.

Casein should never be used in oil mixtures; the resulting grounds yellow badly and have a tendency to become quite brittle or crumbly with age.

Emulsion grounds have been favored by mural painters for painting in tempera, in mixed oil and resin techniques, and in other combinations which are departures from the straight oil method.

When expertly made, such grounds will usually withstand a normal rolling over a thick cylinder when new, a temporary stretching during the painting, and, in the case of murals, another carefully handled rolling during hanging, but it should be kept in mind that they are less elastic than oil canvases, that care must be exercised in their handling, and that repeated stretching or rolling, especially after they are a year old, may result in serious cracking.

COLORED GROUNDS

In order to work on a colored ground and still retain the optical advantages of the brilliant white gesso or oil ground, painters have, from the earliest days, brushed or pounced a thin transparent glaze or *imprimatura* over the white surface; such a coating must be transparent, must consist

of colors ground in a material which will not cause structural failure, and must be applied as thin as possible. In American practice such a layer is usually called a veil. Thin gelatin or glue size or very much diluted shellac, egg water, damar varnish, or glaze mediums may be used. The last two named are not so good, as they tend to produce impervious films which may be too nonabsorbent and glassy. The best veil should be about halfway between a normal continuous film and a size, so that it does not interfere with the binding or other structural relations between coats, and yet so that it is cohesive enough to resist being picked up by the overpainting. A veil may be applied over the white ground before or after the first drawing. In the latter case it may also function as a sort of fixative for a drawing, or it may be applied only in certain parts of the picture, as under the flesh tones, the sky, etc.; it may also be used in intermediate stages of the work after some underpainting has been done. In this case it may, if the technique calls for it, also serve as an isolating layer by being composed of ingredients suitable for the purpose, as mentioned in connection with the glazing of tempera pictures.

Colored ground for use in such processes as gouache and pastel, and in certain straight oil painting techniques where opacity is expected, may be made by mixing pigments in with the final layer of the ground itself. Such tinted final ground coats are usually kept very thin; sometimes a thin layer of tempera paint is employed for this purpose. The bole, or red earth, grounds of some older schools of painting were prepared by coloring the final ground coat; they are of little interest to present-day painters. They usually aimed at a "pure" tint of pale Venetian red which could be used as a middle tone for the dark, warm colors which were glazed or painted over them.

Gesso Substitutes. When a gesso is used for nonexacting or temporary purposes, such as temporary decorations, sketches, etc., time and labor may be saved by using one of the washable casein wall paints which were widely used on walls during the recent past. These paints are made from casein, mica, white pigment, filler, preservative, and lime, and usually pine oil. The material is sold as a semiliquid paste; one gallon is thinned with water to make nearly a gallon and a half of normal-consistency wall paint. For use as a substitute gesso surface, it is applied and sandpapered in the usual manner; such surfaces, however, must never be used for permanent painting. (See page 643.)

As a wall paint, this product is washable, not scrubbable, after it has dried and attained its full strength, which usually takes about thirty days. It is washable only to the extent that it may be carefully sponged. Any slight solution of the surface will not cause serious defects in the appear-

ance of a white or pale-colored wall, but it would be out of the question to rinse off such a surface if it bore artistic or decorative painting of any delicacy.

The straight casein wall paints are not as widely available as they were a few years ago, many of the brands having been "improved" with synthetic resins which make them unsuitable for this purpose.

Gesso as a Ground for Oil Painting. The smooth, absorbent gesso ground is unsuitable as an oil ground for direct oil or oil-resin paints because the extremely absorbent surface will put enormous difficulties in the way of brush manipulation, and the absorption of oil into the gesso will destroy the normal oil-film characteristics of the painting and may also cause the gesso to become yellow. It is therefore necessary to size the gesso in order to make it less absorbent, but this should never be carried to the point of making it entirely nonabsorbent. A considerable degree of absorbency is necessary, not only for a permanent adherence between the ground and paint film, but also for the proper drag of the brush and distribution of paint. Gesso should not be made less absorbent by the addition of oils or varnishes to the gesso batch, but by the application of sizes over the finished gesso panel. Recipes have been published for the introduction of various amounts of oil into gesso grounds, but the material then ceases to be gesso and belongs in the class of emulsion grounds, for the properties of the gesso are thereby altered. Emulsion or part oil part gesso grounds are inferior to both gesso and oil grounds in durability and nonyellowing; casein in particular should never be mixed with linseed oil, as the yellowing which results is rapid and noticeable.

In the sizing of gesso, care must be taken to produce a true size, as defined under *Priming Oil Canvas,* and not a continuous or glassy film. The materials most highly recommended are shellac thinned with alcohol to a watery consistency, and a very weak gelatin solution. When damar varnish is used it should be diluted with an equal volume of turpentine, and, after application, the surface washed or lightly scrubbed with absorbent cotton which has been moistened with turpentine.

The size may also serve the purpose of a fixative or isolating coat over a preliminary drawing. Or it may be tinted and serve as a veil, although, according to the best oil painting practice, gesso should receive a clear size before a colored coating is applied.

A roughened surface may be produced either by manipulating the brush (stippling) in the final coat of gesso, or by adding a coarse pigment, such as pumice or silica, to the batch. The latter method will produce a surface with excellent tooth. Toch[213] recommends imprinting the texture of a coarsely woven cloth, such as a bath towel, on the nearly dry gesso if

a very coarse surface is desired. It should be pointed out that this proce-
dure will not give an exact imitation of cloth weave, because the texture
imprinted will be a negative or reverse of the cloth, but it will give a uni-
formly rough finish. Such textures may be sandpapered to an acceptably
level surface and still retain enough tooth or granular quality for all pur-
poses. Uniformly coarse textures may also be produced with the spray
gun by various spattering manipulations. Either tooth or absorbency is
necessary for a bond with oil paint; a combination of both these proper-
ties is desirable, but either one alone will usually suffice.

Oil Grounds on Panels. Similar requirements govern the application of
oil grounds on panels as on canvases: when a very smooth surface is re-
quired, two or three thin coats of the oil paint are applied over a glue size;
each is allowed to dry and is sandpapered before the next coat is applied.
Pumice or silica ground or mulled into the paint will impart tooth.
Whenever experimental grounds are made (and careful painters will fol-
low this procedure with all grounds), they should be numbered and a
record of the date, the materials, their sources, and other significant de-
tails should be kept in a notebook for future reference. Oil grounds
should dry and age under normal room conditions of temperature and
humidity and with a normal exposure to diffused daylight. According to
the best practice, they should either be used at once or else aged for at
least six months. It is worthwhile to take care in securing the required de-
grees of absorbency and tooth by preliminary trials because efforts to ad-
just these qualities on a finished panel are usually troublesome.

Scratchboard. Known in England as scraperboard, this is a good grade
of stiff cardboard coated with an inert pigment such as clay or whiting
bound in a glue or casein size of the correct concentration to produce a
sort of gesso on which India ink will take well but not penetrate too
deeply, and which can be cut or carved smoothly. In the scratchboard
technique, the board is covered with India ink either solidly or in a draw-
ing. The artist then scrapes the inked surface with special scratchboard
blades, a needle, or other convenient blade, to create a white-line-on-
black drawing. Its effects vary from a very close imitation of wood en-
graving or woodcut to loose, free techniques of its own. Its quality of line
cannot be easily duplicated with pen and brush. The scratchy appearance
of the white areas of the original is not always pleasing; it disappears in a
line-cut reproduction, but although some artists use the technique for in-
dividual drawings, this effect is undoubtedly the reason why it has not
appealed to many. Virtually every illustration or advertisement that ap-

pears to be a reproduction of an original wood engraving is done on scratchboard.

There is little new in this nineteenth-century invention. Painters from time immemorial have employed the scratching-out method in all techniques, and the graffito method was at one time widely used; but the particular qualities of these boards, as they are now prepared, give them just the right properties for this type of work.

Academy board is a good-quality pasteboard or cardboard, sufficiently stiff and rigid to withstand handling, and coated on one side with any suitable oil ground. Sometimes it is embossed in imitation of canvas weave. It has been in use since the commercial introduction of cardboard, about the beginning of the nineteenth century. Academy board is not considered satisfactory except for temporary sketches and studies.

Canvas boards are pasteboard to which prepared cloth has been glued or pasted. Although they are made to be painted upon, they are thoroughly unreliable for permanent, professional painting on account of the doubtful quality of the materials generally used.

Recently there have appeared on the market all-purpose boards, coated with a casein or glue mixture which contains tinting and tooth-imparting pigments. The support is usually common thin pasteboard, which disqualifies the material for permanent work, but such grounds could easily be applied to more permanent supports, such as Presdwood. By carefully balancing the ingredients of the coat to give just the proper amount of tooth and absorbency, a board can be made so that it can be used for pastel, tempera, oil, or watercolor.

I have made grounds of this nature with white lacquer, using a high-grade zinc or titanium white cellulose lacquer and stirring in an excess of dry zinc white and sometimes a little pumice. When sprayed on panels, this mixture produces a mat finish and a highly desirable texture which may be used as a ground for almost all mediums. Such panels made on wallboard have withstood severe conditions for twenty-five years without alteration. The white lacquer should be one of the best and least yellowing grades, with a minimum of plasticizing ingredients. Its flexibility will normally be less than that of any oil or tempera paint that is to be used over it.

The question of the yellowing of grounds and the use in grounds of materials which are not approved for the final coats of permanent painting is one which has not been thoroughly gone into. The yellowing induced by the combining of any appreciable amount of linseed oil with casein is so rapid and intense that it is very likely to cause color change in the average oil painting above it; but there are other materials which,

though they change sufficiently to alter the tones of an artistic painting when used in final coats, do not change enough to warrant their exclusion from grounds. Lithopone, cellulose lacquer, pumice, and other inert pigments would fall into this group. The permanence of lacquer as regards eventual cracking, however, is doubtful.

Metal Supports. Copper plates have been used as supports for oil and oil-resin paintings from early times, particularly in Holland. These have been most successful when the pictures were small and jewellike and consequently were preserved with more than normal care. It is doubtful whether many of these earlier works have survived intact without restoration, because the adhesion between paint and metal is seldom of great permanence. The flexibility of thin metal sheets and their susceptibility to denting by minor blows combine to cause frequent blistering and peeling of the paint film. Zinc, aluminum, sheet iron, and stainless steel have all been suggested as supports, but each has its disadvantages. Easel painting on metal is obsolete; where circumstances require the decoration of metal, results of extreme permanence cannot be expected, especially if the work is exposed to more severe conditions than are usual in the preservation of works of art.

Copper is soft, is easily bent, and its coefficient of expansion is high. Aluminum is seldom pure and has a tendency to react chemically with paint. Zinc is an antioxidant—that is, it inhibits and interferes with the drying action of oils; only resin varnishes and lacquers should be used on it. The same applies to galvanized iron. Iron and steel are the most rigid, but they will often rust underneath their coatings. Stainless steel perhaps would be the best metal to use for such purposes.

Metals must be roughened by sand blasting or by rubbing with fine abrasives, and they must be grounded with at least two coats of stiff, heavy white lead in oil (stippled on), each coat being sanded before the next is applied. Iron and steel require a rust-inhibiting first coat; very stiff red lead in oil is traditional, but a better rust inhibitor is zinc yellow ground in a short tung oil varnish or spar varnish, plus a little lead pigment for stability and some silica to furnish tooth for the second coat, which should be pure white lead in oil. Considering the disadvantages of sheet metal in general, the modern cellulose lacquers which are applied for industrial purposes such as automobile painting may be as permanent a coating as any. A special, hard, adhesive metal primer or first lacquer coat, designed to be sandpapered, is sold; a homemade substitute consists of shellac, whiting, silica, and graphite. The tendency of lacquers to become hard and brittle with age is more of a disadvantage in their use on metals than it is when they are used on wallboard panels.

During the recent past, the industrial coating materials field has been active in research on metal surfaces, but so far little has been done to adapt such work to artists' purposes, and aside from an occasional commercial product whose composition is never revealed, the artist has had few prepared materials to work with.

The permanent adhesion of coatings to aluminum sheets has been enhanced by anodizing or electrolytic treatment which produces a porous, inert, nonprogressive oxidation or corrosion over which various industrial priming and finishing coats are applied. A few painters have been interested in following up this work.*

Glass Canvas. Recent improvements and developments in the glass industry have resulted in the production of yarns made of glass fiber which can be woven into a wide variety of cloths that duplicate all the effects of the usual textile fabrics. Generally known as fiberglass, it is not used as a support for paintings but has found some uses in conservation in certain types of lining operations. Fiberglass products have become standard sculptors' materials in the creation of three-dimensional forms with liquid synthetic resins. The cloth is coated and laminated with polyester resin, and other fiberglass materials are employed in laminations as well as being used as ingredients of mixes in casting synthetic resins. Among these products are fiberglass mat, a loosely woven fabric that is more easily handled than the closer-woven cloth, and chopped fiberglass strands, made by cutting the filaments into short lengths and used in casting mixes and various tapes and twisted yarns that lend themselves to molding and forming with liquid resins. Synthetic resins for sculpture are mentioned on pages 192–94, and further details may be found in the books by Newman,[245] Roukes,[248] and Percy.[254]

Synthetic Fibers. Canvases made from nylon sailcloth, Orlon (acrylic fiber), and other recently developed textiles have been put on the market with claims of certain advantages or virtues they are supposed to possess. It should be noted that any success these materials have demonstrated has been in other fields; no valuable tests or confirmations of their ultimate behavior or their permanence from the standpoint of artists' use have been made, and until such time it would seem the wisest course to continue with the use of linen until newer fabrics have been proven under artists' conditions of use rather than their theoretical value as fibers. Advantages are availability, white color, light weight, and chemical resistance; disadvantage, probable embrittlement.

* Trebilcock, Paul. "Aluminum as a Better Foundation for Oil Paintings," *American Artist,* Vol. 8, No. 10, December 1944, p. 20.

Oil Painting on Paper Not Recommended. How far back in history paper was used as a combined ground and support of oil painting nobody knows, because so few examples have survived. Plain paper, paper sized with gelatin to minimize or retard the inevitable embrittling effect of aging oil paint, and oiled and parchment paper which will take oil colors nicely have always served the artist for small sketches, color notes, and other purposes where longevity of results is secondary. No major works by great painters have come down to us; because of disastrous failures no concerted group revival of the practice lasts very long. There was one about a hundred years ago when a brown oiled paper was used, another about fifty years ago when artists made small examples of their work on glue-sized paper for low-priced sales, and there seems to be considerable recent experiment with it.

The principal attraction in the use of paper to contemporary painters is economy; fair-quality rag paper can be had in large rolls, the artist can stretch it or fasten it down temporarily, and then he need only spend time and money on mounting it and making it more durable *after* the picture is painted, when he can see whether it is a masterpiece or something to be discarded. I know of no oil paintings on paper, regardless of whether they were glued onto or backed with boards or stretched linen, that have survived beyond thirty or thirty-five years without treatment by professional restorers. Parting from the support, by blistering or bursting away, and crumbling and mildewing are some of the common ills. Paper and oil paint do not seem to go well together, mechanically or optically; they are not sympathetic or "naturals" like oil on canvas, tempera on gesso panels, and watercolor on paper. One may be sure that sketches in oil on paper that are exhibited in museums have all been subjected to conservation measures to repair previous damages or to fortify them against future deterioration. However, I would expect an oil painting to be permanent if done on heavy rag watercolor paper (200 pounds or more), either sized or unsized. The back side of a discarded watercolor may be used for this purpose.

Further Research on Grounds. As is the case in almost all of the topics which make up the study of artists' materials and procedures, there is a lack of scientifically accurate data upon which rational painting methods can be tested. Gradually, as the results of further controlled laboratory work done specifically for artists' purposes are accumulated, and correlated to studies of the canvases and panels that have come down to us from past centuries, our standards for permanence and effectiveness will be improved.

An interesting sidelight which developed from the survey of old

American canvases mentioned on pages 249–50, perhaps of greater interest in the museum field than in that of the practicing painter, is that the makers' stencils found on old canvases supply helpful clues in establishing the dates and authenticity of paintings. Firm names, addresses, and designs were frequently changed, and artists' suppliers are listed in the directories of most towns from the late 1700s on.*

* Mayer, Ralph. "Some Notes on Nineteenth Century Canvas Makers," *Technical Studies in the Field of the Fine Arts,*[226] Vol. 10, No. 3, January 1942.

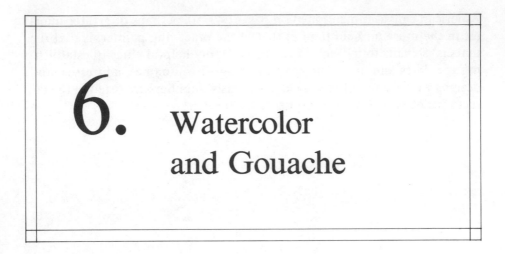

6. Watercolor and Gouache

THE USE OF aqueous paints on paper has increased to the point where they are now accepted as a major art medium; some of our most admired painters work exclusively with these materials. (See pages 118–19.)

WATERCOLOR

The technique of watercolor painting is based on the transparent or glaze system of pigmentation; that is, it utilizes the brilliant white of the paper for its whites and pale tints, and those pigments which are not normally transparent are applied in such thinned-out consistency that their effects are nearly as brilliant as those which are naturally transparent. The opaque method of pigmentation achieves its whites and pale tints by using a white pigment. Whether one is preferable over the other is a matter for the artist to decide; it depends upon what effects and working properties he or she wants, for each has its own peculiar kind of brilliance and luminosity and each its own good qualities.

The term "aquarelle" is not in common usage in America or England, but it specifically designates this type of painting as distinguished from all opaque-medium paintings, such as gouache, casein, etc. Gouache is described on page 291 in this section, and casein paints are dealt with on pages 380–81.

As a general rule transparent watercolors may be freely introduced into an opaque technique done on paper, such as gouache or pastel, so long as the general character of the work remains definitely gouache or pastel. The introduction of opaque effects into a painting which is predominantly watercolor or aquarelle, however, must be subtly and sparingly done; casual or careless attempts to do it usually give unpleasant results. Although touches of zinc white and other opaque pigments can thus be used to advantage, the expert or purist in watercolor realizes that there is a definite limit to the extent to which they may be used if the usually desired watercolor effect of the picture as a whole is to be retained.

THE COLORS

All the permanent pigments approved for use in oil paints may be used, with the exception of the two which contain lead: flake white and true Naples yellow. The naturally transparent pigments such as cobalt yellow, alizarin, and manganese blue yield brilliant effects; the opaque pigments such as the cadmiums can also be made to produce transparent effects when correctly used, because of the thin, sparsely pigmented coats in which they are applied.

Watercolor paints are composed essentially of transparent pigments ground to an extremely fine texture in an aqueous solution of gum. The binding material and pigment must be combined in the proper proportion to permit all of the various manipulations to be accomplished with ease; once this has been done, watercolor paints may be enormously diluted with water and still adhere perfectly to the paper. The ability of the paper to absorb and hold pigment particles in its interstices is at least of equal importance with the adhesiveness of the gum in binding the color to the ground. Anyone who has tried to wash or scrub away the color knows how tenaciously paper clings to the last remnants of color; unlike most of our other painting methods, true watercolor is more like a stain than a continuous film or layer. When watercolor paints are piled up or applied thickly, as in the gouache or casein techniques, the holding or binding action of the paper on pigment particles is naturally less, and the color will have more of the regular paint-film characteristics, will depend a little more on the medium for its binding properties, and may have a tendency to crack especially if the support is not rigid.

When permanent colors are used on pure rag watercolor paper and the picture is kept under the same normal conditions of preservation as are accorded other objects of art, the technique is as permanent as any other. It is not true that the colors are liable to be faded by daylight be-

cause they are exposed in such thin films; only the semipermanent or borderline pigments are likely to fade; they will be affected in the same way when used in oil or tempera, though such change may be somewhat less noticeable in those techniques on account of the larger volume of color employed.

Because of the comparatively low cost and simplicity of a student's watercolor outfit, the medium is universally used as an introductory technique for children and beginners. The production of a successful watercolor painting, however, calls for a considerable degree of technical skill and a well-developed art technique. Because of the portability of the necessary materials, watercolor is well adapted for sketching purposes. For these reasons, it has become customary to distinguish between a watercolor painting, carefully done in the studio or direct from nature, and a watercolor sketch, made as a note for subsequent work in watercolor or some other medium.

Although examples of work comparable to modern watercolor painting can be cited among the pictures of nearly every period, the technique as we understand it today was not appreciated as a standard art method until the eighteenth century, when the English school established it as such.

PAPER

The earliest manuscripts in Europe were on paper prepared from Egyptian papyrus; during the Middle Ages parchment and vellum replaced it; and paper made of linen fibers came into use about the thirteenth century.

The best permanent paper for watercolors is most carefully made from linen rags (a small percentage of cotton is permissible), which are boiled, shredded, and beaten to separate the fibers; the material then assumes the form of a smooth, flowing pulp. It is run over a fine screen in a thin layer, dried, and pressed. This is the briefest sort of outline of the process. For the most permanent kinds of watercolor and drawing papers no chemicals may be employed, with the exception of a little bleaching agent, the surplus of which is destroyed and neutralized by means which leave the most harmless residue in the paper. Care must be taken to avoid all contamination by particles of metal. The fine papers of the Italian Renaissance did not even contain bleaches, but were made most carefully by hand and, according to later writers, probably bleached by exposure to sun and air. The huge paper industry of today, with all its technical refinements, is on a mass-production basis, and even in its most careful

manufacture of grades for the finer sort of commercial purposes, is a thing apart from the comparatively small-scale industry which produces artists' papers. The most preferred handmade or mold-made papers are the English brands, among them James Watman & Son and J. B. Green. "D'Arches" (French) and Fabriano (Italian) are also available. Sadly, a number of the famous centuries-old brands have disappeared in recent years.

The Chinese and Koreans, and later the Japanese, used mulberry bark to make paper that met the very meticulous requirements of their artists, but which has a greater tendency to darken and become brittle with age than has the European product. The Chinese artists expect their paper and black ink to last for a thousand years under normal conditions of preservation, but are aware of the fact that some of their more common colors will fade in less than fifty years.

Paper reveals itself under the microscope as a felted or weblike mass of interlaced fibers. The production of a pencil, crayon, or pastel drawing depends upon the filelike action of these fibers, which, as the material is drawn over the surface, wear it down and hold and retain its particles in their interstices.

Naturally, a substance of this construction is extremely absorbent to liquids, so that in order to apply and manipulate liquid paints or inks upon it, it must be impregnated with sizing. An example of unsized paper is a blotter; another is filter paper, the best grades of which, used in chemical laboratories, are the purest form of paper and are the products of the same establishments that produce our watercolor papers.

The material used for sizing the best watercolor papers during their manufacture is a weak solution of gelatin or hide glue, and the amount used is of considerable importance to the properties of the paper. Paper which has been made with too much sizing will give irregular or spotty results while that which is too absorbent will give dull, sunken-in effects.

Chinese and Japanese papers made in the traditional manner, perhaps with a few European improvements, are sized with a solution of ox-hide glue, which is hardened or set with alum. Some kinds of Japanese paper are sold to artists unsized; ink or color will run or spread on this material unless it is impregnated with size before use.

Laurie[51] suggests that drawing papers treated with alum and resinates, as some are, should not be used for watercolors, as these chemicals may have an effect on sensitive pigments.

When manufacturers add size to paper they do so while the paper is in the pulp stage, but unsized paper and paper which needs resizing as a result of a prolonged soaking in water may be effectively sized by immer-

sion in a weak gelatin solution, ¼ ounce or less to a gallon of water. The amount of gelatin required varies greatly according to conditions, but should always be kept to a minimum.

Paper is made uniformly flat by passing it through a press. Artists' papers are sold in several finishes. *Cold-Pressed* (CP) and *Not-Pressed* (NP) papers have an open or coarse texture and are used for watercolor painting. Some of the heaviest grades are also available in *Rough,* which has a still coarser grain. *Hot-Pressed* (HP) is not so well suited to transparent watercolor but is employed for opaque techniques and other drawing purposes. The coarseness of grain has not so much to do with adhesion of paint (all uncoated papers will seize color particles) but it is valued for the sparkle, brilliance, and other desirable qualities it contributes toward the visual effects of the work.

Fine papers are watermarked or embossed with the manufacturer's mark, the side upon which this can be read being the right side. Many papers are well finished only on one side; the wrong side may contain irregular spots, flaws, and blemishes which do not show up until painted upon, or its grain may not be the same. Other papers may be used on both sides equally well.

Aged papers are prized by experienced watercolorists and some brands which are dated by watermark or dealers' records are preferred by them to those of more recent manufacture; scarcity of the best papers during the 1940s, however, depleted old stocks to such an extent that they are extremely scarce.

Thickness is one of the most important requirements for fine watercolor paper; very lightweight paper will cockle or wrinkle, lends itself to a smaller range of manipulations, and is unsatisfactory for some uses. Paper is graded by the weight of a ream (472, 480, or 500 sheets); the thin paper in common use weighs 72 pounds; an intermediate weight is 90 pounds, 140 pounds is a fairly heavy paper, about the minimum weight suitable for all-around use. Some painters prefer a heavier paper than this, however. The best kinds are obtainable in weights as heavy as 250 to 400 pounds; they come in boardlike sheets that will withstand severe treatment and permit the fullest use of manipulations. The lighter-weight sheets are more often used in the wet techniques where the paper is stretched before use. The heaviest grades do not require stretching; they can be clipped to a thin drawing board or portfolio cover or a very lightweight one cut from a corrugated box, with spring clips or spring clothespins.

Paper Dimensions. Because of ancient custom, because the fine handmade papers do not conform to exact dimensions, and for the sake of in-

ternational efficiency, sheets of paper are sold by standard designations rather than by measurement in inches or centimeters.

Some of the trade names for sizes of watercolor and drawing papers are as follows:

Royal, 19 x 24	Elephant, 23 x 28
Super-royal, 19¼ x 27	Double elephant, 26½ x 40
Imperial, 22 x 30	Antiquarian, 31 x 53

Imperial is the standard-size sheet in which watercolor paper is normally available. Papers of all kinds are also obtainable in pads or blocks, but these are rarely as large as a half-sheet of imperial.

The grain or texture of watercolor paper contributes largely to the final effect of the picture; the varied way the color is taken from the brush by the high and low spots of the grain creates a depth of tone and sparkle which is peculiar to this technique. A medium-coarse grain is most popular, and the coarsest kinds are preferred more often than the smoothest. Beginners are always cautioned against clogging or filling up the grain with heavy strokes, thus producing a dull, flat effect. The quality of the paper plays a very important part in the technical success of a watercolor painting. Work done on paper with a good, characteristic natural texture is distinguishable at a glance and at a distance; use of cheap, inferior papers handicaps the painter not only in manipulations but also in the creation of superior, professional effects, especially when those works are exhibited together with others in which the best materials were used. Some of the machine-made papers have a mechanical monotonous grain, which imparts an undesirable imitation effect to the work.

Vellum and *parchment* are made from the skins of calves, goats, and sheep. Parchment is a coarser material than vellum, but there is no very sharp line of distinction between the two. The finest grades are made from the skins of newborn animals. When soaked in water, they absorb a large amount and become soft and pliable; when stretched, dried, and subjected to a number of finishing and surfacing operations, they present a very good and permanent ground. They have long been obsolete so far as any widely used painting method is concerned, but some painters who like to experiment in various techniques make a hobby of using them— sometimes for oil painting. Miniatures and other small works were often painted on chicken skin.

In recent years, paper has been the subject of much research. Serious deterioration may be halted in many instances by special processes of deacidification (see page 516).

HOME MANUFACTURE OF WATERCOLORS

Few artists attempt to make their own watercolors because the better grades on the market are quite satisfactory and because their manufacture with the facilities at the artist's command is so difficult. Those who have made adequately successful ones usually find that they must do their own formulating by trial and experiment, because each pigment will require its own special proportion of binder.

The chief difficulty in their formulation is in achieving balance of solubility and working qualities, and the chief difficulty in their production is in the fine grinding; in general, the home manufacture of watercolors is not recommended. The commercial product is ground in powerful roller mills such as are employed to make printing inks. The hand-ground colors are more likely to be grainy and to pick up or wash off easily.

Gouache paints, however, can be made much more easily and to good advantage. For that purpose, and because an explanation of the various functions of the modifying ingredients is useful in understanding the behavior and the good qualities or shortcomings of the paints one buys, I include the following average recipe. Published formulas for watercolor binding liquids are scarce; most writers confine their statements to generalities.

Vehicle for Watercolor and Gouache Paints

Pulverized gum Senegal or gum arabic	2 ounces
Boiling water (distilled water preferred)	4 fluid ounces
Honey-water (hydromel) 1:1 or sugar syrup or glucose	1¼ fluid ounces
Glycerin	1½ fluid ounces
Wetting agent	2 to 6 drops
Preservative: Dowicide A (sodium orthophenyl phenate), or a few drops of 10-percent phenol solution	¼ teaspoon

Pour boiling water over gum; mix until dissolved. If lumps persist, allow to stand for a while and stir again. Do not cook. Add other ingredients in order given. If the preservative is in dry powder form, it should be mixed on a slab with a palette knife with a little of the liquid to a creamy consistency before mixing in. Strain through cloth.

This recipe can be altered to meet special or individual requirements by increasing or diminishing the amounts of some of the ingredients. The various ingredients serve the following purposes:

GUM ARABIC. Binding and adhesive. Excess causes hard or glittering surface.

GLYCERIN. Imparts moistness, prevents extreme caking or drying of paints, improves brushability, increases solubility. Excess will cause paint coating to be too soluble; it will pick up too easily.

SYRUP. Acts as plasticizer, contributes smoothness for grinding and painting.

WETTING AGENT. Improves uniform flow of paints on surfaces. It replaces oxgall, formerly used for this purpose.

DEXTRIN. Some painters add various amounts of white dextrin solution to watercolor and gouache paints in order to improve smoothness of texture and brushing quality in some pigments. When this is done, use it in minimum amounts, as colors containing disproportionate amounts of this paste will have properties inferior to those made with gum arabic, and will tend to be similar to the cheaper poster colors. Convenient paste is 1 ounce dissolved in 2 ounces hot water.

ODORANT. If desired, a small amount of oil of cloves may be added to the binder solution, just sufficient to allow its odor to be perceptible; avoid perfuming it strongly. This will assist preservation in preventing mold growth and will improve the odor of the colors.

Recipes are always subject to variation of proportions depending on variable conditions, as explained elsewhere.

Transparent Watercolor Paints. With spatula, mix full-strength pigments and the vehicle to smooth, stiff paste consistency. Use a heavy muller on slab, grind thoroughly and carefully to finest degree. Add more distilled water freely during grinding whenever necessary to maintain fluidity, but allow to dry back to paste consistency before filling containers. It is easier to keep homemade colors in cake form, in small pans or boxes, than in the more fluid form in which they are sold in tubes.

Some amateur watercolor grinders make a more liquid paste than is desired and allow the excess water to evaporate until the mass assumes a drier form; another method is to grind the colors with a gum solution, allow the mixture to dry through evaporation, then regrind the mass with glycerin, thus producing a moist color which will not become dry but which will contain more glycerin than is advisable. Although glycerin is sometimes supposed to be a modern substitute for honey in moist colors, practical results seem to require the use of both.

Distilled water is used because the paint with its finely dispersed particles exhibits colloidal characteristics, and the salts and impurities in ordinary water might interfere with these. Salts are also likely to form a cloudy layer on the picture. Almost all painters ignore the advice to use distilled water for dilution during the painting of pictures, considering it

an overrefinement, but very impure water or sea water must not be used for this purpose.

The remarks on grinding oil colors may be taken as a general guide to the grinding of watercolors, except that within certain limits, which there is no likelihood of exceeding in hand-grinding methods, the colors should be dispersed as finely as possible in order to be held in the grain of the paper, in order to brush out in a smooth manner, and because coarsely ground pigments will not give the desired brilliant color effects.

As a makeshift when no other supplies were available I have made moist watercolors for sketching purposes by grinding pigments in a thick, syrupy solution of ordinary pale-colored gum drops or glycerin tablets in hot water. These candies are similar in composition to the above type of medium and normally contain gum arabic, sugar, glucose, and glycerin in fairly good proportions. Such substitutes are by no means recommended for regular use but come under the remarks on page 10.

Watercolors were originally sold in dry, compressed cakes; these have been almost entirely superseded by the pans and tubes of moist watercolors; because of their convenience the tubes are most popular. A small number of painters, however, still prefer the dry cakes, on grounds of cleanliness and purity. They are made by using a medium composed of concentrated gum Senegal, a little oxgall, and sometimes sugar. Sugar in watercolors acts as a plasticizer and enables the color to be brushed out with greater ease; like glycerin, it also increases the solubility of the dry paint; too much will unbalance the formula and cause the paint to be picked up too easily during overpainting or other manipulations.

Because the drying of watercolor is a simple evaporation of the solvent (water) and involves no chemical reaction which alters its nature, hardened watercolors can be reused by remoistening at any time; hence there are no hazards in their use insofar as doubtful adhesion or binding action is concerned, as there are in the case of casein and tempera paints. (See *Fresh Paint,* pages 5–7.) Blobs of hard watercolor on a palette will reassume their viscous or adhesive stage again when moistened; likewise, paints which have hardened in their tubes can be used if the tube is cut open and its contents used as though it were cake color. Using a muller and slab they can even be reground with water into paste form—providing one is fond of hard labor.

Surface Tension. Some liquids, notably water, have a high surface tension—that is, they tend to form drops rather than to wet a flat surface easily. Other liquids and solutions will wet the same surface easily. On the other hand, the wettability of some surfaces is greater than that of others; some grounds and pigments will repel water while others will moisten

readily. Oxgall or any of the modern synthetic wetting agents not only reduces the surface tension of the liquid but is also an efficient wetting agent for the surfaces. Wetting agents may be purchased in bottles at photographers' supply shops or from the general chemical supply houses. Solutions of aerosol and other wetting agents are also sold in dropper bottles in art supply shops under various trade names.

SOME NOTES ON WATERCOLOR TECHNIQUES

The methods, schools, or techniques of watercolor painting are many; most modern painters do not confine themselves strictly to any one, but utilize any manipulations which will suit their purposes.

Watercolor as a medium for serious or complete works of art came into use around the beginning of the nineteenth century in England; the traditional English method is to build up thin washes of delicately mixed colors, one over the other, until the desired depth and color effect is reached. The composition is usually based on a carefully executed pencil drawing.

A great number of books have been written on this technique and each one generally contributes some additional details of procedure or manipulation, some of which are adopted but most of which have been discarded by the average practitioner of today, who, whatever artistic group he follows, usually relies on one of the more direct, forceful methods.

By applying several broad washes of thin color one over the other, according to the older method, a luminous aerial effect may be obtained; this procedure is sometimes quite useful in putting in skies in pictures which are otherwise painted in the bolder, more direct manner; the combination of the two methods will give solidity to objects in contrast to the aerial quality of the sky. The paper is slightly moistened and an even tone washed over the sky. It is allowed to dry, and then gone over liberally with clear water, scrubbed in a little with the brush; this is blotted with a large sheet of white blotting paper, which takes up about two-thirds of the color. Another wash of color is then applied, allowed to become dry, and the procedure repeated. Depending upon the strength of the washes and the effect desired, three, four, or more coats may be applied; the removal of color from the high points of the grain of the paper each time contributes a sparkle to the effect. Sometimes one yellowish or reddish wash is put on as a first tone under blue skies, or under most of the picture to tone down harsh overbrilliance.

Another watercolor technique or method is to paint, usually with rather intense and final color tones, on paper which is thoroughly wet

(just below the point of saturation, where water would actually lie on the surface). This method produces soft or hazy outlines, but is capable of much variation if parts of the work are painted in a drier stage or if thin washes and dry strokes are combined with it. The paper is kept wet by soaking it thoroughly for an hour or so and then laying it on a shellacked drawing board or sheet of plate glass where it adheres as long as it remains wet. If it is desired to keep it in the wet state for a long time, it may be mounted on a piece of heavy cardboard with a strong hide glue; after this has dried it may be soaked overnight in water: the glue will swell and retain the moisture for many hours.

Another variation of this method, probably springing from the Impressionist school, is to paint a sort of mosaic, leaving a thin white space between certain color spots or brush strokes where sharpness of outline is desired. When the paper is dry, these spaces may be tinted, and the areas pulled together.

The variations and combinations of methods are so numerous that it is seldom possible to tag the work of an artist as belonging wholly to any school founded on strict adherence to one of these systems; therefore, most American painters lump these methods into two groups, classifying their work as either "wet method" or "dry method," depending on whether they work on soaking wet, slightly moist, or entirely dry paper.

The most widely used method at present employs direct bold strokes on dry paper or paper that is moistened occasionally, as required, by a slight spraying or sponging.

When painting is done on dry sheets of heavy paper, the paper is usually fastened to a drawing board with thumbtacks, or clamped to a lightweight board or portfolio cover with spring clothespins, metal clips, or rubber bands. When a more accurate level surface is required, or if lightweight paper is employed, the paper must be stretched or strained on a board. Finished, dry pictures will usually flatten out again on storage.

Stretching Paper. When a watercolor is done on a loose sheet of thin paper or on a pad or block, the wrinkling of the sheet resulting from the unequal swelling of the fibers will interfere with the accuracy of the brushwork; the more detailed the brushwork, the greater the care necessary to prepare a smooth, flat working surface, and pains taken to secure this surface will repay the painter in the long run. For studio work, the paper should be dampened and attached to a drawing board all around, a half-inch or so in, with gummed tape such as is used for package sealing.

The older method in use before the day of gummed tape was to blot off a half-inch margin of the dampened paper and attach it to the drawing

board with starch paste (page 391) or some prepared material such as Higgins' Vegetable Glue; this method is still preferred by some painters. If the paper is not wet enough, it will not stretch properly; if it is too wet, the great contraction on drying will cause it to tear. Apply the water evenly with a sponge or flat brush; cover the paper with a damp cloth for a while, and then test it by bending down a corner. If it springs back into place and retains its full elasticity, it has not sufficient moisture; if it does not spring back, it has enough water. If the corner bends of its own weight, in a soggy manner, it is too wet. As the paper dries with its edges fastened down, it will stretch tight and smooth. When the picture is finished, it is cut away from the board.

Lightweight paper may also be stretched with thumbtacks on a thin drawing board, if the paper is an inch or two larger than the board. The paper is dampened and the edges turned under and fastened to the back of the board with many small thumbtacks. In order to prevent cockling of the paper, a square is cut out of each corner so that the paper may be tacked or pasted to the edges of the board without any folding.

GOUACHE

The practical meaning of the word "gouache" is generally well understood by painters, but there is still a question among some painters as to what is and what is not a gouache painting, just wherein the paints used differ from other water paints, and, indeed, whether such things as special gouache colors are important or whether the term describes only a kind of picture for which a number of different materials can be used.

Gouache is opaque watercolor. It is separate and distinct from the kind of transparent painting on fine, brilliant white handmade paper which we know as watercolor. A gouache painting can, if one pleases, be painted in deliberately applied, smooth, flawless fields of color and with precise lines; but the use to which gouache is customarily put is a painting which gives the effect of free, spontaneous flowing or robust, dashing brush strokes. A well-painted gouache picture of this genre should have no very heavy impasto or abnormal thickness of paint layer or the paint will crack; yet it has the effect of seeming to be thicker or "juicier" than it actually is. However, unlike watercolor, which is little more than a colored stain on the paper, gouache paint has a definite, appreciable film thickness and creates an actual paint layer.

Because gouache paints are opaque and have (or should have) a total hiding power, and because they do not become progressively transparent with age as oil paintings have a tendency to do, their effects do not de-

pend so much on the color of the ground. Transparent watercolor and the delicately translucent tempera paints depend for their brilliancy on a highly reflective pure white ground, which contributes a luminosity or inner glow. Gouache has a brilliant light-reflecting quality of a different and distinctive nature; it lies in the paint surface itself; its whiteness or brightness comes from the use of white pigments. It is most popularly used in a high chromatic key or in strong contrasts of values. The medium is highly appropriate for use in creating the effect of spontaneity and an *alla prima* effect. The average gouache painting is done on less roughly textured paper than the average watercolor, and painters often use tinted paper, or start with a partial foundation painting of watercolor as is sometimes done with pastel.

That the term "gouache" originally may have had meanings other than that of our 200-year-old usage is hinted at in some of the earlier records; for example, a sixteenth-century Italian writer, in reference to the advantages of straight oil painting over the fifteenth-century oil-on-top-of-tempera painting, remarks, "Let us leave gouache (*guazzo*) to the Flemings, who have lost sight of the right road. We, however, will paint in oils."

Proper gouache paints are made by grinding pigments in the same medium as is used for watercolors (see page 286); but by grinding with a definitely larger percentage of vehicle than is used in watercolor, and by adding various amounts of such inert pigments as chalk or blanc fixe (to improve color and textural effects, not as an adulterant), the opaque effect is obtained. Artists can grind their own gouache colors a good deal more successfully and economically than is possible with watercolors and oil paints. Several brands of French and Dutch gouache colors and English "designers' colors" are now on the market; in selecting them one must be careful to select only those tubes labeled with the familiar pigment names on the artists' approved list and to avoid the ones with fancy names, because gouache paints are also highly popular among those who work only for reproduction where permanence of the original work of art is not important, and thus some of the brilliant, fugitive colors are also to be found in these fields. The binders in the designers' colors appear to be composed largely of dextrin.

It would be rather quibbling to claim that paintings done completely in the typical gouache-painting techniques but with the use of other paints—such as casein colors, watercolor mixed with Chinese white, or other aqueous paints—are not "genuine" gouache pictures. However, painters who attempt to duplicate the typical effect of the special gouache colors usually find that these other paints have less sensitivity or delicacy in handling.

So, if it is not too confusing an explanation to make, it can be seen that our use of the term "gouache" includes both the materials and the kind of picture, and that although there are special gouache colors, other water paints with no effective degree of transparency can also be used, at least to fill in or substitute for them.

Aesthetically or optically, as I remarked under *Watercolor,* we generally dislike opaque touches or areas on a picture that is essentially and predominantly a transparent watercolor; we usually prefer these to be pure watercolor, and it requires a bit of skill or flair to work opaque touches into them. But the introduction of transparent watercolor into a picture that is predominately a gouache painting is easier, and is more frequently visually pleasing. However, no generalities of this sort are universally applicable, and individuals often combine many methods in one painting; various combinations of watercolor, India ink, pastel, charcoal, and gouache have long been used to create work of outstanding individual character and technical excellence. Some of the fine gouache colors can be greatly diluted with water so as to act like transparent watercolor washes. This is not what they are designed for, and the result will not be nearly as brilliant as watercolor, but they can be used in that manner if the occasion requires it. Gouache colors can also be used in a sort of intermediate type of painting halfway between the opaque or impasto effect of gouache and fully transparent watercolor, or they may be mingled with watercolor paints to produce denser effects. Polymer colors may be combined with aqueous colors on a painting, but not mixed with them.

Homemade Gouache Paints

The best gouache colors are made with the same kind of vehicle as is used for transparent watercolors but are made up to a more liquid consistency; thus they contain a higher proportion of binder. In the gouache technique the pigments which are normally transparent are rendered opaque, and are made to exhibit their mass-tone or top-tone effects, by the addition of various amounts of inert pigment (precipitated chalk or blanc fixe)—about 50 percent on the average; sometimes zinc or titanium whites are added to the deeper colors in order to bring out their undertones or to reduce the entire palette to a uniform pale tone. When it is desired to secure powerful tinting strength of deep pure tones or, as in the case of whites, great hiding power, some pigments are used full-strength. Gouache colors should be smooth and the pigment particles well dispersed, but they do not require the extremely fine grinding that is necessary for watercolors; some painters find a glass mortar and pestle convenient for making these semiliquid paints. Gouache colors may be kept in screw-cap jars, and if stored for any great length of time should be in-

spected occasionally; if they have thickened, additional water should be put into the jars to keep the color from drying up.

Use the recipes on page 286; grind pigments with the vehicle (pages 141 ff) to a smooth creamy or syrupy consistency, adding distilled water as necessary, or allowing some of the water to evaporate if too fluid. Use glass or porcelain mortar and pestle, or a glass muller on a glass or marble slab.

There is no structural objection to omitting the chalk and grinding full-strength pigments if preferred, but a good white inert pigment adds desirable bulk, brilliance, and smoothness to some of the colors, and, if it is not used excessively, there is no loss of intensity or vividness.

The formulas attempt to bring the entire list'within a desirable range of uniformity of tinting strength and color characteristics. Pigments which are difficult to wet (notably alizarin) may be moistened with alcohol, or alcohol and water, before adding the vehicle.

Paint recipes cannot always be used in a strict cookbook manner; readjustment of final results is often found to be necessary after testing. An original recipe is frequently more valuable as a starting point than as a precise guide to immediate perfection.

A fine gouache paint should be capable of being brushed out to a smooth, flawless layer, and even if it is to be used in the more varied thickness of bristle-brush stroking, this is a good test for quality.

Mixed Colors. Some painters habitually use or have a preference for exact, definite mixtures of pigments (especially grays) which they use to such an extent that sometimes it pays to make up jars full of specially prepared mixtures. Painters and teachers who follow some of the many systems of color theory will also find it helpful to prepare special hues in advance.

For instance, a bright red which fills in a gap in the color scale of permanent pigments between vermilion and alizarin can be made by mixing 3 parts of alizarin red with 1 part of cadmium red, light. For average purposes, however, such mixtures are usually made on the palette as required.

Recipes for Mixing Colors

In the following recipes, volume measurements are given for the convenience of those who have no scale available. Using a set of standard kitchen measuring spoons, T means level tablespoon, t means level teaspoon. A dram is ⅛ fluid ounce; all small 1-, 2-, or 4-ounce measuring glasses are marked in drams. Add water freely to obtain easy grinding consistency whenever required.

Ingredients	By weight	By volume
White		
Titanium oxide	2 ounces	6½ T
Gum solution		7 drams
Black		
Ivory black	¾ ounce	2 T
Mars black	1 ounce	3 T
Precipitated chalk	½ ounce	2 T
Gum solution		6 drams
Red		
Alizarin red	½ ounce	2½ T
Precipitated chalk	½ ounce	2 T
Moisten with alcohol and add:		
Gum solution		5 drams
Indian red	1 ounce	2 T
Precipitated chalk	1 ounce	4 T
Gum solution		8 drams
Light red	1 ounce	2 T
Precipitated chalk	1 ounce	4 T
Gum solution		9 drams
Vermilion	1½ ounces	2¼ T
Precipitated chalk	½ ounce	2 T
Gum solution		6 drams
Cadmium red maroon	1 ounce	1½ T
Precipitated chalk	1 ounce	4 T
Gum solution		8 drams
Cadmium barium red, light or medium	2 ounces	4 T
Gum solution		6 drams
Yellow		
Pure cadmium yellow, light	2½ ounces	8 T
Precipitated chalk	¾ ounce	3 T
Gum solution		8 drams

Ingredients	By weight	By volume

Yellow

Ingredients	By weight	By volume
Pure cadmium yellow, medium	2½ ounces	7½ t
Precipitated chalk	¾ ounce	3 T
Gum solution		8 drams
Pure cadmium yellow, deep (orange)	2½ ounces	7½ T
Precipitated chalk	¾ ounce	3 t
Gum solution		8 drams
Cadmium-barium yellow, light	3 ounces	6 T
Gum solution		7½ drams
Cadmium-barium yellow, medium	2 ounces	4¼ T
Gum solution		6 drams
Dextrin paste		1 t
Mars yellow	¾ ounce	3 T
Precipitated chalk	¾ ounce	3 T
Gum solution		9 drams
Raw sienna	¾ ounce	3 T
Precipitated chalk	¼ ounce	1 T
Gum solution		6 drams
Dextrin solution		½ t
Strontium yellow	2 ounces	8 T
Gum solution		8 drams
Dextrin solution		½ t
Yellow ochre	¾ ounce	2 T
Precipitated chalk	¾ ounce	3 T
Gum solution		6 drams

Blue

Ingredients	By weight	By volume
Manganese blue	1½ ounces	2 T
Precipitated chalk	½ ounce	2 T
Gum solution		4 drams
Phthalocyanine blue, CP	1 ounce	4 T
Precipitated chalk	1 ounce	4 T
Gum solution		8 drams

Ingredients	By weight	By volume
Blue		
Ultramarine blue	1½ ounces	3 T
Precipitated chalk	½ ounce	2 T
Gum solution		7 drams
Phthalocyanine blue 25%	½ ounce	1 T
Precipitated chalk	½ ounce	2 T
Gum solution		4 drams
Cobalt blue	¾ ounce	3 T
Precipitated chalk	¾ ounce	3 T
Gum solution		9 drams
Cerulean blue	2 ounces	4 T
Gum solution		6 drams
Green		
Chromium oxide green	1 ounce	2 T
Precipitated chalk	1 ounce	4 T
Gum solution		8 drams
Viridian	½ ounce	1¼ T
Precipitated chalk	½ ounce	2 T
Gum solution		8 drams
Phthalocyanine green 25%	½ ounce	1 T
Precipitated chalk	½ ounce	2 T
Gum solution		4 drams
Violet		
Mars violet	¾ ounce	1½ T
Precipitated chalk	¾ ounce	3 T
Gum solution		6 drams
Brown		
Burnt umber	½ ounce	1 T
Precipitated chalk	½ ounce	2 T
Gum solution		5 drams

	Ingredients	By weight	By volume
	Brown		
Burnt sienna		½ ounce	2 T
Precipitated chalk		½ ounce	2 T
Gum solution			5½ drams
Raw umber		½ ounce	1 T
Precipitated chalk		¾ ounce	3 T
Gum solution			5 drams

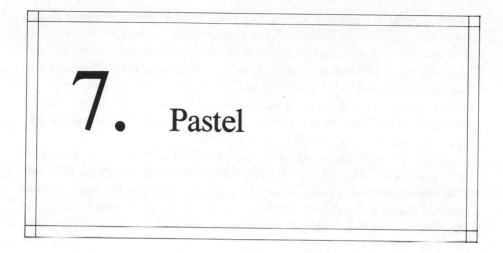

7. Pastel

THE ART OF painting in pastel dates back about two hundred years. If outline drawings in colored chalks or earths are included, the technique may be said to be prehistoric; pastels in our present sense of the term, however, begin with the eighteenth-century portraits in this medium.

Permanence. The process, so far as materials and the chemical characteristics of the results are concerned, is one of the simplest and purest, being a method of painting with pure color without medium, and for this reason it is preferred by some artists who do not want their paintings to suffer those effects of age that are caused by the changes that mediums of other methods undergo. The disadvantages of pastel are its relative fragility under mechanical wear and tear, its color or tonal limitations, and the impossibility of glazing it. When pure, highest-quality paper and only the absolutely permanent colors are used, pastel is among the most permanent forms of painting. Framed under glass and given the care that any work of art normally receives, portraits of the 1750 period have come down to us as bright and fresh as the day they were painted.

 Although pastel painting is uncomplicated by any fluid vehicle or medium, and the binding medium used to mold the pigments into sticks or crayons is a very weak solution just sufficient for that purpose, still it is not quite correct to say that this binder has no effect on the pictures. One

of the charms of the finished painting is its texture; manipulations of the crayons will produce a varied effect—thin or thick, smooth or rough, level or impasto—and without the presence of the binder the pigment particles alone would not be cohesive enough to have this versatility. Then too, the balance of properties of the binder is important; the crayons must be strong enough to withstand a reasonable amount of handling without breaking, crumbling, or splintering too readily, and soft enough to deposit the desirable pastel effect on the paper.

Pastel pictures also sometimes require a fixative to prevent the colors from dusting off. This fixative, when properly made and applied, does not alter the appearance of the picture to any great extent, the main change being a slight lessening of the softness of the borders. This change is usually very much less than the drying change which occurs in the other painting methods.

Prepared artists' pastels are usually sold in three grades, soft, medium, and hard. The soft is universally used, the other two for only special effects and purposes. The soft texture of pastels allows them to be easily manipulated; the common chalk crayons intended principally for blackboard use are unsuited for the purpose. There is no reason why reputable makers of artists' pastels should not state on the pastel label the specific pigments used; when this is not done there is always some doubt as to whether the crayons contain only permanent pigments, since pastels which contain dyes and fugitive lakes of great brilliance have often been placed on the market.

HOMEMADE PASTEL CRAYONS

Homemade painting materials have been discussed on page 9, and also in connection with oil colors and watercolors where the practice was not recommended as a general procedure. However, in the case of pastels it is possible to make highly acceptable crayons at a fraction of the cost of the ready-made product. Because the commercial products are occasionally unsatisfactory, because special unobtainable hues and shades are sometimes desired, and because there is a dearth of information on the subject in print, an outline of the procedures is given here, largely based on Ostwald's instructions.[46]

Materials

Mortar and pestle made of glass or procelain
Gum tragacanth
Precipitated chalk
Pigments (see pages 73–74)

Preservative and mold preventive
Improvised syringe

As a syringe Ostwald suggests using a discarded bicycle pump. An aluminum cake-decorator from a kitchenware shop or a grease gun can also be used. The use of a syringe is optional; hand-molded crayons are usually entirely satisfactory. As a matter of fact, most amateur pastel makers find such gadgets impractical and more bother than they are worth. In a factory, pastel is mixed in a bakery dough mixer or its equivalent and extruded through an orifice from which the cylindrical lengths of pastel are taken up on little grooved or channeled trays, which support and maintain the pastels' shape while they are drying.

Binding Solutions.

Solution A

Water	48 fluid ounces
Gum tragacanth (powdered)	1 ounce
Beta naphthol (preservative)*	½ teaspoon

Solution B

Solution A	16 fluid ounces
Water	16 fluid ounces

Solution C

Solution A	8 fluid ounces
Water	24 fluid ounces

Procedure. Make Solution A by mixing gum and cold water and allowing the mixture to stand in a warm place overnight. Add the preservative and stir with egg beater or electric mixer (recommended) until the mass is homogeneous. This will keep indefinitely in well-corked bottles.

The various pigments will require solutions of different strengths to produce crayons of the proper degree of softness; very few will need the full-strength A solution. (This is a somewhat weaker and more convenient solution than the one recommended in the first edition of this book.) Methyl cellulose, which is soluble in cold (and not in hot) water, has been suggested as a modern substitute for gum tragacanth.

Because of the variations in raw materials, no really accurate instructions can be given for the amounts of binder necessary to make pastels of the proper texture. A small amount of the color or combination of colors

* Sodium orthophenylphenate, mentioned on page 393, is perhaps a modern improvement, but β naphthol will preserve these gum solutions for many years, if the containers are tightly corked.

must be mixed with the tragacanth mass on a slab with a palette knife, formed into a lump or crayon, and tested to see whether the pastels will be soft or firm enough. This test piece may be warmed to hasten its drying. Accurate records of correct proportions should be kept in a book. Always note the source of the material and date purchased.

To begin by making white pastels, weigh out roughly 2 ounces (about 5 ounces by volume) of precipitated chalk, and add about ½ fluid ounce of the dilute C solution, described above. Mix this in the mortar until it is smooth and of the consistency of putty. If it is too dry and stiff add a little water, and if it is too sticky to handle easily with the fingers add more chalk. Roll into sticks with the hand on a layer of newspaper; the forefinger must be held parallel to the stick, *not* at right angles to it. A smoother-looking crayon can be rolled by using a small piece of cardboard (about 3 by 4 inches) covered with a piece of newspaper instead of using the fingers, but most artists do not object to irregularity in the shapes. Length and thickness should approximate those of the commercial product. Set aside on a piece of newspaper and allow to dry at normal room temperature for two days. Occasionally a lot of precipitated chalk will produce rather splintery crayons, with tragacanth; a small percentage of gilder's whiting will usually correct this without decreasing the whiteness of the product.

To make a series of gradations of a color—ultramarine, for example—first make a large amount of the white chalk dough to be used as stock. Then take about 4 ounces of ultramarine and grind it to a smooth paste in the mortar with a sufficient amount of the medium-strength solution B, to a consistency dry enough to keep it from adhering to the fingers. Some artists prefer not to bother with the mortar, but start mixing with a spatula on a glass slab, and finish by kneading with the hands. Mold the mass into a symmetrical cake, slice it into two equal parts with the spatula, and put one of these halves aside to be used in the next step.

Make crayons of this dough; they will be the first or deepest shade of ultramarine. Before the crayons are molded, a small piece of the paste should be dried by warming, and tested to see whether it is of the desired degree of softness. If any alterations in the strength of the gum solution are necessary, make a note of them for future reference, bearing in mind, however, that the amounts apply with exact accuracy only to materials of the same source of supply and date. Mix the rest of the dark blue dough, which was put aside, with an equal amount of the white paste; knead or grind until uniform and free from streaks. This mixture when made into pastels will give value number 2, ½ white and ½ blue. Mold it into a neat form on the slab and slice it into two equal parts as before, put one of

them aside to be used in the number three step, and roll the number 2 crayons. Mark the paper on which they are set aside to dry with the proper number to avoid confusion.

Repeat the same procedure for each shade, adding an equal amount of white dough each time. Between the seventh and tenth steps, depending on the strength of the ultramarine, the color will become so light that further dilution produces no noticeable difference, and the series is finished. However, very pale tints or off-whites with cool or warm colors are quite useful in painting.

Another system is to mix the entire 2 ounces of the dark-colored paste with an equal amount of white stock, which will give the second value (½ white, ½ blue). Divide this into two equal portions, make crayons out of one portion, and to the other add an equal amount of white stock, which will make the third value (¼ blue, ¾ white). Divide this paste in two equal portions as before, make the third-value crayons out of one, and add an equal amount of white to the other to make the fourth value, and so on. This may be a simpler way of measuring the amounts, but it requires grinding a double-sized batch in the mortar each time.

A series could also be made by mixing the colors dry and then adding the liquid. This would require making up separate mixtures of the binding liquid, adjusting them to the proportions of the pigments present. The first method is the easiest.

Ostwald[46] points out that the gradations are to be made according to these proportions so that each subsequent mixture contains the same fraction of the preceding mixture's color, in accordance with a general law that the eye perceives equal ratios, not equal differences, as corresponding gradations.

After a set of single colors is completed, according to the requirements of the individual, mixtures of colors may be made up of two or more dry pigments each, resulting in shades that cannot be purchased ready-made.

Talc has been recommended as a substitute for or addition to precipitated chalk, because its slippery or soapy texture imparts a desirable working property to the crayons.

The eighteenth-century artists' guides are full of recipes for pastels in which each pigment is mixed with a different binding material supposed to give the best results. These include such homely materials as milk, stale beer, and oatmeal water.

The various shades of pastel crayons can be kept clean, whole, and orderly only by the use of separate boxes or compartments, but the pastel adept usually learns how to work from a mixed or less rigidly organized assortment.

RECOMMENDED LIST OF PIGMENTS FOR PASTEL, WITH TYPE
OF BINDER REQUIRED BY THE AVERAGE SPECIMEN OF DRY
PIGMENT

Pigment	*Strength of binder*
White	
Precipitated chalk	Medium
Black	
Ivory black	Medium-weak
Mars black	Medium-strong
Red	
Indian red	Weak
Light red (strong shades make poor crayons)	Weak
Vermilion	Medium-strong
Pure cadmium reds	Strong
Alizarin reds	Strong
Mars reds	Medium
Cadmium-barium reds	Medium
Burnt sienna (serves to replace light red and Indian red)	Medium
Blue	
20% phthalocyanine blue	Very weak
Ultramarine blue	Medium-strong
Cobalt blue	Medium-strong
Cerulean blue	Medium
Manganese blue	Medium
Yellow	
Raw sienna	Very weak
Cadmium-barium yellows	Medium
Ochre	Weak
Pure cadmium yellows	Medium
Strontium yellow	Medium-weak
Mars yellow	Strong

Pigment	Strength of binder
Green	
Chromium oxide	Medium
20% phthalocyanine green	Very weak
Viridian	Extremely weak
Brown	
Raw umber	Very weak
Burnt umber	Medium-strong
Burnt sienna	Medium
Violet	
Mars violet	Weak
Manganese violet	Weak
Alizarin red plus	
phthalocyanine blue	Weak

PAINTING IN PASTEL

The Ground. Special papers with varying degrees of roughness are widely obtainable. Almost any soft drawing paper can be used; the grain must be of such a nature that it will file off the particles of the pastel crayons and retain them. From this standpoint there are two kinds of paper (apart from type or quality); one takes pastel nicely; the other has a hardness of texture that repels the pigment.

Three general types of good pastel paper can be purchased in the shops: (1) the fibrous type, which includes all drawing and watercolor papers whose grain is receptive to the pigment—these being currently the most popular; (2) granular pastel paper, which has a coating of extremely fine-grained inert pigment and which in effect is like a very soft, fine sandpaper; and (3) a special velvety-finish paper that has been coated with powdered cloth (flocked). The regular fibrous or drawing-paper type of paper is best suited to free, bold, textural work, the grained types to smoothly blended or slick effects. For permanent painting, all pastel paper, whether white or tinted, must be made of rags and should be purchased from a reliable source. Prepared canvas is also obtainable, and sometimes thin muslin or similar cloth pasted to cardboard or wallboard is used. A porous coating, such as lacquer or paint into which an excess of pumice, silica, or other tooth-imparting pigment has been stirred, may be sprayed or painted on boards. When the pastel painting is solidly done and the entire surface of the ground covered, the color of the ground is

unimportant; when the painting is loose or sketchy, leaving areas uncovered, the ground naturally influences the entire work, and many pastels depend on the white, gray, tan, or other color of the paper for their effects. The granulated or sparkling effect of a coarse-textured paper showing through sparsely applied strokes is utilized to a considerable extent. Vellum has been used as a surface for delicate work.

Pastels are sometimes applied on paper wholly or partially colored with watercolor, or over drawings begun in gouache, ink, or watercolor, or used in combination with these mediums. As a general rule, the latter may be done successfully only when the opaque color predominates; small touches of pastel in a picture which is essentially a transparent watercolor give an effect that may not always be desirable.

Manipulations. The general rules governing the various techniques of creating artistic works in pastel do not differ from those which apply to the other methods of painting; most schools of painting condemn small, picky strokes and tiny, sharp crayons in general, as they do tiny brushes and tight strokes in oil. They usually insist on large free strokes and the use of plenty of crayon and all possible aids, such as crumbling the crayons and rubbing them in with the fingers; also they recommend the use of stumps and bristle brushes, sometimes trimmed off to make them stiffer, for spreading and blending the colors. A stiff brush is also useful for removing color by dry scrubbing, when corrections are to be made. A rubber finger cot may be used to protect the fingers, but sometimes it is preferable to work without it. The mechanically smooth blends and halftones that may be obtained by manipulations are well known, but are usually condemned on artistic grounds, and held to be pitfalls for those who attempt too much finish and working-over of a pastel painting. Pastels are usually done on an easel sloping forward so that the dust falls away from the picture. The poisonous colors are excluded from the palette (page 75), but no finely divided powders, no matter how inert, should be continuously inhaled. Note the warning on a can of baby powder.

The books by Sears[85] and others listed in the bibliography will supply valuable information on the equipment and the techniques of handling pastel. Any instructive artists' manual is necessarily influenced by its author's aims and purposes; it is understood that the reader will take advantage of the technical aspect of the subject and apply it to his own aims and purposes.

The use of pastel is by no means narrowly confined to the traditional forms of the past, but can be successfully adapted to serve any of our contemporary styles.

Other Crayons. Trademarked brands of pastellike crayons with special performance characteristics are of unknown composition and therefore cannot be commented upon from the standpoint of permanence. In purchasing these, and also the colored pencils which are widely used for special purposes, it is important to select those with true permanent pigment names as noted on pages 34–35.

The ordinary inexpensive wax crayons and chalks such as are used in school work contain the cheapest sort of pigments. Wax crayons are made with paraffin, and aside from their doubtful permanence are adaptable to very few artists' techniques because of the rather smeary quality of the textural or color effect produced—a surface that is not in accordance with our traditional ideas of professional requirements, which are generally the result of the adept or skillful use of a medium that offers some resistance or challenge to the artist. However, some modern painters have no objections to this smeary quality and have utilized the property of wax crayons for interesting textural effects by applying layers of one color over another and scraping or rubbing down through the upper layers. The impermanence of wax crayons is, nevertheless, quite obvious; the surface is extremely fragile and completely incapable of being cleaned or varnished. For a permanent version of these textural effects, see Chapter 8, "Encaustic Painting."

The rectangular sanguine, brown, black, and other chalk crayons of the Conté type, made of compressed pigments, are traditional materials of long standing and completely acceptable.

Fixing and Preserving Pastel Paintings. A pastel picture, especially if it depends on subtle color and the characteristic soft pastel texture, should not be heavily sprayed with fixative in an attempt to make it resistant to smudging when handled. Pastel fixative is intended to be used lightly, so as to reduce the fragility of the picture a bit and to prevent the particles from falling off because of their own lack of cohesion; a further degree of protection by fixing results in changes in color relationships and in loss of pastel quality. Complete protection is supplied by correct framing under glass (see page 517). Most pastel specialists dislike fixatives and use them sparingly. For the past two centuries artists and chemists sought a fixative that would not change the colors, including methods of applying a binder from the rear of the paper, but a law of physics tells us that this is impossible: the color of a pigment always varies when its surrounding medium is changed. (See pages 114 and 121.)

Most of the fixatives sold in the shops are very weak solutions of nonyellowing resins in alcohol. Some of the synthetic resin fixatives contain lacquer solvents of objectionable odor, in place of the alcohol; this is

especially so in the case of the modern types sold in pressure cans instead of bottles.

One of the best fixatives, both as to protection and slightness of change in color effect, may be made by the following formula, which has been adapted from an old one published by Ostwald.[46]

Soak ½ ounce of fresh casein in 4 or 5 ounces of water for about six hours; then add pure ammonia, drop by drop, with constant stirring, until the casein has dissolved to a thick, honeylike mass. Use just enough ammonia to effect the solution; it will usually take about ¼ teaspoonful; never use cloudy household ammonia. Then add a half-pint of pure alcohol; when this is mixed in well, add enough water to bring the total amount up to a quart, and filter before bottling. A fine white precipitate may be deposited on standing; the bulk of the liquid should be poured off without disturbing it. The fixative is never entirely clear in the bottle, but usually displays a slight cloudiness. If desired, ammonium carbonate may be used to dissolve the casein, as described under *Casein Solutions,* page 381. The monoammonium caseinate mentioned in that section will produce the cleanest, most colorless solution. When this variety is used, warming the mixture in a can immersed in boiling water will dissolve the casein without the use of ammonia.

If some of the ordinary grades of denatured alcohol are used, the amount of sediment will be greater, and the color of the liquid will probably be distinctly yellowish or pinkish. Pure grain alcohol is best. Old casein also produces a more yellowish solution. The fixing strength of this solution may be greater than is required. Tests should be made, and the solution diluted with water until it is just weak enough to produce no undesirable color change.

Creative pastel pictures should be lightly fixed, so as to reduce their fragility and prevent their dusting off of their own accord. Framing under glass is their chief protection. (See page 517.)

Spraying any fixative heavily enough to protect the work against damage in handling will cause the whites to disappear, because of the chalk's low refractive index. When pastels must be so handled, as in submitting work for approval, the solution of the problem is for the artist to make a special white pastel with a large percentage of titanium white, which will maintain its opacity under heavy fixing.

Pictures to be fixed should be laid on the flat, level surface of a table or upon the floor, and the atomizer or sprayer must be correctly manipulated. It should be held at the proper distance from the picture for the type of spray it emits, so that the finest, most uniform mist is deposited. Each stroke should begin and end beyond the picture, and if it is necessary to hold the atomizer directly over the paper, a shield made of paper

or cardboard should be improvised and affixed below the nozzle, so that the heavy drops which sometimes accumulate at this point will not fall upon the picture.

Common fixatives such as are sold for preserving charcoal drawings are simply very dilute solutions of mastic, shellac, Manila copal, etc., in alcohol; they have considerable effect on the colors used for pastels, the result tending toward that produced by the use of a strong binder in paint. When such resinous materials are used in fixatives, their proportion should be about 2 parts to 98 parts of solvent. Synthetic resins are also in use, but nowadays many of them contain nitrocellulose in a mixture of various solvents, formulated to yield a mat surface. Spray cans of fixative are very popular, but some artists still prefer the traditional mouth blower. The most efficient sprayer for homemade fixatives and those sold in bottles is the one described on page 508.

The term *workable fixative* means that, after use, one may continue the drawing or painting without being hampered by the repellent surface that some fixatives create.

Mold on Pastels. Mold or mildew sometimes occurs on pastel paintings as it does on other surfaces and, because of the pastel's mechanical fragility and the difficulty of removal of such blemishes, it is surprising that more attention has not been given to its prevention in the past. Paper could easily be mold-proofed during its preparation, by the addition of a small percentage of fungicide (page 392), and the crayons themselves could contain similar material. The adoption of a standard procedure on these points would remove any objection to the use of pastel on this score.

Pastel as a Portable Sketching Medium. Many artists prefer pastel to watercolor as a medium for on-the-spot or outdoor sketches and color notes. A pocket-sized box (for example, a "flat fifty" cigarette tin) with an assortment of crayons, and a glossy paper magazine or booklet to act as a combination paper carrier and drawing board, or a regular pastel sketchbook, comprise the entire outfit.

Mounting Pastels. Because it is often inconvenient to work on stiffly mounted papers or boards, pastels are sometimes mounted after they are made. As Williams[84] points out, fragile as they are, unfixed pastel paintings will withstand a considerable amount of expert handling; direct vertical pressure of a nonabsorbent surface on a pastel picture will do little harm; should a slight amount of color dust off, the effect will not be noticeable. However, any *lateral* movement against the pastel surface would be ruinous. Any number of pastel pictures may therefore be piled

up with a sheet of smooth, coated paper (cellophane is good) laid over each, a stiff board placed at either end of the pile, and the bundle securely and tightly tied together for transportation.

To mount a pastel, lay it face down on smooth, shiny paper or cardboard, dampen the back with a well-wrung sponge, blot dry a half-inch margin all around the edges, and apply paste to it. Place face up on the mount, which should be somewhat larger than the paper, cover with a sheet of smooth paper, rub flat with the hand, and cover with heavy weights until dry. The pastel paper should stretch out tight and smooth. In this as in all other handling of pastel pictures, do not touch the painting with the hand, and guard against the least lateral movement between the picture and the surface which lies against it. Most conservators who specialize in works on paper prefer to fasten the paper to the mount by pasting along the top edge only to avoid the use of gummed or plastic tapes, and to use no other adhesive than paste. See *Mounting and Framing Works on Paper,* pages 516–17. An expert conservator can clean, repair, and even wash pastel pictures by a series of delicate manipulations (pages 515–16).

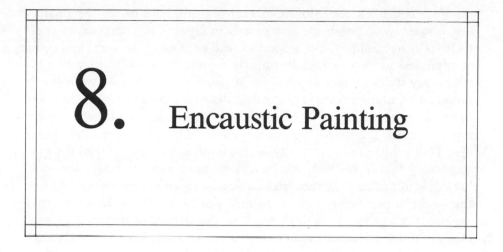

8. Encaustic Painting

ENCAUSTIC OR HOT wax painting comes down to us from ancient Greece, where it was a major creative art process for both easel and mural painting. It is perhaps man's earliest formal easel-painting method, and it shares with the ancient process of fresco a certain fundamental purity or simplicity combined with a rather inconvenient and demanding *modus operandi*. Its use was displaced by other mediums (tempera, oil painting, etc.) with the developing and changing requirements of European art and also because of the cumbersome nature of its equipment, so that during the medieval and Renaissance periods it was a genuine "lost art."

During the eighteenth century, mural painters sought a new material that would give permanent results under drastic conditions, especially dampness; wax seemed to fill these requirements and the reputed excellence of the ancient Greek process offered a goal to artists and scholars; and so, by means of literary research, laboratory investigations, and reconstructions, a revival of encaustic began. This work, which continued through the nineteenth century, is well documented, and today we have not only the ancient sources but also 200 years of later records to guide us in our current revival. Almost all of the practical interest in this medium in the more recent past was centered on its use in wall painting. No completely satisfactory standard mural practice emerged from this work for the simple reason that no superficially applied coating material will long resist the seepage of moisture from the rear.

311

Encaustic has since enjoyed another revival for its use in easel painting, where several points are now greatly in favor of its acceptance. Its effects, its visual and physical properties, and its range of textural and color possibilities make it eminently suitable for use in several different contemporary styles of painting that are not adequately served by our traditional oil-painting process. The greatest deterrent to its use in the past has been the cumbersome charcoal-fired heating arrangements which were not very much improved 200 years ago over what they were 2000 years ago. Today the use of electrically heated equipment has changed the process to one that is relatively convenient. Its permanence and its historical background appeal to the conscientious painter who does not want to risk the doubtful permanence of oil paints applied to canvas in a way that they were never intended to be used, or the still more doubtful permanence of untried synthetic materials with which some experimental painters have been occupied.

The Process. The "classic" or "basic" encaustic method is extremely simple; it consists of painting on any ground or surface with paints made by mixing dry pigments with molten white refined beeswax plus a variable percentage of resin (usually damar), working from a warm palette. The brush or palette knife manipulations can also be assisted by warming and chilling the surface. A final heat treatment, or "burning in" (which is the meaning of the name encaustic) by passing a heat source over the surface, fuses and bonds the painting into a permanent form without altering it, and a light polishing with soft cotton brings out a dull, satiny sheen. When cool, the picture is finished; no further change ever takes place. The work, however, may be set aside at any moment to be taken up again later. Waxes are described on pages 394–96.

The results that can be obtained by variations in manipulating the colors run nearly the entire gamut of easel painting. The *effects* of a heavily encrusted, robust impasto can be produced without overloading the canvas or panel with an exaggerated thickness, and complete opacity and hiding power or transparent and revealing effects can be achieved. Practically any desired surface texture is possible. If the surface is kept warm, free-flowing manipulations and blending may be carried out as with oil colors or enamels; on a cooler surface touches will stand out brilliantly and separately.

Heating Equipment. The ancient Greeks used a barrel-shaped container of glowing charcoal upon which rested a flat metal palette; the colors were manipulated with a bronze spatulate instrument. This tool, which

was referred to in Roman manuscripts as a *cestrum,* was generally kept heated in the charcoal. Today an electrically heated palette is used.

If it is desired to warm the canvas or panel, an electric light bulb or heat element in a reflector can be clamped and pointed at the surface of a panel or at the rear of a canvas, or can be held in the left hand and applied and withdrawn as needed.

An aluminum palette with depressions to hold the molten colors can be purchased (see page 645); its electric element is designed to keep the colors at the right temperature. One may also construct a palette by using a box with a metal top heated by electric light bulbs within. Artists have been most ingenious in inventing various pieces of equipment to suit their purposes. A large palette (18" x 28") that has served many of our present-day pioneers is made from a two-burner electric stove or hot plate, with a flat ¼-inch-thick sheet of iron or stainless steel mounted 2 inches above it by means of iron brackets or legs bolted or welded to it. The 3-heat switches on such stoves are usually turned to high for ten minutes and then operated at low. Obtaining heating elements low enough for use is more of a problem than finding very hot ones—the best operating temperature is probably about 200° to 225° F. When an aluminum surface is used, a very minute dark-colored deposit may sometimes be observed, but this is so tiny that the colors are unaffected by it.

The Colors. Ready-made color sticks with good proportions of pigment, wax, and resin can be purchased if desired but the manufacture of encaustic colors is very simple; the wax and resin are melted together and fine, smoothly pulverized pigments are stirred into it in a small container (empty food tins are convenient), or small amounts can be mixed on the hot plate with a palette knife. The proportion varies with each pigment but it is a simple matter to produce colors that will handle well and will set to a strong, sufficiently hard and tough condition. The surface of the congealed colors can be dented with the fingernail, or can be scratched, but so can oil paint; encaustic is durable when preserved under the conditions that are given to any work of art. There is considerable leeway in formulation; wax colors with 10 percent of damar up to about 35 percent seem to behave in much the same manner. Some painters add a portion of carnauba wax as a hardener or microcrystalline wax as a plasticizer.

The ancient Greeks called their color tablets "waxes" as we call our tube colors "oils," and frequently referred to the finished paintings as waxes. They also had a name for the polishing of statues and stone columns with these waxes—*ganosis.* Many of their stone carvings which we

accept as plain white marble were originally coated with wax colors and smoothly polished. (See *Punic Wax,* pages 395–96.)

Manipulations. The molten colors are applied with bristle brushes and palette knives, with the assistance of heating procedures as previously suggested. A great variety of manipulations is soon mastered by the artist after a short period of experiment. The final burning in or "infusion" is accomplished by laying the painting flat on a table, then passing a reflector light bulb or a therapeutic or diathermic or infrared heat bulb above it slowly and evenly until the entire surface has a uniform dull gloss, indicating that it is welded or fused into a solid, homogeneous unit. Overheating must be avoided or the colors will run; the bulb or reflector should be kept at a uniform distance from the painting by being hung with wires, or slid along a rod or trolley, or by any one of a number of means. When the painting is cool, a light polish with absorbent cotton will bring up a uniform sheen.

Encaustic is one of the cleanest and least messy of techniques; palettes, vessels, brushes, and knives can be quickly cleaned by warming them and wiping off the color with a cloth. Bristle brushes do not have to be kept scrupulously clean, especially if the artist has enough of them to reserve each one for the same color next time. Should a solvent be required, mineral spirits will ordinarily do. Carbon tetrachloride has the reputation of being the best wax solvent; however, it also has a reputation of being one of the more toxic or poisonous ones, and the user is cautioned not to inhale its fumes too frequently or for too long a time. (See page 365.)

In comparison to oil paintings, encaustics seem to repel dust rather than to attract it; they are easily kept clean by light dusting. No varnishing is required; the encaustic painter would no more think of varnishing his works than one would think of varnishing pastels or Japanese prints.

Other Methods. There is much evidence that other wax-painting methods were in use in early times, but most of the workable versions that employ more fluid mediums containing oils, varnishes, and solvents are more likely to have originated not more than 200 years ago. A large number of these can better be classed as wax or wax-resin modifications of oil painting or as wax tempera. Wax may be incorporated into such fluid mediums, or it can be liquefied by saponifying it with ammonia, and these waxy mediums can also be emulsified with gums, etc. Although some painters claim (and with some justice) that the best of these wax-bearing oil and tempera paints have great merit, few of them have the physical or visual characteristics of encaustic. They retain the potential

decay elements of oils and oleoresinous or complex tempera paints; they benefit neither from the test of great age nor from modern laboratory research; furthermore, they lack encaustic's peculiar thermoplastic flow, freedom of manipulation, and Grecian simplicity. So, merely because I think they should be placed in a separate category apart from the "classic" technique outlined above, and without entering into any of the ancient controversies as to their relative merits, I have omitted the other forms of wax painting from this section.

The consensus is that any method that involves a final burning-in is to be classified as encaustic. The eighteenth- and nineteenth-century investigators were impelled to search for ways of utilizing wax in a cold-application method not by ignorance of the molten wax technique, but because, from tales about the half-legendary Greek masters and from vague technical writings, a strong impression was received that the ancients had a *second* way to paint with wax and that this lost secret was the one used in work that required the highest degree of finesse.

Saponified wax and wax tempera emulsions are mentioned on pages 229–31, and a ready-made wax-resin-oil medium on page 650.

Some Further Historical Aspects. The encaustic painter should read some of the books on the subject, particularly if he is drawn toward the type of wax painting just mentioned. (See page 678.) Among the ancient sources from which our knowledge is obtained is Pliny's *Natural History*[4, 5] also referred to on pages 15 and 668–69. His description of encaustic painting as interpreted by scholars and investigators is believed to be sound, but unfortunately he omits or slurs over many studio details, either because they were not known to him at first hand, or because he considered them to be of too common knowledge to record. Pliny perished in the eruption of Mount Vesuvius in 74 A.D., having traveled there to observe it—the same eruption that buried and preserved for us the relics of Pompeii and Herculaneum.

A host of other classical and later writers supply us with further information. No Greek easel paintings of any kind have survived—the closest approach are the Faiyûm burial portraits in wax on wood panels, painted in Egypt and attributed to Greek artists. Although they were painted in a later period they have survived brilliantly for more than fifteen centuries and attest to the permanence of the wax medium. One of the most interesting of the many discoveries of early encaustic relics occurred at St. Médard des Prés in France in 1847 when a tomb was found that contained the remains of a woman encaustic painter surrounded by her materials and *cauteria* (implements and equipment).

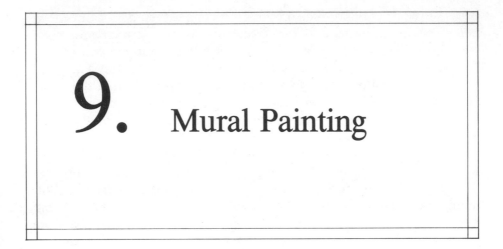

9. Mural Painting

THE TERM "MURAL PAINTING" signifies more than large-scale artistic work done on a wall instead of on the usual movable canvas or panel; it also implies a distinct mural character or feeling that takes into consideration all the aesthetic and technological demands made on mural work by reason of its permanent place as an integral part of the structure of the building.

The technical requirements for a mural are similar to those for oil and tempera easel pictures, and in addition these:

1. It must be absolutely permanent under the conditions to which it is to be exposed for the life of the building—these include the necessary washing or cleaning which is periodically given to walls.

2. It should present a dead flat (mat) finish so that it may be viewed from all angles without undue glare or reflections such as one gets from an oil or varnish surface.

3. The design or picture must be laid out with the understanding that the spectator is ambulatory rather than stationed at an arbitrary fixed point, as in the viewing of easel paintings.

4. The painting must have a mural quality—a very definite, but somewhat intangible character that includes a certain degree of appropriateness to the architecture and function of the room; if it is to be painted in a completed building, it must be planned to fit into the architectural

design rather than to give the impression of being a surface adornment. Proceeding along these lines, our definition runs into aesthetics, which is beyond the scope of the present account. The means of accomplishment are as many as there are schools of artistic thought. A familiar admonition is to maintain the two-dimensional or plane surface feeling of the work as a whole: subjects, whether pictorial or decorative, may be presented in full perspective or recession but not so as to create "holes" in the wall. Some successful painters have disregarded this rule.

Mural painting suffers perhaps more than easel painting from a lack of standardized data obtained from practical and scientific research and experiment, especially in respect to the durability of modern and traditional methods under present-day conditions.

FRESCO PAINTING

The term "fresco" is used to describe the traditional *buon fresco* process—painting upon a wet, freshly prepared lime-plaster wall with pigments ground in water only. When the plaster dries it sets with a rocklike cohesion, and the pigments dry with it as an integral part of the surface. Microscopic examination of a fresco painting reveals definite penetration of the pigment into the interstices of the particles which compose the plaster surface, in contrast to the more definitely superficial adhesion of oil and tempera paints. The pigment particles become cemented to the surface lime in the same manner in which the lime particles bond with each other and with sand.

The desirable features of fresco are many, and the effects are particularly well adapted to mural requirements. The paintings are actually an integral part of the wall, and as such are considered more appropriate than superimposed decoration. They may be viewed from any point with equal visibility and no surface reflection or glare, and they are washable. The ease with which the colors are handled and their interpretation of the painter's intentions appeal to artists. There is a wide range of possible effects, from brilliant luminosity to somber tones.

In the introductory chapter mention is made of one of the important considerations in the study of materials and techniques, namely the appropriateness and suitability of one painting technique or another to the nature and function of the work at hand. In fresco painting we have a method that seems to be universally appropriate for every type of art. So well does fresco fill the technical requirements for wall painting that there is in every period, and in the examples of every individualistic perform-

ance, a completely satisfactory technical achievement. For example, a great range of individual style and purpose is found among the Italian painters of the fourteenth, fifteenth, and sixteenth centuries, and each is equally well served by the same technique.

The chief objection to the process is the susceptibility of the surface to the effects of the acid-bearing fumes, smoke, and soot which prevail in varying concentrations in the polluted air of our towns and cities. Few accurate measurements of such impurities have been recorded, and the effect of various concentrations on frescoes has not been studied thoroughly, but it is generally agreed that fresco is impractical for the exterior decoration of buildings in this age. However, when used indoors and under the same or even somewhat more severe conditions than are imposed upon other works of art, it is absolutely permanent, according to its practitioners and to most of the practical evidence of modern times; some chemists (not so many as formerly) are still of the opinion that it is not. Much research remains to be done on this point, and also on the problem of increasing the resistance of fresco to acid fumes without changing the nature of the technique.

AIR POLLUTION IN CITIES

Few researches have been directly undertaken to determine the extent of air pollution in industrial centers for its effect upon the durability of murals and other works of art, but some data, taken at random from the many studies made on the effect of atmospheric impurities on building stones and on health, show that the impurities have more than one destructive effect. Abrasion is caused by wind-borne particles; chemical reaction is caused by the sulphur-bearing gases emitted from chimneys; solution of the calcium carbonate in marble, limestone, sandstone, and mortar is brought about by the carbonic acid which is formed by moisture and the carbon dioxide of the air. Perhaps the greatest damage is done by soot and dust particles, which contain the most injurious sort of materials; these fine particles cling to surfaces, and the rain, instead of washing them away, leaches out their soluble matter and spreads it over the surface, where it is sometimes absorbed.

The nature and amount of impurities in the air vary with the location and its type of industry or activity, and they change with the progress of the times. A large percentage of city dust in the lower levels is now rubber (which contains sulphur), cement, and asphalt; in upper levels the composition varies. The average climate, temperature, and humidity variations in the United States are as a rule more extreme than those of the

localities where our techniques were originally developed. The obelisk in Central Park, New York, which survived for thousands of years in Egypt, had to be treated with paraffin to check its decay a few years after its arrival here. One single period of heavy fog in combination with smoke can cause great damage.

From some of the older studies we find that the annual soot fall per square mile in Pittsburgh in 1911–12 was measured at 1031 tons; in Glasgow, 820 tons; and in the center of London, 426 tons. More recent figures indicate that modern conditions in large cities where no drastic regulations have been adopted have not improved appreciably. In 1937 the Chicago Smoke Abatement Commission reported an annual soot fall for the entire city of about 16,000 tons; in various districts the estimate ran from less than 500 to more than 1000 tons per square mile. This was thought a highly creditable improvement over bad conditions of recent years. It has been pointed out, however, that as much as an 80-percent improvement in bad smoke conditions could be made without causing much practical improvement in the ultimate ill effects. According to Obermeyer,[221] the annual soot fall in Pittsburgh in recent years has been 986.5 tons per square mile; on the basis of this figure it has been computed that the annual economic loss caused by smoke is $10,000,000. According to examinations by modern methods, the air of New York, St. Louis, Cincinnati, and many other cities is not better. In more recent years, despite organized efforts to combat pollution, and the promise of better conditions ahead, its effect on health, cleanliness, and the deterioration of materials, including works of art, remains severe. Much deterioration that is thought of as natural is due, in part, to gaseous and particulate impurities in the atmosphere. Many different materials are affected: stone, metal, wood, paint, textiles, and leather, especially in the presence of humidity.

One evidence of the action of acid gases is commonly seen when interior brass window and curtain fixtures that are intermittently exposed to semioutdoor conditions exhibit a type of corrosion more severe than that normally caused by exposure to the action of a pure atmosphere.

Ultramarine used in fresco, where some of its surface is in contact with the atmosphere, is extremely susceptible to small amounts of mineral acids; early written accounts of the fresco technique show that painters were aware of this reaction. At the same time, it is to be noted that the frescoes were considered otherwise permanent. The obvious conclusion is that the action of the atmosphere on a fresco painting is one of degree, and further research and experiment on the process may possibly result in a surface that, although not altogether acidproof, will be sufficiently re-

sistant to the actual or average concentrations of atmospheric impurities to remove all doubts as to its permanence. Such improvement might not have to be very great to be effective.

'HISTORICAL NOTES

A study of the history of the fresco technique shows that in the recent past, up to the present-day revival, fresco painting, as practiced during the ages when it was at its highest point of technical excellence, has not engaged a sufficient number of artists to make it possible to base opinions of permanence under modern conditions on actual results. The bad repute into which the method had fallen by the end of the nineteenth century was based on isolated essays into the field by individuals or small groups of painters, and they do not seem to have attained a complete understanding of all aspects of the technology of the materials and methods, if we may judge by what we now hold to be the correct procedures.

So far as we know, the earliest frescoes of a technically highly developed nature were those of the late Minoan period which have been excavated at Knossos in Crete. The process used was essentially the same one that has come down to us through Greece, Rome, medieval Italy, and the Renaissance. Heaton[37] has made a careful examination of the Minoan frescoes, and he demonstrates that they have great technical excellence; then he traces a steady decline in craftsmanship through the above-named civilizations down to our times.

The finest examples recovered from the palace at Knossos were painted with well-prepared native earths—a fine yellow ochre, a red oxide, another red made by burning the yellow ochre, a red oxide, another red made by burning the yellow, a mineral black made of shale, and an Egyptian blue frit. Greens were produced by mixing the blue and yellow.

The Minoans were expert plasterers and mural painters; at one period most of their interior walls, including even those of the common dwellings, were frescoed. The decorations were changed from time to time (perhaps, as Heaton suggests, in the spirit in which we change our wallpaper) by roughening the surface of the old fresco and applying a layer of fresh plaster. The limestone from which the lime was made was quarried nearby, and the final layers of plaster consisted of pure lime unmixed with other materials. Marble dust and sand were used in undercoats of rough plaster and in coarser, undecorated plaster work or stucco, but were evidently omitted for the finest decorative surfaces. The usual method of plastering a smooth masonry wall was to give it a key by

hacking and roughening it, then to apply one coat of the final plaster, usually ¼ to ¾ inch thick, but in some cases a mere wash, just sufficient to hold the pigment. On rough masonry, stucco, etc., a rough coat of plaster was first applied; this consisted of lime, sand, bits of broken pottery, and sometimes fragments of old frescoes.

The relics of these frescoes after some 3000 years are hard and perfectly resistant to severe outdoor conditions. Plaster was employed not only as a decoration, but also as a stucco or protective coating on soft building stone; the above-mentioned account shows that its use as an undecorated stucco antedates its use as a ground for decorative work. The brilliant white pure-lime plaster bearing frescoes appeared in the late Minoan period. Some of the Minoan frescoes were also painted in *secco* (that is, on dried plaster), according to Eibner.[50]

The Etruscans who flourished in the western part of central Italy prior to the Roman period have left us a number of sufficiently well-preserved wall paintings in underground rock tombs. Some of these were painted directly on the stone with a "tempera" of some sort, and others were quite close to true fresco and secco; scholars have attributed the various examples to different periods. Since the discovery and opening of these tombs in the late eighteenth and nineteenth centuries, some of them have deteriorated; the frescoes have suffered to a greater extent than those painted directly on the walls, the principal cause being condensation and seepage of moisture. The modern belief that fresco is permanent only under fairly normal, dry indoor conditions is borne out in this case where it is quite likely that the unsealing of the tombs created more drastic conditions over the past 200 years than those to which the paintings were subjected for the previous 2000.

Asia. In recent times Asiatic examples of the same or similar basic pigment-on-wet-plaster techniques have been studied by scholars. The processes were either independent developments or may have had some connection with the western techniques. Buddhist frescoes of great antiquity have been brought from cave temples in remote parts of western China, and the cave paintings of Ajanta in India have become classics.

The Ajanta murals were painted on rock walls between 200 B.C. and 600 A.D. They were done without medium; the water-ground pigments were painted into a fresh lime *intonaco* laid over a rough mud plaster. The brilliant technical and pictorial accomplishment of the work under very difficult conditions shows great ingenuity and conscientious craftsmanship. It has been suggested that primitive lamps were augmented by daylight reflected into the caves by a system of mirrors. There are no

traces of joins. The pigments used were refined from local earths plus Afghan lapis.

No examples of Hellenic Greek frescoes exist; the Pompeian relics have been considered the nearest thing to them by some authorities. During the entire period of the Roman Empire, fresco was the customary method of mural decoration. The frescoes of the Italian Renaissance have been studied in great detail and we have many technical accounts by writers of the period. Although the process closely followed that of earlier periods, certain departures from the pure fresco technique were initiated; some of these were practiced extensively by distinguished masters, and hence perpetuated by painters of later times. Among these innovations were the use of secco, touching up dried frescoes with pigments ground in egg, curd, or other binding medium, and the addition of small amounts of lime or limewater to the colors. The addition of lime naturally imparts a pale, chalky tone to the painting, and this has created the impression in some schools that frescoes are necessarily done in pale or "pastel" tints.

The actual materials used and, to a great extent, the manipulations employed in the ancient frescoes have been made known to us through chemical and microscopic examination. Some of the early work shows no traces of joins, such as are necessarily present in the known technique where the area of any one section of plastering is limited by the amount of work that can be accomplished in one day. This has been variously attributed to the possibilities that the work was executed by groups of painters instead of by one individual, that thicker and therefore more moisture-holding coats of plaster were used, and that some lost procedure enabled the workers to manipulate the plaster so that it would retain its moisture for a week or more.

Berger[32] and others advanced the theory that fresco had its beginnings in the Byzantine mosaics; the cartoon was drawn on the wall, the cement applied in sections according to the amount of work to be done for the day, and an outline drawing for guidance in placing the tesserae was made on the mortar with pigments mixed with water. With the Cretan discoveries of the early years of the twentieth century, followed by other isolated discoveries in Europe and the Orient, this theory has been disproved, and the development of fresco is now usually traced from the practice of covering unsightly or soft, nondurable masonry with protective smoothing coats of lime stucco, a procedure of several primitive civilizations. The coarser work done for the protection of exterior masonry was left in its rough condition; the finer coats, applied to make walls smooth and level, were made white, as the technique was refined, and finally were decorated with pigments.

MODERN PRACTICE

The chemical and mechanical principles of fresco painting are quite simple, but some practice is necessary to acquire proficiency in the manipulations. This may seem to be a rather trite remark, as it applies to any artistic technique, but in the case of fresco painting it is impossible to gain even a very good understanding of the complete process without a careful study and examination of the actual work in progress. The various precautions and instructions are all to be observed without omission. The requirements for a correctly executed fresco are outlined in the following pages.

THE WALL

Obviously, the wall of the building should be perfectly immovable and not subject to shrinkage, setting, etc. One of the most important requirements, and one which ordinarily is of great concern to the engineer or builder, is that dampness, either by seepage through porous material or by permeation through joints, corners, or flaws in construction, should be absolutely excluded. When moisture penetrates a wall coated with the usual superimposed paints, it causes the paint to peel off; in the case of exposed bricks, tile, stucco, or uncoated plaster, it invariably causes the effect known as efflorescence or whiskers. The moisture will dissolve salts from the building materials and, upon seeping through and drying, will deposit them in the form of a tenacious white, moldy-looking film on the surface. This is bad enough on ordinary stucco or mortar, but on fresco it is disastrous. The weakening effect on the plaster, resulting in possible crumbling or cracking, is obvious.

It has been mentioned elsewhere that practices that were originally functional sometimes survive to a point where they have become almost meaningless conventions. This fact is well known and often discussed, particularly in relation to building and architecture. We no longer are compelled to inhabit cavelike fortresses of stone and brick, but some of our present choices of architectural design are still influenced by archaic standards.

Most published accounts of fresco paintings go into detail on the subject of the preparation of single-story brick or stone walls resting on foundations set into the earth. The mural painter of today, however, more often paints on what is practically a plaster screen or curtain suspended in a steel cage and isolated from the severe conditions which surrounded the older types of wall. Air conditioning is another factor which was entirely unknown to nineteenth- and early-twentieth-century technicians, and the

conditions under which a fresco may now be preserved in a modern building are a great improvement over those of earlier times. The fresco process, developed though it was in an age of stone and brick construction, remains admirably suited to interior wall decoration. On the other hand, present outdoor conditions, especially in large cities, make it necessary to discard outdoor fresco and adopt some substitute; if the current interest in mural decoration continues, one of the alternative means we now have at hand, or some process or improvement yet to be developed, must be employed for exposed surfaces.

The first rule in any sort of wall plastering, as in most applications of coatings to surfaces, is that dampness must be excluded as much as possible; second, it is desirable to guard the plaster from extreme temperature fluctuations, so that the expansion and contraction will not be too sudden.

Creating an air space between the outer wall or shell of a building and the plaster, by constructing a screen or false wall upon which the plaster is laid, is one of the most effective precautions in meeting the above requirements. In ordinary building construction this is known as furring. An exterior wall that has been furred affords protection against moisture either by seepage through masonry joints or by leaks. The insulating effect of the air chamber causes temperature changes to proceed more slowly; consequently, there is less violent expansion and contraction in the plaster, less possibility of condensation of moisture on its surface, and greater isolation from the mechanical strains and stresses of the wall. The furring on ordinary walls usually creates an air space of ½ to 1 inch. According to traditional procedure, the brick false or inner wall to hold the plaster of a fresco is erected at various distances from the exterior building wall, depending upon the particular conditions of each case and upon the judgment of the builder.

All the materials of building construction as well as the soil or rock upon which the building rests are continually subject to expansion and contraction. A plastered wall has a considerable degree of elasticity and in a well-constructed building where such changes are kept to a minimum and proceed very slowly, the wall undergoes a "plastic flow" which takes care of these changes. If plaster were actually the inflexible, unyielding material it seems to be, it could not be used.

When fresco plaster is applied directly to a brick wall, the wall, if old, must be well inspected for mechanical defects, and must be made as uniform as possible. All loose and irregular bricks and mortar must be replaced, as well as occasional odd bricks which would present a different degree of absorption of water. Where any acids or other cleaning solutions have been used, they must be most thoroughly hosed off; greasy or oily spots may be burned out of brick or concrete walls and with a blow

torch. The face of the wall should be level and plumb, the surface itself rough or porous; if necessary, it should be hacked to give a key or bond for the plaster. In the same way that oil paints are taken from the brush and mechanically bonded to the surface by either the tooth (roughness) or the porosity (absorption) of the surface, plaster is attached to brick, stone, and tile. The surface must be either rough or porous; it need not be both. Common brick is rather smooth, but it has the correct porosity. Most clay tiles are nonabsorbent, but those intended to be plastered are made with a scored surface. If a tile or brick wall is both smooth and nonabsorbent it must be hacked all over in order to give it a roughness which will serve as a bond. Mortar joints must not protrude beyond the face of the brick; if any of them do, they must be leveled or they will cause thin spots in the first coat. These spots would be structurally very weak and would also have a water-absorbing capacity different from that of the rest of the surface.

Efflorescence, which has been referred to previously, may be caused by soluble materials present in the brick of the wall; particular attention must be paid to bricks which show any evidence of whiskers. A black plastic or liquid coating made from a variety of asphalts and similar substances (free from coal tar) is used industrially as a plaster bond, because it isolates the plaster from the wall and prevents any water from coming through, but it is not recommended for the highest type of ordinary plastering; according to government standards it is not a suitable or permanent enough substitute for furring. Such materials, however, are the best sort of waterproofers. They are excellent for sealing the back of a portable fresco panel which has been laid on metal lath, for waterproofing exterior walls prior to furring, for use at the joints where water may seep through, and for overcoming unusual danger from dampness in special instances.

Walls made of Portland cement sometimes have the property of exuding laitance, a gelatinous material; hacking the wall will remove it. For general cleaning of old walls before plastering, a hose and a wire brush are used. As a rule, the ordinary Portland-cement wall is too likely to exude soluble salts to be recommended as a suitable surface for fresco plastering.

LIME

Lime, quicklime, burnt lime, or caustic lime is calcium oxide (CaO). It has been made for thousands of years by burning native calcium carbonate ($CaCO_3$) together with wood in specially constructed simple kilns, the calcium carbonate occurring in various degrees of purity in the forms of limestone, chalk, marble, and oyster shells. Lime was used as a plaster

and mortar in practically every early civilization except that of Egypt, where, due to the perfectly dry climate, plasters made of Nile mud and gypsum sufficed until lime was introduced by the Romans.

Various impurities are contained in commercial limes, according to the composition of the original raw material used. Those of high purity (90 to 95 percent or more) are known as high-calcium limes and are best suited for fresco purposes. Those containing from 5 to 30 percent of magnesia are called magnesian limes and are known also as poor or lean limes. In the trade, the very purest varieties (95 to 98 percent) are called fat or rich limes. An average approximate analysis of the impurities in a best-grade lime would show iron and aluminum oxides, silica, and magnesia in amounts of less than 1 percent each.

The Slaking of Lime. When lime is mixed with water, a chemical reaction occurs, and the product is calcium hydroxide, $Ca(OH)_2$, which is known as slaked lime or hydrated lime. Theoretically, lime will combine with water to the amount of 32.1 percent of its weight; actually, it takes somewhat less on account of its impurities. It must be understood that this figure is stoichiometric (based upon the figures of a chemical equation) and the resulting product would theoretically be a dry powder. Because the heat generated by the slaking of lime evaporates a considerable amount of the water, and because an excess amount of water is required to mix the hydrate to a dispersed, colloidal paste or putty that will have exactly the correct plastic properties required of it, approximately twice the above amount is actually used.

It is important that all the water be added at once and quickly mixed with the entire amount of lime; rapidly slaked lime tends to be colloidal, slowly slacked lime to be crystalline. It is impossible to give any exact recipe because of the variability of the factors involved, but approximately five gallons of water are used to each fifty pounds of lime. Too much water will produce a thin mixture instead of the desired plastic putty; too little water will cause "burning" of the lime or will not produce the desired firm cementing of particles.

The heat generated by the slaking of lime is considerable, sometimes reaching 400° C or more, and it may very well be a fire risk, especially in a wooden container. Distilled water, which may usually be purchased in five-gallon bottles, should be used, in order to eliminate the possibility of introducing soluble salts into the wall, as mentioned elsewhere.

It is necessary to age the lime putty before using it; aging improves its plastic qualities and is also a safeguard against incomplete slaking. Freshly slaked lime contains unslaked particles of active quicklime,

which will combine with moisture after the plaster is on the wall, causing the defect known to plasterers as blowing or popping.

Three to six months is the minimum aging period mentioned by writers on the subject; most fresco painters would prefer a year or more of aging. There seems to be no limit to the improvement in plasticity that comes with time. This improvement is undoubtedly due in part to a change in the structure of the putty, resulting from increased dispersion and colloidal quality; it is also possible that a minute amount of carbonation occurs during the aging. Pliny[4] recorded that the plasterers of his day demanded lime that had slaked for three years in order to avoid cracking of the wall.

Aged slaked lime putty is sometimes available through building supply dealers; in fact, most fresco painters will not bother to prepare their own unless they are compelled to, although those with storage facilities will sometimes lay down a supply of the aged product for further aging. Lime putty must be kept from freezing, which would destroy its usefulness completely; therefore, pits for storage are dug well below the frost level. Usually the preaged putty is prepared from the highest-grade material; the dealer is well aware of the requirements for a satisfactory product, and in view of the trouble and investment involved anyway, it would scarcely be worthwhile to substitute an inferior lime for the sake of a small difference in cost.

Lime made from finely divided raw materials is fine and powdery; that made from coarse lumps of limestone is coarse, but much of such coarser lime is pulverized before being placed on the market. American powdered limes are generally preferred to lump limes because they keep better. Lime is subject to air slaking, that is, to being acted upon by moisture from the air; this process will eventually convert it into calcium carbonate, after the manner of the forming of bianco sangiovanni, the white pigment described by Cennini[8] and which can easily be made by molding the lime putty in small pieces and exposing it to the air in a clean place for a few months, whereupon the lime becomes partially carbonated and an intimate mixture of calcium hydrate and calcium carbonate results. When this happens to powdered lime in storage, the carbonate formed on the surface protects the bulk of the material from further action, but when the lime is in lump form the entire supply may be affected.

High-calcium limes, which slake rapidly, produce colloidal putties far superior to those of the slow-slaking "poor" limes, which tend toward the production of gritty, nonplastic masses. Ready-slaked lime sold as a dry powder under the name of hydrated lime is unsuitable for fresco or for a number of other fine plastering uses, as it has the wrong plastic qualities

and will not set to a coating that has the desired properties. None of the various gypsum, magnesian, or proprietary plasters in use for common plastering may be employed.

THE MORTAR

The mortar is composed of slaked lime putty and sand; often part of the sand is replaced by marble dust. The function of the sand is to strengthen the plaster, principally by eliminating shrinkage of the mass during drying. When the correct amount of sand is used, and the grains of this coarse, inert material touch each other, the finer particles of lime or cement surround them and fill in the voids between them. When this condition prevails, any shrinkage of the cementitious material in the mortar from loss of moisture, etc., will only tend to bind the mass more tightly; a more porous condition may be the result, but the mass cannot shrink to lesser bulk than is maintained by the inert material. Formerly great stress was laid on the use of sharp, jagged grains of sand, but according to present opinion, rounded grains or at least a mixture of sharp and rounded grains will form an equally well-knit, permanent mass. The size of the particles, their uniformity, and their freedom from soluble impurities are considerations of more importance. The sand should be as free as possible from salts or other water-soluble impurities; hence sea sand is usually rejected. Sand or marble dust that requires washing must be thoroughly dried before it is used; lime putty will not adhere to it or bind it well if it is wet. The so-called marble dust in common use is more accurately described as marble chips or grit, as it is usually in the form of roughly cubical or pyramidal fragments. The coarser variety used in undercoats averages about $1/16$ inch in diameter; the finer size is more granular, the largest pieces in it running about $1/32$ inch across. A still finer, more uniform variety known as marble flour is less often used in fresco; it is a coarse powder, finer than the usual sand. A very fine grade that meets paint pigment requirements is also available.

After the troweling, the marble chips lying on the surface of the wall will usually present their flat sides or facets to the surface, and they impart a sparkle to the final work. The colors do not take on these tiny freckles. Well-aged lime putty will fill in the voids within the sand or marble dust efficiently and thus lubricate or plasticize the mass, as well as ensure a maximum cementing action; freshly slaked lime whose properties are less colloidal is more likely to leave voids or air spaces.

For maximum strength and durability, all plastic materials are applied in graduated layers, the first layer being the coarsest and the last

being the finest. This principle, adopted in all modern engineering and construction work, was known in prehistoric times and is mentioned by the earliest writers. In modern ordinary wall plastering, the average construction for best results is as follows: The first or scratch coat applied on lath is composed of 1 volume of lime putty to 1½ of coarse sand. Hairs or fibers in ½- to 1-inch lengths are often mixed with this coat to prevent the curled plaster from dropping off the rear of the lath before it sets. On masonry, 3 volumes of sand are used to each part of lime putty. The second or brown coat contains 3 volumes of finer sand to 1 of lime putty; and the finish coat is usually neat, that is, straight plaster without sand. The usual fresco practice differs from this in that the final coat also contains sand or marble dust; it differs, too, in the manner of troweling. Usually in the first coat for fresco, 3 parts of coarse sand to 1 of lime are used. Best practice calls for somewhat finer (but still coarse) sand in the second or brown coat, 2 parts to 1 part of lime; part of it may be replaced by the coarser marble dust or chips. The painting surface is usually 1 part of fine sand and 1 of lime putty. If fine marble dust replaces some of the sand, only enough to produce the sparkle effect should be used, or the porosity of the wall to the colors will be too greatly impeded. It should invariably be sparser than the coarser marble chips which are used in the underlying coat. Fresco painters are beginning to adopt the trade plasterers' practice of replacing half of the lime putty in the undercoats with Portland cement, a procedure which nullifies many of their efforts to keep soluble salts out of the wall, since efflorescence is ordinarily to be expected on Portland-cement surfaces. The first efflorescence from Portland cement is usually the worst, and the wall should be allowed to dry out thoroughly for some months so that any crystalline or gelatinous matter that forms may be scrubbed off.

The Italian fresco painters' names for the various plaster layers are *trullisatio, arenato, arriccio,* and *intonaco,* defined in the glossary on pages 626 ff.

The Hardening of Mortar. The first stage in the hardening of mortar is the evaporation of most of the excess or surface water, resulting in what may be called the initial set, when the plaster, although still wet, assumes a firmness and solidity. The length of time this requires varies greatly, depending upon the proportions and nature of the ingredients, the thickness and absorbency of the coats, etc. In the surface coat it is desirable that this point should be reached as soon as possible in order to conserve valuable working time.

Next, water continues to evaporate until the wall is dry to the touch,

and at the same time carbonation begins; the surface calcium hydrate, $CA(OH)_2$, slowly combines with carbon dioxide, which is always present in the air, to form calcium carbonate:

$$Ca(OH)_2 + Co_2 \rightarrow CaCO_3 + H_2O$$

Here, the fresco painter desires the action to proceed as slowly as possible in order to prolong the working period, and many of the stringent rules and requirements for the lime, the other ingredients, and the method of application were established with this in mind.

Lime is partially or slightly soluble in water; as a result of this property, when it is mixed with water as in the case of the mortar or plastic putty for use in fresco, the water content of the putty will carry a small amount of calcium oxide in true solution. If this limewater is separated and allowed to dry on a nonabsorbent surface, it will deposit a fine white residue of hydrated lime, not in the form of a continuous film, but as powdery particles. When the mass of mortar dries, however, the lime from the solution has the property of combining with the coarser undissolved particles in the manner of a binder, effecting a rocklike cohesion. In the language of mineralogy such a material (which occurs in nature in those geological formations that have been deposited from water solutions) is known as a sinter. Many native rocks such as sandstone, etc., are porous and at the same time bound in a cohesive mass; some of them contain calcium and some contain silica binders. Lime happens to be one of those exceptional materials whose solubility is greater in cold water than in hot; with the temperature changes of slaking, the amounts of lime in solution and in suspension change; 10,000 parts of water will dissolve about 13 parts of lime at the freezing point, about 12 parts at 70° F, and only about 6 parts at the boiling point. Not all of these matters concern the fresco painter directly, but they are mentioned to demonstrate the intricate chemical and colloidal reactions which enter into the slaking and hardening process, and to show that there are good reasons for scrupulous observance of the various precautions recommended by expert fresco painters.

It is customary to explain the binding action of lime by relating it to the action of a liquid binder such as is employed in oil or tempera painting, thereby implying that a continuous film or skin of transparent calcium carbonate entirely surrounds the particles of the mass, and locks in the pigments. The action of the calcium carbonate, however, is purely a binding one, and does not include any locking-in of particles. When a wall surface is converted from lime to calcium carbonate, although the surface will not merge with fresh plaster into a homogeneous layer, it does not consist of a continuous skin, but rather of a porous mass of co-

hesive particles, none of which is protected in any way from atmospheric action. During the setting of the plaster, the chemical action is accompanied by a colloidal action, the semisoluble particles being surrounded by lime in a gel form; but upon hardening, this gel acts only to cement the particles to each other and does not encase them in a protective layer; it is the same material as the particles themselves. The color permanence of fresco lies in the color stability of the pigments.

PLASTERING

The technique of applying the plaster should be learned by the painter by practice; although in ordinary circumstances an assistant or professional plasterer may do the work, an intimate knowledge of the causes and effects of various conditions is necessary for proper control of the fresco.

The technique of throwing or applying the plaster to the wall differs from that of the ordinary plasterer-craftsman, and persons who are experienced in the customary procedure of wall plastering, either amateurs or trade plasterers, must first learn that the work should be undertaken on an entirely different basis in order to meet fresco requirements. The plaster is forcibly thrown on the wall and spread with rather short, pounding blows of the trowel, a minimum of strokes being used to secure an even, natural finish. The longer, more graceful strokes of the expert trade plasterer are discarded, as well as his practice of floating the surface. The object in this case is to obtain a normally porous wall which will hold much water when moistened, whereas in the common technique, denseness, solidity, and rapid drying are the requirements. For the final coat, however, the troweling is continued until the desired polish or uniform smooth, plane surface is attained, and a float is commonly employed.

The cracking of a plaster surface in an allover weblike crackle design may be caused by too rich a lime putty. This can be overcome by continued, careful troweling, as is well known in ordinary plastering practice; but if troweling or floating is carried too far, a nonfresco surface is likely to result—that is, a surface that will not allow the pigments to penetrate and be held by the setting plaster.

The defect known to trade plasterers as map cracks, which is an allover crackle of straight lines 6, 8, or more inches apart, is invariably due to insufficient adhesion or bond between the coats of plaster.

METHODS OF PROCEDURE

Under ordinary circumstances the mural painter, before commencing a fresco, will have assembled a rather complete set of plans, usually includ-

ing a visualization of the entire painting drawn to scale in full color, separate detail sketches of all or most of the significant parts of the work, and a number of sketches of individual elements. Sometimes most of this detail work is done in rather rough outline form so that the artist may alter or finish the plans as he sees fit during the latter stages of the work when a full-sized design *in situ* will give him a better idea of what he requires; other painters prefer to work out everything at the start and follow the original plans down to the last detail.

The next procedure is to enlarge these small sketches to actual size, and draw them in outline on detail paper, a strong yellow paper which comes in wide rolls and is used principally by architects and engineers for their preliminary work on plans, maps, etc. These cartoons, from which the design is to be traced directly on the wall, and which are to be used at least twice, should be carefully rolled up and numbered, and the points where they come together should be in careful, accurate register. When they are entirely completed to the satisfaction of the artist their lines are perforated, an operation most easily accomplished by running over them with a perforating wheel; both the rigid type and the type which turns or swivels freely are used. Some painters prefer to go over the lines with a nonmetallic point after the cartoon is fastened against the soft wall. This results in an incised line on the plaster instead of a colored line, and by some is taken as an essential sign of genuine fresco. Enlarging or cartooning is commonly done by the familiar method of squaring off the original drawing, with the assistance of an architect's or engineer's scale if necessary, and drawing the larger cartoon freehand in relative scale after squaring the wall with a snap line dipped in dry lampblack. Lanterns which will project the drawing on a large scale either on paper or directly on the wall are also in use.

To preserve the cartoon as a record or as an original work of art, it is traced and the tracing is perforated and used on the wall.

The ancient practice of squaring the wall to transfer a cartoon to it before applying the *intonaco* came into use again about the middle of the fifteenth century. Earlier, artists brushed on a *sinopia* or freehand outline in red fresco color mixed with a little lime.

The wall having been made ready, the preliminary coats of plaster are applied as previously described, and when the last coat before the top coat is just firm and hard enough so that it will not be seriously dented or injured by such manipulations, the perforated tracings or detail-paper rolls are fastened to it and the design pounced through the perforations with a little muslin bag of dry color. These lines are gone over with the brush, any fresco pigment mixed with limewater being used, and the design is carried out to any desired degree of detail. Section by section it is

to be obliterated when the final coat of plaster is applied, but the painter needs this complete preliminary drawing.

The final painting coat or *intonaco,* ordinarily consisting of 1 part of fine sand and marble grit and 1 of lime putty, is applied as previously mentioned, and as soon as the initial set makes it possible, the cartoons are traced upon the surface and painted with previously prepared colors selected from the fresco palette list (see pages 76–79). Colors for fresco painting must be ground in distilled water on a slab with a muller until they are as fine and smooth as it is possible to make them by hand-grinding methods. All the fresco pigments will give transparent effects when diluted with much water; when they are applied to the wall in several coats or in heavy concentrations, they all will produce opaque color effects, including those which normally produce transparent or glaze effects in oil. The colors in a final dry fresco painting are very similar in hue to the original dry colors, but the brilliant white of the plaster wall imparts a luminosity to them. Transparent color effect in this medium is caused entirely by the sparseness of pigment particles in a paint well diluted with water; when the glaze colors are applied solidly, they function as body-colors and their effects are those of their mass-tones.

There are a number of variations in painting manipulations in fresco, but for technical and optical reasons most of the color is applied with the point of the brush in a single-stroke hatching manner. Among the features of the technique which appeal to painters are the manner in which brush strokes are taken by the wet surface and the number of strokes or length of single lines that can be drawn without replenishing the brush.

The final coat of plaster upon which the painting is made is applied over the preliminary drawing on the undercoat in sections limited by the amount of painting it is possible to execute in one day or working period. In order to make the joins between these areas as invisible as possible, it is necessary to plan them carefully and to have their borders follow a line of the drawing at the intersection of color areas. When the day's work is done, any excess top coat is carefully cut away with a beveled cut of the trowel or knife so that the application of an invisible join for the next day's work is made easier. The colors will not be absorbed equally at these joins; this point plus the fact that the final dry fresco colors are different from those of the liquid paint have been greatly emphasized by writers as flaws or difficulties of the process. However, the transposition of color hues and values from palette to wall and the manipulation of color effect at the joins are soon mastered by students of the technique and are not matters of great concern to the practical fresco painter.

The work is always begun on the upper left-hand corner in order to avoid spattering and other damages when the following sections are

plastered and painted; and because the brushwork in fresco is a fresh, spontaneous technique, the mixing and gradation of various tones is done on the palette or in jars, the colors being applied to the wall as much as possible in a direct manner. Blends are made by hatching with the point of the brush, and care is taken to keep the painting from being over-worked. A correction is best made by cutting out the undesired part of the final coat with a sharp knife and trowel, preferably within thirty hours after its application. Cuts are beveled, and the areas replastered with fresh plaster.

The imbibing of the color by the wall is clearly apparent while the brush stroking progresses, and the competent painter will cease work as soon as he observes that this no longer occurs; if for any reason the pig-ment is not drawn into the wall, the final result would of course be a dull, dusty, nonadherent pastel effect instead of a rocklike sparkling fresco.

A majority of the present-day American, Mexican, and English paint-ers use pure water, while the addition of limewater seems to be more often favored by the Germans, French, and Italians (judging from their writings). Some art historians refer to a variant of fresco called *mezzo fresco,* practiced in the latter half of the sixteenth century, in which the *intonaco* was allowed to set until it became rather firm. The cartoon was traced on this surface by incising it with a style or sharp point. Since the pigments would then have had less penetration into the half-dry surface, limewater was mixed with them to assure adherence. In general, fresco specialists believe that a full, complete wetness of surface is essential to the success of the process, and I do not know of any modern approval of such methods. As has been previously indicated, the addition of limewater imparts a whitish or pale tone to the colors, because of the drying of the lime particles that it distributes throughout the pigment particles.

Portable Frescoes. The idea of painting small frescoes in the studio so that they can be transported and set into a wall, or of constructing a mural so that it is at least possible to remove it to another place in case the building should be demolished or put to other purposes, has a precedent of considerable antiquity. Examples of frescoes produced in Crete 3000 years ago and exported to neighboring islands have been found. A mod-ern procedure is to fasten a metal lath to a sturdy wooden or angle-iron frame, made rigid by cross-members. The frame is made deep enough so that the final plaster coat is flush with it, and the back is covered with a layer of high-grade dampproof plastic or liquid coating such as is used in building construction. In order to increase its rigidity, the lath is some-times fastened to a solid board backing. Since such frescoes are seldom

intended to be transported frequently, but are made portable only so that they may be moved when necessary, no attention is paid to their great weight or cumbersome construction.

SECCO PAINTING

Although secco is an accepted, durable, and legitimate technique of great antiquity, some painters consider it an imitation of the fresco process, to be adopted only when various conditions will not permit the complex manipulations of true fresco. It is painting on a finished, dried lime-plaster wall with pigments ground in an aqueous binding medium. One of the earliest descriptions of the secco process is that of Theophilus,[7] and in general the best methods have not changed substantially since his time. The finished, perfectly dry lime-plaster wall is thoroughly and completely saturated with limewater (or baryta water) the night before painting; in the morning, the wall is impregnated again, with as much lime-water as it will absorb. Painting is carried out on this moist surface as in fresco, but the colors, instead of being ground in water only, are mixed with a solution of casein. Some modern painters prefer either glue or egg yolk as a substitute for casein. If the wall becomes too dry during the painting manipulations, it may be kept moist by spraying with distilled water, but if it has been allowed to become thoroughly dry, it must be entirely reimpregnated with limewater. All secco painting must be thinly applied.

In general usage the term "secco" is not always strictly confined to the traditional limewash-casein. As in its original Italian meaning, it is often used to signify any dry (as opposed to fresco or fresh-plaster) method of wall painting, and includes such work as regular tempera painting upon a perfectly dry wall or over a dried fresco.

Casein solution is the best medium for the limewash type of secco painting; egg is also used but may yield defective results, especially when insufficient actinic light reaches the mural during the beginning of its drying, because egg will not harden properly without either daylight or heat, whereas casein will harden merely upon exposure to air. The drying of egg, however, may be expedited by improvising a suitable electric heating apparatus which can be passed close to the surface of the freshly painted mural. Some success has been reported with ultraviolet light used in a similar manner. Such procedures are based entirely on theoretical grounds and are by no means to be adopted as regular standard methods.

It has been my experience that lime-casein grounds and casein paints which contain lime in admixture are inferior to ammonia-casein mixtures (see *Casein*, page 380), not only because their range of pigments is limited

to the alkaliproof fresco palette, but also because such paints seem to have a much greater tendency to crack when applied in layers or strokes only slightly thicker than normal.

Since the recent introduction and widespread promotion of casein colors by American manufacturers, a new source of secco material is conveniently at hand. Whether the modern casein colors sold in tubes are good replacements for the homemade variety traditionally used in secco is uncertain. The tube paints undoubtedly contain modifying ingredients to make them perform according to their makers' claims, and some of these might possibly have some adverse effect on permanence or color stability.

There are many variations and personal versions of secco painting; some painters allow the procedures to become so complex that (apart from the preparation and maintenance of the fresh plaster wall) the time, effort, and expense begin to approach those of true fresco. In all these mural techniques, one must be especially careful to observe the precautions mentioned under *Fresh Paint,* pages 5–7, because the condition described there and seepage of moisture from the rear are perhaps the only causes of lack of adhesion of paint met with on plaster walls.

Spirit Fresco. This term must be mentioned because it is still in circulation among artists. In London, about 1880, a mural process called the Gambier-Parry Spirit Fresco was introduced and for a time received much attention. The method was merely a system of painting with varnish colors compounded of materials that would dry flat, would not run down the surface, and could be manipulated in a manner somewhat reminiscent of fresco. The process has long since been abandoned because of its shortcomings and its unsatisfactory durability.

GRAFFITO

The term *sgraffito* was used in Renaissance Italy to designate a popular method of decorating the fronts of stuccoed buildings. The process consisted of laying a coat of pigmented plaster over a coat of another color and, before it had dried, incising the design through to the undercoat. In the traditional method black and white were used, but numerous variations and elaborations, such as the use of many colors and the application of gilding, developed. When lime plaster or white Portland cement integrally colored with pigments is used, the method is permanent outdoors; when white areas are surface-painted in fresco, they have only the doubtful outdoor permanence of fresco painting. The relief should not be so

high that the lines will easily gather dust and dirt. Cement colors are mentioned under *Sculptors' Materials,* page 587.

MURALS IN OIL

There are two divisions to this subject: (1) direct painting on plaster walls, and (2) painting on canvas done in the artist's studio, transported to the wall, and hung (cemented to the wall) either in one piece or in sections.

Plaster walls are technically ill-suited for oil or varnish painting, yet most of our rooms are so painted for decorative purposes. The lack of any great degree of durability in ordinary interior wall paints is a matter of common experience. However, an artist is often called upon to paint in oil on plaster walls, and in such cases he can do little better than use as ground coats the white paints which are sold for interior wall decoration.

For permanent results, new plaster walls must be aged for a period of from six months to two years before the application of oil paint. Free alkali remaining on the surface of fresh plaster has a destructive effect upon all oil or varnish coatings. Painters sometimes neutralize this alkalinity by treating the surface with a solution of two pounds of zinc sulphate in a gallon of water, then allowing the wall to dry thoroughly; but aging is the better practice. As has been mentioned frequently, moisture is the most common enemy of oil paints, and the wall should be tested for dryness (see pages 456–57). Plaster work in new buildings that are still subject to the settling of the structure must be aged longer than is necessary for fresh plaster in old buildings.

Before applying oil grounds to plaster, the surface, which always varies greatly in absorbency to common oil paints over any considerable area, is ordinarily sized, either with a weak casein or glue size or with shellac which has been very much diluted with alcohol. These two materials give results of approximately equal value, and technicians are about evenly divided as to which is better; if shellac is used, care must be taken to see that it is applied as a real size and not in such heavy concentration as to produce a glassy surface, or the subsequent coats of paint will not adhere properly. If an aqueous size is used, the wall must be allowed to dry out again thoroughly before applying an oil coating; it is perhaps safer to make such a size oneself from pure glue or casein than to use the prepared sizes which are sold in paint stores and which may contain alkalis or other materials objectionable for artistic purposes where more than ordinary permanence is desired.

However, modern authorities on paint technology seem to favor a thin priming coat of specially designed paint applied directly to the plas-

ter instead of a sizing. The larger paint manufacturers and official and semiofficial organizations in the field of paint technology have given the subject much attention, and ready-mixed primers, second coats, and finish coats bearing the labels of well-established reliable makers are most likely to be well-balanced materials made in accordance with the most approved standards. Such materials are never sold at cut rates. Requirements for a plaster primer include permanent binding or attachment to plaster, production of a uniform surface upon which subsequent painting will take well, good covering power, and not too great penetration into the wall surface. The formulation of a good plaster primer is a matter of experience, testing, and research.

The second coat should dry to a mat finish and it should have good hiding power or opacity as well as covering or spreading power; it should be white and reflect light well, and it must offer a good surface for receiving and holding the final coat. After it has become thoroughly dry and hard, it may be sandpapered to remove surface irregularities, if desired.

Sometimes an eggshell or semiflat is preferred to a dead mat finish for mural painting; such surfaces usually present a more desirable degree of absorbency or semiabsorbency for final work than does a dead mat finish. This coat should have extremely good hiding power and a high degree of whiteness and reflective power, and should dry to a tough film. Many states have laws that require the formula of a mixed paint to be placed on the container, and any brand which has national distribution ordinarily bears an analysis. The presence of inert pigments in amounts not to exceed 10 percent is sometimes beneficial; hence these materials are not always to be considered adulterants. Examples are silica, which imparts tooth; asbestine, which prevents caking and settling and contributes to a mat finish; and blanc fixe, which imparts structural stability to the film. However, interior wall finishes are less likely to contain such materials than are paints intended for outdoor use, because competitive manufacturers of indoor paints often sacrifice other properties for the sake of extreme whiteness and easy brushing, the two properties which appeal most to the average purchaser.

About the only practical alternative to commercial mixed paints for wall priming is a straight white lead paint, which, taking all factors into consideration, will perhaps serve as well as the ready-mixed wall paints. The remarks on cleanliness mentioned under *Lead Poisoning* on page 104 and under *Toxicity of Artists' Materials* on page 406 should be noted. The following series of coatings made of common, easily obtained materials is based on traditional standard practice, and paints of this sort are still preferred to the modern ready-mixed products by some painters. A comparison of the differences in the four formulas furnishes a good illustra-

tion of the theory of normal flat and semiflat paints described under *Painting in Oil,* pages 153–54. The amount of drier listed is nominal; it is recommended that tests be made and the amount reduced to a minimum for 48-hour or longer drying. If the stiff variety of white lead paste (page 641), which contains no turpentine, is used, add one quart of the turpentine to each of these formulas. The "floor varnish" is any good water-resistant varnish, such as interior spar.

Priming Coat

White lead in oil	100 pounds
Refined linseed oil	3 gallons
Floor varnish	2 gallons
Turpentine	1¼ gallons
Liquid drier	1 pint
	9½ gallons

Covering power: about 600 square feet of plaster per gallon.

Second Coat—Flat

White lead in oil	100 pounds
Turpentine	1¼ gallons
Floor varnish	3 quarts
Liquid drier	½ pint
	5¼ gallons

Covering power over the priming coat: about 700 square feet per gallon.

Third Coat—Flat

White lead in oil	100 pounds
Turpentine	1¾ gallons
Floor varnish	1 pint
Liquid drier	½ pint
	5 gallons

Covering power over the two preceding coats: about 800 square feet to the gallon.

A semigloss or eggshell finish may be obtained by a further variation of this formula, as follows:

Third Coat—Eggshell Finish

White lead	100 pounds
Turpentine	¾ gallon
Floor varnish	1¼ gallons
Liquid drier	½ pint
	5¼ gallons

Covering power over first and second coats: 700 square feet per gallon.

A modern alternative to these formulas calls for the use of lead mixing oil, which is a combination of cooked linseed oil, tung oil, and mineral spirit.

Materials	Priming Coat	Second Coat	Third Coat	Eggshell
White lead in oil	100 pounds	100 pounds	100 pounds	100 pounds
Lead mixing oil	4 to 5 gallons	3 to 4 gallons	3 to 4 gallons	1½ gallons

To the semigloss formula, add 3 gallons of wall primer. The covering power of each of these paints is about 800 square feet per gallon.

Volume equivalents for white lead in oil are given on page 620.

Wall paintings in oil must be executed in as smooth and thin a manner as possible considering the artist's intentions and technique. However, if one attempts to dilute a paint with excessive and haphazard amounts of thinner, or with wax and emulsion mediums, the durability and strength of the film is decreased. Application of damar varnish with a spray gun is an approved method of finishing or protecting the surface; a wax coating as described on page 396 is also recommended. Industrial mat varnishes are liable to accelerate yellowing. As previously mentioned, a glossy surface is a normal characteristic of the oil-painting process, and any attempt to eliminate it by the admixture of certain materials or by the use of special coatings or highly absorbent grounds will result in the sacrifice of important qualities.

Painting on old walls which have been previously decorated offers further complications. If a water or emulsion paint was used in the first place, every vestige must be washed off with warm water and coarse sponges, a little ammonia being used if necessary. Oil paint can be sandpapered down, and when remnants and traces remain, especially if they seem to be well attached, smooth, and hard, they are better left on than

taken off with paint remover. The volatile solvent type of commercial paint remover will deposit paraffin wax on the surface, and will weaken any remnant of old paint clinging to the wall, leaving an insecure basis for further overpainting.

HANGING MURAL CANVASES (MAROUFLAGE)

Mural canvases are attached by the use of various adhesives to plaster walls or other surfaces which have been made level and smooth. The traditional method is to coat the wall and canvas with a thin, even layer of white lead ground in linseed oil to a stiff paste, using large spatulas and the sort of knife referred to elsewhere as a wall scraper. The canvas is attached either from the roll or flat, according to circumstances and the judgment and experience of the worker. Rubber-surfaced hand rollers of sturdy construction are used to force it into contact with the wall and to work out wrinkles, air bubbles, etc. The pressure exerted and the strokes used require skill learned by experience.

The process goes back to an early date. Some of the old formulas call for adding Venice turpentine to the paste to increase its adhesiveness or working properties; such a mixture can be brushed with a stiff bristle brush on both the wall and the canvas, as well as applied with a trowel. Both methods of application are in use at present; sometimes damar varnish is preferred to Venice turpentine. Most instructions call for a specially made, very stiffly ground white paste, but the regular commercial product is in general use. Some modern white lead in oil contains turpentine for convenience in mixing it into house paints; this variety should preferably not be used. For brush application to the wall enough varnish should be worked into the white lead to put it into a short, buttery condition, and for brushing a thin coat into the back of the canvas a further amount must be added so that the mixture is nearly as thin as a liquid house paint.

For the application of oil coatings, new plaster walls must be completely and thoroughly dry; best practice demands that they be at least three months old; after a year they show little change. Plaster walls in new buildings may develop cracks while the building is in process of settling or finding itself, and architects sometimes recommend allowing two years to intervene between the completion of a new building and the painting or hanging of a mural. Cracks and holes should be filled with plaster, gesso, or Keene's cement, which will dry completely in a short time. Architectural and engineering standards allow no more than 3 to 5 percent moisture; the moisture can be tested by the use of an electrical device (see page 457).

The hanging of mural canvases is always entrusted to experienced professional workers; no important jobs should be attempted by persons inexperienced with the particular materials and methods employed; all new or special procedures or conditions must be tested or at least superintended and guided by rigid specifications even when the job is done by experienced mural hangers. The number of helpers, the manner in which the canvas is to be manipulated, and the disposal of ladders and other equipment must be well planned in advance. Minor flaws and defects in the hanging are sometimes rectified by the procedure known to workers as spackling, that is, cutting away the defect sharply and filling in the space with a putty, plaster, or gesso plug which is textured and painted to match the surrounding areas. Plugs in plaster should always be undercut to prevent loosening and minimize further cracking, and care should be taken not to enlarge cracks or small defects. Blisters or loose spots are sometimes slit with a knife and pressed down with fresh adhesive. When it is necessary to join two sections of a painting, the canvas (of one or both sections) is usually made a few inches longer than necessary and painted a little beyond the point where the two edges will come together. When the second canvas is applied, it will overlap the first, and the surplus edge is then cut away by ruling along the line with a sharp blade. This is known as butt join.

The principal disadvantages of the white lead method of mounting canvases are the poisonous nature of the material, which necessitates careful, experienced workmanship and the maintenance of cleanliness (see pages 104 and 406), and a tendency of the oil to soak into and discolor the painting, especially with some types of canvas. The latter disadvantage can be overcome to some extent by thinly shellacking the rear of the canvas, a procedure which is not possible or advisable in some circumstances. The discoloration is most liable to occur when the picture has been painted on gesso or on a weak, old, or poor-quality emulsion ground. Walls must be sized and primed with at least one thin coat of oil paint before the white lead paint is applied. Old paint on walls should be sandpapered in order to ensure the proper tooth for holding the white lead coating uniformly. Despite these objections, the traditional marouflage remains the best all-around permanent method.

When an experienced painter plans a mural he considers all the details connected with hanging the canvas or panel; if he employs a professional mural hanger he will go over these details with him in advance, thereby obviating expensive, annoying, or disastrous complications which sometimes arise when special or unusual situations are not fully considered in the original plans.

Other Adhesives. Aqueous adhesives made from casein, gum arabic, and various mixtures of other gummy or starchy substances are sometimes used; they have certain advantages under some circumstances. Some authorities condemn them on the basis that the water content will attack the ground, cause shrinkage of the linen, and make for poor adhesion by reason of its evaporation. Sometimes blisters are produced by the formation of water vapor or other gases from the adhesive. Danger of shrinkage and water-vapor blisters is minimized if the adhesive is such that it can be allowed to stand fifteen minutes or so after application and still be tackily adhesive enough for canvas and wall to bond with each other if the canvas is hung then.

A recently developed adhesive of particular interest in hanging mural paintings is a casein-latex cement that is an emulsion of a casein glue with rubber latex, commercially made and sold in 5-gallon cans. This material has lasting flexibility and very good adhesive power, and is well adapted to the cementing of two materials which have widely varying properties, such as degree of expansion and contraction, porosity, etc. It has been successfully applied to a number of industrial uses including the mounting of large veneer, plywood, glass, and metal sheets on walls. The formulas of prepared emulsions are not usually published; but inasmuch as the raw materials are readily obtainable, work could easily be done on standardizing various formulas to meet special requirements.

This material is sold in the form of a stiff paste to be applied like any other aqueous adhesive to both canvas and wall in layers of uniform, well-smoothed thickness. For brush application it can be thinned by a careful and thorough admixture of very small amounts of warm water; on account of its emulsive character this must be done carefully, a very small amount at a time; a little too much is likely to destroy all its colloidal adhesive properties. Best results are obtained with this material if the fullstrength pressure of heavy rollers is applied to the canvas in place of the careful, more exactly balanced rolling that white lead receives.

Although aqueous adhesives and some of the newer synthetic adhesives have been used satisfactorily for mural-hanging purposes, especially by those who have given the processes considerable trial and study, the traditional white lead method remains the standard and others are generally regarded as substitutes. The principal disadvantages of aqueous adhesives as compared with the white lead paste are that they dry or set too rapidly for ease in application, and that the moisture is liable to shrink the fabric, loosen the ground, or cause vapor blisters. Professional hangers, however, can successfully mount the average good-quality oil-primed canvas with wallpaper paste. Semigesso and other canvases which con-

tain much aqueous binder must be very cautiously handled. Aqueous adhesives may also be applied to unpainted plaster walls which have been sized according to the regular wallpaper procedure.

GESSO AND TEMPERA ON WALLS

Modern painters have executed murals in tempera on walls coated with gesso, as one would paint an easel painting in tempera on a gesso panel, a procedure inspired, no doubt, by the artist's experience in and preference for the tempera technique. The effect is usually adequately satisfactory, and with it painters have simulated the typical fresco effect with a tolerable degree of success, but the method has certain technical defects. The possibility of safely cleaning such murals is doubtful; the cleaning of tempera paintings requires professional restoring methods, and these are difficult to apply to a vertical wall. Gesso applied directly to old walls of either lime plaster or the more commonly found magnesian or gypsum finishing plaster is of doubtful permanence because of the difference in structural properties of the two materials. In principle, the coating can be compared to one of the commercially prepared casein or glue wall paints; these materials have to be applied in the form of a very thin coating and may crack if piled up over plaster to the thickness of the average gesso application. Plaster walls, unless erected strictly in accordance with approved methods, do not always present the proper uniform surface for permanent adhesion of comparatively heavy coatings with aqueous binders.

Friedlein[68] suggests that walls to be painted in tempera should be specially plastered. Addition of a little casein to the mortar of a wall is said to increase its compactness, hasten its complete setting, and prevent efflorescence. A disadvantage, however, is the chemical action between the casein and the dissolved portion of the lime, which might interfere with the complete hardening action of the mortar. The recipe given for this kind of gesso ground is 10 parts of lime mixed with 8 parts of casein solution, then 30 parts of sand and enough water to make a usable putty. The mortar is applied with plasterers' tools and can be smoothed further with a wet brush. For smooth or polished grounds use either marble flour, diatomaceous earth, or powdered fluorspar instead of sand; with the first two of these, use only 6 parts of casein solution. After this ground has been applied to the wall with trowel and float, it may be smoothed further with a wet brush. If it is applied to panels, both sides should be coated to prevent warping. I have had no experience with these mixtures. Fresco pigments would have to be used.

Another way of applying these easel-painting materials to walls is to

mount linen on the wall with casein or other aqueous adhesive and coat the linen with a gesso, using preferably the recipe that contains formaldehyde (given on page 385).

Painting with egg or other tempera mediums directly on recently dried or old plaster walls is not a very well-standardized procedure and is a subject upon which a little well-directed research could be used to advantage. Gypsum plaster walls should be well sized; for egg tempera, egg yolk well diluted with water is perhaps the best sizing.

Some mural painters have found that egg tempera dries very slowly where daylight is absent. The use of infrared or ultraviolet lamps has been suggested as a solution to this problem.

Again the painter is referred to the remarks under *Fresh Paint* on pages 5–7, for many well-thought-out variations of techniques have suffered through lack of attention to this detail.

PAINTING WITH LIQUID SILICATES

The contributions of modern science and industrial development to the technology of painting have been great. They have led to the perfection and control of materials, have given us an accurate understanding of the methods of the past, and have supplied us with new and valuable additions to our list of materials.

But there has been little progress in the development of distinctly new processes of painting, and few important additions to the number of sound, tried, and accepted methods have been made. For our serious artistic efforts we are still limited to the standard methods of oils, watercolor, fresco, tempera, and pastel.

It has long been a goal of experimenters to develop a painting medium containing liquid silicates, because most of the compounds of silicon (one of the earth's most widely distributed elements) are characterized by properties of an extremely inert and unalterable nature. Sand and quartz (silica), clay, abestos, talc, and glass are some of the materials. Silica and silicates occur as binders in many rock formations.

WATER-GLASS METHODS

In 1825, J. N. von Fuchs introduced a successful method for the economical production of water glass (sodium silicate), an alkaline, syrupy liquid with some binding properties, and he proposed a method, subsequently called stereochromy, for executing murals that when dry would consist of a layer of pigment bound with silica. The process was taken up by paint-

ers, chemists, and inventors of all nations during the nineteenth century; the chemical journals and patent-office files of the period contain dozens of accounts of variations of the process and its application to artistic and industrial painting.

The final improvement and standardization of the method under the name of mineral painting is credited to Adolf Keim of Munich, and took place in the 1880s. Potash water glass (potassium silicate) was found to be superior to the sodium compound (see pages 426–27).

Unfortunately, the method has never been an entirely successful one. The material used, water glass, is not among the stable inert silicates; it is an active material of a strong alkaline nature and it tends to enter into erratic reactions with the sort of materials most likely to be used as grounds. Furthermore, the strongly alkaline or caustic products of its reactions remain in the coating.

The water-glass or mineral painting process depends upon a reaction between the plaster of the wall, the water glass, the pigment, and an application of hydrofluosilicic acid. No chemist would care to hazard an opinion as to what is liable to take place when this process is used for mural painting on a plaster wall under normally variable conditions. It has achieved its greatest success on very carefully prepared special grounds, rather as easel than as mural painting.*

Water glass is an inexpensive, basic material that has a number of uses in industrial processes; the industrial paint laboratories have given it much attention, but so far have succeeded in utilizing it in coatings in only a minor way. In producing a water-resistant coating by itself it is perhaps inferior to an ordinary plain casein solution, to which it may be compared as to waterproofness; mild dampness will affect but not destroy it; wetting will not redissolve the dried material, but is likely to destroy its value in an artistic or decorative painting. Among its present-day uses, water glass finds a large application as an adhesive and is employed to some extent as a protective coating for wood, stone, and concrete, in which case it acts as a sizing material rather than as a continuous film. It is not very permanent and in such uses requires periodic replacement.

SILICON ESTERS

We now come to a process that has been developing during the past several decades and has finally produced pigmented coatings containing the

* A complete account of Keim's perfected process is given by J. A. Rivington, *Royal Society of Arts Journal*, Vol. XXXII, No. 1630, February 15, 1884; and a further account by Mrs. Lea-Merritt in Vol. XLIV, No. 2246, December 6, 1895.

inert silica binder that was the goal of the work described in the preceding account. In 1930, a paper was published by King* describing the successful production of paints in which the binder is chemically pure silica, and which will resist the most drastic atmospheric and chemical attacks. Their color effects, paint quality, and brush control may be made as desirable as those of fresco—perhaps even more brilliantly. The following is a simplied version of the chemists' explanation of the reactions.

An ester is a product formed from the reaction of an acid with alcohol. Among the silicon esters or organic compounds of silicon is ethyl silicate, which may be pictured as being a combination of alcohol and pure silica. This is a clear, volatile liquid with a mild, ethereal odor, resembling some of the volatile solvents. When it is diluted with alcohol to the proper degree and mixed with small amounts of water, a chemical reaction (hydrolysis) occurs, producing alcohol and hydrated silica; the latter is thrown out of solution in the form of a gel or of fine colloidal particles. The silicon esters were discovered in 1846 and their use as stone preservatives was suggested in 1860. Their first practical applications were the result of the work of King and some work by A. P. Laurie in 1923 on their use as stone preservatives.

The silicon esters, which produce an entirely inorganic and imperishable substance (silica), should not be confused with the more modern *silicones* which are silicon resins; these remain organic silicon compounds; they are used industrially as resins and are in a class apart from our present subject.

The actual chemical reactions are somewhat complex and involve colloidal action, polymerization, and intermediate chemical stages; the publications mentioned go into these in detail. (See also page 468.) Only enough water is added to start the reaction and cause partial hydrolysis; at this stage the material is a finished painting medium. When it is mixed with pigments and brushed out, the reaction is completed by the action of the moisture in the atmosphere and the internal changes of the silicon compounds. The alcohol evaporates and the colloidal silica soon sets to a tenacious gel, which, in thin films, becomes dry in a half-hour or less, after which it can be touched and handled with ordinary care. (It can be painted over with a second coat after the initial set, which occurs in a few minutes.) After this the silica gel, or hydrated silica, slowly becomes converted to pure silica (silica dioxide). At present this takes from ten days to four weeks, after which the coat may be scoured with alkaline soaps and a

* King, George, "Silicon Esters and Their Application to the Paint Industry," *Journal of the Oil and Colour Chemists Association,* Vol. XIII. London, February 1930.
 King, George: (I) "Silicon Ester Binder," (II) "Silicon Ester Paint Medium," *Paint Manufacturer,* London, April and May 1931. A less technical version of the above.

scrubbing brush, doused with acid, frozen in ice, or heated in a furnace to white heat, without change.

I first experimented with the silicon esters as promising materials for mural painting in 1930, with the cooperation of the American producer of silicon tetrachloride, and tested paints made with ethyl, methyl, and amyl silicates. (Subsequently, the manufacture of ethyl silicate was undertaken by Union Carbide Company.) During this period I found that very satisfactory paints for mural purposes can be made with these, provided one is willing to go to a little trouble in preparing the palette for the day's work. The inconvenience of such preparations is no greater than that involved in setting tempera or fresco palettes, and the process is much simpler than that of fresco painting.

The coatings are strongly adherent to plaster, gesso, brick, tile, and Portland cement, but the material is porous and does not protect surfaces against decay; for instance, it does not inhibit the rusting of iron. When painted on ground glass it is acidproof and alkaliproof and can be removed only by abrasion, but when painted on cement or other acid-soluble material, it does not prevent strong liquid acids from penetrating the paint and destroying the ground. However, according to such tests as have been made, it seems to offer perfect protection against the highest concentrations of atmospheric acids likely to be encountered in practice.

The best criterion we have for evaluating the permanence of a new medium is its resistance to severe accelerated test conditions; from the way this material survives such tests it seems likely that practical use over a long period of years will prove it to be a permanent medium. Best results have been obtained by applying it to a porous surface; it should be noted that the coating is purely a surface layer, and like any other paint is subject to the wear and tear of mechanical forces. I find that the medium does not form a continuous film; when used clear it has small value as a varnish or fixative; with pigments its binding action is a cementing of fine particles, comparable to the action of the lime in plaster or of the binders or cementitious materials which occur in some natural rocks. In other words, the nature of the coating is of the same type as that of the support on which it is painted. As with fresco, its color stability is the permanence of the pigments themselves; there is no encasement by a transparent film of excess vehicle or medium as in oil or varnish paints, or even so much as in the tempera medium. As noted on pages 3–5, its binding action is classified as cementitious rather than pellicular.

Painting is done with colors made by grinding pigments directly in the medium, and because the pigment particles are not locked in by a continuous film the acidproof, alkaliproof fresco palette must be adhered to. If additional alcohol or other solvent is used to dilute the paint or as a

grinding vehicle for the pigments, the layer may in some cases become weak and chalky. A painting technique is easily acquired; because of the rapid rate of evaporation of the medium and the absorbency of the surface used, oil-painting techniques such as smooth gradations and blends are less satisfactory than fresco hatching methods or tempera brushwork. The paint should be thinly applied, since heavy coats and too much overpainting may cause it to flake off. The color effect is similar to that of fresco, and as in that process transparent pigments function as body colors and transparent effects are obtained by dilution with the clear medium. A container of alcohol, ethyl acetate, or other solvent is convenient for rinsing brushes, but the solvent should not be introduced into the paint. Semihardened or recently dried paint can be washed from palette, brushes, and containers with solvent, but the thoroughly hardened paint can be removed only by abrasion.

An outstanding property of silicon-ester paints is that they can be used with equally successful results on dry, damp, wet, or alkaline surfaces, including fresh plaster, although no water or alkali can be mixed directly into the paint without coagulating it. If any efflorescence comes through the porous surface from soluble salts in the ground, it can be washed off with water. As mentioned previously, although the coating appears perfectly dry and set in a short time and will withstand a limited amount of handling and rubbing, the paint does not attain its full strength for several weeks. Outdoor murals will not be injured by dampness; clothes hung over them during the setting period would protect them from the mechanical or wearing effect of raindrops, but even this is probably not necessary. However, the previously mentioned general rule that no surface paint coating will withstand the staining and peeling effect of moisture seepage from the rear applies to these paints as much as to others.

The principal difficulty encountered in painting with this medium is its property of setting to a useless jelly in the containers after pigments have been ground in it. Because of its rapid rate of evaporation, grinding cannot be done in the open on a slab very conveniently. If this paint were made in commercial quantities it would be ground as pigmented lacquers are—in a ball mill, which is a revolving drum or barrel lined with durable material and containing steel, porcelain, or flint balls or pebbles. The force of the balls as they tumble down upon the mixture of pigment and liquid exerts as good a dispersing action as will be found in any other type of mill used for the production of liquid or semiliquid paints. In large-scale mills of this kind the size and proportion of the mill and balls are matters of careful computation. Ball mills cannot be used for grinding heavy or paste paints.

A small, inexpensive ball mill can be improvised by making a small wooden frame in which two rollers are hung in any convenient manner; a pulley is attached to one of them and connected by a belt or rubber band to a small electric motor. An ordinary friction-top paint can, or a 3- or 4-ounce round screw-cap tin can (such as the ones in which cleaning fluids, etc., are sold), or a strong screw-cap glass jar is half filled with ⅜-inch steel burnishing or tumbling balls, the pigment and vehicle are added, and the can is placed on the rollers. By this method an ounce or two of each color can be rapidly ground and the cans and balls easily rinsed off with denatured alcohol immediately afterward, the balls to be wiped off by rolling in a large cloth. The silicon-ester medium has excellent wetting properties; only two or three minutes' grinding is required to produce a satisfactory paint of smooth, syrupy consistency. Rubber bands or friction tape around the rollers will prevent the cans from slipping. The machine can be improved or refined as desired. A variety of well-made, small-size ball and pebble mills may be purchased from dealers in laboratory equipment.

Since the days of my experiments with laboratory-made quantities of silicon esters previously mentioned, and through a series of events, ethyl silicate has been put into production as a regular industrial product. Its largest use is in the manufacture of casting investments for precision work in the lost-wax process for the production of such products as jet aircraft engine parts. The generic term "silicon ester" is less widely in use than the name of the available material, ethyl silicate. Quite a few artists have painted highly successful murals with it; time alone will tell us whether we are correct in our expectations of its longevity.

Ethyl silicate has a mild ester odor and its fumes are mild and reputedly nontoxic; but it should be treated with the normal precautions as noted on page 365, that is, avoidance of too concentrated and too lengthy inhalation. No injurious effects due to its silica content have been observed; it has passed all physiological tests satisfactorily, as concerns toxicity and skin irritation. It will burn, but is not classed as a dangerously inflammable liquid.

The account of the process in the first edition of this book was its first American presentation to artists; that account is superseded by the information in the present section.

Three types of ethyl silicate are available:

1. *Tetraethyl orthosilicate*—a colorless water-insoluble liquid with a silica content of 28.8 percent and a boiling point of 168° C.

2. *Condensed ethyl silicate*—containing tetraethyl orthosilicate and some ethyl polysilicates. It is slightly yellow in color and contains a minimum of 28 percent silica.

3. *Ethyl silicate 40*—a mixture of ethyl polysilicates prepared by a special process designed to give a silica content of about 40 percent. This clear-brownish variety is the kind that gives best results as a paint binder.

The following recipes are based on recommendations from the producer of the material, Union Carbide Company, 270 Park Avenue, New York, N.Y. 10017.

The binding medium. Two-step method, measurements by volume.

Stir together:
 80 volumes ethyl silicate 40
 18 volumes 190-proof denatured alcohol (see pages 000 for brand names)
 2 volumes dilute hydrochloric acid (0.3 to 5.0 percent in water)

Allow to stand for at least 12 hours, then add

 5 volumes water

(0.3 percent hydrochloric acid is roughly equivalent to N/10 HCl and is made by mixing one part of C.P. concentrated hydrochloric acid with 120 parts of water.)

The company recommends aging the complete solution overnight (at least eight hours) before use, but some artists have experienced better and more certain results when it is used two hours after mixing; its performance seems to be enhanced when the paint is in contact with the wall while it goes through its full series of subsequent reactions—that is, its development throughout the adhesive and hardening phases—rather than allowing the reactions to start during the night while the solution is still in the bottle.

Despite a considerable amount of research by its manufacturers, no practical means of delaying or inhibiting solidification of the paints has yet been developed; hence it cannot be packaged and sold to consumers. Because of the nature of its chemical reaction, hydrolysis, the course of its behavior is unalterably set at the time the water and its catalyst, the acid, are added. Therefore it is up at the top of the list of binders mentioned on pages 5–7. The solution made as the first step of the two-step method will apparently keep for some time, but for artists' mural work, the whole operation is most safely carried out just prior to use.

A simple test for complete hydrolysis is to apply the solution to a glass plate and allow it to dry. If it dries completely and crazes (cracks and chips) when scratched, hydrolysis is complete. If the material on the glass remains moist and sticky, hydrolysis is incomplete.

This liquid is to be used as a binding vehicle for grinding the pigments. The minute amount of hydrochloric acid (a completely volatile material) acts as a catalyzer; without it the reaction would not be speedy or complete enough to serve practical purposes. From the strictest standpoint, this acidity might be considered undesirable because of its destructive effect on the steel balls and on the acid-sensitive pigments (ultramarine and the cadmiums), but in practice the effect is so slight as to be negligible. Its slight etching effect on plaster or cement walls (which immediately neutralize it) may well be an imporant element in the successful adhesion of the paint.

Another recipe for hydrolyzing the ethyl silicate recommended by the company is called the one-step method; in it all the ingredients are mixed at once. In this process also the original instructions call for 8- to 12-hour storage before use:

> 53 volumes ethyl silicate 40
> 42 volumes 190-proof denatured alcohol (Synasol or equivalent good grade)
> 5 volumes water

The following recipe is applicable to all three types of ethyl silicate:

> 15 volumes ethyl silicate
> 8 volumes alcohol
> 2 volumes diluted hydrochloric acid (1 percent by weight in water)

An acid content of 0.03 to 0.1 percent of the final solution is suggested.

The two-step method on page 351 produces the highest silica content, and, so far, has been the most successful for murals on white Portland-cement walls. Because the entire method has as yet no standardized procedure, present-day users consider themselves pioneers, and each one learns a bit more from his venture into an ethyl silicate mural.

Pigmentation. Prior to beginning the day's work, place in the can or jar of the ball mill (pages 349–50) the following ingredients and allow to rotate for about five minutes or until well mixed. Measurements by weight:

> 10 parts hydrolyzed solution of ethyl silicate 40
> 2.5 parts pigment
> 2.5 parts micronized mica

Keep in screw-cap jars; discard all remnants at end of the day's work.

Some variations may be necessary in the proportions of binder to the various pigments; a trial panel as in fresco painting (page 78) will quickly determine the best proportions. Titanium white should be used in preference to zinc white, which is not sufficiently inert to the medium. The trial panel or test block is an important adjunct of the process—as it is in most other methods used directly on plaster or cement walls.

Application. For exterior use, murals should be placed in a protected or semiprotected location if at all possible, under a portico, porch, colonnade, overhanging eaves, etc. Painting on a completely exposed wall with any material will be subject to the mechanical wear of precipitation, airborne particles, etc. Plaster walls are usually used for interior, and white Portland cement for exterior work. This technique can be used on walls with a wide range of textures, from smooth to rough troweled or floated surfaces. A white Portland-cement wall, ground down by going over dry, hard surface with a fire brick, gives an excellent surface. The manufacturers of ethyl silicate recommend a wash with dilute hydrochloric acid, a rinse with plain water, and then application of a priming made of 90 parts Portland cement, 11 parts asbestos powder, and 12 parts casein powder made up to a slurry in water. The presence of casein in this recipe may make it unsuitable for outdoor use; also, the suggestion is presumably meant to apply to solid coats of paint rather than to the usual free style of artists' brushwork. Painting is carried out in any style, with bristle brushes (the process is rather hard on brushes). If the paint is too thick and heavy for some techniques, especially when thin, transparent painting and brilliant effects on a white ground or over an opaque underpainting are sought, the use of a special thinner will give far better results than plain alcohol. Good results have been obtained by using a thinner composed of 1 part of the hydrolyzed ethyl silicate solution to 3 parts of alcohol. One part of this diluent to 2 or 3 parts of the heavy paint usually puts it into the correct state. In attempting to thin paint which has thickened or become more viscous, bear in mind the previously noted lack of adhesion which might possibly result from the use of a reactive material that has already entered into or gone beyond its best adherent stage.

If paints of a good, normal thickness are applied to the wall and thin or glaze coats (if any) are placed over them, far better results are obtained than when thin glazy coats are applied first and heavier strokes painted on top of them. Adhesion over thin glazes or veils is sometimes found to be quite poor.

For clear, brilliant, fresco-like effects use the same single-stroke technique recommended for tempera painting on page 221. In general, a

multicoat painting is much more satisfactory than a single coat; brushability and uniformity of finish are superior in the second coat.

Artists who require an especially facile medium for their manipulations, for delicate or sensitive brushwork of the type not usually associated with large-scale mural techniques, find that adding a small amount of an alcohol-soluble resin to the paint greatly improves its working qualities. The resin acts as a plasticizer and hastens the initial setting and toughening of the paint layer. This, of course, is contrary to the basic principle of the process, which aims at the production of an imperishable, inorganic binder, but the theory is that the amount used is so small (2 to 4 percent) that the strength of the binder is the silica; when the small amount of resin disintegrates, soon or in later years, it is supposed not to matter. The actual test of time will determine this. The material recommended is polyvinyl butyral, trade name Vinylite XYHL (see *Sources of Materials*, page 636), and if it is not available in solution, the dry powder or crystals may be dissolved in alcohol to a heavy, clear solution.

Suggested Palette for Ethyl Silicate Murals

White	Titanium dioxide
Black	Mars black
Red	Light red. Indian red. Cadmium reds (not acidproof)
Blue	Cobalt, cerulean, manganese, phthalocyanine
Yellow	Ochres, Mars yellow, cadmiums (not acidproof)
Green	Chromium oxide, viridian, cobalt green, green earth
Brown	Umbers, siennas, burnt green earth
Violet	Manganese, cobalt (phosphate)

Ethyl silicate painting was first exhibited in the U.S. by a group of artists under my technical supervision in a proposed plan to decorate New York subway stations. Porcelain enamel paintings were also included in the project.*

PAINTING IN PORCELAIN ENAMEL

A recent development for outdoor murals and decorations, or for use where conditions are too severe for the usual painting materials and methods, is the application to artistic purposes of porcelain enamel on metal. The process is the same as that employed in enameling iron signs, store fronts, stoves, refrigerators, etc.

An artist can obtain white or colored enameled sheets in any shape or size from an enameling factory, purchase the colors, paint the pictures in

* *Subway Art,* New York, Museum of Modern Art, April 1938.

his studio, and return the work to the factory to be fired. However, as in any other process, technical perfection can be assured only if he has given the subject some study and if the materials used and their treatment in firing are in accordance with the most approved technical standards. A parallel to the method is the practice of lithography, where the artist has an intimate acquaintance with the craft and where the best results are obtained when he works in cooperation with a printer who is a specialist in serving artists. Similarly, the enameling technicians must have a fair understanding of the artist's technical aims and requirements and have some experience in firing exactly this sort of work.

The regular industrial method consists in coating a specially made iron sheet with powdered frit or porcelain-enamel materials mixed to a paste with water. When this material has dried to a powdery condition on the iron, the sheet is placed in a furnace for a few minutes at a temperature somewhere around 1500° F, where the porcelain materials fuse to a level, glassy coating, the iron and porcelain becoming intimately and permanently bonded with each other; they are practically fused into each other. The porcelain is composed of refractory and fluxing minerals; the frits have been prepared by melting their ingredients together at a temperature in the neighborhood of 2500° F, after which they have been plunged into water, finely ground, and sold to enamelers in the form of a powder or a water paste, sometimes with a little clay added. The colors used are known in the industry as "color oxides"; they are various compounds of cobalt, cadmium, and other metallic substances which have the property of coloring the vitreous mass and retaining their color during the firing process. The first coat on the metal always contains cobalt oxide, which has a particularly good affinity for the iron; therefore the color of the first coat is usually black, bluish, or grayish. Cryolite, feldspar, and fluorspar are among the materials which the manufacturers use as basic substances for these frits; and the whites or other materials employed to impart opacity to the glossy coating include tin oxide, antimony, titanium, and zirconium.

After the first coat of enamel has been fused to the iron sheet on both sides, two separate coats of enamel (usually white) are applied; each is fired at the 1500° F temperature (the figure varies according to the materials and the technique of the enameler, but it is always accurately controlled), and the enameled sheet, in white or color, is ready for decoration. Each subsequent layer of enamel fuses perfectly with the previous layer. A clear acidproof glaze can be applied at the finish.

It is the practice of the industrial plants where this type of enameling is done to spray their products with color mixed with water and, after this has dried, to lay a stencil over the powdery, dry enamel color and rub off

the unwanted portions with a brush or cloth, through the stencil. Only one color at a time can be applied in this manner, and each color must be fired separately. The method has obvious limitations in the case of mural painting of any degree of finesse, and only work of a very mechanical nature can be done by it. The appearance of the vitrified powders is entirely out of line with their final colors in the fired state; before they are fired they are pale grays, pinks, etc. The only advantage this method has over the following one is the fact that through its use of stencils, reproductions and copies of an original design can be turned out with accuracy by factory workers—an advantage of doubtful value in direct artistic work.

Artists' Techniques. To overcome these limitations, I have experimented with methods of painting on an enameled sheet with the vitrified colors well ground in special binding mediums, both oily and aqueous. Complete freedom of painting is possible, just as in oil, tempera, or watercolor work; with minor exceptions, these "oil" colors appear the same when wet as they will after firing. The principal change is one of paint quality rather than a color change; the picture gains a certain depth and substance. The dry vitrified colors may be ground in a number of mediums with a muller; the "oil" medium is a special vehicle sold to the enameling industry for silk-screen work, and is usually called squeegee oil; actually it contains no oil but is composed of resins and solvents. Although the function of the medium is simply to fix the colors to the panel until it is placed in the furnace, where the organic binder immediately goes up in smoke, the use of improper materials will cause defects; so far as I know, the use of drying oils in this standard factory enameling process always results in bubbling or blistering of the surface.

Painting with this medium on the glossy, nonabsorbent enamel surface offers some inconveniences; if the colors contain much medium they are liable to flow and run into one another. An easy way of overcoming this tendency is to mix them on the palette with turpentine, mineral spirit, or a quick-drying solvent such as toluol, acetone, etc. This will cause them to set quickly, and will make cleaner, sharper overpainting possible. Colors ground in an aqueous binder can be used as underpaintings; they supply a good tooth for easy application of the resinous medium, but they must never be used over it.

The painting may be done with some degree of latitude as to thickness of coating, but there must not be too much variation in layers for any one firing. The workers at the enameling plant will adjust the temperature and the duration of the heat to the thickness of the layer, according to their experience and judgment; too great a variation in the layer will

result in defects in either the thin or the thick parts. Normal or a little less than normal oil-painting thickness appears to be most desirable. Too thin or washy a coating may produce a flat quality reminiscent of the effect of lithographed tin; if loose and free its quality will approach that of watercolor. Opaque and glazed effects may be combined as in the oil painting technique; either white pigment or the white of the ground can be utilized. No standard mural technique has been established; so far, the artists who have executed murals in enamel have followed the general examples of oil painting, fresco, stained glass, etc., as to brushwork and effects, but there has been much speculation as to the best way of exploiting the full capabilities of the medium and developing a technique that will possess a true enamel quality. At present, the glossy finish seems to be a definite characteristic, because the mat finishes that have been produced, although successful in themselves, are like any other mat finish in that they are highly susceptible to the mechanical absorption of dirt and staining, and probably much less resistant to wear and scratching than the glossier ones. Also, it is very difficult to wipe out or make corrections while painting on a mat surface. A mat finish seems to be one of the standard mural requirements that enamel must forgo. Panels painted in the oil medium must be dried overnight or longer before being placed in the furnace; or they can be baked dry in mild heat if convenient; but the medium is not formulated to dry perfectly, as is the medium in oil painting, and such panels must be handled with care until they have been fired.

Aqueous Mediums. I find that another successful way of applying the colors is with a water medium. The best ones I have tried are a watercolor binder of the type given on page 284, the essential ingredients of which are gum arabic, sugar, and water; a 20-percent water solution of white shellac made with ammonia; and a casein solution. In general, the watercolor can be scraped off and manipulated in a number of ways. It lends itself to an even, flawless spray-gun or air-brush coat free from brush marks, which some commentators have declared is one of the desirable characteristics of enameling as a technique. Masks, stencils, or friskets can be laid down to facilitate such work; for accurate, delicate, or sharp operations, tracing or frisket paper can be attached with rubber cement either to the unpainted panel or over the dried water-medium colors, and stencils cut out on the panel; with surrounding areas of paint thus protected, sections of the dried color can be washed away with damp cotton. These manipulations cannot be accomplished with the oily medium or when the colors are used without a binder.

Paintings can be done entirely in the studio and sent to the plant for

one firing; for some special glaze effects, or if corrections or overpaintings are required, they can be refired a number of times. Enormous sizes can be made by joining the sheets; their edges can be made flanged and they can be fastened to each other. The largest size sheets are usually 3½ x 8 feet; the enameling technicians recommend a 3 x 3 foot panel as the maximum unit for large jobs; 2 x 2 may be better. There are a number of standard, established methods of joining and erecting these panels, and many experienced firms that can install them.

When the panels are painted in the factory, where there is no transportation problem and where refiring and other manipulations can be done easily, color without strong binder can be sprayed or brushed on. The purpose of the strong binding mediums discussed above is to bring the process within the reach of the average painter by developing a technique that he can learn quickly, to allow work to be executed in a free and direct manner, and to allow painting to be done away from the factory.

With a little experimenting, or in an establishment whose technicians are experienced in such work, the enamels can be applied to aluminum, copper, or other metals. The iron sheets are protected against corrosion by the enamel; only when it becomes chipped by some severe blow are they liable to rust; the use of copper, aluminum, or other metal would not prevent accidental chipping. Damages of this sort should be repaired by painting as soon as they occur; if the sheets are removable they can be refired.

The iron may be purchased in large sheets before enameling and embossed or hammered in relief or repoussé work, then sent to the enameler to receive a ground coat of any color. After this, the design or figures can be overpainted as desired. The metal is made in several gauges, and sculptors have found it very easy to handle for this type of work. No smooth, flawless surface can be made on hand-hammered work, but such perfection is seldom required in artists' sculpture. Technically perfect enameling can be applied, however, to machine-embossed surfaces.

Enamel painting has been done on various metals from the earliest days, and examples have survived in good condition from ancient civilizations. The cloisonné work in which the various colors are separated by metallic strips is well known, and later paintings such as the Limoges and other enamels that were sometimes done with oil show the durability of the medium. The only new thing about this method is that whereas in the past enameling was confined to use on precious objects, a modern low-cost industrial process has made artistic enameling possible on a large scale. This process is under scientific control and in recent years the product has been improved considerably in permanence and flexibility.

OTHER IMPERISHABLE MURAL METHODS

Murals, designs, and decorations on walls can be executed in durable materials and by methods which are not, strictly speaking, painting—for example, colored cements (pages 593–95), sculptured bas-relief, or repoussé metal work that can be colored with paint. In these cases the paints used do not have to be everlastingly permanent because any draftsmanship or subtleness of design would be contained in the sculptural part of the work, and the color areas may be replaced or refreshed by reference to an original color cartoon which can be preserved for the purpose.

MOSAIC

Mosaic, which is one of the oldest methods of wall decoration, is looked upon as a sort of painting without paint—the execution of designs by setting small tiles or tesserae into a wet cement or lime-plaster surface. The units are usually ¼- to ½-inch cubes of opaque glass, but sometimes stone or ceramic pieces are used, and occasionally bits of other imperishable materials (shards, pebbles, shells, etc.). There are several techniques or ways of handling the setting of the tiles into the cement and several kinds of cements, plasters, and waterproof mastics to choose from according to circumstances. The operations are simple in principle, but instruction and practical guidance from an experienced mosaicist is recommended before attempting any important work.

The monumental mosaics of the Byzantine, Early Christian, and Renaissance eras have survived in a better condition than most other works of art, perhaps not only because of the durability of the materials, but also because of the simplicity of restoration by replacement of the tesserae, should any fall out.

Glass is not crystalline in structure but conchoidal; that is, when it is broken, the fractured surface presents a smooth, glossy yet irregular or undulant appearance; it is these fractured sides or facets of the tesserae that are usually used, and they contribute toward brilliant or sparkling effects. Gold tesserae are made by applying gold leaf to the back of clear glass or in between two layers of clear glass, and annealed together. Cut stone tesserae of larger size were used in ancient Greek and Roman floor mosaics, and in mosaic panels set into stucco walls. Natural pebbles and cut stone are often used today.

The two principal methods of setting the tesserae are direct setting into a plaster or cement bed, and what Vasari refers to as *mosaico a revoltatura* or setting a section of the mosaic in a tray of dry, powdered material, pasting coarse canvas over the top surface, then pressing the

assembly into the wet cement wall, and washing off the canvas after the cement has set. Excess or spattered cement is usually removed from the surface with hydrochloric acid.

Mastics (see page 179n) are often used to replace plaster. The first mastic was a linseed-oil compound used in the sixteenth century. Later, asphalt and coal tar mastics were used. Modern varieties made of synthetic resins are the best of all.

The design or cartoon of a mosaic can indicate whether the tesserae are to be set in a haphazard way, or to follow contours of design, or to follow an arbitrary pattern or series of patterns. Almost every step of the process in use today was known to the early mosaicists.

The Renaissance mosaics, especially those of the Venetians, were created under the same traditions as those of earlier periods. The same master painters who were commissioned to do frescoes and other murals also designed mosaics, which were then executed by expert mosaicists who were well-known figures in their day, and who vied with each other in the subtlety of their work and their ability to transpose the original designs or cartoons of the masters into mosaic. The painter who uses the services of a mosaicist to assist or to take over the work therefore has an old tradition behind him.

Recent trends in architectural styles have brought about a favorable situation for both outdoor and indoor mosaic; a genuine revival of its use seems to be forming, in which case procedures, supplies, and facilities for the artist to execute them will become more widespread and standardized.

COMPARATIVE VALUES OF MURAL TECHNIQUES

The qualities of fresco are the standard in mural work; other methods approach them in varying degrees. Straight oil painting on walls or on canvas attached to walls is a poor substitute; no matter how successful such painting looks on the easel or in the studio, it gives a disappointing optical result when applied to the wall, lacking liveliness and almost all of the mural qualities. Furthermore, we are so accustomed to oil painting as a standard method for the production of nearly all of our easel pictures that we expect it to meet other requirements equally well; and to have it result in an effect that is inferior to that of our easel paintings does not satisfy us. Glaze effects which produce a sort of luminous glow on small paintings are even lower in key and hence more unsuccessful in murals. Such paintings require full, individual lighting, and must be viewed

from certain angles and distances to be best appreciated; they consume light, which is understandable when their physics is considered. Oil paint that has been made to assume a flat or mat finish by any means is less durable than a normally glossy oil paint.

The degree in which the tempera effect is more luminous and brilliant than that of oil painting is likewise limited. On the easel or in a frame the difference is marked; in a mural the tempera quality is midway between that of fresco and that of a highly keyed oil. In technical properties, while tempera is an improvement over oil, it does not equal fresco. The secco processes, including painting in size, casein, or thinned egg yolk on dry plaster in a manner calculated to imitate the fresco technique, come closer. When such work is done on moist limewash, its quality is still more like that of fresco. Casein is the best material for this purpose; egg is not only a little inferior as to optical effect, but also has technical disadvantages. Such paintings cannot be cleaned so easily as true fresco, but after they have become thoroughly set they can be cleaned if enough care is taken. Their most apparent inferiority to fresco lies in the comparative dullness or cloudiness of their colors. There is not much difference in the effects produced by glue size and casein. The glue colors seem to have a sort of coarseness; their luminosity is possibly greater than that of casein, but their washability and their durability in our climate are extremely doubtful. Mineral (potassium silicate) painting produces an effect that, when new, compares favorably with fresco; but after more than one hundred years of development the process is still too unreliable to be trusted. A promising fresco substitute in modern painting is the new silicon ester medium, which gives very desirable mural effects. The fresco quality can be duplicated, and results should be permanent if the mural is in a semiexposed position, as in a portico or sheltered by eaves. Porcelain-enamel murals, while they give very striking results, are not appropriate for general use under all circumstances. Mosaic is perfectly adaptable for all mural purposes, indoors and out, but its particular vitreous effect may not be appropriate to all indoor surroundings either.

Outdoor murals, or those exposed to drastic environments, are best executed in mosaic, or with other materials which I have classified as imperishable in the foregoing pages, rather than with surface paints. In addition to the highly destructive concentration of ultraviolet in direct sunlight, and the chemical attack of sulphur and acids in polluted atmosphere, an outdoor surface is continually bombarded by gritty airborne particles, rain, and snow, all of which have a destructively abrasive effect to a degree that is much greater than is generally realized.

Polymer colors have been employed in mural painting since their in-

troduction, and, although data on their longevity on walls is necessarily nonexistent, there does not seem to be any reason why they should not survive indoors, and away from direct sun rays outdoors, as well as or better than do the traditional surface paints.

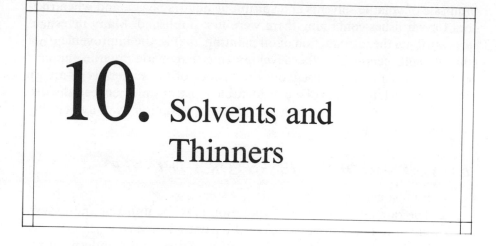

10. Solvents and Thinners

THE LIQUIDS THAT dissolve and mix with oils, resins, and other paint and varnish materials are employed by the painter principally as diluents or thinners. Their use as solvents in the literal sense of the word, that is, as means of putting resins and other solid materials into solution (as in the making of varnishes, etc.), is less frequent. They also find other applications in the arts, as varnish or paint removers, as cleansing materials in the restoration of paintings, and as agents in various art processes such as etching, lithography, etc.

The sole purpose of a thinner is to reduce the viscosity of a paint or varnish so that it may be easily applied to the surface in a thin film.

Volatile solvents and thinners for paints and varnishes were practically unknown to the ancients. According to Pliny[4] some of the crude petroleum from oil wells and some of the balsams and oleoresins from pine trees were distilled locally in a primitive manner by boiling the crude material in a vessel covered with a sheepskin laid over it fleece side down. The condensed volatile liquid which accumulated in the fleece was then squeezed out. Descriptions of distillation by use of an alembic or still begin with the physicians of Alexandria in the third century. The distillation of turpentine, alcohol, and other materials is mentioned in the writings of the early alchemists and craftsmen, but all the evidence indicates that these products were not applied or adapted to practical use (except in medicine) prior to the fifteenth century, when the commercial production

363

and sale of volatile solvents and spirituous liquors began, and when recipes for varnishes containing them were first published. Many investigators attribute the introduction of oil painting, that is, the improvements of the fifteenth century, to the developments that made volatile thinners available to painters. Throughout the history of the materials of art we encounter such instances of a considerable lapse of time between the discovery or first application of a material and its adoption by or availability to painters in general.

PAINTERS' REQUIREMENTS FOR A THINNER

1. It must evaporate completely.
2. The rate or speed of its evaporation must be uniform and exactly suited to the manipulations of the painting process.
3. It must not exert a destructive solvent action on the underpainting.
4. It must not react chemically with the materials with which it is mixed.
5. It must be perfectly miscible with the other ingredients in all proportions in which it is likely to be used.
6. The fumes should be noninjurious to health, and the odor should be nonresidual, that is, it should disappear entirely from the dried film within a reasonable length of time.

When such a material is used as a solvent (as distinguished from a thinner), the additional requirements are fairly obvious: its solvent action must be complete for the purpose, the solution should be stable and must not disintegrate under normal conditions.

EFFECT ON PAINT

The various volatile liquids which are suitable for use as paint and varnish thinners differ from one another only in such properties as rate of evaporation, solvent action, odor, etc. None of them has any binding or film-producing qualities, and none has any drying effect on paints and varnishes except as it allows the paint or varnish to be spread in a thinner film, a greater proportion of the oil or resin being thereby exposed to the drying action of the air.

TWO WARNINGS

1. A few volatile solvents are nonflammable, but as a group, most are highly inflammable. Reduce the fire risk by not buying large quantities at

one time and by keeping the containers tightly closed. Turpentine and mineral spirits are relatively safe in this respect; gasoline, benzol, and acetone are dangerous and must not be used near open flames.

2. Continuous breathing of fairly concentrated solvent fumes in a poorly ventilated room can be injurious to health. In this respect, turpentine, mineral spirits, acetone, and alcohol are relatively safe when handled intelligently under good ventilation. The others, especially benzol, carbon tetrachloride, and proprietary paint removers, must never be breathed continuously. They are best used outdoors. See *Toxicity of Artists' Materials,* pages 406–408.

Solvent Allergy. Most persons can handle turpentine, mineral spirits, alcohol, and acetone in normal studio procedures without ill effects. However, some individuals are hypersensitive to some solvents, especially to turpentine, which can cause skin and respiratory irritations. Switching from turpentine to mineral spirits or wearing polyethylene gloves sometimes permits these people to continue painting in oil. Others have had to switch to aqueous paints.

MUTUAL SOLVENTS

Some liquids have the property of being miscible with two entirely separate classes of substances which are not miscible with each other; for example, acetone will mix with many oils and also with water. The addition of such solvents to certain mixtures of incompatible substances will produce a complete solution. These materials are called mutual solvents and are also known as common solvents or coupling agents.

Some solvents and oils are partially miscible with each other or with water—that is, they are miscible in limited, small percentages; for instance, turpentine will mix with ordinary alcohol in very small amounts. In the present account of the properties of the solvents, such limited mixtures are disregarded; they seldom have any technological significance, and materials that cannot be mixed in all proportions or at least in appreciably large percentages are here considered immiscible for all practical purposes.

The order in which the ingredients are added to mixtures which contain a mutual solvent is sometimes but not always important in obtaining a clear mixture. In most cases the materials are stirred together and the mutual solvent is added slowly until the solution becomes homogeneous or clear, but sometimes the solution must be kept clear all the way through by reversing the order.

The solvents are not classified in this section strictly according to their derivations or compositions, but rather from the viewpoint of their usefulness and behaviors.

TURPENTINE

Turpentine is made by distilling the thick resinous sap of pine trees crop-grown in the southeastern United States and of similar coniferous trees in various parts of the world. Originally the entire crude exudation or oleoresin was known as turpentine. Later the volatile distillate was called "spirits of turpentine" and "oil of turpentine." The resinous portion left after the turpentine is distilled is called rosin. When turpentine is mentioned in old recipes, the entire oleoresin is often meant, particularly when the instructions are to "melt the turpentine." The modern meaning of the term dates from the early part of the nineteenth century, and in America and England turpentine, colloquially shortened to "turps," now refers specifically to the distilled product. The older meaning of the word survives in English in reference to only two products, Venice turpentine and Strasbourg turpentine, two oleoresins which became obsolete so far as their industrial importance is concerned during the nineteenth century, but which are still in use by artists.* (See pages 454–55.)

Turpentine is a colorless liquid with an agreeable odor; its vapor is noninjurious, and it is one of the safest solvents as regards fire risk. Its rate of evaporation is exactly fitted to the great majority of paint and varnish purposes; that is, it allows sufficient time for brushing manipulations, and it evaporates rapidly enough for most uses.

Turpentine oxidizes and polymerizes on exposure to air, sunlight, or heat, but any siccative effect that this property may have on oil paint in actual practice is negligible.

The small amount of gummy residue left after fresh turpentine evaporates is also to be disregarded, as it is seldom over 1 percent even in the worst samples. It does no harm, neither has it any value as a binder. Fresh turpentine is preferable in this respect to that which has been in storage for a considerable time. (See pages 634–35.)

For paint and varnish purposes there is only one grade of pure turpentine. The material known as pure gum spirits of turpentine, when purchased in bulk from a high-grade, well-established paint store, serves exactly as well as the so-called double rectified material put up in bottles for artists' use, and it is more likely to be fresh stock.

* Commercial supplies of turpentine and rosin are known as Naval Stores, and the nomenclature used in this book is that established by the United States Government in the Naval Stores Act of 1924, and now in common use in America and England. Further remarks on these products will be found under *Oleoresins*, pages 194–97 and *Rosin*, pages 187–88.

Wood Turpentine (either steam-distilled or destructively distilled). This material is made from the stumps and scraps of turpentine pines. Although its properties as a solvent and thinner are practically identical with those of the turpentine described above, it is rejected by artists on account of its obnoxious pine-sawdust odor. The artist who is familiar with its odor will at once recognize its presence as an adulterant in gum turpentine.

MINERAL SPIRITS

This product is distilled from crude petroleum oils, and as a thinner it has properties similar to those of turpentine. The best grades are made especially for the purpose in large quantities, and they evaporate at a speed which makes them suitable for paint and varnish use. Mineral spirits is produced by most of the large petroleum refiners, and sold by them under various trademarked names such as Varnolene, Texaco Spirits, Sunoco Spirits, etc. Mineral spirits is also called turpentine substitute or odorless paint thinner. In England it is known as white spirit. During the past several decades mineral spirits virtually replaced turpentine in industrial paints, but artists were slow in accepting it, mostly because of its mild benzinelike odor, which, although not particularly unpleasant, is quite different from the traditional studio smell. It has several advantages: it leaves no sticky, gummy residue in cups, it does not deteriorate with age, its price is a small fraction of that of gum turpentine, and it is less likely to affect persons prone to allergic reactions. It replaces turpentine as a paint thinner and for most studio purposes, except in damar varnish or recipes containing damar, which is incompletely soluble in it. In indoor house painting, where solvent fumes and odors are rather concentrated, mineral spirits is universally preferred.

Considered as a petroleum product, it is intermediate between kerosene and gasoline as to flash point, inflammability, rate of evaporation, and price. Standard requirements for safety in industrial paint use call for a thinner with a flash point above 80° F. Flash point is the temperature at which the vapors will begin to ignite when brought into contact with an open flame.

Most of the solvents described on the following pages will mix with oil paints, but they are not ordinarily employed in the usual traditional oil-painting methods.

BENZINE

Although house painters will sometimes call mineral spirits benzine, the latter word more correctly applies to a variety of grades of petroleum distillates intermediate between mineral spirits and gasoline. They are not so well suited to paint purposes as is mineral spirits; they have a lower flash point, a higher rate of evaporation, and usually a more disagreeably pungent odor. Their principal familiar use is as dry cleaners. The grade on sale in paint stores is usually V. M. & P. Naphtha, a material preferred to mineral spirits by some house painters, though it evaporates more rapidly and has a flash point under 80° F.

KEROSENE

Kerosene is the lowliest member of the petroleum solvent family, and the cheapest; it is a poor solvent, a very slow evaporator, and it has the fault of leaving a residual odor as well as an objectionable oily residue. It is sometimes used to retard the rate of drying of certain industrial mixed oil paints.

GASOLINE

Gasoline evaporates with extreme rapidity as compared with turpentine, and its vapors, especially when mixed with air, are highly explosive. For these reasons it is not used in paint; chemically, it has no more effect on the paint than any of the other solvents. Practically all of the motor-fuel gasoline sold in this country contains added ingredients to improve its performance, and most of these are highly poisonous. When it is required for some special purpose, only high-test, *white* gasoline should be used. Gasoline has the greatest solvent action of any of the petroleum products with the exception of a still more volatile grade that is not frequently encountered, petroleum ether, or casing-head gas. This material may be described as a "super-gasoline"; it has almost instantaneous evaporation.

BENZOL, TOLUOL, AND XYLOL

The accurate chemical names of these products are benzene (not benzine), toluene, and xylene, but these names are used only when the materials are being discussed purely as chemical compounds or as factors in a chemical reaction; otherwise the "ol" designation is in universal use, particularly as applied to the grades commonly employed. These products

are all derived from coal tar; each has its distinctive odor, but the three are similar enough to be easily identified as belonging to the same family. They have very similar solvent action.

Benzol is the commonest of the three. It is an excellent solvent for a number of resins and other organic products, including rubber; its odor will be recognized immediately by users of rubber cement. It has a very low flash point, presents a greater fire hazard than gasoline, and has a bad reputation as a poisoner in industry. However, if the normal precautions for the safe handling of volatile solvents are observed, there should be no danger of poisoning from its fumes when it is used occasionally, or even frequently, under normal studio conditions; but when the fumes are inhaled during continued daily use in poorly ventilated workshops, benzol is dangerous. It freezes solid at about 39° F, but will flash even below 32°.

Toluol is a safer material than benzol; xylol is even better. Toluol is the most used of the three for small-scale technical purposes. Its ordinary or technical grade is nearer to a chemically pure compound than are the corresponding grades of the others.

Solvent Naphtha. The word "naphtha" has been more or less loosely used in the past to describe various petroleum materials such as benzine and the crude products of the early refinement of petroleum. In present-day usage solvent naphtha refers to a rather impure by-product of coal tar distillation belonging to the benzol group. It is a good solvent for coal tar and some asphalts, but is a poor general solvent for paint and varnish materials. It is sometimes useful for this very reason, as it has little effect upon the oils and resins in an oil painting and may be used to wash off superficial dirt, wax, etc., without the film's being affected. It has a penetrating naphthalene (mothball) odor, which, however, is nonresidual. The word "naphtha" is still applied to some special grades of benzine.

ALCOHOL

Ethyl or grain alcohol is produced industrially from a number of different sources and is obtainable in a number of grades. The normal ordinary pure grain alcohol contains 6 percent water, but a 100-percent alcohol is obtainable under the name of anhydrous or absolute ethyl alcohol. This grade must be kept especially well corked or it will absorb water from the air. Denatured alcohol is ethyl alcohol that has been rendered unfit for beverage purposes by the addition of various materials; it is not taxed. There is a heavy tax on pure alcohol. Industrial concerns may purchase specially denatured alcohol made with a wide variety of milder denatur-

ants, depending on the requirements of their processes, but the usual product sold to the general public is called completely denatured alcohol, and contains ingredients that make it unsuitable for many requirements.

For use as a solvent in spirit varnishes such as shellac, a specially denatured grade is usually sufficiently good; for finer uses, 94-percent or grain alcohol may be desired; and in cases where complete freedom from water is required, absolute or anhydrous alcohol is used. Permits may sometimes be obtained to purchase small amounts of these pure products in localities where their sale is regulated, but the sale of tax-exempt denatured alcohol made according to special formulas is restricted to industrial plants. Proprietary brands of denatured alcohol are noted under *Sources of Materials,* page 635; the sale of these is unrestricted. They contain less objectionable denaturants than the common or completely denatured grades.

The rubbing alcohols sold in drugstores are denatured with substances that are harmless to the skin, but they may contain as much as 25 percent water. The denaturants used may be of a kind that would make the material unfit for average paint or varnish use.

Alcohol has a powerful solvent action on dried paint and varnish films; it will not mix with oils (with the exception of castor oil), but it will attack and destroy their dried films. Some oil paintings that have aged twenty-five years or more are destroyed by the application of alcohol; others fifty or seventy-five years old are less hurt. Common grades of alcohol will not mix with turpentine and some other volatile solvents, but some alcohol or alcohol varnishes may be brought into clear solution or admixture with oils and all other solvents by the addition of a mutual solvent; for example, a mixture of common alcohol and turpentine can be made clear by adding a small amount of acetone. Anhydrous alcohol is miscible with turpentine, benzene, etc.

Alcohol is hygroscopic; this property is especially noticeable in the purer grades. Containers should be kept tightly closed; in open containers alcohol loses strength in two ways, by evaporation and by the absorption of moisture from the air.

Methylated spirit is the British equivalent of denatured alcohol and is ethyl alcohol denatured with 10 percent methanol and 0.5 percent pyridine; this corresponds to the completely denatured formula of the United States government. Another English grade corresponding to some of our specially denatured, tax-exempt alcohols permitted for industrial use contains 5 percent methanol and 0.5 percent mineral spirits.

METHANOL

Numerous cases of accidental poisoning occurred through a confusion of terms when two common alcohols were sold to the public without sufficient distinction. Grain alcohol was sold as Cologne spirit, wood alcohol as Columbian spirit or Colonial spirit, and containers were likely to be marked Col. Spirit. This caused the adoption of the name methanol for the material known as wood alcohol or methyl alcohol.

Methanol is sold in a rather pure technical grade, containing less than 1 percent water; also in a 100-percent grade—anhydrous or C.P. methanol. The Columbian and Colonial spirits are intermediate pure grades. Methanol has the same general solvent properties as ethyl alcohol except that it is a somewhat better or more powerful solvent. It may be substituted for the more expensive grain alcohol wherever its poisonous effect can be guarded against. If taken internally it is violently poisonous, and the fumes of the pure material should not be breathed too continuously. However, the small percentage of methanol contained in denatured alcohol does not make that mixture more dangerous to handle than any other solvent.

CARBON TETRACHLORIDE

Familiar under the trademarked names of Carbona and Pyrene as a dry cleaner and a fire extinguisher, this material has a rapid rate of evaporation and is nonflammable. Like all other volatile solvents, it must be used in a well-ventilated place, as its fumes are dangerously toxic if inhaled too continuously and in too strong a concentration. It is not a particularly effective solvent for dried paint and varnish films; otherwise it has fairly good solvent powers, especially for waxes. Its nonflammable nature causes it to be used widely for many solvent purposes, as a substitute for more efficient but inflammable materials. It has a high specific gravity and weighs about 13 pounds to the gallon. It does not mix with water.

LACQUER SOLVENTS

The following solvents, although they form a miscellaneous group of materials with widely varying properties and sources, are ordinarily grouped as lacquer solvents, because most of them will dissolve or mix with nitrocellulose lacquers; the important members of the group are used in large quantities by the lacquer industry. Some of them can be applied to useful purposes in artists' techniques, but the majority are of occasional value only.

ETHER (ethyl ether) evaporates instantaneously. It is called for in certain antiquated recipes requiring such action. It is a powerful solvent for most paint and varnish materials, but also a poisonous, potent anesthetic, and the most explosive and dangerous substance mentioned in this section. Gasoline is mild compared with it. It should be replaced wherever possible.

CHLOROFORM is a nonexplosive but dangerously anesthetic liquid of high solvent power, similar to ether, and should also be avoided.

ETHYL ACETATE is one of the least unpleasant and least harmful materials of this group and one of the best to use either as a solvent for old varnish films or when a rapidly evaporating material is desired. Its odor is comparatively pleasant, mild, and fruity. Having a flash point of 5° C, it must be kept away from flames.

AMYL ACETATE is the familiar "banana oil." Its properties are similar to those of ethyl acetate; it is somewhat less expensive, but also less pleasant to handle. Its strong, penetrating odor is well known.

AMYL ALCOHOL is related to amyl acetate; it has a somewhat milder banana odor and a relatively weaker solvent action. It is employed principally as a diluent or extender, or to impart good brushing properties to industrial coatings, because of its low rate of evaporation.

BUTYL ACETATE and BUTYL ALCOHOL (butanol) are two similar products that have low rates of evaporation. Butyl alcohol (normal butanol) can be used to advantage in clear varnishes to increase the ease of brushing and the leveling of brush strokes.

ACETONE is one of the best and most powerful of the volatile solvents; a paint or varnish material that remains unaffected by it will probably not be dissolved by any other volatile solvent under the same conditions. Acetone is the principal ingredient in many commercial paint removers. It is a comparatively pleasant and safe material so far as its odor and toxicity are concerned, but the usual precautions must be taken, especially as regards its inflammability. Its extremely low flash point, about minus 18° C, is far below its freezing point. It is an excellent mutual solvent or coupling agent in solvent mixtures, as it mixes in all proportions with oils, with water, and with most of the other solvents. It is the usual material employed when a clear mixture of water and oily materials is to be made. Methyl acetone is an impure acetone which contains varying amounts of methanol and methyl acetate.

DIACETONE ALCOHOL, whose solvent action is quite similar to that of acetone, is even more powerful than the latter in most cleansing procedures. It evaporates much more slowly—about 1/60 as fast as acetone. Its boiling point is around 165° C, and its flash point is higher than that of ace-

tone by 25 or 30 degrees. Its odor is mild but lingering. It has a strong penetrative effect, is an excellent coupling agent, and is widely used in industrial lacquers. It will soften, if not dissolve, dried linseed oil films.

TRICHLOR ETHYLENE is a powerful solvent for oils, resins, etc.; it mixes with alcohol and most solvents, and is immiscible with water. It is nonflammable and nonexplosive, with a boiling point of 86.7° C. Because of these properties it is used industrially as a dry cleaner and scouring agent.

TETRACHLORETHANE (acetylene tetrachloride) is another high-boiling (147° C) nonflammable solvent for difficult materials. Its fumes should not be inhaled; some individuals are extremely sensitive to their bad effects; it is best handled in a laboratory hood.

DIPENTENE, obtained from turpentine, may be considered a concentrated extract of wood turpentine. It has a pleasant flowery odor and is an excellent solvent for a number of materials. It evaporates at a rate that makes it useful as an ingredient of rapidly drying varnishes and lacquers. It improves the leveling and brushing qualities of such products by allowing the coating to remain in a liquid condition long enough to flow out.

PINE OIL is a straw-colored to colorless liquid that is a product of the steam distillation of wood turpentine. It has an agreeable odor and a very slow rate of evaporation. It has some value as a solvent for resins and as an odorant and preservative in casein emulsion paints and other industrial products.

BUTYL LACTATE is a fairly good solvent for most varnish materials; it is miscible with all their solutions and has a rather mild, nonresidual odor. Its high boiling point and its extremely low rate of evaporation make it useful as an addition to coatings to delay their setting and thereby improve their flowing and leveling qualities.

OTHER PROPERTIES OF VOLATILE SOLVENTS

The mechanical principles of solution are complex and involve molecular behavior. Some liquids combined in definite proportions will form constant boiling mixtures, that is, mixtures which will evaporate as a single material; in the case of other combinations, the most volatile part of the mixture will evaporate first. The properties of solvents, such as boiling point, solvent power, etc., are usually greatly altered when other solvents are mixed with them.

Many of the solvents mentioned in this section are employed as thinners, extenders, or diluents, regardless of their high or low solvent action on the mixture in question; that is, they are used in combination with an-

other material which acts as the principal solvent, their function being to reduce or increase the rate of evaporation, to improve the resulting product in one way or another, or to lower the cost. Although the word "diluent" is used, the volatile materials employed in varnish and lacquer manufacture do not always dilute or retard the solvent action of the principal active solvent of the formula (as water would when added to alcohol or to an acid or alkali in other chemical processes); rather, when they are compatible and miscible in the formula, they act as extenders of the principal solvent without reducing or inhibiting its solvent power. Often, extenders which by themselves have little or no solvent action on a substance will have a powerful solvent action when combined with other solvents. This property is called latent power of solution.

Another function of solvents in certain coatings is to impart the property of penetration. Many products, such as paints and varnishes, are used as first coats over wood, plaster, and other surfaces which are absorbent in varying degrees, and they must penetrate these surfaces to some extent in order to be effective. Almost all of the solvents and thinners are useful for promoting this action; in accurate industrial formulation some are preferred to others.

Wrinkling of an oil film is a defect which may be prevented by adding a suitable amount of solvent or thinner.

The surface defects in varnish (and very thin pigmented coatings), such as frilling, brush marks, etc., may often be overcome by the addition of various percentages of thinners that have the proper rate of evaporation for the purpose.

Often, but not always, the difficult and awkward brushing quality of a paint or varnish is due to the rapidity with which the solvent evaporates under the brush, not sustaining the fluidity of the medium long enough for it to be manipulated in a desirable manner. Sometimes evaporation is just slow enough to allow easy brushing but too fast to allow the paint to remain fluid for a few minutes thereafter so that the brush marks will level out. In some instances (especially in the case of spray coatings), the paint does not have sufficient speed of initial setting to prevent frilling, drops, or streamlines on vertical surfaces. Generally speaking, the commonest solvents, such as turpentine, mineral spirits, alcohol, etc., will fail only slightly from the point of view of correction. Small amounts of slower or faster evaporating solvents will remedy the faulty condition if other considerations make it possible for them to be added to the formula without danger of overdilution or of too great an increase in the solvent action of the coating so that it will pick up the underpainting during the brushing or flowing period. Both dipentene and pine oil appear to be an-

tioxidants, that is, they delay the drying of oils to an extent beyond that of their slow rates of evaporation.

Some of the essential oils (page 398) were formerly employed for these purposes; the modern industrial lacquers and other products contain slow-evaporating or "high boiling" liquids. A much larger number of solvents than are listed here are in regular use in industry for many special purposes, and materials which will meet very exact requirements can be selected. References to the literature of these materials will be found in the bibliography. See also *Retarding the Drying of Oil Paints* on pages 159–60.

The boiling points given for solvents in technical and scientific publications are usually obtained by accurate studies of chemically pure materials and are approximate for the ordinary grades. The rate of evaporation or the boiling temperature of a solvent is usually expressed by figures which indicate its distillation or boiling range rather than by a single figure. Sometimes this range is two or three degrees and sometimes fifty degrees or more. The boiling-point figures will give an approximate or comparative index to rates and speeds of evaporation.

COMPARATIVE RATES OF EVAPORATION OF SOLVENTS

The following list of solvents is arranged in order of evaporating speeds, starting with the fastest. Because of variation, both in materials and conditions, the numbers (which are my own) are merely rough indications of their comparative rates of evaporation. Carefully measured results of expert investigations seldom agree in detail.

Ether	1
Acetone	5
Benzol	9
Ethyl acetate	10
Carbon tetrachloride	11
Methanol (anhydrous)	15
Ethyl alcohol (anhydrous)	20
Toluol	23
Gasoline*	25
Butyl acetate	30
V. M. & P. Naphtha	40
Xylol	45
Amyl acetate	50
Wood turpentine	80

Butanol	100
Gum turpentine	110
Diacetone	180
Amyl alcohol	190
Mineral spirits*	200
Butyl lactate	500
Kerosene	3000

* Sold in a wide variety of grades; specimens of this material vary considerably.

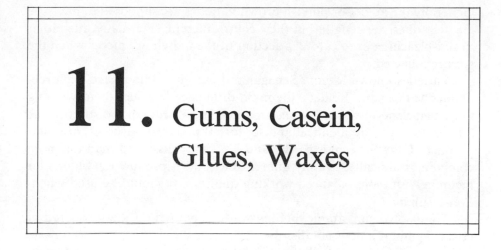

11. Gums, Casein, Glues, Waxes

GUMS

Gums are mentioned on page 175 in connection with the distinction between the terms "gum" and "resin." Gums are the hardened saps which exude or are made to exude from certain trees and shrubs. They are insoluble in alcohol or turpentine, but when mixed with water will either dissolve or swell to a jelly. When a gum is strongly heated it chars like sugar, but a resin will burn with a smoky flame. All gums are quite hygroscopic—that is, they have a tendency to absorb atmospheric moisture; but this is more marked when they are in their original or pure form than when they have been mixed with other materials. In the case of gum arabic in watercolors, for instance, it is even necessary to add very considerable amounts of glycerin, honey, and other materials to induce this property, in order to keep the paint moist.

Gum arabic. Gum arabic or gum acacia is a product of various trees that grow in tropical Asia, Africa, and Australia; the best grades have always been obtained from Africa. Numerous grades come into the market; sometimes they bear the names of the localities of their origins; but in America it is often difficult to secure any specific variety, the material being loosely grouped into two classes: the clean, pale varieties used in medicine and foods, and the darker kinds used for technical purposes.

Generally the amber or pinkish brown varieties are supposed to have the greater adhesive strength, but their color difference is usually due either to sun-bleaching or to careful selection of the individual pieces when the gum is collected.

Varieties known as gum Senegal and gum Kordofan have been recommended as paint binders, the main difference between them seeming to be that Senegal was a French province and Kordofan a district of the Sudan; the trees are identical and so, for all practical purposes, are their products. Gum Senegal is harder and less easily dissolved than the more common grade called simply gum arabic, and it produces a watercolor medium with more balanced working qualities. It should be used whenever available.*

To dissolve gum arabic, boiling water is poured on the powdered or crushed gum; if it does not dissolve at once, it should be left to stand several hours. Cooking or boiling the solution makes it dark, alters its properties, and gives it a pronounced odor. Common mucilage is usually gum arabic cooked with water and containing a preservative and some odorant such as an essential oil.

Gum arabic is used as a binder in watercolors and some tempera mediums, as a strong adhesive, as a size for various industrial purposes, in pharmacy, and in confectionary. When used alone it does not make a satisfactory binding material for pigments, especially in thick layers; some pigments will liver when ground in it, and all recipes in which it is used for this purpose call for plasticizing or toughening ingredients. (See page 286.) In watercolor it serves very well as a binder because it is not called upon to form a thick film. Without preservative, gum solutions will decompose, but not so badly as casein or glue.

Cherry Gum. Most varieties of wild and cultivated cherry trees exude a pale, clean gum that can be dissolved in water. The gums from almond, apricot, peach, and plum trees are said to possess the same properties for all practical purposes. The gum may easily be gathered from these trees, or the imported commercial material may be purchased.

Aged, dry lumps of cherry gum dissolve with more difficulty, and if allowed to stand in water until they are entirely dissolved they may decompose before solution is effected; solution has to be expedited by squeezing the mixture through cloth to separate the dissolved portions from the undissolved remnant. The sticky gum freshly gathered from do-

* Large, clean lumps of gums and resins are sometimes called "sorts"; since early days these grades have sold at premium prices because of their obvious purity, whereas powdered and broken-lump grades might contain dirt and adulterants. However, powdered gums labeled U.S.P. from the druggist in original one-pound packages are pure and perfectly acceptable.

mestic trees will dissolve more easily if very hot water is poured over it and it is well mashed and stirred around, then allowed to stand for several hours or overnight. Cherry gum solutions are not the same type as those of gum arabic, but result from a swelling of the material and an absorption of water. About one ounce of the gum to a half-pint of distilled water will yield a thick solution. This will usually contain finely powdered bark and other impurities and must be carefully strained through cloth; very fine particles will settle out upon standing. If desired, the purified material may be preserved by storing it in the form of flakes, these being made in the same way that glue is flaked, by pouring the solution out on smooth metal, glass, or porcelain plates and allowing it to dry, then scraping it off. The flakes are more readily soluble. The cherry, peach, and other gums gathered from trees in moist weather will obviously be less concentrated than the dry material and this should be taken into consideration when any exact formulas are being followed. Peach gum is found mainly on old or damaged trees.

Cherry gum has an ancient record as a raw material in various processes, the substance and the method of its solution were mentioned by Theophilus.[7] It has been inferred that because this gum was among the early tempera ingredients, it may be a more authentic material than gum arabic for use in following out the techniques of the Northern painters. It was also known in classical times and was mentioned by Dioscorides,[6] but not as a painting material. Recipes for the use of cherry gum in emulsions or to replace gum arabic can be easily worked out; it emulsifies very well with all tempera ingredients; it is an entirely acceptable material, and a favorite with those painters to whom the notion of utilizing domestic, noncommercial materials appeals.

Gum Tragacanth. This material is obtained from various species of *Astragalus,* a shrub native to Asia Minor. It comes on the market in hard, dull, crinkly, ribbonlike pieces, sometimes yellowish, sometimes grayish white. When soaked in water overnight it swells to a gelatinous mass which for some purposes is beaten or shaken to a homogeneous consistency and used as it is; for other purposes it is boiled until it goes into a more fluid but still colloidal solution. Its chief use among artists' materials is as a binder for pastel and chalk crayons; in industry it finds many uses as a thickener and stiffener. *Gum Karaya,* a material which swells enormously in water, is a cheaper substitute for tragacanth in industry.

Sarcocolla. This is a gum obtained from *Astragalus sarcocolla,* a native of Persia. It is mentioned in some ancient writings and also in English eighteenth- and early nineteenth-century painting recipes, but there are

few references to its use in modern accounts of painting techniques. The material is used to some extent in medicine. It comes on the market in the form of small rounded grains and agglomerates. Its properties and behavior are somewhat similar to those of gum arabic, but its chemical composition is different.

CASEIN

Casein is manufactured by allowing or causing skim milk to sour, separating the curd from the whey (the watery residue), and washing and drying it. The crude curd from skim or whole milk has been employed as a binding or adhesive material since the earliest recorded periods, but only in comparatively modern times has the more carefully controlled and uniform product we know as casein been widely available. Although the exact chemical construction of this material and the reasons for many of its reactions are not completely established, the various grades are fairly well standardized and uniform, and the behavior of the product can be controlled much more accurately than that of hide glue. Commercial caseins are produced by three processes and are known as self-soured, acid, and rennet caseins, the first two being useful for adhesive and paint-binder purposes. The usual commercial material is acid casein, made by adding hydrochloric or sometimes sulphuric acid to fresh skim milk, carefully washing and drying the curd. All traces of cream or butterfat must be removed from the fresh milk or the quality of the final product is impaired, especially for use as a paint binder and as an adhesive. It is very important to select only the best-grade, freshest casein obtainable in order to be certain of successful results.

Casein is sold as a slightly yellowish granular powder; aging or exposure to air will turn it more yellowish, change its binding strength, and decrease its solubility. When mixed with water, ordinary casein does not dissolve but forms a sludge. When alkalis are added to the water the casein immediately goes into a colloidal solution. For the coarser sort of cold-water paints and other commercial wall coatings, soda or lime is used to effect the solution, but for use in grounds or tempera mediums for permanent easel painting the only permissible alkaline materials are the ammonium compounds, ammonia water and ammonium carbonate, which are volatile and will leave no residual alkali in the final product.

Any traces of hydrochloric or sulphuric acid that may remain in the casein particles as a result of the process by which technical casein is made (distilled water extract from commercial casein will usually contain

sufficient acid to turn blue litmus test paper red) will be neutralized by the ammonia and so may be disregarded.

Dry casein deteriorates in an erratic manner when allowed to age, especially if exposed to air. It will usually keep unaltered for three to four months in closed tins or glass jars; for careful, accurate formulas it cannot be depended upon for much longer than six months. For this reason many careful users recommend purchasing direct from the manufacturer in small amounts if possible; sources of supply are mentioned in this book. However, old casein, even after being stored for years, usually makes a satisfactory paint binder if the user carefully checks the final products by observation and test instead of relying on recipes that call for accurate measurements.

In most recipes casein is measured by weight for reasons of accuracy, but if no balance is available the volume measurement may be used (see page 385), especially when small amounts are required. In such cases it is always best to test the final gesso or painting medium to ensure proper binding strength.

The history of casein is long; in the form of curd or pot cheese, which may be considered a crude or unpurified casein, it has been used as an adhesive and as a coarse cold-water paint from early times; its efficiency and permanence are well proven. Theophilus[7] described in detail methods for its preparation and use. Because curd or homemade casein contains butterfat and milk sugar, and because its concentration is not easily controlled, its use as a substitute for modern commercial casein is unwise.

CASEIN SOLUTIONS

Casein may be dissolved according to the following method, which is the usual one recommended by writers on the subject. The percentages of water and casein may have to be altered somewhat according to the source of the casein; those given here are based on the casein mentioned under *Sources of Materials*, page 643.

The casein is stirred well with water, preferably in a glass or enameled vessel (it is better not to allow metal to come in contact with it during this procedure), and allowed to stand for several hours. Clear ammonia water is then added drop by drop with constant stirring, a wooden rod or spoon being used, until the material is just dissolved and a thick, honey-like solution is obtained; this solution has a faint ammoniacal odor which persists after thorough stirring. The excess ammonia is then driven off by warming the solution in a water bath (double boiler) or by otherwise causing evaporation. For some purposes this need not be done, but when

the solution is to be mixed with alkali-sensitive pigments or other ingredients, excess ammonia is just as undesirable as excess soda, lime, or other nonvolatile alkali. Such evaporation is especially important if the casein solution is to be emulsified with resins, etc.; otherwise the free alkali will cause the solution to attack or saponify the other materials instead of forming a simple emulsion with them. It is not so important in the case of a simple gesso, where there are no such ingredients to be harmed and where the excess ammonia will pass off with the drying of the gesso layers. Excess ammonia may be discerned by its odor, and also by immersing in the solution a strip of red litmus paper, which will turn blue if ammonia is present. Casein should never be boiled.

Pure concentrated ammonia is generally recommended, but a somewhat more dilute solution can be more easily controlled. About 9 cc of strong (20 degrees Baumé) ammonia will be required to each ounce of casein. When small batches are made it is better to dilute the ammonia to half strength before using. With a little experience, it is easy to discern the difference in appearance between the undissolved or partially dissolved particles of casein and the complete solution, by holding to the light a glass upon which a few drops are spread. At first glance the air bubbles in the completed solution resemble particles. If grocery-store ammonia water is used instead of the drugstore grade, be sure it is the clear, not the cloudy variety.

None of the published accounts of the ammonia process of dissolving casein seem to mention overnight soaking of the casein, but when this is done it increases the strength of the solution so greatly as to throw off the figures given in some published recipes. This indicates that when the ammonia is added immediately after mixing the casein with water, solution is only partially effected, the inner portions of the casein particles remaining undissolved. In very warm weather and when no preservative is used, the casein is liable to decompose if allowed to soak for more than three or four hours. This period is generally sufficient to produce the improved solution; but where it is found that no decomposition takes place, soaking overnight is better.

For use in the average gesso, 4 ounces of casein are mixed with 22 fluid ounces of water and allowed to soak as described above; then diluted pure ammonia is slowly poured in with constant stirring until the solution is complete. This liquid will make a paste with about 4 pounds of precipitated chalk and bind it with average gesso firmness. About 34 fluid ounces of water are then added to bring it to brushing consistency. Because variations in materials and conditions may require further adjustments, and because a smooth mixture free from lumps is produced, it is

always wise to start the gesso in this heavy paste form and then thin it to the consistency required for its purpose. If the casein is not allowed to soak before adding the ammonia, about 6½ ounces of casein will be necessary to bind the same amount of chalk. (Note the remarks on the superiority of glue gesso over casein gesso on pages 264–65.)

When the casein solution is to be mixed with dry colors for painting or employed as an ingredient in tempera, distilled water should be used, and a total of only a quart of water to 4 ounces of casein will give a satisfactory strength in most instances. If desirable or necessary, the heavy solution can be used, with the total amount of water limited to 22 fluid ounces. This results in about a quart of heavy solution. A more convenient small batch for such paint-medium purposes can be made by reducing the figures; for instance, a 4-ounce batch would require ½ ounce of casein, 2¾ fluid ounces of water, and about 1¼ fluid ounces of water for final dilution. The very heavy viscosity of this solution requires it to be diluted with water for the majority of uses. Some writers claim that all the water of a casein solution should be added at the time it is made, and that further dilution will tend to destroy the colloidal character of the mixture; but painters find that they can dilute such a solution freely without bad results. For use in spray guns, casein gesso requires considerable further dilution, as will be determined by experience.

All casein solutions, particularly those that contain no pigments, decompose and acquire a putrid odor rapidly unless preservative is added to them. When a casein solution not containing preservative is used, do not attempt to store a remnant for more than a few days, but throw it away before it begins to deteriorate. The use of preservatives in casein binders increases the resistance of the dried films to mold and bacteria, but cannot be depended upon to give complete protection when external conditions are adverse.

An efficient and harmless preservative for casein is sodium orthophenyl phenate, much used in industry. (See *Preservatives* in this chapter.) It is used in casein solutions in the amount of about ½ to 1 percent of the dry casein; 1 percent may be approximated by using ⅛ to ¼ teaspoonful to 4 ounces of casein. Pine oil is also used in industrial casein paints as a preservative, an odorant, and to prevent foaming.

Because casein solutions change strength rapidly on aging, even when preservatives have been added, careful workers prefer to use freshly prepared solutions rather than to save remnants of batches for later use, thereby assuring a more uniform behavior of materials throughout their work. Although the recommended preservatives will be found efficient for keeping casein mixtures in the studio for a reasonable length of time,

their indefinite preservation on long storage is doubtful. It is an inexpensive material and much trouble can be avoided by making frequent batches of fresh solution.

Ammonium-Carbonate Method. Casein may also be dissolved by the use of ammonium carbonate instead of ammonia water. Ammonium carbonate is a white salt that evaporates and gives off ammonia gas. When it is used, the process of solution is completed within a shorter time because it requires no soaking, but the ammonia-water method does not require heating for gesso use. The solution is as pure as that made with ammonia water; it equals it in binding strength. To make the same quantity of gesso as is produced by the above ammonia-water recipe (about a gallon), stir 22 fluid ounces of water into 4 ounces of casein in a water bath (double boiler), adding the water gradually to form a smooth mixture. Warm the casein in the double boiler gently and then add 1 ounce of pure ammonium carbonate which has been smoothed into a paste with a little water. After the effervescence caused by the heating of the ammonium carbonate has subsided, the solution is completed; it is then allowed to cool, whereupon it becomes the same viscous solution as that produced by the method previously described. Ten additional fluid ounces of water will produce a usable solution for paint-binding purposes; 28 fluid ounces will result in an approximate gesso strength; in emulsions and other mixtures the solution may be used in its concentrated form.

Because ammonium carbonate is so volatile it should be purchased in small amounts and stored in tight bottles or tins.

Soluble Casein. One of the rather recent improvements in casein for paint purposes is the commercial production of a water-soluble variety called monoammonium caseinate. The standard method of dissolving it without ammonia is to dust it into cold water with slow stirring (in the proportion of 4 ounces of caseinate to a pint of water) in the upper part of a water bath (double boiler). As soon as it has been added, place the vessel over the lower part of the double boiler and heat (not too rapidly) to 160° F, with slow stirring. Remove the vessel from the bath; continue stirring until the particles are completely dissolved. This solution will be quite thick and heavy; for average gesso, use the proportions previously given, and thin the batch by stirring in 40 fluid ounces of water and mix with about 17½ pounds of chalk. A more convenient-sized batch for other uses (about 4 ounces), would consist of ½ ounce of caseinate and 2 fluid ounces of water. Two fluid ounces of water added after solution is effected will produce a strong binder; 7 fluid ounces more will make a gesso with a half-pound of precipitated chalk.

This caseinate, when fresh, gives a clean white solution compared with the more yellowish one usually produced by ordinary casein, and it is a superior material for all-around use. In order to make it the manufacturer must select a better, purer, more carefully controlled casein than is usually sold for technical use.

A simplification of this standard method, adequate for use in those cases where precise duplication of binding strengths is not important, is as follows: bring a couple of inches of water to the boiling point in a large enough vessel; mix the caseinate with cold water in a can or jar in the same amounts as above, stirring the mixture slowly and thoroughly until it thickens; then before it becomes too dry or pasty for easy stirring, remove the pot of boiling water from the stove, set the can in it, and stir the solution until the characteristic honeylike mass is obtained. An addition of about half the initial amount of water must then be stirred in so that the mass upon cooling will remain fluid enough to be easily handled and diluted. Upon aging, this material may be difficult to dissolve, in which case a little ammonia should be added and it will dissolve like regular casein.

As previously mentioned, it is more accurate to use dry materials by weight, but when no balance is available the following volume equivalents can be used:

1 ounce casein = 1¼ ounces by volume
½ ounce casein = ⅝ ounce by volume (5 teaspoonfuls)
½ pound precipitated chalk = 20 ounces by volume

Formaldehyde in Casein. Formaldehyde, alum, potassium bichromate, and other chemicals have a hardening or toughening effect on proteins, but it is difficult to maintain the properties or to control the action of a glue or casein solution that contains them, and the recommended procedure is to spray the finished coating with dilute formaldehyde. However, formaldehyde may be mixed into the above solution to produce a binder which has very high resistance to water, if it is stirred in with extreme slowness, not much more than a drop at a time. Use 2 fluid ounces of formalin (40 percent) diluted with 10 ounces of water to every pound of casein in the solution. This is a slow procedure (requiring about 20 minutes), but more rapid pouring would solidify the casein. The solution should be used the same day. Formaldehyde is a powerful fungicide and germicide and in this case will serve as a mold preventive; the large proportion used will compensate somewhat for the disadvantages mentioned on page 373.

Casein as a Binding Material. Casein solutions mixed with pigments will dry to form tough, horny films or masses which are considerably more resistant to moisture than those made with glue or gelatin. When sprayed with formaldehyde in the manner recommended for glue, they will become still more resistant. However, a casein paint is not to be considered an entirely waterproof product; it is always affected by moisture to some extent, and in the case of an artistic painting, where slight alteration of color effect would be ruinous, it cannot be considered washable. The plain white or solid color "washable" wall paints made of casein may be washed or cleaned with damp cloths and sponges because slight changes in flat, blank areas are not noticeable. Dried casein paint films do not alter very much, if at all, with age, and if given the proper care and protection against external mechanical damages are quite permanent. Casein solutions serve very well for poster colors and for secco and other mural techniques.

A solution of casein as described in the preceding pages, made by a formula containing a total of 6 fluid ounces of water to 1 ounce of casein, plus a little preservative, is suitable for grinding pigments; because of the varied ways in which such paints may be employed and the great variation in individual techniques, the exact strength of the solution is best left to the decision of the painter. The paints can be examined and tested as soon as they have dried out thoroughly under average painting conditions. If the binder is too strong they will crack, flake, or chip off; if it is too weak they will be crumbly and will dust off when rubbed with clean cotton; but it will be found that there can be considerable variation in the composition of the binder before either of these defects occurs. If either is going to occur at all, it will be evident very soon after drying.

The film of a pure casein paint may be tested the same as egg tempera, that is, by allowing normally thin brush strokes to dry on a sheet of glass and then scraping them off with a sharp knife. If the paint comes off very easily as a dusty powder there is insufficient binder in proportion to the amount of pigment; if it is tough and strong and difficult to cut, there is enough. The casein film cannot be expected to meet this test in the manner of a tempera or oil paint and curl up in such a flexible shaving; it has, however, sufficient flexibility for the purposes for which it is generally used—i.e., on rigid plaster walls as a substitute for fresco, and as an easel paint on rigid gesso, cardboard, or wallboard.

I have excluded simple casein paints from the tempera classification because they are not emulsions with oily ingredients, and because their behavior is different from that of such emulsions. In some quarters, however, they are commonly known as tempera.

The application of casein paints is discussed in the following section, *Casein Painting.*

CASEIN EMULSIONS

As remarked previously (page 233), casein may be emulsified within resin varnishes and waxes, but because of the danger of excessive and rapid yellowing it is not advisable to use oils. Few standard recipes for casein emulsions are to be found; the experimenter will find that some combinations will serve various purposes. Freshly applied films made with emulsion or other aqueous binders often have a deceptive temporary or false flexibility; the effect may be compared to a slice of fresh bread which has no real elasticity but which can be bent when fresh and will crumble and break when aged.

Damar Casein Emulsion. Dissolve 1½ ounces of casein or monoammonium caseinate, as previously described, in 10 fluid ounces of water. Stir in ¼ teaspoonful of sodium orthophenyl phenate (page 393) and pour in 1½ fluid ounces of heavy (8-pound) damar varnish. Emulsify thoroughly by vigorous stirring or with an electric mixer. When mixed with whiting and other pigments to a stiff putty consistency, this material has desirable properties as a plastic gesso for repairing paintings. When thinned by the addition of more water, the same formula can be used as a tempera medium in which to grind pigments. For the latter purpose the addition of a little glycerin will improve the paint's brushing qualities but will also make the resulting film more soluble.

Some painters report good results from the use of optimum quantities of linseed or stand oil combined with casein, both as a gesso and as a paint, and claim that if the proportion of oil is kept below a certain point, no yellowing will occur. The amounts of oil used in such cases would have to be so minute that it is doubtful whether they would have much plasticizing effect upon the product, although a small amount of oil might help to keep the liquid gesso in suspension so that it would settle less rapidly. I do not know of any accurate formulas for such combinations or of any tests of them over a period of years that have not shown a distinct and objectionable yellowing.

CASEIN AS AN ADHESIVE

Casein as an adhesive has many advantages over hide glues. It can be applied cold; glues require continuous heat in order to be held in a liquid

state. It dries to a more water-resistant mass; when treated with chemicals which harden or tan this mass, it is considerably more waterproof than glue hardened with similar chemicals. Formulas for introducing formalin, alum, and other hardeners into any adhesive must be delicately and accurately compounded or its usefulness is destroyed by changes in its colloidal properties; such materials are more easily combined with casein adhesives than with glues.

When a strong casein adhesive is required, the commercially prepared powders sold in packages, such as Casco glue, are recommended. These are carefully made, and include lime, sodium fluoride, and other materials which are necessary to produce a usable, water-resistant, and powerfully adhesive product. They are widely obtainable in hardware and other supply stores. Instructions on the package must be carefully observed.

The newer casein adhesives containing synthetic resins perform very efficiently, but in cases where the utmost in permanence is required, it may be wise to use the older material until such time as we have further data on the longevity of the synthetic resin adhesives.

CASEIN PAINTING

In the recent past, ready-made casein colors in tubes have become increasingly popular. Casein colors are quite versatile in their effects and applications, but there has been a tendency to stretch their uses beyond those for which they were designed. For example, it is not advisable to use them on canvas because this subjects them to too much flection; casein is the most inflexible or brittle of our permanent mediums. Canvas is a part of the more flexible oil-painting technique; it was developed for oil paints and nothing else. Rigid panels, boards, and (for thinly painted examples) heavy paper are the traditional supports for casein paintings.

Casein paints have a rather heavy, robust body, and in easel painting they are generally used on panels in what is called a "juicy" technique employing a moderate approach to impasto. They are also capable of being used in thin or smooth painting if preferred. However, they should never be piled up to a real impasto degree (as in palette-knife painting), or cracking may occur. If desired, the picture may be varnished with damar to simulate oil painting but one of its two major attractions to artists is its mat or semimat finish. The other major advantage of casein as compared with oil is its speed of drying.

A casein painting may also be glazed or overpainted with oils. Before oil colors or glazes are applied, its surface must be sized with a very thin size coating of much-diluted white shellac—at least 3 parts of alcohol

to 1 of shellac; limit the coating to single strokes and avoid the production of a glossy shellac film, in which case neither permanent adhesion nor satisfactory brush stroking would be assured. Unsized, the casein surface is generally too absorbent for free brush stroking in oil; working with it would be like attempting to paint on blotting paper.

Casein is a coarser, less sensitive medium than gouache, but a casein color can fill in for gouache when necessary. When greatly diluted with water it can even substitute for watercolor, but with a markedly lower degree of brilliance.

Of all the instructions given by specialists in the manipulation of tube casein paints there is one outstanding point that must be observed: use as much water as is consistent with the desired effects and always make sure that the brush is wet with water before dipping it into the paint. Most makes of tube colors probably contain glycerin and perhaps other modifying ingredients to enhance their performance, and they will neither perform well nor dry properly unless plenty of water and wet brushes are employed.

The remarks under *Fresh Paint* on pages 5–7 apply to casein paints as much as to any other medium.

Heavy bristle-brush or palette-knife impasto should be avoided; as previously noted, the dried casein paint layer, although proven to be permanent through the years, has often been known to crack badly when its naturally full-bodied and robust effects are overdone or exaggerated.

The natural surface effect of casein paints is almost a dead mat finish, but for uniformity, and to avoid spottiness, the paintings may be polished with a piece of absorbent cotton to produce a dull sheen. A well-painted casein picture on a strong panel does not require varnishing if a lusterless finish is desired, and it does not have to be framed under glass. It may be cleaned by careful picture-cleaners' techniques, using acetone as a solvent. Acetone, described in Chapter 10, "Solvents and Thinners," belongs to the same group of chemicals as formaldehyde, so that it should have a toughening or hardening effect on proteins rather than a destructive action. However, care must be taken with every picture-cleaning attempt, as noted in Chapter 14, "Conservation of Pictures," and casein paintings must be handled as cautiously as any others.

Varnishing a casein painting will bring out the full, rich depth or resonance of the colors, and at the same time make it resemble an oil painting to a greater or lesser degree, depending on how the paint was handled. Artists who want a medium capable of producing mat or lusterless effects are advised to use casein paints rather than to adopt any of the doubtful means used to create a mat effect with oil paints. On the other hand, artists who wish to make their casein paintings look

like oil paintings can apply a coat or two of damar or acrylic picture varnish in exactly the same way oil paintings are varnished. This is not so contradictory as it may seem at first glance because many artists want to use a paint that dries rapidly, and they like the handling and technical effects of a water medium, plus the deep-toned quality of an oil. In general, the type of picture we have come to describe as a "blond" is better served by a medium which dries to a dull or mat finish.

GLUES

Hide glue and gelatin are more completely discussed in connection with the preparation of gesso on pages 260–65, and also on pages 461 and 637.

All specialty hide or bone glues prepared for specific uses in the various industrial trades contain other materials added to impart various properties; the most common additions are glycerin, which imparts flexibility, and dextrin, which gives a solidity, body, or structural reinforcement to the gel, reduces shrinkage, and improves permanent adhesion.

White glue, sold in the form of opaque white chips or flakes, is simply glue which contains a white pigment such as whiting or zinc oxide; the latter is supposed to increase the adhesive strength of common bone glues.

Fish Glue. Fish glues are ordinarily sold in liquid form, and because they may be used full-strength cold, are often employed where the application of hot glue is impractical. They are mentioned by the earliest writers on technical subjects, but have always been considered less desirable from the point of view of durability and adhesiveness than the hide and bone glues. Few established techniques of the present day call for their use.

Isinglass is a superlative grade of fish glue made by washing and drying the inner layers of the sounds (swimming bladders) of fish. The best grade, Russian isinglass, is obtained from the sturgeon. It bears the same relation to fish glue that gelatin bears to common bone glue; it is a rather outmoded material and has few applications where gelatin cannot be substituted for it.

Parchment Glue. If one should have any reason to attempt the home manufacture of the traditional parchment glue, its preparation is quite simple, according to formulas from those of Cennini down to those of the industrial recipes of the mid-nineteenth century. Boil parchment scraps and clippings in water (1 gallon to each ounce of parchment) for four

hours. Do not allow the water to boil furiously, but keep it just at a boil. The resulting liquid may be dried to thin sheets in the same way commercially prepared glues are dried; when it has cooled and is beginning to thicken it is poured down the sides of metal plates or wire screens and allowed to dry in a free current of air. Formulas for the use of such home-made products must be worked out by the user.

PASTE

Common paste is made by mixing flour or starch smooth with a little water, then adding more water to make a thin milky consistency, and carefully heating with constant stirring until the batch thickens. Proportions vary, depending upon the nature of the material used; some starches thicken more readily than others. Prepared powders are sold in paint stores under various trade names at low cost for wallpaper use, and are to be preferred to ordinary flours for average purposes because they have been selected as the best materials for paste making. A widely used brand is Foxpaste; about 2½ ounces of this with a pint of water will make a very heavy paste. Follow instructions on the package. Such heavy-viscosity pastes do not require cooking; the powder is simply sifted into hot water gradually, with constant stirring.

For more exacting work, as in the mounting of valuable pictures on paper, the following paste is recommended by Plenderleith:[219]

BOOKBINDER'S PASTE

Wheat flour	500 grams (17½ ounces)*
Alum	7 grams (¼ ounce)
Water	2250 ml (4¾ pints)
Formalin	7 ml (¼ fluid ounce)

Mix the flour and a little of the water with the hands to a thick cream, add the alum, then stir in the rest of the water boiling hot. Heat in a double boiler; stir until thick.

Because of variations in the viscosity of pastes made from different flours and starches, and because of individual requirements, published recipes usually require a little adjustment.

Dextrin. Dextrin is manufactured from wheat starch and comes on the market in a number of grades from a pure white, odorless, tasteless

* Approximate equivalents.

product, to a brownish yellow powder with a sweetish taste. The usual commercial grade is canary or yellow dextrin and it finds many uses in industry where a cold adhesive is required, but only the white sort is recommended for paint-binder use. White library paste is often made from dextrin. Its property of drying to a comparatively glossy finish makes it of value in some paper-coating and water-varnish uses. It is employed in some commercial watercolors, and also in admixture with animal glues for special purposes. It is probably the chief binding ingredient in most of the "designers' colors." British gum is a common grade of dextrin.

GLYCERIN

Glycerin or glycerol is a heavy liquid that has oily properties but is miscible with water and alcohol. It is nonvolatile and permanent. The C.P. and U.S.P. grades, which are the only kinds for exacting use, are colorless, odorless, and have a sweetish taste. Glycerin is quite hygroscopic; this property, however, diminishes as it is mixed with other ingredients; for example, glycerin can be added to solutions of gums, etc., up to 20 percent without greatly increasing their tendency to absorb atmospheric moisture. Because of its combination of properties glycerin may be used as a plasticizer in aqueous mediums. Chemically, glycerin is neutral; it is classed as an alcohol. It is obtained from fats and oils as a by-product of soap and candle manufacture.

PRESERVATIVES

In order to prevent solutions of casein, gums, glues, etc., from decomposing on storage, minute amounts of certain materials that have the property of inhibiting the action are mixed with them. Decomposition may be caused by mold (see page 497), bacteria, or fermentation; preservatives that guard against one action will not necessarily be effective against another. A dried film of aqueous paint will resist the growth of mold if it contains a fungicide. For these purposes a preservative:

1. must be water-soluble,
2. must have no effect on the properties or color of the medium,
3. must be sufficiently powerful so that minute amounts will be effective,
4. should not be changed or destroyed by any subsequent treatment the medium undergoes,

5. should be safe, convenient, and unobjectionable to handle (some strong acids will attack grounds, pigments, etc.; some preservatives have a disagreeable odor),
6. should not be volatile. This is important when permanent protection of the film against mold is required.

The amounts of preservative required vary according to conditions; the proportions mentioned here have been adapted from the results of published researches and from manufacturers' recommendations; under adverse conditions they may not be sufficient. The minute quantities used in small-scale batches will have to be approximated. A preservative is not intended to prevent a material from decomposing or losing its desirable properties by chemical or physical action and has no power to check such failures as hardening, becoming rubbery, separation of components, etc., which are due to reactions between ingredients and not caused by organic growths.

Sodium orthophenyl phenate is an effective preservative for casein and gum solutions and meets all the above requirements. A widely distributed product is sold under the trade name Dowicide A. It is a light powder, the dust of which induces sneezing. About 0.5 to 1 percent of the casein or gum content of the solution is recommended; 1 percent may be approximated by using ⅛ to ¼ teaspoon to 2 ounces.

Beta naphthol is an efficient preservative for gums, also for casein; it has been recommended and used for a great many years. The powder is only slightly soluble in hot water, but sufficiently so to obtain the low concentrations required. Use 0.5 percent.

Moldex is a proprietary material recommended as a fungicide in aqueous paints. It is slightly soluble in boiling water; 0.01 percent of the total liquid is recommended.

Several inorganic salts are also used. The best of these are zinc chloride (0.3 to 0.5 percent) and magnesium silicofluoride (0.2 percent); these are especially effective for the prevention of mold on textiles, while sodium fluoride (1 percent) is especially effective for the types of mold that infest wood and cause dry rot.

Formaldehyde: As little as 0.5 percent of this will act as an effective fungicide; it will also inhibit growth of bacteria. Because of its reaction with proteins it is seldom used except in starch pastes, and because it is volatile it is not dependable as a permanent mold preventive for dry films. It is described on page 463.

Phenol (carbolic acid) has been accepted in the past as a more or less standard preservative, antiseptic, and germicide, but it has several disadvantages. It is volatile and has a powerful odor; it is customary in

industry to mask this by the addition of an odorant such as oil of sassafras or some other essential oil. Despite its disadvantages, it is still employed widely, especially with gum arabic solutions, because of its thoroughly known behavior. Owing to its powerfully corrosive action, it should be purchased in weak concentration, a 10-percent solution, for example, to be used for the average formula in the proportion of 1 percent of the total liquid (¼ teaspoonful to 4 fluid ounces).

WAXES

The vegetable and animal waxes belong chemically to the group of oils and fats discussed under *Drying Oils*, pages 120–30, and they enter into the same sort of chemical reactions. Paraffin and other mineral waxes bear the same relation to them as the mineral oils bear to the drying oils; they resemble them in superficial properties, have some similar physical or technical uses, but are in a class apart in their chemical behaviors. When the unqualified term "wax" is used in descriptions of processes or recipes for artists' materials, white refined beeswax is always meant. All waxes melt below the boiling point of water, and can be melted in a water bath.

The temperatures quoted as melting points are taken from several laboratory sources; the range of several degrees is due not only to the variation in raw materials but also to the method used and the conception of which is the exact melting point. There is always some range between the point where solid wax begins to melt and the point where molten wax begins to solidify. Waxes are saponified (made into soap by alkalis) the same as are oils, fats, and resins.

Beeswax: Beeswax may be purchased in two varieties: the virgin, or natural brownish yellow material, which is melted down from honeycombs; and the white product, the best grade of which is carefully separated from all traces of honey and other impurities and bleached by exposure in thin pieces to the sun. The white is usually a trifle harder than the yellow. White wax is recommended for most purposes requiring care, especially when color of the product is an important consideration. When it must be melted, care should be taken to avoid overheating or frying; otherwise it may turn dark brown, as butter does. Beeswax melts at 63°–66° C. Beeswax is the principal wax used in recipes for artists' materials. Other commercially available waxes which find occasional uses may be briefly mentioned as follows:

Carnauba wax: melting range 83°–86° C. Obtained from the leaves of

a Brazilian palm. Carnauba is the hardest of the waxes, useful for imparting hardness and durability to wax mixtures. It is sold in several grades from a creamy yellowish white to a tannish brown color.

Candelilla wax: melting range 67°–71° C. Obtained from a weed native to Texas and Mexico. It has a brownish color, is next in hardness to carnauba, and finds a use in industry as a cheaper substitute for it.

Chinese insect wax: melting range 79°–83° C. This wax is produced by insects in much the same way as shellac, but with an amazing assist from humans. The insects are cultivated on trees in Yunan province, China, and at the proper moment in their development, the eggs are packed in small bundles and are carried by swift runners who travel, during the cool nights, several hundred miles to Szechwan province where they are placed on trees of a different species to complete their life cycle. The product is a fairly hard yellowish white wax used for general purposes in China and Japan; a rather good substitute for beeswax.

Japan wax: a faintly yellowish, rather soft wax with an adhesive or sticky feel, obtained from several species of sumac grown in China and India. Lacquer is obtained from these trees, and the wax is a by-product. Melts at 50°–52° C, but when recently solidified may have an erratically lower melting point for some time.

Spermaceti: obtained from the head cavities of the sperm whale; it is clean, white, translucent, crystalline, and brittle and has a melting range of 41°–44° C. A rather outmoded material in the arts.

Paraffin wax: a refined petroleum product. It is more inert than the animal or vegetable waxes and is unaffected (not saponified) by alkalis. It is sold in a number of grades with melting points ranging from about 50° to 60° C. *Microcrystalline wax* is a special type of paraffin wax sometimes called for in small amounts in recipes as a plasticizer.

Montan wax; ozokerite: so-called mineral waxes, obtained from crude bitumens which occur in various localities. They are usually black or very dark brown.

Ceresin: refined from ozokerite. It is a pure white or yellowish product, something on the order of paraffin wax, but its higher melting point and superior properties cause it to be used as a substitute for beeswax in many applications. Different varieties melt at 61° to 80° C. Some grades are mixtures with paraffin wax.

Stearic acid: refined from animal fats. It is an inexpensive, white, waxy material, easily saponified. Used in a number of industrial products, such as candles, cosmetics, etc. Melting range, 69–71° C.

Punic wax: Pliny and Dioscorides refer to a wax preparation used by painters, and although their descriptions of its preparation are rather

complete, there has been much discussion over its nature and the actual extent and purpose of its application to painting. It was made by exposing yellow beeswax to the air for some time, then cooking it with repeated boilings and additions of sea water and potassium carbonate. The foamy mass was then poured into cold water, and afterward exposed in a basket to the bleaching action of sunlight. Berger's[32] recipe for duplicating Punic wax employs bleached white wax, which should make the sun and sea-water treatment superfluous. One hundred grams of white wax are cooked with 10 grams of potassium carbonate until all the wax goes into solution. The mixture is stirred continuously during cooling, after which it may be thinned to a salve consistency. This soap is supposed to be mixed with pigments and used as a painting medium. According to Laurie,[39] Berger was in error, and the conditions under which the orig-inal product was made did not saponify the wax but merely bleached and refined it. If this is true, Punic wax was merely white refined bees-wax; most modern investigators concur in this opinion. If a saponified wax is required, the wax soap described under *Wax Emulsions* on page 230 is less objectionable material than that made by the above pro-cedure; it is likely to be less hard, which is an advantage in our cold climate.

Most waxes do not dissolve to clear solutions in the volatile solvents, but when the molten wax is thinned with sufficient solvent they will form cloudy liquids or pastes. Carbon tetrachloride is considered the best sol-vent for beeswax.

Waxes have the greatest degree of impermeability to atmospheric moisture of any of our protective materials. Next comes resins, then oils. Waxes have therefore been recommended as final coatings for oil and varnish surfaces, although their resistance to other mechanical forces is less than that of resins or oils.

Heaton[58] recommends the application of wax to tempera murals as giving permanent protection and producing the type of finish that does not easily attract or hold dirt. He describes successfully applying to a mural a solution of 1 ounce of white ceresin in 4 ounces of toluol, by spreading it thinly over the painting with a brush. After the solvent has evaporated, the white, crystalline wax obscures the picture. The face of the picture is then gone over with a suitable heating apparatus, arranged so that it is kept at a uniform distance from the wall, whereupon the ap-pearance of the picture is returned to normal, the wax coating having no optical effect upon it. The mat varnishes made with beeswax, as men-tioned on pages 197–98, will give similar results.

Encaustic or hot wax painting is discussed in Chapter 8.

SOME MISCELLANEOUS OILS

Castor Oil. Castor oil is obtained from the seeds of *Ricinus communis,* a plant which grows wild or is cultivated in many tropical and semitropical regions. Besides having its familiar use in medicine, it is widely employed as a lubricant and as a raw material in a number of technical processes. It is obtainable in several highly refined grades for technical use such as "A.A.," "Crystal," "C.P.," and others. The unique property which distinguishes castor oil from the other vegetable oils is its complete solubility in ordinary alcohol; it also mixes with all vegetable oils, turpentine, and most other solvents.

Castor oil is nondrying, but lacquers, shellac, and other rapidly or strongly drying compounds will carry various proportions of castor oil along with them, generally to the increase of flexibility of the film. Its solubility in alcohol has caused it to be recommended for use in the removal of varnish films from paintings (page 511), and it has been utilized industrially as a plasticizer for cellulose lacquers, shellac, and other coating materials (page 129).

Mineral Oils. The heavier portions of some crude petroleums, after the light or volatile ingredients such as gasoline, mineral spirits, and kerosene have been distilled off, are refined further to produce a great variety of heavy oils for lubricating and other purposes. These materials are not only nondriers, but they are chemically and molecularly different from the vegetable oils and cannot be used in conjunction with any of our accepted painting processes. Because they are called for in certain recipes for such products as polishes, plastic compounds, etc., and are in rather common technical use, a few of the more refined grades may be listed here.

Ordinary refined paraffin oil is sold in several grades, more or less strongly colored, brown or brownish yellow with a very pronounced bluish bloom. These grades are used in the more common floor polishes.

Debloomed paraffin oil has a pale golden color, very slight or no bloom, and is used in higher-grade polishes and household lubricating oils, which are usually perfumed with essential oils such as oils of lemon, citronella, or cedar wood. The most widely available brand is White Rose Oil.

White mineral oil is supplied to industry for use in cosmetics, medicine, etc., in a variety of grades from a thin-flowing oil to a very heavy one. A widely available and uniform brand is Nujol, which is used medicinally. Because of its accurate uniformity and wide retail availability it has become a standard laboratory material.

Petrolatum (Vaseline) and paraffin wax belong to this same family and have only superficial physical properties in common with vegetable and animal oils, fats, and waxes. They are inert to most chemical reactions.

The Essential Oils. The essential oils may be briefly described as the odorous or perfume-bearing liquids extracted from flowers, leaves, woods, and other vegetable sources as well as from some animal sources. They are not oils in the same sense as is linseed oil or mineral oil. The essential oils are of little importance in the consideration of painting materials, but a few of them are mentioned in antiquated recipes. One is oil of cloves, which is a weak preservative whose function is partially the masking of the odor of decomposition; oil of cedar and oil of lavender, aside from the usefulness of their odors, which disguise more objectionable smells, have a definite effect on the physical properties of spirit varnishes and retard the drying of paints. Oils of sassafras, wintergreen, citronella, and lemon, as well as some of the more expensive flower essences, are often used as odorants in various technical compounds. Through long usage and tradition they have become identified with cleanliness and simple, utilitarian purposes and have in the past been deemed preferable to the cloying flowery or spicy perfumes for masking objectionable smells and controlling the uniformity of paint products.

Oil of Spike or Spike Lavender. This material is not to be confused with the true or odorous oil of lavender (*oleum lavandulae*), a flower essence used in perfumery. Oil of spike is distilled from a broad-leafed variety of lavender, *Lavandula spica,* which grows wild in Europe and is extensively cultivated in Spain. It was first produced in the sixteenth century, about when turpentine was introduced, and for some time was rather more widely employed, perhaps because it was more conveniently available. Its large-scale use became obsolete with the commercial production and distribution of American turpentine. Its properties and chemical characteristics are similar to those of turpentine; it has considerably more tendency to gum or oxidize when exposed to air. Because it has a slower rate of evaporation, it has been recommended for use in varnishes in order to improve the leveling or flowing out of brush marks. Most painters have rejected it in favor of turpentine.

Older books sometimes recommend the use of the true or fragrant oil of lavender for the above purposes; also the use of oil of cloves and oil of rosemary for their leveling properties; and oil of cloves for its extremely slow drying rate, which will retard the setting of oil paint. Except for the continued use of oil of cloves by artists, none of these essential oils is at

present employed in paints to any extent. The modern lacquer diluents serve these purposes in industrial use, as mentioned on page 375. Some such additions are quite effective; others, based upon theoretical grounds, may prove less successful in practice. Modern creative painting techniques in general are more concerned with the acceleration than with the retarding of drying. Retarding the drying of oil paints is discussed on pages 159–60.

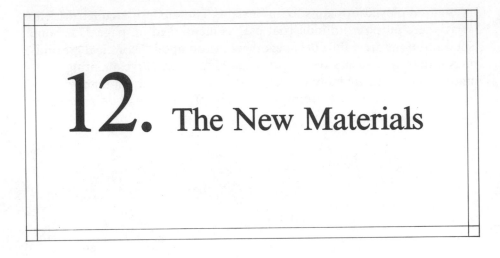

12. The New Materials

D URING THE DEVELOPMENT of Western art over the centuries, the adoption of new artists' materials from time to time followed a definite pattern. No movements or schools of art began as a result of the discovery of new materials or inventions of new techniques. Rather, when new ideas and aesthetic departures arose, they created a demand for new technical methods that could express them in a more appropriate and fluent manner than was possible with the older methods. The pure egg tempera technique, for example, served painters from Giotto to Botticelli; it was ideally suited to the kind of pictures they wanted to paint. With the advent of new forms and new aesthetic and pictorial objectives, some painters began to modify their tempera by adding an oily ingredient (see page 19), thus creating effects that cannot be duplicated by using straight egg tempera. At the same time or later, others overpainted their tempera paintings with oil and varnish glazes, especially the fifteenth-century Flemish painters. With the wider use of linseed oil, oil varnishes, and volatile solvents, and the further development in art forms that required a new kind of technique, straight oil painting was adopted. The entire development from tempera to oil paintings in Venice can be followed in the long life of one artist, Giovanni Bellini, who painted his earliest works in pure egg tempera, after which he turned to intermediate tempera techniques, both the oily ingredient and the glazed type, and finally to a technique that closely approaches the effects of straight oil painting.

None of these new materials were invented for these purposes. They were already widely known for their uses in other fields. Linseed oil, for example—its several methods of refinement and its use as a paint vehicle—was well known as a decorative and protective material at least as early as the fourteenth century.

Many painters are now working in styles that are far removed from those of the past or under circumstances radically different from those that formerly prevailed, and to meet their new requirements they have sought new materials from the number of industrial coating materials based on synthetic resins.

The world of creative painting has been fragmented into many schools and groups. I would venture to say that at no previous period have so many different styles and schools of artistic thought flourished, each actively engaged in turning out works of art, and each with its appreciative audience. Nearly every kind of painting and sculpture of the past has either been continued or resuscitated from its limbo. Also, over the years, many new effects have been discovered that use the traditional means. But the center of the stage has been taken by several movements that have developed since the early decades of the twentieth century. Unlike the earlier innovations that took place within the broad tradition, they are revolutionary, embracing ideas beyond the horizons of what past generations envisaged. It is quite understandable that new effects are being used to meet newer requirements which the traditional methods fall short of satisfying, and that these new effects are already quite well established.

ARTISTS' COLORS BASED ON SYNTHETIC RESINS

The following materials are the principal artists' mediums that have been developed in the mid-twentieth century. Their criteria of excellence are taken directly from the performance of similar products in the industrial coating-material field. So far, our knowledge of their ultimate value in fine-arts painting is somewhat limited because we have no long-term experience to guide us in the best ways to apply them or in the many details of composition and manipulation that ordinarily accumulate over the years of experience. After a decade of use, however, they have lived up to their technical expectations, and no serious technical faults have developed.

POLYMER COLORS

The most widely used artists' colors based on synthetic resins are the so-called polymer colors, made by dispersing pigment in an acrylic emulsion. (See page 192.) These colors are thinned with water, but when they dry, the resin particles coalesce to form a tough, flexible film that is impervious to water.

The polymer colors have a number of excellent qualities for which they have become popular. When they dry, they lose their solubility very rapidly. They may be made uniformly mat, semimat, or glossy by mixing them with the appropriate mediums. They are nontoxic, and because their thinning solvent is water, they may be used by persons who are sensitive or allergic to the volatile solvents.

The name "polymer colors" has been adopted by general agreement. Although it is not specifically descriptive (since virtually every film-former is a polymer of some sort), it serves well to distinguish them from other paints made from synthetic resins, and it also replaces such loose terms as "the acrylics" or "plastic paints." Polymer colors are extremely versatile in imitating or approximating all the effects of the traditional water media. They are the first paints since oil colors that are sufficiently flexible to be used on canvas. With no other medium can a full-bodied, freely stroked or "juicy" effect be obtained with such dispatch. But polymer colors are not a complete substitute for oil paints, and artists whose styles require the special manipulative properties of oil colors, including finesse and delicacy in handling, smoothly blended or gradated tones, or control in the play of opacities and transparencies, find that these possibilities are the exclusive properties of oil colors. The polymer colors, however, are a boon to those painters to whom a high rate of production is important. A painting that might have taken days to accomplish in oil because of the necessity of waiting for layers of paint to dry can be completed in one session. The pigments are identical to those used in oil, except that the only white is titanium. An occasional pigment that works well in oil and watercolor is not compatible with the usually alkaline nature of the polymer medium, and so will not be found in the polymer palette. The medium confers on the pigments a definitely more brilliant or vivid quality than they exhibit in oil paint. They are sold both in tubes and in jars. The colors in the jars are usually a bit more fluid than the tubed kind. Polymer paint films have extraordinary flexibility, an almost rubbery elasticity, which they retain without appreciable embrittlement for a long period of time during the same period of aging in which an oil-paint film would lose a measurable degree of its flexibility. For this reason it is unwise to paint over a polymer ground or a polymer under-

painting with oil colors, for then the rule of "fat over lean" (see pages 161–62) would be violated. We know that oil-paint films will lose some of their flexibility on aging; we know polymer colors will remain flexible for a much longer time (how much longer time is still unknown), and such reversal of good practice is quite likely to lead to eventual cracking.

Painting with polymer colors over oil would seem to be a better procedure, and so it would be, except for the very poor permanence of adhesion between the two pigmented layers. It has been recommended that an oil canvas or oil underpainting be roughened, to enhance the permanence of adhesion, by rubbing it carefully with extra-fine sandpaper or steel wool before applying polymer colors, but the best procedure is to use polymer canvas or polymer primer (polymer gesso) and avoid combining the two entirely. Although the straight polymer medium has the same excellent adhesive properties as the milky-white synthetic glues sold as general adhesives, the pigmented paint film does not have outstanding permanence of adhesion to oil-paint surfaces.

Although all the brands of acrylic polymer colors are made from the same emulsion-polymerized acrylic resin (Rhoplex AC234), their manufacturers use a variety of additives to enhance their working properties and stability, and for this reason not all the colors of different makes can be intermixed freely without curdling of the vehicle. However, a simple test will determine which colors will mix with one another: thin each of the two colors with about an equal volume of water and mingle them with a clean brush on a strip of glass. Close examination while the colors are still wet, by both direct and transmitted light, will disclose any tendency to curdle.

Techniques. The principal difference between handling polymer colors and handling watercolor or gouache is due to the very rapid loss of solubility of polymer colors after application; in this respect they resemble tempera and casein colors. The great difference between the way they handle as compared to oil colors is simply due to the fact that they are water-miscible paints and therefore share the manipulative qualities and the advantages and shortcomings of aqueous media rather than those of oil paints.

Polymer color dries rapidly to an insoluble film which can be dissolved from palette and brushes only with powerful liquids of the lacquer-solvent type. To avoid such difficulties, the painter rests his brushes in a jar or can of water while painting, to keep them from drying, and he uses a plate glass table-top palette which is readily cleaned by scraping with a razor blade.

Other Polymer Materials. In addition to a complete line of colors, the following adjuncts are usually included in each manufacturer's line.

Polymer primer (also called polymer gesso) is made of titanium white and perhaps inert pigment, dispersed in the same polymer vehicle as is contained in the colors, but compounded to a stiffer consistency; the primer is used to prepare painting grounds on panels or raw linen. It is sold in round flat cans with broad replaceable caps. Some confusion has resulted from the unfortunate habit American manufacturers have of labeling polymer primer "gesso" in large type, for it is not really gesso at all and will not serve all the purposes of that material, being completely nonabsorbent, whereas true gesso has full absorbency, a property that is essential for tempera painting, water gilding, and other uses. Gesso has been a specific term for glue-chalk mixtures for more than five centuries, and it continues to be so used. The fine print over the word "gesso" on the label actually makes it read "polymer gesso" or "——— brand gesso"; nevertheless, the confusion persists.

Polymer mediums: two milky-white fluids sold in bottles, regular and mat. The regular or gloss type is identical with the vehicle used in the colors; it is added to the color when it is desired to maintain strength and uniform gloss as it is thinned with water. The mat type is used to create a dull finish and is also useful as a final or protective coating when a dull or reduced gloss effect is wanted. In general, in order to ensure a uniform finish, it is advisable to use the mat type only in final overpainting rather than in underpaintings, because spotty effects are sometimes produced when a clear or unpigmented coating is applied over a surface that has some areas in which the dull medium was used. The dull effect is produced by the addition of a flatting agent, usually an inert pigment of the diatomaceous type, such as Celite.

Modeling paste: This is a stiffer version of the primer or polymer, used to build up underpainting textures and to model in relief.

The *gel mediums* sold with the polymer are similar in function to the gels used in oil painting. They give the colors a transparent quality, and they give bulk to the colors in impasto palette-knife and brush painting. Being entirely compatible with the composition of the colors, they are not believed to have any of the faults that accompany some of the oil-painting gels.

A *retarder* to delay the initial quick-setting property of the colors is available in some of the lines of polymer colors. It is intended to facilitate the fusion of tones, and to enhance the working quality of the paints in situations in which they dry too rapidly—outdoors, for example.

The *ground:* Masonite panels and raw linen may be coated with the

polymer primer described above. This material, as well as the stiffer modeling paste, makes an excellent ground, and the colors adhere securely to it. Acrylic canvas, coated with similar materials, is now available at the supply stores. For reasons stated above, oil-primed canvas is not recommended for use with polymer colors. Polymer colors take well on almost every kind of paper, on real gesso, on plaster walls, and on wood sized with diluted polymer medium. An application of glue sizing before coating with primer is not considered necessary; indeed, most specialists believe it to be harmful.

Special Effects in Polymer Painting. 1. A polymer painting done with the straight tube or jar colors or either type thinned with water will dry to a semigloss finish, depending on the amount of thinning and the degree of absorbency of its ground. Uniformity of either mat or gloss finish is obtained by mixing either the mat or the regular medium into the colors. To approximate the surface effect of oil colors, especially when using fully charged bristle brushes in impasto brush stroking, an admixture of gel medium is recommended.

2. Watercolor. The paints are simply thinned with water and used in the same manner and with the same manipulations as are watercolors. The result is a good approximation of watercolor rather than an exact duplication of its effects, for the full brilliance and sparkle of transparent watercolor on handmade rag paper are never quite duplicated. Quite a good imitation of the runny or spreading effect of a wet-into-wet technique of painting on wet paper can be obtained by going over the colors immediately with a brushful of clear water.

3. Gouache and casein color can be very closely matched with the straight colors, and, when the diluted colors are used on real gesso, they can function in the tempera technique.

Because of their recent introduction, we have few rules for the application of polymer colors to secure the most permanent results other than those just mentioned.

STRAIGHT ACRYLIC COLORS

Quick-drying artists' colors may be made by dispersing artists' permanent pigments in a solution of methyl methacrylate resin in mineral spirits. The colors dry to a dead mat finish, can be diluted with mineral spirits or turpentine for smooth, thin painting, or used undiluted for more robust effects. Because of their quick drying due to rapid evaporation of the

solvent, they are not too convenient for outdoor use, but artists find them highly suitable for many types of work. Because they are based on a nonyellowing vehicle, conservators have found them useful for inpainting.

As is true of the clear acrylic picture varnish noted on page 173, the acrylic colors are so freely soluble in mild solvents that they cannot be overpainted without the underpainting's being picked up. This drawback is easily overcome by spraying on a thin coat of an isolating varnish that is sold with the colors (see page 174); this dries in a few minutes, after which painting may be resumed.

Some writers refer to acrylic colors as oil-miscible, but a coating-materials technologist would not agree with this statement; the longevity of a coating that contains a drying oil and an acrylic resin is questionable.

In the absence of any evidence, there does not seem to be any technical disadvantage in using acrylic colors with polymer colors in the same painting, or in using them over an oil painting or an oil canvas. But according to the law of fat over lean (see page 157) it would not seem advisable to paint over them with oil colors or glazes.

TOXICITY OF ARTISTS' MATERIALS

One of the requirements for a material that can be used by painters, sculptors, and printmakers is that its regular use under studio conditions should not be injurious to health. Traditionally, two kinds of toxic materials are recognized: (1) those that are potentially toxic but can be handled in safety provided the appropriate precautions are taken, and (2) materials of such high toxicity that they are best avoided. An example of the first is flake white (basic carbonate white lead), which has been manufactured for more than 2000 years and for about 500 years was the only opaque white oil color available to artists. The artist who wants to take advantage of its unsurpassed properties can handle it with safety, as have countless generations of painters, by following two simple rules: (1) buy it only in oil-paint or oil-color form and never handle the dry pigment or employ it for any purpose; (2) after using flake white, clean the hands and fingernails thoroughly before touching food. It is not used in water media or in children's paints. (See pages 72, 104.) Naples yellow is the only other lead pigment among the approved artists' colors, and its use requires the same precautions. Examples of the kind of toxic materials whose use is risky are emerald green and the grade of cobalt violet that contains arsenic, and their use should be avoided. The toxicity of cad-

mium yellow, which has almost no significance to the painter, has been exaggerated, and the use of it should be governed by the same sensible precautions as in the handling of flake white. Regulations that require a bold-type poison label on a color that contains toxic pigments are in effect in some local areas. They are intended to guard against accidental poisonings resulting from the easy access to such materials by inexperienced persons and children.

Perhaps the most hazardous materials encountered by painters and sculptors in recent years can be found among the large list of volatile solvents. This applies especially to the use of industrial products based on synthetic resins, and to the raw materials that are ingredients of such products, which have sometimes been used by artists in experiments to obtain novel effects that cannot be obtained by using ready-made or traditional artists' materials, or for the sake of economy, as has been noted on page 189.

Strictly speaking, all of the volatile solvents are toxic. Even the least harmful of them could cause physical disorders if improperly handled—for example, if used for a long time in closely shut or badly ventilated rooms. A federal law requires a poison warning on such a relatively harmless material as turpentine, for the reasons noted above.

The American Medical Association studies the effects of the volatile solvents in industrial use and maintains periodically revised tables and data* in which the various solvents used in industry are rated on a scale of Threshold Limit Values (TLV); these indicate the maximum concen tration of solvent vapors that can be tolerated during an eight-hour day with no ill effects, expressed in parts per million of air. The estimate is based on intermittent use and includes average rest periods. Acetone and ethyl alcohol head the list, each with a TLV of 1000. Turpentine and mineral spirits are far down on the list, but because of their low volatility they do not approach their limits and so are completely safe in studio use.

The solvents designated toxic in Chapter 10 can be handled in operations that require a great deal of time only where there is provision for the removal of vapors by forced ventilation or when pressure masks that operate with compressed air are used. When handling plastics such as epoxy and polyester resins, protective gloves must be used to prevent contact with the hardeners they contain. None of the actual resins are particularly toxic or irritant. Rather, the dangers lie in the solvents and hardeners, which are necessary to make the resins perform properly. The vapors of the solvent MEK (methyl ethyl ketone) are particularly harmful.

* *Annals of Environmental Medicine.* Threshold Limit Values.

The polyesters and the epoxys appear to present the greatest hazards, for all their additives have harmful effects. A number of serious disabilities have been reported in recent years.*

One more aspect of toxicity in artists' materials may also be taken into consideration: the question of what materials should be used by amateur, part-time, or hobby painters and in children's art classes. The statements in this book are addressed to those who are professional users of artists' materials in fine-art creative painting and in illustration or commercial work, all of whom are expected to handle their materials in a rational manner. For the protection of untrained and inexperienced persons who use artists' materials, it is reasonable to agree that special practices be adopted. The United States government, besides the mandatory poison labels noted above, maintains a standard of specifications that controls the ingredients that go into school supplies. The American Medical Association is concerned about the matter,† and its own members who paint are kept advised of health hazards. Danger is lessened when art-material firms omit potentially toxic pigments from their common grades, supplying them only in the more expensive top lines, which the nonprofessional is not likely to buy.

SYNTHETIC ORGANIC PIGMENTS

The synthetic organic pigments are discussed in Chapter 2 and on page 454. Since before the mid-twentieth century, when no more than three of them were approved for use in permanent, creative painting, the artist's palette has been enriched by a number of brilliant pigments of high intensity. Their remarkable resistance to fading under long exposure approaches that of the standard inorganic pigments. In his technical appendix to Woody's book[98] on synthetic media, Henry Levison calls the present "a new era" of pigments, because many of the older rules and the statements in older books are no longer applicable. Under *Permanence of Pigments* (page 99), I noted that when bright reds of improved permanence became available during the early years of the twentieth century, several premature adoptions were made that later proved disappointing. In the 1920s, the artist was taught to limit his palette strictly to the permanent inorganic pigments plus alizarin crimson. Because the other synthetic

* Mallary, Robert. "The Air of Art Is Poisoned." *Artnews,* October 1963.
† Siedlecki, James T. "Potential Health Hazards of Materials Used by Artists and Scluptors." *Journal of the American Medical Association,* June 24, 1968; also McCann, Michael. *Artist Beware: The Hazards and Precautions of Working with Art and Craft Materials.* New York, Watson-Guptill, 1979.

pigments used in industrial paints, printing inks, and plastics were not sufficiently lightfast for artists' colors, it was common practice to discourage their use by referring to them by the disparaging terms "coaltar colors" and "aniline colors." As recently as the year 1950 alizarin crimson, phthalocyanine blue, and phthalocyanine green were the only three synthetic organic pigments universally approved for artists' use.

Artists have become accustomed to keying their paintings within the limits of the permanent palette, depicting their brilliant effects with the cleaner and more brilliant pigments in contrast with duller and more earthy pigments. In traditional painting there were few demands for pigments more brilliant than those that were in use.

Commercial artists, illustrators, and others who work for reproduction, where survival of the original work is not an important matter, have long had brilliant colors such as geranium red and peacock blue at their disposal, and if these were envied for use in easel painting, artists who had regard for the permanence of their work had to learn to do without them. But ever since the early days of painting, artists and color men strove to develop new and better pigments, and there is no reason why new "superbrilliant," intense colors should not continue to be developed and made available.

Most if not all the modern synthetic organic pigments are transparent. Nevertheless, though they are not opaque in the usual sense of that term, when they are used full-strength their extreme intensity makes them perform as opaque or hiding pigments. In mixtures with white and other pigments their transparency causes them to yield pure, clean tints.

The following is a selected list of the synthetic organic pigments that have the highest degree of resistance to fading as determined by industrial pigment and coating-materials technicians, who expose them, dispersed in various paint vehicles, to direct outdoor Florida sunlight for long periods of time. In addition to these pigments, there are a number of others of outstanding resistance to fading only slightly inferior to those listed here. These too may be eventually found suitable for artists' use, as will others yet to be discovered. It should be pointed out that alizarin crimson, which has been on the approved list for permanent painting for almost a century, is not nearly as fade-resistant as these pigments. It seems likely, therefore, that after more thorough investigation of their fade-resistance and their pigment properties, more new pigments for use in indoor easel painting will be included in the Paint Standard.

Because the same name may be used for two or more variants or types and because of the differences in quality between closely similar variants, the number of each pigment that is listed in the Color Index[159] is noted as a positive identification.

Acridone Red C.I. 6800
Acrylamide Maroon Medium
Acylamino Yellow C.I. 65049
Anthrapyrimidine Yellow C.I. 68420
Brominated Anthanthrone Orange C.I. 59300
Carbazole Dioxazine Purple C.I. 51319
Flavanthrone Yellow C.I. 70600
Green Gold (Nickel-Azo Yellow) C.I. 2775
Hansa Yellow 10-G C.I. 11710
Indanthrone Blue, reddish shade C.I. 69825
Indanthrone Blue, greenish shade C.I. 69810
Iso Violanthrone Violet C.I. 60010
Parachlornitraniline Red C.I. 12085
Permanent Carmine C.I. 12370
Permanent Red 7GR C.I. 12370
Permanent Yellow HR C.I. 21108
Perylene Maroon C.I. 71130
Perylene Scarlet C.I. 71140
Phthalocyanine Blue C.I. 74160
Phthalocyanine Green C.I. 74260
Pigment Green C.I. 10006
Pyranthrone Red C.I. 59710
Quinacridone Red, yellowish (scarlet)
Quinacridone Red, bluish; Quinacridone Magenta;
 Quinacridone Violet
Red Lake R (copper complex) C.I. 15585
Thio Indigo Red-Violet B
Vat Orange GR C.I. 71105

All these pigments are vivid, intense, and attractive. Various specialists have recommended over forty synthetic organic pigments as acceptable for artists' colors, but this list is confined to those of the very highest or most outstanding resistance to fading. Most of them are presently being used by manufacturers of artists' colors.

Some artists'-material manufacturers continue the antiquated and confusing practice of labeling the newer colors with proprietary names, perhaps because they do not trust the intelligence of the consumer to recognize a name of more than two syllables. If a pigment so labeled does not bear identification in small type elsewhere on the label, one has a right to suspect that it may contain an inferior pigment. Obviously, no one wants unnecessary pigments or needs pigments whose color properties are already represented by satisfactory and economically advantageous pigments; some of the newer colors may perhaps never come into artists' use for these reasons.

Quinacridone red, yellowish, sometimes referred to as the scarlet type, is among the most fade-resistant of the synthetic organic pigments, being approximately the equal of the phthalocyanines in this respect. The other quinacridones, though sufficiently lightfast to qualify among this group, are less outstanding. The quinacridones were first made in the laboratory in the 1930s in Germany and were developed practically by E. I. DuPont de Nemours Company in the 1950s. Note that quinacridone was suggested by the Paint Standard in 1962.

Phthalocyanine blue and phthalocyanine green are the most remarkably permanent of all organic pigments. Their performance is not far below that of the absolutely permanent inorganic pigments.

Thio indigo red-violet B is definitely superior in fade-resistance to the other thio indigo pigments. The pigments whose names contain indigo or a part of the word are related chemically to natural indigo.

Green gold is semiopaque. Its mass tone is green, its undertone greenish yellow. It produces particularly brilliant greens with phthalocyanine blue. Another name for it is nickle azo yellow.

SOME CATEGORIES OF SYNTHETIC DYESTUFFS

Triphenylmethane Group. 1. Basic group. Brilliant, clear, powerful dyes from which pigments are made by precipitation with acids. Developed during the second half of the nineteenth century, the basic dyes are among the most well known and widely used, but they are far too fugitive to be used for artists' colors. Examples are malachite green, magenta (fuchsine), and methyl violet.

2. Acid group. Related to the basic group and sharing their lack of permanence, each contains two or more sulphonic groups. Examples are eosine, fluorescine, peacock blue. The basic and acid groups of dyes are the common brilliant colors from which most of the old-fashioned impermanent synthetic organic lakes were made by precipitation on inert bases.

Azo Pigments. An important group of pigments that contain the azo group ($-N = N-$) made by the diazo reaction coupling a diazonium salt with a phenol or basic intermediate. There are two types: the insoluble, which are used directly as pigments, of which paranitraniline reds and toluidine reds are examples; and the soluble, which are precipitated with acids. An example is lithol red. In the quite recent past, the main azo pigments usually encountered were paratoluidine, and lithol reds, used in large amounts for printing inks and industrial paints; today some of the azo pigments, such as Hansa yellow, are among our most permanent pigments.

Anthraquinone Pigments. A small group made from the intermediate anthraquinone, derived from the raw material anthracene. The chief example is alizarin crimson—dihydroxy anthraquinone.

Vat Pigments. Another class of pigments, made from anthraquinone by sulphonation. The term comes from the fact that these dyes are insoluble but can be used for dyeing textiles by treating them chemically in the vat, where the color develops within the textile fibers. As pigments, they are precipitated or developed on an inert base. Examples are the perylenes, iso violanthrones, and indanthrones. The pigments whose names are based on the word "indigo" are sometimes classified as the indigo group, for they are chemically related to the natural dyestuff indigo and contain the same chromophore group (see below).

The phthalocyanines and the quinacridones are in categories by themselves.

Phospho-tungstic and Phospho-molybdic Colors. Pigments so designated are made by a process developed during the 1920s and 1930s whereby pigments made from the basic dyestuffs (see above) are made very much more permanent and lightfast by being precipitated with complex mixtures of phosphates, tungstates, or molybdates and strong mineral acid. The resulting improvement in permanence has made these brilliant colors suitable for a greatly enlarged number of industrial purposes and some of them have been tried as artists' colors. They are sufficiently lightfast to be used for some industrial purposes but not for those that require continual exposure to sunlight; their use in creative painting is unwise.

Correlation of Color and Structure. Pigments, as noted on page 112, owe their colors to the kind and proportions of various wave lengths that they reflect or absorb. Intensive research on the relationship between the color of a dye or pigment and its molecular structure and crystalline state has been conducted for a century and is still going on. Many theories have been proposed over the years; a basic one, advanced by O. N. Witt in 1876, holds that certain groups or arrangements of atoms within the pigment molecule control the color effect; these groups are called chromophores. Various other groups, called auxochromes, improve the coloring properties. This topic can be studied in the books on the subject, notably Fieser and Fieser.[161]

LUMINESCENT PIGMENTS

Paints may be made of several different pigments that have the property of emitting a glowing or luminescent effect under various conditions. These are the glow-in-the-dark type, or luminous paints; the fluorescent paints that require excitation by ultraviolet or "black light" to produce the glowing effect; and daylight fluorescent pigments. None of these materials is suitable for permanent fine-arts use: they are described here because they are sometimes useful for decorative purposes.

Luminous paint (phosphorescent paint) contains a pigment that has the ability to store light when exposed to a strong light source for a length of time, emitting it as a greenish or bluish glow, or luminescence, when it is placed in the dark. Luminous pigments are known as phosphors. They are usually zinc or calcium sulphides made by a special furnace process that incorporates minute amounts of other mineral compounds that produce the luminous effect. Luminous paint may be used for such purposes as signs that glow in the dark, and the pigments may also be incorporated in plastic. Since the duration of the luminescence is relatively short after the light source has been removed, such materials are most successfully used when they are placed under an illuminant, for example, an illuminated exit sign, which will continue to glow in the event of a sudden power failure. Luminous paints are also used for theatrical effects, where they serve well because they are not required to glow for more than a few hours and can be kept under exposure to light just prior to use. The principal shortcoming of a luminous sign is that its period of luminescence is shortened by the number of hours it must remain under faint illumination between the end of strong daylight and the beginning of total darkness, when luminescence is discharged rather than stored. When a minute trace of radioactive material is added to a phosphor, it will be continuously excited; such coatings have been used on watch dials. However, because of its toxicity, radioactive material may only be used under strictly supervised workshop conditions and so is not available for general use.

Fluorescent materials: Many minerals and organic substances, including the daylight fluorescent pigments discussed in the next paragraph, have the ability to emit luminescence when excited by concentrated ultraviolet or "black light" lamps. Fluorescent materials of this type emit visible light only while being irradiated, whereas phosphorescent materials continue to emit light for some time after excitation.

Daylight fluorescent paints are a mid-twentieth-century development by which paints, produced from certain synthetic organic pigments, have

such intense luminosity that they exhibit a glowing or fluorescent effect in daylight. They are also known by the trade names of Dayglo and Radiant fluorescent pigments. They constitute the materials that are now generally called fluorescent paints. They are sufficiently lightfast to serve a great many decorative and industrial safety purposes, but, like the great majority of synthetic organic pigments, they are not permanent from the fine-arts standpoint and cannot be used in creative painting or sculpture. They are not dangerously toxic. Several types are made for various pigment purposes in several reds from bluish to yellowish and in orange, yellow, green, and blue shades, and a number of paints containing them are available on the retail market. For full intensity, they must be applied to a brilliantly reflective ground.

Some of the regular synthetic organic dyestuffs are called fluorescent. When they are dissolved, the solution has a brilliant two-toned effect similar to that seen in lubricating oils that are green with a yellow fluorescence. One of them is fluorescine, which in solution is green with a yellow fluorescence; another is rhodamine, whose solutions are red with a golden fluorescence. Pigments with daylight fluorescence may be manufactured by dissolving fluorescent dyes in resins and carefully grinding the resin to particles of optimum size. Such a pigment converts the blue-green component of daylight (which is about 50 percent) to yellow-red. This emission, combined with the pigment's normal yellow-red reflectance of the incident light, increases the total to a much higher level than that of ordinary pigment reflectance and makes the color look much brighter than an ordinary one. Since the glowing effect of these pigments is activated and maintained by components of daylight rather than by electrically produced ultraviolet, they are called daylight fluorescent colors.

NEW PRINTMAKING TRENDS

This section supplements the descriptions of graphic art processes on pages 556 ff. As with other artists' methods, printmaking techniques change and develop to meet the demands and requirements of changing art styles and concepts. While traditional graphic processes are still in wide use, and traditional standards of excellence still prevail in the graphic arts to a great extent, there are also many areas of the field where completely new ideas have taken over. For the most part, the basic printmaking processes are used but they are applied in different ways. With the possible exception of serigraphy, no fundamentally new way has been devised for imprinting ink on artists' proofs for centuries.

COLOR WOODCUTS

One printmaking development of the mid-twentieth century is the trend toward very large woodcuts, done in a broader manner than the relatively finer line and more precise shapes that are characteristic of the traditional woodcut. The smooth, textureless blocks of apple and other woods mentioned on page 579 are chosen for their "sweet" carving properties that facilitate precise control of the carver knife or gouge in any direction on the block, but these considerations are foregone for the sake of the larger and much more economical plank of pine or other softwood. The grain of the wood, which would have disqualified it for the traditional small woodcut, here enhances the print, its pattern adding effectively to the design of the work. Sometimes weathered planks with a heightened grain are employed. Other surfaces such as hardboard and the thicker plywoods are also used.

The woodcut is admirably suited to multicolor prints. Those of large size create clear and expressive effects and separate color blocks are easily kept in register. As with the traditional woodcut, most styles of work succeed best when the number of color blocks is limited to a few tones—two, three, or four, plus the secondary colors produced by overprinting.

THE RELIEF PRINT OR RELIEF BLOCK PRINT

This heading describes a range of block-printing methods in which relief patterns are built up on a block or board with various materials and by various means, as by gluing three-dimensional elements to the surface of a board, or by coating the board with gesso or polymer modeling paste and building up textures or carving or incising it. Other prints are pulled directly from textured surfaces, such as weathered wood surfaces, cross sections of logs, and crumpled or textured metal. Found objects (see page 418) are frequently glued onto the board—flat metal and plastic items, or shapes cut or molded by the artist. The means of creating abstract patterns are unlimited. When hand printing is done on deeply recessed patterns there will be some degree of impression or embossing on the paper, depending on the thinness and dampness of the paper used. Some printing surfaces require a protective or nonabsorbent coating of lacquer or shellac. Soft packing is sometimes used.

THE COLLAGRAPH

The collagraph takes its name from collage. It is an impression made from a board or block on which three-dimensional elements are glued,

and it is prepared in the same way as the relief block print described above. The difference is that it is an intaglio print (see page 557) rather than a relief print. The board or block is inked by filling in its recessed areas, its surface is wiped, as are metal intaglio plates, and it is printed on dampened paper by running the inked board and the paper through an etching press. The collagraph is characteristically embossed; frequently it contains blind (uninked) impressions. When the term "intaglio print" is used to designate an artist's print, collagraph or a process closely related to it is meant.

PRINTING

Woodcuts, wood engravings, lino cuts, and relief prints, if made on type-high blocks (.918 inch thick), may be printed on large commercial printing presses or on a number of small studio models that are available. Artists' proofs, especially relief block prints, however, are frequently printed by hand—that is, by fastening the block face up on a table and, after inking, placing a sheet of paper on it and rubbing the back of the paper with any convenient implement. A favorite one is the convex bowl of a large wooden spoon; some printmakers prefer a metal spoon. The baren, an instrument used to make Japanese prints, is also used; it is a slightly convex stiff pad sheathed in thin bamboo. The printing press is more likely to turn out an edition of prints that are perfectly uniform; however, the rubbing or hand-printing method is capable of much more delicacy of control. A thin card (sometimes waxed) is usually placed over the back of the paper to protect it from being marked by the rubbing. Some artists have printed their proofs without any special equipment, placing the cut and the paper on the floor between books or blocks and applying foot pressure with the weight of the body.

Intaglio prints and collagraphs are printed in a regular etching press. A laundry wringer is said to be a good makeshift substitute, but it is apt to be troublesome.

Inking. Fine-quality printing inks made for the graphic arts give the best-controllable results. The use of other materials, either oily or water-soluble, comes under the heading of experiment. Printing ink is applied to the surface of a relief printing block with a printer's brayer with a rubber face, or with a gelatin or plastic roller. Inking a relief print normally (which means sparingly) gives normal results. A thicker application of ink produces a different line or contour and, depending on the type of paper used, increases gloss. The type of paper used is an important consideration in printmaking. The books on printmaking and the sources

of paper (page 646) can supply details as to the proper grade of domestic, European, or Japanese paper to suit special requirements.

COLLAGE

The French term "collage" is the standard name for the technique of making areas of paper, cardboard, fabrics, etc., adhere to a flat surface as elements of a design or picture. It derives from a nineteenth-century popular recreational craft called *papiers collés* in which all sorts of designs were created by this method. *Découpage* was another word applied to the pasting of cutouts on various surfaces and objects as decoration, but this term refers to the solid, all-over, or overlapping coverage of a surface rather than to the use of the cutouts as individual shapes or patterns in a design.

Collage as a serious art form had its beginning in the revolutionary art movements of the early twentieth century, and most of its technical and aesthetic possibilities were thoroughly explored during the following decades. Those who employed it as an art form were primarily concerned with its aesthetic and expressive aspects, with no thought toward the physical survival of the works. Indeed, much of the material used had an appeal for its fragile or ephemeral qualities. Now that collage is no longer a means for pioneering experiment or a technique for exploring or developing a new concept, but has become a more or less standard artists' technique to be used either by itself or as an element in another painting technique, its survival ought to be considered.

Permanence of adherence is an obvious consideration. When paper cutouts are applied to oil paintings, the traditional pastes and glues have shortcomings, and it is not uncommon for pasted paper to curl away at the edges. It should be remembered that in ordinary usage, especially on a nonabsorbent surface, the technique of gluing two dissimilar materials calls for the application of pressure. Most artists who employ collage find that the best adhesives are the milky-white synthetic glues such as Elmers Glue-all, or the regular medium that is sold with the polymer colors, which is a closely similar product. Some painters who work with polymer colors prefer the medium because it is identical with the binder in the colors and so makes for a homogeneous structure. The straight medium is a strong, efficient adhesive, but the adhesive properties of the pigmented colors are rather poor. Collage seems to be technically more successful when combined with polymer painting than with oil. A final coating of the regular polymer medium is an excellent protective varnish; if a dull or mat finish is preferred, as it almost always is, the mat medium may be used. As an adhesive, the mat medium is less satisfactory than the regular.

It has less strength and is sometimes likely to give spotty results when varnished over. There is no objection to using clear acrylic picture varnish as a final protective coat. It complies with the ideal requirements of a picture varnish (see page 172) in that it is very easily removable, should an accumulation of grime require a complete cleaning of the painting.

Virtually all the work where paper was pasted on panels, on canvases, or over oil paintings has suffered from the effects of aging on the paper. Newspaper and every other form of wood-pulp paper (which means almost every common paper) becomes brownish or yellowish with age and its fiber becomes very brittle and fragile. The latter effect can be guarded against by impregnating the paper with polymer or acrylic varnish and by seeing that it is securely mounted, but nothing can prevent impermanent colors from fading, least of all the vinyl and acrylic resins, which have the highest transmission of ultraviolet and will not block out the effects of light. Very few, if any, commercial colored papers and colored printing inks have sufficient color stability to be used in works of art, but a limited range of permanent colored papers can be obtained in art-supply stores. Good rag paper can be colored with watercolor washes by the artist, as can some of the lightweight Japanese rice papers.

One consideration that is apparently overlooked by some artists who use paper in collage and constructions is the necessity of cleaning a work of art after it has been exposed to a modern environment for a few years. All works done with paper, especially those with complex textures, are best preserved by framing under glass in the same way that pastels, watercolors, and drawings are framed.

Found Object. Collage has relationships with the concept of the found object, an art form in which the artist finds or selects an object and mounts and displays it in such a manner as to exhibit its aesthetic qualities of form, contour, color, texture, etc., as though it were a creation that he had formed himself. When such objects are more or less two-dimensional, such as printed paper items, and are pasted to a flat surface, the work would be called a collage. When the objects are definitely three-dimensional or mounted or joined together with other objects, especially when freestanding, the work is called an *assemblage,* usually with the French pronunciation. Found objects are usually natural things (shells, driftwood, stones), but they may be man-made, especially if their quality is enhanced by age or weathering. A mass-produced item exhibited for the same or similar values is called a ready-made.

The following French terms have been used for the various techniques or processes employed by experimental artists:

Affiches lacérées—torn posters.

Brulage—burning; burned or scorched work.

Coulage (*literally:* leakage)—application of paint to a surface by dripping.

Déchirage—tearing, or torn paper used in collage.

Décollage—partially pasted or partially torn away collage.

Dépouillage—*stripping away.*

Éclaboussage—paint splashed or spattered on a surface.

Flottage—colors floated on water and transferred to a surface.

Froissage—crumpled or crushed paper or other material used in collage.

Frottage—the technique of rubbing (see below). Also, the creation of a pattern by holding paper over a textured surface and rubbing with pencil or crayon; often used as an element in collage, sometimes as a pictorial representation of an area.

Fumage—patterns created by smoking.

Grattage—scratchings or scraped areas.

Lacéré anonyme—a found object (see above) consisting of a poster or other work on paper, found in a torn or battered condition.

Papier déchiré—a collage of torn papers.

RUBBINGS

Copies of incised work such as stone carvings or the memorial brasses in medieval churches may be taken by holding a sheet of paper in contact with the surface and rubbing it with a pigmented substance, thus transferring the design to the paper in the manner of *frottage* (see above).

The traditional rubbing, as preserved and sometimes exhibited in museums, is usually done on a rather lightweight paper or tissue such as one of the Japanese rice or mulberry papers. The rubbing is done with a lump of material called heelball, which is made or purchased for the purpose. It consists basically of beeswax that has been melted and mixed with lampblack or other pigment; in its absence, cobbler's wax may be used. Some of the modern shoemakers' waxes, however, may be found to be too adhesively sticky for the purpose. There is no restriction on the materials used to make rubbings, but the heelball method has been found to be satisfactory over the years.

It has been suggested* that in the case of very delicate or very faint engravings on brass or other material, an ink applied with a chamois-leather dabber may give more satisfactory results; one such material may be made by mixing graphite and linseed oil to a stiff paste consistency.

*The Technique of Brass Rubbing. A pamphlet published by the Ashmolean Museum, Oxford University.

This material may be spread thinly on a piece of Masonite of convenient size for easy portability, protected by a hinged cardboard cover. A few trial rubbings should develop a satisfactory control of materials and a rubbing technique to suit individual requirements.

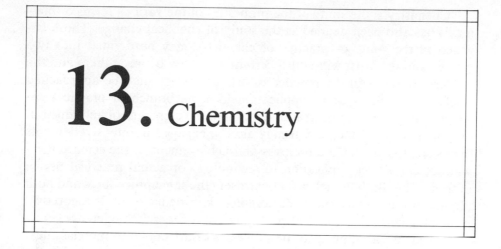

13. Chemistry

THE FIRST PART of this chapter is a general outline of certain elementary or fundamental theories of chemistry combined with descriptions of the chemicals and raw materials likely to be encountered. As in the preceding chapters, completeness has been subordinated to the main purpose of supplying the most useful information in the most available form for those with little or no chemical background, and the section does not attempt to be a thorough orthodox manual of instruction. A good deal of the material is elementary, well known to the reader of average education, and perhaps understood by him more thoroughly than the chapter presents it. It is included as a matter of record and to establish a basis for many of the statements made and the terminology used throughout this book and other technical works; also to avoid repetitions and distracting remarks in the text of the various sections. The second part of the chapter deals with chemistry as it is directly involved in the various processes discussed in the text.

The complexity of all the various chemical and physical changes that artists' materials may undergo should be taken as a warning to abide strictly within the bounds of the accepted rules and regulations governing the methods, procedures, and choice of materials of the various painting techniques. All these regulations have been most thoroughly investigated by competent authorities during the recent past, and most of them are based on sound theories substantiated by the test of time and use.

421

Chemistry is the study of the properties of the various forms of matter. It has also been defined as the study of chemical change. Those engaged in the study or practice of chemistry may be divided into two classes, and the artist will note a certain similarity between them and the modern divisions in the practice of art. Chemistry may be approached solely for its utility or its application to some branch of practical endeavor, such as medicine, the production or development of an industrial or commercial product, etc. It may also be engaged in intensively for its own sake, that is, for the progress and achievement of the science itself without any direct application to technology or actual practical use in everyday life. Both branches follow closely the same procedures and both require of the chemist the same complete knowledge of basic theoretical principles, correct methods of procedure, and general competence.

Chemistry as applied to the processes of art falls into the classification of applied technology. In the present account we are interested in the realization of only enough basic principles to explain the limited number of reactions with which we come in contact; materials and reactions have not been considered beyond the point where they have to do directly with our own problems.

PART ONE: DEFINITIONS, THEORIES

The difference between chemical change and physical or mechanical change is perhaps the best-known or most remembered principle of chemistry.

A physical change is one in which the properties of a substance are altered in such a manner that the original nature of the substance may still be recognized; although there may have been great changes in appearance, usefulness, or function, still these are limited to properties such as size, shape, color, or consistency. If a stick of charcoal is rubbed to a powder, it is changed, useless as a drawing crayon, more useful perhaps as a black powder to be dusted on a surface, but at any rate it is still charcoal. Paper torn up into tiny bits is still paper; it is even possible to mash it up to a pulp with water and make a continuous sheet again.

When damar resin is dissolved in turpentine to make damar varnish, coated on a surface, and allowed to dry, the entire procedure is mechanical; the coating is nothing but a thin film of the original resin, only its shape having been altered, and if desired, it could be dissolved into a varnish again. When linseed oil dries, the change is chemical. The dried oil film is an entirely new material; it resembles the original oil in color, but otherwise we could not identify it with either the original oil or the

oxygen which combined with it. Oxygen is a colorless gas; linseed oil is a mobile liquid which is miscible with and soluble in turpentine. The new product is neither, but is a dry, horny, insoluble mass that cannot again be used as a painting medium. A chemical change is one in which the properties of the original material or materials are entirely changed, and the resulting product is a new substance, with new properties. The actual process of a chemical change is called a reaction. Some reactions are reversible; one or more of the original materials may go back or be caused to go back to their original state. Other reactions are irreversible and their products will not combine again.

Chemical reactions occur because atoms have a selective affinity for each other; under the proper conditions they will join readily with certain substances and be repelled by others. This is not an explanation, but a description of what occurs.

Elements.　According to chemical theory, all matter is divided into elements or simple forms. These are the primary substances with which everyday chemistry deals. Some of these elements are of common occurrence, while others are rare. Many elements are familiar substances, e.g., iron, copper, oxygen, sulphur. Others are known to us only as names—we seldom have occasion to use or even to see such elements as sodium, potassium, barium, or cadmium, which are actually silvery metals. We recognize these elements through familiarity with their *compounds*. A chemical compound is a combination of two or more elements in definite, fixed proportions.

Atomic Theory.　An atom is an infinitesimally small particle, the smallest unit of a substance that can enter into a chemical combination. Atoms of the same element are identical in size and weight; atoms of various elements have their own respective definite sizes and weights; each one has been measured and tagged with a number or atomic weight. We have, for the present, no concern with what goes on within the atom; for our purposes, it is the unit of matter. A truly scientific study would explain the dynamic structure of the atom and its attractions and repulsions caused by inner electrical charges; for practical purposes, however, the simpler graphic descriptions, such as the definition of valence on pages 427–28, are entirely adequate to give a basic understanding of the behavior of materials in common use.

Molecules.　Atoms of the same or of different elements combine to form molecules. A molecule is the smallest unit of an element or compound that can exist by itself in its recognized form.

Variation in Matter. Substances differ from one another in their properties and behaviors according to the differences in the atoms of which their molecules are composed; the atoms may differ in three ways—in kind, number, and arrangement.

1. Kind: Iron oxide (iron and oxygen) and cadmium sulphide (cadmium and sulphur) differ because they consist of atoms of entirely different substances. They may be compared to two houses, one made of red and yellow bricks, the other of black and white bricks.

2. Number: Red iron oxide, two parts of iron and three parts of oxygen (Fe_2O_3), differs from black iron oxide, which contains three parts of iron and four parts of oxygen (Fe_3O_4). These compounds may be compared to two houses of red and yellow bricks, one with two red bricks to every three yellow bricks, the other with three red bricks to every four yellow bricks.

3. Arrangement: Two substances that differ by reason of the arrangement of their atoms may be compared to two houses containing the same number of red and yellow bricks, but having them placed in a different arrangement or pattern. Examples of such compounds (they are called isomers or polymers of each other) will be given toward the end of this section.

Modern chemistry and, in particular, the making of synthetic resins and pigments deal with these points; physical properties and behavior characteristics are built into these products by varying the number and arrangement of their molecules.

BEHAVIOR OF SOME COMMON CHEMICALS

Substances may be classified according to their uses and behaviors into two broad groups—the active and the inert, those that readily enter into changes when subjected to certain conditions and those that remain unaffected. Although the artist is interested in employing materials which will be inert or permanent to all forces with which they are likely to come in contact, he also depends upon the activity of some of his materials to produce these eventually inert results. Examples of some of these reactive substances are the lime in fresco painting and the linseed oil in oil painting, both of which unite with atmospheric gases to produce durable surfaces. Examples of absolutely inert substances that will not react with the substances with which they ordinarily come in contact are the permanent pigments, which remain unaltered when exposed to sunlight, air, heat, and admixture with other pigments or with mediums.

Acids and Alkalis. These are two groups of active chemical substances; they are strongly opposite and may be considered widely divergent poles of action. The typical mineral acid, such as sulphuric or hydrochloric, has a sour taste and is violently reactive when brought into contact with many substances, with the result that it has a destructive, disintegrating effect on their properties.

An alkali or base is to be considered the direct opposite of an acid; when the two are mixed, they react and neutralize each other. Typical alkalis, like acids, behave with destructive violence on many substances, notably upon fats, oils, waxes, etc.; their action is called caustic, as distinguished from acid. They have a bitter taste and a soapy feel. When they are brought into contact with red litmus (a vegetable coloring matter) the litmus turns blue. Acids will turn blue litmus red. Papers dyed with blue and red litmus are used to test the acidity or alkalinity of materials. Sodium hydroxide (caustic soda or lye) and strong ammonia water are examples of strong bases.

Materials of acid or alkaline properties have a wide range of degree of activity; in some of them the action is violent, in others so feeble that for a number of practical purposes they are acids or alkalis in name only. Generally, however, in the materials used by artists for permanent painting, minute traces of free acids or alkalis are sufficient to interfere with processes or cause eventual disintegration, as in the case of the substances that are used to manufacture or purify oils and pigments and are sometimes incompletely washed or removed from the finished product. Similarly, the success of some processes depends upon the very mild action, or the action of very minute amounts, of reactive materials.

Weak and Strong Reactive Solutions. The foregoing remarks on the behavior and properties of these substances do not constitute a *definition* of the terms "acid" and "alkali." Chemically, an acid is any substance that is capable of liberating hydrogen ions (an ion is an electrically unbalanced or charged atom), an alkali or base is one that yields hydroxyl (OH) ions, and a salt is one that yields any other ions. The "strongest" or most reactive substance, therefore, will be the one that in solution dissociates best, or liberates its ions most readily. This is a constitutive property of the substance, and not due to its degree of concentration. For instance, no matter how powerful or concentrated a solution of a mildly alkaline material such as sodium bicarbonate may be, or how well it will serve its purpose when used as a detergent or to destroy or remove other substances, it will never have the severely caustic activity of even a comparatively dilute solution of sodium hydroxide. Acetic acid, full-strength (99

percent), is called a weak acid, because it becomes so slightly dissociated that its reactions are slow. Hydrochloric acid, which in full-strength or concentrated form is only a 37-percent solution in water, has a powerful and violent action on metals; even in dilute solutions its dissociation is practically complete. Concentrated sulphuric acid, which is about a 98-percent solution, is a definitely "weaker" acid than hydrochloric. Acids are mentioned further in Part Two of this section under *Etching.*

Alkaline Substances. Caustic soda or lye is the most active of a series of familiar sodium compounds that are alkaline in reaction. Next comes sodium carbonate, in crystalline form known as sal soda or washing soda, and in somewhat more concentrated form known as soda ash. Lye is highly caustic, and must be handled with care; it will destroy or dissolve animal tissue, and when it is dissolved in water, a considerable amount of heat is given off. Washing soda has a similar soapy feel, bitter taste, and property of turning red litmus blue, but to a lesser extent. It may be handled without the drastic effects of lye, but it is sufficiently powerful to be somewhat injurious to the skin, reddening and roughening it, as is well known; it will dissolve wool and react with oils, fats, etc.

Next comes sodium *bi*carbonate or sodium acid carbonate (baking soda), which is mild enough to be handled freely and to be taken internally; yet it has all the attributes and properties of an alkaline substance. Borax (sodium tetraborate) also is a mildly alkaline salt.

Another salt with mildly alkaline properties is trisodium phosphate, which is in wide use as a cleaner and detergent, and which has the same property of being amenable to control as some of the volatile solvents referred to in the section on *Cleaning Paintings,* pages 470–92. A weak solution may safely be used to clean painted woodwork and walls; a strong, hot solution is a good paint remover. It should not, however, be used to clean artistic paintings or sculpture; it has a destructive effect on such delicate surfaces despite its controllable action.

Similarly, there are numerous materials of mild acid reaction; boric acid, so weak that it is employed as an eyewash, is a familiar example. The fatty acids and other acid and alkaline constituents of natural products with which we often have to deal, although perfectly capable of entering into chemical reactions as such under the proper conditions, are actually rather feebly reactive materials.

Salts. A salt is a chemical compound that, as we have seen, is neither an acid nor a base; it may, however, have either an acid or an alkaline reaction, or it may be neutral. A typical salt may be produced by the action of an acid on a metal or another salt, by the action of one salt on another, or

by the neutralizing reaction of an acid and a base. Some salts are inert; others are very active. Common salt (sodium chloride) is a typical example of a soluble neutral salt; barium sulphate is an example of an insoluble salt; there are many degrees of variation. Many of our pigments are insoluble salts that have been made by mixing two solutions of salts together, whereupon, by a chemical reaction known as double decomposition, two new products are formed, one of which remains in solution in the water, the other falling out of solution as a finely divided powder or precipitate.

Some of the inert neutral salts are the most stable of our materials; others are not reliably so; but in order for most of them to enter into reactions, the proper conditions must be present. When two stable inert pigments containing elements that are theoretically capable of reacting on one another are mixed, it is often the case that on account of the stable, inert character of the pigments there is no danger of such action, because the conditions necessary for such a reaction will never be present. On the other hand, certain otherwise inert materials may be extremely sensitive to such mutual action. No indiscriminate rule may therefore be made, but the characteristics of each pigment or other material must be learned.

The carbonates and the sulphides of metals are all extremely sensitive to action by mineral acids; the oxides are inert substances more often than not. The salts of many metals and groups of metals have general properties in common, such as color. Most crystalline salts of nickel are green; those of copper, blue; and those of cobalt are rose-colored, changing to blue when they are made anhydrous. Chromium was named for its varied colors; all of the compounds of this metal are highly colored. Zinc and aluminum compounds are white or colorless; very slight traces of iron impart a yellowish color to a solution or composition. These general remarks on color do not apply to compounds containing more than one metallic element.

Sodium and potassium are two very similar elements whose compounds are closely allied. From the viewpoint of technical uses, a broad general statement is that a potassium compound is more active and will give somewhat better results than its analogous sodium compound, but the less expensive and more available sodium compound is usually adequate for the purpose. There are occasional exceptions to this statement; sometimes one compound is entirely unsuited to a reaction that calls for the other, and sometimes the two will give distinctly different results.

Valence. Atoms of an element may be graphically imagined to have a certain number of arms or hooks by which they become linked to other atoms to form compounds. The number of such hooks an element has is

called its valence; for example, it will be seen in the formulas in the following pages that oxygen has a valence of 2, hydrogen 1, carbon 4, and the benzene radical a valence of 6. A radical is a molecular group of two or more elements that often hang together and act like a single element during a reaction; the hydroxyl (OH), carbonate (CO_3), sulphate (SO_4), and ammonium (NH_4) radicals are familiar examples. It should be clear that these arms, links, bonds, etc., are theoretical descriptions of behavior, not tangible items. Valence can be more scientifically defined as the number of hydrogen or chlorine atoms with which an atom of the element in question will combine, the valence of hydrogen and chlorine being 1.

Some elements are polyvalent, that is, they have the ability to form perfectly normal and saturated compounds in more than one proportion; for example, iron, as in the oxides previously mentioned (number 2 on page 424), has a valence of 2 and 3, depending upon the conditions under which the combination occurred.

Nomenclature. The names of the elements were derived from a number of sources. The elements that were known in very early times, or whose prominent compounds were known, have names that come from basic roots of the various languages; those more recently isolated were named (in Latin or Greek form) for their properties, their compounds or sources, or in honor of their discoverers or of the land where they were discovered.

Binary compounds (those that consist of two elements) customarily take the name of the more definitely metallic or electrically positive element, followed by the name of the more negative element with the ending *ide.* Sodium sulphide is a compound of sodium and sulphur; zinc oxide, of zinc and oxygen. Some elements may function in both ways. For example, chromium occurs in the usual acid compounds—chromic acid and its salts, which are called chromates.

A substance that can be identified as the salt of a normal acid is named after the metallic constituent followed by the acid name ending in *ate.* Sodium sulphate (Na_2SO_4), for example, is the sodium salt of sulphuric acid (H_2SO_4); it can be made by the reaction of sulphuric acid and a sodium compound. Sometimes the significant elements of two acids are identical in kind but different in number. The salt corresponding to the acid with fewer atoms to the molecule takes the ending *ite;* sodium sulphite (NA_2SO_3), for example, is the sodium salt of sulphurous acid (H_2SO_3). The endings *ic* and *ous* are employed to designate numerical variations in an acid or oxide; the molecules of the *ous* compounds have fewer atoms or a smaller proportion of oxygen than do those of the *ic* compounds.

Generally the acids, and most of the salts, that end in *ous* are the

more unstable, and those that do not contain their maximum complement of atoms are called unsaturated. Some of them will take up additional atoms with avidity; others will freely disintegrate or give up their atoms. This is not to say that the *ous* compounds are always unstable or unreliable as regards permanence; for instance, the ferrous (iron) oxides are as thoroughly inert and permanent pigments as we may desire, and would require the most drastically severe chemical conditions or extremely high temperatures to be altered.

Further designations are given to compounds for other reasons, which are often self-evident. The prefix *hyper* is applied to the numerically highest in a series of compounds; the prefix *hypo* indicates the lowest. The prefix *per,* as in peroxide, perchloride, etc., denotes the higher of two compounds—usually the higher in valence as distinguished from the first, lowest, or *mono* form. The prefix *proto* is obsolete; it referred to this lower form. *Thio* means sulphur-bearing. *Azo* refers to nitrogen.

Other prefixes referring to numerical variations are *di* (or *bi*), *tri, tetra, sesqui,* etc. *Meta, ortho,* and *para* refer to variations in arrangement.

Oxidation. The chemical combination of a substance with oxygen to form an oxide is the commonest reaction in nature. When a substance burns, it oxidizes; combustion is defined as rapid oxidation with the accompaniment of heat and flame. An example of slow oxidation is the rusting of iron. Iron oxide for use as a pigment, however, is made by the calcination (roasting) of an iron salt, where by close control of the process a number of shades and hues can be produced.

Some oxides may be reconverted to the original metal, or from the *ic* to the *ous* form, by reduction, which may be considered a reverse process. In chemistry, the terms "oxidation" and "reduction" are sometimes applied to reactions not involving oxygen, where a substance is changed from a numerically higher atomic form to a lower, or vice versa.

Polymerization. Polymerization occurs occasionally in artists' materials and processes; it is a reaction where nothing enters into or leaves a compound but where the change is internal and its molecules proliferate or become rearranged in a different pattern, altering the properties of the substance as definitely as they are altered in any other chemical reaction. The term is rather loosely used in this book and in most other technical accounts to describe changes that may be complex reactions involving other considerations at the same time.

Catalyst. A catalyst is a substance that assists in the production or acceleration of a chemical reaction without itself entering into the reaction.

Hydration. Some compounds, especially oxides, exist in a form where the hydroxyl radical (OH) is combined with them; they are not pure or simply hydroxides, but "hydrated oxides." Such materials can be reduced to the pure oxide form by subjecting them to heat. This process involves a chemical change and is not to be considered a mere driving off of water; the temperature required is usually quite high.

Water of Crystallization. Many salts occur in more than one structural form in combination with water. Thus the transparent blue crystals of copper sulphate, although perfectly dry to the touch, contain 7 molecules of water to each molecule of the salt, and the chemical formula is written $CuSO_4.7H_2O$. If the crystals are heated, the water is driven off, and anhydrous $CuSO_4$ (a white powder) is the result.

Hydrolysis. This is a chemical reaction caused by the action of water; it results in the decomposition of a salt to produce a new substance.

Solubility. Solid substances are soluble or insoluble in water and other liquids to varying degrees; tables are published in chemistry handbooks, listing the solubilities of all chemical compounds. With few exceptions, heat increases and cold diminishes the solvent power of a liquid. A solution that contains as much of the solid material as it will hold at normal room temperature, so that further addition would not go into solution but would remain in the liquid as undissolved matter, is called a saturated solution. When a liquid is heated so that it will dissolve more than this normal amount of solid, and is then cooled to room temperature, the additional amount of solid will fall out or crystallize, and the resulting liquid will be a saturated solution.

Absorption and Discharge of Moisture. Some crystalline substances have the property of losing their water of crystallization when exposed to dry air; sal soda is an example. This property is called *efflorescence*. Others, notably calcium chloride, alcohol, and lye, will absorb moisture from the air. Such materials are called *hygroscopic*; and if the affinity for water is so great that the substance becomes spontaneously dissolved or wet, the property is termed *deliquescence*. The same terms are used to denote the same properties in noncrystalline materials.

Allotropic Forms. When an element exists in more than one form, as regards superficial physical or structural properties, these variations are called allotropes. The various forms of carbon, e.g., lampblack, diamond, graphite, etc., are familiar examples.

Symbols. In the early days of chemistry the cabalistic symbols of the al-chemists that were employed ceremonially (as much to mystify the lay-man as for any other reason) survived for a while, as a sort of shorthand or convenient method of representation. With the scientific development of chemistry, a universal system of shorthand designations for the various elements and their reactions came into use.

An atom is represented by the initial letter of the element. Where more than one element has the same initial, another significant letter is added in lower case; thus, C is carbon, Cl is chlorine, Cd is cadmium.

Chemical Formulas and Equations. A chemical formula expresses in concise form the number, proportion, kind, and arrangement of atoms in one molecule of a substance. A chemical equation expresses the reaction that takes place between two or more substances and the resulting redis-tribution of the atoms in mathematical balance, according to atomic theory and other laws. For example, the chemical equation involved in etching is:

$$3 \text{ Cu} + 8 \text{ HNO}_3 \rightarrow 3 \text{ Cu (NO}_3)_2 + 2 \text{ NO} + 4 \text{ H}_2\text{O}$$

$$\frac{3 \text{ parts}}{\text{copper}} + \frac{8 \text{ parts}}{\text{nitric acid}} = \frac{3 \text{ parts}}{\text{copper nitrate}} + \frac{2 \text{ parts}}{\text{nitric oxide}} + \frac{4 \text{ parts}}{\text{water}}$$

The coefficients, or large numbers preceding the symbols, refer to the number of molecules or parts by weight of each substance that will com-plete the reaction according to the law of definite proportions; they are like the figures in a recipe. The small subscripts refer to the number of atoms of the element which combine to form a molecule of the particular substance; these are fixed and invariable for each substance. The group of symbols enclosed in parentheses is the nitrate radical previously men-tioned. Its valence is 1; the valence of copper is 2; therefore, two of these nitrate groups are combined with one atom of copper, and the parenthe-ses in this particular case indicate that the subscript 2—the small figure below the line of the letters—qualifies the entire group.

If the numbers of atoms of each element, as indicated by both the coefficients and the subscripts, are added, they will be seen to check, or balance, on each side of the equation. For instance, there are 24 atoms of oxygen indicated for the nitric acid, and the total on the right-hand side of the equation is also 24—18 in the copper nitrate, 2 in the nitric oxide, and 4 in the water. Matter is indestructible and all the ingredients that enter into the reaction must be accounted for.

In the actual etching process, considerable water is also present, but although it makes possible the particular reaction, it does not enter into it,

and so is ignored in the equation. The copper nitrate dissolves in the water as soon as it is formed, the NO passes off as a brown gas, and the copper is apparently eaten away. The color of copper nitrate is green; if we saved the greenish solution instead of pouring it out, and boiled off the superfluous water, we could obtain crystals of copper nitrate, which in turn could be reduced to pure metallic copper. Without the water, a somewhat different reaction would occur.

As a matter of fact, the above reaction is a rather complex one. The left-hand group shows the beginning, the right-hand group shows the result, but the reaction actually occurs in two stages, and should be represented by two equations, were we interested in following up its theoretical aspect rather than its practical application.

ORGANIC CHEMISTRY

Compounds of the element carbon are so numerous and are arranged into groups and series of such complexity of structure and behavior that their study is treated as a branch of chemistry separate from the study of the inorganic compounds that have been discussed heretofore in this section. There is no precise line of demarcation between organic and inorganic chemistry; the simpler compounds of carbon, as well as those in which carbon is not a significant constituent, are generally studied and considered in connection with inorganic chemistry.

Originally the term "organic" was applied to all substances of animal and vegetable growth, and the term "inorganic" to those of mineral origin; and although many organic compounds have long since been manufactured synthetically, the original distinction still influences our understanding of the subject, and it is a good enough rough idea of the matter, especially for purposes of technical application.

One's general impression of such distinctions is influenced largely by typical or majority examples. One becomes accustomed to identifying organic products of vegetable or animal origin with the characteristic attributes of such matter as compared with the dead or inanimate nature of inorganic materials. We infer that organic products have a definitely limited life span, are more flexible, yielding, or malleable than inorganic materials, and more subject to decay on aging and exposure to adverse conditions. Such a viewpoint is generally correct; but on the other hand, the number of inorganic substances of mineral origin that can be used in the arts is also limited. When one thinks of mineral substances, the first picture in one's mind is usually that of rocks and other durable, inert materials; as a matter of fact, large categories of inorganic substances, natural and artificial, are among the most unstable and violently reactive ma-

terials that exist. The organic products in approved use in the arts, while not in a class with granite or cast iron, are nevertheless adequately durable for the purposes for which they are intended and the conditions under which they are expected to survive.

Such natural organic products as are used virtually in their native states, as resins, gums, oils, etc., are not single, definite chemical compounds, but are mixtures, in varying proportions, of highly complex chemical compounds of carbon, hydrogen, nitrogen, oxygen, and other elements. Other organic materials, such as the synthetically manufactured products, are less complex in structure and may be refined to grades that are pure compounds of definite, and sometimes simple, chemical composition. Alcohol, glycerin, benzol, ether, and acetone are definite single compounds. The coal tar colors are also definite compounds of uniform composition, but of such variety and complexity that a special study is necessary to gain a thorough and accurate understanding of their properties.

An organic salt is called an ester. The various acids, esters, and simple compounds that combine to make up the complex mixtures that are our raw materials may often be isolated and sometimes produced artificially, but such products are not always successful substitutes for the natural materials.

Structural Formulas. In the realm of organic chemistry, differences in arrangement and pattern occur with such frequency, and the series and combinations are so complex, that the empirical formula (the type used in this section up to now) is seldom informative, and in order to express the complete meaning, the structural formula is used.

For instance, the empirical formula of water is H_2O; its structural formula would be written H-O-H; each of the hydrogen atoms is then clearly seen to be linked with the oxygen atom. Because this is obvious, and because the structural formula in this case does not furnish any additional information, it is never used.

Benzene (benzol) is C_6H_6, and as benzol it is so written. But the benzene radical is such an all-important nucleus of so many series of compounds and reactions that its symbol, a hexagon, is commonly used for compounds that contain it.

simplified to

The three inner lines indicate additional hydrogen atoms, and are meaningful only when a chemical reaction is involved; otherwise the simplified symbol is used. When the benzene molecule enters into reactions and combines with other materials, some of its hydrogen atoms are replaced by those of the new material in various positions. Its compounds vary greatly according to the kind, number, and position of the elements that replace its hydrogen atoms. Note also the structural formulas on page 468.

Hydrogen peroxide, H_2O_2, is a compound that differs from water in number rather than in arrangement; its structural formula, if it were used, would be H-O-O-H. This is an instance of an unsaturated compound, where one of the atoms—in this case, oxygen—is very readily given up, or as it is termed, loosely linked. This property makes the compound a valuable oxidizing agent, and as it gives up one of its oxygens on merely coming in contact with various substances, it can be employed for bleaching—nascent oxygen having a bleaching action. Bleaching powder and Javelle water act on the same principle, the oxygen in these instances being indirectly released by the action of chlorine.

The behavior of many unstable compounds can be attributed to loose linkages or unsaturated molecules, i.e., molecules which do not contain their full complement of atoms but whose bonds may be considered temporarily linked up with bonds for which they do not have a strong affinity or attraction. In such cases, the molecules will avidly take on certain other atoms or readily yield up some of their own to the disintegration of the entire substance.

PHYSICAL TOPICS

The Colloidal State. When matter exists in particles of a very minute size, it is subject to a series of reactions different in nature from those hitherto described. In order to exhibit colloidal characteristics, these particles must be dispersed in another substance. A typical example of one class of colloid is a solution of glue in water. When glue is dissolved in water it forms a thick, viscous solution. The glue, however, does not enter into what we are familiarly accustomed to regard as a true solution, as when salt is dissolved in water, but its particles remain dispersed in a suspended equilibrium and are not easily separated from the water by ordinary means such as settling or filtration, as would be the case with coarser particles in suspension. The word "colloid" is taken from the Greek and means gluelike; it refers to a condition, not a specific class of substances; many materials exist or can be caused to exist in both the colloidal and

noncolloidal states. The study of colloids is complex and must be gone into in its entirety for a good understanding. The process of dissolving casein (pages 382–83) demonstrates the difference between an ordinary suspension of coarse particles in water and a colloidal solution.

The classifications of various two-phase colloidal systems or dispersions, with typical examples, are:

Solids in liquids—suspensions of fine particles, such as clay in water.
Solids in gases—smoke.
Solids in solids—colored glass, gems, etc.
Liquids in gases—mist.
Liquids in solids—solid emulsions (butter, etc.).
Gas in liquids—foam.
Gas in solids—solidified foams (volcanic ash, etc.).

The dispersed material is called the internal or inner phase, and the material in which it is dispersed is known variously as the continuous, external, or exterior phase. The molecular arrangement of the material that acts as the surrounding medium plays an important role.

To exhibit true colloidal characteristics, the particles must measure, in at least one dimension, not more than 200 millimicrons and not less than 5 millimicrons. (A micron is a millionth of a meter. A millimicron is a thousandth of a micron.) A rough description is that, as to particle size, the colloidal realm lies somewhere between the smallest particles visible through an ordinary microscope and the largest molecules; the largest molecule is supposed to measure much less than 1 millimicron. A colloidal solution may also be considered as halfway between a true solution and an ordinarily coarse or filterable suspension.

The tremendous extent of increase in surface produced by such minute subdivision is not always realized, but this magnification of surface area and the consequent predominance of surface phenomena is considered the chief element governing colloidal behavior. If a cube measuring ¼ inch were subdivided into particles of the minimum colloidal size, the surface area would be multiplied by the million and would total somewhere in the neighborhood of an acre.

A familiar example of the changes in properties caused by increase of surface is the well-known spontaneous combustion of rags, cotton waste, etc., when such materials are soaked in drying oils. Normally the oxidation or drying of linseed oil by the absorption of oxygen from the air is a mild and slow reaction, and no change in temperature can be observed;

but when the oil is spread over such a finely divided substance, and is exposed to the atmosphere over such a widely extended surface, the heat developed by the reaction is so greatly magnified that it may be sufficient to ignite the materials.

Returning to our example of a colloidal solution of glue or gelatin, we find that the heavy, viscous, liquid form of this two-phase system may be transformed to another colloidal form, that of a jelly, by allowing it to cool. The transformation in this particular case is reversible; that is, the gel may be transformed back to the liquid or sol form by warming it.

It has been found that with certain two-phase systems of dispersions, not necessarily entirely of colloid dimensions—for example, in certain paints that are dispersions of relatively coarse pigments in oil—similar changes in consistency may be produced by merely shaking, stirring, or otherwise disturbing the equilibrium by mechanical means. This phenomenon has been called thixotropy, or change by touching. The theory has of recent years been applied to paints and explains certain hitherto unaccountable actions. For example, when certain mixtures of ultramarine and oil, ground to produce a stiff paste, are reground, stirred, or agitated, they become liquid or stringy; on being allowed to rest, they go back to the paste or buttery form. Certain heavy viscous paints which have thixotropic properties will, upon being brushed out, become fluid; the paint brushes easily and levels out free from brushmarks (page 439).

Colloidal phenomena also contribute to the drying of a linseed oil film, to the action of lithography, to the behavior of pigments in mediums in general, and to the making and use of emulsions.

Molecular Cohesion or Adsorption. The familiar word "absorption," which refers to the imbibing of a liquid by certain spongy or loose-textured solids through porous action, is not the same as the term "adsorption," which is used to indicate the adhesion of a liquid, gas, or solid to the surface of another solid by molecular attraction.

Adsorption may be pictured as a sort of freezing or gluing on of a substance; an adsorbed layer of a material is usually held so strongly that it cannot be washed away with liquids that would ordinarily dissolve it. Gases, liquids, and solids are adsorbed equally. In the past, the term has been used mostly to describe the adsorption of gases. According to present theories, only matter whose molecules arrange themselves in a certain pattern will form adsorbed layers. The molecules of such matter have their axes parallel, all pointing in the same direction, and are described as being oriented or polarized. As previously noted, the internal structure of molecules, which we have disregarded in this account, has

much to do with their actions. Adsorption in itself is not a chemical action but its occurrence usually depends upon some chemical reaction.

Emulsions. Emulsions are described in outline in the chapter on tempera painting. In order to produce an emulsion by mixing oil and water, which ordinarily are immiscible, a third substance—namely, an emulsifier or stabilizer—must be present. Some of the raw materials employed for the desirable properties they impart to the finished emulsion are in themselves very good stabilizers; other combinations of oily and aqueous solutions will not readily enter into stable emulsions without the presence of an additional stabilizer. The words "oil" and "oily" in this connection are meant to include waxes, fats, and resins.

An emulsion is a colloid or two-phase system, but not all liquid colloidal solutions are emulsions. Egg yolk is an emulsion, the tiny globules of egg oil being dispersed in the water ingredient. Egg white is not an emulsion, since it contains no such dispersed oil droplets; it is simply a colloidal solution of albumen in water. A casein solution by itself is not an emulsion. But both of these colloidal solutions will readily form oil-in-water emulsions when shaken up with a vegetable oil.

A second type of emulsion also exists: the water-in-oil type, an example of which is butter, where the water is dispersed in tiny globules throughout the butterfat, which acts as the dispersing medium. Such emulsions are evidently formed when the stabilizer is in colloidal solution in the oily rather than in the aqueous liquid. This seems to be the case when resins, water-insoluble or metallic soaps, or finely divided pigments in suspension act as the stabilizer, rather than when water-soluble stabilizers are present.

When emulsions contain a heterogeneous collection of ingredients containing both the hydrophile (water-affinity) and lipophile (oil-affinity) types of stabilizers, systems recognized as dual or multiple emulsions are likely to be set up; in these, the little globules of the dispersed liquid act as a continuous phase for still tinier droplets of the dispersing liquid within them. As many as five such systems within each other have been detected in microscopic examinations of such emulsions.

The dispersed drops of oil in an oil-in-water emulsion are understood to be surrounded by adsorbed films of emulsifier, but these do not protect them from breaking up under certain conditions. By the addition of enough emulsifier of the opposite type, an otherwise stable and balanced oil-in-water emulsion may be transformed or inverted to a water-in-oil emulsion, the dispersed drops expanding into a continuous medium and the dispersing medium contracting into globules.

The amount or proportion of oil has little to do with this difference. Some oil-in-water emulsions contain very little oil, with the globules spread through the mass in a sparse manner; others may contain more oil than water, and still be of the O/W type, the globules sometimes being close-packed or jammed together in such a way as to distend or compress their shapes without its disturbing their adsorbed layers or skins. The same is also true of the W/O type. The subject is discussed further in connection with tempera emulsions in the second part of this section (page 457).

The study of emulsions and their applied technology comes somewhere near the head of the list of those branches of chemistry that are in an incomplete state of standardization or establishment, and a knowledge of physical chemistry and its mathematics would be required to attain much more knowledge of the subject than the inkling here presented. Most of the definitely accepted theories are of comparatively recent establishment.

Consistency. The study of consistencies of materials comes under the branch of physics known as rheology. This section is intended to define some of the terms used in paint technology, to convey an idea of some of the factors involved in paint manufacture and control of uniformity, and to point out some of the desirable qualities of painting materials. Gardner's book[205] will supply further details.

The *consistency* of a substance is its resistance to deformation or flow. This resistance may be due to viscosity or plasticity.

The *viscosity* of a substance is its resistance to deformation or flow when these are directly proportional to the force exerted at all times. For example, if a cup with a small orifice at its bottom is filled with varnish, no matter what the consistency of the varnish may be, it will flow from the cup without regard to any factor of pressure.

Mobility is the ease with which a material flows. It is the reciprocal of viscosity; the greater the mobility, the less the viscosity or plasticity. Sometimes a distinction is made between mobility and *fluidity,* mobility being a special case of fluidity at an infinite rate of shear. Normally, fluidity is a word more frequently applied to free-flowing liquids of low viscosity, mobility to the flow of thicker or more viscous paints.

The *plasticity* of a substance is its resistance to deformation or flow when a certain initial finite force (the controlled stroke of the brush, the graver, the palette knife, the chisel) is necessary to overcome the internal friction and cause the material to flow. When a material is in the *plastic state,* it will retain its shape after deformation. Some paints have greater

plasticity and less mobility than others, when their brush strokes "stay put" instead of flowing out.

One can understand more about this study and its complexities when one notes the various means by which consistency measurements are made in the laboratory. When the measurement is made so that a liquid's specific gravity is a factor—for example, when a measured amount is timed as it flows down through a small orifice by its own weight—it is reported in terms of *kinematic viscosity*. The rising-bubble type of instrument (see page 199) gives results in terms of *absolute viscosity*. Other viscosity and mobility measurements of a material are made by observing the speed of a rotating member immersed in it; or the rate of fall of a small ball through a cylindrical container filled with it; or the time required for a perforated disc at the end of a plunger or piston to sink through it to the bottom of a cylinder when various loads or weights are placed on top of the plunger. Each one of these and other instruments is used for a specific type of material and for revealing pertinent and appropriate rheological properties. The method described on pages 661–62 was designed to compare just those properties which are relevant to the manipulative qualities of artists' oil paints.

Thixotropy is a property of gels or viscous materials to decrease in viscosity upon mechanical disturbance. For example, a paint may seem very stiff, but upon being stirred or brushed will be found to be of satisfactory consistency. The speed or time required for a fluid paint to become a gel (to "set up") has much to do with the leveling of brush strokes or their persistence in impasto.

The universally condemned and outmoded gel painting medium called megilp (page 180) enhanced the manipulative quality of stiff paint not merely by increasing its mobility but by conferring upon the paste a third property, which the technologists would probably classify as thixotropy. Addition of such a gel to paste oil color lubricates it, as it were, allowing a certain slip or slickness to brush manipulations so that with the same brushful of paint one may obtain smooth or rough textures at will and perform all sorts of strokes and flourishes with greater facility.

PART TWO: PRACTICAL APPLICATIONS

The first thing to be borne in mind is that many of the artist's raw materials—oils, resins, gums, glue, casein, eggs, etc.—are natural products. This means that they are highly variable mixtures and concoctions of a number of things and so cannot be expected to exhibit exactly standard or

uniform behavior in chemical reactions as do the simple, pure substances discussed in the first part of this section. Second, with few exceptions, the chemistry of these products is not at all well established and in many cases even where materials and processes have been standardized and put under chemical control, we have, after decades of scientific study, little conclusive evidence regarding their underlying principles, particularly as they are applied to artistic painting.

A good deal of the best work on the chemistry of natural raw materials used for painting has been done either in industrial laboratories or by men who have approached the problems from the viewpoint of industry. This has directed research into channels not directly in line with the application of results to artistic painting, because the commercial or industrial value of these products as artists' materials is insignificant as compared with their commercial value in other uses.

At the present writing there is a need for a great amount of planned, systematic laboratory research to be done from the standpoint of the practicing painter; we are handicapped in almost every branch of the technology of artistic painting by lack of reliable data, and too often must depend on opinion, conjecture, and guesswork in passing judgment on what is correct and what is wrong.

The establishment of the Commercial Standard for Artists' Oil Paints, reprinted in the Appendix (pages 651 ff.) and commented upon on page 13, has filled a long-felt need in bringing order out of a great confusion that existed up to that time. It was set up by practical, experienced artists, technicians, and manufacturers, independent of the bias of the latter but at the same time taking due consideration of the demands imposed upon them, their limitations, the availability of supplies, and the problems of distribution.

DRYING OILS

An oil, according to the broad and simple definition of general chemistry, is a glyceride of a fatty acid, a fatty acid being an organic acid that belongs chemically to a certain family or series of acids of similar constitution and reaction, the most important members of which occur in fats and oils of animal and vegetable origin. A glyceride is an ester or salt containing glycerin. This definition excludes such oily liquids as the petroleum or mineral oils and the essential oils, which are of different composition; these are called oils because of their external or superficial characteristics. It includes the fats; the vegetable oils are actually liquid fats. Vegetable and animal waxes are also included. Because of

the multiple glyceride molecules, drying oils can be called polymers (see page 429).

When we come to study the composition of the vegetable oils, however, we find that they consist of rather complex mixtures of a good many variants of these acids and esters with other materials, in varying proportions. The glycerides themselves are not simple esters, but triglycerides, that is, combinations of one molecule of glycerin with three of the fatty acid radicals, the latter occurring in every possible complexity of combination: they may all be the same acid, they may be two or three different acids, and the two latter combinations may appear in perhaps forty different types of arrangement. The glycerides in drying oils will combine readily with oxygen, as indicated by the fact that in their structural formulas their molecules are pictured as unsaturated; that is, their structure or arrangement includes double bonds or links that are able to combine with various numbers of oxygen atoms, depending upon the type of glyceride.

The drying properties of most oils are due to the presence of glycerides of linoleic and linolenic acids, which have the property of combining spontaneously with atmospheric oxygen to start a chain of reactions ending in the conversion of the oil to the tough, durable, insoluble film known as linoxyn. The action of moisture on certain of the glycerides of linolenic acid, particularly in the absence of daylight, is also one of the chief causes of the yellowing of oil films. Linseed oil has a larger percentage of linolenic acid and its glycerides than any other drying oil except perilla oil, which dries better, forms a harder, tougher film, and yellows much more than linseed oil. Compared with linseed oil, poppy oil contains a smaller total amount of these glycerides, and little or no linolenic acid, and this minimizes one of the causes of yellowing of its films.

However, because the presence of these constituents in sufficient amounts is necessary for an oil to dry in the proper manner to a tough, durable, nonshrinking, nonspongy film, the inferiority of poppy oil to linseed in this respect must be attributed to their absence. Impurities in oils such as chlorophyll, the green color in grass and foliage which becomes red, yellow, and brown as they fade, add to the yellowing of linseed oil but are not a major cause since they are mostly destroyed during the refining process. The mechanism of film formation is noted on page 120.

Several much-quoted letters written by Rubens[28] recommended exposure to sunlight for certain oil paintings that had in each case been boxed soon after being painted, and stored for some time. For centuries artists have known that freshly painted oils should be exposed to daylight

under normal conditions, that continual or severe exposure to bright, direct sunlight is not beneficial, and that the darkening of oil paintings from continued absence of light during the drying process is a reversible reaction that can be corrected by further exposure to daylight.

These facts have been substantiated in the twentieth century by a large amount of research by Eibner[163] and others, and considerable data on various reactions of the drying oils are on record.

Artists are not always aware of the fact that color instability, fading, darkening, and the embrittlement of oil films are caused by definite chemical reactions, the altered product being the result of a chemical change of which in many cases the ultraviolet in daylight is the active agent.

The presence of normal or diffused daylight is necessary for the correct drying of an oil film, but any prolonged exposure to the direct rays of the sun is harmful, leading to cracking caused by too rapid or violent drying action. A normal range of temperature and humidity, such as lies within the bounds of what are considered to be average, comfortable indoor conditions, is best. Excessive heat will accelerate and cold will retard the drying process; both are detrimental to the durability of the paint. After the painting has become completely dry, it will endure a slightly wider range of temperature and humidity, and should be altogether unaffected by the absence of daylight. Cracking may be caused by extreme and rapid loss or gain of weight in the oil film; the drying curves (see chart) of linseed and poppy oils when they have been subjected to abnormal conditions of temperature, sunlight, and humidity will usually end in an abnormal loss of weight; the curves of poppy oil are always more exaggerated. An abnormally dry atmosphere will tend to cause more rapid drying and to show a curve that has abnormal characteristics; it is almost certain that this condition is detrimental to the life of the film. Even after oil paintings have become thoroughly dry, it is rather common knowledge that they should be kept in well-conditioned rooms, and that the dry air of some steam-heated rooms is injurious to them to almost as great an extent as is storage in a damp, unheated place.

Studies of the Drying of Oils. The drying curve is a means of graphically recording the changes that take place in the drying of an oil film; the vertical range indicates the percentage of gain or loss in weight, and the horizontal distance indicates the number of days of drying. It must be noted that in order to make a clear comparison an extremely good curve for linseed oil was chosen, and a rather poor curve for poppy oil, but the characteristic difference always exists in some degree. Eibner has recorded accurate details of such comparisons; the results of much similar

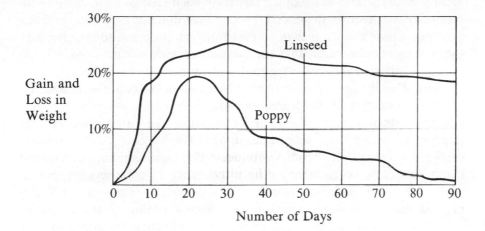

work on linseed oil, from an industrial rather than an artistic painting viewpoint, are also available in the scientific and technical journals.

The optimium behavior for a drying oil is evidently for the curve to reach its height in the shortest possible time and for the decrease thereafter to be as small as possible. As indicated in the curves, the ultimate change in the linseed oil under normal conditions is small enough that danger of failure from shrinkage is at a minimum; the amount of change in the poppy oil is dangerously near if not beyond the bounds of safe practice. As noted under *Painting in Oil* (page 157), however, the manner in which the paint is used is probably the greatest factor in its success or failure in these respects. As shown by Eibner,[163] the drying curve of linseed oil is altered in a very harmful way by an abnormally damp atmosphere, and it is likely that a film dried in an abnormally dry atmosphere is likewise weakened, although not to such a great extent. Moist air retards and dry air accelerates the speed of drying. Drying in strong direct sunlight has an injurious effect on linseed oil and a worse effect on poppy oil. The action of various pigments with the oil, and also their mechanical effect on the structural strength of the film, are further factors in the success or failure of paints. This mechanical or structural effect may be roughly compared to the effect of sand in plaster, as explained on pages 328–29. Some interesting studies on the causes of cracking in artists' paints were made by Eibner in 1920.

The loss of weight in a drying oil film appears to reach its limit after two and one-half months with the average good oil and, theoretically, varnishing can safely be done after this point. However, this statement is based on laboratory tests where thin films of the pure oil without pigment are applied to glass, and conditions in an actual painting will vary so

greatly from these as to make the results of such tests of little value as direct guides to practice. In general, I should say that it is better to varnish a painting a little too soon than to postpone the process indefinitely with the not uncommon result that the picture remains unvarnished and exposed to surface dangers for longer than was intended.

The selection of a specific type of linseed oil, the process by which it has been refined, and the degree to which it has been processed are the determinants of its successful behavior in paints. An oil is not necessarily inferior in quality because it is unsuitable for use in artists' materials; each grade is carefully produced to meet the requirements for which it has been placed on the market. The difference in cost between oils of various types of refinement is ordinarily a few pennies per gallon. Cold-pressed linseed oil has a reputation of long standing as the finest for artists' colors; but because it has so few other industrial applications, because its yield is low, and because the production of oils is based on such huge quantities, it is no longer produced in America. (See page 644.)

Sun-refined oil also has an ancient record as a desirable material for use in artists' painting methods* but a modern industrial oil chemist would probably take issue with its proponents on the grounds that it is old-fashioned and that any or all of its good properties could be duplicated or exceeded by oils refined by modern methods; yet the fact remains that it *does* perform well and has been used in easel paintings that have survived for centuries. There is a need for much modern laboratory investigation of linseed oil for artists' use, in order to establish reliable data on these and other similar points.

Yellowing of Oils. In all discussions of the yellowing of oil it must be understood, as Eibner and others have pointed out, that the matter concerns only clear oil films and the use of oils in techniques other than normal oil painting. In practical usage, correctly executed normal oil paintings do not turn yellow. The surface of protective coatings, dirt, and other removable or remediable conditions may cause browning or yellowing, but when the well-painted surviving examples of old oil paintings are cleaned of such extraneous matter, they are seldom if ever found to have suffered from yellowing of linseed, poppy, or walnut oil. It is only when the rules for correct procedure are disregarded, when inferior oils, poorly compounded oil colors, or faulty methods of application are employed that failures occur from this cause. The pigment in a well-formulated oil paint will mask any such slight changes; the proper dispersion of the pigment will prevent settling in the film or the formation of

* *Cennini,*[8] Chapter 92.

a layer of clear oil on top; and holding the oil content to a minimum and using the best kind of drying oil for the purpose will further safeguard the paint layer from yellowing or cracking.

Photochemical Embrittlement and Its Effect on the Permanence of Paintings. The longevity of a paint or varnish or any organic coating material is dependent on several factors. Once the coating has been applied to the surface and allowed to complete its drying process, it may live for five years or a thousand, depending, naturally, on many circumstances, the physical properties of the materials themselves being perhaps the most significant. Among the properties and performances of coating materials upon which their permanence depends, adhesion and flexibility are of great importance. Adhesion of an oil paint to a surface is a complex function; several physical properties enter into its perfection, one of which is flexibility, a basic property. The enduring flexibiltiy of an organic coating material is probably the greatest contributing factor toward its survival in good conditon.

In the case of oil painting it has been said that "oil is the life of the paint," because the linseed or other vegetable drying oil is the ingredient that confers flexibility on the coating. It has also been said that "oil is the enemy," but this expression taken, I believe, from a remark in one of Rubens' letters, refers to *excess* oil, a quantity over and above the amount necessary to manufacture a good oil color and to bind the pigment well, locking it into a good, tough layer that will attach itself strongly to the ground. It is not a disparagement of good linseed oil, but rather an admonition to keep the oil content of a paint down to the correct amount and not to add excess oil in a haphazard manner for the sake of some immediate improvement in ease of manipulation.

During the life span of a coating material, it is subject to many adverse influences which can eventually cause defects and blemishes, a most important one being a gradual degradation in flexibility or a progressive embrittlement during normal exposure to air and sunlight. In the case of oil paints, the chemical reactions impelled by these actinic or photogenic effects are normal factors in the drying formation of good paint films, but they are also progressive; in oil films and also in some of the other types of paints, some kind of action may continue for years.

In previous remarks concerning the addition of resinous painting or glazing mediums to oil paints, it was noted that the addition of any resin—soft, hard, or synthetic—tends to decrease their flexibility, and that therefore the well-balanced medium must contain another ingredient to compensate for this. Among the available nonyellowing, time-tested materials in general use, two heavy-bodied linseed oils, namely stand oil

and sun-thickened oil, are outstanding and are generally recommended. The theory behind such a balanced medium is that if it is not added in excessive quantities, but just sufficient to confer the desirable fluid manipulative qualities upon the oil colors when needed, such paints will have the same elasticity and other physical properties as the straight tube colors.

With some of our other accepted, proven systems of painting, such as tempera or casein painting, their inherent low degree of elasticity or flexibility is so pronounced that their use on flexible canvas is precluded, and these mediums are considered permanent only if a rigid board is used as a support. With the standard or classic uncomplicated methods of oil painting, the use of canvas is unquestioned. In centuries-old paintings, the proportions of survival in good condition and of decay are the same for canvas and wood panels.

Among the modern or scientific laboratory methods useful in establishing data on the probable longevity of paint films are the accelerated exposure tests, whereby in the span of a few hours one can obtain an indication of the relative endurance under normal or adverse conditions, over a period of years, of a group of materials of varying compositions. Much has been said and written pro and con about the use and value of such tests, but when run by experienced technicians with standardized, accurately controlled apparatus and competently interpreted, they supply us with much definite information about the tendency of various materials to resist or succumb to the effects of years of actual exposure to sunlight, oxygen, variation of temperature and moisture, and the like.

Standard tests to determine the extent to which various vehicles and mediums are apt to yellow check up very accurately with the results of actual experience. Standard tests for the loss of flexibility upon aging include exposure to the highly destructive ravages of a powerful source of ultraviolet rays at close range, which under properly controlled conditions exert a drastic and devastating effect on oil painting materials, and indicate the degree of photochemical embrittlement to be expected under natural exposure to daylight over a long period of years.

It is best to use the ultraviolet tests in a technique that has been called diagnosis, rather than post mortem—that is, to observe the time required for the first evidence of the film's breakdown, rather than expose it for a definite number of hours, or run it to complete destruction of the coating. One method is to apply the material on several small metal test panels of standard dimensions by means of an appliance which deposits a uniform layer in a controlled wet-thickness accurate to ½ mil (0.0005 inch). It is then dried under standard conditions. After several hours' exposure to the ultraviolet, one of these panels is bent over a standard mandrel in an-

other appliance, the pieces are bent at various intervals thereafter, and the end point is reached when the first cracking occurs. The results are compared with other test panels, with standard materials, or with previously obtained data.

Cleavage in Oil Paintings. Our traditional oil painting process has served artists for over four centuries and when the painter follows in the footsteps of the past and does not stray too far from the rather simple rules of procedure that have been developed over the years, it is a completely reliable and trustworthy easel painting method.

The oil painting process is generally praised above all others because of its flexibility and its adaptability to fit a wider range of artistic or creative possibilities than the other methods of easel painting. But just because there are so many variable effects available to the painter, there is sometimes a temptation to carry experiment and innovation beyond the limits of safety, as regards permanence of results.

Actually these limits are prescribed by one consideration, which is the complete functioning or operation of a single group of chemical reactions that we know by the phrase "the drying of linseed oil." If this chemical change is allowed to occur in its entirety without hindrance, in a normal manner, no reasonable variation in practice will lead to bad results. One can even go so far as to say that the other factors that contribute to the development of blemishes and defects are secondary, and a painting in which the drying-oil reaction takes place unhampered can still be permanent when they are present to a considerable degree.

One of the unhappy occurrences that painters sometimes experience is cleavage, a technical term that describes the kind of cracking in which the paint detaches itself from the ground or underpaint and drops off in flakes. It can happen to seemingly well-painted examples, and present a baffling problem to the painter, but on going over the details of his technique, he can usually attribute the lack of adhesion to some point where the normal functions of the drying oil have been rendered ineffective.

The dried oil point, as I have previously mentioned, is an *adequately* tough, durable, elastic, adherent coating but it does not possess these qualities to an illimitable degree; to perform satisfactorily it requires compliance with all the rules of correct application and the auxiliary conditions of correct painting grounds. Under such conditions it will remain permanently adhesive, but it is not in a class with other materials in this respect—for example casein, which is such a powerful glue that it may be used to join woodwork and furniture. Linseed oil is not sold in bottles in the hardware store as an adhesive, because it just isn't good enough. Conversely, durable articles are not painted with casein paint

because it is inferior in nearly every other respect to linseed oil for that purpose.

Linseed oil paint is a "plastic," not a solution that dries by evaporation and that can be reconditioned by adding more solvent when it thickens. During the chemical reactions (oxidation and polymerization) by which the fluid oil paint is converted to the solid or dry stage, it goes through an intermediate sticky or adherent stage, and it is at this point, in common with most other coating materials, that the "gluing-on" action is performed. So it is most important to get the paint onto the canvas, the panel, or the wall before this stage is reached, and not waste a good part of it by allowing the paint to arrive at the viscous stage while it is still on the palette or in the pot. This, by the way, is one of the several arguments in favor of a clean palette with fresh paint as opposed to the foul palette, which some painters seem to prefer and upon which paint is allowed to accumulate and age until its drying action has proceeded to some extent. The better tube colors, by aging and chemical means, have already been brought to the point where they are ready to work properly right out of the tube. This matter is mentioned under *Fresh Paint* on pages 5–7.

Another interference with the function of the oil-paint reaction by which the adherent stage may well be nullified is the practice of adding silica or other dry powder pigment, in order to secure a mat finish or for some special textural effect. If this works, by absorbing the surplus oil from the paint or by presenting dry or dryish particles on the top surface, what is to prevent it from also operating on the undersurface? Adhesion might also be destroyed there by preventing the oil from going through its normal drying action in sufficient contact with the ground. The whole structure of the paint layer might also be weakened by introducing tiny voids, dry points and coarse agglomerations of undispersed particles, all of which can act as nodes or starting points of cracks as the various stresses are created during the drying process of the oil paint, which normally requires a well-dispersed pigment phase in order to produce the characteristic durable paint film.

Another interference with the normal drying action of linseed oil paints is the "drowning" of colors with excessive amounts of turpentine, which would attenuate the oil layer beyond the point where normal properties are produced. The mature and experienced painter usually knows just how far he can go with turps. Another can be the use of reactive pigments that have a definitely adverse effect on the drying-oil film; again the careful painter will not use pigments that are not on the approved list. Badly proportioned paints do not give normal results either; those that are underpigmented do not have the structural reinforcement necessary to form a durable linseed oil film, while overpigmenting colors will lack

adhesion for reasons similar to those that affect the paints containing dry pigment described above. The addition of some of the essential oils used by some artists to delay the drying of their paints between working periods has been stated to cause serious interference with normal drying reactions, but more investigations will have to be made to determine just how much damage this would do under the average conditions of easel painting. The general consensus is that the most durable paints of any type are those that go through their drying process in a normally prompt and undisturbed manner.

Departure from normal conditions of the simple time-tested rules of application can also lead to the development of other defects in which no cleavage occurs, such as ordinary cracking (the division of a paint layer into areas bounded by sharp, fine lines of separation) and fissures in which the separation of the "islands" of paint are wide and ragged, exposing the underpainting or ground. The addition of inherently bad materials (e.g., Vandyke brown or asphalt) can be one of the several causes of these defects, as can the overpainting of high oil absorption colors (prone to greater shrinkage) with the less distensible low-absorption colors. However, these types of cracking, sometimes called age cracks, are not necessarily accompanied by complete absence of adhesion.

INFLUENCE OF THE GROUND OR UNDERPAINTING

Besides the absence of an adequately adherent or gluey property of the paint itself, permanent adhesion can suffer from lack of two normal attributes in the ground, one or the other of which (and preferably both) should be present to some extent. They have a direct bearing on the drying reactions of the oil and have been part of the rules for oil painting as far back as rules are recorded.

One of these is the presence of a degree of close, almost microscopic granular roughness of surface in the ground or underpainting, known to painters as tooth. Tooth assists the bottom surface of the paint layer to grip its base securely while it is setting and hardening, causing it to stay in one place even when a considerable degree of contraction and shrinking occurs. The coarse texture of heavy, impasto brush strokes, ridges, and furrows of undercoats does not necessarily supply tooth; the surfaces of such textures can be just as slick as those of level ones and cleavage sometimes occurs on them also. The experienced painter does not apply fresh coats over slick and glossy surfaces but gives them tooth by scraping, by rubbing with pumice, or by similar means.

The other aid to the permanent adhesion or anchorage of oil films is some degree of absorbency in the ground—for the sake of clarity I should

say a very slight degree of absorbency in what is ordinarily called a non-absorbent ground. The definitely absorbent grounds, such as insufficiently sized gesso and the "semiabsorbent" canvases of the shops, will draw too much oil out of the paints and leave the pigment particles insufficiently bound, thus inviting another type of defect. A good oil ground has just enough of this faint absorbency to give at least some small penetration of the fresh paint into the surface.

The best-quality ready-made regular or normal canvas has these properties to the correct degree, and so has the homemade canvas prepared by applying a thin glue size to closely woven, stout linen and applying one or two coats of white lead plus 3 fluid ounces of turpentine to the pound.

As the experienced painter knows, the two ground properties just mentioned are doubly important, as they also take the colors from the brush properly and allow free manipulation of the paint in a satisfactory manner; in the traditional painting techniques, these ideal adhesive structural properties of a painting surface coincide with ideal manipulative properties.

LITHOGRAPHIC VARNISHES

Lithographic varnishes, from which many types of inks for other printing purposes are also made, are heat-bodied linseed oils, very much like stand oils. A mixture of commercial litho varnishes of various degrees of viscosity will give results entirely different from those of a single, straight varnish of the required consistency, because many of the physical properties of an oil such as adhesion, leveling, tackiness, and wetting power, are appreciably changed and altered the more the oil is cooked and bodied. The mixtures will therefore consist of what we may consider different substances, or oils of different properties, rather than of merely heavy and light variants of the same oil. The thickening of drying oils is due to an increase or decrease in some sort of colloidal condition as well as to molecular rearrangement and oxidation. Recipes call for mixing various proportions of several litho varnishes, not because a single varnish of the required viscosity cannot easily be made, but because such mixtures will give different results.

The difference between a stand oil and a litho varnish is not very great, but stand oils especially prepared for paints will give better and more certain results, and litho varnishes should not be substituted for them. Litho varnishes are often set on fire for a while, as part of their process of manufacture; such a burnt oil can be distinguished from stand oil by its odor.

ACID NUMBER

Oils and resins are, as previously defined, variable mixtures of highly complex organic chemical compounds, among which are acids or compounds of an acid nature that are capable of reacting chemically with alkalis under the proper conditions, although they are not strongly reactive substances as compared with the familiar mineral acids. For purposes of classification and comparison, and as an index of technological behaviors, an established, standard laboratory method of measuring the total amount of such reactive compounds is used; the result is expressed in a figure termed the acid number. Refined linseed oils of low acid number usually run about 1 to 3, paint-grinding oils from 5 to 10, but one should insist that the pH read no lower than 6.5. This can be tested by using an archivist's pencil. (See *Conservators' Supplies*, p. 639.) The alkaline substances, usually calcium carbonate or magnesium carbonate, are added because the natural decay of paper produces acids which in turn speeds up its decay. The alkaline substances can absorb these acids and thus form a reserve of resistance against future decay.

IODINE VALUE

The term "iodine value," which is often encountered in descriptions of oils, fats, and waxes, refers to the result of a standard laboratory test. The unsaturated fatty acids of these materials will absorb iodine; the iodine number is the percentage of iodine absorbed; hence it signifies the proportion of these fatty acids, and its magnitude is an indication of the purity and film-forming or drying quality of the oil.

Perilla oil is the only one of these materials with a higher iodine number than linseed, some samples of it running over 200. Cold-pressed raw linseed oil has an iodine value of 177–189. Lewkowitsch[164] places walnut oil far down on the list, with an iodine value of 145, and poppy oil still lower, at 133–143.

PARTICLE SIZE

Modern pigments are produced to conform to the requirements of the purposes for which they are used, and all the paint pigments must pass through a No. 325 screen. This means that for proper dispersion in the various liquid paints no further reduction in the particle size of a pigment is required. Paint mills have a different purpose, as discussed in Chapter 3. It is *dispersion*, not *reduction of particles size;* squeezing, not crushing.

Particle size of pigments is controlled during their manufacture or processing. Paint technologists call the milling process dispersion; artists prefer the term "grinding" because it relates to the hand and muller action. Some pigments are smooth, soft, and finer than the maximum particle size, some retain a sharp, gritty character even when they are finely grained, but all good pigments must conform to certain standards of uniformity. The study of the particle size, the particle-size distribution, the bulk, the wettability, and other physical properties of pigments has become an important element in modern paint technology and in the production of good paints.

DRIERS

The drying or the acceleration of the drying of oils by the addition of driers has been variously explained since the oxidation of oils was recognized early in the nineteenth century. The most convenient statement in the recent past has been that such action is catalysis, the drier acting as a starter or accelerator of the reaction without entering into it. Certain actions of paints and varnishes that contain driers, however, contribute to the theory that the reaction is more complex. It has been pointed out that all the salts that act as driers are those of polyvalent metals, indicating that the process involves a change from one form of molecular arrangement to another; the gelation of an oil film involves reactions of a colloidal nature which also have a bearing on the drier's action. If oil is painted out upon sheets of metal, it is well known that certain metallic grounds inhibit or retard its drying action, while others accelerate it; those substances that retard, such as zinc, are called antioxidants. Progressive drying is a term applied to the continued action of a drier upon an oil film after its primary purpose (that of producing a solid film) has been accomplished; driers that display this characteristic to a marked degree have a harmful effect on the durability of the film.

Driers containing lead or other materials that are sensitive to external conditions will impart the same color effect to the final paint as though a lead or other susceptible pigment were used. Driers are, as a general rule, more satisfactory in artists' paints when put into solution and added to the finished oil or medium than when cooked into the medium. The normal drying action of a pigment that produces satisfactory films with oil, such as white lead or umber, is very much more desirable than the action of added chemical driers. Note the precautions concerning the use of driers on pages 201–202.

Colors ground in poppy oil require more driers than linseed oil colors to accomplish the same effect, but because the poppy-oil film is less dura-

ble than that of linseed, excessive amounts must be even more carefully restricted. Manufacturers of prepared artists' oil colors add driers to some of the slow-drying pigments, but the careful maker holds these additions to a minimum, the aim being not to make all the pigments dry in the same length of time but to bring the rate of those that dry very slowly closer to that of the rest of the palette.

RESINS

The composition of resins varies considerably; those usually classified as balsams and also a few of the "gum resins" contain benzoic and cinnamic acid; rosin is largely abietic acid and a substance called resene. Resene appears to be the ingredient that imparts durability to the harder resins. The harder copals, damar, and sandarac consist of their particular characteristic resin acids plus resene; the pine exudations have a more complex composition, containing these materials plus volatile liquids and some resinates (esters of rosin acids). The synthetic resins are products of several different complex reactions; they are outlined on pages 188–94 and are discussed in detail in the standard technical books listed on pages 683–84 and 686–87.

SYNTHETIC RESINS

On page 189 the statement is made that the artist or nonprofessional experimenter cannot deal with the problems involved in the development of new easel or mural painting vehicles or mediums. The properties of each specific grade or variant of any class of synthetic resin are predetermined by its molecular structure, by variations in its basic and modifying ingredients, and in some cases by the solvents used. Each of these products is designed or engineered to meet the requirements of the industry for which it is produced in commercial quantities; in other words, it is a "tailor-made" material with exactly the right chemical, physical, and performance properties built into it to make the best possible machinery enamel or boat paint or floor varnish. So far no resin has been made or designed especially to meet artists' requirements.

The second half of the job, the compounding of existing raw materials into a finished product, is no less a task, involving many perplexing problems that can be solved only by a competent technical staff working in a properly equipped laboratory with the accumulated data, skill, and experience that is the full-time work of specialists.

An enormous amount of development work is continuously in process in the industrial laboratories; materials are frequently rendered

obsolete and newer resins and techniques may very well replace those presently thought of as suitable for artists' purposes. (See pages 401–406.)

SYNTHETIC ORGANIC COLORS

The synthetic organic pigments are considered to date from 1856 with the discovery of Perkin's violet (mauve), although picric acid, a yellow dye for wool, was made by Woulfe in 1771, and a red dyestuff called rosolic acid was made by Runge in 1834. The development of organic chemistry since the last half of the nineteenth century has produced dyes and pigments of every conceivable color, shade, and nuance, and, in our own time, more than three dozen pigments whose fade-resistance under long outdoor exposure to direct Florida sunlight, under scientifically controlled conditions, makes them eligible for consideration as artists' colors.*

Raw Materials. Synthetic organic dyes and pigments are made from five basic raw materials: benzene, toluene, xylene, naphthalene, and anthracene. These are aromatic hydrocarbons produced by the distillation of coal tar—a by-product of the coal-gas and coke industry—and from some petroleum residues.

Intermediates. In the manufacture of organic products the raw materials are first converted to compounds known as intermediates, by a number of reactions such as nitration or addition of nitro groups (azo 2), and by the addition of sulphonic groups (SO_3 $_H$H), hydroxy (OH), carboxyl (COOH), and halogen (Cl, Br, I) groups. The various dyes and pigments are made by combining these intermediates in various ways. A few of the great number of intermediates are aniline, anthracene, beta naphthol, and benzaldehyde.

The synthetic organic dyes and pigments may be classified into groups of families according to their molecular structure and the methods by which they are manufactured, as outlined on page 411, where this subject is continued.

VOLATILE SOLVENTS

Turpentine. Turpentine and the other products of pine distillation, such as wood turpentine, pine oil, dipentene, and terpineol, have the property

* Vesce, Vincent C. "Exposure Studies of Organic Pigments in Paint Systems." *Office Digest,* Federation of Societies for Paint Technology, Vol. 31, No. 419, Part 2, December 1959.

of polymerizing upon aging and passing into other heavier, more viscous forms that are less volatile and usually have a less agreeable odor. The action is more rapid in the presence of sunlight, air, and moisture, and it is usually accompanied by oxidation. This is the reason fresh materials are always recommended and are best preserved in full containers, brown bottles, or tins.

These spontaneous reactions occur very slowly; when turpentine is used as a thinner for paints and varnishes it evaporates much too rapidly for any of them to take place; it is therefore just as inert, and has the same indifferent effect upon paint films, as its petroleum substitutes. These remarks apply only to the fresh product. Turpentine that has undergone changes by reason of long storage is easily recognized upon examination; if it has lost its pleasant odor and acquired a disagreeable sharpness, or has become viscous and gummy, it should be discarded. Containers in which turpentine has undergone these changes should be well rinsed out or discarded; a small amount of gummy residue may affect a fresh supply or speed up its reactions.

Turpentine should be kept in full, tight containers away from light; but its preservation is seldom a matter of much concern because of its universal availability and because the average painter will consume his supply rapidly.

Turpentine is almost a pure, refined chemical; it contains 92 to 96 percent of a compound known as pinene. Wood turpentine usually contains, in addition, appreciable amounts of dipentene. Pine oil is largely terpineol.

Evaporation of Solvents. The mechanism of solvent evaporation and the variable degrees of solvent retention by various lacquer, varnish, and paint films has been studied extensively by industrial paint technologists, and it is an important element in the formulation and manufacture of varnishes. Among the principal factors involved are the molecular structure of the film and the physical properties of the solvent.

WATER

The role of water in the various processes of the artist is considerable, yet it is often overlooked. Water is probably the greatest or most universal solvent; hence it is easily subject to contamination. Pure water will dissolve and hold, in minute quantities, substances which for all practical purposes we ordinarily consider insoluble. All natural waters from springs, wells, lakes, and rivers, such as are used for general water supply, contain varying amounts of salts that have been dissolved from the rocks

and earths with which the water has come in contact. Everyone is aware of the fact that excellent drinking water is often unfit for certain uses; for instance, it cannot be used in storage batteries because of the salt it contains. Hard water—that is, water with a relatively large amount of calcium salts—cannot be used for laundry work or in steam boilers without first being treated chemically.

Writers on watercolor technique usually recommend distilled water, which is chemically pure, because the salts in ordinary water are liable to break up the fine dispersion of some colors, causing agglomeration of particles, or graininess; also because of the minute cloudy or whitish film that such salts may deposit on drying. Practical watercolor painters, however, usually disregard this precaution as an unnecessary overrefinement unless the water supply happens to be unusually bad in this respect.

It is avisable to use distilled water in the preparation of tempera emulsions; small amounts of mineral salts have a bad effect on the formation and stability of emulsions and colloidal solutions. Rainwater is free from mineral salts but not altogether reliable, as it has plenty of opportunity to pick up impurities, especially if it passes through polluted atmosphere.

Fresco painters always are very careful to use nothing but distilled water, because experience shows a decided danger to the surface effect from the introduction of small amounts of impurities. Also, mineral salts may easily interfere with the colloidal nature and hence the plasticity of the mortar.

Water may act as a destructive force on all sorts of paintings, either by coming into direct contact with the paint film from the front or rear, or in the form of atmospheric moisture. For this reason, new plaster walls must be allowed to become thoroughly dry before oil paint or adhesives are applied to them. According to the best practice, it is advisable to wait at least three months before the application of ordinary oil paint to new walls; for permanent artistic painting and permanent adhesion of mural canvases, one must be even more careful; as much time as two years has been recommended. Plaster applied directly to exterior walls presents a very doubtful surface for permanent painting.

The destructive alkaline reaction of plaster walls upon paint coatings diminishes with the aging of the plaster. In industrial practice, when circumstances make it impossible to allow sufficient time for this purpose, the walls are neutralized by applying a solution of zinc sulphate of about 20-percent concentration; but aging is preferable. When a wall is completely dry, the alkaline action of the plaster has much less effect upon paint coatings; moisture is necessary to cause a reaction between the alkali and the paint. According to some experienced workers, 3 percent of

moisture is the maximum allowance for correct procedure; according to others, 5 percent is permissible.

An old method of testing the moisture content of a wall is to affix a sheet of gelatin to the wall by its upper edge; the moisture in the wall (and in the atmosphere as well if it is not a dry day) will cause it to curl up; if this occurs within five minutes the wall is too damp. The modern method is to use specially constructed moisture meters; some of these are described in Gardner's book.[205] The usual moisture meter is based on electrical resistance: it measures the electrical resistance of a solid material and compares it with that of a standard built into the apparatus. Some models are designed for testing plaster, others for wood. The modern moisture meter is a convenient and accurate instrument; it resembles a portable radio in appearance and is operated by a battery within the box. There is a dial on the outside of the box, and a contactor at the end of a cord. When the contactor is held against a plaster wall, the meter indicates whether or not that area is dry enough for painting or adhesives. Somewhat larger models will also test the dryness of lumber, plywood, textiles, and other materials. The meters operate upon principles which ensure their accuracy under variable conditions.

TEMPERA EMULSIONS

As stated before on page 438, the published data on the theory and practical applications of emulsions are not very complete, and there have been no exhaustive studies of the subject from a tempera-painting viewpoint. Most of our opinions are based on observations of an empirical nature and adapted from theoretical and industrial researches; as a result, we are still somewhat in the dark as regards a complete control over the practical technology of emulsions as applied to artists' paints.

When a tempera emulsion dries, the oil globules seem to disperse into a homogeneous mass with the water-soluble and stabilizing ingredients, so that the film takes on the character of a clear solution of these ingredients in an oil film. Laurie[51] says that the oil content alone should be sufficient to bind the pigment; as noted previously on page 132, this amount is really quite small compared with the amounts we are accustomed to employ in paints in order to grind and apply the colors. He describes some experiments to determine how much oil, according to this theory, should be added to artificial emulsions. Equal amounts of pigments are ground with different amounts of oil (thinned with turpentine to make grinding possible), until the amount of oil that will produce an adequate bond is discovered. To this suggestion might be added the remark that a good starting point for such experiments could be obtained by grinding

a measured amount of pigment to a very stiff paste with oil, then adding an equal amount of pigment ground with turpentine; for in the case of the average pigment, 50 percent of the volume of oil necessary to grind the paste is not far from the amount necessary to bind the color.

The proportion of oil to pigment thus arrived at is then to be used as a starting point for experiments in adding various amounts of the aqueous ingredient. It must be understood that this whole method is a theoretical one, to be used as a basis for experiments rather than accepted as a regular procedure. In most cases it will be found that for the production of an emulsion which is of any practical value as a painting medium, the amount of water or water solution will have to be considerably greater than these theoretical figures indicate. Pure egg yolk, which yields a satisfactory but none too hard film, contains only about one-fourth or less oil by weight.

Composition of Hens' Eggs. The chemistry of egg ingredients is extremely complex. Almost all of the published researches on eggs have been done from the viewpoint of nutrition and not in relation to their technical uses. The following data have been adapted from various food sources. The percentages given are average and approximate.

Whole Egg

Water	73.0%
Water-soluble ingredients	14.5%
Oily ingredients	12.5%

Yolk

Water	49.0%
Water-soluble ingredients	17.5%
Oily ingredients	33.5%

White

Water	87.0%
Water-soluble ingredients	13.0%
Oily ingredients	a trace

TYPICAL ANALYSIS OF HENS' EGGS

Yolk

Water	49.5%
Fat	18.0%

Lecithin and allied substances	11.0%
Proteins	14.5%
Dextrose	0.3%
Cholesterol; lutein; other substances	5.7%
Ash	1.0%

White

Water	86.2%
Proteins	12.7%
Dextrose	0.5%
Ash	0.6%
Lecithin, cholesterol, egg oil	traces

Egg oil is a nondrying oil which imparts desirable properties to the tempera film. It is carried along by the powerfully drying and adhesive proteins to produce a film that becomes dry.

The proteins in egg are complex; they are almost all of the type that coagulates upon being exposed to the light and air in a thin film. They are usually grouped together and referred to as albumen.

Albumen is an efficient stabilizer of oil-in-water emulsions. The egg oil and the albumen are the principal ingredients of the egg tempera film; the other substances contribute auxiliary properties.

Lecithin is a still more powerful stabilizer of oil-in-water emulsions than albumen, and tends to form permanent, finely dispersed emulsions in many natural animal and vegetable products. It is classed as a lipoid, lipoids being a group of natural organic substances that have many of the properties of fats. It occurs in egg oil together with other similar compounds of which it is the principal one (about 10 percent of the yolk).

Lecithin from vegetable sources (principally soya beans) and from egg is produced commercially; also egg oil that has been expressed from hard-boiled eggs. These have been applied with little success in the production of paints, but are used to considerable extent in the tanning of leather and other industrial processes, and also as an emulsifier in various edible products.

Cholesterol, another lipoid or fatlike substance, is an important constituent of many animal glandular products and is a recognized stabilizer of the opposite, or water-in-oil, type of emulsion. Lutein is a fugitive yellow coloring matter; chemically, it is almost identical with many vegetable yellows. Dextrose is a form of sugar commonly called grape sugar. The ash is the residue left after the egg has been ignited; it consists of inorganic or mineral salts of some variety.

In the study of emulsions it is recognized that cholesterol and lecithin have an "antagonism"; lecithin absorbs water and acts as an oil-in-water stabilizer, while cholesterol tends to stabilize the water-in-oil type of emulsion. The process of both of these materials might possibly have some bearing on the erratic action of egg-yolk/linseed-oil emulsions mentioned in Chapter 4.

Tempera emulsions or painting grounds containing wax, egg yolk, or (especially) casein will invariably turn yellow if they are emulsified with ordinary linseed oil; they will turn less yellow with poppy oil, and least yellow with stand oil thinned with a little turpentine. Correct procedure thus seems to prohibit, in general, the use of these animal products with vegetable drying oils. The yellowing is usually attributed to the action of water on the glycerides of the oil during the drying process, but it is quite likely that it is increased by the action of some substance that is common to most of these animal products, because other emulsions of linseed oil, such as gum tempera, do not turn yellow to such an extent, if at all. When linseed oil is emulsified with casein the yellowing is so pronounced that casein/linseed-oil emulsions are forbidden by all careful investigators; when it is emulsified with egg, the yellowing is slight enough to be controlled and kept to an acceptable minimum; nevertheless it is present.

An emulsion is usually made by pouring one of the ingredients into the other in a thin stream while stirring the mixture vigorously. In general, they are best made when both phases are of rather heavy or viscous consistency. Some emulsions will not combine without the vigorous agitation of a mixing machine, and most of them will not remain in suspension or contain very finely divided droplets unless given a complete and thorough mixing. The most convenient apparatus for the manufacture of small quantities of emulsions is an electric mixer such as is sold for household use, and if it is of the type that can be held in the hand as well as placed in a stand or holder, its usefulness is increased. Care must be taken to keep both motor and stirring blades clean; the stirrer should be cleaned and dried after each using, and the motor oiled regularly. Do not allow the cord to come into contact with liquids. The shape and size of the container should be in proportion to the amount of liquid used. If the container is quart-size or smaller, from three to five minutes' mixing with one of these little machines will usually be sufficient. When small batches are wanted—4 ounces or less—emulsions may be more conveniently made by shaking the oil and aqueous ingredients together in a tall bottle no more than three-quarters full. Oil-sample vials or the common 8-ounce or 4-ounce nursing bottles that are scaled in half ounces are convenient. Emulsions may also be made by mulling the oily ingredient drop by drop into the aqueous ingredient on a slab. On a large industrial scale,

all three of these principles are used, but usually an industrial emulsion is considered crude or incomplete until it has been put through a second very powerful machine that makes the emulsion more permanent by decreasing the size of the particles. An ordinary egg beater and jar are a less convenient but often adequate substitute for the electric mixer.

When a wax is to be emulsified it is melted, and the water or aqueous solution, warmed to a temperature above the melting point of the wax, is added in a thin stream with constant agitation. If the solution is allowed to cool too much, the wax will solidify upon coming in contact with it, and the emulsion will not be formed. A solid with a melting point higher than that of boiling water may be emulsified by melting it and thinning it to a liquid form with an oil or volatile solvent, if such a mixture is suitable for use in the formula. All the waxes melt below the boiling point of water and can be melted in a water bath, but when they are mixed with resins, the mixture requires direct heat.

Some of the modern synthetic industrial emulsifiers may eventually prove to be well suited for the preparation of painting emulsions of improved behavior and stability.

GLUES AND GELATIN

Properties and uses of glues and gelatin are discussed under *Gesso Grounds* in Chapter 5 and on page 390. That the chemistry of these products is not well established and the control of their manufacture is largely empirical will be gathered from the statements in those sections.

From the maker's viewpoint, gelatin is simply a pure form of glue, made from more delicate animal tissues and refined with greater care and cleanliness than is ordinary glue. Chemically, the complex proteins of which glues are composed can be grouped roughly into two classes, sometimes called chondrin and glutin; the former is responsible for its adhesive properties and the latter for its gelatin. Glue contains more chondrin and less glutin than gelatin.

Technologically, the difference between glue and gelatin is considerable. The user of both of these products regards gelatin not as a purified glue, but as a material of the same origin, with similar properties, especially when used as a size, but of different behavior when used as an adhesive or binder. The difference in composition involves colloidal as well as chemical properties, and the behavior of each of these materials as an adhesive or as a constituent of a binder of film-forming medium is different from the behavior of the other. The best grade of bone glue is inferior to all but the very lowest grades of hide glue.

The highest-grade gelatin will make the stongest jelly, but its binding,

adhesive, and finishing properties will not equal those of the high-grade skin glues. Rabbitskin glue has the correct balance of properties for use in gesso. The calfskin glues are so pure that they may be considered gelatins from the manufacturers' viewpoint; nevertheless, they have the adhesive strength of hide glues and are also balanced enough for use in gesso. Selection of a glue for technical purposes is usually based upon the correct balance of properties rather than upon one desirable property. A heavy viscosity in the liquid state is apparently considered an indication of a glue's adhesive strength, and is also a desirable quality for uses where too much penetration is not wanted, as in application to cloth when it is undesirable for the liquid to soak entirely through to the other side of the fabric. The jelly strength is a definite indication of a glue's value for sizing, gesso, and some other binding purposes.

Glue, gelatin, casein, albumen, egg white and yolk all belong to the same class of products of animal origin (proteins). One of the properties that members of this particular group happen to have in common is the ability to form viscous colloidal solutions in water; and one of the reactions some of them display is a property of being coagulated or denatured when exposed to certain conditions, such as heat (as in hard-boiled eggs) or air and sunlight (as in drying of egg tempera). Glue dries and hardens to form adhesive or binding layers, but none of its original properties are changed, and subsequent application of water will redissolve it. Casein forms similar dry films of adhesive or sizing qualities, but these films are not so completely soluble in water. The dried product resembles the original casein, which did not dissolve without ammonia; it is therefore very definitely more resistant to moisture than is glue. It is a mistake, however, to consider casein films or paints completely waterproof. Compared with those of glue, they are merely more resistant to disintegration by moisture—in many cases sufficiently resistant for certain purposes where glue would fail; but casein paint films and gesso may be picked up or disturbed by water to a considerable extent.

Glue and casein paint films, putties, gesso, and the like may be enormously improved, to an extent that will render them more impervious to atmosphere moisture (and for all practical purposes to applied water or aqueous mediums if these are carefully handled and not scrubbed in), by the application of certain chemicals that have the property of toughening, hardening, or tanning them. Here again, the resulting surfaces are sometimes inaccurately called waterproof; their resistance to moisture is increased appreciably, but water, although it will not completely destroy them, can, if not carefully applied, damage them severely. The differences between glue and casein hold true in tanned products: the chemically hardened casein is proportionately more moisture-resistant than the

chemically hardened glue. In industrial use, solutions of the following materials may be added to the batch or sprayed onto the surface to harden glue and casein films: alum, chrome alum, sodium or potassium bichromate, and tannic acid. But although these chemicals are or have been used industrially, they are not to be recommended for materials for permanent painting, because their products will remain in the film; therefore more volatile substances are employed for artists' purposes. The best hardeners belong to a class of completely volatile materials (ketones and aldehydes) of which formaldehyde is the most widely used example; the best hardener for casein, glue, or gelatin is a 4-percent solution of formaldehyde, which is brushed or sprayed directly onto the film. A 40-percent formaldehyde solution is universally obtainable in drugstores, usually under the name of formalin. Its highly penetrating, unendurable fumes are familiar to most people through its use as a fumigant; however, when it is diluted with 9 parts of water to give the 4-percent solution, it can easily be handled and there is no irritating effect on the eyes and throat.

Acetone also has a powerful coagulating or flocculating effect on casein and aqueous colloids in general, but it is not generally used in this connection; no controlled definite recipes for its application as a hardener of such films are in circulation.

All of the above-mentioned materials can be added directly to glue or casein liquids so that they will harden to tough, water-resistant films, but the disadvantages of the films containing such active chemicals are obvious. The behavior of glue and gelatin is tricky and erratic in this respect; such hardening materials must be added to them just prior to use, and must be very delicately controlled. There is less difficulty in the case of casein; the commercially prepared adhesives described on pages 387–88 contain many such materials, and the industrial flat casein wall paints sold in paste or powder form usually contain lime, which not only assists in their solution but has the property of increasing their resistance to washing. For permanent artists' materials, spraying with the formaldehyde solution is the only approved method of hardening or tanning casein or glue films. A recipe for the addition of formaldehyde to a casein solution is given on page 385. Great care must be used in mixing.

It is neither necessary nor desirable to heat glue or casein over 160° F; heating to the boiling point is definitely destructive and spoils the product for use in any exact formulas.

The addition of small amounts of alum (about 5 percent) to hide glue or gelatin in order to harden it and render it less hygroscopic, for use as a sizing for paper and for other uses requiring weak concentrations, is a procedure that has been employed effectively since early times. It is not

used with bone glues; when alum is added to a solution of bone glue the solution becomes muddy or turbid. This is used as a test to distinguish hide from bone glues. For modern synthetic resin glues see page 417.

PLASTER OF PARIS AND GYPSUM

When native calcium sulphate (gypsum, $CaSO_4 \cdot 2H_2O$) is roasted at 212–374° F, it loses three-fourths of its water of crystallization and becomes $CaSO_4 \cdot \frac{1}{2}H_2O$, the familiar plaster of Paris. When mixed with water to a plastic consistency or a heavy cream, it takes up the 1½ parts of water again and, when dried, hardens to a uniform solid mass that is inert and no longer reacts with water. If plaster of Paris is soaked in a large excess of water, enough so that it settles to the bottom of the vessel instead of forming a paste, it will take up the water and become inert in the form of fine particles without solidifying to a continuous mass. The material has enough hydraulic characteristics to set, at least partially, under water; therefore it must be stirred often during the first thirty minutes of slaking, and once every day until it is smooth and creamy, after which setting will not occur. Chemically, both the slaked and the hardened plaster of Paris are the same as the original gypsum, but they differ from it and from each other in crystalline structure.

Use in Gesso. As noted under *Gesso,* Cennini used slaked plaster of Paris as a pigment for gesso. The painters of his day and locality used it because it was the most brilliantly white, inert, and pure material of its type widely available; but when whiting in uniform, pure grades became an article of commerce, it replaced this material. The very fine Paris white was a further improvement, and precipitated chalk, a still later one. In accounts of other countries and times, chalk is as frequently mentioned as gypsum or plaster of Paris for use in painting grounds.

A chemically precipitated calcium sulphate is also available; under the microscope, the particles of this variety show up as long, needle-shaped crystals that have a tendency to mat or felt with each other. For this reason some writers of the past have recommended slaked plaster of Paris for producing a gesso of superior durability or elasticity. Finely powdered native gypsum and slaked plaster of Paris, however, do not have this monoclinic crystalline structure to any marked degree; moreover, it is extremely difficult to obtain any of these products in a pure state, free from lime or other alkaline impurities.

Pure plaster of Paris when mixed with an equal volume or about one third its weight of water will set rapidly, becoming hard and solid in five to fifteen minutes. This is the reason why plaster of Paris is used for

molding; the speed of its setting is greater than that of the evaporation of water, hence there is no shrinkage. Most other plastic materials shrink upon setting. Plaster of Paris hardens best in a dry atmosphere. It sets because of its slight or partial solubility; the small amounts in solution crystallize out and interlock or cement with the insoluble particles in a way similar to that in which lime sets. The addition of as little as ¼ of 1 percent of hide glue will delay its setting for two hours; fish glue or any sort of viscous glue solution will retard the setting of plaster. Slow-setting and medium-setting plasters are sold ready-mixed with retarding ingredients. Gypsum and plaster of Paris were used in the earliest primitive civilizations.

Keene cement is a thoroughly burnt gypsum from which all the water of crystallization has been driven, and it contains additions of alum or other salts. It dries to a very hard mass and is used as a patching plaster for walls and in places where the surface may be subject to much wear.

SOAP AND SAPONIFICATION

Soap is made by boiling an oil, fat, resin, or wax with an alkali. The water-soluble soaps used for washing purposes are made chiefly from vegetable oils and animals fats. A carefully made neutral soap, such as cake shaving soap, Ivory, Lux, etc., contains no alkali; however, when it is mixed or dissolved in water, a minute amount of alkali is produced by a chemical reaction (hydrolysis)—sufficient in many instances to alter the surface color effect of a painting. The principal action underlying the functioning of soap as a detergent or cleanser is generally supposed to be a colloidal one; the various theories that have been advanced are based on various interpretations of the chemical nature of dirt. The particles of dirt are usually considered to be more strongly attracted by the soap solution than by the substance they stain.

The removal of varnish from paint with soapy water is clearly, from observation, a process of solution, accompanied (or preceded) by some saponification, which is probably the most essential part of the action. Disadvantages of the use of soap for this purpose, other than those enumerated in the discussion of the cleaning of oil paintings, are: (1) color particles are drawn into the soapy solution from an otherwise seemingly unaffected film, (2) soapy water seeping into cracks does far more harm than plain water, and (3) the presence of dirty suds hinders visual control of the progress of the work. Some of the modern detergents have been used by restorers; this development is now being carried on.

Some dirt films are attached by superficial adhesion, some by absorption; those of an oily nature can be removed by aqueous solutions only

when they are emulsified by soap, or saponified (made into a soap) by free alkali. Free alkali will attack and sometimes destroy absorbed layers.

The so-called metallic soaps, whose manufacture also involves the saponification of oil materials but which are insoluble in water, are described on pages 184–85.

LITHOGRAPHY

From the period of the development of the lithographic process down to recent times, the chemical principles underlying the various attractions and repulsions peculiar to lithography were not entirely explained in a way satisfactory to workers on the subject. The usual explanation that the free fatty acids combine immediately and directly with the stone to form calcium oleates, etc., and that the natural acid of the gum formed arabinates, was not convincing to those who were familiar with the feebly reactive nature of the acids of oil and gum. The improbability of the occurrence of such reactions with infallible precision under the variable conditions present in lithographic practice has been noted, but not studied until comparatively recent times.*

The conditions set up in the stone are not caused by superficial coatings of oleates, arabinates, and other products of reactions which could be dissolved with solvents, but are permanent effects in the stone itself that are produced chemically and can be removed only by mechanical means, that is, by grinding the layer completely off the stone.

The action, according to modern investigators, is adsorption, a reaction referred to in the first part of this chapter. Many substances, particularly when their surfaces have been recently and carefully cleansed, have the property of adsorbing layers of acidified gum arabic and lithographic crayon to produce conditions under which lithography is possible. According to this theory, an adsorbed layer of fatty acids is formed under the crayon marks, and nonpolar deposits incapable of adsorbing fatty acids are set up on the rest of the stone by the acidified gum arabic of the etch. These layers are so thin as to be immensurable; it has even been suggested that they are monomolecular, because of certain theories of adsorption.

The animal and vegetable oils, fats, and waxes of the lithographic crayon contain fatty acid molecules, which are capable of forming orientated layers, as previously described in this section under *Adsorption.* If

* Tritton, F. J. "A Study of the Theory of Lithographic Printing." *Journal of the Society of Chemical Industry,* Vol. 51, pp. 299–306, 307–313. London, 1932.

pure mineral oil, which has a different molecular arrangement, is applied to a sensitive stone, it will not set up a lithographic printing condition; if minute amounts of fatty acid are added to it, a very slight smudging effect will be produced, because the material then contains some traces of orientated acid molecules. These facts contribute toward the proof of the present theory.

The reason why lithographers have found it wise to allow the etch or gum solution to dry before washing it off is that a very concentrated solution of gum is required, and this is most easily obtained by allowing the solution to dry down on the stone.

The operation known as rolling up is important, because it speeds up and completes the process of adsorption by means of mechanical pressure, an established way of accomplishing this.

ETCHING

Preceding remarks on the nature of acids will throw some light on the reason for accurate formulation of etching mordants, as regards both choice of acids and concentration.

In the first place, a certain optimum dilution with water is required to secure the proper dissociation or ionization of an acid so that it may act most efficiently on a metal. An extremely violent action is not desirable, because it would be uncontrollable and probably erratically uneven, and also because the force of the bubbles of a violent ebullition and the heat generated thereby would have a mechanically destructive effect on the fragile coating of the material used as a resist, particularly where there are delicate lines.

Sometimes when a metal is immersed in a full-strength acid—for example, zinc in concentrated sulphuric acid—the metal becomes almost immediately coated with the end product (zinc sulphate), which effectively protects it from further action by the acid. If the acid were diluted with water, this salt would go into solution as soon as it was formed, and the metal would remain clean and exposed to the action of the acid as long as desired.

On the other hand, a too dilute solution is also impracticable: the length of time a plate would have to remain immersed or in contact with the acid would eventually cause the ground or resist to be affected; and the etcher also wants a certain amount of continuous bubbling to occur so he may know how the reaction is proceeding and thereby be in control of it. False biting through the failure of the resist in spots can be

immediately observed by the bubbling, and steps can be taken to stop it by rinsing the plate, drying it, and giving these places an additional touch of acidproof varnish or resist.

Copper is much less reactive chemically than zinc; comparatively, it can be classed among the inert or durable metals.

HYDROLYSIS OF ETHYL SILICATE

Ethyl silicate is hydrolyzed with water to produce silicic acid and ethyl alcohol; the silicic acid in turn dehydrates to an amorphous form of silica that is extremely resistant to most chemicals and heat.

$$Si\begin{cases} OC_2H_5 \\ OC_2H_5 \\ OC_2H_5 \\ OC_2H_5 \end{cases} + 4H_2O \rightarrow Si\begin{cases} OH \\ OH \\ OH \\ OH \end{cases} + 4C_2H_5OH$$

(Tetraethyl orthosilicate + water = hydrated silicate + ethanol.)*

The hydrolysis of a typical molecule of ethyl silicate 40 can be pictured as follows:

The complex silicic acid in turn reacts with other similar molecules or ester molecules, splitting out water or alcohol and polymerizing finally to yield an adhesive form of silica $(SiO_2)_x$.†

* Cogan, H. D., and Setterstrom, C. A. "Properties of Ethyl Silicate." *Chemical and Engineering News,* Vol. 24, No. 18 (September 25, 1946).
† Cogan, H. D., and Setterstrom, C. A. "Ethyl Silicates." *Industrial and Engineering Chemistry,* Vol. 39, No. 11 (1947):1364.

14. Conservation of Pictures

THIS CHAPTER IS not designed to be a complete manual of instruction; should some of the data seem to be presented in too great detail in proportion to their importance, it may be explained that this is done because these facts, some of which are common knowledge to experienced restorers, have hitherto remained unpublished, or because published accounts of them are vague, contradictory, or not readily available.

The modern tendency is to refer to this subject as the conservation of works of art; this term includes all measures taken and studies made for the purpose of rehabilitating damaged or deteriorated works and preserving or maintaining works of art under correct conditions. Restoring refers only to the replacement of missing portions, imitating the original by the use of paint or building up missing fragments of sculpture. The distinction is a proper one, but it still seems convenient for the general art public to refer to the entire subject in ordinary conversation as restoring and to call its practitioners restorers. One may call the result a restoration.

Proficiency in conservation is not entirely a matter of fundamental artistic and chemical knowledge, materials, methods, etc.; these are necessary equipment, but their successful application is a result of expert skill and a sense of judgment developed by experience. Aside from understanding the strictly technical aspects of the craft, the worker must have an adequate comprehension of the artistic nature of the work upon which he or she is engaged. Toch[213] mentions preliminary experience and stud-

ies on the subject, and recommends continued study and experiment upon old and worthless pictures in various stages of decay. Perhaps the paramount consideration is the restorer's attitude toward the work; the pictures entrusted to him should be treated in a conscientious manner to the best of his ability, uninfluenced by other considerations. A well-qualified restorer may sometimes resort to unsound procedures, not through ignorance, but because of various circumstances.

In connection with this type of work, "inexperienced persons" means persons who have not completely restored hundreds of old paintings and so become thoroughly familiar with the emergencies that suddenly arise, with the little differences between one painting and another that may indicate totally different methods, or with the dozens of variations of cause and effect for which there are no written directions. The term "inexperienced" also includes the professional painter with a successful restoration or two to his or her credit. An experienced conservator is continually learning.

It is expected that the information in this section will be utilized by the amateur; the foregoing remarks are intended to emphasize the necessity of knowing how much one dare attempt, and under what circumstances the work may be within or beyond one's capabilities.

General Rules. Most of the rules and instructions for restoring have exceptions, modifications, and limitations; these should be more or less obvious to the intelligent operator. However, it takes an experienced worker to judge when to take a short cut, when a step may be eliminated from a prescribed procedure, or when to omit a precaution; skimping of some of these may create serious difficulties.

In attempting restorations, try to avoid doing anything that cannot be undone; keep it possible to return the picture to its status quo if necessary.

Do not treat a dilapidated canvas that is to be restored as though further rough handling will not matter. The difference between an average conservation problem and a complicated or hopeless case is often slight. Also, every new blemish means just so much more work. The most troublesome operations the professional restorer is required to perform are often those made necessary by previous unskillful attempts at restoration.

Attempt should be made to save every vestige of original paint; repainting should be done only where all original paint is missing, as in the case of holes, burns, etc.

Too little perfection is preferable to overdone restoration. Work must be planned in advance in this respect, and judgment exercised in its execution.

Excellent restoration has been practiced for a good many years. Gen-

erally speaking, the old, well-tried methods are superior to the more recent ones, but a considerable number of the modern materials and recipes are superior to the old.

As mentioned in the section on painting in oil in Chapter 3, linseed oil is not a particularly good adhesive or glue. Therefore remember that a powerful glue is not necessary to make paint adhere to canvas; what is more important is stability—the power of the binding material to "stay put" or remain unchanged under normal conditions. In the same connection, it should be borne in mind that conditions only slightly away from normal tend to destroy this adhesion.

One of the most powerful enemies of oil paintings is water, including water vapor or moisture in the air. Canvas is commonly sized with glue before an oil ground is applied. The picture consequently is separated from the cloth by an exceedingly thin layer of glue; if this be moistened from the back, the picture may immediately detach itself from the canvas. Water seeps through cracks and fissures when applied on the face of a painting and may produce the same effect. It is inadvisable to use water or mixtures containing water for cleaning most old pictures, and when the experienced restorer finds it necessary he will use it as sparingly as possible and dry the picture thoroughly immediately afterward.

Proprietary nostrums for the cleaning and "regeneration" of paintings, whose composition is never published, bear the same relation to correct restoration as patent cure-alls do to the practice of medicine, and should be strictly avoided.

Repainting. From the very start of conservation, so far as can be learned from old writings, correct attitude and taste and propriety of results have been matters of great concern to those interested in the conservation of art; some of the earlier writers are surprisingly in agreement with much modern thought on the subject.

Repainting, or inpainting, as it has been called, must be strictly limited to the replacement of missing parts without concealing any of the original paint and without any attempt to "improve" the picture with new paint.

Various writers have proposed different approaches to repainting; in the case of a valuable artistic work, it is generally desirable to recondition the picture so that repairs are not readily apparent but so that upon close examination all the restored spots may be detected without trouble. Some of the suggested methods of accomplishing this are to use an entirely different technique of brush stroking from that used in the surrounding paint (hatching, stippling, etc.); to model fillings or plugs so that they lie slightly below the surface; to paint them carefully but in colors a shade or

two away from the surrounding areas; or to leave them vague and blank, tinted to match approximately the surrounding paint.

Besides the arresting of decay and prevention of further disintegration, the purpose of sincere restoration should be to present an acceptably good appearance to an object so that it may be seen or studied as a whole without the distraction of serious blemishes—not to reproduce what the restorer thinks the lacuna or defective element would have looked like, or to attempt a forgery or fake of the original. A blemish on the flesh of a figure or a clear, pale sky, for example, might call for closer attention to the surrounding texture, color, or draftsmanship than one on a dark background where an imperfection would be less distracting to the viewer.

In the case of a semivaluable painting regarded by its owner primarily as a wall decoration, or of a portrait that is valued for reasons other than its artistic or historical value, the restorer is usually called upon to duplicate its original condition without blemish. In the instance of a modern work that has become damaged, particularly when the original artist repairs it or supervises its repairs, the same flawless perfection is required. Flatly painted areas such as plain backgrounds, or small lacunae in areas of single, flat tones, which bear no particular relation to individual draftsmanship, are completely restored in almost all cases.

In writing descriptions of specific restoring processes, it is usually necessary to proceed on the assumption that a complete, flawless result is desired, and to leave the distinction between restoration and original work to the judgment of the restorer, whose decisions will usually be dictated by the conditions and auspices under which he or she works.

LINING

When injuries or decay in a painting on canvas have occurred to such an extent that patching (page 486), retouching, or other simple treatments will not rectify the defects or check the future disintegration of the picture and preserve it indefinitely, the painting must be lined.

This procedure consists in mounting the entire picture, including the old canvas, upon a new support, usually a new linen canvas. Formerly the lining process was widely called relining but this term is now rejected by conservators; it infers a double lining, a procedure used only on some very decrepit canvases. Canvases may be mounted on wooden panels for further rigidity, but this is usually considered an inappropriate alteration of the original work; furthermore, many old restorations of this kind have developed blisters, warping, and cracking, defects which would not

have occurred if canvas had been used; also, eventual further restorations are made more difficult—one can never give the work any further treatment from the rear, and the rectifying of any inadequate or faulty treatment that may become apparent during the operations is made extremely difficult. It does not follow the first admonition under *General Rules* above. Except under unusual, special conditions, canvas is preferred. When additional rigidity is desired for any special reason, a well-braced Presdwood panel is better than wood—at any rate, in this climate.

The traditional lining method, in use since at least 1750, employs hot glue mixed with starch paste. Although it has been largely superseded by methods that use wax-resin adhesives, it is given here in detail because it is the basic process from which the others have evolved. Choice of materials and details of procedure should be determined by the nature and extent of the defects and the degree of correction that is desired.

The usual procedure, based on traditional methods, is to stretch the new linen on a temporary stretcher, eight or ten inches longer each way than the original, and give it a good sizing with a weak solution of hide glue or gelatin. The linen should be strong and of the best quality. As with linen that is prepared for artists' canvases, its weight should be sufficient to withstand all the strains to which it will normally be subjected, and a flat, square weave with identical threads in the warp and woof is most desirable. (See page 641.)

For small pictures, up to 24 inches or thereabouts, the ordinary stretcher bars will serve for the temporary frame; but because longer stretcher frames will warp and twist in an annoying manner, careful workers use heavier wood for larger canvases, 2 inches x 2 inches or 2 inches x 4 inches, joined with iron angles. The outline of the picture area may be ruled on both sides of this canvas with a pencil.

If the paint film is decrepit and likely to part from its canvas, paper is pasted over its surface, as described under *Transferring*. Some conservators advise this in all cases, others only when they deem it necessary, but it is always safer to do it, especially when using an aqueous adhesive. The picture is then carefully and neatly cut from its original stretcher; sometimes the tacks are first removed with a screwdriver and the margin trimmed off with scissors or a sharp blade. When the picture is to be replaced in its old frame (and so far as circumstances permit, in every case), care must be taken not to diminish its size. A painting that is dilapidated around the edges is often trimmed to a smaller size by the restorer when with a little extra care and time he could preserve its full original size.

The back of the picture is gone over with sandpaper if necessary, to remove all knots and irregularities, and then scrubbed with a whisk

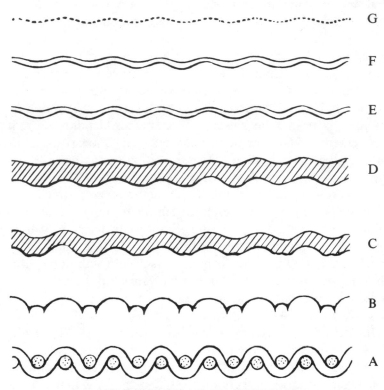

G

F

E

D

C

B

A

ANATOMY OF AN OIL PAINTING

(Reading up from the bottom of the diagram)
A—Linen support.
B—Glue sizing.
C—First coating of ground.
D—Second coating of ground.
E—The Painting. This may be one simple, directly applied paint film, or
 it may consist of several layers, e.g.,
 1. Underpainting
 2. Overpainting
 3. Glazes or scumblings
 4. Isolating varnishes or veils.
F—Picture varnish.
G—Dirt.

broom or vacuum-cleaner brush. Previous to this, all significant inscriptions or stenciled marks should be photographed or carefully traced and preserved.

Glue Method. (See pages 479 ff. for modern methods.) Hot glue is applied to the front of the new canvas within the penciled outline; after it has set sufficiently, second and third coats may be applied, according to the restorer's judgment and experience. The glue should be applied with a wide, flat varnish or enamel brush, and great care should be taken to keep the layer smooth and uniform. A typical mixture is French rabbit-skin glue, heavy wallpaper paste, and Venice turpentine. Three ounces of the paste are dissolved, free from lumps, in 10 to 12 fluid ounces of water and mixed with 6 fluid ounces of glue that has been soaked overnight in cold water, drained, and melted. An ounce or two of Venice turpentine is them emulsified into the hot glue-paste mixture with an electric mixer. Glue without paste will shrink too much and will not give a structurally durable film. The Venice turpentine imparts a little flexibility; also, without it the glue will not have the desired adhesive tackiness or penetration. Many other aqueous adhesives, including the casein-latex cement, have been recommended for relining. Glue and paste mixtures should contain a little preservative (see page 392) in order to prevent the formation of mold, should the painting be stored under conditions that would encourage its growth.

The back of the old painting is then given at least a thin coating of the hot glue and placed on the glue-covered area of the new linen. The canvases are pressed together with a rubber roller, or by rubbing with the palm of the hand, care being taken not to exert enough pressure to disturb the uniformity of the glue layer. Blisters or air bubbles are avoided by rubbing from the center outward. Pieces of plywood, Presdwood, or other boards of the correct size (larger than the picture but smaller than the inside dimensions of the temporary stretcher) are useful for building up a support under the temporary stretcher so that this and other operations on the surface of the picture can be done against a solid backing. The picture is then set aside until it is nearly but not quite dry, after which it is ironed on the back with the heaviest sort of tailors' iron (about 20 pounds is a desirable weight; a lighter iron is less useful). A continuous gliding motion should be used rather than a pronounced stroking. The purpose of this ironing is to force the adhesive through the old canvas to the back of the ground, and also to cause a smooth, level condition. If the iron is too hot, it will cause the glue to liquefy to a greater extent than is necessary and to flow unequally. If the iron is too cool, the glue will not liquefy sufficiently to penetrate into the old picture and strengthen the

adhesion of the ground to the canvas. Very hot irons will sometimes burn the paint.

For this operation the picture must lie face down on a perfectly smooth, hard surface; Presdwood free from blemishes is a good base. If the picture has any sort of impasto or sharpness of brush stroke, the points must be preserved by interposing a piece of blanket material, a pile fabric such as thin velvet or other fairly thick, soft cloth, between the table surface and the face of the picture. A small spot or point of paint raised any considerable distance above the level of the picture will be flattened out by pressure against an unyielding surface; this might not be so very harmful were it not for the fact that the point is then likely to be surrounded by a small crater or concavity, which will emphasize its crushed condition. Ironing the face of the picture is generally to be avoided; the experienced worker will know when it is necessary; and whether he irons it directly or protects it with a piece of cloth, he will take great care that the iron is not hot enough to burn the paint. Beeswax or paraffin may be spread over the surface to allow the proper slip and protection. When the picture is perfectly flat, it is ready to be cleaned. If paper has been pasted upon it, it is rippled off after sponging it with warm water. This water must not be allowed to soak into the picture, but it must wet the paper thoroughly; some skill must be exercised. The Presdwood or plywood panels mentioned earlier are useful as a support in such an operation. Special papers that offer the least resistance to removal are noted on pages 483–84. When the surface of a painting has been faced with paper during relining, it may be found advantageous to give the canvas a reironing or repressing after its removal in order to attain a final degree of level smoothness with which the sheets of paper may have interfered.

Some writers recommend that ironing and other operations be carried out after the picture is on its final stretcher; this is a more cumbersome procedure; it requires the use of handled implements, made of thin wood or sheet metal and resembling trowels or mortarboards, for working on the parts of the canvas that lie over the stretcher.

PRESSURE IN LINING

In published accounts of conservation techniques, little or no mention is made of the use of presses and clamps during lining, yet they have been used to a considerable extent by professional restorers. A study of all the literature on the subject of restoring tends to give one the impression that their use is not in accordance with approved practice or that it is unnecessary. Yet many old paintings that were lined seventy-five years

ago or more, and are in perfect condition, often show unmistakable evidence of pressure. All scientific and technical accounts of other adhesive procedures assume that pressure during the hardening of glues is essential.

By far the greater number of old paintings that require reconditioning present complications of more than one defect, usually rendering the literal application of published instructions impossible, as these instructions almost always assume that the defect under discussion is present in an otherwise intact picture. This is particularly true in the case of those pictures that have as an additional defect an irregularity of surface that requires flattening.

Very often an old painting on canvas has an allover crackle creating a sort of swollen, rounded effect, each unbroken area seeming like a raised island in the network of cracks; sometimes these areas are concave or sunken. Such irregularities of surface are caused by the unequal tension put on the fabric by the unbroken areas of paint and glue size, and the network of cracks where the film is discontinuous. It is often impossible to spread a coat of lining cement to a sufficiently uniform thickness so that the particular canvas being treated will be perfectly flat; in some cases the adhesive's slight variations in thickness, or unequal tension, will be transferred to the surface in the form of bumps or other irregularities. Often such conditions cannot be corrected by repeated ironing, but they may be minimized and usually entirely corrected by a skillful application of pressure.

The piling of weights on the average painting is usually ineffective; an enormous weight is necessary to equal the pressure of the most indifferently powerful press or clamp. The work of professional restorers will naturally be greatly facilitated by a properly designed press of a size large enough to accommodate most pictures; it may be specially constructed, adapted from machinery intended for other purposes, or improvised according to the ideas and resources of the restorer, and may operate on a number of fairly obvious principles. Good results, however, may be had by using large-sized carpenters' or cabinetmakers' clamps, the advantage of a press over these being principally one of convenience. The all-metal clamps are more desirable than the wooden ones.

Any stable, heavy plywood, especially the 13/16-inch panels and dieboards described on pages 251–52, can be used as press boards. An adequate supply of Presdwood is also very convenient; when it is used together with the heavier panels its smooth side may be placed against the picture; it is also useful as a smooth, flat surface for ironing upon, and in the manipulation and handling of canvases generally. As mentioned before, when a canvas is mounted on a temporary stretcher, it is often con-

venient to have a panel or several sheets of Presdwood cut to a size around which the stretcher will fit so that work of various kinds may be done on the face of the picture while it is resting flat on a solid surface.

With canvases in a press, the same precautions must be taken as in ironing; if they have impasto or sharply pointed brush strokes, these must be protected as previously described so that they are not flattened out. When an aqueous adhesive has been used to reline a painting and ironing is not effective in producing a flat, level condition, the canvas may be pressed after redampening the back of the new linen with a wet sponge. This treatment obviously intensifies the inherent disadvantages of aqueous lining noted in the next section. After the canvas and glue have absorbed a fair amount of moisture and have once more become uniformly damp and flexible, the canvas is placed under pressure for about forty-eight hours, preferably longer. Sheets of waxed paper should be used to prevent the moist canvas from sticking to the press boards, and strips of it may be placed along the borders of the face of the picture where the glue may have spread through the edges. Avoid wetting the margin of the new canvas excessively to guard against getting the glue at the edges too moist. When it is necessary to repeat the pressing, the glue must be made malleable again by rewetting the linen. When finished, stretch the picture immediately after removal from the press.

Upon removal from the press, the picture should be stretched without delay. Even if it seems perfectly dry, it usually retains sufficient moisture to cause buckling and inequalities if it is allowed to remain exposed to the air for long without being stretched. If the temporary stretcher is still attached, however, the canvas may be held taut enough to prevent this. Sometimes the procedure of dampening and ironing the canvas is repeated several times in order to flatten obstinately uneven pictures, because ironing or pressing will have little effect unless the picture is in a malleable condition. This moistening and steaming of the canvas is a good reason for preferring nonaqueous adhesives, as discussed under the next heading.

For various reasons it is sometimes desirable to reinforce a canvas by gluing a strip along a side or sides where the canvas goes over the stretcher, instead of relining the whole picture. These strips may be glued on with strong relining glue, care being taken that their inner edges do not extend beyond the part of the picture concealed by the rabbet of the frame. The strips should be wide enough for the outer edges to extend about 2 inches beyond the edge of the picture, so that they may be properly stretched. If raw linen is used, such strips should be impregnated with glue size before being glued on, and after they have been ironed or put through a press between strips of wood they should be painted with a

good oil paint; their back sides may also be sprayed or brushed with formaldehyde if desired. The inner edges may be raveled, as explained in connection with glued patches. Linen for this purpose should be strong but of a lighter weight or more open weave than the usual canvas type, and the glue should be applied evenly and not too heavily, or buckling may occur.

NONAQUEOUS ADHESIVES FOR LINING

In several places throughout this book the harmful effects of water upon paintings have been noted. Water mixed into oil colors, especially when emulsified, produces weak, spongy films and favors rapid yellowing of the oil. Moisture in the atmosphere has its deleterious effects; water is generally taboo in cleaning old paintings on account of its effect on the entire structure of the picture.

During the 1930s it became more and more apparent to museum and other scientific conservators that the penetration of moisture into the size that isolates ground from linen, and the effect of moisture on the ground itself, especially if it should contain casein or glue, leave the painting in a weakened state. By midcentury a beeswax-resin compound had become the standard lining adhesive, the glue method being continued for the most part in special cases—for example, where there are a multiplicity of defects and where painting that has deep-set wrinkles, buckles, and other irregularities of surface could not be made so smooth and level otherwise. Most workers, however, would prefer not to resort to it, even though a painting retains a degree of surface irregularity, which, after all, is a natural condition in an old picture that has suffered neglect or injury; but patrons often insist on a slick, unblemished result. However, as noted further on in this section, wax-resin procedures have been greatly improved in this respect in recent years. If the whole structure has been properly impregnated with wax adhesive the painting is preserved to a much greater degree than if it had undergone a glue lining.

The Wax-Resin Adhesive. A typical formula widely used since the early 1930s is 5 parts of beeswax (preferably unbleached), 3 parts of rosin, and 1 part of Venice turpentine. Individual workers vary this basic recipe according to their preferences; sometimes part of the beeswax is replaced by microcrystalline wax (from 10 to 50 percent); sometimes the harder and less brittle damar is substituted for rosin. I have also used ester gum, which is harder and has a higher melting point and a lower acid number than rosin. The Venice turpentine provides an adhesive stickiness that is desirable during the handling of the canvas. At the present writing few of

the synthetic resins or waxes have been found to be improvements, but they are future possibilities; one of the points of improvement would be a bond that imparts more rigidity or stiffness to the final structure without increasing brittleness.

The wax recipe is one of the few given in this book that involve the direct heating of inflammable materials; the melting point is rather high for the mixture to be made conveniently in a water bath. However, if the can or vessel is not too full, and a metal plate is placed between it and the electric coil or gas flame, the fire risk is not great. If the mixture is to be thinned with turpentine, the light should be extinguished, and the can removed from the stove before stirring it in. The Venice turpentine is stirred in last, after the mixture has been removed from the stove.

After stretching a piece of heavy, close-woven, square-weave linen on a temporary stretcher (see page 473), apply the molten wax adhesive as uniformly as possible to the picture area of the linen and to the back of the picture, and bring the two into the proper contact with the picture side down on a smooth tabletop or sheet of Presdwood. Care must be taken to make the coating thick enough to provide a good bond, and thin enough that it is possible to manipulate the iron without getting into trouble on the score of having the wax melt and run into unequal ridges and wrinkles. Care taken in applying a very even, uniform coating of wax with the brush or spatula will repay the worker in this respect.

Instead of raw linen, prepared painters' canvas was formerly recommended as being more easily managed in amateur use, but for complete permeation of the wax, for permanence and best professional results, plain cloth is always used. The account mentioned on page 485 recommends the application of the wax to the old canvas, followed by a thorough ironing until, upon turning the picture over, the wax is observed to have come through the cracks of the old painting and to have soaked into the protecting paper. The new linen is then laid on and given just enough ironing to create a perfect and uniform bond between it and the softened adhesive wax.

The use of any appreciable amount of turpentine in wax adhesive is unwise; it will produce a salve effect like that of floor wax, with the result that the coating will be too tender, and the picture too susceptible to denting from minor contacts. For smoothing the wax on the mounted canvases, one may use electric irons of various weights, from the heaviest sort as used in glue relining, to those of smallest size, such as the rectangular irons and the small tacking irons of various shapes sold for the mounting of photographs.

The purpose of ironing a wax-mounted canvas is to bring it to a smooth level condition, and to impregnate as much of the entire structure

as possible with wax. Most workers iron until the rear is uniformly impregnated. Obstinate spots often may be flattened by careful application of spot pressure, as described under *Patching*.

After the ironing is completed, a coating of talc dusted over the rear of the canvas will prevent the adhesive from sticking to any surface even under pressure. Glassine paper, as noted on page 484, is a good facing material to place against the front of a picture during lining with wax-resin compound, which does not stick to it.

One of the devices used to flatten cracks and rectify the defect known as cupping (the concavities or depressions that sometimes exist inside the boundaries of a network of cracks), is the use of a glass with smoothly rounded edges, such as a heavy drinking tumbler, or, better, a squat jelly jar. With the lined canvas held face down on a hard, smooth surface such as Masonite, the canvas is first ironed to soften the adhesive. The glass is then grasped in the hand, open side down, and rubbed firmly over the heated area in a circular motion until the adhesive cools. A little experience will allow determination of the correct heat; surplus adhesive may be worked out at the edges of the picture. More hot adhesive may then be brushed on and ironed in. The rubbing can be repeated several times and more adhesive added if necessary. In many cases the surface can be made as smooth and flat as that of a pressed glue lining.

New Adhesives. New adhesives are now widely used by professional art conservators and restorers. The best known among them, Beva 371, formulated by Gustave A. Berger, based on ethylene vinyl acetate, is made especially for art conservators. Although designed for use on the vacuum hot table (see below), it has been successfully applied utilizing a dry-mounting press or a hand iron. Beva comes in the form of a gel and is thinned with petroleum solvents, such as xylene or V.M. & P. naphtha—both harmless to most paintings—to the consistency of light cream. It can then be easily applied to a stretched lining canvas by brush, roller, or spray gun. If the painting needs to be consolidated, or strong adhesion is required to eliminate cracking or cupping, Beva can be applied to the reverse of the painting in addition to the new support, with or without penetration as might be required. Beva sticks to almost every material except silicone. Silicone-coated paper must therefore be placed under the painting and on all surfaces in contact with the adhesive when it is in its "active" stage, i.e., when it is in solution or in molten form, from about 130° F and up. Silicone paper (release sheets) may be purchased from outfits serving art conservators. (See *Sources of Materials,* page 639.)

The Beva-coated surfaces should dry overnight. During drying, the adhesive hardens and becomes a transparent, elastic film that is no longer

tacky. The painting can be placed on the lining fabric and aligned at leisure. The two canvases are then attached to each other by heating them to 150° F under light pressure, usually on the vacuum hot table, and allowing them to cool. At the temperature of 150° F Beva is as tacky as masking tape, yet too thick to penetrate even into the finest and most absorbent materials. It is this quality that prevents staining. A firm bond is formed almost instantly upon cooling. On the vacuum hot table it takes about fifteen minutes to reach the temperature of 150° F, and the entire painting is simultaneously heated all over its surface. Because the painting is held under pressure during heating and until it has cooled, it cannot distort. If a hand iron is used it should be heated to about 200° F, just below the boiling point of water, because a rapid heat transfer from the iron to the adhesive is desirable. Heating is done locally, where the iron is in contact with the art object. The local heating often causes uneven shrinkage in the materials being bonded. Waviness and folds may result; these are hard to straighten, especially on stiff materials such as paper and oil paintings. With unprimed canvas and soft fabrics and textiles, good results can be achieved, because these materials can absorb the tensions resulting from local heating. It is recommended to have two irons on hand, one hot and one cold, and use the cold one to press down the activated glue immediately after pressing with the hot iron.

A 10-percent Beva solution is very useful for the application of "facing paper" to paintings that would be damaged by aqueous glues. Also, a number of artists use Beva for collages, taking advantage of two unique qualities of this adhesive: (1) Beva makes possible the mounting of all kinds of materials without staining, and (2) Beva eliminates the tensions created when using aqueous glues. Additional information on the uses of Beva accompanies each can. Beva is removable with petroleum solvents, mineral spirits, and/or heat (150° F).

A contact adhesive originally designed for use in outer space has proved helpful in the treatment of modern paintings, especially of acrylics, which are heat-sensitive. The adhesive GE SR-574, a fully cross-linked silicone acrylate, comes in the form of a film on a release sheet. The film is placed on one or both of the surfaces to be bonded, and light pressure is applied. Great care must be taken to assure good alignment and proper application. It is removable with petroleum solvents. At this time the GE film is available from the manufacturer in large quantities only. For safety precautions see page 364.

The Hot Table. In the early 1950s, conservation specialists began to introduce heated tabletops on which lining operations could be carried out without recourse to the electric iron. With a hot table, the impregnation

of the canvases is uniform and thorough, and it is especially useful in treating very dilapidated or fragile paintings. During the 1950s and 1960s the hot table was developed in several variations, with controls for maintenance of uniform temperature and other attachments. A major development of the 1960s was the perfection of the vacuum process, in which the hot table has a tightly fitting cover of rubber or plastic sheeting, and the heated adhesive is forced through the canvas and flattened against the table by the application of vacuum, supplied by a pump built below the table.*

Other Lining Developments. Fiberglass cloth of comparable weave is sometimes used to replace linen as a lining support. Besides having the advantage of an expected long life on aging, it becomes sufficiently transparent, upon impregnation with wax-resin adhesive, to make the rear of the original canvas visible, so that original markings are preserved. It is sometimes used as an additional layer with linen to increase the rigidity of the support. Another development has been the use of Mylar sheeting to replace glassine paper in facing a painting during lining.

TRANSFERRING

Some conditions of structural decay cannot be rectified by lining, but by their nature require the removal of the paint film from its old support and the remounting of it upon an entirely new support; the most approved procedure is to use the same type of support as that originally used, unless some complex condition requires a change. In reconditioning a very decayed painting, the restorer must determine for himself whether transferring is required or whether relining will suffice.

The removal of the paint from the ground, or of the paint film together with the ground from the support, is a delicate and painstaking operation; yet it is not always so desperate or dangerous a measure as is popularly supposed. All conservation processes, even the most simple, demand of the operator the same skill and expert care; transferring differs from the others only in requiring a greater amount of time and painstaking effort.

Among the paintings so handled in the past are many well-known early Italian works that were transferred from panels to canvases in the eighteenth century after being brought to Paris.

The first procedure is to paste several sheets of tissue paper over the

* Ruhemann, H. "The Impregnation and Lining of Paintings on a Hot Table" and "Restoration of La Haie ... by Van Gogh." *Studies in Conservation,* Vol. 1, No. 2, June 1953.

surface exactly as in the lining of decrepit or flaking oil paintings. Strong flour or starch paste is used; it may be brushed on the picture as well as over the paper; should the paper become accidentally torn to a minor extent during application, it may be patched with a bit of paste-soaked paper; after the patch is dry a light sandpapering will remove the bump. Irregularities such as wrinkles (which a skillful operator will avoid) and overlapping of sheets may likewise be made smooth by a few rubs with fine sandpaper after the paste has become thoroughly dry. Other materials have been recommended by various workers: layer on layer of tissue paper until a sort of cardboard has been built up; muslin or mosquito netting as either a first, intermediate, or last layer, with tissue paper; cartridge paper; and laminated cardboard. The main requirements for a paper for this purpose are that it should be of such a nature that it will serve as an adequate bond and protection for the paint film and not present too much resistance to removal at the end of the process. I have also used newsprint paper as a one-sheet facing on paintings; it is available in 50-pound rolls about 40 inches wide.

Professional scientific conservators pay considerable attention to the kind of tissue paper used for different requirements. Japanese mulberry paper is excellent for various purposes—both the lacy, soft, open-fibered type called mending tissue and the smoother, calendered varieties. When they are placed over a painting, molten wax compounds may be put on top of these thin tissues and ironed through them with a tacking iron to bind blisters and semidetached particles, the paper preventing loose pieces from being displaced while the molten compound permeates the crevices in all directions, encasing the entire structure with the preservative wax.

The final removal of paper, by dampening and stripping or gradually rippling it off, must be done with care and attention; it is frequently a time-consuming job, so that effort and attention in selecting the correct paper facing for the circumstances of the job will repay the worker in relative ease of its removal. As waxed paper is used to face the pictures in pressing glue-lining jobs, glassine paper (obtainable in rolls) is good for facing during the wax relining technique, as it separates readily from any wax that may seep through. Mylar sheeting is also used for this purpose.

After the paste has dried thoroughly and completely, the canvas is cut from the frame; if it were cut from the frame before pasting, it would buckle and curl up during the drying of the paste. There is even some likelihood of this after the drying, and the careful restorer will guard against this. He may handle a small picture as it is cut from the frame, or he may reinforce it by stiffening the edges; if the paper is made ¼ inch

or more larger than the painting all the way around, strong kraft paper or gummed paper strips may be pasted to this margin and folded under to make a sort of marginal frame. The picture may also be held flat, face down on the table or drawing board, by the use of gummed strips on this margin, or by weights.

However, the most convenient and safe method of handling the picture is the following, which is based on an account by Dr. F. Schmidt-Degener of the Ryksmuseum, Amsterdam.* The procedure described in the original account is the removal of an old glue relining and its replacement with a new piece of linen attached by the wax-resin mixture referred to on page 480, but the method outlined is also well adapted to the entire removal of the old canvas. The picture is first cut from its stretcher and four strips of heavy kraft paper about 10 inches wide or more, depending upon the size of the picture, are pasted along each of its edges not more than 1 inch in, on the face of the canvas. These strips are then pasted securely to a flat wooden frame made large enough so that there is a margin of 7 or 8 inches all around, between the canvas and the frame. The strips are then soaked with water and allowed to dry overnight, after which, if the work has been properly done, the paper will have stretched tight and the old canvas will be held in a taut, flat condition. (I have also used a single large sheet of draft paper with the picture shape cut out of its center and squares cut out of its corners where it folds over the corners of the frame.) The face of the painting is then protected by pasting over it squares of tissue paper overlapping each other by more than ¼ inch. (A single sheet of newsprint paper may also be used successfully.) When the paper has dried, the picture, thus mounted, is laid face down on a table and held rigid by iron weights on the corners of the frame.

The removal of the old canvas is accomplished by dampening it with a sponge, whereupon the linen, which is usually isolated from the ground by a layer of glue size, will become detached and may be carefully peeled up. The safe removal of the linen calls for patience and skill gained by experience; in many cases knives, abrasives, sponges, etc., must be used. After the canvas has been removed, exposing the back side of the ground, all traces of the old sizing must be scraped away from the ground. In a case of the removal of an old relining, a relatively thick coating of old glue must be removed; the account referred to recommends that equal tension be maintained on the old canvas by dividing it into squares and removing the glue with damp sponges and rounded knives in alternate squares, so that when the work is half finished it will present a checkerboard effect. The moistening of old canvases without these precautions of

* The *Museums Journal,* Vol. 32, pp. 86–87. London, 1932.

stretching, pasting, and gradual, uniform application of the water is most liable to lead to damages to the painting through the too sudden shrinkage of the linen.

The new linen is mounted on a temporary stretcher just small enough to fit within the wooden frame upon which the old picture is mounted, and cemented to the back of the old picture in the manner of the lining process. The type of adhesive in each case is to be chosen according to the requirements of the work and the experience of the worker. The last operations are the cutting away of the paper frame and the careful removal of the newsprint or tissue with warm water and sponges, an operation that is not so difficult as it is tedious. A number of sheets of plywood or Presdwood cut to the proper sizes will aid in pressing and other operations, as previously described.

Pictures are similarly removed from wood panels by pasting a rather heavy protective layer over the surface and reducing the thickness of the panel to the thinnest sort of film, which can then be scraped away from the ground. The thickness is reduced by planing or by the use of a machine saw which can be set so that its penetration is limited. The back of the picture is crisscrossed with saw cuts, which are made as deep as is deemed safe, and then the squares are knocked out with a chisel. Murals have been safely transferred from plaster and masonry walls by laboriously chipping away the support from behind with a chisel. Sometimes such a picture, with its pasted gauze and paper protection, is rolled directly onto a large cylinder as it is separated from the wall, and is carried to a studio for complete removal of the adherent wall fragments, and for lining and repairing.

PATCHING

Small punctures and larger tears may be repaired by applying individual patches behind them, provided the painting is otherwise in good condition. The adhesive used is either of the wax-resin or of the aqueous glue type. The former is the easier to apply; it is less likely to make a mark on the face of the painting at the edges of the patch, and is more in accordance with the most approved modern practice. Also, it is more easily removed, if this should subsequently be necessary for any reason. The glue patches are more useful when the tear is accompanied by any considerable amount of wrinkling, buckling, or pulling of the threads, because the dampening of the canvas and subsequent application of pressure is more effective than the other procedure in correcting such defects; but when the buckling is not too pronounced the wax patches will also accomplish this

purpose. All patched spots will require some filling in, as described on pages 498–501.

The damaged canvas is laid flat and the edges of the tear fitted together; all overlapping threads or fibers, especially those that have a tendency to protrude upward, are trimmed with a sharp blade. A patch is cut from prepared oil canvas, and coated on the primed side with the wax-resin compound mentioned on page 479, placed behind the damage, and carefully pressed flat with a warm, not hot iron. The heat and pressure should be just sufficient to create a flat, level condition; too much will cause the wax to run in an irregular manner; too little will not allow it to penetrate and adhere permanently to the fabric. Some of the wax may appear around the outside of the patch; if it does, it should appear evenly all around; if desired, it can be neatly scraped or cut away after it hardens. The layer of wax should be fairly thick. A rubber roller may sometimes be found useful in making such patches flat.

Before the wax has become entirely hard, weights or slight clamp pressure may be applied to the patch in order to assure a flat, level surface, if it seems necessary; not so much pressure should be used that the wax is forced out.

These operations are performed with the painting lying on a smooth table; for manipulations that require work on the face of the picture, the canvas should be supported from behind with several sheets of wallboard or a piece of wallboard resting on blocks, etc., as noted previously. The excess wax that fills the cavity should be carefully scraped out as thoroughly as possible, and the damaged spot or slit filled in and touched up with paint, as described farther on. This type of patch can be pulled off with the fingers quite easily; it is a good idea to make it round or oval, so that the danger of accidental pulling up of corners is minimized.

Sometimes when paintings have been patched with the wax adhesive, pressure applied to the face of the picture in handling it during the subsequent filling in, repainting, or other finishing operations is sufficient to make the edges of the patch show through on the face of the picture; even the ironing may have this effect. To guard against this, I have used a method whereby the patch is incompletely cut out of a much larger piece of canvas, as shown on page 488.

The patch is applied in the manner previously described and the entire square of canvas is allowed to remain until the job is completely finished, when the tiny connections A and B are cut with a keen blade and the surplus pieces pulled off. Bigger patches may have more than two of these points if desired. The square should be larger than the iron or at least large enough to bear careful pressure of the iron without its edges' becoming imprinted on the face of the picture. The wax adhesive is ap-

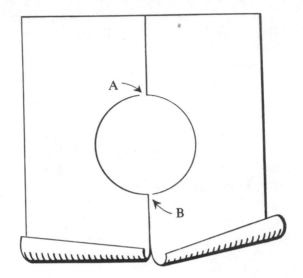

plied to the patch and the corresponding area of the original canvas only; the ironing may cause some of it to exude under the surplus canvas, but this does not prevent easy peeling off of the latter, and the excess wax may be neatly cleaned away later.

The type of cloth used to patch canvases has a great deal to do with the smoothness of the finished work; prepared canvas is mentioned above because it is perhaps the easiest for the inexperienced person to handle. Thinner material of an open weave, such as fine linen or the type of silk bolting cloth used in silk-screen printing, will sometimes give good results. A square of linen with its edges raveled by the removal of several threads is the patch most favored by professionals.

Temporary repairs of small tears and punctures can safely and easily be made by applying a piece of surgical adhesive tape to the rear, but this cannot be relied upon for permanent results.

Pressure may be applied to patches of any kind by the following method: carefully round or bevel the edges of square pieces or strips of Presdwood so that these edges will not be impressed on the canvas; place one of the pieces on each side of the patched spot, and over each a piece of wood of somewhat smaller area (if aqueous glue has been used, slip a piece of waxed paper under each piece of Presdwood to prevent it from sticking); hold the arrangement in place with a screw or spring clamp. If the patch is far from the edge of the picture and only small clamps are available, an arrangement of wooden bars and blocks with clamps at either end can be improvised.

Aqueous Glue Patches. The big disadvantage of this method as compared with the preceding one, which employs a wax adhesive, is that the more powerfully adhesive glue will almost always pull or pucker the canvas around the patch, and make an irregularity which is clearly seen on the face of the picture. This becomes more pronounced with age.

Instead of prepared canvas, square or oblong pieces of plain linen are used, and a few strands are pulled out along each side. If the raveled sides are kept as straight and smooth as possible, the effect is that of a beveled edge which has less tendency to impress its design on the face of the picture than a sharply trimmed edge.

The linen is applied with hot glue of the type used in lining; the mixture may be thinned down somewhat with water, leaving it strong enough to supply permanent adhesion but not so strong that it has a puckering effect on the canvas. This is not a simple matter and requires some experience and judgment. Some writers recommend lightweight muslin or gauze for this purpose, but old pictures patched with these materials and glue often show the same kind of pucker or patch mark as is produced by linen and glue.

Woven or Mesh Patches. Nail punctures and similar small holes or slits may be patched by weaving a few strands of linen together, laying them over the back of the tear (Scotch tape will assist), and impregnating them with glue; when the glue has set partially, it is covered with a piece of waxed paper; rather mild pressure is applied with a clamp for thirty-six hours or so, in the manner previously described. Fish glue, slightly thinned with water, seems to be satisfactory for such patches. They are inconspicuous in appearance and do not affect the face of the picture. Even on larger holes and tears where there is not too great a space, I find that these patches, because of their open-mesh structure, hold plugs firmly and do not cause wrinkling. The wetting with glue and subsequent pressing will flatten puckered or wrinkled tears more successfully than will the wax-resin method. Too much pressure may produce an impression of the woven threads on the surface. Other more intricate methods, which include weaving in strands of linen, are practiced by expert restorers; they call for considerable skill, patience, and ingenuity. Frequently a minor damage or very small puncture can be plugged with gesso or picture putty without any patch or backing; often a few single strands or threads laid across a slit will suffice. A bit of surgical plaster also makes a good emergency patch.

The wax-resin patches are the easiest ones for the nonprofessional restorer to use, as in the case when an artist must mend a tear in one of his own works. Older methods of sticking on muslin or gauze patches with

shellac, powdered resins, etc., have been more or less discarded, as they tend to give brittle, nonpermanent, or blistery results.

Blisters and semidetached pieces of paint may be glued down and pressed, if glue can be inserted under them. Such operations call for some practice and skill. A hypodermic syringe is often useful for inserting the glue behind blisters and other raised areas; in this case it is necessary to make a small hole by puncturing the film with a solid needle before inserting the hollow needle. It is sometimes recommended that these spots should first be softened with solvents, but this procedure is not always useful. The impregnation of a loosened surface by flooding it with gum, resin varnishes, or oil is likewise of doubtful value, except in some unusually complex cases.

In the hands of the experienced restorer, perhaps the best results are obtained by ironing wax-resin adhesive through mulberry tissue with a tacking iron as mentioned on page 484. It is very difficult to evaluate the results of any fastening down of detached spots as far as permanence is concerned, because one cannot see behind the paint film to check up on the degree of penetration or the uniformity of the adhesive's contact.

Because of the difference in textural and color effects between fresh repairs and old surfaces, all repairs such as patching, lining, and filling in must be followed by cleaning and revarnishing operations whether or not the original surface condition of the picture was poor enough to have required such treatment had the structural defect not been present.

CLEANING PAINTINGS

REMOVAL OF OLD VARNISH

The removal of old varnish by dissolving it and washing it away is not to be carried to the point where the painting is denuded of every trace of its protective coating, because this is liable to result in the condition which the restorers call skinned. A painting so scoured presents the characteristic appearance of having had a minute amount of its surface peeled off; delicate tones, glazes, and lines are often partially or completely destroyed; points of white or pale-colored ground or underpainting will show up in a sort of granular or stipple effect over large areas, and the entire color effect may be altered so as to appear clouded. It is desirable, therefore, to proceed with the solvent under such control that a minute amount of the original varnish, made thoroughly uniform and dilute by the solvent, will be left. This can be done if the solvent is correctly applied; the surface will appear thoroughly clean, yet a very small trace of

varnish will remain upon it. Among professional restorers, the operation of removing the varnish from a picture is called stripping.

The standard method of removing varnish from a painting by use of solvents is to apply the material with small wads of absorbent cotton such as is sold in drugstores. This cotton is not only safe so far as abrading or tearing up delicate surfaces is concerned, but it also applies the solvent in a controlled manner and reabsorbs and holds in the greater amount of the dissolved material. Its whiteness and purity make possible a close observation and control of the amount of film being removed. The best grades, put out by the well-known makers of surgical dressings, have long fibers and are most satisfactory because they are free from the fuzzy lint of the cheaper grades; but the cheaper grades sold in one-pound rolls under the name of hospital cotton are also adequate, and often seem to be more absorbent than the more expensive varieties.

In describing the usual method, we will assume that we have an average, well-painted American portrait about a hundred years old, covered with a film of old varnish that has turned a dark brown color and is encrusted with accumulated dirt that seems to have become occluded into the film.

If the picture has been lined and is still on its temporary stretcher, it is laid upon the supporting boards mentioned on page 476; if it is on its permanent stretcher, cardboards must be stuck under the canvas and made rigid by being supported with blocks or boards of the proper height to fit between them and the table. This is to preclude undue flection of the canvas and to prevent the worker's bending the canvas over the inner edge of the stretcher, which would result in marks or cracks. Under no circumstances should pictures be cleaned with solvents in other than a horizontal position. The surface grime is first removed with balls of cotton that have been dipped into a nonaqueous liquid that has little or no solvent effect on the varnish, such as turpentine, mineral spirit, or solvent naphtha. The cotton should be well squeezed out so that it is just moist. This preliminary operation is not absolutely essential, but a heavy superficial coating of blackish dust often obscures the color of the varnish and interferes with one's judgment of the progress of the cleaning. Next, the solvent is selected according to the judgment and experience of the restorer, or after preliminary trials at the edge of the picture. Suppose a mixture of 5 parts of alcohol, 3 parts of turpentine, and 1 part of ethyl acetate is chosen: an ounce or two is poured into a suitable vessel and a wad of cotton is dipped into this and rather well squeezed out. The wad should then be compact and not more than about an inch and one-fourth in diameter, or small enough to be conveniently held and controlled between the thumb and two fingers. It is applied with a circular or back-

and-forth motion, care being taken to keep the strokes small and to complete the removal of varnish to the desired extent before moving on to the next area. The rubbing face of the wad is continually examined for any traces of color, and should the greenish, yellowish, or brownish color of the removed varnish show any marked change, or should there be any other indication that traces of color are beginning or about to be removed, the action is immediately halted by application of turpentine; an open container of turpentine and a well-soaked cotton wad are kept available for that purpose. The action may sometimes be more closely controlled by continual alternate applications of turpentine and cleaning solvent, one wad of cotton for each held in either hand.

When the face of the cotton has become saturated with varnish, it will neither distribute further solvent nor absorb more in the correct way, and it is turned around to present a fresh surface; one may usually use three sides of a wad, then tear it open and get one more useful surface from the interior. The used balls of cotton should be thrown into a container and disposed of as soon as the work is over.

Very sensitive or delicate surfaces that might be injured by a wholesale rubbing may require a gentle *rolling* with a small cotton swab. A small surgical forceps is a very convenient holder for a tiny bit of absorbent cotton for use on small areas. These miniature pincers snap into place and grip very firmly whatever they can hold; they are among the most useful instruments for many studio and workshop purposes.

When small spots of varnish of a greater thickness than the rest of the coating persist after the bulk of the surface is perfectly clean, or when such spots are found to be drops and spatters of a less soluble material, it is always dangerous to attempt their removal by continued scrubbing with the solvent, because the clean areas surrounding them are most likely to be skinned, every trace of varnish being removed. The paint film in those areas, if not actually picked up, will then be exposed to the danger of becoming weakened, softened, or altered in color value by the continued action of the solvent. The removal of such spots is best accomplished with the knife, in the way in which flyspecks, spatters, and freckles are removed. (See pages 495–97.)

The ideal volatile solvent or mixture of solvents will contain no water; if ordinary alcohol or a mixture containing it is compared in practical use with a solvent that contains anhydrous alcohol, it will be found that in many instances the surface of an old oil painting will be bloomed or whitened by the solvent that contains a little moisture, and that it will not be so affected by the anhydrous solvent. It is possible that the water content of some alcohols will be great enough to produce all the undesirable and harmful effects that follow the application of water to an old, cracked

oil painting. The anhydrous denatured alcohols described on pages 369–70 and 635 are miscible with turpentine. Anhydrous alcohol, ethyl acetate, turpentine, xylol (or toluol), and mixtures of these solvents are sufficient to carry on most picture-cleaning manipulations; acetone and some of the other more powerful or special materials are useful in special cases. As mentioned in Chapter 10, the principles underlying solvent action and the behavior of mixed solvents are rather complex; the properties of the different solvents are best learned by experiment. There is no general rule for determining which solvent or concentration is best in each case. Experience and careful preliminary trials are the best guides. Diacetone alcohol is a powerful and controllable solvent that may be tried full-strength.

The user of solvents must at all times be aware of the necessity for observing a due amount of caution in regard to their toxicity and inflammability, as noted on pages 364–65.

Areas of paint composed of lead pigments that have become darkened by the action of sulphur-bearing fumes from a polluted atmosphere can usually be restored to their original color by the application of hydrogen peroxide with a cotton wad. This reaction has been known since the early nineteenth century, when hydrogen peroxide was first obtainable. Sometimes the paint whitens immediately; sometimes it must stand for fifteen minutes or so for the reaction to be completed.

Castor oil has been recommended for retarding and controlling the action of solvents, especially alcohol, on a painting; and according to Lauric[51] an undesirable absorption of alcohol by the paint film is thereby diminished. He recommends coating the picture with the oil and applying a mixture of alcohol and solvent into this with a soft brush, having more castor oil available to retard the action if it becomes necessary. He does not approve of the "harsh and wholesale" absorbent cotton.

Castor oil serves another purpose in the removal of varnishes and repaints. One of the most successful paint-remover patents employs a waxy material dissolved in the volatile solvents. The wax not only holds the solvent in place so that it will not flow from vertical surfaces so easily, but also keeps the solvent in contact with the paint or varnish for a longer time than if the solvent's evaporation were unhampered. It is occasionally necessary to apply the strongest possible solvent action to an intractable painting; an addition of castor oil, 25 percent or less, will sometimes increase the solvent action of alcohol, apparently by holding it on the surface for a longer time. A wax salve made by thinning molten beeswax or paraffin with turpentine may also be used as a base for solvents.

If castor oil has been used in the cleaning of a painting, every vestige

of its oiliness must be rinsed off with repeated applications of solvents, because it is an entirely nondrying substance, and paint or varnish applied over a trace of it may remain sticky for months. A disadvantage in its use on old paintings is the difficulty of removing it entirely from deep cracks and the canvas under the cracks; in my opinion, its use in general is rather unwise.

Soap and other powerfully detergent chemicals are ordinarily taboo in the cleaning of pictures. In the past, pure, neutral soaps have sometimes been recommended for perfectly intact, uncracked surfaces, but their use is never really safe, especially in the hands of an inexperienced worker.

The experienced restorer can often make good use of cleaning materials and methods that would be dangerous in unskilled hands, and there are, as has been previously noted, exceptions to the general rules and prohibitions, particularly in the case of such expert workers. The use of soap solutions by persons of limited experience is perhaps the cause of more injuries to old paintings than is any other procedure; although pictures may sometimes be cleaned successfully by this method, the number of old paintings that have suffered damage from it is quite large. The only alkali given any sort of approval is ammonia, which is volatile and leaves no residue; its action, however, may sometimes be destructive so far as the life of the paint film is concerned, and it is not to be used except in very special cases and by experts. Laurie[51] quotes a recipe of Dutch origin for a cleaning agent made by treating copaiba balsam with ammonia, adding the latter drop by drop with continuous shaking until the mixture becomes clear and has a faintly ammoniacal odor. This combination is a powerful solvent, but its action may be controlled to some degree and is immediately arrested by an application of turpentine or kerosene. It works well, without apparent harm to old paint films. Saponin or powdered soap-tree bark, which foams and duplicates part of the action of a soap solution without any of its dangers to the paint film, has also been recommended. Its value for delicate surfaces is well known and there are no objections to its use in cleaning pictures other than those which apply to water alone.

Smoke and soot deposits, even though they are apparently of a greasy nature, will sometimes yield readily to swabs dampened with plain water.

Pettenkoffer Method. Some cracked, dead-looking, or otherwise deteriorated varnish films may be "regenerated" by exposing them to the action of alcohol vapors, which cause the surface film (especially when it is mastic varnish) to coalesce and appear as though it were in its original state. The process is named for its inventor, Max von Pettenkoffer, and

was in considerable favor during the nineteenth century, but because the varnish tends to revert to its former bad condition upon further aging, and in some cases to become even worse, the method has more or less fallen into disrepute. The fumes have a slightly similar effect when applied to a resinous or bituminous painting that contains wide traction fissures, but hardly enough to be of much practical value in the restoration of such pictures. Liberal application of copaiba balsam to the surface assists and improves the Pettenkoffer process. The procedure is best carried out by laying the picture face up in a shallow box made of sheet metal, to which a well-fitting lid is applied. The lid is lined with absorbent cotton held in place with wire screening, and the cotton is well soaked with alcohol, but not to such an extent that it will drip.

In practice, the process is ordinarily less desirable than the procedure it was designed to supplant, namely, the removal and replacement of old varnish. The action of fumes of alcohol and other volatile solvents can, however, be useful as an intermediate stage in some complex restoration processes.

Repaints. It is not always possible or desirable to preserve repainted areas or former restorations when cleaning an old painting with solvents; they are usually removed and, if necessary, replaced.

After the painting is cleaned, it is allowed to dry until it is free from tackiness; any necessary patches or fillings are made, and before these are repainted the entire picture is given the thinnest sort of coating of damar or retouch varnish that will produce a uniform gloss. The colors are thereby brought out in their final effect so that the repaints may be made accurately. When flat (mat) varnishes are used, they will occasionally seem to discolor the repaints unless these are first isolated with a very thin protective coat of glossy varnish. Some workers recommend coating all repaints with a thin isolating varnish that is insoluble in the solvent used in the finishing varnish; others condemn the use of any such intermediate varnishes, and bring out the tones for repainting by applying copaiba balsam considerably diluted without harmful effect on the structure of the complete film. This subject is continued on page 501 and its ethical implications are touched upon on pages 471–72.

CLEANING PAINTINGS WITHOUT SOLVENTS

The cleaning of paintings with solvents may be inadvisable or impractical in many instances, and methods are resorted to that may be classified as mechanical as distinguished from those using solvent action.

The older books on the subject describe an abrasion or attrition

method for removing films of varnish (particularly mastic), which consists in crushing a bit of mastic, damar, or rosin, and rubbing it with a thumb or fingertip (protected by a piece of goldbeaters' membrane) into the varnish film. The powdered mastic acts as a starter, the rubbing is done firmly and in small circles, and the varnish will continue to dust up and be removed. This procedure is practical only on works of the most level smoothness; the grooves and pits of brush strokes, canvas weaves, etc., will mostly remain untouched. The method is no longer widely used.

Use of Knives. In many cases the use of a knife or scalpel is the safest and best way to remove varnishes and overpaintings, especially from complex or delicate paintings. It is particularly effective when it is necessary to remove heavy repaints in oil or tempera from a delicate surface. The type of knife designated No. 1 in the accompanying drawing is best for general use in the removal of varnish; the blade, though small, is rather heavy. It is, however, necessary for complete practice to have an assortment of lighter blades like the one designated No. 2, and instruments for special needs; these can be found among surgeons' instruments; they can be altered or ground down to serve various purposes. Modern scalpels with thin replaceable blades are not always good for this purpose, as the blades do not have sufficient weight. No. 3 is described on page 500.

Obviously, considerable experience and practice is necessary to gain expert control over such manipulations. Although the method is slow and tedious compared with the use of solvents, very precise work may be

done; films of varnish and paint can be taken off without disturbing delicate glazes or scumblings, and dirt or varnish may be safely removed from the most intricate surface irregularities. Even a fraction of a film may be removed, and the depth of scraping is at all times entirely under control. For the removal of maculae and small, thick areas of varnish from an otherwise clean surface, this method is the only satisfactory one.

When it is used by a person of limited experience, the errors likely to ensue will usually be much less serious in extent and nature and much more easily corrected than those caused by an inexpert use of solvents. The blades must be constantly sharpened on an Arkansas oilstone during their use. The scraping is ordinarily done dry; an occasional wiping of the picture with cotton moistened with a liquid inert to the materials being worked on will bring out the colors, if desired. In some special instances it may be advisable to soften a heavy coating with solvent before using the knife.

MOLD (MILDEW)

Exposure to strong sunlight (or ultraviolet light) and fresh air usually destroys and stops the growth of mold on fabrics. Provided a painting will withstand a cautious application of water, mold may usually be removed from its surface by rubbing with absorbent cotton moistened with a 10-percent solution of magnesium fluosilicate (silicofluoride), rinsing off the solution afterward with cotton moistened with distilled water. This method will leave a minute amount of the chemical on the surface, which will guard against the recurrence of mold. Make sure the substance is really mold by examining it with a microscope or magnifying glass, because whitened varnish or oil and crystallized or powdered salts are often mistaken for it. Some other fungicides are mentioned under *Preservatives*, pages 392–94.

Mold is a kind of fungus, the spores of which thrive on sized fabrics, glue, paint films, wood, etc., and once it flourishes, it will spread to adjacent surfaces of nearly any nature. Mold begins as a white, feathery growth (mycelium), developing quickly into a denser and more or less colored substance, depending upon its species. The commonest types are *Penicillium*, usually green, and *Aspergillus*, usually black or blackish, but many other varieties also occur. Various materials will grow certain types more rapidly than others.

The growth of fungi is encouraged by warm, humid, dark surroundings. For example, it occurs frequently on paintings that have been boxed and stored in the hold of a ship. It also flourishes in liquid paints, aqueous solutions of gums, etc. Mold should not be confused with bacteria.

INSECTS

Damage caused by insects is encountered most frequently by artists who live in semitropical climates, although the omnipresent cockroach and its larger relative the palmetto bug of Florida can also cause problems. Insects can be controlled safely by spraying the work area and surroundings—easel, storage shelves, picture frames, and so on—with an efficient liquid insecticide readily available in any hardware or grocery store. A very fine mist or faint spray may also be applied directly to the painting involved if absolutely necessary. Following its active toxic period, the insecticide should evaporate completely and the nonaqueous nature of the spray should not have any effect on oils, polymers, tempera paint, gesso, or other mediums; but extreme care should be used with watercolor and other more fragile paintings if they are affected. If the insects are attacking a painting in progress, it might be possible to eliminate them by introducing a tiny amount of water-soluble insecticide into the colors.

FILLING IN HOLES AND TEARS

After a painting has been lined and cleaned, or a damaged spot backed up with a patch, the holes, slits, and flaked areas must be filled up level with the surface. In England this process is called stopping. Two general types of plastic material are in use: an aqueous glue plaster on the order of gesso, and a linseed oil–whiting mixture similar to common putty. The use of commercially prepared crack-fillers (both those sold as plastics with a varnish base, and the dry powders intended to be mixed with water) is inadvisable, not only because of their doubtful composition but, chiefly, because of their extreme hardness when dry. In general, materials that dry to a very hard consistency are not so good as those that are somewhat softer than the surrounding paint film; they seem to be less permanently adhesive and more liable to crack.

Another method of filling in places where the canvas is missing is to procure a piece of canvas of identical weave, lay it face up beneath the damaged spot, and with a keen, pointed blade cut around the tear or hole, just trimming off its edges, and at the same time cutting through the new piece of canvas. This will produce a patch or canvas plug that will fit the hole exactly. Such plugs must be used at the time when the patch or relining is applied. Great care and dexterity are necessary to get good results with this method; the weave of the patch must line up accurately with the weave of the original canvas.

If a flawless job is desired, every spot where the paint or ground has

become detached from otherwise intact canvas *must* be filled in before repainting. Superficial scratches and minor flakings are often touched up without first being filled in, but daubing oil paint over any appreciable break in the coating will never obliterate it; frequently it emphasizes the blemish by thickening its edges.

Plastic Gesso. Dissolve ½ ounce of casein in 3½ fluid ounces of water, according to any of the instructions under *Casein Solutions,* pages 381–88. Emulsify with ¾ fluid ounce of damar varnish by shaking together in a bottle; mix to the stiffest possible paste with whiting or chalk as required, using a spatula or stiff palette knife on the rubbing slab. Other glue and casein gesso formulas may be used, with or without oil or varnish additions, according to the user's preferences, so long as they are made in the stiffest possible form with as little water as possible to minimize shrinkage, and so long as they comply with other obvious requirements. It is not advisable to use plastics that are deliberately formulated to give a crackled effect; if such imitation of the defects of the picture is required, it is best produced by carving with a needle or by the means suggested below. Pigments may be added to the whiting if it is desired to match any special color.

Imitation of Textures. When the gesso plug is nearly dry and almost completely set, soft enough to receive impressions but firm enough so that pressure will not pick it up, a piece of cloth or canvas that matches or closely approximates the weave of the original canvas is pressed upon it so that the texture of the repaired spot will be the same as that of the surrounding parts of the painting. Restorers can save for this purpose scraps from the edges of canvases they have lined, and sometimes one is able to steal a small scrap from the edge of the stretcher without harm.

All attempts to match weaves and textures require great care. Even a fairly smooth picture will require some roughening of a gesso plug to prevent a slick shininess. It may be pointed out that pressure of cloth produces a reverse or negative of its weave, which sometimes appears very different from the surrounding area. Numerous other materials will suggest themselves—coarse leather, embossed cardboard, or the often useful veined leaf of a tree or plant.

Picture Putty. Rub stand oil with whiting or chalk to a stiff paste with a spatula, then knead in more chalk by hand, rolling the putty between the palms; this is a rather sticky job at the start, but with a little practice one can do it efficiently, using dry chalk as a baker uses flour. The rolling warms the mass and softens it so that more chalk can be folded in until

the mass becomes less sticky; finally, the stiffest sort of putty is produced, stiff enough to retain its form when molded into a shape. If desired, a few drops of syrupy cobalt linoleate added to the oil will make this material dry more rapidly.

One of the heavy white pigments (zinc or titanium) should be added to the chalk in sufficient amounts to produce an opaque color; also, any pigment or mixture of pigments may be added to produce useful shades. The bulk of the filler, however, should be chalk or whiting, which reacts definitely with the oil to form a puttylike mass, and which also imparts a desirable texture.

The paste may be molded into conveniently shaped pieces and kept in tight jars; the wrinkled skin that forms on the surface is peeled off before use. There is no danger that such wrinkling will occur in the small and comparatively thin layers in which the putty is used on pictures. This material is to be employed where more flexibility is required than the gesso plug presents. Canvas weaves, coarse textures, or veined leaves may be imprinted upon it the same as upon the gesso plugs or it may be modeled into textures that match the brush stroking; this may be done as soon as the putty is smoothed. Whiting, talc, or other pigments may be dusted on the putty to prevent adhesion while pressing it. Picture putty may be applied over a first layer of gesso if desired. Textures should be impressed or built up in the plug; the repainting is to be thinly applied or stippled on.

Manipulations. The manipulations involved in the stopping or filling in of lacunae may be facilitated by the use of a good many types of instruments. Doerner[55] recommends kneading a plastic putty into tiny pills and rolls and pressing them in with the fingers, allowing them to set partially and then wiping off the excess with a well-wrung cloth that has been dipped into capaiba balsam thinned with turpentine. All traces of excess putty are to be removed from the surrounding parts at once. The area is also to be slightly moistened with capaiba balsam solution before the plastic is used.

I find that certain small blades and surgical instruments are invaluable for this sort of work—particularly the angular keratome, an eye instrument which is, in effect, a miniature triangular trowel set at an angle at the end of a thin handle (No. 3 on page 496). It is made in three sizes, the smallest of which is the most useful. This instrument should be of the best tempered steel, and before it can be used the two edges of the blade, especially the left-hand one, must be ground and sharpened to a keen cutting edge, all or most of the beveling to be done on the top side in order not to interfere with the smooth, trowel-like undersurface. Any

plastic material may be applied with this, pressed and worked into the spaces, smoothed, and then, provided the edge is keen, sliced off level with the paint film while it is still in a plastic state. The instrument has been described in so much detail because it serves a number of other useful purposes in the studio or workshop. The smoothing of a sticky or tacky material with a palette knife or any other flat instrument is often made easy by dipping the blade in some liquid—water, alcohol, or turpentine.

REPAINTING (INPAINTING)

Before touching up the blank areas of gesso patches, these highly absorbent spots must be treated with very thin shellac carefully applied with a finely pointed brush until the surface shows an incipient gloss; otherwise the absorbent dull spot will persist after repainting and even after the varnishing of the picture. Applying the shellac before the plug is thoroughly dry may cause it to crack. If tempera repaints are used to touch up such spots in an oil painting, they should be sized with damar in order to give them the same resistance to absorption of varnish as the rest of the picture has. The oil-putty type of plug does not require this treatment.

Obviously the new painting material must not turn yellow, or rather, it should accompany the rest of the paint film in such changes as are likely to take place, and here the restorer must judge for himself. An average, fairly new oil painting may be matched in this respect by squeezing oil colors onto unglazed paper, which will absorb the excess oil, and then mixing them with a glaze medium such as the stand oil–damar recipe recommended on page 208. When tempera colors are used, there will be little or no change with time, but the restorer must know exactly how the color is going to match when dry. Some restorers paint one approximate coat in tempera and a second or glazing coat with dry colors mixed with nonyellowing glaze medium. A great many methods suggest themselves. Pigments mixed with polyvinyl or other synthetic resin solutions that will remain undisturbed by varnish are used by some restorers; these are not easy to manipulate.

A patch can seldom be made to match with one coat, even when this is stippled on carefully so as not to run over the edges, because of the difference in the color of the grounds and other optical circumstances. If the color is first matched approximately, preferably keeping on the light side, it will generally be found that a second coat can be readily made to match the picture exactly.

In all operations of the type just discussed, the object of the restora-

tion must be taken into account. Curators of valuable collections some-times desire the restoration to be unnoticeable when the picture is viewed in the ordinary manner and at the same time easily distinguished from the original work when examined closely; in other cases the blemishes are required to be entirely concealed. Repaints are also mentioned on pages 471–72 and 495.

OBSERVATIONS

Published Instructions. Some writers on the conservation and restora-tion of paintings are given to making statements that are more or less true in a general way, but may lead to misunderstandings.

A good many solvents and mixtures have been recommended as materials that will dissolve and remove the varnish and dirt from old paintings without dissolving the underpaintings; others are condemned because their action is so violent as to remove everything at once.

As a matter of fact, there is no universal foolproof liquid whose ac-tion is selective enough to remove varnish and automatically stop at the color layer in all cases; some are merely more amenable to careful, expert manipulation than others. In other words, these recommended solvents should be described rather as being more useful than the others to the ex-pert worker in his efforts to remove only the top layers of old varnish, leaving the color coat undisturbed (preferably, in the average case, with a minute trace of old varnish still adhering to it). The more violent solvents are those whose solvent action happens to be of such a nature that they will not respond to such expert handling but will continue to remove everything with which they are brought into contact, too rapidly to be controlled by the special technique of the experienced picture cleaner.

The behavior of volatile solvents is purely mechanical, while that of water solutions such as soap or mildly alkaline compounds usually in-volves chemical action. Sometimes writers who warn against skinning a picture will recommend such water solutions, but their effect is most cer-tain to be the entire removal of all traces of the varnish. In fact, as a gen-eral rule, they come closer to being automatic or selective solvents than the alcohols or ethers; but after they have destroyed the old varnish film, skinned the picture, and stopped short of picking up color, they will im-mediately begin their less apparent destruction of the oil paint film, at-tacking it chemically so as to make it weak and spongy, altering the color effect by causing a sort of permanent bloom, seeping into cracks and de-stroying the adhesion, etc.

The mistake of assuming that a faulty condition under discussion is

the sole defect of a painting, and thus ignoring the existence of complications that would contraindicate the proposed remedy, has been referred to previously.

Theoretically sound materials, such as colors ground in pure damar or synthetic varnish, are often recommended without taking into consideration the obstacles to manual execution that are involved and are sometimes very difficult to overcome.

Floating Signatures. Writers on the authentication of old pictures refer to a test of the genuineness of a signature. When the painting has been signed by the original artist the signature will usually be part of the paint film; when the signature has been applied at a much later date over the varnish, or in paint of different or much newer materials, it is said to be a floating signature. When a solvent is applied to such a picture, dissolving the varnish but not removing any paint, it can readily be discovered whether the signature was painted along with the picture in the same materials or whether it was added later.

Obviously, certain conditions must be taken into consideration. It can easily be understood that in some instances even a floating signature may be genuine; but in the great majority of cases, particularly when there are other reasons for suspicion, it is taken as conclusive evidence of fraud.

A restorer as such is less concerned with this aspect of floating brush strokes than with the problem of their preservation. While it is often necessary to remove fraudulent or undesirable overpainting and signatures, and while this work calls for considerable skill, understanding, and a comprehension of what is to be expected in the original underpainting, so many unorthodox methods have been used in painting that the restorer is often called upon to preserve legitimate floating brush strokes which will be considerably more affected by solvents than the rest of the painting.

Among examples of this sort of painting are the fine lines of the rigging of ships, which in some instances seem to have been ruled with a fine brush or pen over an isolating varnish, and delicate touches, scumbles, and glazes on portraits, clouds, foliage, and water, which have been applied over an isolating varnish so that free work and corrections would be possible during application without danger to the underpainting. The use of megilp, the addition of resin to oil colors, and other unorthodox or experimental techniques on the part of the original artist offer complications that present themselves suddenly during cleaning and serve to reinforce the rule that paintings of any value should be restored only by highly qualified and experienced workers.

CRADLING OLD PANELS

When the wood of a panel picture splits, warps, or is in danger of this type of disintegration, it is made sound and permanently conserved by cradling, that is, by gluing crisscross strips of wood to its back under pressure so that not only is the condition remedied but the panel is strengthened and preserved against future decay. Like many other procedures of its kind, this is simple enough in theory, but must be executed in an expert and conscientious manner; if a specialist is not available the actual work may be done by any competent cabinetmaker, amateur or professional, but the decision as to whether or not the panel should be cradled, and if so, to what extent, should be made by an experienced person. Old panels are ordinarily improved by cradling, but sometimes a panel is injured by further complex warping and splitting after cradling. Because of this and also because museum conservators are more concerned with prevention of further decay than they are with making the surface slick, they are turning away from traditional cradling and adopting new methods that employ wax-resin adhesives and aluminum "beams," individually designed to suit the specific needs of each panel. Traditional cradling, however, is still practiced by experienced cabinetmaker-specialists and desired by some collectors.

The classic method consists of gluing mahogany or oak strips, about ⅝ x ¼ inches, to the back of the panel, laying them on edge, about two inches apart for the average panel, and parallel with the grain of the wood, which usually runs parallel to the long sides of the picture. A strong hot glue or casein adhesive is used. At intervals of the same distance that separates these strips, they are slotted so that the cross strips can lie flat against the panel. These cross strips are not to be glued down, but must be able to move when the panel contracts or expands. They are usually about half as high as the strips through which they run. Before the strips are glued on, the thickness of a warped panel is usually reduced by

planing it down at the rear, so that it will be more responsive to straightening treatment.

The cradled panel is then put into a press (see pages 477–78), and allowed to remain there for at least a week. Regardless of how much the vertical-strip system is simplified, it should be understood that the cross strips are not to be fastened; otherwise, more serious splitting or buckling will take place. Sometimes new panels of thin wood are cradled so that they will resist conditions they may be called upon to endure.

The cross strips, which are laid flat, may measure about ½ x 1½ inches; the dimensions of both strips are subject to much variation, according to conditions. Formerly the prime consideration was a flat, neat-looking job; present opinion is that the stationary strips should be rather high to ensure rigidity.

It has also been suggested that thin panels be mounted on heavy plywood panels on the theory that the thicker the support, the less effect warping will have on the picture. I do not know of any record proving the value of this over a period of years. Contrary to popular opinion, the complete painting or varnishing of back and edges to prevent absorption of moisture is not always advisable, as it may encourage dry-rotting of the wood; the end grain at least should be left uncoated so that air has access to it. As in other conservation procedures, a complexity of defects will sometimes result in conditions that demand special treatments. Very thick panels may be planed down; severely warped panels must be put under pressure carefully and gradually; a decrepit condition of the paint and ground layer often creates additional complications.

Wood worms or beetles in panels and furniture are easily destroyed by the application of carbon bisulphide. This is a much recommended material, the vapors of which are noninjurious to paintings, but its actual contact with paint is to be avoided, as it is a powerful volatile solvent. The technical grades have a disagreeable odor, which, however, is nonresidual; the pure or C.P. grade is less unpleasant. The material is inflammable, but a mixture of 20 parts with 80 parts of carbon tetrachloride is nonflammable. The carbon tetrachloride has considerable action in this case and is not entirely a diluent; it has been recommended as a wood-pest destroyer alone because of the toxicity of its vapor, as mentioned in connection with precautions for its use.

VARNISHING PICTURES

The application of a thin, uniform, flawless coat of varnish, especially on a smooth old painting, is not the easiest process connected with oil paint-

ings. They may be brushed or sprayed; spraying is the easier way to get a thin, uniform, flawless coating. An industrial power gun with a moisture trap that will deliver a well-atomized fan-shaped spray is best for conservators, especially for large areas, but the average painter requires simpler and less expensive equipment. (See page 644.)

The optical effect of a heavy, glassy coat of varnish is not desirable in the light of present standards of taste, and the thinnest film that will produce a satisfactory, uniform surface is in accordance with the most correct practice from every viewpoint. A heavy coat of varnish is actually less durable than a normally thin coat and is more subject to various forms of decay. Also, because of its contraction upon drying, a heavy coat applied over old or weak paintings is liable to cause eventual damage to the underlying paint that it is designed to preserve.

Varnishing is best done in a warm, dry place. Clear, windy days are best; humid or muggy days in midsummer are worst. In cold weather, varnish, brush, and picture sometimes require enough warming to take the chill out of them. The varnish is diluted with its solvent to exactly the proper consistency for best results (determined by experience, or, if it is a new material, by experimental trial). The brush should be a wide, flat bristle varnish brush of the best quality obtainable; uniformity or symmetry of thickness and freedom from shedding bristles are the two principal requirements. Some experienced varnishers prefer a softer brush, and use one of ox hair or red sable. Some prefer a rather thick brush, while others cannot get one thin enough. The thin or sparse brush is perhaps better, because it will not deposit such thick laps at the edges of the strokes: furthermore, it seems to do better work with less effort. The 2½- or 3-inch sign-writer's cutter described on page 529 makes an excellent varnish brush. If I were to have a special brush made either for varnishing or for applying gesso, it would be a 3- or 4-inch regular artists' flat bristle brush, possibly somewhat thinner than the average "flat," but of about the same quality, and with the same incurving ends. These are largely matters of personal preference; varnishing is essentially an operation for which one must acquire the knack, and the tools are of secondary importance. Recommendations as to how to brush out a thin coat of varnish or flow on a heavy one are similar to the previously criticized instructions for restoring, in that conditions vary so much. The following procedure may be entirely opposed by those who prefer other techniques.

The brush is dipped completely into the varnish once and then, depending upon one's experience and judgment, both sides of it and sometimes the edges are wiped off on the edge of the container so that just enough varnish remains in the brush to deposit a film of the desired thickness across the picture for one or two brush widths. After the varnish

has been spread over part of the picture, or, in the case of a small picture, over all of it, a second application of the empty brush is made all over with a short back-and-forth wrist motion in order to work the varnish well into the canvas weave; then a rapid single-stroke one-way brushing is done at right angles to the previous brushing to distribute the varnish more equally and to minimize laps in the first stroking; lastly, there is a straight, extremely light, rather slow brushing in the original direction with the empty brush held very flat, as a finishing or smoothing manipulation.

In our modern cities it is seldom possible to work in a dust-free atmosphere unless a specially constructed and air-conditioned room is available, and the warning to guard against dust as much as possible will be anticipated. After the varnish on a painting has dried for about ten minutes or as long as it takes for it to become set so that it will not run, the picture may be leaned at an angle, face against the wall, to finish drying. There may be some circulation of air, but no direct drafts. In a reasonably clean place there will be small danger of the picture's acquiring much dust in this position; coarse dust will not settle upward, but a swirling current of air might carry it upward against the picture.

It is not possible to apply a brush coating of varnish to a painting in a vertical position without sagging or frilling of the varnish; the defects known as curtains, tears, streamlines, etc., are practically unavoidable. However, pictures can be so varnished by an expert use of the pressure-type spray gun, provided one is thoroughly familiar with the particular varnish being used, and is able by the correct spraying manipulations to avoid the above-mentioned defects as well as the unpleasant "orange peel" effect that sometimes results. Toch[213] has devised a method of making balls of absorbent cotton covered with well-washed old lint-free sheeting, dipping these into a dilute varnish, and applying an even coating to a painting *in situ*, as French polish is applied. Usually only one very thin coat may be thus put on, and it does not take well on all types of paintings. The varnish recommended for this purpose is damar in turpentine plus 10 percent of stand oil, thinned down considerably with a mixture of half turpentine and half mineral spirits. This treatment is most effective on paintings in fairly good condition, where the greatest defect is a dulling or blooming of an otherwise intact surface.

As mentioned under *Varnishes* in Chapter 3, damar is first choice as a picture varnish; mastic is easier to apply in a flawless coating but will turn yellow and is more likely to bloom. None of the other materials made of tree resins are in a class with these two. Flat (mat) finishes should be tested for yellowing, for nonpolishing when rubbed, and for streaky or grayish effects on dark or deep-toned paintings. Cellulose lacquers and

industrial varnishes made from synthetic resins contain a variety of oils and plasticizers; they become brittle and lifeless with age, turn yellow, and are too far removed in general properties from the materials used in the average oil or tempera painting. Perhaps their greatest disadvantage is their insolubility in the normal painters' solvents; most of them require the paint-remover type of solvent and therefore present complications both in application to and in removal from paint films. Some modern synthetic varnishes that can be freely thinned and dissolved with mineral spirit or turpentine are also in use, particularly the methacrylates, which appear about equal to damar in all-around qualities. Methacrylate (clear acrylic) picture varnish (pages 172–73) is generally accepted, but the use of varnishes made of other synthetic resins, particularly those whose ingredients are not identified, is not recommended.

Art-supply stores are usually stocked with an assortment of liquids in pressure cans that will deliver a spray of varnishes, fixatives, and enamels. The contents of some of these cans, particularly those that are especially made for fine-arts use and bear the labels of reliable artists' material firms, may be trusted to be of acceptable quality. Acrylic picture varnish, mat and glossy fixatives, and damar varnish are simple materials; the enamels and other industrial finishes, however, especially those brands not specifically made for permanent painting, are to be avoided.

These products were hailed by many artists for their great convenience and have become widely used, but others have criticized them for being wasteful, messy, and an extravagant way to buy relatively inexpensive materials. Spray products sold for general use by firms other than art-material specialists are best avoided.

Sprayers. Among studio spray devices, the simplest is the common mouth-blower, useful for fixatives and water media but the worst sprayer to use with varnishes because of condensation of moisture from the breath; moisture is one of the principal causes of the blooming of varnish. The common rubber-bulb and glass jar atomizer, such as is sold in drugstores, has long been used by painters. The best kind, if it can still be found in the art-supply shops, has two rubber bulbs—one to squeeze and the other, larger and thinner, which is covered with a cord netting, to act as an air-pressure reservoir to ensure a steady, uniform spray. But the most recent and best of all the inexpensive hand-held sprayers (see *Sources of Materials,* page 644) has a plastic holder with a spray-release button, a replaceable pressure can filled with propellant only, and 4-ounce screw-top jars to hold one's own liquids. It will handle any liquid that is not too viscous and is easily kept clean by rinsing out the jars with the appropriate solvent (such as water, mineral spirits, or acetone) imme-

diately after use and then putting some clean solvent in the jar and spraying it through. For varnishes and mediums, acetone is the most efficient cleaner; for the sake of economy one may keep a small bottle, labeled wash acetone, into which remnants may be returned.

Removal of Bloom from Varnished Paintings. As mentioned in the discussion of varnishes (page 179), a mild surface bloom is not a serious or permanent defect when it occurs on a well-varnished painting. It may be removed from a picture that is well protected by an unbroken film of varnish by placing a few drops of light machine oil (such as is sold in small oil cans for household use) on a flat folded Kleenex tissue and rubbing the picture's surface with small circular and back-and-forth strokes, using as firm a pressure as the canvas will take without injury. The oil should remove the bloom immediately, but satisfactory technique calls for evenly distributing the smallest possible amount of oil on the surface, and rubbing should be continued until all excess oil is absorbed back into the tissue. Certain types of cloth may also be used; a soft, coarsely knitted cotton generally known in house-furnishing departments as an absorbent floor cloth works well, but some experimenting is necessary before using untried fabrics; the requirements for such a cloth are that it should not scratch the varnish or deposit lint, and that it should absorb and retain excess oil. If one doubts the quality of the prepared oils on the market, a satisfactory material can be made by mixing 6 parts of Nujol or de-bloomed paraffin oil with 3 parts of olive or rapeseed (colza) oil, and 1 part of highest-quality kerosene. Although these materials do not affect a varnish film, they must be used with discretion and never applied to a cracked paint film that is not thoroughly protected by an intact coat of varnish, or to an unvarnished painting, because the oil might cause damage if it were allowed to soak into the canvas or paint. Freshly applied varnish must be thoroughly dried, preferably for several weeks, before such treatments are applied.

Occasionally a painting will display a more serious type of persistent bloom that appears to be internal. The causes of this are liable to be both complex and obscure, and its diagnosis would call for examination by a technical expert.

PHOTOGRAPHIC RECORDS

All works of art should be photographed before and after any extensive cleaning, repairing, or restoring. Such photographs should be made in a professional manner and care must be taken to record the exact extent of

the original damages, not exaggerating them but at the same time making sure that the camera does not minimize them; in other words, the actual condition as observed on close examination should be depicted. In the case of important works, it is often necessary to make more than one photograph for this purpose: sometimes it is desirable to have a close-up of some unusual defect or a detail of the varnish or some other surface effect (that is, focusing on the surface of the film to show the condition of the varnish), as well as a deeper view of the actual picture disregarding the surface. Sometimes it is desirable to photograph a condition or texture in a raking light (extremely oblique), to show textural or surface irregularities. (Also see page 609.)

The record of the finished restoration should be made under identical photographic conditions (as to camera, film, lighting, and development) if it is to have any value for comparison purposes, and no attempt should be made to conceal blemishes that may purposely or unavoidably have been left in the finished work.

FRAMING PICTURES

The universal practice of fastening canvases in frames with nails or brads is bad, mainly because removal of the painting almost always damages both frame and stretcher. A better way is to use two-inch iron mending strips available in hardware stores. These have a screw hole at either end, and when the stretcher is not flush with the frame the strip can be bent into a Z shape by holding it in stretching pliers firmly with one hand and using another pair of pliers in the other hand, or by placing it in a vise and using a hammer to bend it to the proper dimensions. The strips are fastened to the frame with short screws, and, if desired, into the stretcher as well.

Improper framing may cause panel pictures to warp, bulge, or split. They must not fit too tightly. They must be held firmly but also be able to expand. One very old and reliable method is to have the frame ¼ or ½ inch larger than the panel in both directions and to cut 3/16- or ¼-inch slices from a bottle cork and place them at intervals around the rabbet of the frame so that they cushion the edges of the panel while holding it snugly in the frame. The panel is then secured firmly in the frame with mending strips. The corks may be fastened with glue or small brads.

An unframed canvas on a lightweight chassis must never be hung for any great length of time—especially not on a wall whose other side is outdoors—or it will be very likely to warp. The lightweight stretcher bar

was designed when no painting was ever shown without a sturdy, bracing frame. Modern paintings that show to best advantage unframed must be on heavy stretchers with some provision for bracing at the rear—for example, with plywood triangles screwed to the rear corners. Simple stripping adds finish and it protects edges, but the chassis supports the lattice strips rather than being braced by them.

All works on paper, such as prints, watercolors, and drawings, require framing under glass. Pastels need a special type of framing. (See pages 516–17.)

Strainers. A strainer is a rigid chassis with no provisions for expanding the corners. It should not be used for permanent, creative painting. Museum conservators report that the nonexpansible strainer is responsible for much of the trouble they have with modern paintings. Its use is a reversion to crude and primitive methods used centuries ago and is motivated by one consideration—economy. There is no evidence that artists of the past were more affluent than those of the present, but there is plenty of proof that they never tried to effect economies at the expense of quality. The use of second-grade materials and inferior methods in creative painting, sculpture, or printmaking is a mid-twentieth-century phenomenon.

CLEANING AND REPAIRING PICTURES ON PAPER

For this type of work an understanding of the properties and characteristics of paper and the nature of the materials that compose the picture is essential. Prints (the term being used here in the narrower sense, meaning pictures made by the customary offset or type-printing methods), etchings, lithographs, and line engravings, whether in black or in colors, are made with oily inks and can be wet in water without injury; therefore the easiest way to perform such operations as are required in cleaning and bleaching them is often to immerse them in trays of water or solutions. It is needless to refer to the fragility and sensitivity of such pictures, particularly old ones, when they are wet, and it should scarcely be necessary to point out the care and delicacy with which they must be handled during operations; for this reason more than the usual attention must be given to order, system, and convenience in the workroom, implements, and apparatus. Print papers, unlike the watercolor papers described on pages 282–85, often contain a number of ingredients such as fillers, coatings, and extra amounts of size, added to impart desirable qualities.

There are a number of details of precaution to be observed. Many have been omitted here; some are analogous to those given in connection with the treatment of oil paintings; and others will be obvious to the intelligent worker. The best teacher of careful manipulations is a varied experience; worthless prints of considerable age are easy to obtain, and experiment on them is simpler and can be carried out more systematically than is the case with oil paintings.

Large trays of glass or acidproof white enamel, such as are used by photographers, are employed; the wet paper is handled by placing under it a sheet of plate glass somewhat larger than the picture, but smaller than the tray or tank. When this is lifted from the bath the picture adheres to it, and after the liquid has drained off, blotting paper is carefully used to remove excess moisture, and the paper is allowed to dry on the glass. An adequate supply of largest-size white blotting paper is a necessity; also a set of smooth drawing boards, cardboards, or Presdwood in various convenient sizes. Wooden or metal screw clamps, flat, wide camel-hair and hog-hair brushes for paste and for washes, a wide rubber roller, sponges, tweezers, etc., are a few of the miscellaneous articles indispensable in this work; others will occur to the restorer. A sink or tub with running water and a small rubber tube attachment are also essential.

The resistance of printing ink to water and to chemical solutions, and the apparent recovery of the paper after its wetting, must not lead one to suppose that such treatment may always be carried out without danger. The sizing with which many papers have been prepared may be entirely or partially washed away and may have to be replaced before retouching or restoring can be done. Some papers are made of two or more plies or sheets of paper pressed together; these will sometimes separate or at least blister when immersed in water. Should such multiple sheets become blistered or partially separated, a prolonged soaking in a tub of water will generally allow one to strip off the extra plies, and the thin sheet with the picture may be remounted on good drawing paper or cardboard. It should be superfluous to add that in all such separating operations, including the removal of old mountings from prints, etc., two layers should never be forcibly pulled from each other; no separation should be attempted until the paste or glue has been dampened to such an extent that the layers will come apart easily and with no trace of any damage to the fibers of the valuable layer.

Some Japanese prints, as well as some artists' proofs of colored block prints, monotypes, etc., are made with aqueous paste colors instead of with the more usual oily ink, and cannot always be immersed in water with safety; but they will usually stand a limited amount of cleaning if it is carried out correctly.

CLEANING AND BLEACHING

The first procedure in cleaning prints is to remove oily or greasy stains, if any, by applying a volatile solvent with absorbent cotton or a soft brush. Acetone and diacetone are good solvents, but according to the nature of the stains other solvents may be required. Carbon tetrachloride and gasoline are the best wax solvents. Occasionally prints may be completely immersed in solvents if a cautious testing shows that their lines or colors are not affected by them. Those who are not familiar with the use of volatile solvents are advised to note their individual properties and the precautions to be observed in handling them, for both fire risk and toxic effects, as discussed on pages 365 and 406.

According to Scott,[207] the best material for removing linseed-oil and paint stains of long standing is pure, colorless pyridine applied with a brush of glass fibers. Repeated applications, followed shortly after by removal of the liquid with blotting paper, will often either remove such spots or diminish them to such an extent that they are made inconspicuous. The print is allowed to dry until the odor of the pyridine has disappeared. Ordinary impure pyridine is a yellowish liquid with a highly disagreeable odor; it is used as an alcohol denaturant.

A coat of simple-solution varnish can usually be removed by immersing the print in alcohol, scrubbing it gently with a camel-hair brush while in the bath, rinsing with fresh alcohol, and drying. Weak ammonia water is also sometimes useful for this purpose. Oil or oleoresinous varnishes are seldom applied to prints; when they have been used they can seldom be removed without leaving blotchy remnants. Superficial dirt, pencil marks, etc., are removed with Artgum or soft bread pills.

The customary method of bleaching, cleaning, and removing common foxing or brown stains that resemble iron rust (but are usually a species of mold) is to immerse the print in alternate solutions of bleaching powder and hydrochloric acid, the strength of these solutions to be kept dilute so that they will not harm the paper. The report quoted above recommends a ½- to 1-percent solution of bleaching powder, which will be ¼ to ½ ounce of powder to a quart of distilled water, and 1 fluid ounce of C.P. hydrochloric acid to one quart of water.

For applying bleaching action to pictures that will not withstand immersion in solutions, and particularly for restoring the original whiteness of highlights and other spots on a drawing that has been touched up with white lead watercolor, a recommended procedure is to make a flat plaster of Paris cast or tile, and after impregnating the porous surface of this with peroxide of hydrogen, to arrange the drawing or print with its face down ⅛ inch or so from the cast, whereupon the darkened areas are bleached in

a few hours by the action of the peroxide. The same method may be used to treat other bleachable conditions. When the drawing or print is so sensitive to water that even moist vapors such as these will cause ill effects, as in the case of fragile mounted or unmounted India-paper prints, an ethereal solution of hydrogen peroxide is recommended. Ether is shaken with peroxide solution in a bottle; it extracts the peroxide from the water solution and floats on the top of the water in a well-defined layer. (See remarks, page 372, for precautions in handling ether.) In connection with this procedure and with direct applications of hydrogen peroxide solution to paint surfaces that are partially but not entirely resistant to aqueous solutions, it has been found that the destructive effect of water is greatly diminished by addition of 50 percent of pure ethyl alcohol to the solution. Hydrogen peroxide is universally obtainable in 3- to 4-percent solutions, and also in a powerful 30-percent solution called superoxol, which requires careful handling, as it attacks the skin.

Another method sometimes found effective (and one that does not appear to have been published) is to allow the fumes of a strong reaction of concentrated bleaching powder and acid to come into contact with such spots. A small swab of absorbent cotton fastened to a wooden applicator is dipped into rather concentrated hydrochloric acid (1:1) and then into a dish of dry bleaching powder, particles of which will adhere to it. While the fizzing reaction is still going on, the cotton is brought close to the darkened spots, whereupon the fumes effect rapid bleaching. The same materials may be applied over a flat surface as in the preceding method, except that in this case glass instead of the acid-soluble plaster must be used.

Writing-ink stains are removed by the bleaching-powder process, which is the basis of most of the prepared ink eradicators. A more powerful remover of inks and similar stains is oxalic acid, a 10-percent solution of which may be applied with a glass rod. However, the application of chemicals without subsequent immersion in or through washing with water is not to be recommended; chemicals left behind in the paper weaken it and cause eventual staining. After every chemical treatment paper should be well washed in running water in the same way that a photographer washes his pictures, and for the same reason.

Prints in storage will absorb atmospheric moisture, which is nearly as great an enemy to them as it is to oil paintings. Authorities on the conservation of prints consider it very important to sterilize them after the removal of mold marks. This is best accomplished by subjecting them to the vapors of thymol by placing them in a tight cabinet containing a dish of thymol over the heat of an electric light bulb. The material is volatilized by allowing the light to remain on for two hours, after which the

print is left in the cabinet for twenty-four hours longer. The procedure can be repeated as often as necessary without harm to paper or vellum, but printed surfaces may sometimes be spoiled by the solvent action of the fumes. This process, which is described in detail by Plenderleith,[219] does not give permanent protection against further infestation.

Antiquated recipes often recommend restaining the brilliant white paper of a cleaned print with solutions of tea, coffee, ale, tobacco, etc., or smoking it over a damp wood fire, in order to bring it back to a "natural" aged appearance—a procedure not in accordance with modern practice or taste.

Very fragile pictures, prints on India paper or Japanese tissue, and pictures done in soluble or sensitive line or color that will not withstand immersion may be treated from the rear by pressing upon them blotting paper impregnated with the solutions, or may be pressed between two nearly dried blotters. The disadvantage of this procedure is that only partial results are effected and badly blemished prints are not well cleaned or bleached; however, in some cases little else can be done.

Pastels. The restoration of pastels requires delicate operations. As noted in "Pastel," they will survive a limited amount of pressure in contact with glossy paper or cellophane so long as there is no lateral movement, but every precaution should be taken to avoid rubbing their surfaces. A layer of dust can often be removed with a blast of air, and I find that sometimes, but not always, a careful light contact with a sheet of paper coated with a very slight, well-dried film of rubber cement will result in the dust's being picked up without too much removal of color. Tears can be plugged by mounting the picture, cutting out a patch from paper of the same thickness and texture, and proceeding as in the case of canvas plugs for oil paintings. These patches can be tinted with watercolor before being coated with pastel; all repainting and matching of colors will require very careful preliminary selection of crayons and usually the manufacture of special shades. It is not a difficult matter to retouch and smooth out blemishes if one has learned the manipulations of applying pastel, and with a picture that has been done in an average good thickness of color (as the early portraits usually were), minor spots can often be smoothed out with a delicate handling of a leather stump.

Beaufort[210] recommends cleaning and bleaching a pastel by taking it through most of the operations to which prints are subjected, from the rear, carefully floating the picture on the surface of the solutions and the water, if necessary attaching its edges to narrow strips of thin cork with thumbtacks. A sheet of strong drawing paper is used as a support in place of the plate glass, and after a preliminary floating on water to remove

creases, the print is picked up with the drawing paper and floated for a few minutes on a very weak solution of Javelle water or other single-solution bleach. As a final treatment, the pastel on its drawing-paper support is placed in a tray and its surface gently flooded with water for a few moments, after which it is removed and carefully dried.

Watercolors. As watercolor painters know, the average completely dried watercolor painting will withstand a careful and not too prolonged rinsing in water provided it is not rubbed while wet. Bleaching colored pictures or pictures on colored paper is not to be undertaken thoughtlessly; many colors and colored inks, especially the older ones, are susceptible. Retouching of mended watercolors is done with weak colors in a stippling manner with the point of a small, nearly dry brush. In the case of any picture on paper, when the sizing needs replacement for purposes of retouching, a very dilute solution of gelatin is best—a half ounce or less to a gallon of water.

DEACIDIFICATION

Using a solution called Wei T'o, it is now possible to deacidify paper. The paper to be treated with Wei T'o should be carefully rinsed in plain water and placed on a sheet of absorbent paper. Both sheets are then dried with a hair drier or radiant heater. When all is thoroughly dry, and preferably a bit warm, as much Wei T'o solution as seems necessary to drench the paper to be deacidified is poured into a dry glass. To apply the solution, use a clean new wide brush (a good housepainter's brush will do) which must also be thoroughly dry. The dryness of the materials is stressed because Wei T'o is extremely water-sensitive and precipitates out of the system even with the small quantities of water present in the fibers of the paper or brush at normal room conditions. Liberally brush the Wei T'o onto the reverse side of the paper being treated and allow it to dry. The paper is now deacidified. Paper acidity may be determined by using an archivist's pen (see *Sources of Materials,* page 639).

MOUNTING AND FRAMING WORKS ON PAPER

Many prints, drawings, pastels, and watercolor or gouache paintings require conservation treatments as a result of improper or deficient framing or mounting procedures. After one has gone to the trouble and expense of securing the best permanent rag paper for the work, he should continue his efforts to maintain the quality of his work by using permanent mounts and mats and avoiding the use of cheap wood-pulp cardboard and paper.

Papers that have been in close contact with such inferior products frequently acquire yellow or brownish stains. The relatively short time that it takes for newsprint or other wood-pulp paper to turn brown and become brittle is well known. What is not generally realized is that the chemicals that cause this change become volatile on aging and will migrate to surrounding surfaces; pictures that are backed with cheap pulp cardboard or kept in contact with ordinary mat board may eventually be affected by them. When a museum acquires works so mounted, such mounts and mats are replaced with rag boards, also known as museum boards, which are free of the trouble-making impurities found in ordinary cardboard. Rag boards protect the works themselves and prevent them from contaminating others with which they may be stored in close contact. (See *Sources of Materials*, page 646.)

Pictures on paper must be hermetically sealed against dust and polluted air. Glass of picture-frame quality is very thin and is easily cracked. A small crack at an edge may easily be overlooked, and if it is allowed to remain, a thin, sharp line of discoloration may result. The rear of the frame should be inspected occasionally to detect any leaks.

Conservation specialists avoid the use of gummed pulp-paper tape and synthetic adhesive tapes, none of which are considered sufficiently permanent for works of art; their favored adhesive is plain starch or flour paste. A matted work is usually attached to its mount with paste along the upper edge only.

Pastels must be framed under glass with an extra-thick mat that will prevent any possible contact between the surface of the picture and the glass. The two-hundred-year-old pastels mentioned on page 299 owe their survival in part to careful framing.

Works on paper can generally be protected from damage caused by ultraviolet rays and strong artificial lights by using a special grade of Plexiglas, UF1, in framing. In addition to being an effective ultraviolet filter, this transparent rigid plastic sheet has other advantages over glass, especially when the work is to be shipped. In fact ordinary Plexiglas sheets have long been used by artists to frame work for sending to exhibitions because of the high breakage rate in the shipment of glass-framed pictures. A word of caution in framing pastels with Plexiglas: allow more space between the pastel and the glazing than would be necessary with glass because the plastic has an electrostatic property that may disturb the color particles. Plexiglas, both ordinary and light-filtering varieties, is obtainable from local plastics dealers.

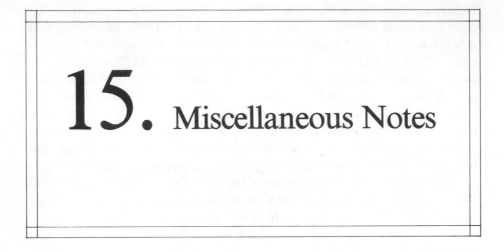

15. Miscellaneous Notes

THE STUDIO*

An ideal painting room has always been designed with a north light and with an absence or minimum of outdoor obstructions. The light from the north is steadier, more constant, and less glaring throughout the day; eastern exposure is second best because the glare diminishes early in the day; a southern exposure is more uniform throughout the day, and perhaps better than east or west, if the window has a white muslin curtain across it to keep out the glare of the direct sun. However, some painters do not object to their light being glaring and changeable; they seem to be able to get along under conditions that would be intolerable to others.

Studio windows are large because the average painter requires a large area of the room to be evenly illuminated, not just a little spot. They are large because the artist wants *intensity* of light as well as quality, and because it requires a large area of window surface to illuminate the painting area on dull days and in late afternoons. The argument over the advantages of overhead skylights versus side windows has been going on for many years, and it seems to be a matter of personal preference or to depend on the type of work being done. However, a skylight is most desirable when a studio is adjacent to taller buildings or other obstructions to light. Reflection of light from buildings, trees, and other objects can color

* Pages 518–22, up to *Brushes,* are reprinted from *The Painter's Craft* by Ralph Mayer.[62]

518

the light, and windowpanes that reflect the sun can be quite annoying.

As for artificial studio lighting, progress has been steady during the past thirty-five years or so, since "daylight" lamps began to come into use—a different story from the days when the best solution to the problem was a mixture of two different sources—an incandescent bulb (say a 150-watt reflector flood) and a blue daylight bulb or white fluorescent tube, or simply a mixture of tinted fluorescent tubes. Whether artificial studio lighting is a makeshift to be used from necessity when a north-light studio is not attainable or whether it is better than daylight is a moot point. Some artists will work only by daylight; others, backed up by scientific optical specialists, tell us that this is mere prejudice combined with a psychological element and the conditioning of habit, and that a painter can easily adjust to the change from daylight to modern lighting. Also, they argue that, because of its uniformity and control of color quality, modern artificial studio lighting creates working conditions more efficient than the variable and unreliable circumstances that nature offers.

The lights that seem to have solved the problems of studio illumination to the satisfaction of most painters and sculptors are the color-corrected fluorescent tubes. One, called "critiColor," available from the Verd-A Ray Corporation, 615 Front Street, Toledo, Ohio 43605, as well as some other makes, has been on the market since about 1967. Their appearance is no different from ordinary fluorescent tubes; they come in the same lengths and they fit the ordinary fluorescent fixtures. The inner surface of the glass tube has a coating that filters the light to a very close match to daylight over the entire spectrum, and it gives a quality of illumination that is agreeable to work under. Color-corrected tubes are widely used, not only in artists' studios but also in industrial applications, such as for color-matching in factories where accurate and uniform production is a necessity. In order to secure the intensity of illumination that is satisfactory for most uses, most painters will find that a longer or a larger number of tubes will be required than with regular white fluorescents. My own four 96-inch tubes in an ordinary fluorescent fixture hang nine inches from the ceiling of a room nine feet high—that is, about one hundred inches above the floor. The tubes are five feet in from the windows. I can paint by window light until the daylight fades, then switch on the tubes and continue painting without being bothered in the least by the change.

METHODS OF ENLARGING AND
TRANSFERRING DRAWINGS

Tracing Methods. Tracing paper, a thin semitransparent paper or plastic material, is the usual and simplest means of copying a drawing, the paper fastened or held firmly over the surface and the lines gone over with a pencil. A transparent sheet, such as acetate, may be used to cover and protect a valuable drawing from being injured. Tracing may be made on heavier paper if a tracing box is used, a wooden box that contains an electric light and has a top that is a sheet of ground glass. An assortment of modern thin tracing materials made of plastic rather than paper is available. One side is mat, the other shiny; they are more transparent than tracing papers. Tracing cloth is a thin, treated cloth used by engineers and architects in place of tracing paper when there is need for a tough, durable tracing that can be stored indefinitely. It has a faint blue color. A cartoon (the preliminary life-size drawing for a mural painting) is transferred to the wall by going over its lines with a tracing wheel—a small spiked wheel at the end of a wooden handle—which perforates the paper. The cartoon is then fastened to the wall, and its perforated lines are pounced, or tapped, with a small muslin bag containing charcoal, burnt umber, or another pigment in special cases. A cartoon can be saved by perforating a tracing-paper copy of its lines instead of the original.

Transfer Paper. The ordinary typewriter carbon paper as well as colored varieties obtainable in art-supply shops is used by artists for transferring drawings onto canvas, but a much better product is *graphite paper,* which deposits an image that is the equivalent of a soft lead pencil, generally better than the greasy carbon paper marks. A homemade version is made by rubbing soft graphite or a number 4 to number 6 lead pencil on tracing paper or other thin stock.

Squaring. The most widely used method of transferring a drawing to a large canvas or a wall and at the same time enlarging it to suit its new situation is called squaring or squaring off, and it consists of ruling the drawing into precisely measured squares. The canvas or wall is then ruled into the same number of squares. Each square of the drawing is copied freehand onto its corresponding large square; the amount of detail that is feasible to include will depend on the number of squares one has chosen to use in the first place. When the original drawing or other work must be preserved intact, a sheet of acetate or tracing paper may be fastened over it and the grid of squares ruled on this protective surface with black drawing ink and a ruling pen. Squaring was used in early civilizations; it

has sometimes been referred to as graticulation. It was used in ancient Egypt and perhaps earlier.

MECHANICAL AIDS TO ENLARGING, REDUCING, AND COPYING

Pantograph. A simple, inexpensive device that operates on essentially the same principle as lazy tongs. Four rigid, flat bars (wood or aluminum) are jointed in a rectangle; the ends of the strips overlap and can be adjusted according to the scale of the copy desired; the end of one strip is securely anchored to the drawing table. There is a tracing point at one joint and a drawing arrangement, usually a pencil holder, at an opposite end. As the tracing point is passed over the original, the four bars move in unison and the copy is drawn on the sheet of paper that has been appropriately positioned on the drawing board. The pantograph is available at complete art-supply shops in a number of grades ranging from professional models of great precision to inferior, rather inaccurate toys.

Camera Lucida. An optical device for projecting an accurate image of an object or a scene on a surface for tracing. It has been widely and successfully used, especially by commercial artists and illustrators, and is available from art-supply sources in various qualities up to finely made optical instruments for professional use. The modern camera lucida consists of a stand with an adjustable arm at the end of which is a prism, which interposes an accurate image between the eye and the drawing paper, on which it can be traced. The size of the image may be varied by adjusting the distances or by the use of lenses placed between the prism and the drawing surface or the eye of the viewer and the prism. Popular since the early nineteenth century, the camera lucida replaced a larger, more difficult apparatus called camera obscura, which had been used since the sixteenth century. The camera obscura was a box with a small aperture containing a double convex lens, sometimes large enough to be a chamber in which the artist sat. Its Latin term means "dark chamber," and the principle of the apparatus is the source of our modern camera. Camera lucida means "bright chamber."

The Opaque Projector. This term covers several different versions of a machine ranging from a simple lantern the size of a slide projector in which a small drawing (up to 6 x 6 inches) may be projected onto a canvas, panel, or wall for tracing, to large machines used in commercial-art studios that sell for hundreds of dollars and have a number of re-

finements and conveniences, such as a hood enveloping a slanting or horizontal drawing board and curtains to screen the working area from the room lighting. Each has its own proprietary name. Artists have also used ordinary slide projectors with black-and-white or color slides, tracing the images directly on wall or canvas.

BRUSHES

"The hairs and bristles which are used in the manufacture of brushes vary greatly in quality, the best ones being expensive and not common on the market; but the greatest element in brush making is skilled, expert workmanship." This sentence opened the section on brushes in the first edition of this book, and at the present writing it is of interest because of the scarcity of the raw materials. Brush-making craftsmanship is still continued on a high level by the best manufacturers, but owing to present world conditions the best hairs and bristles are no longer so easily available.

If the topics in this book were arranged in order of their ultimate importance to the practicing painter, this section would begin on the first page; there is no item of greater importance to the successful execution of a painting than a sufficient quantity of the very-highest-grade brushes that it is possible to find. It is one department of the artist's equipment where no skimping or compromise should be allowed; one may go without or use makeshift supplies of some items but poor brushes are a severe handicap to good painting.

In the midst of a completely revolutionized machine age, the mass production of artists' brushes is one of the few surviving examples of a real handicraft industry, for in the making of a first-class brush every major operation is performed by skilled craftsmen and the finished brush represents the culmination of ages of development in a superfine product that has had expert care and attention in every stage.

The tips or points of paintbrushes are the natural ends of the hair or bristle—they are never cut or trimmed; all shaping and trimming is done at the root end, by skillful operations. The hairs and bristles of the best brushes are appreciably longer than the portion that protrudes out of the handle; sometimes more hair is held within the metal ferrule than is visible outside, depending on the purposes and quality of the brush. The operations employed in making various types of artists' brushes are all similar, as outlined in the following paragraphs.

The wooden handles of all artists' brushes are shaped and proportioned to suit the main purposes for which each is intended; long-

established usage has decreed the proper length and balance suitable for each, and so the various types can be distinguished from one another at a glance. Watercolor brushes have short, black handles; oil-painting sables have long slender handles, usually cedar-colored, while the handles of oil-painting bristle brushes are very long, shaped proportionately to the size, and usually blond in color.

Red Sable Watercolor Brushes. The one source of hair for the finest brushes is the tail of the kolinsky (known also as Siberian mink or red Tartar marten). No other hair has the same springiness, durability, and combination of desirable properties.

This hair is delicately tapered; the tip is slender and comes to a fine point, and beyond its widest point or "belly" the hair again tapers somewhat toward the root. Some brushes are set so that the opening of the ferrule grips the belly; others are gripped above or below this point. The character of the brush varies according to the point at which the hairs are gripped. The hairs are cut from the tail, sorted according to length, and separated from the fur, misshapen hairs and those with defective and damaged points being removed; the hairs are then heat-treated and degreased. The shortest hairs are about 1⅛ inches in length and the longest 2¼ inches; the fact that the longest are six times as valuable as the shortest partly explains the sharp jump in price as the brush size increases. By the time it is ready to be made into brushes, the hair will have cost the brush maker, under current conditions, something like $2500 per pound, which accounts for the high cost of such brushes. By ingenious and skilled hand operations each brush is shaped, uniformly sized and set into its ferrule in a rubber compound and vulcanized, and the metal ferrule is firmly attached to its handle by means of an efficient crimping machine.

The best watercolor brush is shaped like figure 1 in the drawing below; there must be no concavity between its tip and its belly (widest girth). An exaggerated form of the concave tip is seen in the "lemonseed" shape (figure 2) that inferior brushes assume when wet. Watercolor brushes may be examined by wetting them, shaking out the water, and shaping them gently with the fingers. Resiliency of hair and sharpness of point is apparent to the experienced user. A shipment or lot of any kind of finest-grade artists' brushes will be uniformly acceptable, but in the case of the watercolor brush, there are enough slight differences in individual brushes to cause very particular artists to make their own choices.

Second-best red sables: Next to the top-quality watercolor brush one has a choice of pure red sable with a shorter or smaller hold of hair within the ferrule, or a blend of red sable with ox hair. Ox hair, from the ears of certain species of cattle, is firmer, stiffer, and more springy than red sable.

Bright Flat Round Filbert
WHITE BRISTLE OIL BRUSHES

Bright Flat Round Long
RED SABLE OIL BRUSHES

(1) (2) (3)

RED SABLE WATERCOLOR BRUSHES

Next in quality are a number of other hairs sold under the names of Russian sable (fitch), brown sable, black sable, etc.

Other Hairs. There are several other kinds of hairs used in paintbrushes, and the nomenclature of some of these is not very clear. Camel-hair brushes (actually made from nearly every kind of animal except camels; the best grades are made from squirrel tails) are too soft and have not sufficient elasticity or "life" for average professional purposes, yet their floppy or moplike character makes them desirable for some manipulations. An inferior grade of sable is generally preferable to camel hair. Ox hair is much less expensive than red sable and generally inferior, but its greater rigidity makes it desirable for some uses.

The Chinese and Japanese brushes in reed and bamboo handles are obtainable in a number of styles and are liked by some artists; others are unable to use them. Made from many varieties of hair, they are designed

for procedures that are entirely foreign to most of our Western purposes, but the sensitive character of line and versatility of effect they produce show their value when employed in trained hands. Their characteristics as a general rule are those of the better Western brushes.

Red Sable Oil Brushes. While the customary brush for oil painting is the bristle brush, the red sable oil brush is also extensively in use, especially for styles of painting that call for smooth, flat, or precise stroking. The rounds (brush shapes are defined below) do not have the pronounced bulge or belly of the watercolor brush but are of more slender construction and taper directly into the ferrule. The brights have sharper corners and less thickness than the longs; sizes are smaller and numerical designations are not the same as in bristle brushes.

Bristle Brushes. The standard artists' oil-painting brush is made from superlative grades of bleached white hogs' bristles, carefully gathered and selected before they reach the market; the very highest grades disappeared in the early 1940s, and although the kinds now available are considerably improved over those of recent years, the best of our present supply of brushes is definitely below the old standard.

In Siberia, Manchuria, and Eastern Europe, from whence the bulk of the good bristles formerly was shipped, these bristles originated in very small, hand-selected units before being gathered in commercial quantities, and some experts doubt whether such sources will ever open again.

Bristle brushes are still made with the same care and expert workmanship, however, and the details of their craftsmanship entail difficult hand operations similar to those outlined under red sable watercolor brushes. Instead of the sharp tips of hair, natural bristle has a split end, forked and branched like a miniature twig; this is called the flag. Artists' oil-painting bristle brushes come in three major shapes—rounds, flats, and brights (supposedly named for a Mr. Bright). The rounds come to points that vary from fairly sharp to quite blunt. The flats are broad with flattened ferrules and straight edges; their length should be about 2½ times their width. The brights are also flat, and somewhat sharper at the corners, with less thickness of bristle; their length is about 2½ times their width. Like the sables, the best sorts have a considerable hold of bristle within the ferrule in order to create springy resiliency. The final test of the excellence of a flat bristle brush is its ability to retain its shape under controlled pressure in the hands of a competent painter; a poor brush will splay out at the corners like a broom. Some hog bristles are normally curved; one of the skills of the brush maker is to construct the brush with

incurving bristles, so as to counteract its tendency to spread. Brushes are normally protected by a bit of starch or gum from damage to the bristles and their flags before getting into the consumers' hands; hence in the shops the common ones may look as good as the better grades. About the only test for quality in an unknown make is to put it to use in painting. All the brushes in a lot of high-grade bristle brushes will be fairly, if not exactly, uniform.

Flat brushes are more versatile than round ones; hence they are much more popular. The brights also are popular for manipulating very buttery paints. This was not so among the older painters, whose oil paint was perhaps more fluid, and to whom round brushes were standard equipment with the flats a novelty for occasional use and the brights unknown. No doubt this accounts for the difficulties some painters encounter when they attempt to copy the pictures or emulate the techniques of earlier work, the round bristle brush having gone completely out of use in some schools of painting.

Less-used shapes in bristle brushes are the chisel-edge flats, which are beveled or wedge-shaped at the end, and the very useful oval or filbert brush, which is a flat brush with distinctly rounded corners, resembling the shape of a well-worn flat brush.

Some painters like brand-new brushes; some like them well broken in; others like them worn down almost to the point where they become useless. In the days when first-rate brushes were easier to come by, artists were advised to have dozens of them on hand, so that brushes in all three of these states were available and the demise or loss of a pet brush was not such a tragedy. Today's advice is to be alert for the appearance of any superlative brushes and to hoard the best ones carefully.

When pressed firmly on a canvas and drawn across with the handle held at a sharp angle to the surface, a good, long bristle brush will form a point of contact a short distance from the ferrule, known as the heel. This action will not occur properly with a brush that has been allowed to accumulate dried paint at its root, or with one that is either too harsh or too limp.

Special Brushes. A large variety of brushes other than the sorts that artists customarily use will be found in the more complete supply shops. Made for specialty uses, such as lettering, lining, and architects' and decorators' work, these are often of considerable value for special manipulations and to meet the various requirements of the individual's purposes.

Single-stroke brush: a broad, flat red sable brush of great versatility, originally designed for lettering; the larger sizes are useful for broad wa-

tercolored washes and for general use in watercolor. Their widths are indicated in fractions up to one inch, not by number (figure 3 on page 524). Cheaper grades containing various amounts of ox hair are also available; in fact some painters prefer these to the pure red sable for operations where their greater springiness is desirable. O'Hara,[77] whose books deal with the direct, bold sort of watercolor painting, recommends ox hair for nearly all purposes, and he demonstrates its use in a series of illustrated instructions and training exercises. Strokes of considerable delicacy and variety can be obtained by using the edge; and if, instead of slanting the brush as one would a pen or pencil (which would cause the hairs to bunch up and make a line wider than the chisel edge), one leans it in the direction opposite to that of the stroke so that its right-hand or leading corner does not touch the paper, the hairs of the left side will trail out singly and produce a very thin line. A solid covering stroke on rough or roughish paper is made by holding the brush vertically to the paper and stroking with the width of the brush; the same result can be obtained with the brush held at a 45 degree angle if the stroke is made very slowly. By drawing this same 45-degree stroke rapidly across the paper, a broken, sparse, or dry-brush effect is produced, even with a well-filled brush. A slightly different broken effect can be obtained by holding the brush at more of an angle—even flat against the paper.

Architect's rendering brush: This is an oversize or giant round watercolor brush, sizes 24, 26, 28, and 30 usually made of best-quality ox hair and therefore less expensive than a middle-sized red sable would be. Useful for broad washes and all-around painting in watercolor, because of its size, the ox hair can be handled much as red sable can in smaller brushes. Invaluable to many watercolor painters.

Riggers: These are blunt, long, half-size lettering brushes. Lettering and show-card brushes, dagger-shaped and diagonal liners, fitches, and fresco brushes all have their uses, and they come in a variety of grades. A fitch brush is a diagonally edged bristle brush and has no relation to the animal of the same name, from which the hair known as Russian sable is obtained.

Quill brushes: In the old days brushes were set in birds' quills taken from the portion lying between the feather and the root, instead of metal ferrules. Quills come from pigeon, duck, goose, swan, eagle, and condor feathers and, in the days before numbering systems were standardized, were sold under these names. Many styles of quill-set brushes are still on the market, particularly the long, soft sable and camel-hair lettering brushes, the hair of which would be cut or broken if gripped by metal ferrules. Quill-set brushes are less expensive than those set in metal ferrules.

Brushes for Manipulations. The artist has several tools that can be used to modify or alter oil paint *after* it has been stroked on the canvas. Although any and all brushes may be used for these purposes, there are a few that are specially intended for such uses, never to be dipped into paint or used to apply it to the surface, but rather to be used in a clean, dry condition for stroking the paint after its direct application. These include the following:

Badger blender: Sometimes called a sweetener, this brush was in much wider use in the days when very smooth, imperceptible gradations between colors were more frequently sought after than they are at present. The badger brush flares out in a form that somewhat resembles a shaving brush; it has the same hair, white at the ends with a black band around the center, and is mounted on its handle with pieces of quill bound with twisted wire. Its shape is round but fanned out instead of pointed; its flat, blunt end is intended to be tapped or pounced exactly perpendicular to the painting's surface. The badger brush is intended for a special type of manipulation—namely, the modifying of juxtaposed or overlaid color areas already on the canvas to create soft, gradual transitions from one to the other and to thin out glazes. It works best when clean and dry; when it becomes clogged it does not serve to best advantage.

Fan brushes: These are sometimes called dusting brushes. These sparsely bristled, flat fan shapes are used, like the badger blender, for delicate or wispy manipulations of wet paint surfaces or to soften oversharp contours; they are also made in red sable.

Completely different textural and blended effects are produced by various means, and for less "perfectionist" blends the ordinary blunt bristle or sable brush will give acceptable results in some cases. Since ancient times artists have also used a number of other means to manipulate paint that has already been applied to the canvas; tapping with a piece of sponge or a tied or folded pad of cloth of smooth or rough texture, with the fingertips, with bits of leather—all will produce effects that may be useful in various circumstances.

These are manipulations frequently criticized, as is the whole principle of glazing, because their abuse, or too great a dependence on their effects, may create an unwanted lack of strength and forcefulness of character; but, like every other tool at the artist's command, they can be very successful if used with intelligence and a sense of appropriateness. More details on their practical handling are given under *Glazes and Glazing,* which begins on page 203.

Brushes for Varnishing and for Applying Gesso. It is just as necessary to use the highest type of brush for these operations as it is for creative painting. The bargain brush and the dime-store variety will produce inferior work; their bristles will break or pull out and their lives will be brief, and therefore they are poor bargains. The requirements for such brushes are mentioned under the descriptions of their uses on pages 267–68 and 503–507. I find that a high-quality 2½- or 3-inch brush for these purposes is widely available under the name of sign-writer's cutter, a chisel-edge brush of soft white bristles with a short handle.

A Quick Way to Dry Brushes. For the careful blending of color areas, for glazing, and for other manipulation of wet-paint coatings, a number of clean, dry brushes will be required. This is especially important for the application of smooth, flawless work in any kind of painting. When I find that my supply of brushes is not large enough to serve this demand, I use a rapid way of coping with the situation.

First, clean the color out of the brush with several rinsings in a container of turpentine or mineral spirits, and wipe with a cloth. The brush is now sufficiently clean, but it is not dry enough for use in continuing or repeating the glaze or blending manipulations. Dip it into another container of acetone, rinse it well, wipe with a cloth, and twirl it briefly or flick it on your sleeve. The acetone washes out the turps and dries almost instantly, and the brush is ready for use. Acetone, being a mutual solvent, will also wash water out of a damp brush. Keep flames away from acetone vapors. It must be realized, however, that this procedure is a temporary expedient; the brush is sufficiently clean to resume painting but it is not clean enough to be put away until it is cleaned as follows.

Cleaning Brushes. There is only one correct way to clean and preserve paintbrushes of any kind. Immediately after use, the paint or varnish should be thoroughly rinsed out with the appropriate solvent, and the brush shaken or wiped with a cloth, then washed well with warm water and a cake of common yellow household soap, great care being taken to rinse out all traces of soap under running warm water. Brushes that have become stiffened with shellac may be washed in borax solution. Those upon which oil paint has hardened and which require cleaning with paint remover, trisodium phosphate, or prepared brush-softener lose much of their life. When simple-solution varnishes dry on a brush they cause less damage than do oil paints, and are usually removable with their solvents. However, the rubber, glue, or resinous setting of brushes is often weakened by such treatments. When a clear, simple-solution varnish such as

damar is washed out with soap and water, a white, soapy residue sometimes clings to the base of the bristles and leaves the brush in a generally unsatisfactory condition for future use as a picture-varnishing brush. If picture varnishing is frequently done, a brush should be reserved exclusively for the purpose (see page 506; it can be kept in a soft or easily softened condition (provided it is not stored for too long a period) by washing it out well in several fresh changes of its solvent and folding a piece of kraft paper tightly around it in a manner similar to that in which new varnish brushes are packed. One make of varnish brush is sold wrapped in a durable jacket of strong fiber paper with a twine fastening.

House painters' brushes that are in continual use are sometimes kept suspended in a can of linseed oil, or half oil and half pure turpentine, after being rinsed. Brushes left in containers in this manner must never lean against or touch the sides or bottom of the vessel. A clean, dry brush stored in a closed box or drawer will keep better than one left suspended in liquids. When brushes are stored for any long period of time, it is usual to put camphor, naphthalene, or paradichlorobenzene in the box as protection against moths, which are just as fond of red sable as they are of mink.

The studio brush cleaner is a convenience and a turpentine saver. It consists of a covered tinned container of mineral spirits within which is fitted an inner can with a wire mesh or perforated bottom, which is placed an inch or two above the bottom of the outer can. The surplus paint is wiped out of the brush with a rag; the brush is rinsed in the mineral spirits by scrubbing it not too vigorously on the mesh false bottom and is then dried with a rag. The pigment settles to the bottom of the can where it remains undisturbed and the upper portion of the solvent becomes clear again. The solvent will gradually become oily by accumulation and the outfit requires occasional cleaning and replenishing.

Brushes for Polymer Colors. In polymer painting one may use any kind of brush that suits his manipulations. Long-bristled brushes are the most popular. Polymer is more destructive to brushes than are the traditional easel-painting media. They seem to suffer more rapidly from the gradual accumulation of solid color at the root end, and their shapes seem to be more subject to distortion. Because of constant submersion in water in a jar, if it is not to be hopelessly clogged, a greater strain is put on the bristles. The brush makers have therefore designed a special "polymer brush" or "acrylic brush" with nylon bristles, and in shapes designed to suit the majority of uses.

KNIVES

The following hand-tempered steel blades are in use.

Palette Knives. For mixing colors on the palette or slab and for general studio purposes. Slender, limber blades, four to six inches long, with tapered and rounded tips, both with straight and angular tangs. Angular ones are designed to keep knuckles out of the paint.

Painting Knives. Thin, delicate, very sensitive blades, sometimes welded to long handles, used for direct painting—the application and manipulation of paint on canvas. Obtainable in a multitude of shapes, styles, and sizes, they should, because of their fragility, be well cared for and not abused by using them for other purposes. History does not record much widespread use of these implements prior to the middle or late nineteenth century. The bronze *cestra* that were used by ancient encaustic painters (see pages 312–13) are close relatives. Although there is a definite distinction between the painting knife and the ordinary palette knife, the technique is always referred to as palette-knife painting.

Palette Knives Painting Knives

Spatulas or Paint Knives. Very finely tempered large, strong, flexible counterparts of palette knives, with straight forms, bluntly rounded ends, and sturdy construction, used for mixing and grinding, stirring, and other heavy-duty operations. The 6-inch blade is a typical size. Best ones come from cutlery, hardware, or paint-factory supply sources. The right kind for paint use is tempered to bend at the proper point, not too near the handle.

Another useful implement in the studio is the wall scraper or slice, a wide (2½-inch) blade of triangular or fan shape with its straight edge at the tip, illustrated on page 106. A good wall scraper is a well-balanced, handmade tool, flexible, limber, and tempered to curve under pressure at the correct point. Select the most supple one out of a dozen. It should be well cared for and its corners kept from being damaged. The inflexible, cheaper, putty-knife variety is not so good for the purposes referred to in this book.

The Bone Folder. This is a flat, flexible, spatulate implement the shape of a doctor's tongue depressor, only a little larger. The original bone folder was a very sturdy implement, actually made of bone, and capable of being used to fold a great pile of pages by the application of much force. It was used in business firms for folding letters in large-scale mailings. Those used today are made of relatively lightweight white opaque celluloid. Graphic artists use them for rubbing the back of the paper in imprinting a monotype and also for similar operations in linocuts, woodcuts, and the like. They work well when used to pull a print. Although flexible, they bend near the hand and exert a flat, uniform pressure. (See pages 579–80.)

The artist must discover for himself how many special studio appliances are really useful and how much is just gadgetry. Not all of our best traditions point toward bare simplicity in studio practice; in very old books and records, one finds a great amount of attention paid to implements that are intended to assist the painter in his work.

PALETTES

The conventional wooden palette is not so universally employed as it was in the recent past. Its brown color served without many disadvantages up to the days when painters adopted a new attitude in regard to the choices of their color keys and to conceptual color, at which time a cleaner or paler background for mixing colors became necessary. Then, with the

further development of art down to our present contemporary styles, a white palette became increasingly popular. The traditional oval palette of graceful curve is sometimes used by painters because of custom when a solid table next to the easel would better serve the purpose and leave both hands free. Large-size wooden palettes are called arm palettes.

There are many cases, however, where a lightweight palette held in the hand is necessary for the proper execution of a particular technique. For this purpose, the white lacquered aluminum palette originally intended for use with aqueous mediums can be employed, as well as the regular traditional wooden palette, which may, if desired, be colored white by the artist. The insolubility of shellac in oils, turpentine, and mineral spirits makes it useful for such coatings; white pigment may be stirred into the shellac to color it. The wetting power of alcohol makes it unnecessary to grind or mull the pigment for this purpose. Where a more universally resistant coating is required, the shellac may be replaced by white lacquer. Such palettes must be kept especially clean and no oil colors should be allowed to dry on them, because the removal of old dried paint will usually require solvents that will remove the shellac or lacquer surface. The white pigment may be tinted to a cool, neutral, or warm tone if desired.

The modern tendency is to work from a scrupulously clean palette and waste remnants of paint rather than allow them to accumulate. Glass and china plates are easily cleaned of hardened paint by scraping them with a razor blade, with or without softening the paint with solvents. A badly stained ground glass or stone slab can be scoured by grinding pumice and turpentine on it with a muller. I do not mean to say that every artist must necessarily work from a scrupulously clean or aseptic surface each time work is resumed, particularly if it pleases the individual to use a well-weathered palette, but for the sake of color control and for the quality of the paint the artist applies, some reasonable limit in this direction should be observed. See pages 5–8 for an important consideration involving the nonadhesion of paints for which a foul palette is sometimes responsible.

Disposable or "Peel-Off" Palettes. These are oblong, palette-shaped pads of paper with thumbholes, and they are a boon to those who wish to avoid the messy cleansing of a permanent palette; leftover dabs of paint are simply put on a new sheet. They are sold in two or three sizes, the paper is "paintproof," and they have become quite popular. Clipping a turpentine or painting-medium cup to an edge is not so practical, as the whole pad may be ruined by spillage.

Some artists collect and use numbers of plain white dishes and small

porcelain, glass, or tin vessels of little or no value, so that they may be thrown away without much loss in case the accumulation of paint or varnish gets beyond the point where they are worth saving. This follows an ancient procedure; painters from the earliest times have used seashells of various types in the same way. Lightweight dishes made of plastic ware are also convenient, especially for mural work. The majority of painters prefer a palette arrangement in which the depressions are not so deep and not so completely separated from one another that the colors cannot be rapidly and easily taken up and scrambled together with the brush when desired.

Preserving Oil Colors. As is noted above, the freshness of oil colors is an important consideration. Their usefulness may be prolonged for several days by removing the blobs of color from the palette and placing them on a strip of glass, which is then submerged in a tray of water; if a metal palette is employed, the whole thing can be kept under water. Colors thus treated will not keep indefinitely; after the water has been shaken off and the final drops allowed to evaporate, the colors should be examined for thickening—especially the rapidly drying pigments such as the umbers. Keeping them away from air in this way delays the drying action; it does not stop it, for, after all, water also contains oxygen.

Some painters claim that they can preserve their palettes for a longer time by keeping them in a refrigerator or freezer. This works well for a limited time, but the colors will eventually pass through their adhesive stage, so after they have warmed, they should also be closely examined for thickening, which will be most noticeable with the fast-drying pigments and least apparent with the slow driers such as the cadmiums. Oil colors, either on the palette or in the tube, are not affected by storage in sub-zero temperatures.

INKS

Chinese or India Ink. The description of India ink in the general pigment list gives the principal ingredients of the material, yet it is a crude description in view of the traditional Chinese and Japanese products, which are most complex mixtures, involving a number of minor additions and manipulations both for ceremonial reasons and to impart further brilliancy, working qualities, and delicacy and range of tone. The native painters have always been exacting connoisseurs on the subject, demanding their favorite brands, whose histories are often long and distinguished and whose manufacture continues in establishments where the processes

have been handed down for centuries. These inks are sold in little sticks that are rubbed with water on stone blocks or in shallow mortars; even the manner of rubbing is said to influence the delicate character of the ink.

Liquid India ink has practically replaced this material in modern American usage; it is sold in two varieties: the waterproof, which will withstand washes after it has dried, and the soluble, the dried film of which may be washed away by going over it with water. The latter kind is usually more applicable to fine lines and delicate manipulations and effects. Both may be freely diluted with water while in the liquid state. The inks that become insoluble in water after drying are usually made with a water solution of shellac and borax.

Colored Inks. Most colored drawing inks are carefully formulated to meet every requirement except that of permanence of color and can never be relied upon for other than temporary results. There are, however, a few colored inks that are permanent. They contain lightproof pigments rather than soluble dyes, and, provided that the pigments used in their manufacture are among those approved for creative painting, they may be safely used. Among these, one brand of American pigmented drawing inks comes in a range of eight opaque colors and white, and another, imported from Germany, has sixteen translucent colors plus black and white, which are opaque. The colors in this line are labeled with their true pigment names, one of the few lines of inks with pigments identified rather than being labeled with hue designations (Sky Blue, Deep Purple), fanciful names (Periwinkle Blue, Sunset Orange), or proprietary names (Blimpo Red, Akasaka Blue).

Writing Ink. The principle upon which the composition of writing ink is based is the action of atmospheric oxygen on an acid mixture of iron salts and tannin, a material obtained from an infusion of nutgalls. Modern writing ink is made by combining tannic, gallic, and dilute hydrochloric acids with an iron salt, phenol, and a blue or black dye. The dye is used to make the ink visible at once because the reaction between the oxygen, iron, and tannic acid is not completed for a day or two, and the fresh writing would not be satisfactorily visible without dye. The best modern writing ink is a carefully balanced mixture of ingredients, designed to have the best flowing properties and least corrosive action on pens and paper, and to give the most permanent results. Many modern proprietary writing fluids of special characteristics are inferior to the standard black or blue-black iron gallotannate ink. Iron gallotannate writing inks have been in use since the twelfth century; all of their properties have been

standardized and greatly improved in recent years. Their permanence, however, is not usually considered great enough for general artistic use, especially where there is continual exposure to daylight; permanence for use in records and documents, which are ordinarily kept filed away in darkness and in which considerable fading or color change could occur without seriously impairing legibility, is another matter.

Ink for writing and drawing was invented in China and Egypt at about the same time; according to various researches, the date in each country is generally believed to be not much before 2500 B.C. These inks were of the same type as our modern drawing ink—mixtures of carbon and binders. The Romans called their carbon ink *attramentum.* Later they also used sepia. The earliest record of the material we now know as writing ink, as it has been made and used from medieval times down to the present, is in the writings of Theophilus,[7] who described an iron-nutgall ink. Pliny,[4] however, about ten centuries before this, knew that paper treated with copperas could be blackened with an infusion of nutgalls.

Felt-Tip Markers. A mid-twentieth-century innovation; coarsely painted markers and finely pointed pens whose tips are made of felt or nylon and whose bodies are reservoirs for free-flowing inks that dry instantly. These are industrial products for general use rather than artists' implements. Nevertheless, many artists find them well suited for sketching and drawing. The colors in most of them are soluble dyes and therefore are not permanently lightproof; they should never be used for fine-arts purposes. There is, however, at least one brand that is refillable with permanent carbon inks and that has replaceable tips. Colored inks are also sold with these, but only two pigmented inks, red and black, are perfectly permanent. The others, though they are offered as permanent, contain soluble dyes and no soluble dye will withstand exposure to light without fading. However, they may be permanent if kept away from light in a sketchbook or portfolio, but it is not advisable to use any but the carbon-black kind if the work is to be hung on a wall and exposed to light. (See *Sources of Materials,* page 646.)

TAPE

For masking out circles (over six inches in diameter) use ¼-inch masking tape, which is sufficiently flexible for that purpose and also for curves. Because of the slim masking afforded by its narrow width, it may be useful to add a "skirt" once the tape is applied. For this use, sections of wider masking tape (¾-inch tape would be appropriate). The representational

painter, especially one whose style is precise, can also use an occasional masked hard-edge to speed up the painting of neat lines or shapes. There are several brands of tape available in ⅛-inch to ¼-inch widths and in an innumerable range of colors for use by designers and draftsmen. The metallic silvery variety (Mylar) can be used for masking off color slides, for which purpose its opacity, light weight, and not-too-tenacious grip make it serve well. These tapes seem to have good properties for masking out small forms in precision painting as well.

NOTES ON GILDING

As noted elsewhere in this book, an informative outline of a process such as the following is not intended to be a complete course of instruction that will enable the reader to master a technique; ordinarily even a more completely detailed manual presupposes that the user will also have other means of augmenting his knowledge on the subject. This section deals with gilding primarily from the standpoint of its most exacting use, that is, in paintings or "gilding on the flat," rather than on frames and carved ornaments. However, the processes are basically the same in either case.

Gold in Paintings. Thin leaves and foils of the precious metals were used as embellishments or to function as elements of design in paintings and for decoration in very early times, and their use in more modern ages, although by no means universal or widespread, has never halted completely. Our traditions of gilding as an element in easel and mural painting begin with early European art; besides the gold used on illuminated manuscripts and miniatures in various civilizations, the most notable examples of a well-developed craft are to be seen in numerous Sienese and Florentine tempera paintings. Modern use of gold and silver effects falls into two groups—carefully controlled elements or fields of gold in work that emulates its medieval and Renaissance use; and more casual or occasional lines, areas, and splotches of metallic or glittering nature in contemporary designs.

Gold is highly inert and permanent; it does not tarnish or change its color in any way. It is one of our most ductile or malleable substances, which means that it can be rolled or beaten out to infinitesimally thin leaves and drawn out to the most tenuous wires. Hence, despite its high intrinsic value, we can afford to use it in thin layers over large areas. Thompson[70] points out that originally the use of gold leaf on religious paintings and their carved frames or settings was intended to create the impression that the work was a slab of solid gold. No one really believes

that a gilded panel is a massive chunk of gold; still, such an impression *is* the sought-after effect, and if the surface does not have a metallic, rather than a coated or painted, effect it is not successful. He also points out that gold and silver effects in the average run of paintings are to be considered darks in the composition or design, unless they are covered with stamping (designs pressed in by hammering on the finished gilding with small punches such as those sold for leather work), in which case the resulting frosted effect is equivalent to a light in the design.

Gold Leaf. The metallic leaves are sold in tissue-paper books; real gold is available in 3½-inch squares, 25 to the book. By rolling under great pressure and repeated beating with hammers of various weights, with the gold in between goldbeater's skin (an animal membrane), it has been re-duced to a thickness of about $1/300,000$ of an inch, and 2000 leaves weigh about one ounce. The cost of gold leaf therefore is in great part due to the labor involved.

Kinds of leaf available: Books of gold leaf are sold in a deep rich gold, or 23½ karat; lemon gold, 18½ karat; and pale gold 16 karat. The latter two are somewhat thicker and a little easier to handle. Special double-weight gold, which costs more than the ordinary but makes up for that in ease of handling, may be available from some sources. Another more easily handled form of gold leaf available in the 23-karat grade is called patent gold, "for gilding in the wind." The balls on flag poles and other outdoor objects are gilded with this material but its effect is inferior for use on surfaces that are to be closely observed. This leaf is pressed onto squares of tissue paper that can be picked up in the fingers and applied like a transfer. Gold leaf is also available in ribbon form, sold in tissue-paper rolls of various widths, and other special sizes are made for indus-trial use.

Gold Powder. Powdered gold cannot be bought at present because of government restrictions. However, tablets of real gold watercolor are available in the completely stocked art-supply shops; these are set in little porcelain pans and are equivalent to what the old books refer to as shell gold, a tiny drop of gold watercolor in a mussel shell. Gold watercolor suffices for very thin lines, small illuminations, and repair touches, but it does not have the continuous metallic surface effect necessary for use on areas of any great extent unless it is burnished. It would be impossible to grind dry gold leaf or gold filings into a powder with a mortar and pestle, just as it would be impossible to pulverize a lump of soft wax; it amalga-mates or coalesces into a mass, so that a wet process has to be used. A pinch of gold powder can be obtained by dumping a book of gold leaf

into a glass mortar together with honey, and grinding to a smooth paste, then washing out the honey with several changes of warm water, allowing the gold to settle each time and finally drying it on filter paper. When mixed with a *weak* gum solution or watercolor medium it may be used on paper or parchment as in illuminated manuscripts, where it can be burnished to the highest degree of brilliance. It is the most expensive way of using gold in painting.

Gold leaf is the flimsiest and most fragile of materials, and cannot be handled in any other way than by the traditional techniques that have been developed over the centuries. To get an idea, gently remove a leaf from its book and hold it up to the light by two corners; opaque and metallic as it is, light will be transmitted through it, revealing a characteristic green color. This effect can sometimes be observed from the interior of a shop that has gold lettering on its window. Now give it a sharp puff of breath and see it disintegrate into fragments.

Up to comparatively recent times there were dozens of old-time craftsmen gilders in every large town, and the artist who had his frames gilded could learn the process by direct contact with a worker who had mastered the craft in his youth and could handle the leaf with spectacular deftness, accuracy, and dispatch; nowadays it is difficult to locate a really professional gilder because of the complete change in the public taste. Gold-leaf frames and decorations are no longer in great universal demand; formerly it was almost indecent for an artist to exhibit a painting in any other kind of frame.

Gilding, however, is not too difficult a craft to master from an artist's standpoint. The average amateur gilder cannot hope to attain professional skill quickly, but with a little practice he can succeed in turning out adequate results for many purposes, even though a job may take much more time, and there may be more leaf on the floor than on the picture.

APPLICATION OF THE LEAF

Thompson's book, *The Practice of Tempera Painting*,[70] gives a very clear account of the precise and meticulous gilding methods in use since medieval and Renaissance days and is highly recommended as a guide to its practice. There are not many writings on the modern aspects and trade methods of gilding; the best source of information is direct contact with an experienced gilder. There are two kinds of gilding with gold and other leaf: (1) water gilding and (2) oil or mordant gilding. Burnish gilding (high-polish, mirror-finish) can be had only on water-gilded surfaces. Both kinds can be used for the regular metallic effect (usually called mat gilding). Mordant gilding is by far the simpler, easier method. However,

it is recommended that the beginner read over the section on water gild-
ing, as it contains some details that are relevant to both and are not re-
peated under mordant gilding, which is outlined on page 542.

Water Gilding

Water gilding requires more skill, more careful preparation of sur-
face, and more meticulous work than oil gilding, but it is the best method
for use on gesso surfaces. Briefly outlined, a gesso surface is prepared as
described in Chapter 5, the smoother and more nearly perfect the better,
because every little imperfection will show up in the final result. It is tra-
ditional, but not essential, to redden the surface by applying two more
very thin and very smoothly sanded coats of a sort of red gesso made of a
smooth earth color (bole), water, and glue. This can be bought in ready-
made paste form (without the glue) in jars under the name of "Gilders'
Delight Gold Size." It is prepared for use by dissolving ½ ounce of gelatin
or rabbitskin glue in 10 ounces of water and mixing it with enough of the
red paste to make a *thin* creamy, easy-brushing coating; exact proportions
are not important.

Glair. At one time, glair, or egg white, was used instead of glue gelatin;
as a size it works as well as gelatin, but it is not in very widespread use
because of its rank odor. Glair is made by beating the white of an egg to a
stiff froth, adding two or three ounces of water, and allowing it to stand
overnight. The liquid is used in the same way as the gelatin solution.

Implements. Gold leaf could be applied to surfaces only in a crude and
haphazard manner without the use of three pieces of equipment: (1) the
gilders' cushion or board, which is a sort of gilders' palette on which the
leaf is laid out flat and, if required, cut into smaller pieces; (2) the gilders'
knife for handling, straightening out, and cutting the leaf; and (3) the
gilder's tip for picking it up and laying it on the surface. An examination
of the first two might enable one to make adequate homemade substitutes
when they are not obtainable.

The gilders' cushion is a thin board about 6 x 10 inches, padded with
a thin layer of cotton wool and covered with a piece of sheep or calf
leather, tacked on with the suede side up. It is dusted with dry red earth
or bole to prevent the gold from adhering. Two strips of leather are
tacked to the underside of the board—one a short loop to serve as a
thumbhold so the cushion can be held as a palette, the other, attached
flat, to act as a holder into which the gilder's knife is sheathed. The best
type has a screen of wrapping paper around one end to shelter the leaf
against air currents.

The gilders' knife is like a steel table knife, or somewhat longer, with a squared oblique end instead of a round end. It must not be so sharp as to cut the leather, but sharp enough to cut the leaf.

The gilders' tip is a sort of flat brush, a double card about four inches long between the layers of which is mounted a rather sparse row of camel hair; its function is to carry the leaf from cushion to the surface. Tips come in various hair lengths; the longest is required for use with whole leaves and the shorter ones are best for smaller pieces. Immediately before use, the gilder runs the tip over his hair which makes it faintly oily, so that when it is pressed against the leaf, it will pick it up securely enough to carry it to the surface. The gilders' tip is a relatively modern improvement apparently not much more than two hundred or three hundred years old; Cennini used a piece of cardboard.

Laying the Leaf on the Cushion. Dump one or more leaves of gold on the sheltered end of the cushion. Pick up a leaf by sliding the knife under it flat along the cushion, then allow an edge or a corner of the leaf to touch the cushion, and by turning the knife between the thumb and fingers let it fall and spread out on the open end of the cushion. A sharp rap with the flat of the blade next to the leaf should disturb it enough so that the knife will glide under without injury to it. Repeat this operation as many times as it takes to unwind the leaf and lay it flat without any folds—with some experience the leaf can be quickly spread out and untangled with few turnovers. To remove the wrinkles and make it lie perfectly flat, blow a short, staccato breath *directly down* upon it, a little puff of air delivered somewhat as though one were blowing a crumb from between the lips.

Cutting the Leaf. Draw the knife across the leaf at about half the pressure required to cut through it, about an inch; then, without lifting the blade, draw it back again at full pressure. If the knife is sharpened to the correct degree and has no nicks or roughness, the gold will be sharply separated and the leather not cut. Do not attempt to make cross cuts. Do not skimp when filling in small areas; the pieces must be cut considerably larger than the areas they are intended to cover.

Laying the Leaf. Holding the cushion in the left hand, and the tip between the left forefinger and second finger, the knife in its sheath or else held between the other fingers, the gilder wets an area of the gesso somewhat larger than the piece of gold, using a soft brush. He adds 15 to 20 percent alcohol or some wetting agent to the water; most gilders add a small amount of gelatin or glue solution to augment the adhesive action

of the wet gesso. After replacing the brush in the water container he then takes the tip in his right hand, runs it over his hair, and presses it against the leaf, which adheres lightly to its under side, allowing about ½ inch of the leaf to overhang the hairs. When this edge is touched to the wet gesso, it is taken by the surface somewhat in the manner of a magnet, and lies flat upon it. The tip must not be allowed to get wet; the motions from hair to leaf to gesso are made rapidly and deftly, the tip being held flat and smartly withdrawn the moment the leaf touches the wet surface. While the ground is still wet (but not too wet), the gold should be pressed down (not rubbed) with a wad of absorbent cotton.

The gilding then proceeds in continuous order, overlapping the leaf at all edges to avoid missing spots. Little or no attention is given to repair or improvement of imperfections; these are made after the whole area is done, when it is gone over and missing spots filled in. Small patches do not require much wetting.

Burnishing. The bright mirror finish is produced by rubbing the gilded surface with an agate burnisher as soon as it is dry. The expert gilder can tell when the gesso is ready by tapping it with the burnisher and listening to the sound. If there is any dampness in the gesso, the agate will rip the surface instead of polishing it. Proceed cautiously. One soon learns the degree of pressure and method of stroking that give best results. Generally it is preferable to rub the surface first with a gentle, circular motion, then to go over it with firm pressure, using both hands, in one direction. Reburnishing after a few days will usually heighten the gloss. For flat areas, the larger the agate, the better. Cennini used dogs' or wolves' teeth instead of agate. Gold burnishes only on gesso or bole. Actually it is the gesso that is polished; the gold follows and duplicates the texture of the surface.

Mordant Gilding

Gilding by the use of oil or mordant size is a much simpler process, and much easier for the beginner to master. Mordant size is applied to any nonabsorbent paint or ground surface: canvas, panel, wall, glass, metal. If the surface is absorbent, like gesso, it must first be sized with shellac, either plain or with a little pigment mixed in. If a very smooth finish is required, surfaces must be well sanded, because the gold will bring out every grain or speck of texture.

The procedure is to brush or stipple the size over the surface thinly and smoothly, wait until this coating is in the correct stage of tackiness or partially dry condition, apply the leaf, press it down with a bit of absorbent cotton (never rub or use a lateral motion which will mar the surface),

and continue the laying, being careful to overlap each edge. In some instances, especially for small spots and delicate lines, the leaf can be laid by pressing it directly from the book without using the tip.

There are two kinds of mordant size. Regular gilders' oil size contains golden chrome yellow; it is intended to be applied the night before. It holds its tackiness for forty-eight hours and is therefore useful for long operations such as mural decoration. Its yellow color not only makes the areas clearly visible but also serves to render minor faults inconspicuous at a distance.

The other kind is a clear, amber-colored synthetic varnish sometimes called japan gold size or quick-drying size. The usual material of this type is ready to receive the leaf within an hour; the length of time for which it remains in this state varies according to circumstances (the weather, the nature of the ground, etc.), but it becomes totally dry and no longer adhesive within a relatively short time; a typical quick-drying size stays tacky for a half-hour or so. The entire drying time may be slowed, if desired, by the addition of oil size or of oil colors. It is more convenient than the slow-drying oil size for small bits of gilding; because of its thinner consistency this varnish size can be used more readily than the heavier oil size. Fine lines and dots, etc., can be brushed on a surface with accuracy, and the leaf or cut pieces of a leaf pressed upon them directly. The previously mentioned patent gold is sometimes convenient for this. Both types of oil size need a nonabsorbent surface.

Nonabsorbent surfaces can be produced by going over absorbent, spotty, or sunken-in areas with any type of paint or varnish; shellac is usually convenient for this purpose because of its fast drying rate and its ability to remain nonabsorbent after sanding. It may be colored by mixing dry pigment into it, especially if one desires to have the gilding present an antique or worn-down effect with an underlayer of bole-colored ground showing through in places. This surface must be meticulously smoothed with fine sandpaper or with 00 or 000 steel wool before stippling or brushing on the gold size.

It is best to allow the gilding to remain overnight with all its overlappings, hanging excess pieces, and surplus edges of repairs, so that adhesion is assured; but, if desired, it can be carefully trimmed up while still tacky, especially if it requires going over again or there are many faults to be repaired. This cleaning is called skewing and is done by gentle scrubbing with any soft sable or camel-hair brush; a flat, chisel-edge, camel-hair brush is the standard. A soft brush can also be used for tamping down the leaf in moldings or carvings.

Oil size is supposed to produce brighter effects than the varnish or quick-drying variety. The correct degree of tackiness when either is ready

for use is ascertained by touching it slightly with a clean fingertip; it should be somewhat tacky or sticky but not feel wet.

OTHER LEAF

Silver Effects. Silver leaf is applied to gilding the same as gold leaf, except that because it cannot be drawn out so thinly, it is heavier and easier to handle. If a tip is needed, a special double-thick variety is supplied. Formerly silver leaf was often used and then coated with a transparent golden lacquer to imitate gold. Because silver tarnishes and discolors so readily, it has in recent years been replaced by palladium. Gold and palladium leaf can be used together in designs, especially to create inlaid effects, by using rubber cement as a resist; the cement is applied to a finished, gilded surface around the design, and after sizing and application of the second metal over this design, the rubber cement is rippled away in the usual manner. Scrambled or freely mixed effects of palladium and the different shades of gold are also possible.

Palladium is a precious metal of the platinum group; it does not tarnish, and may be used in the same manner as gold. Not only does silver leaf require careful lacquering after application, but the books of leaf must be well protected lest they become discolored in storage. Deliberate tarnished or antique effects may be made on silver by the application of potassium sulphide or other sulphur-bearing solutions, before the lacquering.

Imitation Leaf. These products perhaps should not be mentioned among materials used in permanent works of art, for they do not retain their original brilliant effects long enough to be considered suitable for this purpose. Bronze leaf, Dutch metal, or metal leaf are names for an imitation gold leaf in various shades; there is also a copper leaf, and, to imitate silver, an aluminum leaf. All these come in books measuring about 5 x 5½ inches. With the exception of aluminum (which has a rather dull, leaden effect as compared with silver), they have a bright, shiny effect between that of mat and burnished gold but they become somewhat duller when varnished. Unlike gold and palladium, they must be shellacked, lacquered, or varnished to prevent rapid tarnishing. They do not have the extreme fragility of gold and may be picked up or applied directly from the book to oil or varnish gold size.

Bronze Powders. The bronze powders and paints available in a very large variety of shades are inferior even to the imitation leaf; they change in color and lose their brilliance too rapidly even to repair or retouch the

bronze leaf. Tinsel and glitter are in the same class—unless for any save the most temporary kind of decoration.

Polymer Gilding. A quick and easy way to apply gold leaf to nonabsorbent surfaces, such as metals, polymer paint, modeling paste, or porous surfaces that have been rendered nonabsorbent by sizing or varnishing, is to brush on a layer of polymer medium (page 404) and apply the leaf immediately to the wet surface. Patent leaf (see page 538) is convenient for this purpose. Especially in the case of carved or embossed objects, the leaf must be pressed firmly with absorbent cotton or with a camel's-hair mop or dabber brush.

PERSPECTIVE

The surface of a picture is a plane figure of two dimensions bound by the frame, and any lines or masses depicted upon it lie within that plane and have only length and breadth. Aesthetically, a two-dimensional picture or design may be entirely successful, but the development of most schools of art has led to a demand for perspective or a means of creating upon a two-dimensional surface the effects of three dimensions.

Perspective in a picture is a sort of optical illusion perceived by virtue of training and education and made possible by certain mechanisms (sometimes called defects) of the human eye. It is therefore an artificial system evolved for the purpose of creating an effect, and as such it must follow arbitrary rules and laws.

The rules of our system of perspective apply principles that have been worked out by geometry; however, exact perspective as studied by mathematicians is not strictly applied to the usual pictorial technique, but only such basic points as are of practical value. Writers on the subject have always gone to great lengths to point this out and to make artists aware that according to their artistic intentions they must consciously decide for themselves just how far the construction of a drawing should follow mathematically produced points, and just where these points should serve as guides for selective approximations, so that the results may be those of their conception and not an example of applied mechanics.

The present account is a short outline, for reference purposes, of a few of the basic geometric constructions, selected for their simplicity and practical application; for a more thorough study, the reader is referred to the complete manuals on perspective, where the relationship of these basic rules to artistic purposes is shown. (See bibliography, page 693.)

Application of Perspective to Pictures. A defect of our system of perspective from the mathematical point of view is that a vanishing point is really accurate only when the subject is viewed from one point or station and when the line of vision is trained directly on one point of the scene. Artists seldom attempt to secure extreme mathematical accuracy in all parts of a complex drawing; the reason for special care and accuracy in the guide lines or underpainting is that the artist may thereby guard against too great an error in perspective, the assumption being that one is necessarily bound to deviate somewhat from mathematical accuracy during creative work, and that the more accurate the guide lines the easier it will be to keep within the bounds of acceptably correct drawing or to control deviations at will. Whether or not distortion, or departure from realistic perspective, is advisable is entirely the concern of the artist; but it is almost universally expected, according to the general ideas on art at present, that such effects will be deliberate and controlled rather than accidental.

Some kinds of painting are not concerned with perspective or third-dimensional relationships, but we have become so imbued with the third-dimensional feeling that it influences most of our works.

Aerial Perspective. In nature, the distant parts of a landscape assume a less brilliant color than the objects in the foreground; they are often made hazy or given a bluish-white tone by the volume of atmospheric moisture through which they are viewed. This effect may be directly translated to a picture without the use of rules or laws other than those that can be learned by observation of natural phenomena. Other elements being equal, objects have a tendency to become cooler in color (to move away from the red-orange-yellow side of the spectrum and toward the green-

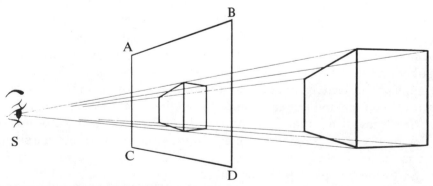

PERSPECTIVE, FIGURE 1

blue-violet side) as they recede; this change may be depicted by mixing more white or pale pigment with the colors. In black and white pictures, bold contrast is used in the foreground and grays and blending tones in the distances. The Chinese and Japanese painters utilized this method of depicting recession by interposing mists and aerial softening in some of their monochrome landscapes.

Linear Perspective. We observe, in addition to these color changes, that objects in the background appear to diminish in size as they recede, that parallel lines appear to converge, and that horizontal lines assume various angles. Depending upon our degree of skill, we are able to approximate these relationships, so that our drawings appear more or less correct according to our impressions, by the application of a geometric perspective that conforms to established rules. An *isometric drawing* is one in which each dimension of an object is represented in its actual measurement or proportion. This method is represented in its actual measurement or proportion. This method is sometimes used in mechanical drawing and mathematics, but it gives a distorted view of the object, whereas a draw-

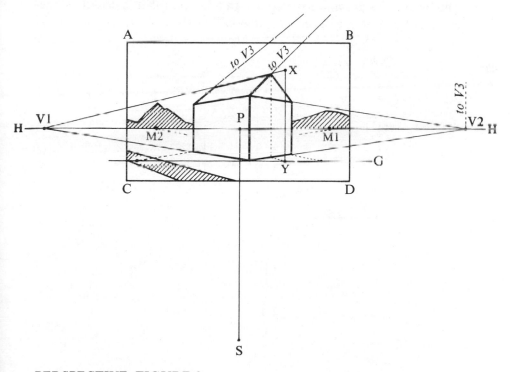

PERSPECTIVE, FIGURE 2

ing in true perspective of the *apparent* dimensions, though not in accordance with the actual measurements, gives a true impression of the object as viewed.

The terms used in these notes are those universally employed in reference to the construction of perspective drawings. "Observer" refers to the artist, or original observer of the scene; "spectator" refers to the person looking at the finished picture.

Picture plane (ABCD in figure 1): an imaginary transparent plane interposed between the subject and the eye of the observer, as if it were a sheet of glass, through which the cone of vision passes, converging upon the observer's eye. This plane corresponds to the surface of the picture.

Cone of vision: a term used occasionally in the explanation of perspective, especially when the eye is compared to a camera lens. The light rays reflected by the subject pass through the picture plane and converge upon the eye; they are depicted as imaginary lines that form a conical design and delineate the perspective points on the picture plane as they pass through it.

Horizon line (HH): a construction line drawn across the picture plane, parallel with its upper and lower sides. In a landscape it is usually somewhere near the center; in a sea view it would be the actual horizon; in any

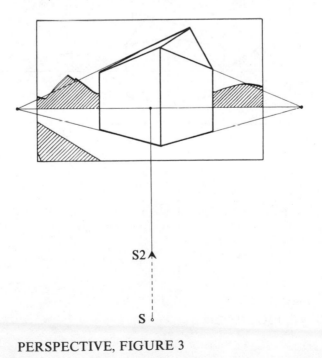

PERSPECTIVE, FIGURE 3

landscape it may vary in position, depending upon the nature of the scene and its significant objects, but it is always on a level with the eye of the observer. For purposes of perspective construction it is sometimes necessary to extend the horizon line beyond the picture on either or both sides.

Point of station (S): the point corresponding to the eye of the observer, fixed in front of and opposite the middle of the horizon line, at a distance varying according to the requirements of the picture and the judgment of the artist. This point is normally about as close to the picture as one can stand and take in the whole view comfortably. The distance is not selected according to any strict rule, but should depend mostly upon the width of the angle of view of the subject. One traditional method is to construct an inverted equilateral triangle on the horizon line of the picture and use its apex as the station point. Another familiar procedure is to make the distance slightly less than the width of the picture. The station point is the basis of mathematical perspective. Because it is fixed, placed

PERSPECTIVE, FIGURE 4

outside the picture plane, and accurate only when used as if a person were sighting along a line with one eye, some of the flaws of a purely mathematical perspective as applied to artistic purposes are evident. Almost every painting contains more than one system of lines, and spectators view it from many points. In figure 1, the eye corresponds to the station point; in constructing a drawing the artist makes a simple diagram, for convenience swinging the station point down, placing it below the picture plane as in figure 2. If the distance between station point and picture plane is shortened, that is, if the observer moves forward, the recession of background will be more violent and objects in the foreground will loom up. If the distance is lengthened, that is, if the observer moves backward, the recession will be more gradual and the scene will be flattened out. Raising this point on the diagram is equivalent to coming nearer to the subject; lowering it is the same as retreating in order to include more foreground, as the following constructions will show.

Point of sight (P): the point on the horizon line opposite the eye or station point.

Line of vision (SP): a straight line drawn from the station point to the point of sight. Also called the central visual ray.

Parallel perspective and oblique perspective: When a side of an object is parallel to the picture plane and when the line of vision is exactly in its center, the object is said to be in parallel perspective; when the object is turned, it is in oblique or angular perspective. Figures 7 and 9 are in parallel perspective and figures 2 and 3 are in oblique perspective.

Ground line: the base or lower boundary of a picture plane. The term may also be applied to a similar construction line used anywhere in the picture to measure off points or to determine the scale of a figure, in which case it should preferably be called a scale or scale line (CD; also GG; see figure 2).

Vanishing points (V_1, V_2): The lines that lie in a plane of any single object or group of objects, if extended toward the horizon, will meet at a point in infinite distance; in a picture, the point on the horizon line where they apparently converge is called the vanishing point. Depending upon the directions in which the planes face, a scene may have many or few vanishing points. Figures 7 and 9 are in parallel perspective and therefore each has but one vanishing point, the point of sight. The other figures are in oblique perspective and have a vanishing point on either side of the point of sight. *Lines above the horizon line always converge downward to it; those below the horizon line converge upward to it.* Lines lying on a plane parallel to the picture plane do not approach the horizon line and therefore do not converge. For example, the sides and rungs of a perpendicular

ladder that faces the observer do not converge; if they do, the line of sight has been shifted and they no longer lie on a plane perpendicular to it. Lines such as the edges of some sloping roofs and stairways do not lie in planes parallel to the horizon line in the actual scene, and their points of convergence do not lie on the horizon line but meet at a point directly above a vanishing point (V_3, figure 2), or, if downward, below it. When lines are drawn from S to the two vanishing points of a rectangular figure they always form a 90-degree or right angle.

Figure 2 shows most of the construction lines and points discussed above.

Figure 3 shows what happens in this scene when the observer moves forward, raising the station point from S to S_2.

Figure 4 shows what happens when the observer moves back, lowering the station point from S to S_4.

Figure 5 shows what happens when the observer moves to a higher level, raising the horizon line from HH to H_1H_1.

Figure 6 shows the result of shifting the station point to the left.

Lines of measurement: In order to locate the depth of objects in recession or to determine the distance between objects that recede at regular intervals, lines of measurement are used. A line of measurement is found by laying off a point on the horizon line using a vanishing point as a center and the distance between it and the station point as a radius. A

PERSPECTIVE, FIGURE 5

PERSPECTIVE, FIGURE 6

line drawn from this *point of measurement* to a point on the ground line is
a line of measurement.

One of the most convenient methods for placing objects in recession
is to mark off a crisscross or checkerboard pattern of squares on a ground
plan or floor of the scene (figure 7). The usual procedure is to mark off the
width of these squares on the base of the picture (the smaller they are
made, the more accuracy of detail can be obtained) and connect these
points with the vanishing point. From the vanishing point, a point of
measurement is established as described above, and the line of measure-
ment MG is drawn to the opposite lower corner of the figure. The squares
in perspective recession are then obtained by drawing horizontal lines
through the points where this line intersects the convergent lines. If de-
sired, another line of measurement may be drawn on the opposite side of
the point of sight.

The line XY is the actual scale height of the objects. Some artists be-
lieve this method to be too mechanical, the recession sometimes being
defective for its purpose—too sudden or too gradual—so they establish
the points of measurement by trial or judgment instead of by actual mea-
surement. If receding points are required in an area which is in oblique
perspective, both vanishing points and both lines of measurement must

be used and the lines of the squares are then determined by the two sets of intersections instead of being made parallel to the ground line.

Projection of a Ground Plan into Perspective. Figure 8 shows a method for the accurate projection of the ground plan of an object in oblique perspective; this method can be used when it is desired to project the ground plan in scale or proportion to actual measurements and in any size, either larger or smaller than the drawing of the ground plan. The rectangle F corresponds to the floor of the little house in the other diagrams, and the terms and principles discussed under those examples apply here.

First select the station point to conform with the direction and distance of the observer from the object. In this particular case the observer is slightly to the left and quite close to the nearest point of the object. Draw a vertical line upward from S. Draw a horizontal scale line (GG) at any convenient distance above the plane. If the object is part of a scene and it is desired to insert it into a picture plane, the distance between d and GG will naturally have to be made great enough to accommodate the

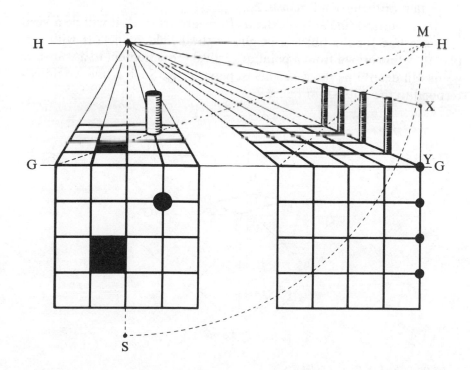

PERSPECTIVE, FIGURE 7

foreground. Draw a horizon line (HH) parallel to GG, and at a distance above it equal to the height of the observer's eye level, so that its intersection with the vertical line will be the point of sight (P). From S draw a line parallel to a side of the rectangle and another at a right angle to it, and use the intersections of these lines with the horizon line as vanishing points (V_1, V_2). Using these vanishing points as centers, locate the points of measurement according to previous instructions. The following basic elements of a perspective drawing have now been established: station point, horizontal scale line, horizon line, vanishing points, point of sight, and points of measurement.

Draw a vertical line from the point of the ground plan nearest the observer (a) to the scale line GG, and draw lines from this point (a_1) to both vanishing points. From point a_1 lay off on the scale line the actual desired scale measurement of a-b, and connect the point b_1 with its point of measurement M_1. Repeat this procedure on the other side of a_1, using the measurement a-c. From the point b_2, where the line of measurement from M_1 intersects the line from a_1 to its vanishing point, draw a line to the opposite vanishing point V_2. Repeat this procedure on the other side to locate c_2, and draw the line c_2-V_1. The rectangle a_1, b_2, d_1, c_2 is the projection of the ground plan F.

If the vertical line a-a_1 is extended upward from a_1, it will be a vertical scale line for the object's height or the height of details within its planes. A line drawn from a point of vertical measurement to a vanishing point will determine these heights in perspective. Such a line would correspond to the line XP in figure 7.

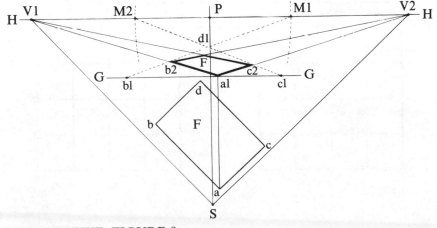

PERSPECTIVE, FIGURE 8

Circles and Curved Lines. The projection of curves in perspective is usually accomplished by reference to straight lines or rectangles. For example, if a circle is to be placed in perspective, a square whose sides are the same length as the diameter of the circle is constructed below a ground or scale line, put into correct perspective, and the circle inscribed freehand within this rectangular shape, where it will assume the form of an ellipse. When the curved figure is more complex than a simple circle, it is sometimes convenient to block off the guide-figure in rectangles and refer to each section separately by an application of the checkerboard system. The final result will depend upon the skill and experience of the artist.

Sometimes it is desired to depict a circle in perspective with greater accuracy than can be obtained by drawing an ellipse freehand within the perspective square, or the circle is viewed at an unusual angle or has complexities of construction the drawing of which requires a little more guidance than that supplied by the perspective rectangle. Figure 9 is a

PERSPECTIVE, FIGURE 9

fairly obvious illustration. One must determine the place where the forward edge of the circle in perspective is to come, and through that point draw a horizontal scale line. A square is laid off below this line, a circle inscribed within it, and diagonals are drawn upon it. The square is put into perspective by means of vanishing and measurement points, as previously described; the location of the far side of the figure is obtained by drawing a line, MG, from either point of measurement to the opposite upper corner of the square already constructed. When the perspective circle is to be inserted into a picture, the vanishing point of the plane upon which it lies must be used.

The lines of measurement will form the diagonals of the perspective square. A vertical line is drawn through the center to the vanishing point, and another line through the center at right angles to this. These lines meet the sides of the perspective rectangle at the points where the ellipse will be tangent to it. Draw vertical lines upward from the points where the circle intersects its diagonals, and connect the two points where these lines meet the scale line with the vanishing point. The intersections of these lines with the diagonals supply four more intermediate points, so that the ellipse may now be drawn with eight guide points. If the perspective rectangle is in oblique perspective, both points of measurement must be used and each of the two cross lines is drawn to a vanishing point instead of being at right angles to each other.

NOTES ON THE GRAPHIC ARTS

In the fine arts, graphic arts designates all processes for the production of multiple-proof pictures on paper on a handmade basis, the work being done either wholly or in most part by the original artist, and editions limited. Prints are made either in black and white or in multiple color impressions and the individual copies or proofs may be signed and numbered by the artist in pencil on the lower margins. Making an impression is called pulling a proof. The term "graphic arts" excludes all forms of mechanically reproduced works photographed or redrawn on plates; all processes in which the artist did not participate to his or her fullest capacity are reproductions. The standard name for an artist's proof is *original print*.*

Sometimes the term "graphic arts" is abbreviated to "graphics."†

* *What is an original print?* Print Council of America, 527 Madison Avenue, New York, N.Y. 10022.
† In recent years the commercial printing trades have tended to use the term "graphic arts" to cover the entire field of printing and lithography, but from the fine-arts standpoint it still means techniques used directly by creative artists as distinguished from the common mechanical processes.

Japanese prints, for instance, have been condemned as works of art by certain connoisseurs and artists, especially by the Japanese, not only because they were originally works on popular subjects for distribution to the public, as distinguished from the more esoteric and precious paintings, but because their production was several steps removed from the work of the original artist and depended upon the cooperation of expert engravers and printers; they are now, however, as thoroughly accepted as the other forms of Japanese art.

The major traditional graphic-arts processes of long standing and continued popularity are: lithography, etching, drypoint, woodcutting or wood engraving, aquatint, and soft-ground etching. Engraving on copper and steel, and mezzotint engraving are almost as obsolete in art as they are in commercial reproduction. They have their practitioners, and perhaps in recent years their number has been increasing, but these are usually workers in other techniques who employ metal-plate engraving occasionally. Serigraphy and a few other graphic processes have been added in the twentieth century.

The bibliography on printmaking on pages 680–82 lists the specialized books on the various individual processes discussed in this chapter.

Copper-plate etching has always enjoyed the position of an important if not a major art medium since the time of its mechanical perfection and improved control of effects, which dates from the early seventeenth century. Early writers tell us that during the sixteenth century it was used in its first stages of development as a possible labor-saving substitute for engraving, attempts being made to subordinate its characteristic qualities to imitate engraved lines, rather than to exploit all its characteristics and evolve a unique tradition. The origin of etching has also been attributed to early metalworkers and armorers who used it for decorative designs on metal. It soon superseded engraving as a sensitive artists' medium.

The woodcut was the earliest form of multiple reproduction of pictures and designs, but it soon became obsolete for most purposes and was little used until its revival as an art medium in our own day. Wood engraving came into wide use as a means of reproduction and illustration during the middle of the nineteenth century, but newer reproduction methods introduced toward the beginning of the twentieth century caused it to become obsolete quite suddenly. Although the adaptability of its effects for certain work had caused it to be appreciated as an artistic medium to some extent during its life as a common means of reproduction, it was, with a few notable exceptions, never widely selected as an art medium until its twentieth-century revival as such. Woodcut and wood engraving are known as relief processes to distinguish them from the metal-plate prints. The two groups are inked differently. The metal-plate

processes, etching and line-engraving, are classed as intaglio processes; the ink is applied to the plate and wiped off, the lines being left charged with ink, which is deposited on the paper by running plate and paper through a roller press in contact with each other. The wood blocks are inked by a roller that deposits a coating of ink on the raised surfaces; this in turn is deposited upon the paper by vertical pressure. Other characteristics that distinguish the effects of the various processes are: etched lines do not taper and expand as engraved or pen-drawn lines do, but are usually the same width throughout; the grain of lithograph and aquatint masses and the fine lines of etching masses disclose more of the paper than the solid block print does, thereby imparting more granulation or depth to the print.

Limited Editions. A traditional rule is that proofs of the highest degree of excellence may be obtained only in limited editions, owing to sacrifices in finesse that must be made when a durable, lasting plate for quantity production is required.

A considerable group of present-day artists and commentators on art, however, point out that the graphic-arts processes were originally adopted not only for their sympathetic rendering of line, form, and tonal effects, but equally as much for the multiplication and consequent distribution of proofs. They claim that the limitation of editions by the destruction of the plates, or by the adoption of techniques and effects not capable of resisting for long the wear of continued impressions, is a comparatively recent development fostered by artists and dealers for monetary reasons. They call the resulting rarity of such prints artificial, and cite the case of lithography, where the works of modern living artists command higher prices because of their scarcity than the proofs of some accepted masters of the nineteenth century whose works were turned out in fairly large editions. Although anxious to develop good craftsmanship, they are willing to sacrifice the attainment of superlative technical results if these require such delicate plates and time-consuming printing manipulations that large editions sold at low prices are out of the question.

On the other hand, the artist who, by great application and development along individual or personal lines, is capable of producing superlative proofs continues to produce them in strictly limited editions. The term "superlative proofs" here implies prints which completely and thoroughly fulfill the most exacting requirements of perfection of control over the medium both in relation to the artist's intentions and from the viewpoint of the fullest textural qualities inherent in the medium itself.

This question, although it is not a purely technical one, must influence an artist in his choice of technique as it involves details and various

adaptations of the graphic-arts processes. New standards of excellence, both artistic and technical, always become established with the development of any new methods and materials, and in their own way they become just as complete artistic expressions as the older traditional standards.

Newer Practices. Conversely, the more influential causes of change or development in artists' techniques, namely the development of new artistic or aesthetic movements, almost always demand newer technical approaches with which to achieve fuller expression and appropriateness (see page 26). In the print field, we have witnessed such developments during the more recent past; the tendency has been to combine any or all of the gravure or incised metal-plate techniques (engraving, etching, aquatint, and their variants) in one plate to secure textural and linear qualities that were not so boldly evident in the older or more "purist" approach if limiting the plate to a single operation or, at the most, the modification of a single process with a lesser amount of one other—such as an etching with a few drypoint strokes or an aquatint background. Modern metal-plate techniques have for some time utilized traditional means as well as innovations. Current procedures are described extensively by Hayter.[114] The newer printmaking techniques are outlined in the section beginning on page 414.

LITHOGRAPHY

Lithography was invented in Munich in 1798 by Aloys Senefelder, and thereafter came into wide use both as an artistic medium and as a means of reproducing pictures for publication.

Simply outlined, the process consists of drawing or painting with greasy crayons and inks on a particular species of limestone that has been ground down to the desired texture. After several subsequent manipulations, the stone is well moistened with water, whereupon the parts not covered by the crayon become wet, while the areas where the greasy drawing was made repel the water and remain dry. An oily ink is then applied with a roller; it adheres only to the drawing, being repelled by the wet parts of the stone. The print made by pressing paper against the inked drawing is not a reproduction in the same sense as is the mechanically reproduced print, but it is a true autographic replica, in reverse, of the original drawing on stone. The direct manner in which the drawing is made and the range of tones that can be obtained make the process popular. Lithography is called a planographic process to distinguish it from intaglio, relief, and stencil methods.

Lithography, unlike etching, enables the artist to confine his efforts to the execution of the drawing; because the printing is a somewhat mechanical procedure, the object of which is to turn out exact copies of the drawing as it appears on the stone, the great majority of artists have this work done by professional lithographers. However, it is generally considered necessary for the artist to have mastered the actual procedure involved in the printing process while learning lithography, in order to be thoroughly familiar with its requirements. Considerable knowledge and proficiency is required for the production of fine prints, and the number of professional artist-lithographers who can turn out really superior proofs from the stones entrusted to them is limited. This is particularly true in work involving any great delicacy of tone or line. Some artists will carry their effort to secure completely faithful replicas of their original drawings to the point of having the prints made on paper of a tint that matches the original gray or tan color of the stone.

The autographic quality of lithography is not always emphasized by some lithographers; for instance, Brown,[108] who based his instructions on the artist's carrying out every phase of the process himself, regarded the final proof as the principal consideration. In one case he worked on the introduction of a development whereby a new tonal effect was added during the printing process. Unless the printer is an accomplished expert, very sensitive or delicate tonal effects must be foregone.

Lithography is widely used as a means of commercial reproduction, and although the basic principles are unchanged, many variations in technique are used by industrial lithographic establishments. The artist has small concern with these procedures; none of them improve and most of them detract from the quality of the work from an artistic viewpoint, for the aims of the industrial lithographer are not those of the artist, and the commercial lithograph is definitely a reproduction, not an artist's proof. Practically every artists' lithographic process in use today was known, at least in principle, to the inventor and early workers of the craft.

Lithograph Stones. The limestone from Solnhofen, Bavaria, with which Senefelder first perfected his original process, is the best. Many substitutes are quarried in various parts of the world, but all are inferior. The best-quality stones are those of a gray or "blue" color. The yellow or tan stones appear to be of a softer or looser texture and not capable of taking such a satisfactory grain; also, delicate work done on them is more likely to be injured during the printing process; nevertheless, some artists express a preference for them. Stones showing any color variation are usually rejected, as streaks or spots indicate a variation in composition or

texture that may interfere with the printing; but many such defects do now show in the final prints. A small stone, 10 x 12 inches, is about 2¼ inches thick and weighs about 30 pounds. For perfect proofs and to prevent breakage in certain types of presses, the thickness must be accurately uniform. The larger stones are made proportionately thicker; a stone measuring 18 x 22 inches will be approximately 3 inches thick and will weigh about 100 pounds.

The artist does not require many stones, as they are ordinarily cleaned and refinished as soon as an edition has been pulled, although the stone with its original drawing may be preserved for several years, if desired. The great majority of artists, especially those to whom lithography is a minor or occasional activity, own no stones but rent them from the printer or supply house, where they have the graining and resurfacing done. Few maintain their own presses, and a good proportion of the finishing and printing work they do is carried on outside their studios, in workshops of professional artist-lithographers, in art schools, artists' societies, and occasionally in an industrial lithographic shop. Much of the best work is done by artists under such conditions, with the close cooperation and supervision of professional printers, the best of whom are not only artists in their own right but sympathetic to and cooperative with the aims of the artist who makes use of their professional services. Although every material used throughout the technique is available ready-made in adequate quality, there are always a number of experimental-minded artists who make their own crayons and other materials, and who are constantly striving for improvements in the drawing and printing of their work.

The chemical reactions involved in lithography are noted in Part Two of the chemistry chapter, pages 466–67.

Metal Plates. Plates made of zinc or aluminum, light in weight and just thick enough to be rigid, have long been in use to supplant the more cumbersome stones; in industrial lithography they have practically replaced them. They are sold ready-grained to imitate the texture of stone, and also in a variety of other grains for various types of artistic and reproduction purposes.

The technique of using metal plates is basically not very different from that applied to work on stone, but there are naturally many points of variation in manipulations. In the case of metal plates, the possible manipulations are more limited in number and are somewhat more difficult to master. Often, because of the darker tone of the zinc, the artist is led into the production of more contrast than would be created on the paler stone. An expert can ordinarily distinguish at once between proofs made

from plates and those made from stones; those made from stones are universally considered to be superior, and although some artists find the plates adequate for some types of work, the stone retains its position as the standard material among artists.

Graining. The grain is imparted to the stone by grinding its surface with flint, sand, or other abrasives. The stones are finished by laying two of them face to face and grinding them with the abrasive and water. Metal plates are grained by machine; the grains of abrasive are tumbled upon their surfaces with small balls or marbles. Zinc plates do not act well when old; they should be freshly prepared, and protected against atmosphere and moisture until used.

Transfer Lithography. In order to overcome some of the limitations of lithography as compared with other methods of pictorial production, artists have for many years made lithographs in an indirect manner, by drawing with lithographic crayons on paper. These drawings, which are obviously made without many of the disadvantages and limitations attendant upon work done directly on the cumbersome stones or inflexible plates, are sent to the printer, who, by a rather simple process, transfers them to a stone or plate and turns out final proofs that are not reversed— that is, the picture is reversed when it is transferred to the stone, and the prints taken from the stone reverse it again so that they reproduce the original point for point.

In average hands, the resulting proofs are greatly inferior to those obtained by direct drawing on the stone or plate, and a person of any experience at all can detect the difference immediately. For simple sketches or simple black and white contrasts they often suffice, but for work of any degree of delicacy the process is not to be recommended to the average artist; in fact, it has been claimed that such prints should not be called lithographs. On the other hand, very fine results have been obtained with transfer papers, especially by the leading printmakers of the late nineteenth century, who were conscientious students of the process. By the use of specially coated transfer papers, work of considerable finesse and delicacy has been transferred to zinc plates with much success by experienced specialists.

Specially prepared and coated transfer papers can be purchased but they are not widely available; the paper in general use in America is a fine variety of rather heavy tracing paper—the least transparent kind, such as is made up in pads or blocks. This paper has a grain that takes the crayon in a way that superficially resembles the effect produced by the average

coarse-grained stone. The undesirable textures of the drawing in the final proof are caused partly by the fact that a reverse image or negative of the original textures of the crayon marks is deposited on the plate or stone in place of the textures caused by the stone itself in the direct method. Regardless of superficial resemblances in the textures produced, drawing with crayon on paper, as explained on page 1, is somewhat different, both in the mechanical action involved and in the results obtained, from drawing on stone or plate, the tooth of which is tiny pits rather than matted webs. The mechanical handling of the transfer will also contribute to loss in textural quality, although expert manipulation can keep such changes to a minimum.

The directions and precautions to be observed in making the drawing are practically the same as those for drawing on stone. The paper must be kept free from grease. Not so much freedom in manipulating the crayon is possible. The principal advantage of transfer over direct lithography is that an easily transportable pad or portfolio is available for rapid sketches and direct work on the spot.

Despite the superiorities of direct work on stone, large numbers of transfer prints are continually being produced. The results obtained by the use of coated papers approach the original lithographic quality more nearly than do those obtained with the common tracing papers.

Drawing on Stone. In most instances preliminary drawings or sketches the exact size of the print are made on paper and traced faintly on the stone as a guide to the drawing. The usual tracing material, to be rubbed or drawn on the back of the paper, is sanguine crayon, which contains no grease, has no effect on the stone, and because of its red color will not become confused with the black drawing. Some lithographers prefer soft lead-pencil lines. If too many chalk or lead-pencil lines are put on the stone, they may clog the grain and interfere with the action of the lithographic crayon.

The greatest care must be taken to keep the stone absolutely free from greasy impurities and adherent dust. Breathing upon the cool stone causes condensation of moisture, through which the crayon slides badly. One must never touch the sensitive surface with the fingers; in order to prevent smudging, some convenient form of bridge may be used as a hand rest. A stave from a small barrel or keg is the simplest.

The main point to be observed in regard to the drawing is to apply the crayon with the proper touch to obtain the desired effect. The normal lithograph texture is the granular one produced by more or less minute portions of the paper showing through the black printing ink, even in the

heavy black areas. The crayon is dragged across the surface with a sensitive touch; if rubbed back and forth with a heavy hand, it would tend to fill up or overload the texture of the stone so that dull, coarse blacks would be produced instead of the luminous sparkle. The use of flat areas of tusche (mentioned below), or of benzol or other solvent, will create dead flat printing areas; such effects may of course be desired at times, but the normal technique avoids them. The use of a knife, a pointed rod of abrasive material, a hard ink eraser, and many improvised tools for scratching out or producing special results, is learned by practice and experiment; the extent to which one may employ very delicate effects depends upon the capabilities of the printer and is a matter of individual discovery. The variations in texture attainable by manipulation of the crayon are seemingly unlimited.

The Crayon. The two main requirements for a satisfactory crayon are: it should be of the proper degree of hardness to produce the desired mass or line effect on the surface and to work in a sympathetic manner; it should contain a correct blend of materials so as to deposit the necessary grease-receptive, water-repellent printing areas. Crayons in the form of square sticks about 2 inches in length, as well as those in pencil form, are universally sold in an adequate range of hardness: No. 0, very soft; No. 1, soft; No. 2, medium; No. 3, hard; No. 4, very hard; No. 5, copal. Some recommend Nos. 3 and 4 for most uses and the softer ones for use in cold weather only, and disapprove of No. 5 entirely. The crayons that are intended to be used in the customary crayon-holder or port-crayon and sharpened to suit exact requirements are sometimes considered more professional than the pencils, which are perhaps easier and more convenient for the majority of artists; but this may be prejudice. Fine points are best made by sharpening with a thin blade from the point toward the holder rather than away from the holder in the manner of sharpening a lead pencil.

An inky liquid that contains the ingredients of the crayon in liquid form is much used for pen and brushwork, and to produce solid blacks. This is called tusche, never, correctly, lithographic ink; the latter name applies only to the printing ink employed to produce the final proofs, and its use in reference to tusche leads to confusion.

Lithographic crayons and tusche are always black, regardless of the color in which the final proof is to be printed, because the drawing is judged and the printing manipulations regulated according to experience gained by working with black; a litho crayon made with a red pigment, for example, would distort all of the practitioner's judgment, based as it is on the black and white technique. Lampblack is used in crayons because

it works well, is of the correct texture, and does not interfere with the functioning of the process.

Although the ready-made materials are of acceptable quality for normal practice, a few lithographers prefer to make their own, believing that they obtain superior results from special formulas. The following seven recipes by Senefelder are typical of the average materials in use.

Wax	4	8	4	8	8	8	8
Soap	6	4	4	4	5	5	6
Lampblack	2	2	2	2	3	3	3
Spermaceti			4	4			
Shellac					4	4	
Tallow						2	4

After being melted in a shallow pan in the order given, the blended materials are ignited and allowed to burn for a minute or so; then the flame is extinguished by covering the vessel. This procedure is repeated many times, and imparts hardness to the crayons. Upon cooling, the mass is cut or sawn into convenient pieces.

The lithographer who is interested in making his own crayons to meet various requirements will seldom be satisfied to copy old recipes, as commercial brands of crayons can be had to match the properties of most of these, but will usually wish to do further experimenting. Brown[108] lists nearly a hundred formulas in his book and mentions some additional raw materials. The following are the properties that various raw materials will impart to the crayons.

Ingredients that deposit strong printing areas:
 Tallow—imparts softness and greasiness
 Stearic acid—imparts comparatively granular, nonsticky quality
 Oleic acid—softness, greasiness
 Palm oil—softness
Ingredients that deposit less strong printing areas:
 Beeswax—smoothness, adhesiveness
 Carnauba wax—hardness
 Japan wax—softness, some stickiness, adhesiveness
 Linseed oil—greasiness and softness
Ingredients that have weak printing action:
 Soap—smooth or slippery quality; also solubility in water. Necessary
 in liquid tusche. Liberates free fatty acids when wet with water.
 Crayons will print but will not manipulate or draw well without it
 Mastic and other resins—stickiness, solidity
 Shellac—hardness

Ingredients that have no printing action; small amounts will impart fluidity, softness, or smoothness:
 Paraffin wax
 White mineral oil
 Vaseline

The sole function of the lampblack is supposed to be to color the crayons, but it also contributes a little solidity and drag to their drawing qualities. The addition of lye partially saponifies the oils and fats, but under the conditions of the mixture probably does not make complete soaps of them.

Preparation of the Stone for Printing. First the edges of the picture are neatly ruled off and the margins of the stone are thoroughly cleaned with snakestone and water. A rather wide margin, at least two inches all around, is necessary for convenience in printing. The manipulations as outlined in the following paragraphs are usually carried out in the order given, but sometimes the order is varied; occasionally some procedures are omitted and some repeated more than once, according to the preferences of the printer.

The Etch. At the beginning of this section the lithographic process was outlined, and reference was made to intermediate steps between the making of the drawing and the inking of the stone. The principal one is the application of the etch.

When the drawing has been completed, its entire surface is gone over with an acidified solution of gum arabic, which deposits a film on the un-inked portions and completely desensitizes the stone, making it incapable of further grease adsorption. This solution is called the etch, a misnomer carried over from the very earliest experiments by the inventor of lithography, who at first attempted to produce relief and intaglio printing surfaces on the stone. The etch does not eat away the stone with the crayon acting as a resist to produce a raised or relief printing surface. More accurately, it could be called a fixative or desensitizer; any smudges or accidental inkings of the blank portions of the stone will not take after the etch has been applied; the ink will be confined to the drawing.

Both the gum-arabic film and the one deposited by the crayon are tenacious and insoluble, and may be repeatedly sponged and rinsed with water and turpentine respectively without injury to their water- or grease-repelling properties, or to the definition of their areas.

The stone at this stage is thoroughly desensitized, and the first part of our original outline explanation must be somewhat elaborated; the pro-

cess actually depends upon the fact that the greasy crayon sets up an insoluble, grease-attracting, water-repelling condition, and that the acidified gum solution or etch sets up a water-attracting, grease-repelling condition, not by the action of superficial, adherent films, but in the surface of the stone itself. Further remarks on the subject will be found in Chapter 13, "Chemistry" (pages 466–67). After the etch has been applied and the subsequent manipulations have been carried out, the portions of the stone that have not been drawn upon are so desensitized that even when the stone is dry, if printing ink is smeared on these areas, it may easily be washed off with a damp sponge. When the stone has been thoroughly wetted, no trace of ink will be taken from the inking roller by even the most minute points of exposed stone. The further manipulations referred to, although they may be considered minor refinements from the point of view of the general underlying principles of the process, are actually of great importance in securing perfect results, and the manner in which they are carried out governs the success or failure of the printing process.

A typical formula for etch to be used on stone contains gum arabic and nitric acid. Dissolve gum arabic in the proportion of 1 ounce to 2 or 3 fluid ounces of water, and add C.P. nitric acid in small amounts until a few drops of the mixture applied to the face of a stone just barely show a definite bubbling action—about a teaspoonful to 3 or 4 ounces of solution, or about 1½ parts to a hundred, will be required. Too much acid is suspected of being a cause of loss of delicate tones in the final proofs. The concentration of the gum solution is not a matter that requires accurate measurement. For zinc plates the most frequently recommended etch is chromic acid in the same amounts, with the addition of 15 or 20 drops of phosphoric acid; for aluminum, the chromic acid is omitted.

The etch is applied all over the stone with a sponge or wide camel-hair brush, and dried by fanning; after it is thoroughly dry, it is washed off with a sponge and water. The stone is then given an application of plain gum-arabic solution, and again fanned dry.

The crayon drawing is next washed off with turpentine, whereupon the image seems completely destroyed, but the grease-attracting, water-repelling condition that was set up in the stone is still there. The stone is then rubbed with a small amount of a weak asphalt solution, fanned dry, washed with water, and inked while wet.

The inking roller is a carefully made piece of equipment on the order of a wooden rolling pin, smoothly and tightly covered with fine calfskin over a layer of felt. Loose leather grips over the handles allow for control in manipulating. The manner in which this implement is cared for and used throughout the process is of great importance.

The stone is now cleaned of all accidental defects; the margins are made clean, and, if desired, minor corrections are made on the drawing. The inked stone is then well dusted with powdered rosin (to make it more acid-resisting), and is re-etched for a few minutes and washed off, after which the rest of the process is repeated. When the stone is finally ready to be inked for printing, it is placed on the bed of the press, and while thoroughly wet is inked with the roller; the prints are made by placing dampened paper on the stone, protecting it with a clean sheet of paper over which a piece of fiberboard is laid. Pressure is applied by means of a lever, and a crank runs the stone under a greased, leather-covered wooden scraper, which transfers the inked drawing to the paper.

The crayon drawing is washed out because it is composed of waxes, soaps, and other ingredients not desired in the final printing, which is done with an ink made with thickened linseed oil. If the crayon drawing were allowed to remain, it would eventually be carried away by the proofs and the inking roller, but the dozen or more prints made while traces of it were still on the stone would be wasted, as they could be defective in tonal qualities. The crayon is formulated solely for its drawing properties and the action it causes in the stone; it is not wanted after these properties have been utilized and the lithographic condition has been set up in the surface of the stone.

The first inking or rolling-up of the stone is an important step in completely establishing the permanent grease-receptive condition of the printing area.

Printing or Lithographic Inks. Black and colored printing inks differ from the colors sold in tubes for oil painting in that they must be ground to the very finest sort of grain and the most complete dispersion possible, by being repeatedly put through powerful and accurately adjusted roller mills. The consistency requirements differ from those of oil colors in that printing inks must be capable of depositing on the paper a smooth, level, uniform stain rather than a thick painty layer. The color effect is generally that of watercolor, the underlying white paper contributing brilliancy and luminosity to the tones; but opaque color effects are not entirely unknown.

In order to meet these requirements the ink makers produce a very stiff paste, capable of being spread or rolled out to a level flat film on the inking roller, and having just the necessary degree of snap or sticky tackiness, combined with a certain oiliness. Specially made litho varnishes, which are heat-bodied linseed oils, are cooked for the purpose, and are commonly burned or ignited during the process; the viscosities and other

physical properties are closely controlled, and the various grades are standardized and sold by universally known numbers. Litho varnishes that are combinations of two or more viscosities are often called for in ink formulas, not because any exact viscosity desired could not be produced, but because such mixtures will give results that are different from any that can be obtained by the use of a single oil (see page 450).

An ink reducer or extender is a diluting medium with which a printing ink can be made weaker in color or more transparent without any alteration in its body or working properties. Prepared mixtures are sold for the purpose.

Lampblack can be ground into litho varnishes in the same way oil colors are made at home, but the resulting material would be inferior to the manufactured inks, the production of which requires a high degree of skill and powerful machinery.

ETCHING

Etching consists of drawing with a fine steel point, or needle, on a soot-blackened metal plate that has been coated with a ground of acid-resisting wax or varnish. In the true etching, the drawing does not depend upon any lines the needle may scratch on the plate; the lines merely cut through the wax, exposing the brightly polished metal. Phonograph needles are popular for this purpose; they have rounded points. The plate is subsequently immersed in an acid bath, which bites out or etches the exposed lines.

After the etched plate is cleaned, it is inked, and prints are pulled from it on a special roller press. Editions of thirty to a hundred proofs are commonly pulled, after which the plate is customarily destroyed. Technically, the size of the edition is limited by the ability of the metal to endure the pressure, which eventually wears down the sharpness of the lines. If the plate is "steel-faced" or electroplated, clear, clean editions of several hundred proofs may be produced. Steel facing is a misnomer; nickel or chromium is used. The question of the number of proofs to be made involves several considerations (see pages 558–59).

The wax coating or resist protects the surface of the plate and confines the action of the mordant to sharply incised lines; but after this action has proceeded a very minute distance below the surface, there is nothing to prevent it from eating away the metal horizontally as well as downward. The result is that the etched line is an undercut affair; the edges of the lines have little solidity or support and will wear away with

greater rapidity than will those of an engraving, whose grooves have walls that are straight-sided or beveled.

Each step in the etching process is very largely mechanical, subject only partially to individual control; but the handling of all the stages and the manner in which they are combined make for entirely individual and sensitive results; judged by any standards, etching is a true fine-arts medium. If any of the steps is simplified or made easier by too radical a departure from the traditional methods, the results will usually display some lack in the qualities expected of an etching. Because the lines made by the needle are uniform in width and do not taper or expand as do those of an engraving or a pen drawing, because the action of acid is uniform on every part of the exposed metal, and because the pressure of the roller press should be mechanically uniform so that the proofs are alike, the artist must, as it were, play one mechanical step against another in order to exploit the medium to the fullest extent; he cannot control the sensitive quality of line, mass, or tone directly or completely in any single one of his operations. A technically perfect etching is distinguishable from a mediocre attempt at a glance; technique and artistic accomplishment are more closely interrelated in etching than in any other graphic medium.

The Plates. Smooth, highly polished plates of zinc or copper 1/32 inch thick are commonly used. These plates are fairly easy to obtain at artists' supply stores; the specialist in etching, however, usually obtains them from one of the firms which specialize in etchers' or engravers' supplies. Copper is the traditional choice; it is preferred to the somewhat less expensive zinc on account of its superior crystalline texture or grain, its better behavior throughout the process, and other qualities more subtle, which can be learned from an actual comparison of the two better than from a description.

Zinc plates, however, are adequate when the work is simple and without great delicacy of line or effect—especially when all the lines are of equal value or not too subtly different in value. Steel, a more coarsely grained metal, is sometimes etched; it is chosen for use only in the production of large editions, as in the case of commercial work or book illustrations, and is incapable of application to fine points. The earliest etchers employed iron or steel and overcame its disadvantages to some extent by the exercise of much skillful effort, as well as by a realization of its limitations.

Copper-plate etchings and engravings may be, and for large editions always are, faced or electroplated with nickel or chromium; resistance to the wear of continual impressions is thereby greatly increased. The mod-

ern process is greatly improved over the original "steel facing" in which iron was used.

Preparation of the Plate. Before applying the ground, the surface of the plate must be made perfectly clean by rubbing it with a soft cloth and one of the volatile solvents and a little whiting. If it is discolored or tarnished, the application of a mixture of vinegar and salt will usually remove all traces of tarnish. The exposed metal must present a chemically pure surface for the mordant to act upon, and the uniform and complete adhesion of the ground requires a clean surface.

A hand vise that has a wooden handle and iron jaws is clamped to a corner of the plate, which is then heated and its face rubbed with a ball of wax ground, which is sometimes enclosed in a wrapping of cloth. Learning to apply the ground in a sufficiently uniform coating is a matter of experience; the thickness will depend largely on personal preference. Some grounds are intensely black in color; most are transparent and require blackening so that the scratches of the needle will be visible. This is accomplished by holding the plate face down and smoking it for a few moments over the flame from a number of wax tapers twisted into a bunch. Some etchers dislike the sooty layer, and dispense with this smoking operation, especially when the ground they employ is intensely black. I have tried blackening wax-gilsonite grounds by melting the wax and then dissolving in it some oil-soluble black dye, such as nigrosine. This increases the ground's blackness and opacity.

The requirements for a perfect etching ground are: (1) it must give perfect protection to the plate against any concentration of acid likely to be used; (2) it must be of the correct degree of softness so that the needle will cut cleanly through it without any chipping and expose the copper in clear, sharp lines; (3) it must not be so soft and tender that it will be easily destroyed by accidental handling or that the scraped particles will cling adhesively to the surface of the plate or needle instead of falling away as they should.

The traditional ground is pure beeswax or a mixture of beeswax and asphaltum. This can be and is improved upon by a number of special formulas; prepared grounds sold by dealers in etching supplies serve the purpose well and few etchers find it necessary to make their own. Among the published formulas that have been favorites of various etchers is the following, for Rembrandt's ground (so called), in parts by weight:

Yellow beeswax	2
Mastic resin	2
Asphaltum	1

Another version:

Yellow beeswax	4
Burgundy pitch	1
Common pitch	1
Asphaltum	4

Instructions: melt ingredients together carefully with occasional stirring, adding them in the order named. The molten material is inflammable; make small batches and guard against fire. Some recipes call for white beeswax.

These recipes probably originated in the seventeenth century. Paste grounds, which are applied with a roller, contain the same ingredients thinned down to the proper consistency with the turpentine or mineral spirits.

The trouble with most formulas of this nature, especially the old ones, is that the asphaltum, pitch (rosin), and other materials are so unstandardized and vary so much in properties that one always has to do a good deal of adjusting and experimenting before the recipe begins to work as it should. The etcher who makes his own grounds, however, is usually a person who wants to experiment. The properties of the various ingredients are as follows:

Wax: the basic material for the ground; almost good enough alone, but needs the properties of the other ingredients to perfect it. Use as much as possible, which will probably be about half to one-third of the mixture.

Resin (mastic, damar, or rosin): the least acid-resisting of any of the ingredients. Use as sparingly as possible; its function is to set up or harden the ground, to make it less tender, and to raise its melting point.

Asphalts: highly acid-resisting; the softer varieties will impart flexibility, and the harder varieties will also contribute strength and resistance to handling. Asphalt will tend to shorten the mixture or lessen the natural sticky adhesiveness of the wax. The hardest and most brittle asphalt is gilsonite, which is like a hard resin; the softer, more elastic kinds among the standardized varieties are Trinidad, Barbados (Manjak), California, and Egyptian asphalts. There are a number of other soft asphalts, both native materials and by-products of oil refineries, that are used industrially in large amounts but are sometimes difficult to obtain at retail. Asphalt will also color the ground, but when the ground is spread thinly and evenly over a plate this coloring will be no more than a transparent brownish tinge, and for an intense black coating against which the copper-colored lines incised in the ground will show up with greater contrast, the plate must be smoked.

Liquid Grounds. The prepared liquid grounds are made by dissolving the solid materials used in the regular grounds in a quick-drying volatile solvent. Ether and chloroform are the traditional solvents in use; the substitution of less dangerous materials from the long list of modern solvents available should be an improvement. The drawback to the use of liquid grounds is their tendency to collect dust particles, which produce weak spots in the coating. The liquid ground is applied by pouring it over the plate; the plate is manipulated so that the ground spreads evenly, then the excess ground is allowed to drain from one corner back into the bottle, an operation requiring some skill.

A recipe for a liquid ground that I have used in experiments is as follows: melt 4 ounces of beeswax; stir in ¼ ounce of powdered nigrosine base, or other oil-soluble aniline black, until dissolved. Pour into 2 ounces of gilsonite that has been melted in a separate can. Remove from stove and thin with a mixture of ½ ounce of kerosene and ½ ounce of mineral spirits poured in slowly with stirring, followed immediately by 8 fluid ounces of toluol. The petroleum solvent is used to start the thinning; if a highly volatile solvent were added first, it would cool the mass too quickly, causing it to solidify in lumps, and the solvent would boil away. (All thinning of varnishes must be done in places with good ventilation and in the complete absence of flames or electric heaters.) This ground can be made more brittle by adding rosin or mastic or by increasing the proportion of gilsonite, and softer by the substitution of a softer asphalt for the gilsonite. A liquid ground can also be made by thinning the molten wax with a ready-made solution of asphalt.

Etching the Plate. The plate prepared for etching is immersed in a bath of mordant, which bites or eats away the metal by chemical action. The commonest receptacle in use is a glass or china tray such as is employed by photographers; a wooden tank or one lined with sheets of lead could be used, if necessary. Acid-resisting porcelain-coated metal is not reliably resistant to the strong concentrations of acids employed in etching mordants.

The traditional mordant is 4 parts concentrated nitric acid and 6 parts water (concentrated C.P. nitric acid is a 68- to 70-percent solution of HNO_3). Nitrous acid, which is similar in action to nitric acid, is preferred by some etchers. Further remarks concerning the action of acids in etching will be found in Chapter 13, "Chemistry" (pages 431 and 467). Before the acid is poured into the tray for use, it is customary to dip a strip of clean zinc into it for a few moments until it bubbles freely. This ionizes or begins the dissociation of the acid, and puts it in a condition which ensures its immediate and steady, continuous action upon the plate. During

the reaction between the acid and the copper, the bubbling that occurs should be watched, and if any bubbles start over areas that are supposed to be protected by the ground or resist, the plate must be removed at once, rinsed, dried, and given further protection by applying an acidproof varnish or resist to these weak points. The defect caused by such accidental solution is known as false biting.

After the plate has been bitten to the correct depth to produce the finest or lightest lines desired in the particular work in hand, it is removed, rinsed, and dried, and the portions that are to remain finely etched are covered with acidproof resist, applied with a small brush. The plate is then bitten again to produce the next coarser or heavier lines, and so on; experience will determine the depth to which the various kinds of lines should be etched. After the plate has been etched as far as one wishes to go, all traces of varnish or ground are removed with the appropriate solvents, and a trial print is made, whereupon the plate may be regrounded and any corrections or additions made by further etching. There are several variations of etching procedure, and some etchers will change their techniques according to the particular work in hand.

Iron (ferric) chloride is sometimes used as an ingredient of mordants on the theory that its action tends to be more selectively vertical than that of nitric acid; that is, the lines will be bitten down rather than sideways (see pages 569–70). This result is caused by the rapid deposition of salts on the little walls of the lines, their surfaces being thereby protected from further action of the acid. After a somewhat longer time, the bottom of the etched line also becomes clogged with these salts and the action ceases.

Before a plate is immersed in acid, the back and edges must be coated with a liquid resist or acidproof paint. The usual material sold for the purpose is a solution of asphaltum in volatile solvent, which dries quickly to a rather brittle finish and which is sufficiently acid-resisting to protect the plate from etching solutions. The advantage of "walling wax" is the elimination of a tray or bath, the larger sizes of which can be expensive. If a wall of wax is built along the edges of the plate, acid can be poured upon the surface alone.

The ebullition caused by the action of nitric acid on a metal is rather violent (perhaps because a double reaction takes place) and tends to disturb the resist coating at its edges; the result is apt to be a coarsening of the lines. For this reason some etchers use the so-called Dutch mordant, a milder solution that appears to have originated about the middle of the nineteenth century; it is made by dissolving ½ ounce of potassium chlorate in 5 fluid ounces of hot water, cooling, and adding 1 ounce of concentrated hydrochloric acid. Dutch mordant has a milder action on

copper than the nitric acid solution, and is considered more certain to etch fine lines sharply. Potassium chlorate should not be used in other mixtures; it is not a safe substance for haphazard experiments. Correct laboratory technique calls for slow, cautious addition of any concentrated acid to water, never water to acid.

The remarks on materials used in an etching ground apply as well to the liquid resists or stopping-out varnishes, except that these varnishes do not have to meet such precise requirements and a larger variety of materials can be used, according to the judgment and experience of the user. It should be remembered that from the viewpoint of solubility, alcohol-soluble coatings, such as shellac, are different from those that dissolve in benzine, toluol, etc., such as the usual asphaltum and wax compounds; when a plate bearing both kinds is to be cleaned for printing, it must be washed with each of these types of solvent separately. The more powerful paint-remover solvents, such as acetone, will usually remove both kinds of coatings. Waxes and waxy materials are used to plasticize these acid-resisting varnishes, that is, to render them less brittle, so that when they are scratched through with the etching needle, the line will be clean and sharp. If, for example, the highly acid-resisting varnish made of pure gilsonite and solvent were scratched with a needle, the edges of the scratched varnish would chip away in a rough and erratic manner. An acidproof stopping-out varnish or resist, in the thin layers in which it is applied in etching, is usually just about adequately resistant to the mordant to accomplish its purpose and cannot always be depended upon to resist stronger concentrations of acid or to withstand immersion in acid for extended periods.

An important consideration in etching, as in any other chemical reaction, is the temperature. In order to secure uniform, controlled results, and to be able to rely upon former experience in timing the etching periods, careful workers will use a thermometer. Normal room temperature, about 65° F, is standard; as is usual in most chemical reactions, heat accelerates and cold retards the action.

Soft-Ground Etching. Soft grounds are made of the same materials as the regular grounds, plus 50 percent of tallow. They need not contain any blackening material. When a plate coated with soft ground is covered with a sheet of paper and then drawn upon with a pencil, the ground under the pencil pressure will adhere to the sheet, and when the paper is lifted away, the ground under the lines of the drawing will come away with it. Such a plate differs from one made with a needle in that the line can be made to vary in strength through width instead of through depth

of biting, and the plate may be bitten without so much use of stopping-out operations. The character of the line is more or less grainy, like that of a crayon line, depending upon the texture of the paper.

Drypoint. Technically, the drypoint occupies a position between the etching and the engraving; the process is simple, direct, and autographic.

A copper plate, the same kind as is used for etching, is blackened with the soot of burning wax tapers, and the drawing is scratched directly upon its surface with a needle whose point must be sharp rather than rounded. Sometimes a diamond point is used. The plate is then cleaned, inked, and printed. Drypoint and etching are often used in the same plate.

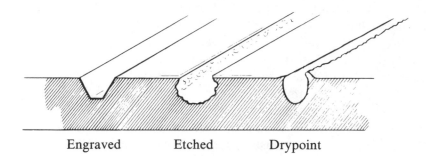

Engraved Etched Drypoint

As illustrated in the drawing above, the natural drypoint line has a characteristic soft effect from the ink deposited by the burr or raised edge. This burr is delicate and will not hold up under any severe treatment or withstand the wearing pressure of very large editions; when required, it can be removed entirely by using a scraper, the same triangular-edged instrument used in copperplate engraving. A sharper line will then be produced. Drypoint is considered best adapted for direct, spontaneous work, and its effects are less deep and varied than those of etching.

Aquatint. An aquatint is an etching in mass instead of in line, and is made possible by the application of a special ground that consists of powdered rosin of various degrees of fineness. The acid surrounds these particles of rosin and bites through to the metal at their edges, thereby creating a grainy effect; the irregularities of the grains prevent the texture from appearing mechanical. There is no technical or artistic objection to combining line etching or drypoint with aquatint; almost all aquatints require line work and rely upon it for many of their results. Such prints are usually called aquatints, even though the major part of the work is line. A

great number of variations and modifications are in general use to produce a number of variously grained effects.

Aquatint is practiced only by experienced etchers who have an inclination to experiment with materials and develop their own methods and manipulations; few artists are content to follow any set or standard procedures after becoming interested in the technique. The principal methods may be outlined as follows:

The plate is grounded by covering it with a layer of powdered rosin. This is accomplished by dusting the rosin on through a cloth bag, by sifting it through sieves from a height of several feet, or by shaking it around in a specially made box, then inserting the plate and allowing the powder to settle upon it. The plate is then warmed on an electric or gas heater for a few moments, which fuses the particles and causes them to form a hard ground of granular texture. If this were immersed in acid, the result would be a plate that would print a solid area of granular tone; the acid bites through the points unprotected or insufficiently protected by the fused particles of rosin, which is a semiacidproof material whose resistance can be controlled by varying the thickness of film and the duration of biting.

Another method of graining a ground is to run a plate coated with regular etching ground through a press together with pieces of sandpaper, the operation being repeated as many times as necessary.

Before the biting, the picture is made by painting upon the grounded plate with regular stopping-out or resist varnish, and gradations of tone are produced by repeated biting and stopping out.

Many varied textures are obtained by such manipulations as producing white lines by painting with resist varnish before applying the rosin, or by drawing on the plate with acid-resisting grease pencils.

Printing Etchings. In etching, the printing is so much a part of the complete process that the etcher usually prints his own plates. After he has succeeded in printing a perfect trial proof, he may turn the rest of the edition over to an expert printer, but the number of such experts is so limited and the effects are so dependent upon the artist's personal work that this is seldom done. The planning of the composition, the original strokes of the drawing, and the biting of the lines are all carried out with the final printing in view.

The plate is inked by working the ink into the etched lines thoroughly with a dauber, in all directions. When the lines have been filled in with ink to the satisfaction of the printer, the surplus ink is wiped from the flat surface of the plate. Theoretically, a technically perfect etching should be wiped absolutely clean, and the final proof should consist of inked lines

clearly printed on clean paper, without smudging or other effects caused by ink remaining on the flat areas of the plate. Actually, tradition and taste allow for considerable latitude in this connection, and the artist ordinarily obtains a number of different effects by manipulating the process of wiping the plate. However, overdependence upon accidental inking effects is usually condemned.

The inks used in etching differ from ordinary printing inks according to obvious differences in function; they are, however, basically similar to the others in that they are black or colored pigments ground into thickened linseed oil by roller mills. A number of satisfactory inks are on the market; the principal variation an etcher will need is in tone or color. After a little experiment he will soon discover the make or type of ink that best suits his particular purposes, and will not usually change unless he changes the other details of his procedure. Etchings are ordinarily printed in normal, true black; sometimes they tend toward the brownish, or are even a definite brown. Etchings in other colors are rarely made. Multicolored etchings made with single impressions by such procedures as inking various parts of a single plate by hand with inks of various colors do not conform to artistic requirements and are not color etchings but colored etchings. Color etchings would be made in the same way as other color prints, by printing each color impression separately.

ENGRAVING ON COPPER AND STEEL

Successful engraving requires a well-developed personal skill in manipulating the gravers, or burins. The gravers are tempered steel instruments with oblique points and wooden or cork-covered handles designed to fit into the palm of the hand. The steel is grasped with the thumb and fingers near its point, and the edge of the thumb must press against and glide along the surface of the plate in order to guide the point in a free and sensitive manner and to prevent it from becoming buried in the metal. The plate rests upon a circular leather pad, and is held by the engraver's left hand in such a way that it can be tilted and revolved, these motions being coordinated with the movements of the graver and used equally, especially in engraving curved lines. When the work is finished, the burr that the graver raises in occasional and varied places must be removed by rubbing with a few strokes of the scraper held flat, after which the plate is ready for trial impressions. The scraper is a triangular blade with sharp edges, which removes the burr without injuring the plate. Printing is done as in the case of etchings, except that after the plates are inked they are wiped very clean; the printing of an engraving is an altogether mechanical operation.

WOODCUTS AND WOOD ENGRAVINGS

The term "woodcut" is correctly applied to work done by cutting out the surface of a smooth plank of hardwood with a knife, aided by the use of small V and U gouges for more delicate lines. Seasoned planks of apple, pear, cherry, beech, and sycamore of type-high thickness (.918 inch) are preferred. (See page 415 for modern practices.)

The term "wood engraving" is applied to work done on blocks made by sawing the wood so that the surface is the end of the grain; and instead of knives and gouges, gravers are used—the same tools employed in metal-plate engraving. Carefully prepared blocks of boxwood are sold for this purpose, as well as red maple blocks, which are considered second choice but are adequate for most uses. Compared with woodcutting, wood engraving is essentially a white-line-on-black-background technique; that is, one works from black to white to a greater extent than when cutting on a plank where larger areas of white are incised and the black and white masses are manipulated more equally. The earliest masters of the woodcut produced work of strength combined with delicacy of line, but the technique is at present considered more adaptable to robust, free work, while the wood-engraving technique is preferred for work that requires more refinement or accuracy of line. In addition to the regular graver, smaller versions called tint tools and splitsticks are also used.

At the peak of its development during the nineteenth century, wood engraving was used principally as a means of reproducing drawings and photographs, and its characteristic qualities were subordinated to the production of imitative effects. Its use as a purely artistic technique is modern, dating from the end of World War I.

The revival of woodcut as a fine-arts medium for original prints antedates that of wood engraving by a few decades. The woodcut is an excellent medium for color prints, which are made by cutting a separate block for each color and aligning the progressive impressions by means of register marks on the margins of the blocks. No technical consideration regulates the number of colors that can be used, but, for considerations of aesthetics or taste, the printmaker seldom uses more than three or four colors plus the secondary color effects obtained by overprinting the blocks.

LINOLEUM CUT OR LINO CUT

The limitations and restrictions imposed upon an artistic medium by certain intractable materials are overcome by a competent mastery of the technique; exploitation of all the medium's desirable qualities then becomes possible. As a result of this, a certain element enters into the work

which enhances it, according to most artistic doctrines. In such traditional techniques, the substitution of newer materials that lack some of the properties of the old materials and do not present such difficulties will result in effects that lack this element; it is for this reason that the easily cut linoleum is less esteemed by artists than is wood. The linoleum will not take very delicate or subtle cutting, and its characteristic effect is composed of rather blocky or poster-like forms. However, the technique enjoys a certain popularity among artists for the production of less exacting and more casual work.

For the most part, the remarks on woodcutting apply to linoleum cutting; lighter-weight tools made for the purpose are now sold in place of the regulation wood-carving knives and gouges, but they are less satisfactory. Linoleum is composed of burlap coated with a heavy layer of linoxyn, which is made of polymerized oil mixed with ground cork and pigments. The best grade is known as battleship linoleum, and is usually brown or gray. (See *Sources of Materials,* page 647.) If desired, it may be mounted or purchased ready-mounted on wooden blocks so that the cut is type-high in order that it may be taken by a printing press. Small, inexpensive presses may be purchased or improvised; when regular printing ink is used the printing presents few difficulties. Fairly satisfactory (but not perfect) impressions may be made even by such makeshift procedures as placing the inked linoleum cut and the paper between boards or between the leaves of magazines, and bearing down on them heavily with one foot.

THE MONOTYPE

The monotype occupies a place between the graphic arts and painting, the proofs being unique and not identical multiple replicas of an original picture. But because these proofs are indirectly produced and printed on paper, and because usually an artist turns out an edition of several copies or versions of the same subject, monotypes are generally classed among the graphic arts. They usually display accidental effects; ordinarily no effort is made to prevent this, and only approximate results are expected in the making of duplicates.

The usual monotype is a painting in any convenient medium that does not dry too rapidly—ordinary oil paint, printing inks, or even aqueous paint—done on a metal plate or a sheet of plate glass, either freely or following a transferred outline drawing. A sheet of paper is laid over the painting, held firmly with the fingers of one hand so that there is no lateral movement, and rubbed with a bone folder or any convenient implement (i.e., the bowl of a large wooden spoon) to effect the transfer of the

painting. Many variations suggest themselves to artists, and there are few standard methods.

SERIGRAPHY (SILK-SCREEN PRINTING OR SCREEN PRINTING)

Serigraphy is a twentieth-century multicolor printmaking technique developed in America. Its first formal introduction as an artists' technique occurred with an exhibition of serigraphs at the New York World's Fair in 1939. Since that time it has become a widely accepted medium for artists' original prints. The method is basically a stencil process, where the designs are placed upon a piece of fine mesh fabric (originally silk, thus the name "silk-screen" printing) attached to a wooden or metal frame; various film-forming materials, as well as hand-cut film stencils and photosensitive emulsions, are used as resists. The frame is made about two inches deep so that it forms a box, with the screen fabric constituting the bottom. The specially made color in the correct semiliquid consistency is then poured into the frame, the frame is placed in contact with the surface to be printed upon, and the color is scraped over the stencil with a squeegee, thus being deposited upon the paper or other ground through the meshes of the uncoated areas of the fabric. Although successful monochrome prints can be made with one impression, almost all of the development work on screen printing as a fine-arts medium has been done with the aim of producing color prints in a full, unlimited range.

In the past, artists have taken up many stencil processes for the multiple production of their works, but because of technical limitations none of these have developed beyond the status of minor techniques or mechanical reproductive processes. The screen printing technique, however, demonstrates all the major attributes of a true graphic-arts medium. The name "serigraph" was proposed by Carl Zigrosser to indicate an artist-made screen print as distinguished from screen printing work executed on an industrial or purely reproductive basis. The prints may be described as resembling gouache paintings with some color-lithograph qualities, specific effects varying according to the technique or style of the artist.

The origin of the screen printing process has been explained in various ways. Perhaps its oldest related forerunner is a certain type of large Japanese stencil sometimes to be seen in museums and collections, in which the most delicate and fragile sort of paper-cutting had its elements joined and kept in place by means of human hairs pasted across them so that they acted as stencil ties and, at the same time, did not cause any interference with the deposition of color on the textile or paper that was to receive the design.

The silk-screen printing process as we know it comes out of the small New York workshops where it was gradually developed into the standard procedure for the decoration of textiles in loose, freehand patterns and for the inexpensive production of multicolored posters. Many individual small inventions and improvements were accumulated; at first the free-hand patterns were mostly done by painting the resist portion of the screen with opaque lacquers or paints with starch, or with gum-thickened solutions of water dyes.

With the introduction of Profilm, a patented material that replaced the liquid resist, the process became more adaptable to use by individuals, by decorating departments of various establishments, and by workshops that specialized in screen printing for various purposes. Eventually it was applied to printing on nearly every conceivable surface, shape, and material, and for innumerable purposes. This versatility of application is the reason for screen printing's growth since the 1940s as both a commercial and a fine-arts printing technique.

Today these activities have assumed the proportions of an important industry served by a number of dealers in supplies and equipment. New materials and techniques have been introduced by these manufacturers and dealers that have changed the very nature of the process and the range of its applications. The introduction of synthetic screen printing fabrics, for instance, is what precipitated the name change from "silk-screen" printing to "screen" printing. The nylons, polyesters, Dacrons, and other fabrics proved to be so much better and cheaper than natural fiber silk for most applications that few printers today actually use the silk fabrics. These screen fabrics are now classified as either multifilament or monofilament, depending on the structure of the weave. Multifilament fabrics, as the name implies, are woven from strands of the fabric that are made up of several filaments. These fabrics are graded from 6XX (coarsest) to 25XX, depending on the strands per square inch. Monofilament fabrics are woven from single-filament strands of a fabric, and are graded according to the number of strands in the fabric per square inch; monofilament nylon ranges from 74 through 457, monofilament polyester from 54 through 420. The weight and fineness are expressed by X: one X is standard, XX is extra weight, XXX extra strength.

Many other new materials have been introduced that improve either the speed and quality of the printing or the durability of equipment. Synthetic products have replaced the once-standard rubber squeegee blades; they do not wear down as easily from the friction during printing. Stainless steel screen mesh is also used by both artists and commercial printers who are trying to achieve the ultimate in screen durability and print registration.

The Basic Printing Set-Up

Screen printing was first publicly sponsored as a fine-arts medium by the New York W.P.A. Art Project, which organized a production unit for screen prints as a division of its graphic-arts department. The development of the process for artists' use was due largely to the work of Anthony Velonis, who made considerable progress in establishing and standardizing techniques and in furthering their adoption by artists. The following outline is based largely upon his practice and recommendations. While newer and more sophisticated printing set-ups are being used by professional artists in their studios and ateliers, this basic outline helps to explain the basic printing procedures.

The frames are sturdily built of good lumber about 2 × 2 inches, and brass hinges with removable pins are fastened to one of the long edges (referred to here as the back edge) so that the frames can be hinged to the baseboard (a plywood board somewhat larger than the screen) and interchanged. The baseboard, in turn, rests on a work table. The screen fabric is tightly stretched by tacking it onto the frame or by using a special clamp frame or a cord-and-groove frame, after which the margins and edges are completely shellacked or lacquered. The frame must be large enough so that a margin can be left around the drawing for manipulation of the paint.

Printing operations are facilitated if a screen-door spring is attached

to an upright at the back edge of the baseboard and hooked to the side of the frame near the front edge, so that the frame is held up some inches above the baseboard and is in contact with the paper only while the print is being made. This is known as "off-contact" printing. Registers, similar to those used when paper is placed in a printing press, are made by gluing three small squares of thick cardboard or celluloid to the baseboard as guides to hold the paper in place, two along the front edge and one at the left near the front. Simple guides may also be improvised from gummed paper tape by folding a short strip, gum side in, then folding back the end of each side and gumming it together and to the baseboard. When pointed upward, these will lie flat as the screen presses against them.

Before the printing operations are started, the baseboard may be propped up at an angle on the table by placing a length of wood under its rear edge.

Another method of hinging the frame, which has become more popular than the one shown in the drawing, is to use a hinge-bar at the back edge; this is a wooden bar of the same height as the frame, fastened to the base by means of two bolts and wing-nuts, so that when the screen lies flat on the base its top surface is flush with that of the bar. The screen is hinged to the bar with the hinges lying flat across the two. As noted by Shokler,[113] this not only puts less strain on the hinges so that they will hold the screen in good register longer, but by loosening the wing-nuts and placing cardboard strips between the bar and the base, the screen can be adjustable to any thickness of printing stock, such as cardboard or wallboard.

In place of the spring, most printers prefer a prop-bar, an 8-inch stick with a hole bored in one end through which a screw of slightly smaller diameter fastens it to the left-hand edge of the screen about 2 or 3 inches from its front edge. The screw is fastened loosely so there is free play, and when the screen is raised to remove the print and replace it with another paper, the prop falls down automatically and supports the screen away from the base. A flick of the finger swings it away for the next impression.

Stencil Methods

Tusche-Washout Method. This was the technique most often used by artists when they first became interested in screen printing in the 1930s and 1940s. It is still used today, though most artists now prefer photographic methods for making stencils of freely drawn or painted images.

The tusche-washout method involves painting or drawing an image directly onto the top surface of the screen fabric with a greasy material like a lithographic tusche or grease crayon. Once the image is drawn, one end of the screen frame is elevated and a water-based glue solution is

pulled evenly across the screen fabric. When this has dried, the grease marks on the fabric can be removed with mineral spirits or paint thinner, thus leaving the image areas of the fabric open for printing. A good glue solution is 50 parts Lepage's liquid glue, 40 parts water, 8 parts vinegar, and 2 parts glycerin.

Hand-Cut Films. Profilm, as was mentioned earlier, helped to expand the range of applications for screen printing. Since its introduction, many other stencil films have been developed that vary in thickness, solubility and support backing. These films are made of two layers: one a thin coat of either a lacquer-based or water-based stencil material, and the other layer either a glassine paper or plastic support sheet. The stencil layer is adhered to its backing sheet with rubber cement. Because the films are transparent, they can be laid over a drawing that indicates which areas of the film should be cut. The stencils are cut from this material with a small, very keen stencil knife, care being taken to cut through the top layer of the film but not through the support sheet. The cut-out areas are removed, and the finished stencil is made to adhere to the frame-stretched fabric by placing it under the frame with the stencil film in contact with the flat, printing side of the frame. Working on the top, ink side of the frame, the appropriate solvent is wiped across the screen fabric so that the solvent goes through the fabric to lightly dissolve the stencil film emulsion. As the film dries, it is wiped with a clean dry cloth so that it becomes attached to the screen fabric. Once the film is dry and firmly attached, the paper or plastic support sheet can be pulled away from the screen and the image can be printed.

Direct-Method Photo Stencil. This is one of the two photo-stencil processes used most extensively by artists today. This technique, like the indirect method described below, employs light-sensitive chemicals that will change the physical characteristics of the stencil-making material when exposed to ultraviolet light rays. The light source can be a carbon-arc lamp, a photo flood lamp, a vacuum exposure table, or other high-intensity ultraviolet light source (in the upper, visible blue range of the spectrum).

The image to be printed must be prepared as a film positive—an opaque design on a piece of transparent acetate. This film positive can either be made from a continuous-tone photographic negative exposed onto high-contrast litho film, or drawn by hand on the acetate with an opaque ink. Tonal gradations must be conveyed using halftone screenings.

With the direct-method process, a light-sensitive chemical is mixed

into a special gluelike emulsion that is used to coat the entire screen fabric. Once the sensitized emulsion is dry, the film positive is placed in direct contact with the coated screen and the two are placed in front of an ultraviolet light source. A calculated exposure is then made through the film positive towards the coated screen fabric. Those areas of the screen that have been exposed to the ultraviolet light will harden, while those areas that the film positive concealed from the light can be washed away from the screen with hot water. The result is that the image becomes the open areas of the screen through which the ink can pass.

Indirect-Method Photo Stencil. The indirect method employs a film made with a layer of light-sensitive gelatin spread across a backing sheet of plastic. The film is manufactured in different degrees of light sensitivity and with varying thicknesses of support backing. The main reason for choosing to make an indirect screen is that it will reproduce finer and sharper details than with the direct method because of its independence from the screen mesh weave. The disadvantage of the indirect film is that it will not make a screen that is as durable, and it tends to be more expensive than the direct method.

A film positive is placed in direct contact with a piece of indirect film exposed to an ultraviolet light source, and then developed in special chemicals. Once developed, the film is washed out with flowing hot water so that the soft image areas on the film will wash away and the exposed, nonimage areas will remain unaffected by the water. While still wet, the film is placed in contact with the flat, printing side of the screen frame where it will become attached to the fibers of the screen fabric as it dries. The fabric must be blotted on the top side with a newsprint pad to ensure proper adhesion. Once the adhered film is dry, the support backing can be pulled away from the screen, thus leaving the stencil ready for printing.

Multicolor Prints. The methods for producing multicolor prints are in general the same as those used in any graphic color-printing process. The serigraph, however, has the advantage that a key screen that will print the complete design is in the great majority of pictures unnecessary or undesirable. The number of colors and textural effects that may be employed is unlimited, and color applications may be continued indefinitely, the same as in painting. Transparent and opaque areas may be manipulated in many ways. The paint is carefully rinsed out of the screen with solvent at the end of each run. The same stencil may be reprinted in another color or partly blocked out and reprinted in part. When the sten-

cil is no longer required, it is carefully removed by washing it with the appropriate solvent, and the screen, scrubbed and cleaned with the appropriate mesh preparation, is ready to receive another drawing or stencil. An instructive and interesting record of a serigraph can be made by keeping a series of successive proofs of each single color impression together with a series of progressive proofs, by holding out a print from each run to show the work at each stage.

Equipment. All the equipment and materials for the process may be purchased from the regular dealers in screen printing supplies and from some artists' supply stores. The mechanical items can be made by simple carpentry if necessary. One or two screens will be sufficient for the average artist's use. Depending upon the size of the edition and the number of color impressions used, the fabric will eventually wear out and require replacement.

A simple way of handling the wet prints is to hang them up to dry with spring paper clips or clothespins with strong wire stretched through them.

The material sold as transparent base is a paste of alumina stearate ground in the same vehicle as the pigments with which it is intended to be mixed to produce transparent effects. Its use is an important factor in the production of good prints. It may be mixed with regular artists' oil colors, if desired. The mediums are formulated to work well in the process and to dry very rapidly—needing from a half-hour to overnight.

SOME NOTES ON SCULPTORS' MATERIALS

Sculptors employ three broad categories of technique: *carving, modeling* (normally preparatory to casting), and *assembly.* The last is relatively new, deriving from the revolutionary art movements during the first quarter of the twentieth century in France, Russia, and Germany; it includes all work in which preformed elements are joined, such as welded metal constructions.

MODELING MATERIALS

Modeling clay (plastelene, modeling wax): a nonhardening gray-green mass which, if of the best quality, has a pleasing, short, plastic quality. Cheap grades have less desirable properties; they may be sticky or over-

firm. The original plastelene modeling clay was an Italian product said to be made of tallow, sulphur, and a special clay.

Sculptors' clay (*wet clay*): This clay comes in dry powder form and is moistened before use. It is a native earth consisting largely of kaolin combined with silica. Many varieties of clay occur in nature, and various small percentages of impurities are the chief causes of their distinctive properties; for every use there is a best-suited variety. When wet, all clays are plastic to some degree and can be modeled; if the molded objects are fired in a kiln or furnace at high temperatures they become hard and rocklike, retaining their shapes. Some of the most plastic modeling clays, however, are not well suited to ceramic uses. The varying degree of plasticity in clays has been attributed to a number of chemical or physical causes, and the question is still greatly disputed.

Sculptors' clay is selected for plasticity and moisture-holding properties at a sacrifice of other properties that are important in potters' clay. Sculptors' clay is used only to make models, which are to be cast in some other material soon after they are completed. Useful varieties occur in all parts of the world. The largest American sources of supply are Florida, Tennessee, New Jersey, and Kentucky. Among sculptors a variety imported from France is sometimes preferred.

Sculptors' clay will last indefinitely in its original powder state or if kept in a wet or moist condition; when it is much kneaded and aged in the moist state it improves in plasticity. If wet clay is allowed to set and harden, a considerable amount of reworking, usually by mechanical means, is required to bring it back to its smooth plastic form; on account of its low cost and the labor involved in reworking it, hardened plastic clay is ordinarily discarded. When a piece of sculpture is being molded in clay, it must not be allowed to dry out, because of the cracking and shrinkage that would ensue; it must therefore be moistened by a liberal spraying or whisking of water every twelve to twenty-four hours, and in the average climate is best wrapped in damp cloths and then covered up to minimize evaporation of moisture during periods when the work is set aside. This is most easily accomplished by constructing a light, movable framework covered with a piece of waterproof sheeting. Wet clay is stored in a pail or tub, covered with wet cloths, and the container is closed with a tight-fitting lid.

Terra-cotta is a ceramic clay usually but not always containing iron oxide, which imparts a characteristic reddish color to it. Pale, whitish varieties are also in use, as well as those of intermediate colors obtained by mixing clays and by adding small amounts of iron oxide or other coloring ingredients; but the traditional terra-cotta color is a pale tile red, such as would result from mixing burnt sienna, white, and a little red

oxide. Sculpture modeled or cast in this material is directly fired in kilns and made permanent and durable. Its surface may sometimes be colored, glazed, or enameled with various ceramic materials before firing.

Plaster of Paris is described on pages 464–65.

Brass-Pipe-and-Wire Armature
for Clay Modeling

STONES

The use by the ancient Greeks of a fine snow-white or creamy white native marble of smooth crystalline structure established this material as a traditional standard for artistic sculpture and architecture in Europe. The Romans perpetuated this tradition by using similar white marbles; they also carved many other native stones. In America the standard marble, and for many years in the past the only acceptable standard sculptors' medium, has been the pure white or slightly toned Carrara marble from Italy. Sculptors, however, have always employed an almost unlimited number of stones of various colors, textures, and degrees of hardness, durability, and ease of manipulation. Each one is selected not only for its technical fitness for the work in hand but also for its appropriateness to the nature of the work.

All stones are perfectly durable and permanent when preserved under normal indoor conditions, but for outdoor use they vary greatly. The conditions that outdoor sculptures have to withstand are both chemical and mechanical, and include wearing or abrasion and destruction by water, frost, and the action of acid or acid-forming gases in the atmosphere. Few stones will withstand great heat, as in the case of fires. I do not know of any researches into the durability of artistic stone sculpture under exposure to weathering, but from the studies that have been made of different kinds of building stone subjected to the severe conditions of industrial centers, it is clear that great care is necessary in the selection of stones for outdoor sculpture. The remarks on pages 318–19 regarding the durability of outdoor frescoes and the effects of normal and polluted atmospheres apply also to artistic sculpture.

Marble and limestone: Chemically and geologically, limestone and marble are closely related. Both are usually composed of more or less pure calcium carbonate; some marbles are dolomites—calcium-magnesium carbonates containing approximately 2 parts of magnesite to 3 of calcite. Commercially, the term "marble" is used in a broad sense, and is applied to many of the finer varieties of limestone, particularly to those that are close-grained and will take a polish or will display decorative patterns or color effects when polished. For sculptural purposes, marble may be defined as a smooth, close-grained, compactly crystalline calcium carbonate, capable of taking a smooth, high polish; it is usually white, although colored marbles in great variety are also used. Limestone in this connection is softer, more easily worked, and commonly of a characteristic light gray or tan color, with a smooth, close-grained, but rather dull and sandy instead of crystalline texture, which takes a mat surface rather than a high polish. A glossy polish on marble is never durable under outdoor conditions. Oölitic limestones are composed of small, rounded grains bound together compactly.

Because marble consists of practically pure calcium or magnesium carbonates, it is extremely sensitive to the solvent action of air polluted by acids—principally carbonic acid from the carbon dioxide normally present in the atmosphere, and the sulphur acids which originate from smoke and soot, fuel formed by the action of moisture. Marble is not an indefinitely permanent stone when exposed to the elements or to the atmosphere of industrial centers, as can be seen by the wearing away of old gravestones and monuments, especially those that have been subjected to the high concentration of atmospheric impurities in cities. There is considerable difference in the resistance of various marbles to atmospheric action, however, and the dense varieties selected for sculptors' use are among the most durable. The occurrence of flaws or defects in the interior

of a block of marble is a matter that cannot be foreseen, but in general these defects occur with less frequency among the selected grades than among the others. The better grades of Italian statuary marbles are particularly free from major flaws, but sometimes contain "pinholes." Only the most compact and hard marbles and limestones should be used in outdoor sculpture.

Marbles and limestones occur in America in a great variety of color, from a pure flawless white to black, and in numerous veined and figured designs. The availability of the well-known stones of European and American quarries varies continually; the dealers in cut stone for sculptural purposes are generally able to supply any type, but stones from specific quarries such as the historically famous Greek and Roman sources are sometimes not to be had. Most of the American stones and the principal stones of the world are described in a publication compiled by Lent.[239]

The most desirable grade of Carrara marble is known in the trade as Italian Statuary, a snow-white or creamy white stone of fine, compact, crystalline grain; it is the standard for working qualities and finish. The grade called Blanco (Bianco) P. is a bluish white variety of the same general properties.

Although the Italian white marbles are traditionally preferred among sculptors, a few of the finest American grades approach them closely in purity of color, fineness of grain, freedom from veins or clouds, and uniformity of texture, and some are considered equal to the Italian marbles by trade authorities. Among sculptors, individual preferences are based principally on carving properties; other artistic criteria might shift the ratings, but marbles will usually be graded by the trade in the following order:

Vermont White Statuary
Georgia White
Colorado Yule Statuary
Alabama Cream
Tennessee Pink

Although liked by sculptors for their carving properties, the last two are generally rated as distinctly inferior to the others in all-around architectural properties. The best black marble is Belgian Black, a dense, hard stone. An American black marble that approaches its jet color is Rockingham Royal Black, a Virginia stone with white stripes or veins.

Among the many limestones, the French varieties enjoy the best reputation among artists; they are mostly cream-colored stones with excellent sculptural properties. Some of the principal names are Caen stone,

Peuron, Lotharinga, Euville, and Normandeaux. Many American varieties of limestone are suitable; the most widely used are the Indiana limestones, the best grades of which are known as Indiana Select Buff Statuary. A few others are Batesville (sometimes called Batesville marble) from Arkansas, either gray or cream in color; Dunville stone from Wisconsin, an easily worked variety; Napoleon Gray, a dark limestone; and Texas limestone. Soft, porous limestones may weigh as little as 110 pounds per cubic foot, and the compact varieties 150 to 170 pounds. Limestones vary in color from white to black; most of those in general use, as stated above, are pale tan or gray.

Sandstone is a porous material composed of fine particles of silica; different varieties have their grains cemented together by calcium carbonate, clay, iron oxide, or silica binders. The last-named material is the most durable. Some sandstones disintegrate quite rapidly when used outdoors, while others are among the most permanent of stones. The best and most durable varieties occur in Ohio and are gray or buff in color. Freshly quarried sandstone often contains natural moisture (quarry water) which dries out after cutting; such stones become harder, less porous, and less easy to carve.

Brownstone is a sandstone that contains iron.

Onyx marble is a translucent variety of marble that when polished acquires a glass-like quality and exhibits layers and figurings of a variety of colors. It is seldom used for artistic sculpture. Usually it is available only in small pieces.

Alabaster is a pure, snow-white, translucent or semitranslucent stone; two entirely different minerals of similar appearance have been used under this name. The material in common use for many years is a variety of gypsum (calcium sulphate) that occurs in large solid masses. It is very soft, can be scratched with the fingernail, and is durable only under conditions of careful conservation. It can be blocked out with a hand saw. Inferior pieces sometimes contain brownish veins and clouds. The other kind, which was used by the ancients, is pure white calcite, a native calcium carbonate of definite crystalline structure, really a type of marble.

Granite is a much more compact, durable mass than marble; it is carved with greater difficulty, and for outdoor use is a stone of far greater durability and permanence of polish than marble. It occurs in many variations of composition, color, texture, and hardness. The most durable kinds are well known for their use in building construction and are generally of a grayish or reddish color. They consist largely of silica and silicates. Geologically, or from the viewpoint of their origin, granites are in a different class from the other stones mentioned here; they are cut from igneous rocks, formed by the cooling of molten material; the other stones

are classed as sedimentary rocks, deposited by water from the decomposition of other matter.

Soapstone is a silicate of this same class; it is rather soft and easily worked, but will resist great heat and severe chemical conditions. A Virginia stone sold under the name of Alberene occurs in some variation of hardness and ranges from a medium gray color to a fairly deep black. Because soapstone is so easily worked it was used by primitive societies for making implements, cooking utensils, and sculpture.

AVERAGE WEIGHTS OF VARIOUS MATERIALS IN POUNDS PER CUBIC FOOT*

Alabaster (carbonate)	170	Metals	
Alabaster (sulphate)	143	Aluminum	170
Brick	120	Bronze	520
Cement (solid)	196	Iron, cast	449
Clay, dry	120–160	Iron, wrought	480
Cork	15	Lead	708
Glass	150–175	Marble, average	162
Granite	170	Mortar, lime	103
Limestone (average in		Plaster of Paris	140
general use)	160	Sandstone (average)	155
		Soapstone	170
		Terra-cotta	121

CEMENTS

Cast stone and cast concrete: Models in clay, plaster, or modeling wax may be sent out to be cast in artificial stone, a material that can be made to duplicate exactly almost any natural stone in color or texture, and the best varieties of which are at least as durable as the stones generally used for carving. The process requires expert workmanship, and although there are many establishments that can produce cast stone of a quality adequate for average architectural use, there are few craftsmen who can turn out satisfactory casts of sculptors' work of the proper degree of durability and strength. The material can be refinished, carved, and polished after casting. The usual composition of commercial cast stone is similar to that of a high-grade Portland cement and sand mixture, but the individual workers on artistic cast stone will seldom give out any information regarding details of their process. A magnesia cement, as described below, is probably used more often than Portland cement. Aside from the

* Compiled from several sources. See page 608 for woods.

durable and varied results, the chief advantage of these methods over the duplication of models by commercial stone carvers is the saving in expense. Instead of using casting methods to duplicate the effects of carved stone, sculptors are beginning to employ it in an entirely separate technique in which its own properties can be used to achieve new effects, especially in color.

Portland cement, so called from its resemblance to an English building stone, is an artificially compounded mixture of lime, silica, and alumina, made by calcining limestone and clay in kilns or furnaces. Some varieties are made from a natural mixture of these materials that occurs in certain localities. All brands of cement vary in properties in accordance with the locations of the factories, cement being made in places where all the materials can be quarried locally. Native and artificial cements were used in ancient Rome, where the latter were made from slaked lime mixed with a fine volcanic ash, notably that obtained from Pozzuoli. Such materials are still in use to a limited extent today; they are called Puzzolan cements. A white variety of Portland cement is also on the market; this is somewhat inferior in strength and other mechanical properties but is widely used for its color effect. Cement is sold in 94-pound bags and must be kept dry; preferably it should be fresh stock.

Neat cement, or pure cement and water, is not used for structural purposes very often. *Cement mortar* is composed of cement and sand mixed with water, usually in the proportion of 3 parts (by volume) of sand to 1 of cement. *Concrete* is a mixture of 3 ingredients—cement, sand, and coarser pieces of crushed stone or similar inert material. The coarse pieces are called the aggregate. The addition of about 2 percent of plaster of Paris to cement mortar or concrete delays its setting; the substitution of hydrated lime up to 10 percent of the volume of cement makes the mortar more plastic without changing its properties appreciably, except that a slight additional denseness or water-resistance may result. The sand and also the coarser pieces, or aggregate, perform the same function as the sand in lime mortar described under *Fresco Painting* in Chapter 9, but the hardening and setting of concrete is a more complex and less well-understood process than the hardening of lime mortar. The assorted sizes of the sand grains and aggregate have much to do with the strength and compactness or porosity of the resulting mixture. After the initial set, which starts as soon as the water begins to evaporate, cast concrete must remain in its mold or forms for at least a day and, after it is removed, the rapid-setting variety will require about a week to attain its full strength; the slow-setting variety will need a much longer period. Cement is hydraulic, that is, it will harden or set under water, and after casts are removed from their molds they are often immersed in water or cov-

ered with wet cloths for the purpose of curing them while they are setting.

Cement and concrete mixtures may be colored by the addition of pigments up to 10 percent of their volume. The following pigments are in use:

Black	Black oxide of iron (Mars black)
Blue	Ultramarine or cobalt blue
Red	Pure artificial red oxides or Mars colors
Brown	Umbers and siennas
Yellow	Mars yellow, ochre, raw sienna
Green	Chromium oxide and viridian
White	White cement is used, with minimum additions of titanium or zinc oxides if necessary. Marble dust is also employed

The addition of some pigments to cement has a definite effect upon the strength of the mass. Lead-bearing pigments, pigments that are water-soluble, and those that react with or are harmed by the alkali in cement could not be employed, for obvious reasons. Copper and lead pigments weaken the mass considerably, as do zinc white, some of the carbon blacks, and some impure red oxides, especially Venetian red. The umbers and the pure red oxides or Mars colors will strengthen the mass somewhat, and the best grades of ultramarine have a very definite strengthening effect upon it. The others have little or no effect. These remarks are based on the results of architectural use and laboratory testing. Sometimes the brilliant aniline toners and other semipermanent pigments are used in the coloring of cement for industrial purposes. Cement colors must be alkaliproof, lightproof, and of the type that is not prone to efflorescence. The carbon blacks are frequently bad in this last respect; Mars black is satisfactory. Test blocks exposed under actual conditions for six months will indicate the value of a pigment.

Colored cements have been used for decorating walls both in relief and in the flat. (See page 359.)

In casting cement the materials are measured and mixed dry as thoroughly and intimately as possible; water is then stirred into the mixture until the mass is just wet enough to be handled properly in the use for which it is intended. Molds are filled by pouring the material in and tamping or packing it well. Too much water will cause separation and floating of fine particles to the surface. As in similar procedures, the best cement work requires an experienced hand. The usual mixes are, by volume:

For general all-around purpose:

Mortar—1 part cement to 3 parts sand. (This mix is used more often than any other.)

Concrete—1 part cement, 2 parts sand, and 3 or 4 parts aggregate

Lean mixture for walls, etc.—1 part cement, 3 parts sand, 6 parts aggregate

Cement sculpture in the round is cast by the usual sculptors' methods. Modeling can also be done in cement, solid or over an armature; such work may be made hollow in order to decrease its weight by covering the framework with wire netting, and plastering this with a mixture of 3 parts Portland cement to 1 of aged lime putty. Rough modeling can then be done with a mixture of 2 parts of cement to 1 of finely crushed aggregate; and the finish coat, which should be kept thin, may be made of 5 parts of Portland cement to 1 of lime putty, pigments being added if desired.

As previously remarked, these notes deal primarily with materials; references to applications and methods of procedure are incidental and are not to be taken as a manual of instruction.

Ciment fondu: French term for cement that has a high aluminum content and that is especially suited to make lightweight, hollow concrete castings by adding chopped glass fiber to the aggregate. It has excellent weathering properties and can be cast with a uniformly smooth surface. Lightweight *ciment fondu* is advantageous in the case of large-scale work, and it has become popular in recent years. Many variations in color and texture can be produced with different aggregates and coloring pigments.

Plastic magnesia or oxychloride cement: This product is perhaps best known for its use in the building trades in making composition floors, stucco for frame houses, etc. The nomenclature of the basic material used is somewhat vague, and the dealer from whom it is purchased should understand the purpose for which it is wanted; it is variously called plastic magnesia, calcined magnesite, caustic magnesite, and light-burned magnesite. It is made by calcining magnesite, a native magnesium carbonate, at a limited temperature so that it is not entirely converted to magnesia (as limestone is converted to lime) and a little less than 10 percent of the final product is still magnesium carbonate. The rest is magnesium oxide plus whatever impurities happened to be in the original ore. Dead-burned magnesite, roasted until all the carbon dioxide has been driven off, is unsuitable. The present main source of calcined magnesite is California.

When this product is mixed to a plastic consistency with a *strong* solution of magnesium chloride, it sets rapidly to a hard mass; and when used like Portland cement, that is, to bind together a mass of inert materials, it is known as oxychloride or Sorel cement. The solution of magnesium chloride must be tested with a hydrometer (page 621), which should read from 18 degrees to 25 degrees Baumé (1.14 to 1.21 specific gravity). A quicker-setting mix and a stronger mass can be made by using a

slightly more concentrated solution, 22 degrees Baumé (1.18 sp. gr.), while some workers prefer a still stronger solution, 24 to 25 degrees Baumé (1.20–1.21 sp. gr.). The material can be used by sculptors to model sketches, for which purpose it is a time- and labor-saver compared with the procedure of making plaster casts. Some workers have been very successful in using it in the making of cast or artificial stone, achieving various color and textural effects by adding cement colors, marble chips, and other substances. In molding or casting any kind of cement, best results require expert manipulations. The addition of inert materials gives various structural properties to oxychloride cements.

At least two sizes of aggregate must be used, one coarse, such as sand or marble grit, the other fine, such as silica, clay, magnesia, etc., so that a compact mass will be formed, the voids between the coarse sand being filled by the finer grains.

Since the discovery of this cement by Sorel in France in 1853, no complete version of its chemical composition has been worked out, and technical advances, tests, and formulations have been made in an empirical manner. Upon setting, the cement forms a mass of interlocking crystals of mixed magnesium oxychlorides; a colloidal or physical action also takes place, similar to that which occurs in the setting of lime, a gel being formed that ultimately binds the aggregate into a rocklike, cohesive mass. Because the mass expands instead of shrinking, the setting reaction apparently occurs before the water has a chance to evaporate.

The following weight recipes have been recommended by the Dow Chemical Company* as examples of typical or starting-point formulas.

STANDARD TESTING AND STUCCO MIX

1 part plastic magnesia (12.5%)
2 parts 120-mesh silica (25%)
5 parts Ottawa sand (62.5%)

Ottawa sand is a standardized material used in tests of various kinds; it consists of uniform, rounded grains of pure silica sand. Glass fiber and other modern materials can be used to create new effects.

STANDARD FLOORING MIX

5 parts plastic magnesia (50%)
3 parts silica (30%)
2 parts shredded asbestos fiber (20%)

* Seaton, Max Y. "Plastic Magnesite and Oxychloride Cement." *Chemical and Metallurgical Engineering*, Vol. 25, p. 233. New York, 1921.

BUREAU OF STANDARDS FLOORING MIX

45 parts calcined magnesite
15 parts silica
15 parts wood fiber, medium
10 parts talc
10 parts asbestos
 5 parts red iron oxide

SCULPTURE CAST IN METALS

Bronze.　The traditional metals for casting works of art from clay or wax models are bronze, which is normally an alloy of copper and tin, and brass, which is normally an alloy of copper and zinc. Alloys are used instead of single metals because of their more desirable properties; the various metals impart certain characteristics to the mixtures. The compounding or formulation of an alloy is not a haphazard matter, but is an involved and complicated study, and the various formulas approved for specific purposes have been adopted for good reasons. There are innumerable recipes for bronzes, most of which are designed for specific purposes other than the casting of works of art. Modern sculptural bronze usually contains an addition of zinc, melted in just before casting. Small amounts of lead and other metals are also found in various bronzes.

The use of more modern innovations, such as aluminum, stainless steel, and Monel metal, is so recent compared with the traditional use of bronze that no standards have been established, and sculpture in such materials may still be classed as experimental. Foundaries are more likely to use a regular standard alloy than to mix special formulas for sculpture. The principal concern of the sculptor in the selection of bronze is probably color.

Metal casting is ordinarily done in foundries by craftsmen experienced in the careful handling of sculptors' models; only a small minority of sculptors have sufficient first-hand experience or knowledge to even criticize or guide the work in progress, although a general understanding of the processes should be acquired in order to plan models from which technically successful castings can be made, and so that the results will coincide with the original intention.

It is not the aim of this brief survey of sculptors' materials to go into any detailed account of methods and procedures, but some mention must be made of them in relation to the properties of materials.

The two standard methods for casting bronze from clay or plaster models are the sand-casting method and the *cire perdue* or lost-wax

method. The sand process is the one in common industrial use; the lost-wax process is the traditional method for hollow casting of sculpture. Either one may be used for artistic work, depending upon circumstances. The method in use for the reproduction of a piece of sculpture by the lost-wax process consists in making a negative gelatin piece-mold of the original model and from this mold making a hollow model in wax, by coating the inside of the assembled mold with molten wax. After the wax model has been assembled, packed with foundry sand, and corrected and reworked by the sculptor, rods of wax are attached to it in several places. The model is then encased in fire-resisting plaster or clay; the entire structure is held together by means of pins, and placed in a hot oven or kiln until the clay mold becomes dry and the wax has melted and run away through the vents or holes in the mold created by the wax rods, which had been arranged so that they ran through the clay. The mold is then packed into sand, well supported by a sort of built-up kiln, and melted bronze is poured in through the apertures or gates, which were provided for by the wax rods. After the bronze has cooled, the mold is removed, the sand core is shaken out, and the casting is cleaned and finished.

In the sand method, a mold is made from a special foundry sand packed around the model; this mold is enclosed in a steel frame (flask), the two halves of which fit together accurately and closely. A sand core is then fitted into the mold so as to leave a space between it and the mold, into which the melted bronze is poured. All metal castings require chasing and other finishing operations after they are taken from the molds.

The casting of hollow bronze statuary is an ancient procedure, and the early bronzes of all civilizations have been well studied and analyzed. Details may be found in the works of Lucas,[42] Partington,[43] and other writers on various early cultures. Both of the methods outlined above have been traced back to early times, and it is doubtful which one antedated the other.

Melting Points of Some Metals in Degrees Fahrenheit. These figures have been compiled from a number of sources. Further data on bronzes will be found in Henley[200] under "Alloys."

Aluminum	1216	Iron	2741
Antimony	1166	Lead	621
Arsenic	1562	Nickel	2646
Cadmium	610	Platinum	3191
Chromium	3488	Silver	1760
Copper	1981	Tin	450
Gold	1945	Zinc	787

COLORING AND TONING OF SCULPTURE

Plaster casts are colored with paint coatings more often to imitate some conventional sculptors' material than to produce highly colored effects or to use color as a part of the design. The painting or toning of bronzes is usually done by chemical treatment.

Coloring Plaster Casts. Before paint coatings are applied to absorbent, porous materials such as plaster, the surface should be sealed or sized in the same manner in which linen canvas or plaster walls are sized before oil painting, in order that the coating may take evenly and adhere permanently. Very thin solutions of glue or casein can be used, but the best size is shellac diluted to a very thin, fluid consistency with alcohol. The shellac must not be strong enough to give a glossy finish, as this effect is likely to persist and impart a glossiness to the final coating; also it will prevent the final coating from adhering well. Thin coatings of size should be applied until the surface begins to show a faint, incipient gloss; then they should be allowed to dry thoroughly.

For the green patina, or *vert antique* finish, which simulates corroded bronze or copper, the first coat is an oil or casein paint of a dark brown color, about the shade of an old penny. When this is dry, a bluish green paint is tippled on with the end of a bristle brush; this paint should preferably be made of coppor carbonate, a pigment that is chemically the same as the actual corrosion on copper and its alloys. The green may be tinted or toned with other pigments to obtain variations in shade, and when dry may be coated with flat varnish; or the pigment may be mixed with flat varnish or with white flat wall paint. However, casein binders are most popular for painting plaster casts, and realistic stone effects are obtained by tinting a casein paint with various pigments and coarse inerts. More uniform textures may be produced by spraying than by brushing. Stipple coats should be of very thick consistency—a semipaste is about right—so that the stipple effect will not flow out and entirely conceal the undercoat. A final finish or protective coating for sculpture, either painted plaster or bronze, is a wax paste rubbed in well with cloths. A wax salve can be made by melting white beeswax and thinning it with a solvent.

A wax salve can also be used as a base for metallic effects with bronze powders, by melting carnauba wax and thinning it to the desired consistency with good quality floor or spar varnish, taking some of this up on a cloth, dipping it into the bronze powder and rubbing it vigorously on the shellacked cast. Dry bronze powder can also be dusted into the freshly

applied wax with a brush. Such operations call for the use of a certain amount of restraint and skill gained through experience; dull pigments, rotten stone and other powders can be combined with the bronze to tone down over-garish effects.

Patina on Bronze. The natural finish on bronze is usually preferred; bronzes will age to various dark brownish tones, depending upon their composition. The green, blue, or red patina found on ancient bronzes can be rather easily reproduced by chemical treatments that result in coatings of approximately the same chemical composition as that of the patinas produced during the natural corrosion of copper and its alloys. Bronze is an alloy of copper and tin, brass of copper and zinc, but much statuary bronze contains additions of zinc and other metals in various amounts. The green copper carbonate patina is said to be more permanent than the blue variety; the latter, when artificially produced, is likely to revert to the green form upon aging.

Because the toning of bronzes is an artificial expedient, even if it is chemically identical with outdoor weather and age corrosion, a simple pigmented coating like that used on plaster casts might just as well be substituted for it. Green age corrosion could logically be considered inappropriate for modern indoor sculpture. A plain dark brown or blackish finish is generally found acceptable in most instances.

The general formula books give many recipes for coloring metals by immersing them in or coating them with chemical baths, probably the most reliable calls for washes of dilute acetic acid alternated with exposure to the fumes of strong ammonia. Nearly all the published recipes for greens call for chlorides, but according to Fink and Eldridge[209] the use of sal ammoniac (ammonium chloride), hydrochloric acid, or any other chloride is to be condemned because chlorides induce "bronze disease," a malignant form of corrosion that spreads rapidly and has a destructive effect. The same authors recommend that the antiquing of valuable bronzes be done as much as possible with fumes instead of with solutions, and they suggest wetting the object and placing it in a closed box or cabinet with a dish of the volatile material on the floor. Their intention is to produce a permanent, stable coating that will not cause progressive decay. By first exposing the bronze to the fumes of a strong acetic acid or ammonia, or both, and then to carbon dioxide from a cylinder, they obtain coatings of blotchy greens and blues that have a natural effect. An imitation of the red patina is produced by submerging the bronze object in water in which precipitated chalk is suspended, and which contains 2 to 3 percent of iodine (tincture of iodine having been added); the object is

kept in this solution from 3 to 8 days. After all painting operations the bronze is thoroughly dried, preferably in an oven, and waxed with a paste of beeswax in toluol.

In applying the ordinary published formulas for patinas it will be found that manipulations are as important as exact formulas for securing desirable results. The following formulas were taken from a number of sources and are typical of a great many others; recipes for producing nearly any color on metals can be found in the above-mentioned books.

Vert antique: Produce a dark brown or blackish finish on the bronze by heating with a torch and, while it is hot, applying a solution of 1 or 2 ounces of potassium sulphide (liver of sulphur) and 2 or 3 ounces of lye in a gallon of water. Over this, stipple the following solution with a paint brush:

Copper nitrate	8 ounces
Ammonium chloride	4 ounces
Acetic acid	4 fluid ounces
Chromic acid	1 fluid ounce
Water	1 gallon

When this is dry, brush on another coat if necessary.

Verde green:

Copper nitrate	5 ounces
Ammonium chloride	5 ounces
Chlorinated lime	5 ounces
Water	1 gallon

Use at ordinary temperature.

Bluish green:

Sodium thiosulphate (hypo)	1 ounce
Iron (ferric) nitrate	8 ounces
Water	1 gallon

Apply boiling or nearly boiling.

Red:

Copper sulphate (blue vitriol)	6¼ ounces
Basic copper acetate	1 ounce
Alum	2½ ounces
Water	1 gallon
A few drops of acetic acid	

Use hot.

WOODS

The blocks, logs, and planks of wood used by sculptors must be well selected from properly seasoned stock, and as free as possible from defects in the inner mass of the wood. Obviously, many such defects are discovered only as the outer portions are cut away, and in some woods they are impossible to foresee; certain species of wood are notably free from such flaws, while others are more likely to exhibit them. If the wood has a very pronounced, bold grain or is distinctly two-toned in color, these markings will have their effect upon the sculptural forms, and while experience may be a guide to the sculptor in planning his general results, most of such graining will contribute entirely accidental markings. In the veneer industry, where thin plies of wood are sliced or sawn from the log at various angles in order to take full advantage of various grainings and markings, the manufacturer is seldom sure of the exact results until the log has been cut.

Both hardwoods and softwoods are used by sculptors; the requirements for a satisfactory wood are that it should last indefinitely and not be subject to splitting, cracking, or similar defects during work or upon aging. For general purposes a wood that presents a pleasing and responsive texture under the tools is preferred, but some of the close-grained hardwoods are also used; these are difficult to cut and chip away. A most desirable property in any wood is uniformity or freedom from irregular soft or hard spots. The woods technically best suited to carving are uniform and solid throughout. The logs of some woods have cores (heartwood) much less dense than the outer wood and of an entirely different texture.

Artistic wood sculpture may be stained or dyed any color, and oiled, waxed, or polished like furniture, but this procedure is seldom, if ever, resorted to; rather, the material is ordinarily left as nearly in its original state as possible. Some woods may be given a high smooth polish by simple rubbing; others, notably walnut, have a naturally attractive finish after being cut. When a smooth yet natural finish is desired, most hardwoods will take on a pleasing surface if rubbed or buffed with thin shavings of their own wood.

The following descriptions of various woods apply to dried and cured products obtained from dealers. The use of blocks or logs obtained directly from domestic or forest trees is not recommended unless one is experienced enough to be able to cure and season each variety in the correct manner, and to know what to expect in the way of internal defects and subsequent splitting, warping, etc. Nonartistic uses of some woods

are mentioned as indications of their properties and as guides to their appearance and identity.

AMERICAN WALNUT: This is the standard wood for carving; its texture, grain, uniformity, durability, and surface quality leave little to be desired. It is obtainable in logs 12 inches or more in diameter and in blocks cut to any desired size. The color, while it varies a little and may sometimes be streaky, is never far from the well-known dark or medium brown. There is some variety of graining; it runs from a straight grain to a rather curly effect.

FRUIT WOODS: Imported apple and pear wood and, to a lesser extent, plum wood are used. These are rather soft, but otherwise perfect materials for carving. Their colors range from a golden yellow to a yellowish red; their grain and texture are smooth and uniform, and they have great permanence and stability. Apple wood is normally obtainable in small blocks and in logs which run from 6 to 10 inches in diameter and about 3 feet in length. Pear may usually be bought only in lumber form, in planks 1 to 2¾ inches thick, 6 to 12 inches wide, and 6 to 8 feet long. Plum wood is less common. American fruit woods are not so frequently available, as they do not seem to be produced in commercial quantities and are not aged by the same careful treatments, some of which are rather complex.

CHERRY WOOD: This material resembles mahogany in its reddish color, and has a pronounced straight, uniform grain. It is obtainable in logs 12 inches or more in diameter and in planks 1 to 4 inches thick, 6 to 12 inches wide, and 8 feet or more in length.

MAHOGANY: The strength, durability, and closeness of grain of this red wood are well known. Some experience and skill are required to carve it, because many specimens will display splintery or softwood qualities. The best and hardest varieties come from Mexico, Cuba, and the Dominican Republic. African and Philippine mahoganies are valued for their interesting grain in veneer work, but they are rather soft woods, less desirable for carving. Mahogany is to be had in large sizes, the logs running up to 48 inches in diameter. Blocks cut to any size are usually available.

LIGNUM VITAE: This is the heaviest, hardest, and densest commercial wood. It is difficult to work, but is valued by a few sculptors for the rugged, stonelike effects that may be produced. The grain is uniform and fine, the surface takes a high natural polish, and the color varies from a light olive green to dark brown or nearly black. The wood is obtainable in logs from 3 to 24 inches in diameter and from 2 to 10 feet in length. It grows in the West Indies and in Nicaragua.

MAPLE AND BIRCH: These are hardwoods of very similar character; both

are to be had in several grains. The texture is hard; the color varies with different kinds, but is generally uniform throughout. Most varieties are rather too plain and uninteresting in grain to be popular for use in sculpture. Both woods are available in logs and blocks of various sizes.

EBONY, AFRICAN: This is a perfectly black, dense wood of close smooth grain, rather tough and difficult to work. The choicest grade is called Gaboon ebony, logs of which usually vary from 4 to 8 inches in diameter and from 3 to 4 feet in length. Rather small blocks are usually available.

Other Woods

The commercial demand for rare and fancy woods for furniture veneers has made a large number of woods (mostly of tropical origin) available on the market. Other imported woods are used for various mechanical and decorative purposes. Most of the materials in the following list have been selected as suitable for carving when special or unusual textural or color effects are desired; a few more common domestic varieties have also been included. Drawbacks to the use of some of the woods listed are their high cost, the fact that they are rare or not widely employed, the supply being therefore irregular, and the difficulty of obtaining them in large enough blocks.

The remarks on dimensions and availability are subject to continual revision, because trade conditions vary from time to time, especially with some of the rarer woods.

AMARANTH OR PURPLEHEART: a hardwood of rich purplish color, imported from the Guianas. It has a close, even texture, and usually an interesting varied grain. Generally available in planks 1 to 2 inches thick.

AVODIRE: an African hardwood of light color and fine, silky texture, used in large quantities for decorative work. Available in planks 1 and 2 inches thick.

AYOUS: a similar African wood, somewhat softer than avodire, with a pronounced striped grain. Comes in large logs.

BALAUSTRE: a South American wood of a brilliant orange color. The logs run 6 to 8 inches in diameter and 8 feet or more in length.

BALSA: a well-known softwood of cellular structure and extraordinary light weight, used for a number of mechanical purposes. Obtainable in blocks and planks.

BASSWOOD: a common American and Canadian softwood, easily worked. Has an even texture and a straight grain. Available in planks.

BOXWOOD: two varieties are on the market; the West Indian is more common but less esteemed than the Turkish. Boxwood is tough, hard, ex-

tremely fine-textured, of a pale creamy color, and rather difficult to work. Used for wood-block engraving. Comes in round and half-round logs 6 to 8 inches in diameter, and also in rather small blocks cut to dimension.

BUBINGA (BOIS DE ROSE D'AFRIQUE; FAUX BOIS DE ROSE DU CONGO): an African rosewood of hard texture, good durability, and red color. Comes in huge logs and is obtainable in planks and blocks cut to dimension.

BUTTERNUT: an American wood resembling walnut in every property but color; it is a yellowish gray. Available in planks.

CAMPHOR WOOD: a hardwood from Formosa, with a strong camphor odor. Available in planks 4 inches thick.

CANALETTA OR CANALETE: a hard, dense wood from the West Indies. Has black streaks with a metallic luster, and the heartwood is purplish lilac. Available in 1-inch planks.

CANARY (BRAZILIAN SATINWOOD): a light yellow wood with dark streaks. It has a hard texture. Available in 1- and 2-inch planks.

COCOBOLA: a very hard, dense, tough wood of a bright red color and variable grain, imported from Nicaragua and Panama. Familiar through its use in knife handles. Comes in logs 6 to 8 inches in diameter, and in planks ⅝ to 2 inches thick, 4 to 6 inches wide.

DEGAME (LEMONWOOD): a Cuban hardwood, yellowish to creamy white in color. Comes in logs 10 inches or more in diameter and 12 to 14 feet long.

EBONY, BROWN (PARTRIDGE, COFFEEWOOD, SOUTH AMERICAN GRENADILLA): comes in logs 12 inches or more in diameter and 6 feet or more in length.

EBONY, MACASSAR (COROMANDEL): from Indonesia. Comes in logs 12 inches or more in diameter, and 8 feet or more in length; also in planks. Both this and brown ebony find the same uses as African ebony, but are considered inferior substitutes.

HAREWOOD (ENGLISH SYCAMORE): a variety of maple with a fine, delicately figured grain. Comes in several colors—pink, silver gray, and weathered—all of which are probably artificial. Available only in planks 1 to 2 inches thick.

IMBUYA (EMBUYA): sometimes called Brazilian walnut on account of its brown color. Has a figured grain; comes in logs of various sizes suitable for carving and in planks 1 to 2 inches thick.

KINGWOOD: a South American hardwood of a rich violet-brown color, sometimes almost black, streaked with markings of light and dark golden yellow. Will polish to a bright luster. Available in logs 6 to 8 inches in diameter.

Koa: a very lightweight Hawaiian wood, hard, durable, and with a pleasing grain.

Koko (East Indian walnut): a hard, dense, close-grained dark brown wood from Burma. Available in logs and in planks from 1 to 2 inches thick.

Lacewood (silky oak): an Australian wood with an interesting straight oak-like grain. Comes in very large logs up to 40 inches in diameter, and in planks.

Lancewood: a rare wood similar to degame, but considered its superior in strength and resiliency.

Laurel, East Indian: a dark, reddish brown wood with a wavy grain, strong and elastic. Comes in logs up to 30 inches in diameter and 10 to 17 feet long.

Padouk (corail, vermilion): a deep red or bright red African hardwood. Comes in very large logs up to 36 inches in diameter, and in planks 1 to 2 inches thick.

Perola: a Brazilian hardwood of a pale rose color, with firm, close grain and even texture. Used for furniture and flooring. Available only in planks.

Primavera (white mahogany): a pale hardwood of variegated grain from the west coast of Central America. Available in large planks 1 to 4 inches thick, and in large logs.

Rosewood, Brazilian (jacaranda, palisander): valued as one of the finest of the rare woods. The rosewoods are all smooth, even textured, and easily finished. They come in huge logs, in planks, and in blocks of almost any desired size.

Rosewood, East Indian: striped grain; color varies from a straw-yellow to red or deep purple.

Rosewood, Honduras: the lightest-colored rosewood.

Satinwood, East Indian: long valued as one of the finest decorative woods. Has an excellent luster, a golden color, and a varied, figured grain. Comes in big logs and in planks.

Satinwood, San Domingan: considered the best variety of satinwood. Used by the early designers and makers of fine furniture. Obtainable in planks.

Snakewood (letterwood): comes from Surinam. Reddish brown with dark spots that sometimes resemble snake markings. It is a durable, dense hardwood and is familiar through its use in walking sticks, fine modeling tools, etc. Available only in logs, 5 to 8 inches in diameter.

Teakwood: several varieties of teak—Java, Rangoon, Malabar, etc.— are obtainable in a variety of colors, but golden brown is most common.

Sometimes teakwood has a wavy or streaky grain. Besides being adaptable for many mechanical uses because of its great strength, durability, and resistance to severe conditions, it is also well suited for solid carving. Available in logs, in blocks cut to dimension, and in planks.

TIGERWOOD (AFRICAN WALNUT): a light golden-brown wood free from defects. Has a variable figured grain and presents a glossy surface without polishing. Comes in large logs, up to 36 inches in diameter, and is available in planks.

VERMILION (EAST INDIAN OR BURMA): dark vermilion to light pinkish in color, with a varied mottled grain. Practically the same wood as African padouk and comes in the same sizes.

ZEBRAWOOD (ZINGANA, ZEBRANO): an African wood with a more or less evenly striped grain. Comes in huge logs sometimes over 3 feet in diameter, and also in 1- and 2-inch planks.

Weights of Various Woods

No table of the densities of woods can be precisely accurate because of the number of variable factors involved. The following table has been compiled from several reliable sources and checked with actual dealers' supplies. Blocks of wood for carving are sometimes sold by the pound.

The figures represent pounds per cubic foot, in normal air-dried condition. Fresh or green wood will vary appreciably.

Wood	lb	Wood	lb
Aspen	25	Maple	35
Balsa	7.5	Oak	42
Basswood	25	Padouk	70
Beech	41	Pear	47
Birch	42	Plum	51
Boxwood, Turkish	63	Pine (average)	35
Boxwood, West Indian	53	Primavera	36
Butternut	25	Purpleheart	55
Cherry	40	Redwood	27
Chestnut	39	Rosewood, Brazilian	50
Cocobola	75	Rosewood, Honduras	71
Ebony, Indian	72	Satinwood	64
Ebony, East African	62	Snakewood	69
Lignum Vitae	84	Teakwood	40
Mahogany, African	34	Walnut	37
Mahogany, West Indian	24	Zebrawood	64

SOME NOTES ON PHOTOGRAPHY

More and more the camera has become a legitimate part of the artist's equipment. It is used in two primary ways: to photograph works of art for presentation or record-keeping, and to augment sketches and drawings made in the field for work to be completed in the studio. In both cases, one must have a knowledge of photography and some general experience.

To make successful slides of artwork, light reflections must be eliminated. The major method of control is to have two light bulbs in reflectors, preferably mounted on regular lightweight photo-light stands or clipped to easels or other convenient objects. In most cases, placing the lights at seventy-five degree angles, equidistant on either side of the picture, will avoid reflections. If there should be any, however, move both lights to angles of still greater degree or farther apart. Another aid is to cover the reflectors with special elastic plastic covers made expressly for the purpose of eliminating reflection. These are sold at most photo shops. The light bulbs or photo-lamps should be chosen according to the type of film used. For example, Kodak type A, for the professional, is in wide use for this purpose, using two 75-watt lamps. Additional information on other films can usually be obtained from a reliable photo dealer. As far as the type of camera is concerned, a 35-millimeter single-lens reflex (SLR) camera is entirely adequate for slide work as well as for taking snapshots in the field.

The second use of photography—as an adjunct to or substitute for sketches and as memoranda for details—is an entirely legitimate procedure not to be confused with basing a picture on a photograph or copying a photograph onto canvas or any other means of duplicating it in paint. Instead such photographs are used to refresh the memory of the artist. They are also capable of furnishing details that a sketch would frequently overlook both in nature and in buildings and other works of man. In addition to the 35-millimeter SLR camera and its 50-millimeter normal lens, many artists find a 35-millimeter wide-angle lens invaluable as well as a 135-millimeter telephoto lens. The next larger camera, one which produces 2¼-by-2¼-inch negatives, is also useful, especially for good black and white prints. Whatever choice is made, none of this equipment will be too burdensome in the field. Anything larger, however, will not only be awkward to carry about but actually would seem to indicate that the main interest is photography per se and not painting.

In the studio, the slide viewer is an additional piece of equipment that is useful when slides are made to supplement sketches. There are several models available that produce healthy-sized, bright enlargements. (See *Sources of Materials,* page 648.)

16. Appendix

THE USE OF FORMULAS

In using formulas, a certain understanding of the subject is necessary; while in general they are to be accurately followed, especially where they are accompanied by minute instructions, they sometimes serve best as hints or starting points for independent development of recipes to meet one's own needs and requirements. This is more true of the older or outmoded formulas; the modern ones are usually in accordance with the average requirements of the times.

Very old recipes must be interpreted with care. Our nomenclature, the quality of various present-day grades, and the modern understanding of basic principles underlying technical practices are often at variance with those of former times. Many untried and often-copied recipes have been reprinted in various recipe books; some of these are or have become unworkable, while some have been taken from the specifications of patents that are sometimes incomplete or not entirely practical.

Often procedures that originally had some reasonable justification have been blindly perpetuated to the point where they have lost all meaning. For instance, I have encountered practical varnish makers who, having learned the trade as apprentices to men of older generations, insisted upon throwing a slice of bread or a handful of feathers into each batch, and according to their notions no varnish could be good without

these additions—though they could not explain why. This is merely the survival of a sensible procedure of an earlier day, when thermometers were not in general use in varnish kettles; an expert varnish cooker could judge and control the heat of the oil or varnish by observing the charring of such materials, which were eventually strained out and which had nothing to do with the quality of the product.

Formulation. Formulation involves combining materials in definite proportions and manner so as to utilize the desirable qualities of each, to overcome or neutralize undesirable qualities, and to create a product whose properties will best meet the requirements for which it is intended. It is one of the most important applications of the knowledge of the properties of materials. General rules governing the behavior of any class of materials cannot always be applied to every member of the class; the properties of individual substances and their alteration when mixed with other materials must be learned from experience as well as from a study of the basic principles governing chemical and physical behavior.

Some materials may be added to a mixture in undefined amounts, whereas other combinations of materials require exact measurements, and often the manner or sequence of the addition is important. In some cases there will be a little leeway as to accuracy of measurements, and published recipes should always indicate this; most of the successful standard formulas are the results of careful development and are to be followed with accuracy.

When a recipe calls for "3 to 5 parts" of a material, this should not be taken to mean that it does not matter what quantity between these limits one throws in; rather, it means that according to the special properties required, an individual will find somewhere within this range the amount needed to give him his best results. If a writer states that a little turpentine added to a paint will improve its working properties, he expects the reader to have sufficient experience with the materials to add an appropriate amount, and to realize that too little will not accomplish the purpose and that too much may overdilute the mixture and weaken the resulting film. On the other hand, if a number of various ingredients are listed in exact amounts with explicit instructions for their combination, the assumption on the part of the reader should be that here is a recipe that has been worked out to give definite results, and that it must be followed accurately. Whether or not it can be adjusted or altered to fit different circumstances or special requirements in individual cases can be determined by trials.

In following out the directions of a technical recipe one must have sufficient knowledge of the subject and sufficient experience with the ad-

justment of formulas to make them work successfully. The writer of a cookbook supposes that the reader is a good enough cook to be able to interpret brief directions and a list of ingredients and their amounts without requiring an appendix to each recipe instructing him in the rudiments of cookery. When a recipe fails to give the promised result, the experienced worker can usually tell where the fault lies and correct it in a second attempt. The tyro, however, is likely, under the same circumstances, to condemn the recipe as no good. Recipe books such as those listed on page 688 under "Formulas" may disappoint those who expect invariably perfect results at first attempts, particularly in the case of straight recipes without some text to supply an explanatory guide.

In any experimental or testing work it is truly necessary to preserve accurate detailed records of all work done, including dates, sources of materials, and all other relevant data. Materials, whether put into use or put away to age, should be well identified either by being labeled with detailed descriptions or by serial numbers referring to descriptions in a notebook. Painters who have spent much time in experimental work on materials often find that after a few months or years the results of careful and interesting work are useless because of the absence of records.

The conversion tables on pages 617–19 may be used to change figures from one system of weights and measures to another; where the formula is written in pounds or gallons, quarts, and pints, and it is desired to reduce these to ounces in order to make small lots (especially when multiple experimental batches are to be made), the pound figure can be converted to ounces by multiplying by 16, the gallons figure to fluid ounces by multiplying by 128, the quarts figure, by 32, and the pints, by 16. A recipe calling for 5 pounds of a dry material to 1 gallon of a liquid would then read 80 ounces to 128 fluid ounces; to make about 4 fluid ounces, which is a convenient small batch, find the figure which will divide all the amounts into conveniently measurable figures near that amount; in this case it would be 32, which gives a resulting recipe of 2½ ounces to 4 fluid ounces. To alter the strength of a solution of known percentage, the calculations noted on pages 621–22 may sometimes be used.

The more modern recipe books of miscellaneous technical formulas are sometimes valuable; usually they are more helpful as sources of hints for experimentation than as sources of ready-made, usable formulas. Some of the best of these compilations of miscellaneous technical recipes are listed in the bibliography.[199, 200, 201]

Some recipes call for the melting of inflammable materials, and when these are followed, precautions should be taken to prevent accidental ignition; also provisions for the control of a fire must be considered in advance. Melt as small a batch as is convenient, keep the space around the

stove clean and clear, and use a metal or asbestos plate between the vessel and the gas flame or electric coil. Sand or a Pyrene extinguisher will put out small fires; water is likely to make grease or oil fires spread, although enough water in one good dousing will put out any fire except burning benzine or other similar volatile liquids. A stirring rod is likely to make a small can tip over. A flat cover larger in diameter than the can or pot will smother a small fire. Never heat mixtures containing inflammable volatile solvents over a direct flame. When a molten wax or resin is thinned with volatile solvent, a large percentage of the first addition passes off in the form of vapor; therefore, even in the case of the less inflammable solvents such as turpentine or kerosene, all such thinning must be done away from the stove or other flame, and with good ventilation. All waxes may be melted in a water bath, but mixtures with resins will ordinarily require direct heat.

Mixing of Smooth Pastes. Various powders and liquids require different methods of mixing to produce pastes free from lumps; some recipes indicate the correct procedure. In the case of the usual paint the vehicle is poured gradually into the pigment in a container, with continual stirring, to produce a stiff, smooth paste, the last part of the liquid being added after this stage has been reached. When small amounts are made on the slab with palette knife and muller, or with a mortar and pestle, the same procedure is followed: the paste is kept stiff until free from lumps, after which it is thinned to the final consistency. Gesso is mixed in the same way except that such a high degree of smoothness is not required; it is usually strained or squeezed through cheesecloth, which disperses minor lumps. Materials such as flour, starch, casein, etc., are mixed in the reverse manner, because they are acted upon by the water, and some solution or swelling to form a colloidal mass is involved. Starch or flour paste is commonly mixed by sifting the dry powder into hot water gradually in three or four successive portions, stirring continuously and mixing to a uniformly well-suspended condition before adding the next portion. Materials that tend to repel wetting are made into a stiff paste by continued stirring with a round rod in a container, or by mulling.

Pharmaceutical Names. The pharmacists have a terminology and system of weights and measures of their own. The names of various chemicals and natural products as established by custom and usage in the technical arts and in manufacturing are often at variance with those officially established in pharmacy; this is sometimes important to remember when purchases are to be made from a retail druggist or even from some wholesalers whose trade is principally with pharmacists.

Apothecaries' measures and weights (page 616) are used for prescriptions, and more often than not antiquated names—obsolete in common usage, mostly Latin or Latinized—are used to describe materials. There is, however, a good reason for this. Many of the products are complex mixtures designed for medicinal use; others are simple substances but must be of a certain uniform quality or potency required in medicine; through the use of such specific terms for these materials, the druggist knows exactly the proportions, quality, and strength of the product designated by the physician.

WEIGHTS AND MEASURES

If one does a great deal of work on formulas and homemade products, it is advisable to have a scale or balance capable of weighing out small amounts of dry materials with a fair degree of accuracy. Small balances, adequate for most purposes, can be bought at moderate cost; fine ones of high accuracy are expensive. Second-hand scales originally intended for various uses can sometimes be picked up.

Persons who have but occasional use for weights may have portions of materials weighed out at a shop; many users of homemade products prefer to measure as many of their materials as possible by volume. Because materials vary as to size of lumps or particles, etc., and because some formulas call for extreme accuracy or for very small portions, this is not always feasible. The recipes quoted in this book mention volume measurements whenever they may be used. Measuring glasses of the following sizes will be found useful:

1 quart, graduated in ounces.
1 pint, graduated in ounces.
2 ounce, bell- or cone-shaped, graduated in drams (⅛ fluid ounce). Also obtainable with additional scale in milliliters (cubic centimeters).
Cylinder graduated in milliliters (cc), capacity 25, 50, 100; or any larger size, depending upon requirements.
For very small, accurate amounts of liquids, especially in small-scale experimental batches, a Mohr's pipette, 10 ml capacity, graduated in tenths. A large choice of measuring glasses will be found at laboratory supply houses.

A handy means for measuring approximate small volumes and proportions of pigments, pastes, and other dry and fluid materials is a set of aluminum kitchen measuring spoons: tablespoon, teaspoon, half and quarter teaspoons (3 teaspoons = 1 tablespoon; 25 quarter teaspoons = 1 fluid ounce; 1 quarter teaspoon = 1 percent of 4 fluid ounces). When

using these for dry powdered material, one should fill them without packing or tamping the powder in, then level if off with a palette knife. These measurements are occasionally referred to in the recipes. Throughout this book the term "fluid ounce" or "ounce by volume" have been used to distinguish the ounce by volume from the avoirdupois ounce, which is simply called ounce. The list on page 620 showing fraction and decimal equivalents may be used to convert a decimal number in a weight or measure to its approximate fraction.

United States Systems

LINEAR

Inches (ins. or ")	=	Feet (ft. or ')	=	Yards (yds.)
12		1		
36		3		1
198		16½		5½

AREA

Square inches	=	Square feet	=	Square yards
144		1		
1296		9		1

VOLUME

1728 cubic inches	=	1 cubic yard
27 cubic feet	=	1 cubic yard
1 cubic foot	=	7.48 gallons

A cubic foot of water at 62° F weighs 62.2786 pounds.

LIQUID MEASURE (CAPACITY)

Ounces (fl. oz.)	=	Gils	=	Pints (pts.)	=	Quarts (qts.)	=	Gallons (gals.)	=	Cubic inches (cu. ins.)
4		1								
16		4		1						28.90
32		8		2		1		.		57.75
128		32		8		4		1		231.00

1 British Imperial gallon = 277.3 cubic inches = 1.2 U.S. gallons.
1 gallon of water at normal temperature weighs 8⅓ pounds; a pint weighs abo t a pound.

APOTHECARIES' MEASURE

Minims	=	Fluid drams	=	Fluid ounces	=	Pints	=	Gallons
()		(f³)		(f³)		(O)		(G)
60		1						
480		8		1				
7680		128		16		1		
				128		8		1

The ounce, pint, and gallon are the same as ordinary liquid measure.

WEIGHT (MASS)

The grain is the same in the three systems that follow.

Avoirdupois (Commercial or Customary System)

Grains	=	Drams	=	Ounces	=	Pounds
(gr.)		(dr.)		(oz.)		(lbs.)
27.34		1				
437.50		16		1		
7000.00		256		16		1

TROY WEIGHT

(Used by jewelers and refiners of precious metals)

Grains	=	Pennyweight	=	Troy ounces	=	Troy pounds
(gr.)		(dwt.)				
24		1				
480		20		1		
5760		240		12		1

1 lb. troy = .823 lb. avoirdupois
1 carat = 3.2 grains

APOTHECARIES' WEIGHT

(Used by pharmacists, physicians, and in some special technical processes)

Grains	=	Scruples	=	Drams	=	Ounces	=	Pounds
(gr.)		Э		ʒ		ʒ		℔
20		1						
60		3		1				
480		24		8		1		
5760		288		96		12		1

Metric System

Because our own system is so strongly rooted in our culture, the Americans and British have long resisted efforts to change to the metric

system, and have only recently adopted it, although it is still not in common usage here.



LENGTH

1 millimeter	=	0.001 meter (mm)
1 centimeter	=	0.01 meter (cm)
1 decimeter	=	0.1 meter
1 meter		
1 dekameter	=	10 meters
1 hectometer	=	100 meters

WEIGHT

1 milligram	=	0.001 gm
1 centigram	=	0.01 gm
1 decigram	=	0.1 gm
1 gram (gm)		
1 dekagram	=	10 gm
1 hectogram	=	100 gm
1 kilogram	=	1000 gm



VOLUME (CAPACITY)

1 milliliter = 0.001 liter = 1 cubic centimeter (ml or cc)
1 centiliter = 0.01 liter
1 deciliter = 0.1 liter
1 liter (= 1 cubic decimeter = 1000 ml)
1 dekaliter = 10 liters

Conversion Factors

WEIGHT

To convert	*to*	*multiply by*
pounds (avoirdupois)	grams	453.6
	kilograms	.45
	troy pounds	1.22
grams	grains	15.43
	drams	.56
	troy drams	.26
grams	ounces	.0353
	pounds	.0022
grains	grams	.0648
	drams	.0357
	ounces	.00229
	pounds	$\frac{1}{7000}$
ounces (avoirdupois)	grams	28.35
	grains	437.5
	pounds	$\frac{1}{16}$
	troy (or apothecaries') ounces	.91
	troy pounds	.076
	pennyweight	18.23

To convert	*to*	*multiply by*
	troy (or apothecaries') drams	7.29
troy pounds	pounds (avoirdupois)	.823
	kilograms	.373
	ounces (avoirdupois)	13.17
troy (or apothecaries') ounces	ounces	1.1
	drams	17.5
	pounds	.069
	pounds (troy)	$\frac{1}{12}$
kilograms	drams	564.38
	grains	15432.4
	ounces	35.27
	ounces (troy)	32.15
	pounds	2.3
	pounds (troy)	2.7

FLUID MEASURE (CAPACITY)

fluid ounces (U.S. and apothecaries')	milliliters	29.57
	fluid drams	8
	liters	.03
	cubic inches	1.8
	gallons	$\frac{1}{128}$
liters	pints	2.11
	quarts	1.06
	cubic inches	61.025
liters	fluid drams	270.5
	gallons, U.S.	.26
	gallons, Imperial	.22
	fluid ounces	33.81
gallons	cubic feet	1.34
	gallons, Imperial	.833
	liters	3.785
	ounces	128
	milliliters	3785.4
fluid drams	milliliters	3.7
	fluid ounces	.125
	cubic inches	.2256
	pints	.0078
	quarts	.004

To convert	to	multiply by
milliliters (cubic centimeters)	fluid drams	.27
	minims	16.23
	fluid ounces	.0338
	cubic inches	.061
	pints	.0021
	quarts	.001
pints	milliliters	473.179
	cubic feet	.017
	cubic inches	28.9
	gallons	.125
	liters	.473
	minims	7680
quarts	milliliters	946.36
	cubic feet	.033
	cubic inches	57.75
	fluid drams	256
	gallons	.25
	liters	.946

LENGTH

inches	millimeters	25.4
	centimeters	2.54
	meters	.0254
meters	inches	39.37
	feet	3.28
	yards	1.09
	centimeters	100
centimeters	inches	.3937
	feet	.0328
millimeters	inches	.03937
	feet	.00328
feet	centimeters	30.48
	meters	.305

Obsolete: 1 ell = 45 inches or 114.30 cm.; 1 cubit = 18 inches or 45.72 cm.

THERMOMETER SCALES

The centigrade thermometer has zero (0 degrees) as the freezing point of water and 100 degrees as the boiling point; the Fahrenheit scale has the freezing point at 32 degrees and the boiling point at 212 degrees.

To convert centigrade degrees to Fahrenheit multiply by 9, divide by 5, and add 32. To convert Fahrenheit to centigrade, subtract 32, multiply by 5, and divide by 9.

EQUIVALENTS OF FRACTIONS AND DECIMALS

.0156	$1/64$.3125	$5/16$
.0312	$1/32$.3333	$1/3$
.0500	$1/20$.3750	$3/8$
.0555	$1/18$.4375	$7/16$
.0625	$1/16$.5000	$1/2$
.0714	$1/14$.5625	$9/16$
.0833	$1/12$.6250	$5/8$
.1000	$1/10$.6666	$2/3$
.1111	$1/9$.6875	$11/16$
.1250	$1/8$.7500	$3/4$
.1666	$1/6$.8125	$13/16$
.1875	$3/16$.8750	$7/8$
.2000	$1/5$.9375	$15/16$
.2500	$1/4$		

APPROXIMATE EQUIVALENT VOLUMES OF WHITE LEAD IN OIL

Weight	Volume
100 pounds	3¼ gallons
50 pounds	1⅝ gallons
25 pounds	6½ pints
12½ pounds	3¼ pints
5 pounds	1¼ pints
1 pound	1 gill

DENSITY—SPECIFIC GRAVITY

The *density* of a substance is the relation between its weight and volume—for example, the number of pounds to a gallon. This is the usual standard in industrial or technical work; in science the gram and milliliter are used, and the density of a substance is expressed in grams per milliliter. One milliliter of pure water weighs one gram.

The *specific gravity* of a liquid or solid is its weight divided by the weight of an equal volume of water; thus the specific gravity of linseed oil, which is lighter than water, will run around 0.933, and the specific gravity of carbon tetrachloride, which is heavier than water, is 1.59. The specific gravity of distilled water is 1 at 4° C.

Hydrometry. A simple and easy method for determining the specific gravity of a liquid is to use a hydrometer, which is a slender sealed glass tube bearing graduated marks and weighted at the bottom. The liquid, at normal temperature (70° F) or at any special temperature to which the instrument may have been calibrated, is poured into a glass cylinder of convenient size, and the hydrometer is carefully immersed in the liquid and allowed to float in it freely, whereupon the specific gravity is read directly from the mark that coincides with the surface of the liquid when the hydrometer is at rest and floating clear of the walls of the cylinder. Measurements of extreme accuracy and comparisons of slight variations in specific gravities can be obtained only by experienced technicians and by the use of more precise apparatus. For accuracy and convenience, hydrometers are usually made with a small range, suitable for use in one type of solution or liquid.

In general technical practice, it is customary to use hydrometers marked with the Baumé scale instead of the less convenient specific-gravity scale; there are two Baumé scales, one for liquids lighter than water, and one for liquids heavier. If it is necessary to convert Baumé figures to specific-gravity figures and vice versa, a conversion table should be referred to. These are widely available and are published in all of the chemical handbooks and many technical works.

CALCULATIONS FOR ALTERING THE STRENGTH OF SOLUTIONS*

The following methods are universally accurate by weight; when amounts by volume are taken (especially when the solutions are weak or when there is not too great a difference between strengths), the results will be sufficiently accurate for most technical purposes. When absolute accuracy is necessary in volumetric work, as in carefully controlled laboratory

* Adapted from R. Harman Ashley, *Chemical Compositions* (New York: Van Nostrand, 1927). This book contains a complete account of calculations of this kind. Other simplified methods for altering the percentage composition of solutions and dry mixtures can be found in Olsen[204] under "Rectangular Method for the Dilution and Concentration of Liquids and Mixtures," and in *Stevens' Arithmetic of Pharmacy* by C. H. Stocking and J. L. Powers (New York: Van Nostrand, 1937), under "Alligation."

procedure, the correct volumes are calculated by dividing the weight amounts by the specific gravity of the solutions $= \left(\dfrac{\text{mass}}{\text{sp. gr.}} \right)$.

1. To dilute a solution of known strength to any required amount of lower-percentage concentration, divide the lower-percentage number by the higher, and multiply the quotient by the amount of weaker solution desired. The result will be the amount of original solution that must be mixed with sufficient water (or other solvent) to produce the amount of weaker solution desired.

For example, to make 16 ounces of a 4-percent solution of formaldehyde from the 40-percent solution in which it is commonly sold, divide 4 by 40, which will give 0.1; multiply this by 16. The result, 1.6 ounces, is the amount of 40-percent formaldehyde solution to be mixed with enough water (14.4 fluid ounces in this case) to produce 16 ounces of 4-percent solution.

2. To dilute a given amount of solution of known strength to any weaker concentration by adding water to it, subtract the lower-percentage number from the higher, divide the difference by the lower number, and multiply the quotient by the amount of liquid to be diluted. The result will be the amount of water required to produce the weaker concentration when mixed with the original amount of the stronger.

For example, if one has 10 fluid ounces of 40-percent formaldehyde to be diluted to a 4-percent solution: $40 - 4 = 36$; $36 \div 4 = 9$; $9 \times 10 = 90$, which is the number of fluid ounces of water to add to the 10 fluid ounces of formaldehyde to produce the 4-percent solution. In this case, the ratio happens to be in round numbers, 9 to 1, and any convenient amount could be made by using these proportions.

OIL INDEX OF PIGMENTS

(The following table gives information with which the list on pages 133–34 was computed.)

Pigment	Origin	Weight of pigment (pounds per solid gallon)	Bulk of 100 pounds of pigment (gallons)	Oil absorption, by spatula method		
				Pounds of oil per 100 pounds of pigment	Gallons of oil per 100 pounds of pigment	Gallons of oil per 100 gallons of pigment
Aluminum stearate	Domestic	8	12.5	28	3.6	29
Aluminum powder (pure aluminum, treated)	Domestic	21	4.8	16	2.1	44
Emerald green	Domestic	28	3.6	13	1.7	47
Venetian red (40% iron oxide)	Domestic	29	3.5	15	1.9	54
White lead (basic carbonate, Dutch process)	Domestic	57	1.8	8	1.0	56
Spanish red oxide (native, 85% iron oxide)	Spain	37	2.7	13	1.7	63
Chromium oxide green	Domestic	43	2.3	12	1.5	64
* Cobalt green	Germany	44	2.3	12	1.5	65
Cobalt violet	Domestic	31	3.2	16	2.1	65
* Cobalt violet	Germany	29	3.5	18	2.3	66
Zinc oxide (French process, green seal)	Domestic	47	2.1	12	1.5	71
Zinc yellow	Domestic	28	3.6	20	2.6	72
French ochre (native, 22% iron oxide)	France	24	4.2	25	3.2	76

* Data based on previously unpublished figures.

OIL INDEX OF PIGMENTS (continued)

Pigment	Origin	Weight of pigment (pounds per solid gallon)	Bulk of 100 pounds of pigment (gallons)	Oil absorption, by spatula method		
				Pounds of oil per 100 pounds of pigment	Gallons of oil per 100 pounds of pigment	Gallons of oil per 100 gallons of pigment
Cadmium-barium yellow, light (CdS + BaSO$_4$)	Domestic	35	2.9	17	2.2	76
Cadmium-barium yellow, golden (CdS + BaSO$_4$)	Domestic	35	2.9	17	2.2	76
Cadmium-barium red (CdS + CdSe + BaSO$_4$)	Domestic	36	2.8	17	2.2	79
Cadmium-barium maroon (CdS + CdSe + BaSO$_4$)	Domestic	36	2.8	17	2.2	79
* Naples yellow	Germany	55	1.8	12	1.5	82
Indian red (98% iron oxide)	Domestic	43	2.3	15	1.9	83
Ultramarine blue	Domestic	19	5.3	35	4.5	85
Titanium dioxide (low absorption)	Domestic	33	3.0	20	2.6	87
Prussian blue (C.P. Milori blue)	Domestic	15	6.7	50	6.4	96
Cadmium-barium orange (CdS + BaSO$_4$)	Domestic	35	2.9	22	2.8	97
Alizarin red	Domestic	14	7.1	55	7.1	100

* Data based on previously unpublished figures.

OIL INDEX OF PIGMENTS (continued)

Pigment	Origin	Weight of pigment (pounds per solid gallon)	Bulk of 100 pounds of pigment (gallons)	Oil absorption, by spatula method		
				Pounds of oil per 100 pounds of pigment	Gallons of oil per 100 pounds of pigment	Gallons of oil per 100 gallons of pigment
Ivory black (12% carbon)	Domestic	22	4.5	35	4.5	101
Raw Turkey umber (native, 46% iron oxide)	Cyprus	26	3.8	30	3.9	103
* Cerulean blue	Germany	40	2.5	22	2.8	112
Raw sienna (native, 73% iron oxide)	Italy	26	3.8	35	4.5	118
Yellow iron oxide (95% Fe_2O_2)	Domestic	32	3.1	29	3.7	119
Black iron oxide (98% oxides)	Domestic	40	2.5	25	3.2	128
Burnt sienna (native, 77% iron oxide)	Italy	29	3.5	35	4.5	129
Burnt Turkey umber (native, 53% iron oxide)	Cyprus	30	3.3	35	4.5	136
* Cobalt yellow	England	43	2.3	31	4.0	174
Cobalt blue	Domestic	32	3.1	43	5.6	180
Lampblack (99% carbon)	Domestic	15	6.7	85–100	11–13	164–194
Carbon black (99% carbon)	Domestic	15	6.7	85–150	11–19	164–284
Viridian	Domestic	30	3.3	60	7.7	233
* Cobalt blue	Germany	30	3.3	60	8.9	270

* Data based on previously unpublished figures.

GLOSSARY

This lists includes some of the words and terms used in art and its technology; others will be found in the index.

AGGREGATE. The coarse or inert ingredients that are mixed with cement in the making of concrete.

ARRICCIO. In fresco practice, the plaster coat that underlies the final painting coat; traditionally composed of lime and sand. In English, brown coat.

BASE. The inert pigment used in the manufacture of lakes. In chemistry, an alkaline or alkaline-forming substance.

BLOOM. A foggy, whitish (or blue-white), dull surface effect that forms on varnished pictures or other varnished objects.

BLUSH. Bloom. The term is usually applied to bloom on cellulose lacquers, and more often implies a basic or internal defect than a surface condition.

CAMAÏEU. A technique of painting in monochrome, using two or three tints of the same pigment without regard to local or realistic color.

CHIAROSCURO. A technique of pictorial representation wherein objects are brought out strongly by the use of black or any dark color and white, generally in bold contrast; the entire picture is usually dark, relieved by white accents. Also an element of this effect in any picture.

CHROMATIC PIGMENTS. Distinguished from black, white, or gray, which are referred to as achromatic pigments.

CISSING. Running streaks and bare spots in color that should lie smoothly, usually due to poor wetting of the surface.

COVERING POWER. The extent of the area over which a given amount of liquid paint or varnish will spread to give a satisfactory coating when it is applied in a normal layer, ordinarily expressed in square feet per gallon. Sometimes confused with hiding power.

C.P. Chemically pure, or a grade of material as free as possible from all traces of impurities. Sometimes applied to commercial pigments to designate a grade free from extender or added inert pigment.

DICHROISM. The property of a substance that exhibits two different color effects when it is viewed under two different circumstances, or sets of circumstances. An example is alizarin crimson, which displays a deep maroon color when it is painted opaquely and a transparent ruby-red color when spaced out in a thin layer and viewed by transmitted light. Another example is the so-called suede effect discussed on page 121. See Metamerism.

DISTEMPER. A term employed in Great Britain to designate aqueous paints made with a simple glue-size or casein binder, such as are used for flat indoor wall painting and decoration. Among the American products that may be classified under this heading are calcimine, cold-water paints, and showcard and poster colors. The term is rather more descriptive of bulk or house paints than of artists' paints. The word "distemper" is not in com-

mon use in the United States. Confusion sometimes arises when its French equivalent *détrempe* is carelessly translated, because in France this term has two meanings, both distemper and tempera. Italian art terms are not so freely adopted into French in their original forms as they are into English, and in French one sometimes finds tempera treated as a foreign word, whereas in English and German it is part of the language.

DOCTOR. A scraper or knife edge used to scrape off paste paint from a surface.

EASEL PAINTING. Creative painting executed in one of the standard techniques, such as oils, watercolors, tempera, gouache, or pastel; most frequently intended to be framed and hung on a wall. The term distinguishes this major fine-arts form from other fields of painting such as mural painting, illustration, and decorative or applied arts. It also implies an adherence to professional and technical standards of permanence, or the ability to survive indefinitely when preserved indoors under the conditions normally afforded works of art.

EMBU (French). In an oil painting, a dull spot in an otherwise glossy surface, caused by a sinking-in of the oil color. Term not in general use.

ENAMEL. (1) A vitreous glaze or porcelain containing pigments, applied to metal or pottery objects and fused to produce a smooth, hard, durable surface by heating in a kiln or furnace.

(2) An object so decorated.

(3) A liquid paint that dries with an extremely high gloss, its effect approaching that of a vitreous enamel.

FILLER. See Inert pigment.

FILM FORMER. Any fluid material or ingredient that, when applied over a surface, will set to a solid continuous layer of film and perform the functions of a paint vehicle, medium, or varnish.

FIXATIVE. A dilute resin solution applied by a sprayer or atomizer to bind the loose particles of charcoal, pastel, or crayon pictures and prevent them from coming off. A fixative differs from a varnish in that it serves only one purpose, that of binding the particles in a weak surface manner; it does not lock them into an impervious film. To accomplish this function, it would have to be so concentrated that it would have an undesirable optical effect on the picture. (See pages 307–309.)

FLAT COLOR. An area of unbroken single hue and value.

FROTTIS. French term for a glaze.

GANOSIS. The toning or dulling of stone sculpture—for instance, by the application of colors mixed with wax.

GESSO. A solid coating made with a purely aqueous binder, either glue, casein, or gelatin solution. It is usually pure white in color, and the dry ingredient is either whiting, chalk, or slaked plaster of Paris, sometimes with a small amount of zinc or titanium white to enhance whiteness or opacity. Gesso is used as a painting ground by applying it in liquid form with a brush, or as a putty and modeling material, in which case it is made into a stiffer, plas-

tic paste. The word, an Italian form of the Latin *gypsum*, was used by Renaissance craftsmen. See pages 257 ff. and the important warning on page 404.

GRISAILLE. A technique of monochrome painting in two or three shades of gray, as in the imitation of bas-relief. Also a rough grouping into one class of all methods of painting that differ from a simple direct technique; more specifically, the method of painting in full modeling in black and white or other simple contrasting tones, and applying transparent color over this in thin layers or glazes. Also the name of a pigment used in glass painting.

HALF CHALK (HALF OIL) GROUNDS. Emulsion grounds. Grounds made of chalk and glue are universally known as gesso grounds in America and England; I should interpret the German term *Halbkreidegrund* to mean semigesso ground.

HIDING POWER. Degree of opacity in a paint or pigment; ability to mask or conceal an underpainting. Covering power is sometimes confused with it.

HUE. The simple color of a substance, for example, red, orange, bluish green.

HYDROFUGE. A means of removing moisture; a substance or apparatus so used.

HYDROPHILE. A substance that has an affinity for or will attract water.

HYDROPHOBE. A substance that repels water.

HYGROSCOPIC. Having the property of absorbing and holding moisture when exposed to the air.

IMPASTO. Thick, heavy painting; usually oil painting composed of pronounced bristle-brush strokes or palette-knife applications, which stand out in relief and are plainly apparent to the spectator.

IMPRIMATURA. A veil or thin glaze of color applied to a ground as a preliminary coating. Term not in very wide use.

INERT PIGMENT. A finely powdered substance which when mixed with a colored pigment causes no appreciable changes in its shade or hue. Although inert pigments are used largely as adulterants or cheapeners, many of them are also employed to impart valuable or desirable physical or structural properties to paints and other mixtures. (See pages 97–98.)

INTENSITY. Degree of chromatic reflections; the less white reflected from a surface, the more intense the chromatic or the black effect will be.

INTONACO. The final layer of lime plaster upon which a fresco is painted. This is the only one of the Italian terms for the specific layers of fresco plaster that is in wide use.

JAPAN. A loose term applied to two classes of varnishes: (1) Varnishes that are mixed with paints in order to impart a gloss. These are generally composed of resins and solvents with little if any oil, and are too brittle to be used alone. (2) Decorative japans. These are cheap enamels, almost always black, and almost always containing asphaltum. Used to decorate articles made of sheet iron and other metals. Some japans dry in the air and others require baking.

JAPAN DRIERS. A confusion of terms. Sometimes the materials referred to are varnish paints containing added liquid driers; more often they are resinate driers in solution having no properties in common with the japans described above. Japan colors sold in tubes and cans are ground in a quick-drying, resinous varnish that contains little or no oil; they are intended for tinting and underpainting purposes in industrial work, where a high oil content would be undesirable, and for quick-drying sign painting and similar decorative work that is to be protected with a layer of clear, durable varnish. They are not to be used in permanent painting.

LIGHTFAST. Resisting fading on long exposure to sunlight. When the term is applied to an artist's pigment it means absolute permanence; when it is used in connection with an industrial pigment or dye it indicates that the color will resist fading for a satisfactory length of time depending on the purpose for which it is employed.

LIPO. Prefex signifying oil or fat. Lipophile: a substance with the property of attracting fats or oils, or selective affinity for oil over water. Lipoid: a material belonging to a specific group of chemical compounds that resemble fats or waxes in many of their properties.

LOCAL COLOR. The true or actual color of an object as distinguished from the color effect it produces when viewed as part of a whole composition or when influenced by light or atmospheric conditions in nature or, in a painting, by the technique and intentions of the painter.

MAROUFLAGE. Process of affixing canvas to a wall by means of a cement, traditionally white lead ground in oil. Term not in common use in America.

MEDIUM. (1) The liquid constituent of a paint, in which the pigment is suspended, or a liquid with which a paint may be diluted without decrease in its adhesive, binding, or film-forming properties. (See Vehicle.)

(2) The mode of expression employed by an artist: etching, painting, sculpture, etc.

(3) The actual instrument or material used by an artist: oil paint, chisel, needle, etc.

In general usage, the plural form of (1) is correctly mediums, that of (2) and (3), media.

METAMERISM. A term used in color technology to describe an undesirable effect sometimes exhibited when two colors that match each other under one kind of illumination (daylight, fluorescent tube, tungsten bulb) differ from each other when seen under another light source. The main cause of metameric pairs is a difference in the coloring ingredients of which the substance is composed. For example, one paint may contain a single pigment, the other a mixture. Other factors may be variations in gloss, surface texture, and ratio of pigment to binder. The artist can avoid the occurrence of this effect when repainting or adding new touches to a picture by using identical pigments rather than a mixture of other pigments and by duplicating the other relevant conditions.

MONTAGE. A picture or abstraction made by combining various ready-made

elements such as drawings, paintings, or photographs, either whole or cut-out.

OCCLUSION. The surrounding of isolated particles of a substance by a solid or semisolid. Absorption or adsorption of gases by a solid.

PAINT QUALITY. One of the desirable visual attributes of a finished painting; the term does not refer to good or bad ingredients. Paint quality is intrinsic or material beauty or successful surface effect; it implies a skillful handling and a fully realized use of the medium as opposed to smeary, inept, or dull handling. It is a technical matter apart from aesthetic content and good or bad taste.

PALETTE. Besides being used to refer to the implement upon which a painter holds or mixes his colors, this term is employed to denote a selected assortment or limited group of colors chosen for use in a painting technique.

PENTIMENTO (repentance). Obliterated painting subsequently revealed by reason of the overpainting's becoming transparent, a characteristic of linseed oil since its refractive index increases with age.

PLASTICIZER. Substance added to varnishes, lacquers, and paints in order to impart or maintain necessary properties or to correct undesirable characteristics. The term is most often used in connection with products that impart flexibility and overcome a natural tendency toward brittleness, but it is also applied to materials that improve brushing qualities, smooth compatibility with pigments, etc. When used to impart permanent film qualities, plasticizers should be nonvolatile.

POLYMERIZATION. Molecular realignment impelled by some external force or treatment. An internal chemical change by which the properties of a substance are changed and its molecular weight increased without the addition of any new ingredient.

RICE PAPER. Japanese papers of various types and finishes made for artists' use, including those made from mulberry fiber, are commonly grouped under this name.

SATURATION. Of a color, the degree of its intensity or vividness. Of a material in solution, concentration to the limit of its solubility.

SPACKLING OR SPARKLING (probably from the German *spachteln,* to putty up). The rectifying of a defect in a plaster wall or a mural painting by digging out the defective spot and filling it in with a platic gesso, plaster of Paris, Keene's cement, or other similar material.

SUBSTRATE. Base (as applied to lakes or let-down pigments). Also underlayer. Obsolete in art terminology.

TACK OR TACKINESS. Adhesive stickiness, such as that of the surface of incompletely dried varnish.

TEMPER. This verb is familiar through its use in referring to a conditioning process such as the heat treatment of steel and other materials, whereby strength, flexibility, ductility, or other desirable properties are imparted. As applied to paint technology, the term has never had any wide usage in America, but in European writings, both old and modern, it has been em-

ployed to denote the conversion of an intractable, nonplastic substance into a material that has desirable properties for the purpose for which it is intended. In this sense, tempering would include making dry colors or stiff paste paints brushable, permanently adherent, etc., by adding the proper medium or liquid, making a brittle or unyielding substance flexible or ductile, or imparting any good quality to a nonplastic material by the use of a liquid, a wax, etc. Our word "tempera" (see page 214) has the same derivation and was used in early Latin and Italian writings to mean any liquid medium with which pigments could be combined to make a paint, the resulting product being distinguished from fresco color, which contained no added medium. Later the word "tempera" was applied to paintings done with egg yolk; after other materials were developed, the term came to include, as it now does, all painting techniques that employ emulsions, and sometimes (but not accurately) any aqueous opaque paint as distinguished from oil paint.

TESSERA. A small vitreous or ceramic cube or a stone; one of the units of a mosaic.

TONER. A synthetic organic color that is insoluble and so can be used directly as a pigment. It is much stronger than a lake. (See page 33.)

TOOTH. A slight roughness or coarseness in the surface of a dried paint film or painting ground, which assists in the application and bonding of a subsequent coat of paint.

TRACTION. A defect of paint or varnish coatings, where the film cracks and the edges of the cracks recede to form wide, open fissures, disclosing the underlying surface. Colloquially called creeping or crawling. See also Cissing.

TRULLISATIO. The first coarse undercoat of fresco plastering. Term not in common use.

U.S.P. When these letters follow the name of a material they indicate that the material conforms to the specifications of the United States Pharmacopoeia, and that it is approved for use in medicinal preparations. This grade is usually below the C.P. grade in absolute chemical purity, but of more than adequate purity for average technical use. Corresponds to the British B.P.

VALUE. Degree of lightness and darkness; artists' equivalent of scientists' term "brightness."

VEHICLE. A liquid used as the carrier of pigments in a paint; the term is interchangeable with medium, but is perhaps more properly applied to the liquid used as an ingredient in manufacture than to a liquid added during painting procedure.

VERDACCIO. A neutral, brownish color used in underpainting, outlining, or shading; no specific composition.

WHITEWASH. A simple mixture of dry hydrated lime and water; some improved and more expensive whitewash powders contain opaque white pigments and additional binder, or are wholly of the calcimine or cold-water paint type. Common whitewash is not water-resistant, and rubs off easily.

SOME SOURCES OF MATERIALS MENTIONED IN THE TEXT

In a work of this nature it is difficult to recommend commercial brands or sources of materials; because of the ever-changing nature of trade conditions, one cannot vouch for the perpetuation of either the quality of any product or the policies of any firm. Also, the availability of certain materials may be sharply affected by world conditions and government restrictions.

These notes refer to basic raw materials, rather than to prepared or manufactured artists' materials, except for a few cases where highly specialized products are concerned and for the list of specialties on pages 649–50.

The regular retail sources of chemicals and raw materials are to be recommended; when materials are unobtainable from them, some of the large manufacturers and direct importers will sell their products direct in lots of one gallon or one to five pounds; most of them, however, prefer to recommend retail sources.

The mention of a source for a raw material does not necessarily imply a blanket recommendation for everything offered for sale by the concern, especially where it handles prepared or manufactured painting supplies as well as basic raw materials.

Obvious difficulties prevent the list from being exhaustive, and it has been rather localized around New York.

Complete but rather indiscriminate lists of manufacturers and dealers in miscellaneous chemicals and raw materials, covering the entire United States and Canada, may be consulted in the following two annual publications:

The Green Book. Oil, Paint, and Drug Reporter, Schnell Publishing Company, New York.
Chemical Buyer's Guide Book. Chemical Markets, Inc., New York.

No distinction is made in these books between large-scale manufacturers, brokers, and establishments selling small quantities at retail.

Several of the well-known manufacturers of prepared artists' painting materials sold at artists' supply stores put up simple materials such as damar varnish, stand oil, and Venice turpentine, in small bottles; the convenience and availability of these in small amounts are at least partial compensation for their higher cost. The painter who is experienced with these products can usually judge their quality.

The firms in the following lists are arranged in alphabetical order.

GENERAL RAW MATERIALS AND CHEMICALS

There are dealers in all large cities, especially in industrial centers, who sell small retail amounts of a general line of chemicals, gums, resins, solvents, glues, waxes, etc., in both technical and chemically pure grades. Some of them specialize in supplies for industrial manufacturers; others are also wholesale druggists. Although they will seldom disclose the original sources of the goods they offer for sale, these products can usually be relied upon; the business of such concerns depends upon supplying the correct material for the purpose. However, the grades of raw materials, especially of products such as oils and resins, which are adequate for industrial use, are often not the best possible for artists' use. These concerns will usually stock additional supplies if there is a reasonable demand for them, or they will secure special materials on order. The following are a few firms of this type:

> Amend Drug & Chemical Co., P.O. Box 797, Hillside, NJ 07205. Chemicals and general raw materials.
> H. Behlen & Bro., Route 30, Amsterdam, NY 12010. General painters' supplies, oils, gums, resins, glues, waxes, gilders' supplies, etc.
> Berg Chemical Co., 920 East 132nd St., Bronx, NY 10454. Solvents, also chemicals, some oils, gums, etc.
> City Chemical Corp., 132 West 22nd Street, New York, NY 10011. Complete stock of chemicals, gums, resins, solvents, and other raw materials.
> Fisher Scientific Co., 52 Fadem Road, Springfield, NJ 07081.
> Process Chemicals Inc., 89 Lincoln Ave., Fairlawn, NJ 07205.

LABORATORY SUPPLIES AND APPARATUS

These are obtainable in most large cities; some of the nationally known concerns that carry complete mail-order lines are:

> Central Scientific Co., 2600 South Kostner Ave., Chicago, IL 60603.
> Fisher Scientific Co., 52 Fadem Road, Springfield, NJ 07081.
> Gardner Laboratory, Inc., 5521 Landy Lane, Bethesda, MD 20014. Specialists in equipment for paint technology.
> Arthur H. Thomas Co., Third and Vine, Philadelphia, PA 19105.

For paint and color laboratory equipment:

> Gardner Laboratory, Inc., 5521 Landy Lane, Bethesda, MD 20014.

Among the simpler pieces of laboratory apparatus and equipment that are useful in the studio are the following:

For grinding pigments and other dry materials, also grinding or mixing powders with liquids—a glass mortar and pestle; these are obtainable in various sizes. The porcelain varieties are preferred by some; glass ones are usually adequate and more easily cleaned.

For dividing mixed liquids that will separate into two layers (for instance, for separating the oil from water in the sun-refining process)—a separatory funnel, which is a globular container with a stopper on top and a long stem below; the flow of liquid is controlled by a stop cock at the point where the stem meets the globe. The funnel is held in a common ring or clamp stand while in use.

The suction pump, bottle, and Buchner funnel described on pages 108–109.

Glass mullers, described in connection with the home manufacture of oil colors.

Other miscellaneous pieces of equipment whose value depends upon the type of work being done are the following, obtainable from common retail stores:

For the intimate mixing of blending or pigments and other dry powders—a rotary flour sifter.

Aluminum egg separator.

Rotary egg beater and jar.

Small household or beverage mixer with electric motor. The kind that can be held in the hand as well as set into a stand is most convenient. More expensive and more professional small mixers have motors designed for continuous operation. A mixer may also be improvised by attaching a small motor, such as one from an electric fan or a dictaphone, to a vertical propeller shaft.

One-ounce, screw-cap, clear glass jars to contain tempera paints, colors ground in water, etc. Larger sizes are also useful for storage of pigments. The squat form, with straight sides, without shoulders.

Measuring equipment is mentioned on page 614.

SOLVENTS

Turpentine. The clean, fresh material known as "gum turpentine," when purchased from a well-established paint store that buys its materials in standard grades from reputable manufacturers, is identical with the so-called double rectified turpentine put up in small bottles and sold by artists' supply dealers, and is likely to be fresher stock. The dealers in the artists' grade are certainly entitled to a higher price in return for their careful selection of pure material and for the investment required to carry

it in stock in conveniently small bottles, but the pure turpentine sold in bulk is not inferior in quality. It should be rejected if it is cloudy, yellow, or if its odor is strange. If the head of the barrel or the label on the can in which the dealer receives his shipments bears the name of the original producer and the words "pure gum spirits of turpentine," this is a further guarantee, because such labeling and nomenclature are regulated by the government, as noted on page 366. Small cans and bottles of pure gum turpentine are available at paint, hardware, and chain food stores with this same labeling; they should bear the seal of the Turpentine Farmers' Association Co-operative.

Mineral Spirits. This material may also be purchased at paint stores; it is often called turpentine substitute or known by one of its trademarked names—Varnolene, Texaco Spirits, Sunoco Spirits, etc. It should be distinguished from the other common materials sold as painters' benzine or naphtha.

Alcohol. Each of the larger distillers of industrial alcohol is permitted to put out a "proprietary brand" of specially denatured alcohol, which is sold under a trademarked name without restriction. The retail dealers in general raw materials and chemicals and the better paint stores usually carry it in stock.

Proprietary Solvent Formulation No. III, authorized by the government, is prepared under U.S. permit as follows: to 100 gallons of specially denatured alcohol Formula No. 1 (SDA No. 1), add 1 gallon methyl isobutyl ketone, 1 gallon ethyl acetate, and 1 gallon gasoline or rubber hydrocarbon solvent. SDA No. 1 is prepared, under U.S. permit, by adding 5 gallons wood alcohol (methanol produced by the destructive distillation of wood) to 100 gallons ethyl alcohol. Since wood alcohol as such is no longer readily available, an alternate, authorized formulation is commonly used to prepare SDA No. 1. The alternate formulation is prepared by the addition of 4 gallons methanol and ⅛ ounce Bitrex[B] (denatonium benzoate) to 100 gallons ethyl alcohol. The components of Proprietary Solvent No. III are compatible with most paint and varnish applications. This material is preferred over the more heavily denatured completely denatured alcohol formula for most uses.

Proprietary Solvent No. III is available in two grades, one containing about 7 percent water and another water-free (anhydrous), which is desirable or in some cases necessary for certain uses. In addition to Proprietary Solvent III, which is available from U.S. Industrial Chemicals Company (99 Park Ave., New York, NY 10016), some of the many names under which similar material is sold are Synasol (Union Carbide), Neosol (Shell), and Paco Solvent (Publicker). Proprietary Solvent III may be ob-

tained from U.S. Industrial Chemicals Company in 5-gallon pails, and 30-gallon and 55-gallon drums.

The strength of alcohol (percentage of alcohol in relation to the percentage of water) is reckoned by the "proof" system. In the United States, 100 percent anhydrous alcohol is 200 proof, 96 percent alcohol is 192 proof, 95 percent is 190 proof, and 94 percent is 188 proof. (The usual denatured alcohols are 188 proof.) The proof numbers are double the percentage of alcohol by volume. The British proof system is different. The sale of the specially denatured alcohols (which are designated by numbers) is strictly regulated by the government; such materials are sold not at retail but only to industrial concerns. A permit to buy the more expensive pure grain alcohol or anhydrous alcohol for stated purposes, especially in small amounts, can be obtained in most states.

Other Solvents. All of the other solvents mentioned in this book can be purchased from the raw-material and chemical supply houses listed above, in the ordinary or technical grades as well as in the more expensive chemically pure grades. The best-quality technical grade of a solvent will often be found suitable for most studio uses, especially when a purer grade is very expensive; but usually, when the purest grade is obtainable, the difference in price will not make it worthwhile to use the inferior grades, particularly when only small quantities are needed. As a general rule the pure grades are more pleasant to handle because of their more agreeable odors.

ETHYL SILICATE PAINTING

Celite: Available at building-supply firms; made by Johns-Manville, 600 Sylvan Ave., Englewood Cliffs, NJ 07632.

Ethyl silicate: Union Carbide Co., 270 Park Ave., New York, NY 10017.

Micronized mica (*Micatone*). The English Mica Co., Glover Rd., Kings Mountain, NC 28086. The U.S. Mica Co., Center Building, 26 6th St., Stamford, CT 06905.

Vinyl-butyral resin (*Vinylite XYHL*): Union Carbide Co., 270 Park Ave., New York, NY 10017.

NATURAL RESINS

(Also called varnish gums, see page 175.)

These may be obtained from the suppliers of general raw materials and chemicals. The direct importers of natural resins were formerly good sources of resin at wholesale prices, but the almost complete replacement

of natural by synthetic resins in the varnish industry has greatly reduced their number; furthermore, most of this trade is in original cases of several hundred pounds. Some of the importers are:

O. G. Innes Corp., 10 East 40th St., New York, NY 10016.
William H. Scheel, Inc., 38 Franklin St., Brooklyn, NY 11222.
S. Winterbourne and Co., 38 Richmond Terrace, Staten Island, NY 10301.

SYNTHETIC RESINS AND PLASTICS

All these products are marketed under trade names. There are retail outlets in most cities where sheets, rods, blocks, and other forms of plastic are sold; most of them also carry resin solutions and ingredients for coating and laminating. Because these materials are primarily intended for large-scale industrial use, some specific materials are available only from their manufacturer.

Industrial Plastic Supply Company, 309 Canal St., New York, NY 10013.

The special books on plastics on pages 686–87 and 692 list many sources.

The following concentrated acrylic solutions are available in reasonably small quantities (1 or 5 gallons) direct, or from the manufacturers' sales offices in most large cities.

Methyl methacrylate soluble in mineral spirits and turpentine:
Acryloid F-10: Rohm and Haas, 467 Boulevard, Elmwood Park, NJ 07407.
Lucite 44: E. I. duPont de Nemours, 350 Fifth Ave., New York, NY 10001.
Methyl methacrylate soluble in toluol:
Acryloid B-72: Rohm and Haas, 467 Boulevard, Elmwood Park, NJ 07407.
Acrylic polymer emulsion:
Rhoplex AC234: Rohm and Haas, 467 Boulevard, Elmwood Park, NJ 07407.

ADHESIVES

Glues: The sheets of French rabbitskin glue mentioned in the text bear the imprint "Chardin, Pantin, France," and the material is obtainable from most of the retail dealers in technical raw materials and chemicals and from some of the more complete paint stores.

American glue manufacturers seem to have reorganized their trade and now produce glues in a limited number of extensively used grades instead of including the wide variety of special or superfine grades formerly produced. A pure rabbitskin or coney glue which appears to be about equal to the French product is made in powdered and flake forms by Fezandie and Sperrlé, 111 Eighth Ave., New York, NY 10011. Because of long usage and wider availability in retail amounts, the French material seems to be the standard. American calfskin glues, paler, cleaner, and definitely stronger in jelly strength than rabbitskin glue, are also available; recipes for employing them to replace rabbitskin glue must be worked out by the user. They are closely related to gelatin, but their properties are balanced enough for general adhesive and binding purposes.

The best American glues are not always easy to obtain in retail amounts; they are sold for industrial use in barrels and large bags, and there is small demand for one- or five-pound lots. Wholesale dealers will sometimes, but not always, have open packages on hand. Those put up by the art-supply firms are the easiest to obtain.

Gelatin: The best grades of clear, white technical gelatin come in thin, crinkly sheets about 9 x 3 inches, put up in one-pound packages wrapped in pale blue paper, imported from France, Belgium, or Germany. The best American grades come in powdered form. Edible gelatin also can be used, but the grocery store variety comes in very small packages and is by comparison very expensive. The technical kind is used for chemical and biological laboratory purposes, and is obtainable from chemical, laboratory, and drug supply houses.

Fish glue: sold in liquid form, and may be purchased in hardware and chain stores in good quality in small bottles and cans.

Casein: will not give good results unless it is fresh stock and of the best quality. It is obtainable from the usual general chemical or raw-material supply houses; some careful users, however, prefer to buy it direct from the manufacturers. Powdered casein in 1-pound cans is available from The Pilot Chemical Co., 1030 Jackson Ave., Long Island City, NY 11101.

The prepared casein adhesive is sold in powder form under many trademarked names such as Casco Glue, Le Page's Casein Glue, etc., in some hardware and paint stores. Instructions on the package must be carefully followed.

Cellulose cements: for joining a large number of flexible and inflexible materials, especially when a very rapid setting is desired. Available in tubes. A widely distributed brand is Duco Cement.

Synthetic polymer adhesives: milky-white fluids that are water misci-

ble but form a waterproof bond when dried. They work well without pressure and are especially useful for adhesive purposes where flexibility is an important factor. But some workers find that when solidity or rigidity of the joint is required, casein glue is preferable.

They are made of polyvinyl acetate and other polymer dispersions; the straight or regular medium that is sold with the acrylic polymer colors will serve much the same purpose. A widely distributed brand is Elmer's Glue-All.

Epoxy cement: This powerful contact adhesive that requires no pressure or clamps is widely sold in hardware and other stores packaged in two tubes, resin and hardener, to be mixed just before use. Hands should be washed after coming in contact with the hardener, which usually contains skin irritants. The numerous brands are of approximately equal adhesive strength, but some of them produce colorless results, whereas others give darker, more visible joins.

The enormous adhesive strength of epoxy cements puts them in a special class; they can be relied on for permanent joins of the same or dissimilar materials, and will withstand severe tension. They have been employed for such difficult purposes as joining aluminum aircraft parts in place of riveting.

CONSERVATORS' SUPPLIES

While many of the materials used by conservators are no different from those used by artists, there are some items that are difficult to obtain and there are several sources that specialize in conservators' and restorers' equipment.

Archivist's Pen and other instruments to measure the acidity of paper: Talas, 130 Fifth Ave., New York, NY 10011. This firm carries a full line of conservators' supplies, including silicone paper and Wei T'o.

Beva adhesive: Produced by Adam Chemical Co., P.O. Box 15, Spring Valley, NY 10977.

Wei T'o: Developed and produced by Dr. Richard D. Smith, P.O. Box 419, 224 Early Street, Park Forest, IL 60466. Also available from Talas, 130 Fifth Ave., New York, NY 10011.

Conservation Materials Ltd., 340 Freeport Blvd., Sparks, NV 84431.

PIGMENTS

Dry colors are sold in small amounts in some artists' supply stores; they are put up in small packages by some of the well-known manufacturers of prepared artists' materials.

> Fezandie and Sperrlé Division, Leeben Color and Chemical Co., Inc., 111 Eighth Ave., New York, NY 10011. This firm has a complete line of nearly every available pigment used by artists, selected and assembled from worldwide sources. These are sold in small or large amounts from a mail-order list only.
>
> New York Central Supply, 62 Third Ave., New York, NY 10003.
>
> Pearl Paint Co., 308 Canal St., New York, NY 10013. A large assortment of artists' pigments in bulk in stock.

While painters who use dry colors should insist upon securing the purest, highest-grade pigments, there are some purposes for which more commonplace and more easily obtainable grades are useful. These grades are universally sold in paint stores. For the best artistic painting purposes, however, only pigments of known origin should be chosen, and for these one should go to reliable dealers who have the knowledge and facilities to test and select their supplies from among the best sources.

All colors sold for ceramic uses are specially treated. They contain fluxing and refractory ingredients and are not suitable for paint purposes.

CONTAINERS

> Baehm Paper Co., 53 Murray St., New York, NY 10007, carries a complete assortment of bottles, jars, tins, tubes, color envelopes, etc.

GOLD AND OTHER METALLIC LEAF, GOLD SIZE, BRONZE POWDERS, AND ACCESSORIES

> H. Behlen & Bro., Route 30, Amsterdam, NY 12010. Agate burnishes and other gilders' supplies. Catalog.
>
> Hastings and Co., Inc., 2314 Market St., Philadelphia, PA 19103. Gold, silver, palladium, sizes. The Hastings brand is widely sold in retail shops.
>
> M. Horowitz, 166 Second Ave., New York, NY 10003. Gold leaf and sign-writers' supplies.
>
> Leo Uhlfelder and Co., 420 South Fulton Street, Mt. Vernon, NY 10553. Bronze powders. (This firm also sells such supplies as Venice turpentine, rabbitskin glue, mullers, etc.)

LINEN FOR CANVAS

Correctly woven pure linen of quality and dimensions suitable for painters' canvas is more difficult to obtain than one would suppose.

Samples and prices of Belgian linens especially woven or selected for artists' purposes can be had from Utrecht Linens, 33 35th St., Brooklyn, NY 11232. Their close-woven linen "Duck" 74D is recommended for general use; 72D is a smoother, lighter weight of the same grade; and 76D is very heavy and extra wide for more special uses. Several other weaves and weights are also available.

Many art-supply shops stock raw linen in various widths and weaves. One such is Pearl Paint Co., 308 Canal St., New York, NY 10013 (selected Belgian and Irish linens for artists' canvas). Another good source is New York Central Supply Co., 62 Third Ave., New York, NY 10003. In comparing prices, the width must always be noted and the price figured on a basis of square feet or square yards. It will generally be found most economical to use width for your larger dimension whenever possible or else to plan the size of remnants, so that they may be large enough for use rather than wasted as scraps.

DYES

Dyestuffs for all purposes, soluble in water, oil, or alcohol, may be purchased from:

Bachmeier and Co., 154 Chambers St., New York, NY 10007.
Fezandie and Sperrlé Division, Leeben Color and Chemical Company, 111 Eighth Ave., New York, NY 10011. Mail order only.

WHITE LEAD IN OIL

For priming canvases and for other uses that will consume comparatively large quantities of paint and do not warrant the purchase of the expensive and more carefully prepared flake and Cremnitz whites sold as artists' tube colors, white lead ground in oil may be bought in cans or pails. The brands of the large well-established producers are carefully compounded and serve well for these purposes. Most of them are blends of pure white lead carbonates made by more than one process.

The modern product is now sold in two varieties; one is straight white lead in oil, the other is a softer paste that contains a small amount of turpentine or mineral spirits so that it can be more easily broken up with oil and thinners and mixed with tinting colors.

It should be understood that this product is recommended only for use in grounds; it is unsuitable for painting pictures or where it is to be left exposed without overpainting.

Although white lead in oil has been important to artists for five centuries, the United States government ruled in the 1970s that wall paints containing more than a tenth of a percent of lead could not be sold in interstate commerce because of an increase in lead poisoning among children who ate chips of old paint from the walls. Abruptly the trade in artists' white lead in oil halted as well. Thanks to a concerted effort among artists (who should be well acquainted with the safe handling of all paints and pigments), the ban on lead-bearing paints for artists' use was lifted. Even so, the art-supply dealers have been slow to restock and white lead in cans is difficult to find.

OTHER PIGMENTS IN OIL

Zinc oxide and all the common pigment colors sold in cans at paint stores are ground in oil to a rather soft consistency. They are useful for some purposes, but never as oil colors for artists' painting. They should bear the label of a well-known, reputable maker, and the zinc oxide should be of the French process variety (red, green, or white seal). The best brands of zinc are ground stiffer than the other tinting colors and are useful in making oil grounds, etc. The cheap grades of painters' colors in oil sold in cans are often poorly ground and grossly adulterated; many states require the makers to print formulas on each package. The colored pigments are ground with an excess of oil for convenience in tinting liquid paints and, even if pure, are poorly adapted to most techniques of artistic painting.

GLASS MULLERS

Leo Uhlfelder and Co., 420 South Fulton St., Mt. Vernon, NY 10553. Fezandie and Sperrlé Division, Leeben Color and Chemical Company, 111 Eighth Ave., New York, NY 10011. Mail order only.

PORCELAIN ENAMELING

The following concerns can supply iron sheets enameled with white ground color, and are experienced in firing the finished work:

Ferro Enamel Corporation, 4150 East 56th St., Cleveland, OH 44015. Porcelain enamel manufacturers in many American cities.

The untreated iron sheets are made by a number of steel and iron companies; one of the most widely used brands is Armco enameling iron,

made by ARMCO, Inc., of Middletown, Ohio, and distributed by offices and dealers in many places, where it may be purchased at retail. Edgecomb Metals Co., Woodward Industries Park, Liverpool, NY 13088, and Mapes and Sprowl, 2400 Bedle Place, Linden, NJ 07036, are distributors.

Ceramic colors, dry and ground in the oil medium, may be purchased from Harshaw Chemical Company, Small Package Department, 1945 East 97 St., Cleveland, OH 44106.

WASHABLE CASEIN WALL PAINTS

Under a great variety of trademarked names, such as Sunflex, Luminall, and Textolite, these paste or semiliquid paints are sold in most paint stores. A gallon will make about 1½ gallons of finished paint. Some dry-powder paints are sold in competition with them; these are seldom of equal value, and will not usually produce as fine or resistant a surface. The original plain *white* casein paint is recommended for the limited uses mentioned in the text. Avoid the modern "improved" types such as Super-Luminall, Kem-Tone, etc., which are excellent for the purposes for which they are designed but less suitable here. It should be understood that nothing mentioned under this heading is recommended for permanent painting.

OILS

Selected painting oils are put up in small bottles by the manufacturers of prepared artists' materials; when it is important to use the best grades of exact materials, only the very highest-quality brands are reliable. When larger amounts are required, when one desires more exact identification of the oil, or when for the sake of economy one is willing to take the trouble of shopping for and storing a large can of oil, these materials may be purchased in lots of one gallon or more from the general raw-material supply houses.

The following varieties of industrial linseed oil mentioned in the text are made by the manufacturers indicated. They are not sold direct to retail users, but may sometimes be obtained through the retail dealers in general raw materials. The price range of the various kinds of linseed oil is not great; while the costs fluctuate according to market conditions, there is seldom a differential of more than a few cents per gallon between linseed oils of various degrees of refinement. The fact that an oil is unsuitable for artists' use does not necessarily signify that it is an inferior oil;

all these oils are made with equal care to meet the requirements of their various purposes.

	Archer-Daniels-Midland	Spencer Kellogg
Alkali-refined Stand oil	Superb OKO Linseed M2½	Superior OKO Linseed M2½

As noted in the text, the highly bleached paint oils are less desirable than those of a more normal color, but the color stability of stand oil, and perhaps some of the modern pale varnish oils, is satisfactory.

Cold-pressed linseed oil: made by Caledonian Oil Mills, Blackscroft, Dundee, Scotland, and distributed by Winsor and Newton, Inc., 555 Winsor Dr., Secaucus, NJ 07094; sold in art-supply stores.

Poppy and walnut oils: Welch, Holme and Clark Co., Inc., 1000 South 4th St., Harrison, NJ 07029. Will sell as little as one gallon direct.

SPRAYERS

Preval sprayer: Precision Valve Company, P.O. Box 309, Yonkers, NY 10702. An inexpensive pressure-can sprayer with removable glass jar and replacement propellant can, sold in art-supply stores.

STRETCHERS

The stretcher strips in stock in the art-supply shops are the lightweight variety referred to on page 245. They are made of good-quality, seasoned wood on automatic machines and are available in every length from 6 to 60 inches; they are adequate for the average picture up to 40 inches if it is to be well framed. The heavier 2½-inch-wide variety, made by the same factories, can be obtained from the shops on special order; when ordered with crossbars, draw a diagram on the order blank, as . A lightweight stretcher can be ordered in fractional inches, and also with a crossbar, but the crossbar will not be expansible as are those on the heavy type.

Custom-made stretchers: Some specialty frame-workshops make heavy stretchers to order; these are likely to be more accurately cut than the factory-made product. One such is: D. Matt & Co., 223 East 80th St., New York, NY 10021.

Stretchers with corner devices: These are generally considered the very best type of stretcher. Tension on the canvas may be kept under control, and the steel or aluminum contrivance at the corners makes these points

the strongest parts of the chassis rather than the weakest, as they are in the usual tongue-and-groove corners. Though these stretchers are widely used by conservators for lined paintings and by museums to replace inadequate stretchers, they are, perhaps, too expensive for the artist to use on every picture. However, some painters do use them, especially when the work is commissioned. Three sources of these stretchers are:

> I.C.A. Spring Stretcher, 344 South Professor St., Oberlin, OH 44074. The chassis is made of demountable strips of redwood molding with a specially designed bevel and has an aluminum device with a steel spring at each corner and crossbar end. Tension is adjustable. It is claimed that the spring action puts less strain on worn and fragile canvases than do other types.
>
> James J. Lebron, Special Services to the Fine Arts, 31–36 58th St., Woodside, NY 11377.
>
> Phillips Stretchers, North Egremont, MA 01252. The corners have threaded steel dowels that are expanded by a wrench. Straight-beveled pine strips.

A nonexpansible chassis is not a stretcher but a strainer, which is necessarily a temporary device as a canvas support. There is an Italian stretcher now under scrutiny that is spring-loaded in both directions; the canvas is held under continuous tension by strong free-moving parts that allow the stretcher to adjust to all dimensional changes of the canvas caused by variations of temperature and humidity. The springs in this stretcher can continuously expand the canvas, thus absorbing the "sag" in large paintings. Joshua Bugaycr Fine Art Stretchers and Services, 5604 New Utrecht Ave., Brooklyn, NY 11219.

Stretchers have become so prohibitive in price that many artists make their own. Another possibility is to ask a good cabinetmaker to make a sturdy stretcher by copying a bought model. Good stretching (see pages 245–46), wetting the canvas after stretching, and restretching before priming are also important.

ENCAUSTIC SUPPLIES

> Joseph Torch, 29 West 15th St., New York, NY 10011. Electric palettes, wax-resin colors, raw materials, and papers.

PENS: REED, QUILL, AND FELT-TIP

Gemexco Inc., 419 Park Ave. South, New York, NY 10016. Reed pens.

F. M. Nonaka and Co., 655 Battery St., San Francisco, CA 94111. Reed pens.

Pentallic Corp., 132 West 22nd St., New York, NY 10011. Goose and turkey quills.

Felt-tip pens, permanent carbon ink, replaceable tips: Sold in art-supply stores and made by:

Faber-Castell Corp., 41 Dickerson St., Newark, NJ 07103.

Marsh Stencil Machine Co., Belleville, IL 62222. Model 77; used with T-21 Black Ink. Both makes sold in art-supply shops.

HEELBALL FOR STONE RUBBING

Rubbing kits: Old Stone Enterprises, 77 Summer Street, Boston, MA 02110.

PAPERS

Artists' papers of all kinds are available in well-stocked art-supply shops. The best-quality hand-made all-rag watercolor papers are less easily found than they were in the recent past. Some of the old brands are no longer hand-made.

Andrews-Nelson-Whitehead Company, 31–10 48th Ave., Long Island City, NY 11101. Nearly every kind of paper mentioned in this book for painting, drawing, printmaking, and technical purposes. Also special and decorative papers from worldwide sources.

C. T. Bainbridge's Sons, 50 Northfield Ave., Edison, NJ 08817. Rag board for mounts and mats.

Arthur Brown & Bro., 2 West 46th St., New York, NY 10036. Japanese rice papers.

New York Central Supply, 62 Third Ave., New York, NY 11103. Carries papers made by Andrew-Nelson-Whitehead, above.

Technical Papers Corporation, 29 Franklin St., Needham, MA 02194. Papers for printmaking.

Torch Art Supply, 36 West 15 St., New York, NY 10011.

INDUSTRIAL PAINTS, ETC.

In buying ready-mixed paints, enamels, varnishes, lacquers, etc., one should select the products of the large, nationally known, reputable com-

panies; materials that are not sold below the generally prevalent prices for highest-quality goods are usually guaranteed against inferior results. The majority of failures of such materials are caused by improper selection of the product for the purpose, or by improper application. Well-established, complete retail stores are usually able to supply information and advice on these prepared products. They are mentioned here only in connection with the purposes for which they were designed, not as materials with which to paint pictures. (See page 189.)

LITHOGRAPHERS' SUPPLIES

Crayons, transfer paper, tusche, etc., are obtainable at some artists' supply stores. See also printmakers' supplies.

J. H. & G. B. Siebold, 150 Varick St., New York, NY 10013.

PRINTMAKERS' SUPPLIES, ETCHING AND LITHOGRAPHIC PRESSES, TOOLS

A well-stocked artists' supply shop will often carry enough etchers' and engravers' materials for most purposes. The following concerns specialize in these materials:

Charles Brand, 84 East 10th St., New York, NY 10003.
The Craftool Co., 1421 West 240th St., Harbor City, CA 90718.
Graphic Chemical and Ink Co., P.O. Box 27, Villa Park, IL 60181.
National Steel and Copper Plate Co., 543 West 43rd Street, New York, NY 10038.
Rembrandt Graphic Arts Co., Inc., The Cane Farm, Rosemont, NJ 08556.

Steel facing of etchings: Cronite Co., 1 Beekman St., New York, NY 10038.
Wood blocks: The Sander Wood Engraving Co., 212 Lincoln St., Porter, IN 46304.
Battleship linoleum: Arthur Brown and Bro., 2 West 46th St., New York, NY 10036.

SUPPLIES FOR SILK-SCREEN PROCESS

Materials and equipment for this technique are available in most cities from dealers who specialize in them and also from some artists' supply houses. Among many dealers are:

Arthur Brown and Bro., 2 West 46th St., New York, NY 10036.

Colonial Printing Ink Co., East Union Ave., East Rutherford, NJ 07073.

Sam Flax, 25 East 28th Street, New York, NY 10016.

Joseph Mayer Co., 22 West 8th St., New York, NY 10011.

Naz-Dar Company, 45-45 39th St., Long Island City, NY 11104.

SLIDE VIEWERS

The models listed below may be available in large photographic supply stores other than those given here.

The G.A.F. Viewer has an ordinary 3-by-4-inch screen but has a device that projects a 30-inch picture onto a wall. It is widely available throughout the country.

Kindermann Tageslicht is a German import that is compact and portable and gives a brilliant 7-by-7-inch picture. Available from: Willoughby-Peerless Industrial Dept., 110 West 32nd St., New York, NY 10001.

The Olden Traveler is also portable, with an adequately bright 8-by-8-inch screen. Available from: Olden Camera, 1265 Broadway, New York, NY 10001.

SCULPTORS' MATERIALS

General:

Ettl Studios, Inc., Ettl Lane, Greenwich, CT 06830.

Sculptor's Supplies Ltd., 99 East 19th St., New York, NY 10016.

Sculpture Associates, Ltd., 114 East 25th St., New York, NY 10010.

Sculpture House, 38 East 30th St., New York, NY 10016.

Sculpture Services, 9 East 19th St., New York, NY 10003.

Stewart Clay Company, 406 Jersey Avenue, New Brunswick, NJ 08901.

Carving tools:

Frank Mittermeier, Inc., 3537 East Tremont Avenue, Bronx, NY 10065.

Marble and other cut stones: The following is one of many dealers, most of whom specialize in the products of various quarries.

Vermont Marble Co., 60 East 42nd St., New York, NY 10017: and 61 Main Street, Proctor, VT 05765.

Tropical woods:
J. H. Monteath Company, 2500 Park Ave., Bronx, NY 10451.

Plastic magnesia, fillers, and supplies:
Marbleoid Corporation, 2515 Newbold Ave., Brooklyn, NY 10462.
Smith Chemical Color, Inc., 104–20 Dunkirk St., Jamaica, NY 11412.

SPECIAL PRODUCTS CURRENTLY AVAILABLE FOR PAINTING, SCULPTURE, AND PRINTMAKING

The author does not recommend any specific brands of prepared or ready-made artists' colors or mediums. The various products listed here—both novelties and items of long standing—are examples of specialties or unusual materials of one kind or another mentioned in the text pages as noted, where further references are made to their ingredients— some favorably, some adversely.

Inclusion of names in this list does not imply any approval or recommendation whatsoever, either in reference to their own value, or any preference over other brands of the same or similar materials that may have been omitted. There is little information based on impartial, scientific laboratory or performance tests on any of the modern synthetic or complex products; descriptions of products in this section are based on data supplied by manufacturers.

"Oil Colors Ground in Sun-Thickened Linseed Oil." (See pages 124–25.) A limited series of colors; can produce effects reminiscent of Rembrandt's surface textures. Made for years by Binney and Smith, Inc., 1100 Church Lane, P.O. Box 431, Eastern, PA 18042.

"Magna Plastic Colors." A line of artists' colors, permanent pigments ground in an acrylic resin with solvents and plasticizer. Miscible with turpentine and mineral spirits. Dries rapidly, mat effect on all surfaces. Bocour Artists Colors, 1 Bridge St., Garnerville, NY 10923.

"Magna Varnish." A clear isolating varnish (see page 172), sold for use with the Magna Plastic Colors and also useful as an isolating varnish in oil painting and some complex techniques. Without its use, the Magna colors are too rapidly picked up by additional coats. Bocour Artists Colors, above.

"M Varnish." A clear solution of methacrylate resin in mineral spirits and turpentine, formulated by the author, and intended for use as a final picture varnish. Pearl Paint Co., 308 Canal St., New York, NY 10013. Production pending. Other water-white picture varnishes have been made by artists'-material firms, but few are identified as to contents.

"Carborundum Powder." An abrasive used to roughen the surface of muller or slab, and also used to give texture to gesso panels. (See

pages 142 and 268.) King and Malcolm, 57–10 Grand Ave., Maspeth, NY 11378.

"Gel." A clear jelly painting medium made by grinding a colloidal "transparentizer" in linseed oil. M. Grumbacher, Inc., 460 West 34th St., New York, NY 10001. (See page 212.)

"Aquapasto." A water gel material to be mixed with watercolors for heavy impasto effects. Winsor and Newton, Inc., 555 Winsor Dr., Secaucus, NJ 07094.

"Cel-Tested Color." A line of opaque colors that will "take" smoothly on acetate film and other plastics. (Developed for animated-cartoon work; not intended for fine-arts painting.) M. Grumbacher, Inc., above.

"Dorland's Wax Medium." According to the maker's description and instructions for use, this is a highly developed wax medium, a complex mixture of ten or more ingredients, each of which is a recognized paint constituent. Intended to be mixed with various proportions of artists' oil colors for a variety of painting purposes and effects, and also with either oil colors or dry pigments on a gesso panel as a cold-painting version of encaustic, to be fused by the final application of heat. Siphon Company, Ignacio, CA 94947.

"MG White." A tube color for oil painting with properties like those of the emulsion white described on page 152. Mixes with oil colors, is quick drying, gives mat finish, retains brush strokes and impasto shapes. M. Grumbacher, Inc., above.

"Underpainting White." Performance is similar to that of above product. Shiva Artists Colors, 4320 West 190th St., Torrance, CA 90509.

The significant ingredients or compounding methods upon which the performance of either of the above two products is based are not revealed.

POLYMER COLORS AND THEIR ADJUNCTS

The following trade names are some of the more widely distributed brands of acrylic polymer colors and mediums sold in art-supply stores:

American. "Acrycolor." Danacolors, Inc., 1833 Egbert Ave., San Francisco, CA 94124.

"Aqua-Tec Acrylic Polymer Colors." Bocour Colors, Inc., 1 Bridge St., Garnerville, NY 10923.

"Hyplar Artists' Colors." M. Grumbacher, Inc., 460 West 34th St., New York, NY 10001.

"Liquitex." Binney and Smith, Inc., 1100 Church Lane, Eastern, PA 18092.

"New Masters" (acrylic-vinyl copolymer). Hunt Manufacturing Co., Speedball Rd., Statesville, NC 28677.

"Shiva Acrylic Colors." 4320 West 190th St., Torrance, CA 90509.

English. "Cryla." George Rowney and Co. Ltd., 10–11 Percy St., London W.1, England; American distributor: Morilla Co., Inc., 4301 21st St., Long Island City, NY 11101.

"Reeves Polymer Colors." Reeves and Sons Ltd., Lincoln Rd., Enfield, Middlesex, England. Canadian distributor: Reeves and Sons Ltd. (Canada), 16 Apex Rd., Toronto 19, Ontario.

Mexican. "Politec Acrylic Colors." Politec Co., Tigre 24 (Actipan), Mexico 12, D.F., Mexico.

THE PAINT STANDARD

The following is a reprint of those sections of Commercial Standard CS98–62, published by the United States Department of Commerce, that concern specifications, labeling, and guarantees.*

The Standard was published by the National Bureau of Standards as the result of work completed in 1938 by the Paint Testing and Research Laboratory of the Massachusetts Art Project, WPA, under the direction of Frank W. Sterner and Rutherford J. Gettens. It is not a government regulation, but was arrived at by conference and voluntary agreement by leading American manufacturers, artists, and other interested persons. A standing committee on which manufacturers and artists' organizations are represented meets periodically for revisions. This text incorporates the amendment of 1952 and a correction of the figures in paragraph 20a (2) of 1955. As of this writing, it is in the process of revision. The new number is T-51. The Standard is referred to on pages 13 and 35.

ARTISTS' OIL PAINTS

(Effective November 15, 1962)

1. PURPOSE

1.1 The purposes of the Commercial Standard are to serve as a guide to artists in the purchase of paints of satisfactory color, working quality, and durability; to eliminate confusion in nomenclature; to promote

* Copies of Commercial Standard CS98-62 available from Superintendent of Documents, Washington, D.C. 20025. (Ralph Mayer was chairman of the first standing committee.)

fair competition among manufacturers by providing criteria for differentiation among paints of known satisfactory composition and others of unknown or inferior quality, and thus to provide a basis for certification of quality.

This Commercial Standard covers minimum requirements for artists' oil paints of satisfactory color and durability. It is not intended that all paints meeting the requirements shall be identical nor of uniform excellence in all respects. Variations in manufacture and grinding not controlled by the specification may cause some artists to prefer one brand over another, both of which are acceptable under this specification.

2. SCOPE

2.1. This Commercial Standard covers one grade of artists' oil paints and includes criteria of color, nomenclature, chemical composition, working qualities, light fastness, and performance. It also covers methods of testing to demonstrate conformance with the Standard, packaging, and a means for labeling and identification.

3. NOMENCLATURE

3.1. The paint names given in table 1 indicate the chemical nature of the pigment or are those which, through usage, have become associated with that pigment. The use of these names for similarly colored pigments is not permitted by this Standard.

4. GENERAL REQUIREMENTS

4.1. *Pigments* shall be of good grade. Composition and identity shall conform to those listed in table 1. Organic lakes or tones shall not be used to fortify or sophisticate inorganic pigments. Substitution of similarly colored pigments is not permitted.

4.2. *Vehicles* shall consist of pure drying oils; linseed and/or poppy oil only.

4.3. *Driers* may be used in minimum amounts in paints that contain pigments which have a retarding effect on the drying of oils, to allow them to conform to drying-rate requirements (paragraph 4.4). The maximum amount of drier, however, shall not exceed 0.1 percent of cobalt or 0.2 percent of manganese, calculated as metal, on the weight of oil.

4.4 *Drying rate* shall be determined by the sand- and pressure-testing devices. Paints shall dry to both tests within 21 days and not under 3 days at 23 degrees C and 55-percent relative humidity. See paragraph 6.3.

4.5 *Consistency* of artists' oil paints shall be determined by use of a standard 2-kg Paste Paint Consistometer. Readings between 2 and 5 will be acceptable under this Standard. See paragraph 6.5.

4.6. *Brushing* quality of artists' oil paints shall be determined by observing the handling quality of the paint when manipulated with a brush. All artists' oil paints shall brush out smoothly, evenly and easily, leaving a normal brush mark. They shall not be sticky, thick or rubbery, nor too fluid. There shall be no free or excess oil. They shall not contain skin and shall be uniformly ground. They shall retain their form and shall not level out when applied with a palette knife. See paragraph 6.6.

4.7. *Tinting strength* of artists' oil paints shall not be less than that of the standard adopted for each pigment. See paragraph 6.7.

4.8. *Composition* of the paint, governed by the relative amounts of vehicle, pigment, and inert used, shall produce a paint of satisfactory working qualities, conforming to all requirements of this Commercial Standard.

4.9. *Inerts and fillers* shall not be used as extenders, reducers, or diluents.

4.10. *Bodying agents,* such as metallic soaps and/or refined beeswax, may be used only in minimum amounts to produce desirable working qualities, consistency, and to prevent settling of pigment.

5. DETAIL REQUIREMENTS

5.1. *Lightfastness.*—All pigments included in table 1 have been shown to resist fading satisfactorily when used in oil painting and under normal conditions of exposure. No accelerated method of testing for light fastness has been found to be directly comparable with normal use conditions, but for purposes of test, exposure to sunlight under specified conditions has been found to be of some value as a means of grouping paints on the basis of fastness under test conditions (paragraph 6.4). The grouping of pigments covered by this Commercial Standard, when painted in oil on nonabsorbent supports and unmixed with other pigments, is shown in table 1.

5.1.1. Group I paints shall resist fading at full concentration when exposed to direct sunlight at southern exposure under glass at 45-degree angle for 2 months. This shall include at least 600 hours of sunlight, as shown by weather reports from the nearest United States Weather Bureau station.

5.1.2. Group II paints shall resist fading to direct sunlight under the above conditions for 1 month. This shall include at least 300 hours of sunlight.

5.1.3. The above tests shall be made in the period from April 1 to October 1 of any given year. If this method is impractical, or in case of dispute, the paints shall be tested under conditions agreed upon by all parties concerned, but in no case shall their severity be less than specified above either in respect to numbers of hours of direct sunlight or duration of the exposure.

5.2. *Names* under which artists' oil paints conforming to this Commer-

cial Standard are sold, the pigments used in their composition, and the light-fastness group of each, shall conform to table 1, glossary of terms. Only paints whose labels and contents conform to the nomenclature and composition as indicated in the glossary of terms and in paragraph 5.2.1 are acceptable.

TABLE 1. *Standard paints—glossary of terms*

Paint name	Pigment*	Test group (see par. 5.1)
Alizarin crimson	Pigment made from 1–2-dihydroxyanthraquinone and aluminum hydroxide.	I
Burnt sienna	Iron oxide prepared by calcining the natural earth, raw sienna.	I
Burnt umber	Iron oxide and manganese dioxide pigment prepared by calcining raw umber.	I
Cadmium orange	CP cadmium sulfide, CdS, or cadmium sulfoselenide, CdS + CdSe.	I
Cadmium-barium orange	Cadmium sulfide, CdS, or cadmium sulfoselenide, CdS + CdSe, coprecipitated with barium sulfate.	I
Cadmium red, deep Cadmium red, medium Cadmium red, light	CP cadmium sulfoselenide, CdS + CdSe.	I
Cadmium-barium red, deep Cadmium-barium red, medium Cadmium-barium red, light	Cadmium sulfoselenide coprecipitated with barium sulfate, CdS + CdSe + BaSO₄.	I
Cadmium yellow, deep Cadmium yellow, medium Cadmium yellow, light	CP cadmium sulfide, CdS.	I
Cadmium-barium yellow, deep Cadmium-barium yellow, medium Cadmium-barium yellow, light	Cadmium sulfide coprecipitated with barium sulfate, CdS + BaSO₄.	I

Paint name	Pigment*	Test group (see par. 5.1)
Cerulean blue	Combined oxides of cobalt and tin, $CoO.nSnO_2$.	I
Chromium oxide green	Anhydrous chromic oxide, Cr_2O_3.	I
Cobalt blue	Combined oxides of cobalt and aluminum, $CoO.Al_2O_3$.	I
Cobalt green	Combined oxides of zinc and cobalt, $CoO.n.ZnO$.	I
Cobalt violet	Anhydrous cobalt phosphate, $Co_3(PO_4)_2$, or arsenate, $Co_3(AsO_4)_2$.	I
Cobalt yellow	Potassium cobaltinitrite, $CoK_3(NO_2)_6.H_2O$.	II
Flake white	Basic lead carbonate, $2PbCO_3.Pb(OH)_2$.	I
Green earth	Natural earth consisting chiefly of the hydrous silicates of iron, aluminum, magnesium, and potassium.	I
Hansa yellow	Pigments based on a coupling of a substituted phenyl amine with an aceto-acetarylide. The three approved pigments are listed in the Color Index as follows: Hansa yellow G—CI pigment yellow 1 (CI 11680). Hansa yellow 5 G—CI pigment yellow 5 (CI 11660). Hansa yellow 10 G—CI pigment yellow 3 (CI 11710). . . .	I
Indian red (blush shade)	Nearly pure iron oxide, Fe_2O_3. It may be either natural or artificial in origin.	I
Ivory black	Amorphous carbon produced by charring animal bones.	I
Lamp black	A nearly pure amorphous form of carbon made from the condensed smoke of a luminous flame.	I
Light red (scarlet shade)	Nearly pure iron oxide, Fe_2O_3.	I
Manganese blue	Barium manganate with barium sulfate, $BaMnO_4 + BaSO_4$.	I

Paint name	Pigment*	Test group (see par. 5.1)
Manganese violet	Manganese ammonium phosphate, $MnNH_4PO_4$.	I
Mars black	Ferro-ferric oxide, $Fe_2O_3 + FeO$.	I
Mars brown	Artificial ochre consisting chiefly of iron and manganese oxides, $Fe_2O_3 + MnO_2$.	I
Mars orange	Artificial ochre consisting chiefly of iron and aluminum oxides, $Fe_2O_3 + Al_2O_3$.	I
Mars red	Artificial ochre consisting chiefly of iron and aluminum oxides, $Fe_2O_3 + Al_2O_3$.	I
Mars violet	Artificial iron oxide, Fe_2O_3.	I
Mars yellow	Artificial ochre consisting chiefly of hydrous oxide of iron and aluminum, $Fe_2O_3.nH_2O + Al_2O_3.nH_2O$.	I
Mixed white	Mixture of zinc white, ZnO, and white lead, $2PbCO_3.Pb(OH)_2$, percentages to be declared on label.	I
Naples yellow	Lead antimoniate, essentially $Pb_3(SbO_4)_2$.	I
Phthalocyanine blue	Pigment made from a synthetic organic dyestuff, which is copper.	I
Phthalocyanine green	Pigment made from a synthetic organic dyestuff, which is chlorinated copper phthalocyanine.	I
Prussian blue	Ferric ferrocyanide, $Fe_4[Fe(CN)_6]_3$.	I
Raw sienna	Natural earth that consists chiefly of the hydrous silicates and oxides of iron and aluminum.	I
Raw umber	Natural earth that consists chiefly of the hydrous oxides and silicates of iron and manganese.	I
Rose madder	The synthetic red organic dyestuff 1, 2-dihydroxyanthraquinone precipitated on a base of aluminum hydrate.	I
Strontium yellow	Strontium chromate, $SrCrO_4$.	II

Paint name	Pigment*	Test group (see par. 5.1)
Titanium white	A white containing at least 30 percent of titanium dioxide, TiO_2, and free from lead, balance either $BaSO_4$ and/or ZnO.	I
Ultramarine blue	Complex silicate of sodium and aluminum with sulfur.	I
Ultramarine green	Complex silicate of sodium and aluminum with sulfur.	II
Ultramarine red	Complex silicate of sodium and aluminum with sulfur.	I
Venetian red	Artificial or natural iron oxide with varying proportions of inert.	I
Vermilion	Mercuric sulfide, HgS. Can be designated as English, French, or Chinese.	II
Viridian	Hydrous chromic oxide, $Cr_2O_3.2H_2O$.	I
Yellow ochre	Artificial or natural mixture of hydrous iron oxide with alumina and silica.	I
Zinc white	Zinc oxide, ZnO.	I

* There is no claim that all the pigments listed in table 1 are stable and desirable under all conditions. The list at present includes only the better known and more stable pigments. It is to be understood that the chemical formulas used in the tables are not intended to indicate the exact chemical composition of the pigments but rather their approximate or substantial composition. It is recognized that in the preparation of certain pigments it is often necessary to incorporate modifying materials which are not to be regarded as fillers, extenders, or adulterants.

5.2.1. *Special considerations.*—The following general practices of the trade in labeling artists' oil paints are permissible:

(1) Descriptive adjectives such as pale, light, lightest, medium, or deep may be added after paint names.
(2) Manufacturers may supply white paint under a "trademark" name, provided the label indicates the pigments used.
(3) Proprietary names may be used for Phthalocyanine blue and Phthalocyanine green, provided the standard designation appears on the tube label in parentheses under the proprietary name.

5.2.2. *New materials under study.*—In line with developments in the industry, pigments are under consideration for possible future acceptance as standard colors, pending additional investigation and testing. Those currently in this group are listed in table 2.

TABLE 2. *New materials under study*

Paint name	Pigment
Cadmium-vermilion reds: light, medium-light, medium, dark, and maroon.	*Typical structural formula* Cadmium-mercury sulphides
Quinacridones Quinacridone Magenta Quinacridone Red, blue shade Quinacridone Red, yellow shade Quinacridone Violet	Pigments made from linear quinacridone compounds as follows:

5.3. *Containers.*—Artists' oil paints shall be packed in tubes made of a suitable metal.

5.3.1. Standard size tubes shall be approximately 2.5 x 10 cm over-all and shall contain not less than 37 ml of paint.

5.3.2. When smaller size tubes are required, they shall be approximately 1.3 x 10 cm over-all, containing not less than 10 ml, or approximately 1.3 x 5 cm over-all, containing not less than 5 ml.

5.3.3. White paint may be packed in tubes approximately 3.8 x 15 cm over-all, containing not less than 62 ml.

6. METHODS OF TEST

6.1. *Sampling.*—The contents of a previously unopened tube of paint shall be completely emptied on a glass slab and mixed thoroughly with a spatula in order to obtain a homogeneous sample.

6.2. *Pigments* generally may be identified by the usual methods of analysis and identification of inorganic and organic compounds.

6.3. *Drying rate.*—Apparatus, preparation of samples, schedule, procedure, and interpretation are given below.

6.3.1. *Suggested apparatus.—*

 (1) Humidity- and temperature-controlled test room, maintaining approximately 23 degrees C temperature and 55-percent relative humidity.

 (2) Sand-testing apparatus. (See fig. 1.)

 (3) Pressure-testing apparatus. (See fig. 2.)

 (4) Bronze template 0.25 mm in thickness, for use on 7.5. x 12.5 cm test panels. (See item 5.)

 (5) 7.5 x 12.5 cm glass panels (window-glass thickness).

 (6) 2-ml measuring ring.

 (7) Doctor blade.

STANDARD, FIGURE 1. *Sand-type machine for drying-rate test.*
For description and close-up photograph, see H. A. Gardner, *Physical and Chemical Examination of Paints, Varnishes, Lacquers and Colors,* ninth edition, Washington, D.C., Institute of Paint and Varnish Research (1939), pp. 110–11.

(8) 50-ml burette.

(9) Palette knife.

(10) Glass or marble mixing slab.

6.3.2. *Preparation of test panels.*—Two ml of the paste paint are measured out in the ring and placed on the test plate; $1/5$ ml of turpentine is added from a burette or graduated syringe and thoroughly mixed with the paste with a palette knife. The thinned paint is spread out on the glass panel to 0.25 mm in thickness with the aid of the template and a doctor blade.

6.3.3. *Schedule.*—All tests are to be conducted in the controlled test room, and the specimens are to remain there until the tests are completed. The first test is to be made at the end of 3 days (72 hours) and the

STANDARD, FIGURE 2. *Pressure-type machine for drying-rate test.*
For description and close-up photograph, see H. A. Gardner, *Physical and Chemical Examination of Paints, Varnishes, Lacquers and Colors,* ninth edition, Washington, D.C., Institute of Paint and Varnish Research (1939), pp. 118–19.

second at the end of 21 days (504 hours) after the paint has been applied and the sample has been deposited in the test room.

6.3.4. *Procedure and interpretation.—*

(1) Surface-drying rates shall be tested with the sand-type instrument (fig. 1), which permits 1 g of sand to flow over the painted surface held at an angle 45 degrees with the vertical. For incidental tests, if this instrument is not available, sand may be poured by hand from a teaspoon. Sand shall not stick to the film nor leave a visible mark.

(2) Film-drying rates shall be tested with the pressure-type instrument (fig. 2), by which a 200-g weight is applied. For incidental tests, an ordinary metal ring with a sharp edge (like a wedding ring) pressed on the paint film by a 200-g weight may be used. The ring shall leave no visible mark on the film.

6.4. *Light fastness* shall be determined in an out-of-door (roof) exposure rack.

6.4.1. The exposure rack shall be constucted to hold panels at a 45 degree angle to southern exposure. The specimen shall be protected from rain and dirt by glass windows placed not less than 2 inches from the surface of the specimen. The windows shall be kept clean throughout the test. No obstruction shall interfere with exposure to full sunlight at all times of the day.

6.4.2. Support for exposure tests shall be smooth opaque white, or opal, glass. Two specimen panels at least 7.5 x 12.5 cm in size shall be prepared by brushing out the paint as it comes from the tube without addition of thinner. In referee tests, a Bird applicator giving a film thickness of 0.075 mm shall be used. When dry, but not before 1 week, one specimen is placed in the exposure rack and left for a period conforming to its light-fastness group (see paragraph 5.1). The control panel shall be kept in diffused light during the period. The extent of fading shall be judged by comparison of the exposed panel with the control panel. A suitable varnish may be applied to differentiate between fading and chalking.

6.5. *Consistency* is measured with an instrument by which the paste paint is deformed under pressure.

6.5.1. *Equipment.—*

(1) Brass template approximately 4 inches square and 6.3 mm thick with centered hole (diameter 2.0 cm) to contain 2.0 ml of paint.

(2) Glass plate with eight concentric circles, numbered from 0 to 7 withradii 1.0, 1.5, 2.0, 2.5, 3.0, 3.5, 4.0, 4.5 cm respectively. The innermost circle corresponds to the center hole in the brass template.The chart is drawn on paper and glued to the back of the glass.

(3) Wooden frame for housing template and glass.
(4) Palette knife for applying paint to template.
(5) Two-kg weight.
(6) Glass plate for placing on top of paint after template has been removed.

6.5.2. *Procedure.*—Place the glass plate with concentric rings face up in the bottom of the wooden frame. Place brass template over glass plate; if no frame or housing is used be sure the template is centered. Fill hole of template with paint to be tested and level off. Lift template from plate, take the plain glass plate and lay on the paint and apply evenly the 2-kg weight, allowing it to stand until the paint has ceased to spread. Paint of proper consistency shall spread over the number 2 ring and not over the number 5 ring.

6.6. *Brushing quality.*—This quality shall be determined by technicians skilled in the use of artists' oil paints. The characteristics of the paint shall be observed so as to determine its conformity with paragraph 4.6. The following descriptive terms denoting certain qualities of particular significance to artists shall be used in accordance with the definition given:

Smooth, describes a paint which spreads evenly and easily, leaving a normal brush mark.

Sticky or tacky, describes a paint which is thick, viscous, or rubbery, and difficult to apply.

Fluid, describes a paint which flows too rapidly for correct handling. Paints very fluid in character leave few or no brush marks, and when applied in impasto lose form and "level out." Any change in the level of paint over a period of 24 hours should be observed.

6.7. *Tinting strength.*

6.7.1. *Suggested equipment.*—

(1) Syringe, template, measuring ring, or other suitable device for volumetric reduction of paste paints, 20:1 and 10:1.
(2) Glass slab for use in mixing the pastes.
(3) Spatula (paint knife) for mixing.
(4) Reflectometer (or other suitable colorimetric device) for determination of reflectance.*

6.7.2. *Materials.*—Zinc oxide standard reduction paste made from the following formulas as outlined by the Federation of Paint and Varnish Production Clubs, Official Digest, No. 120, p. 1029 (November 1932) and published in H. A. Gardner's *Physical and Chemical Examination of Paints, Varnishes, Lacquers, and Colors,* 11th edition, page 40 (1950).

* Such as the Hunterlab D 40 Reflectometer.

300 parts by weight Green Seal zinc oxide.
64 parts by weight poppy seed oil.
2 parts by weight calcium stearate.
1 part by weight turpentine.

6.7.2.1. If, for certain uses, it is found that the above reduction paste dries too slowly, it is permissible to add 0.213 part by weight of 6-percent cobalt naphthenate drier to give 0.02 percent of metallic cobalt based on the weight of the oil.

6.7.3. *Procedure.*—Reduce 1 volume of the paint to be tested with 20 volumes of the standard reduction paste. Mix thoroughly with a spatula on glass slab. (The tinting-strength tests for Green Earth and Ultramarine Red and Cobalt Violet are made by reduction with standard reduction paste 10:1. The tinting-strength standards of paints made with these pigments have been made by 10:1 reduction instead of 20:1 because they have inherently low tinting strength.) Paint out or spread out the reduced paint on a test panel of suitable material to a thickness adequate to produce total opacity. After drying, the daylight reflectance (CIE illuminant source C) at 45 degrees shall be determined by means of a device such as specified in paragraph 6.7.1. The value obtained should not exceed the "Y" values in table 3 by a relative value of greater than 10 percent in reflectance. Only the "Y" and "Value" columns are to be considered in making tinting-strength observations; the columns "X," "Z," "Hue," and "Chroma" are given in table 3 as general information. The tristimulus values in table 3 were obtained in 1951 from the original master set of tinting-strength standards on file in the National Bureau of Standards. These color swatches were in force as standards from May 10, 1942, until they were superseded by this paragraph January 1, 1952.

7. LABELING

7.1. *Labeling* of artists' oil paints shall indicate the following:

7.1.1. The complete paint name, indicating pigment composition in conformance with the standard nomenclature in the glossary of terms (tables 1 and 2, paragraphs 5.2 and 5.2.1), shall be clearly printed on one side of the tube in letters of equal size and importance. Subtitles, which are permitted in paragraph 5.2.1, shall appear in smaller type and in parentheses directly under the paint name.

7.1.2. Contents expressed in milliliters.

7.1.3. The guarantee of conformance to the Commercial Standard.

8. IDENTIFICATION

8.1. In order that purchasers may be assured that artists' oil paints actually comply with all the requirements of this Commercial Standard, it is recommended that manufacturers include the

following statement in conjunction with their name and address on labels, invoices, sales literature, etc.

This artists' oil paint complies with Commercial Standard CS98–62, as developed by the trade, under Commodity Standards Procedures, and issued by the U.S. Department of Commerce.

The following abbreviated statement is suggested when available space on labels is insufficient for the full statement: Conforms to CS98–62.

TABLE 3. *Tinting-strength standards**

Paint name†	Tristimulus values			Munsell notation		
	X	Y	Z	Hue	Value	Chroma
Alizarin crimson	42.0	31.0	34.2	6.0RP	5.7	10.0
Burnt sienna	39.8	34.5	22.4	2.5YR	6.2	4.5
Burnt umber	31.4	30.0	24.8	6.5YR	5.8	3.0
Cadmium orange	55.9	46.0	17.7	2.5YR	7.3	9.5
Cadmium-barium orange	61.2	57.0	31.3	7.5YR	8.0	7.5
Cadmium red, deep	30.8	24.0	23.6	9.0RP	5.2	5.5
Cadmium red, medium .	40.8	30.0	20.7	4.0R	5.8	10.0
Cadmium red, light	50.9	40.0	24.2	7.5R	7.0	10.0
Cadmium-barium red, deep	38.3	32.0	33.6	9.0RP	6.0	5.0
Cadmium-barium red, medium	41.4	31.5	24.8	4.0R	6.0	9.0
Cadmium-barium red, light	51.4	39.0	24.8	7.0R	7.0	12.0
Cadmium yellow, deep .	60.4	57.5	18.3	9.0YR	7.8	9.0
Cadmium yellow, medium	65.1	67.5	17.7	4.0Y	9.0	12.0
Cadmium yellow, light ..	66.4	74.5	21.2	8.0Y	9.2	9.0
Cadmium-barium yellow, deep	63.9	62.5	25.4	1.0Y	8.2	8.0
Cadmium-barium yellow, medium	67.9	71.0	25.4	4.0Y	9.2	9.5
Cadmium-barium yellow, light	69.6	77.5	34.2	8.5Y	9.2	7.5
Cerulean blue	50.8	55.0	81.4	1.0PB	8.2	4.5
Cobalt blue	43.6	45.0	83.8	3.5PB	7.2	8.0
Cobalt green	58.9	63.0	73.8	1.0B	8.2	1.3
Cobalt violet	55.3	49.5	76.7	2.5P	7.4	5.5
Cobalt yellow	69.2	74.0	47.2	7.5Y	9.3	5.0
Green earth	58.4	62.5	68.4	9.0BG	8.2	1.3
Indian red	25.6	21.5	21.2	1.0R	5.2	4.5
Ivory black	32.0	33.0	41.9	5.0PB	6.6	0.4

Paint name†	Tristimulus values			Munsell notation		
	X	Y	Z	Hue	Value	Chroma
Lamp black	13.9	14.0	20.1	5.0PB	4.2	1.3
Light red	33.6	27.0	20.7	6.0R	5.7	6.0
Manganese blue	52.9	59.0	87.3	7.0B	8.1	6.0
Mars violet	24.1	22.0	26.6	2.5RP	5.1	2.5
Mars yellow	55.5	55.0	28.3	1.0Y	7.8	6.5
Phthalocyanine blue . . .	16.2	17.0	56.1	3.5PB	4.6	14.0
Phthalocyanine green . . .	18.0	26.0	39.5	7.5BG	5.3	8.0
Prussian blue	15.4	16.0	46.0	4.5PB	4.2	10.5
Raw sienna	55.0	54.0	37.8	1.0Y	7.6	4.5
Raw umber	41.9	42.5	38.4	1.5Y	6.9	2.0
Rose madder	63.5	57.5	67.3	2.5RP	7.4	6.0
Strontium yellow	72.7	79.0	54.3	10.0Y	9.3	5.0
Ultramarine blue	35.8	36.0	79.7	5.0PB	6.3	10.0
Ultramarine green	56.2	59.5	78.5	1.0PB	8.2	2.5
Ultramarine red	56.1	50.5	69.0	0.4RP	7.3	7.0
Venetian red	27.7	21.5	13.6	7.0R	5.0	6.0
Vermilion, English	49.7	37.5	26.6	5.5R	6.4	10.0
Vermilion, Chinese	50.9	42.0	42.5	10.0RP	6.9	9.5
Viridian	41.8	49.5	64.3	7.5BG	7.3	4.5
Yellow ochre	67.2	67.5	49.6	1.5Y	8.7	5.0

* Tinting-strength standards for the following pigments have not yet been established:

Chromium oxide green	Mars black	Mars red
Hansa yellow	Mars brown	Naples yellow
Manganese violet	Mars orange	

† For a detailed description of the ISCC–NBS color names for these paints reference may be made to NBS Circular 553, The Inter-Society Color Council–National Bureau of Standards, *Method of Designating Colors and a Dictionary of Color Names,* by Kenneth L. Kelly and Deane B. Judd. Available from Superintendent of Documents, U.S. Government Printing Office, Washington, D.C. 20025.

BRITISH STANDARD 2876: 1957

Published by the British Standards Institution and titled *Powder Pigments for Artists' Use,* this standard differs from CS98–62 in that it is confined to pigment specifications, does not consider performance characteristics, and is not limited to colors suitable for permanent fine-art painting; therefore it has a number of colors not included in the American list. Its nomenclature varies from American practice in the following instances: Aureolin for cobalt yellow, lemon yellow for barium yellow, terre verte for green earth, and French ultramarine blue. It also has cadmium green for the mixed color called permanent green by American manufacturers.

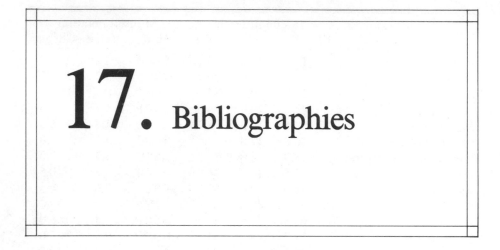

17. Bibliographies

In the following lists of books, an attempt has been made to select representative works on each subject, rather than to collect every available reference. The lists are therefore by no means exhaustive. As far as possible they include only widely available volumes; few of the books mentioned are not to be obtained at the larger, more complete libraries. An effort has also been made to limit the listings to American and English works, mention being made of books in other languages only when they contain significant material not available in English. Most of the complete manuals and studies listed contain extensive bibliographies on their specialized subjects; these should be consulted when further titles are required.

The annotations are intended as brief guides. Partly adverse criticism does not imply that the work is considered bad; books of slight value and outmoded books have been excluded. Inclusion not only denotes approval, at least in part, but in many cases indicates that the work has in some way influenced the material in this book.

Books have been listed by subject rather than alphabetically by author because this seemed a more efficient method.

It may be remarked that few intelligent users of technical books expect that they can be taught a craft by reading about it; they recognize that such books are similar in function to their other means of acquiring proficiency, and that some degree of skill is required to get the best from them. Also there are valuable books on techniques written by artists on the basis of personal experience; these are naturally colored by the writers' own artistic aims and practices, which are often at variance with those of the reader. One must be able to ex-

tract from such accounts the matter that is directly applicable to general technical procedure or to one's own purposes, and to overlook such prejudices and opinions as may be antagonistic to one's own. Technical works written from an industrial or other nonartistic viewpoint are also difficult to apply, and only the artist of considerable practical experience in the materials or methods under discussion can adapt or transpose such matter to his or her own purposes. However, because this branch of the subject has a fundamental bearing upon any complete study of the materials, selections of these works have been included.

My precautions on page 668 about adopting old writings and obsolete recipes as guides to practice should be noted.

Some of the more complete books on artists' materials and techniques contain extensive bibliographies, notably A. P. Laurie's *Materials of the Painter's Craft,* which has books and manuscripts from classical times to 1910; and Maria Bazzi's *The Artist's Methods and Materials,* which includes books up to the 1950s.

The following two general art bibliographies cover all branches of the visual arts as well as the technical. New editions are expected as time goes on.

Guide to Art Reference Books—Mary W. Chamberlin. Chicago, American Library Association, 1959.

The Harvard List of Books on Art—E. Louise Lucas. Cambridge, Mass., Harvard University Press, 1952.

GENERAL REFERENCE

Dictionaries of Art and Technical Terms since 1962

A Dictionary of Art Terms—Reginald Haggar. London, George Rainbird, Ltd., 1962; New York, Hawthorn Books, Inc., 1962.

The Pergamon Dictionary of Art—John FitzMaurice Mills. London, Pergamon Press, 1965.

A Dictionary of Art Terms and Techniques—Ralph Mayer. New York, Thomas Y. Crowell Company, 1969; New York, Apollo Editions, 1975 (paperback).

Architectural Terms

Dictionary of Architecture—Henry H. Saylor. Science Editions (paperback). New York, John Wiley & Sons, 1952.

The Penguin Dictionary of Architecture—John Fleming, Hugh Honor, Nikolaus Pevsner. Baltimore, Penguin Books, Inc., 1966 (paperback).

Commercial Art Topics

Advertising Agency and Studio Skills—Tom Cardamone. New York, Watson-Guptill Publications, 1959, revised 1970, 1981.

Fell's Guide to Commercial Art—Roy Paul Nelson and Byron Ferris. New York, Frederic Fell, Inc., 1966. Extensive bibliography.

Preparing Art for Printing—Bernard Stone and Arthur Eckstein. New York, Reinhold Publishing Corporation, 1965.

The Complete Airbrush Book—S. Ralph Maurello. Secaucus, N.J., Amiel Publishing Company, 1954.

How to Cut Drawings on Scratchboard—Merritt Dana Cutler. New York, Watson-Guptill Publications, 1960.

Drawings on Scraper Board—Edward S. Billen. London, Sir I. Pitman, 1952.

Reference Encyclopedia of Package Printing Techniques and Equipment— Robert P. Long. Philadelphia, North American Publishing Company, 1973.

EARLY PAINTING MATERIALS AND METHODS

The older books, including those of the mid-nineteenth century containing translations and comments based primarily upon studies of the early manuscripts, are valuable sources for study but as a rule cannot be used as practical manuals for artists. For example, the English books of the middle of the nineteenth century that mention tempera methods and materials were written from an oil-painting viewpoint, the interest in tempera being purely academic; the identification of raw materials mentioned in early documents and the interpretation of procedures recorded call for technical and artistic qualifications that the authors of these books did not always possess. See the next group of books for works written from a more modern viewpoint. Modern students apply analytical and synthetic methods to the examination of early works of art, and combine the results so obtained with the study of early writings to a greater extent than did former authors, the majority of whom relied almost entirely upon their own translations or interpretations of books and manuscripts.

The student or user of the books in this section should also note the matters discussed on pages 18, 28–29, and 212–13.

1. *Theophrastus' History of Stones,* with an English version and notes by Sir John Hill. London, C. Davis, 1774. Manuscript of the fourth century B.C.; one of the earliest Greek sources. Pliny incorporated it in his works. Mentions a few pigments, etc.

2. *Vitruvius on Architecture.* Edited and translated with notes by Frank Granger. 2 Vols. New York, G. P. Putnam's Sons, 1931–34; London, William Heinemann, Ltd. A first-century B.C. treatise on architecture, building and general mechanical and technical subjects, including many topics relating to the Roman materials and methods of fresco painting of the day, which were based on Greek practice.

3. *Ten Books on Architecture,* by Vitruvius (Marcus V. Pollio). Translated by Morris Hickey Morgan and edited by Andrew Howard and Herbert L. Warren. Cambridge, Mass., Harvard University Press, 1914. (A standard American translation.)

4. *The Elder Pliny's Chapters on Chemical Subjects.* Edited with translation

and notes by Kenneth C. Bailey. 2 Vols. New York, Longmans, Green, and Company, 1929.

5. *The Elder Pliny's Chapters on the History of Art.* Translated by K. Jex-Blake; commentary and introduction by E. S. Strong, and notes by Dr. Heinrich L. Uhrlichs. London, Macmillan, 1896. Updated with a new introduction and select bibliography by R. V. Schoder. Chicago, Argonaut Inc., Publishers, 1966. Pliny's work is largely a compilation of the general knowledge of his day (first century A.D.), some of it mythical and some correct. Some of his material on painting comes from Greek sources, other parts stem directly from Vitruvius. He is rather vague on many important details of studio practice, either because he felt that they were common knowledge and not worth going into, or because he had slight first-hand acquaintance with them. Pliny, Vitruviuus, and Theophrastus are almost our only literary sources for studies of Greek and Roman materials and techniques. When other writers of this and earlier periods are cited, it is usually with reference to a brief mention or to isolated remarks, sometimes merely a clue or the incidental use of a term or name of a material in some nontechnical work.

6. *The Greek Herbal of Dioscorides.* "Illustrated by a Byzantine A.D. 512, Englished by John Goodyear A.D. 1665, Edited and first printed by Robert T. Gunther, Oxford; printed by John Johnson for the author at the University Press, 1934." Manuscript originally written in the first century, and rather widely disseminated and translated in medieval times. A description of natural products and some processes, written form a medical viewpoint. Mentions a few pigments, oils, resins, gums, and solvents.

7. *Theophilus, The Various Arts.* Translated from the Latin with an introduction and notes by Charles R. Dodwell, Oxford. New York, Thomas Nelson & Sons, 1961. The treatise of Theophilus Presbyter, generally accepted as the standard work on early Northern methods and materials, as that of Cennini is for Italy. The date is disputed, but is more often said to be twelfth than eleventh century. The work covers a variety of arts and crafts. There are also numerous earlier English and later French and German translations.

8. *The Book of the Art of Cennino Cennini,* a fifteenth-century *trattato* (treatise), our most complete and authentic source for early materials and techniques. Three manuscript copies exist. They have been translated in the following editions:

Di Cennino Cennini, Trattato della pittura. Messo in luce la prima volta con annotazioni dal Cavaliere Giuseppe Tambroni. Rome, 1821.

Il libro dell' arte o trattato della pittura di Cennino Cennini da Colle Valdelsa; di nuovo publicato con multi correzione e coll aggiunta di piu capitoli tratti dai codici fiorentini—Carlo e Gaetano Milanesi. Florence, 1859.

Cennino Cennini da Colle Valdelsa, Il libro dell' arte. Edizione riveduta e corretta sui codici. Lanciano, R. Carrabba, 1913.

Le livre de l'art ou traité de la peinture par Cennino Cennini traduit par Victor Mottez, mis en lumière pour la première fois avec des notes par le Chevalier G. Tambroni. Paris and Lille, 1858; second edition, Paris, L. Rouart et J. Watelin,

1911. The second edition includes seventeen chapters newly translated from the Milanesi edition, a preface by Mottez, a letter form his friend Auguste Renoir, and further notes and clarifications on fresco.

Boken om malarkonsten fan V. Mottez franska version—Sigurd Moller. Stockholm, A. Bonnier, 1948.

Cennino Cennini da Colle Valdelsa, das Buch von der Kunst oder Tractat der Malerei. Übersetzt mit Einleitung, Noten und Register versehen von Albert Ilg. Vienna, Wilhelm Baumuller, 1871, new edition, 1888.

Das Cennino Cennini Handbuchlein der Kunst neuübersetzt und herausgegeben—Willibrord Verkade. Strasbourg, Heity, 1916.

Cennino di drea Cennini, written 1437 and published in Italian 1821 by Tambroni—Mary P. Merrifield. London, E. Lumley, 1844. The first English translation; of considerable interest, but superseded since 1899 by that of Lady Herringham.

The Book of the Art of Cennino Cennini—Christiana J. Herringham. London, George Allen, 1930. A carefully studied translation from the point of view of an artist and practical student of techniques, with notes including a review of and some comparisons with other early manuscripts, interpretations and explanations of the texts, and studies of the materials mentioned. Opinions on modern materials and their applications somewhat out of date (original edition 1899).

Cennino di Drea Cennini da Colle di Val d'Elsa. Il libro dell'Arte. Edited by Daniel V. Thompson, Jr. New Haven, Yale University Press, 1932. The translation is in a companion volume:

The Craftsman's Handbook—Daniel V. Thompson, Jr. New Haven, Yale University Press, 1933. This presentation of the original and its translation is made in the light of modern understanding of the technology of painting. Paperback reprint, New York, Dover Publications, 1954.

9. *The Student's Cennini. A Handbook for Tempera Painters*—Viola and Rosamund Borradaile. Brighton, England, The Dolphin Press, 1942. An interpretation and guide to the practical application of Cennini's instructions on tempera painting.

10. *De pictura*—L. B. Alberti. Translated with introduction and notes by John R. Spencer. New Haven, Yale University Press, 1956. Revised ed. (paperback), 1966, entitled *Leon Battista Alberti on Painting*. A fifteenth-century Florentine work on various aspects of art and painting, noted for its study of perspective.

11. *Vasari on Technique.* Translated by Louisa S. Maclehose. London, J. M. Dent, 1907. Paperback reprint, New York, Dover Publications, 1960. An English translation and commentary. Vasari published *Lives of the Painters* in 1550 and revised it in 1586. Originally it contained several technical chapters entitled "The Three Arts of Design," which constitute an outline of first-hand technical data on sixteenth-century painting, sculpture, and architecture written by Vasari as an active practitioner. They are concise, to the point, and free from the fables, legends, and flights of fancy to which he was prone as a histo-

rian, and, as noted on page 18, his anecdotal biographies have been copiously quoted by later writers and students, but his technical chapters are generaly ignored; somehow they have been consistently omitted from the many English and American editons of the *Lives*. Vasari's tales about the Van Eycks and Antonello da Messina, for example, have been generally disproved, but their influence still lingers, depite the fact that they were doubted as early as 1781 (see item number 5).

12. *A Tracte, Containing the Artes of Curious Paintinge, Carvinge and Buildinge*—Richard Haydocke. Oxford, 1598. A translation of *Trattato del arte della pittura, scultura ed architettura* of Giovanni Paolo Lomazzo, Milan, 1584.

13. *Arte de la pintura su antiguedad y grandezas*—Francisco Pacheco. Seville, 1649; Madrid, 1871. Spanish treatise on painting by Velasquez's father-in-law.

14. *Leonardo da Vinci, Treatise on Painting.* Translated and illustrated by A. Philip McMahon, introduction by Ludwig H. Heidenreich. 2 Vols. Princeton, Princeton University Press, 1956.

15. *A Critical Essay on Oil Painting*—Rudolph Erich Raspe. London, H. Goldney, 1781. "An essay on oil painting; proving that the art of painting in oil was known before the pretended discovery of J. and H. Van Eyck, to which are added Theophilus, de arte pingendi, Eraclius de artibus Romanorum etc., review of Farinator's Lumen Animae." Raspe's studious work is a milestone of research on artists' technical practices; he introduced the manuscripts of Theophilus, Eraclius, and Cennini and was the first to point out the inaccuracies in some of Vasari's historical statements. Raspe is better known as the author of *Baron Munchausen.*

NOTE. Numerous practical handbooks on artists' methods and materials were written in England during the seventeenth and eighteenth centuries; they are interesting, but they seldom contain valuable information that is not found in the earlier works or matter of practical value that has not been superseded by nineteenth-century books. Most art libraries contain examples. The following is a small selection.

16. *A Very Proper Treatise Wherein Is Breefly Sett Forthe the Arte of Limning.* London, 1573. 6th edition, 1605.

17. *A Treatise concerning the Arte of Limning, Writ by N. Hilliard.* First annual volume of the Walpole Society, Oxford, Oxford University Press, 1912. Manuscript on miniature painting written about 1600 by Nicholas Hilliard, first great English miniaturist.

18. *Ars Pictoria, or an Academy Treating of Drawing, Painting, Limning, Etching. With Appendix on Miniature Painting*—Alexander Browne. London, 1675.

19. *Polygraphice: or the Arts of Drawing, Engraving, Etching, Limning, Painting, Varnishing, Japaning, Gilding, etc.*—William Salmon, M.D. London, 1672. Many later editions. 8th edition, 1701. Covers several odd topics as well as artists' materials.

20. *The Art of Painting in Oyl*—John Smith. London, 1676. Many later editions. 6th edition, 1723.

21. *A Treatise on the Art of Painting*—W. M. Craig. 2 Vols., London, 1817. Translation of *Het groot schilderboeck* by Gerard de Lairesse. Amsterdam, 1707.

22. *The Practice of Painting Made Easy; in Which Is Contained the Art of Painting in Oil, with the Method of Colouring*—Thomas Bardwell. London, 1756. This book had a high reputation in its day and although Bardwell printed an elaborate royal copyright and autographed every copy of the edition it was widely pirated and copied.

23. *The Handmaid to the Arts*—R. Dossie. London, 1758. 2 Vols., 1764, 1796. Covers a number of arts, crafts, and trades as well as Dossie's "materia pictoria." Interesting preface.

24. *The Art of Painting in Oil and in Fresco*—J. F. L. Mérimée. Translated from the 1830 edition (Paris) by W. B. Sarsfield Taylor. London, Whittaker and Company, 1839. One of the first of the carefully written books on methods and materials; an authentic account of the knowledge of its day. However, this period was a low point in the rational development of artists' technical practices and the reader should not blindly accept the book as a guide to practical painting, especially on the point of his recipes for oil painting vehicles and mediums, some of which, although attributed to early European masters, actually stem from outmoded trade or industrial practices. Some will be recognized as among those hardy perennials, the "secrets of the old masters."

25. *A Manual of Fresco and Encaustic Painting*—W. B. Sarsfield Taylor. London, Chapman and Hall, 1843. One of the earliest complete and intelligent English studies on fresco.

26. *The Art of Fresco Painting as Practised by the Old Italian and Spanish Masters—with an Inquiry into the Nature of the Colors Used*—Mary P. Merrifield. London, C. Gilpin, 1846. Reprinted by Alec Tiranti, Ltd., London, 1952, with illustrations and with an introduction by A. C. Sewter. Paperback reprint, London, Alec Tiranti, and New York, Transatlantic Arts, 1966.

27. *Original Treatises Dating from the Twelfth to the Eighteenth Centuries, on the Arts of Painting, etc., etc.*—Mary P. Merrifield. 2 Vols. London, J. Murray, 1849. Paperback reprint under the title *Materials and Methods of Painting of the Great Schools and Masters,* 2 Vols., New York, Dover Publicatons, 1960. English translations of many old manuscripts. For the Strasburg manuscript, see number 57.

28. *Materials for a History of Oil Painting*—Sir Charles L. Eastlake. London, Longman, Brown, Green and Longman, 1847. Paperback reprint, 2 Vols., New York, Dover Publications, 1967. With a new introduction and glossary by S. M. Alexander. One of the most complete studies of painting materials, methods, and techniques ever undertaken on the basis of literary sources of the past. There is also a two-volume edition of 1869, which contains added posthumous notes and an index which is lacking in the original; the author had planned to expand his work to larger proportions.

29. *Ancient and Modern Colors from the Earliest Periods to the Present Time with Their Chemical and Artistical Properties*—William Linton. London, Longman, 1852. A study of ancient colors and mediums from documentary sources.

30. *Hints to Young Painters and the Process of Portrait Painting*—Thomas Sully. Philadelphia, J. M. Stoddart, 1873; reprinted in a limited edition with an illustrated introduction by Faber Birren, New York, Reinhold Publishing Corporation, 1965. Contemporary accounts of various early nineteenth-century American artists' techniques.

31. *A Documentary History of Art.* 2nd edition. Edited by Elizabeth B. Holt. Garden City, N.Y., Doubleday and Company, 1957.

TWENTIETH-CENTURY STUDIES OF EARLY PAINTING MATERIALS AND METHODS

The general books on painting materials and methods listed in the next group also contain many references to this subject, especially in relation to modern practice.

32. *Beitrage zur Entwickelungs-Geschichte der Maltechnik*—Ernst Berger. Munich, Callwey, 1904–09. Vols. 1 and 2 —antiquity; Vol. 3—from the Byzantine era to the Van Eycks and oil painting; Vol. 4—sixteenth to eighteenth centuries. Vol 3 contains the De Mayerne Manuscript in German and in the original polyglot in which it was written. Complete studies of painting techniques from manuscripts, archaeological relics, and chemical research. Fully illustrated. Contains some original opinions that have since been much disputed.

33. *Mural Painting*—F. Hamilton Jackson. London, Sands and Company, 1904. Written as a handbook for painters, this book is most interesting for its excellent reviews and reprints of older practices in encaustic, fresco, and oil and as a record of past experimental work.

34. *Arts and Crafts of Ancient Egypt*—W. Flinders Petrie. Edinburgh, T. N. Foulis, 1909. Petrie has written much else on Egyptian techniques.

35. *Fresco Painting, Its Art and Technique*—James Ward. London, Chapman and Hall, 1909. A description of the buon fresco process of Renaissance Italy and its adaptation to English practice; description of nineteenth-century English methods; critical studies of frescoes of the Italian masters.

36. *Greek and Roman Methods of Painting*—A. P. Laurie. Cambridge, University Press, 1910. "Some comments on the statements made by Pliny and Vitruvius about wall and panel painting." Original interpretations and studies of early methods and materials.

37. The work of Noël Heaton on the Minoan frescoes, referred to in the text, was published in several papers, with additions and alterations appropriate to the interests of the various audiences to whom it was presented, as follows: "The Decorator of Ancient Times." *Papers of the Paint and Varnish Society,* London, 1911, p. 93; "Minoan Lime Plaster and Fresco Painting."

Journal of the Royal Society of British Architects, London, 1911; "The Materials and Methods of Decorative Painting." *Royal Society of Arts, Cantor Lectures,* London, 1912; "The Mural Paintings of Knossos." *Papers of the Society of Mural Decorators and Painters in Tempera,* Vol. II. London, 1925. (See number 58.)

38. *On the Nature and Method of Execution of Specimens of Painted Plaster from the Palace of Tiryns*—Noël Heaton. N.d., n.p.

39. *The Materials of the Painter's Craft in Europe from the Earliest Times to the XVIIth Century with Some Account of Their Preparation and Use*—A. P. Laurie. Edinburgh, T. N. Foulis, 1910. An illustrated study of ancient painting materials and methods, with an extensive bibliography.

40. *The Pigments and Mediums of the Old Masters*—A. P. Laurie. London, Macmillan, 1914. Studies of old techniques based on chemical and microscopic examinations as well as upon a study of early records. Microscopy of brushwork and microchemical examination described.

The writings of A. P. Laurie, the most distinguished British authority on painting techniques of the first half of the twentieth century, have had a great influence on all modern workers in the field.

41. *On the Chemistry of the Ancient Assyrians*—R. Campbell Thompson. London, Luzac and Company, 1925. Contains many references to pigments.

42. *Ancient Egyptian Materials and Industries.* 2nd edition—A. Lucas. London, E. Arnold and Company, 1934. A carefully authenticated study of Egyptian technology, including the materials and methods used in the arts.

43. *Origins and Development of Applied Chemistry*—J. R. Partington. London, Longmans, Green, 1935. Studies of pigments, other materials, and technical processes of the earliest civilizations; very complete and detailed references.

44. *The Materials of Medieval Painting*—Daniel V. Thompson, Jr. London, G. Allen and Unwin, 1936. Early methods and materials lucidly explained. Paperback reprint, New York, Dover Publications, 1956.

45. *A Method of Painting in Classical Times*—Prentice Duell and Rutherford J. Gettens. *Technical Studies,* Vol. IX, No. 2, October 1940. A review of Etruscan wall painting with a detailed technical study of one of the tombs at Tarquinia.

NOTE. See also recent editions of old works such as 8, 10, and 11.

PAINTING MATERIALS AND METHODS—TWENTIETH CENTURY

46. *Letters to a Painter on the Theory and Practice of Painting*—W. Ostwald. Translated by H. W. Morse. New York, Ginn and Company, 1907. The first twentieth-century book on the subject, by a noted German chemist (see number 271); contains much original and practical information on the principles of sound working methods.

47. *The Chemistry of Paints and Painting.* 4th edition—Arthur H. Church. London, Seely, Service and Company, 1915. For many years the outstanding

artists' book on materials and methods. Although outmoded in part, it is still of considerable value and interest. The author was a leading English authority of the nineteenth and early twentieth centuries.

48. *Materials for Permanent Painting* (1911) and

49. *How to Paint Permanent Pictures* (1922)—Maximilian Toch. New York, Van Nostrand. Instructions to artists on correct technique for oil painting, by an American authority.

50. *Entwickelung und Werkstoffe der Wandmalerei*—Alexander Eibner. Munich, Heller, 1926. A study of mural methods and materials of all ages. Extensive bibliography.

51. *The Painter's Methods and Materials*—A. P. Laurie. Philadelphia, Lippincott, 1926. Paperback reprint, New York, Dover Publications, 1967. Covers most of the essential points on oil, tempera, and fresco painting in a satisfactory manner.

52. *The Permanent Palette*—Martin J. Fischer. Mountain Lake Park, Maryland, National Publishing Society, 1930. Some data and personal recommendations on materials and methods for permanent painting, clearly presented.

53. *Simple Rules for Painting in Oils*—A. P. Laurie. London, Winsor and Newton, 1932. Concise short book of outlined rules for art students.

54. *Notes on the Techniques of Painting*—Hilaire Hiler. New York, Oxford University Press, 1934. Preface by Sir William Rothenstein. Reprinted London, Faber and Faber, 1968; New York, Watson-Guptill Publications, 1969, with a cogent preface by Edwin Smith and a less sound "Notes for American Readers" by Robert Massey. Contains practical hints and personal observations on artists' materials and procedures, also a large polyglot bibliography. Includes many compiled recipes and instructions, mostly of French origin.

55. *The Materials of the Artist and Their Use in Painting, with Notes on the Techniques of the Old Masters*—Max Doerner. Translated from the German by Eugen Neuhaus. New York, Harcourt, Brace, and World, 1934. Covers the various techniques of painting from all angles of interest to the artist. The translation does not have quite the clarity and directness of the original, and the contents have not been adapted to American or English usage. Doerner's analyses of the techniques of the old masters are very well done, and are based upon a study of old pictures, documentary evidence, and reconstructive methods.

56. *Materials and Techniques of Painting*—Kurt Wehlte. New York, Van Nostrand, 1975. With a supplement on color theory.

57. *The Strasburg Manuscript, a Medieval Painter's Handbook, Translated from the Old German* by Viola and Rosamund Borradaile. London, Alec Tiranti Ltd.; New York, Transatlantic Arts Inc., 1966 (paperback). The earliest surviving German manual on painting techniques, presumed to be fifteenth century. This first complete English translation has the original old German and a modern German translation of the editor's text on facing pages.

58. *Papers of the Society of Mural Decorators and Painters in Tempera.*

Vol. I—Edited by M. Sargant-Florence, 1924; Vol. II—Edited by John D. Baxter, 1935; Vol. III—Edited by M. Sargant-Florence, 1936. London, Dolphin Press. Studies, papers, and reports by members of the Society on the methods and materials of painting.

59. *Scientific Aspects of Artists' and Decorators' Materials*—R. S. Morrell. London, Oxford Universtiy Press, 1939. A small volume in which is reviewed, in outline, the history of painters' methods and materials, the chemical processes involved, and comments purely from a scientist's viewpoint. By the author of number 165.

60. *Painting Materials*—Rutherford J. Gettens and George L. Stout. New York, Van Nostrand, 1942. Paperback reprint, New York, Dover Publications, 1966. A concise, authentic encyclopedia of current and historic data on all branches of the field about equally divided in the interests of the painter and the conservator. Text is arranged under six categories, each of which was originally published separately in *Technical Studies* (see item number 226) 1936–41; bibliographies at the end of each section.

61. *Fresco Painting*—Olle Nordmark, New York, American Artists Group, 1947. One of the best and most practical modern guides to painting in fresco and secco. Details follow the author's own personal practices and few alternative or variant procedures are mentioned, especially in secco painting where his version of the procedure is more elaborate than most.

62. *The Painter's Craft*. 2nd revised edition—Ralph Mayer. New York, Viking Press, 1977. An introduction to the field covered by the author's *The Artist's Handbook;* written as a text for a college or art-school course on the subject, illustrated with photographs. The first and second revised editions have a diagram in silk-screen color. Paperback reprint, New York, Penguin Books, 1979.

63. *The Artist's Methods and Materials*—Maria Bazzi. Translated from the Italian by Francesca Priuli. London, John Murray; New York, Pitman Publishing Corporation, 1960. "The object of this manual is to make available, a ready reference to basic recipes, both ancient and modern, which will be easy to consult." A complete and inclusive compilation of formulas and instructions for painting materials, from the earliest books and manuscripts to the 1950s, and an extensive bibliography.

64. *Is Your Contemporary Painting More Temporary Than You Think? Vital Technical Information for the Present-day Artist*—Louis Pommerantz. Chicago, Artists' Equity Publications, 1962. An excellent small book by a leading conservator that tells exactly why various faulty practices used by some contemporary painters will result in early disintegration of their works.

65. *Course in Making Mosaic*—Joseph L. Young, New York, Reinhold Publishing Corporation, 1957. "An introduction to the art and craft." A historical review and a clearly presented and well-illustrated guide to modern practice.

66. *Collage*—Harriet Janis and Rudi Blesh. Philadelphia and New York, Chilton Company, Book Division, 1962. A very complete illustrated work on

the history of collage and other revolutionary techniques that stem from its concepts.

67. *The Technique of Collage*—Helen Hutton. New York, Watson-Guptill Publications, 1968.

See also number 201 (*Formulas for Painters*).

TEMPERA

Cennini's treatise is still the basic book on egg tempera; see number 8. The general works on painters' methods and materials listed in the preceding section include important references to tempera painting, especially numbers 46, 51, 55, 58, 62.

68. *Tempera und Tempera Technik*—Ernst Friedlein. Munich, Callwey, 1906. One of the first modern practical handbooks on the subject. Contains a collection of its author's own recipes for a large number of grounds and emulsions. Although many of these are outmoded or contrary to best practice, as will be realized by experienced painters, the book contains much of interest.

69. *A Manual of Tempera Paintings*—Maxwell Armfield, with a foreword by Sir Charles Holmes. London, George Allen and Unwin, 1930. Practical applications of the classic method to newer uses.

70. *The Practice of Tempera Painting*—Daniel V. Thompson, Jr. New Haven, Yale University Press, 1936. Paperback reprint, New York, Dover Publications, 1962. A book of instruction on tempera painting, based upon and derived from the method of Cennini and adapted to modern usage.

71. *Papers of the Society of Mural Decorators and Painters in Tempera.* See number 58.

72. *Tempera Painting*—Zoltan Sepeshy. New York, American Studio Books, 1946. Modern tempera painting based principally on techniques developed for the author's personal requirements. Explicit detail, clearly presented and illustrated.

WATERCOLOR

73. *The Art of Landscape Painting in Water Colors*—Thomas Rowbotham. London, Winsor and Newton.

74. *A System of Water-Color Painting*—Aaron Penley. London, Winsor and Newton.

75. *A Guide to Water-Color Painting*—R. P. Noble. London, George Rowney and Company.

The above three small handbooks, first published in the nineteenth century and continued in many reprinted editions, are practical guides to the older type of craftsmanship.

76. *Making Water Color Behave* (1932) and

77. *Making the Brush Behave* (1935)—Eliot O'Hara. New York, Minton,

Balch. These two books, ostensibly written for the novice, contain much of interest to professional painters. Manipulations are explained according to the writer's personal methods. Modern, direct methods are emphasized.

78. *Water Color, Gouache, and Casein Painting*— Adolf Dehn. New York, Studio Publications, Inc., in association with Thomas Y. Crowell Company, 1957. A practical illustrated guide to these techniques by a noted American artist.

79. *Watercolor Lessons from Eliot O'Hara*—Carl Schmalz. New York, Watson-Guptill Publications, 1974. Selected from the watercolor course of O'Hara.

80. *Watercolor Bold and Free*—Lawrence Goldsmith. New York, Watson-Guptill Publications, 1980.

81. *The Watercolor Painting Book*—Wendon Blake. New York, Watson-Guptill Publications, 1978.

82. *Wash and Gouache*—Marjorie B. Cohn. Boston, Fogg Museum, 1977. A study of the development of watercolor.

PASTEL

83. *A Manual on Pastel Painting*—Len A. Doust. London, Frederick Warne and Company, Ltd., 1933. Instruction on technique; studies of the various effects that can be produced by pastel.

84. *The Art of Pastel*—Terrick Williams. New York, Pitman Publishing Company, 1937. Instructions and hints on techniques.

85. *Pastel Painting Step by Step*—Elinor Lathrop Sears. New York, Watson-Guptill Publications, 1947. Completely detailed and illustrated guide to modern practice.

See number 46. Ostwald was a great proponent of pastel.

ENCAUSTIC

86. *Encaustic, or, Count Caylus' Method of Painting in the Manner of the Ancients. To Which Is Added a Sure and Easy Method for Fixing of Crayons.*—J. H. Muntz. London, 1760.

87. *Saggi sul restablimento dell' antica arte de' Greci e Romani pittori. Appendice. Analisi ... della Cerographia del Signor G. Tomaselli*—Vincenzo Requeno. Venice, 1784. Second edition by G. Molini. 2 Vols. Parma, 1787. The "Abbe Requeno" is one of the most widely quoted eighteenth-century investigators of encaustic.

88. *On the Antiquity and Advantages of Encaustic Painting, with an Examination of the Process Employed in That Art by the Ancients.* Philosophical Magazine, London, Vol. 1, 1798, pp. 23 and 141. An abstract of a treatise: *Antichita, Vantaggi e Metodo della Pittura Encausta; Memoria del Ch. Sig. Giovanni Fabroni.* Rome, 1797. Reviews the eighteenth-century investigators of encaustic and their theories: that the beeswax was mixed with mastic resin (Requeno),

that it was saponified (Lorgna, Bachelier), that it was mixed (emulsified) with gum and honey (Astori), and—Fabroni's own conclusion—that it was thinned with naphtha.

89. *A Treatise on Fresco, Encaustic and Tempera Painting*—Eugenio Latilla. London, 1842. See number 25. Reviews eighteenth-century researches on encaustic and describes a method for a fluid wax medium for murals to resist damp walls, and the portable furnace for burning-in.

90. *Die enkaustische Malerei*—F. X. Fernbach. Munich, 1845. A review of the early researches and a manual of encaustic materials and manipulations.

91. *Mural Painting*—Frederic Crowninshield. Boston, Ticknor and Company, 1887. Reviews the ancient methods and describes "modern encaustic," a fluid wax medium for mural painting.

92. *Encaustic Materials and Methods*—Frances Pratt and Becca Fizel [Fizell]. New York, Lear Publications, 1949. First-hand outlines of the studio procedures of seventeen contemporary painters who employ wax in their paintings. Some follow the principles of the traditional varieties of encaustic; others are scarcely qualified to be included under the term. Also includes a brief review of the ancient literary sources and the eighteenth- and nineteenth-century reconstructions, lists of materials, equipment, and sources of supply.

See number 32 (Berger), Vol. 1. Important work in German. Illustrated. Note my comments on Berger's version of Punic wax, page 395.

See number 33 (Jackson). Contains an excellent review of the ancient encaustic techniques with recipes and excerpts from earlier investigators, including Cros and Henry, and Paliot de Montabert.

MOSAIC

93. *A History of Mosaics*—Edgar Waterman Anthony. Reprinted by Hacker Art Books, New York, 1968.

94. *Mosaics*—Ferdinando Rossi. New York, Praeger Publishing Co., 1970. By an Italian; a beautiful, inclusive book.

95. *Mosaics*—Angelica Garnett. New York and Toronto, Oxford University Press, Handbooks for Artists, 1967 (paperback). A useful book explaining the process clearly, well put together.

96. *Mosaic*—Peter Fisebar. New York and Toronto, McGraw-Hill Book Company, 1971. Rewritten and revised by the author from his book *Das Mosaik*.

POLYMER COLORS AND OTHER SYNTHETIC MEDIA

The following books were published during the 1960s by painters who have made special studies of synthetic media and who are familiar with their working qualities through practical experience. All contain much information on the subject, including accounts and illustrations of the techniques used by vari-

ous contemporary painters. The one general criticism of these useful books is that they tend to strive for all-inclusiveness by describing materials that can be classed as peripheral and to accept manufacturers' claims and optimistic recommendations without comment. Some of them also tend to stress the advantages of the newer materials without mentioning their limitations and to note in detail the inferiorities of the traditional painting materials without mentioning the points in which they excel.

97. *Synthetic Painting Media*—Lawrence N. Jensen. Englewood Cliffs, N.J., Prentice-Hall, 1964.

98. *Painting with Synthetic Media*—Russell O. Woody, with a technical appendix by Henry W. Levison. New York, Reinhold Publishing Corporation, 1965.

99. *Painting with Acrylics*—José Guiteréz and Nicholas Roukes. New York, Watson-Guptill Publications, 1965.

100. *Acrylic Painting*—John FitzMaurice Mills. London, Sir Isaac Pitman Sons, Ltd., 1965.

See also numbers 213 and 215.

101. *Plastics Engineering Handbook of the Society of Plastics Industry, Inc.* 4th edition. New York, Reinhold Publishing Corporation, 1976.

PRINTMAKING

The first three are some of the earliest treatises on lithography.

102. *A Complete Course in Lithography*—A. Senefelder. London, 1819. The original work of the inventor of the process.

103. *The Art of Drawing on Stone*—C. Hullmandel. London, 1824.

104. *A Manual of Lithography*—A. Raucourt. London, 1832.

105. *A History of Engraving and Etching from the 15th Century to the Year 1914*—Arthur M. Hind. Boston, Houghton Mifflin Co., 1923. Paperback reprint, London, Constable and Company; New York, Dover Publications, 1962.

106. *American Graphic Art*—Frank Weitenkampf. New York, Macmillan, 1924, and Johnson Reprint Corp., 1970. A history and critical review of all artistic, reproductive, illustrative, journalistic, and industrial graphic-arts media in the United States. Illustrated. Bibliography.

107. *The Art of Etching*—E. S. Lumsden. Philadelphia, Lippincott, 1925. Complete and detailed English manual of practical etching; illustrated. Includes variations such as dry point and aquatint. Paperback reprint, New York, Dover Publications, 1962.

108. *Lithography for Artists*—Bolton Brown. Chicago, University of Chicago Press, 1929. An outline of artistic lithography for the artist who prints his own stones and makes his own crayons, inks, etc., based on the author's personal opinions and preferences.

109. *Making an Etching*—Levon West. New York, Studio Publications, 1932. An elementary outline of the process; illustrated with 17 action photographs, and reproductions of typical works of 16 artists.

110. *Handbook of Print Making and Print Makers*—John Taylor Arms. New York, Macmillan, 1934. Brief, concise outlines of the graphic-arts techniques, and a rather complete outline of the history of each. Critical estimates of the artists of the past and present.

111. *The Art of Aquatint*—B. F. Morrow. New York, G. P. Putnam's Sons, 1935. Describes the technique of aquatint and all its variations, with reproductions of contemporary American work.

112. *An Outline to a History of Woodcut*—Arthur M. Hind. London, Boston, Houghton Mifflin Company, 1935. Paperback reprint, 2 Vols., New York, Dover Publications, 1963.

113. *Artists' Manual for Silk Screen Print Making*. 3rd edition—Harry Shokler. New York, Tudor Publishing Company, 1960. A practical, efficient, and lucid account of the serigraph for creative artists, by one of the pioneers of the medium.

114. *New Ways of Gravure*—Stanley W. Hayter. London, Routledge and Kegan Paul, Ltd., 1949. A practical guide to all incised plate techniques, from early and standard procedures up to recent innovations in textural effects. With a preface by Herbert Read, an excellent historical section, and the author's views linking techniques with aesthetic content. Covers contemporary or advanced styles as well as the traditional.

115. *Creative Lithography and How to Do It*—Grant Arnold. New York, Harper & Brothers, 1941. Paperback reprint, New York, Dover Publications, 1964. A practical illustrated handbook by an American artist and printer of lithographs.

116. *Autolithography, the Technique*—Henry Trivick. London, Faber and Faber, 1960. An authoritative English manual with exceptionally good illustrations. The title word is the author's way of distinguishing between the creative print and ordinary lithography.

117. *A History of Engraving and Etching*—Arthur M. Hind. Boston, Houghton Mifflin Company, 1923. Paperback reprint, London, Constable and Company Ltd.; New York, Dover Publications, 1963.

118. *Serigraphy: Silk-Screen Techniques for the Artist*—Kenneth W. Auvil. Englewood Cliffs, N.J., Prentice-Hall, Incorporated, 1965.

119. *Silk-Screen Color Printing*—Harry Sternberg. New York, McGraw-Hill, 1942.

120. *Printmaking Methods, Old and New*—Gabor Peterdi. New York, Macmillan, 1959. Revised, 1980. Traditional metal-plate methods applied to contemporary purposes. Includes everything except lithography, etching, woodcut, silk screen.

121. *How I Make Woodcuts and Wood Engravings*—Hans Alexander Mueller. New York, American Artists Group, 1945. A very useful exposition of practical methods.

122. *Wood Engravings: An Adventure in Printmaking*—David M. Sander. New York, Viking Press, 1978.

123. *Modern Methods and Materials of Etching*—Harry Sternberg. New York, McGraw-Hill, 1949. Traditional materials adapted to the art of its period.

124. *Frontiers of Printmaking; New Aspects of Relief Printing*—Michael Rothenstein. London, Studio Vista Limited; New York, Reinhold Publishing Corporation, 1966. Contemporary printmaking from relief blocks and various materials.

125. *Linocuts and Woodcuts*: A *Complete Block Printing Handbook*—Michael Rothenstein. London, Studio Vista Limited, 1962; New York, Watson-Guptill Publications, 1964. Reprinted 1965 and 1967. Includes the subjects treated in number 124.

126. *How to Draw and Print Lithographs*—Adolf Dehn. New York, American Artists Group, 1950. Instruction by an eminent American artist.

127. *Wood Engraving*. 2nd edition—John Beedham, with introduction and appendix by Eric Gill. London, Faber and Faber, 1948. A small but cogent book on the technique as a fine art.

128. *How Prints Look; Photographs with a Commentary*—William M. Ivins, Jr. New York, Metropolitan Museum of Art, 1943. Paperback edition, Boston, Beacon Press, 1958. The traditional printmaking techniques and their variants clearly described with the aid of photographs and macrophotographs.

129. *Intaglio Printing Techniques*—Ruth Leaf. New York, Watson-Guptill Publications, 1976.

130. *The Tamarind Book of Lithography*—Garo Z. Antreasian with Clinton Adams. New York, Harry N. Abrams, 1971.

131. *Screen Printing*—J. I. Biegeleisen. New York, Watson-Guptill Publications, 1971.

132. *The Complete Printmaker*—John Ross and Clare Romano. New York, The Free Press, Macmillan, 1974.

133. *Collagraph Printmaking*—Mary Ann Wenniger. New York, Watson-Guptill Publications, 1975. Paperback reprint, 1980.

134. *Monoprints for the Artist*—Roger Marsh. New York, Transatlantic Arts, 1969.

135. *The Art of the Print*—Fritz Eichenberg. New York, Harry N. Abrams, 1976.

136. *Abstract Printmaking*—Robin Capon. New York, Watson-Guptill Publications, 1973.

137. *Innovative Printmaking*—Thelma R. Newman. New York, Crown Publishers, 1977.

138. *Health and Safety in Printmaking: A Manual for Printmakers*—Cherie Moses, James Purdham, Dwight Bowhay, and Roland Hosein. Edmonton, Alberta, Canada, Alberta Labor Occupational Hygiene Branch, 1978.

CHEMISTRY AND TECHNOLOGY OF PAINTING MATERIALS

The books on the technology of paints, varnishes, pigments, and their raw materials are written mostly from the viewpoint of large-scale industrial production, and although they are of value for study and reference, the information they contain is only occasionally directly applicable to artists' practice.

The procedure for gathering chemical or technical references from periodicals is familiar to those who are equipped to assimilate such information. Scientific, technical, and trade journals are systematically indexed and are also brought together periodically in such indexes as *Chemical Abstracts, Industrial Arts Index,* etc., and in the catalogs of libraries.

Besides the general chemical journals, the following periodicals may be mentioned as having particular interest for those concerned with the subjects mentioned above: *Journal of the Oil and Colour Chemists Association; Official Digest* (Federation of Paint and Varnish Production Clubs).

Industrial paint magazines in English are: *American Paint Journal; Oil and Colour Trades Journal* (British); *Oil, Paint and Drug Reporter; Paint* (British); *Paint and Varnish Production; Paint Industry; Paint, Oil and Chemical Review.*

General

139. *Chemistry and Technology of Paints.* 3rd edition— Maximilian Toch. New York, Van Nostrand, 1925. A standard American work for paint manufacturers and chemists.

140. *Outlines of Paint Technology.* 3rd edition—Noël Heaton. London, C. Griffin, 1947; Princeton, N.J., Van Nostrand, 1947. A standard review of industrial practice.

141. *The Chemistry of Paints, Pigments, and Varnishes*—J. Gauld Bearn. London, E. Benn, Ltd., 1933. A concise outline of industrial methods.

142. *National Paint Dictionary.* 3rd edition—Jeffrey R. Stewart. Washington, D.C., Stewart Research Laboratory, 1948. Concise definitions of all terms and names used in the American coating-materials industry.

143. *Organic Coatings in Theory and Practice*—A. V. Blom. Amsterdam, Elsevier Publishing Company, 1949. An outline of the scientific principles and theories upon which the technology of surface coatings is based; the production of industrial coatings, laboratory research, and test methods.

144. *Modern Paint and Coatings.* Published by Communications Channels, Atlanta, Georgia.

145. *Paint Film Defects: Their Causes and Cures*—Manfred Hess (translated from the German). New York, Reinhold Publishing Company, 1951; 2nd edition, 1965; 3rd edition, London, Chapman and Hall. An exhaustive review of all points related to the failure of industrial coating materials during storage and application, after application, and after the use of coated objects.

146. *Paint and Varnish Production Manual.* Edited by Verne C. Bidlack and Edgar W. Fasig. New York, John Wiley and Sons, 1951. The manufacture

of industrial and architectural coatings; equipment, raw materials, and factory procedure.

147. *Organic Coating Technology*—Henry Fleming Paine. 2 Vols. New York, John Wiley and Sons, 1954. Covers same subjects as preceding title in more complete detail. Vol 1—"Oils, Resins, Varnishes, Polymers." Vol. 2— "Pigments and Pigmented Coatings." A complete, authoritative outline of the subject.

148. *Principles of Surface Coating Technology*—Dean H. Parker. New York, Interscience Publishers, 1965.

149. *Protective and Decorative Coatings*—Joseph J. Mattiello. 4 Vols. New York, John Wiley & Sons; London, Chapman & Hall Ltd., 1942. An authoritative work written by a number of specialists in their fields. Vol 1—"Raw Materials for Varnishes and Vehicles." Vol 2—"Raw Materials: Pigments, Metallic Powders and Metallic Soaps." Vol 3—"Manufacture and Uses of Paints, Varnishes, Lacquers, and Inks." Vol 4—"Special Studies."

150. *A Glossary of Pigments, Varnish and Lacquer Constituents*—J. H. Martin and W. M. Morgano. New York, Chemical Publishing Company, 1959.

151. *Fundamentals of Paint, Varnish and Lacquer Technology*—Elias Singer. St. Louis, American Paint Journal Company, 1957.

152. *A Textbook of the Chemistry and Technology of Paints, Varnishes and Lacquer*—Paul Nylen and Edward Sunderland. London and New York, Interscience Publishers, 1965.

153. *Federation Series on Coating Technology.* Edited by Wayne R. Fuller. Federation of Societies for Paint Technology, 121 South Broad Street, Philadelphia, PA 19107. Pamphlets that outline modern practices.

Unit 1, "Introduction to Coatings Technology"—Wayne R. Fuller. 1964.

Unit 2, "Formation and Structure of Paint Films."—Wayne R. Fuller. 1965.

Unit 3, "Oils for Organic Coatings"—Fred L. Fox. 1965.

Unit 4, "Modern Varnish Technology"—Alfred E. Rheineck. 1966.

Unit 5, "Alkyd Resins"—James R. Blegen. 1967.

Unit 6, "Solvents"—Wayne R. Fuller. 1967.

Unit 7, "White Hiding and Extender Pigments"—Willard R. Madson. 1967.

Unit 8, "Inorganic Color Pigments"—W. R. Fuller and C. H. Love. 1968.

Unit 9, "Organic Color Pigments"—J. G. Mone. 1968.

Unit 10, "Black and Metallic Pigments"—W. S. Stoy, E. T. Usowski, L. P. Larson, D. Passigli, W. H. Byler, R. Evdo, and W. von Fischer. 1969.

Unit 11, "Paint Driers and Additives"—W. J. Stewart. 1969.

Unit 12, "Principles of Formulation and Paint Calculations"—W. R. Fuller. 1969.

Pigments

NOTE: The more complete books on painting materials and methods as well as the general books on paint technology have extensive chapters on pigments.

154. *Colors for Painting*—Riffault, Vergnaud, and Toussaint. Translated from the French by A. A. Fesquet. Philadelphia, Henry Carey Baird, 1874. A complete and authentic contemporary account of early and middle nineteenth-century methods.

155. *A Treatise on Color Manufacture*—Georg Zerr and R. Rubencamp. London, Charles Griffin and Company, 1908. An English translation of a German work; and a more recent German edition, Berlin, Union, 1922.

156. *Artists' Pigments*—Frederick W. Weber. New York, Van Nostrand, 1923. A catalog and description of pigment colors, with a considerable section on elementary theoretical chemistry.

157. *Chemistry and Physics of Organic Pigments*—L. S. Pratt. New York, John Wiley and Sons, 1947. A very complete account of modern practice.

158. *Pigments, Their Manufacture, Properties and Use*—John Stuart Remington and Dr. Wilfrid Francis. London, Leonard Hill, Ltd., 1954. A technical review of the manufacture of modern chemical pigments.

159. *Color Index.* 2nd edition. Bradford, England, Society of Dyes and Colourists; Lowell, Mass., American Association of Textile Chemists and Colorists, 1956. The official catalog of all dyestuffs, with sections on paint pigments. The C.I. number and the standard C.I. name of a dye or pigment identify it precisely and distinguish it from its variants, which always differ in color and pigment properties.

160. *Exposure Studies of Organic Pigments in Paint Systems*—Vincent C. Vesce. Philadelphia, December 1959, *Official Digest,* Federation of Societies for Paint Technology.

161. *Organic Chemistry*—Fieser and Fieser. Boston, Heath and Company, 1944.

162. *The Natural Pigments*—Kenneth Walter Bentley. New York, Interscience Publishers, 1960. (Vol. 4 of *The Chemistry of Natural Products.*)

Drying Oils

163. *Über fette Öle, Leinölersatzmittel und Ölfarben*—Alexander Eibner Munich, B. Heller, 1922. An important work on drying oils with particular reference to artists' paints.

164. *The Chemical Technology of Oils, Fats, and Waxes*—J. Lewkowitsch. 3 Vols. London, Macmillan, 1922–38. A complete, authoritative treatise.

165. *An Introduction to Drying Oil Technology*—M. R. Mills. London, Pergamon Press, Ltd., 1952. A clear and concise account of the sources, production, and treatment of the drying oils and their uses.

Varnishes

166. *Varnish Making*—T. Hedley Barry and George William Dunster. London, Leonard Hill, Ltd., 1934.

167. *Varnish Constituents*—Herbert W. Chatfield. London, Leonard Hill, Ltd., 1944.

168. *On Picture Varnishes and Their Solvents*—Robert F. Feller, Elizabeth

H. Jones, Nathan Stolow. Oberlin, Ohio, Intermuseum Conservation Association, 1959.

Natural Resins

169. *Natural Varnish Resins*—T. Hedley Barry. London, E. Benn, Ltd., 1932. A complete study of varnish resins.

170. *Die Harze*—Alexander Tschirsch and E. Stock. Berlin, Borntraeger, 1933–35. An exhaustive treatise on all natural resins.

171. *Natural Resins.* Brooklyn, Research Laboratories, American Gum Importers, Inc., 1938. Physical and chemical properties, solubilities, etc., in tabular arrangement.

172. *The Technology of Natural Resins*—Charles L. Mantell and C. W. Kopf, J. L. Curtis, E. M. Rogers. New York, John Wiley and Sons, 1942.

173. "The Chemistry of Damar Resins"—J. S. Mills and A. E. A. Werner. London, *Journal of the Chemical Society,* September 1955, p. 3132.

See also number 193.

Asphalts

174. *Asphalts and Allied Substances.* 4th edition—H. Abraham. 2 Vols. Princeton, N.J., Van Nostrand, 1938, 6th edition, 4 Vols. 1960–62. The most complete work on the subject.

175. *Asphalt; Science and Technology*—Edwin J. Barth. New York, Gordon and Breach Science Publishers, 1962.

176. *Asphalt, Its Composition, Properties and Uses*—Ralph Newton Traxler. New York, Reinhold Publishing Company, 1961.

Waxes

177. *Commercial Waxes*—Harry Bennett. Brooklyn, Chemical Publishing Company, 1944. The technology of waxes.

178. *Adventures in Man's First Plastic*—Nelson S. Knaggs. New York, Reinhold Publishing Company, 1947. Interesting nontechnical story of the waxes with a technical reference section and bibliography.

179. *The Chemistry and Technology of Waxes*—Albin H. Warth. New York, Reinhold Publishing Company, 1947.

See also number 163 (Lewkowitsch).

180. *Das Grosse Buchvom Wachs*—Reinhard Büll, ed. Munich, Verlag Callwey, 1974.

Lacquers, Synthetic Resins, and Plastics

181. *Pyroxylin Enamels and Lacquers.* 2nd edition—Samuel P. Wilson. New York, Van Nostrand, 1931.

182. *The Chemistry of Synthetic Surface Coatings*—William Krumbhaar. New York, Reinhold Publishing Company, 1937.

183. *Synthetic Resins and Allied Plastics.* 3rd edition—R. S. Morrell; collab-

orators: T. Hedley Barry, R. P. L. Britton, H. M. Laughton. London, Oxford University Press, 1951.

184. *Technology of Plastics and Resins*—J. Philip Mason and Joseph F. Manning. Princeton, N.J., Van Nostrand, 1945. Complete college textbook.

185. *Plastics in the School and Home Workshop.* 3rd edition—A. J. Lockrey. Princeton, N.J., Van Nostrand, 1946.

186. *Handbook of Plastics.* 2nd edition—Herbert R. Simonds, Archie J. Weith, and M. H. Bigelow. Princeton, N.J., Van Nostrand, 1949 (based in part on 1st edition by H. R. Simonds and Carleton Ellis). Very complete volume (1511 pages) covering the technology of the field.

NOTE: Lacquers and synthetic resins are also treated in the general books on paint technology, especially in number 147 (Paine). See also number 245.

Solvents

187. *Solvents.* 6th edition, revised and enlarged—Thomas H. Durrans. Princeton, N.J., Van Nostrand, 1950.

188. *Industrial Solvents.* 2nd edition—Ibert Mellan. New York, Reinhold Publishing Company, 1950.

189. *The Handbook of Solvents*—Leopold Scheflan and Morris B. Jacobs. Princeton, N.J., Van Nostrand, 1953. Text and also data on each solvent in tabular form.

190. *Solvents Guide.* 2nd edition—C. Marsden and Seymour Mann. New York, Interscience Publishers, 1963.

191. *Toxicity and Metabolism of Industrial Solvents*—Ethel C. Browning. Amsterdam and New York, Elsevier Publishing Company, 1965.

Gums

192. *The Water Soluble Gums*—Charles L. Mantell. New York, Reinhold Publishing Company, 1947. A technical handbook covering all the natural gums.

193. *Vegetable Gums and Resins*—F. N. Howes. Waltham, Massachusetts, Chronica Botanica Company, 1949. Covers both the water-soluble gums and the natural varnish resins as well. Much data on gum collecting, botany, trade conditions, and variations of species.

194. *Water-Soluble Resins (Synthetic)*—Robert L. Davidson and Marshall Sittig. New York, Reinhold Publishing Company, 1962.

Adhesives

195. *The Technology of Adhesives*—J. Delmonte. New York, Reinhold Publishing Company, 1947. Specializes in synthetic adhesives.

196. *Adhesion and Adhesives*—N. A. De Bruyne and R. Houwink. Amsterdam, Elsevier Publishing Company, 1951. Part 1—"Theories Relating to Adhesion." Part 2—"Technology and Practices." Complete and up-to-date.

197. *Treatise on Adhesion and Adhesives*—Robert L. Patrick. New York, M. Dekker, 1967.

198. *Testing Adhesives for the Consolidation of Paintings*—G. A. Berger. Studies in Conservation 17, No. 4. London, International Institute in Conservation of Historic and Artistic Works, 1972. See number 200.

NOTE: The following books cover a wide range of general workshop, studio, and industrial procedures.

Formulas

199. *The Scientific American Cyclopedia of Formulas*—Albert A. Hopkins, editor. New York, Scientific American Publishing Company.

200. *Henley's 20th Century Book of Formulas, Processes, and Trade Secrets*—Gardner D. Hiscox, editor. New York, Norman W. Henley Publishing Company.

These books are periodically revised and enlarged.

201. *Formulas for Painters*—Robert Massey. New York, Watson-Guptill Publications, 1967. Paperback edition, 1979. "Two-hundred formulas for making paints, glazes, mediums, varnishes, grounds, fixatives, sizes and adhesives for tempera, oil acrylic, gouache, pastel, encaustic, fresco and other painting techniques."

Chemistry Handbooks

202. *Handbook of Chemistry*—Norbert A. Lange. Sandusky, Ohio, Handbook Publishing Company.

203. *Handbook of Chemistry and Physics*—Edited by C. D. Hodgman. Cleveland, Chemical Rubber Company.

204. *Van Nostrand's Chemical Annual*—Edited by John C. Olsen. New York, Van Nostrand.

Tables, factors, and concise reference data for chemists. These books are usually revised annually.

Testing and Analysis

205. *Paint Testing Manual: Physical and Chemical Examination of Paints, Varnishes, Lacquers, and Colors*. 12th edition—Henry A. Gardner and George G. Sward. Bethesda, Maryland, Gardner Laboratory, Incorporated, 1962. Revised periodically. The most complete volume on the subject; known as the "paint chemists' Bible."

CONSERVATION, ART TECHNOLOGY, RESEARCH, ETC.

206. *The Cult of Old Masters and the Romney Case*—Richard W. Lloyd. London, Skeffington, 1918. The story of litigations on the authenticity of old masters.

207. *The Cleaning and Restoration of Museum Exhibits*—Alexander Scott. London, H.M. Stationery Office, three reports, 1921–23–26. Modern methods of conserving and restoring all types of museum exhibits. Also see a more re cent addition in *Museums Journal*, Vol. 33, pp. 4–8, April 1933.

208. *The Gentle Art of Faking*—Riccardo Nobili. Philadelphia, Lippincott, 1922. An interesting essay on the counterfeiting of works of art from the earliest times to the present.

209. *The Restoration of Bronzes and Other Alloys*—C. G. Fink and C. H. Eldridge. New York, Metropolitan Museum, 1925. (Also see *Encyclopaedia Britannica*, 14th edition, article "Bronze and Brass Ornamental Work," section "Corrosion and Restoration.") A description of the restoration of corroded antique bronzes and other metals by an electrolytic method which converts the corrosion back into its metallic form, thereby retaining the surface markings of the original work.

210. *Pictures and How to Clean Them*—T. R. Beaufort. New York, Frederick A. Stokes, 1926. Deals mainly with the conservation and repair of pictures on paper.

211. *The Scientific Examination of Pictures*—Martin A. De Wild. Translated from the Dutch. London, G. Bell, 1929. Original researches on the applications of modern techniques to the identification of pigments in old Dutch and Flemish paintings; conservation and x-ray photography.

212. *A Study of Rembrandt and the Paintings of His School by Means of Magnified Photographs*—A. P. Laurie. London, E. Walker, Ltd., 1930.

213. *Paint, Paintings, and Restoration*—Maximilian Toch. New York, Van Nostrand, 1931. An account of modern advances in the technology of pigments, solvents, identification of old paintings, and techniques of conservation.

214. *The Brushwork of Rembrandt and His School,* illustrated by photomicrographs—A. P. Laurie. London, Oxford University Press, Humphrey Milford, 1932.

215. *Antiques, Their Restoration and Preservation.* Revised editon—A. Lucas. London, Edward Arnold Company, 1932. Conservation of miscellaneous museum exhibits: a complete guide to the subject.

216. *Infra-red Photography*—S. O. Rawling. London, Blackie and Son, Ltd., 1933.

217. *Conservation of Antiquities and Works of Art*—H. J. Plenderleith and A. E. A. Werner. New York, Oxford University Press, 1956; revised 1971. Information is given on materials and methods used in conservation of museum objects, and causes of their deterioration are discussed.

218. *New Light on Old Masters*—A. P. Laurie. London, Sheldon Press, 1935. A general account of methods, materials, and technical studies of painting, in a rather popular version.

219. *The Conservation of Prints and Drawings*—H. J. Plenderleith. London, The Museums Association, 1937. A sequel to number 217. Both of these small books are compilations and reviews of the most modern and approved

methods as standardized and practiced by their author at the British Museum. Written with regard for the requirements of the nonprofessional restorer.

220. *Curatorial Care of Works on Paper*—Anne F. Clapp. Oberlin, Ohio, The Intermuseum Laboratory, 1975.

221. *Stop That Smoke!*—Henry Obermeyer. New York, Harpers, 1933. A popularized account of air pollution in America, with bibliography and sources of data on many aspects of the subject.

222. *How to Take Care of Your Pictures*—Caroline K. Keck. New York, The Museum of Modern Art and the Brooklyn Museum, 1954.

223. *A Handbook on the Care of Paintings*—Carolina K. Keck. New York, Watson-Guptill Publications, 1965. Both of Mrs. Keck's excellent books are written for the nonprofessional reader.

NOTE: A great deal of material on air pollution from official and semioffi-cial sources is to be found in libraries; most of it deals with health and indus-trial control, very little with its effect on works of art.

224. *The Care of Paintings*—George L. Stout. New York, Columbia University Press, 1948. A thorough and clearly presented introduction to the subject of conservation. Covers the structure of paintings, their ills, and standard museum conservation methods. By one of the leading authorities.

225. *The Treatment of Pictures*—Morton C. Bradley. Cambridge, Mass., Art Technology, 1950. A compilation of some top-level, professional conservation procedures. Brief but precise descriptions in sufficient detail to serve as a practical guide to the treatment of various specific examples of faulty pictures on canvas, wood, and paper. A decimal classification system, instead of paging, permits of future expansion and emendation so that from its rather small be-ginning it may grow to cover all subjects relative to the conservation of pic-tures. Illustrated. Lists of materials and sources; glossary.

226. *Technical Studies in the Field of the Fine Arts.* Cambridge, Mass., Fogg Museum, Harvard University. Published from 1932 to 1942, this quar-terly journal was the only publication in its field in English. Contains original papers on materials and methods of art and archaeology by both the staff and outside contributors, and abstracts of all the important publications in this field throughout the world. The gap in publication of abstracts in this field, from 1943 to 1952, has been filled by the following volume, 227.

227. *Abstracts of Technical Studies in Art and Archaeology 1943-1952*—Rutherford J. Gettens and Bertha M. Usilton. Washington, D.C., Freer Gal-lery of Art, Smithsonian Institution, 1955. Compiled with the assistance of an international team of specialists, this useful volume contains 1399 abstracts covering the entire field for the decade when no specialized periodical record existed to record them. Since its publication, abstracts in this field have been covered in number 229.

228. *Studies in Conservation.* The journal of the International Institute for Conservation of Historic and Artistic Works (IIC), now published quarterly. Vol. 1, No. 1 is dated October 1952. Publishes a wide variety of articles per-taining to conservation, museum technology, and artists' materials and tech-

niques, similar to those that appeared in number 226 above. The IIC is the central agency in its field. Its members staff the world's museums and private conservation laboratories. All interested persons and institutions may apply for associate membership and receive all its publications; persons of outstanding accomplishment in the field may be elected Fellows. Its headquarters are at the National Gallery, Trafalgar Square, London W.C. 2, England. The American Group issues its own informative bulletin periodically and holds an annual meeting in May.

NOTE: The following books, previously listed under other headings, also treat these topics:

24. Mérimée (1839)
40. Laurie (1914)
47. Church (1915)
51. Laurie (1926)
55. Doerner (1934)

229. *Art and Archaeology Technical Abstracts.* Published by the Institute of Fine Arts, New York University, for the International Institute for Conservation of Historic and Artistic Works, London. The IIC's (see 228) current continuation of international abstracts covering the field of its journal. From 1955 to 1965 it was known as the *IIC Abstracts.* It is now published in four numbers to the volume, each volume covering about two years, and is available from Conservation Center, Institute of Fine Arts, 1 East 78th Street, New York, NY 10021.

230. *The Cleaning of Paintings*—Helmut Ruhemann. London, Faber and Faber; New York, Frederick A. Praeger, Inc., 1968. A very complete work on all aspects of the subject by a leading museum authority.

231. *Conservation and Restoration of Pictorial Art.* Bromelle and Smith, eds. London and Boston, Butterworth, 1976.

232. *Heat Seal Lining of a Torn Painting with Beva 371*—G. A. Berger. Studies in Conservation 20, no. 3. London, IIC, 1975. See number 228.

PICTURE FRAMES

233. *How to Make Your Own Picture Frames.* Revised (3rd) edition—Hal Rogers and Ed Reinhardt. New York, Watson-Guptill Publications, 1981.

234. See *Curatorial Care of Works on Paper,* number 220.

SCULPTURE

235. *The Technique of Early Greek Sculpture*—Stanley Casson. Oxford, Clarendon Press, 1933. Complete study of Greek methods of stone carving.

236. See *Vasari on Technique,* number 11.

237. *The Treatises of Benvenuto Cellini on Goldsmithing and Sculpture.* Translated by C. R. Ashbee. London, Edward Arnold, 1898.

238. *Modelling and Sculpture*—Albert Toft. Philadelphia, Lippincott,

1924. A beginner's manual of materials, tools, and methods of procedure for modeling, carving, casting, and bronzing. Reproductions of sculpture of all ages critically analyzed.

239. *Trade Names and Descriptions of Stones*—Frank A. Lent. New York, Stone Publishing Company (the magazine *Stone*), 1925. A descriptive list of all the American commercial varieties of building stones and the important European stones.

240. *Modelling and Sculpture in the Making*—Sargeant Jagger. New York Studio Publicatons ("How to Make It" series), 1933. A short, elementary outline; photographic illustrations.

Italian Renaissance methods are described in *Vasari on Technique* (number 11) and in the following:

241. *The Materials and Methods of Sculpture*—Jack C. Rich. New York, Oxford University Press, 1947. A complete book of traditional materials and methods for carving, modeling, casting, and finishing sculpture. Paperback reprint, New York, Dover Publications, 1975.

242. *Sculpture in Wood*—Jack C. Rich. New York, Oxford University Press, 1970.

243. *What Wood Is That?*—Herbert L. Edlin. New York, The Viking Press, 1977.

244. *Sculpture, Principles and Practice*—Louis Slobodkin. Cleveland, World Publishing Company, 1949. A complete manual.

245. *Plastics as an Art Form*—Thelma R. Newman. Philadelphia, Chilton Books, 1964, revised ed., 1969; London, Thomas Yoseloff, 1967. A complete and profusely illustrated book, describing all the available plastics, methods of manipulation, and detailed instructions for specific applications.

246. *Plastics as Sculpture*—Thelma R. Newman. Philadelphia, Chilton Books, 1974.

247. *Welded Sculpture*—Nathan Cabot Hale. New York, Watson-Guptill Publications, 1968. A manual of contemporary practice.

248. *Sculpture in Plastics*. Revised edition—Nicholas Roukes. New York, Watson-Guptill Publications, 1978. An illustrated guide to the practice of forming plastic sculpture in many techniques.

249. *Contemporary Stone Sculpture*—Dona Z. Meilach. New York, Crown Publishers, 1970.

250. *Modeling the Figure in Clay*—Bruno Lucchesi and Margit Malmstrom. New York, Watson-Guptill Publications, 1980.

251. *Terracotta: The Technique of Firing Clay Sculpture*—Bruno Lucchesi and Margit Malmstrom. New York, Watson-Guptill Publications, 1977.

252. *Figure Sculpture in Wax and Plaster*—Richard McDermott Miller. New York, Watson-Guptill Publications, 1971.

253. *Greek Sculptors at Work*—Carl Bluemel. London, The Phaidon Press, 1955. Studies of ancient carving techiques.

254. *New Materials in Sculpture*—H. M. Percy. London, Alec Tiranti, 1965.

255. *A Concise History of Modern Sculpture*—Herbert Read. New York, Oxford University Press, 1964.

DRAWING AND PERSPECTIVE

(See also Drawing and Anatomy, pages 697–98.)

256. *Perspective as Applied to Pictures*—Rex Vicat Cole. Philadelphia, Lippincott, n.d. A thorough and complete English textbook for artists.

257. *Freehand Perspective and Sketching*—Dora M. Norton. Pelham, New York, Bridgman Publishers, 1929. A short study in nonmathematical perspective for beginners.

258. *Perspective*—Frank Medworth. New York, Charles Scribner's Sons, 1937. Perspective applied to pictures from a careful, accurate viewpoint, dealt with in an advanced manner.

259. *Mastery of Drawing*—John Moranz. Peterborough, New Hampshire, The Richard R. Smith Company, 1950.

260. *The Drawing Book*—Wendon Blake. New York, Watson-Guptill Publications, 1980.

ORIENTAL MATERIALS AND TECHNIQUES

261. *On Japanese Pigments*—T. Takamatsu. Tokyo, 1878. Researches on the nature of Japanese pigments. The total list resembles those in the seventeenth- and eighteenth-century English manuals, where all sorts of permanent and fugitive colors are named without discrimination; the vegetable pigments, for the most part, are very similar in nature to those in European use in the seventeenth and eighteenth centuries. Of historical interest.

262. *The Pictorial Arts of Japan*—William Anderson. London, Sampson Low, 1886. A complete, illustrated study of art, artists, and techniques.

263. *On the Laws of Japanese Painting*—Henry P. Bowie. San Francisco, Paul Elder, 1911. An exposition of Japanese theories, principles, and techniques by an American who was trained in the Japanese school of painting. Reprinted by Dover Publications, New York, 1951; paperback edition, 1956.

264. "Studies on the Ancient Pigments in Japan"—Rokuro Uyemura. *Eastern Art,* Vol. III. Philadelphia, 1931.

265. "Linear Perspective in Chinese Paintings"—Benjamin March. *Ibid.*

266. *Some Technical Terms of Chinese Painting*—Benjamin March. Baltimore, Waverly Press, 1935. A study of Chinese artists' terms, techniques, materials, etc.

267. *Perspective in Early Chinese Painting*—Wilfrid H. Wells. London, E. Goldston, 1935. Analyses and theories of Oriental rules of perspective.

268. "Fresco paintings of Ajanta"—Rahim Bux Khan. London, *Journal of the Oil and Colour Chemists Association,* Vol. 32, 1949, pp. 24–31. A complete outline of all technical aspects of the murals in these rock caves.

COLOR

The following books present the two major systems of color notation. Their numerical designations for hues, tints, and shades of color are intended to be used for accurate identification and specification of colors. The Munsell system is widely used in science, technology, and industry. The Ostwald system is also employed in industry and other activities where the application of principles is especially appropriate. It is more popular in Europe than in America.

269. *The Munsell Book of Color*—Albert H. Munsell. Baltimore, Munsell Color Company, 1946. "An illustrated system defining all colors and their relations by measured scales of hue, value and chroma. Introduction by Royal B. Farnum. 10th edition, edited and rearranged." Published in a Library Edition and in a somewhat condensed Pocket Edition, both in 2 volumes. Albert H. Munsell first published his system in 1905, and its color charts and practical application in 1919 (*Atlas of the Munsell Color System and a Color Notation*), both superseded by the current two-volume editions. Over a period of years professional societies in various fields have been engaged in improving the accuracy of the system by eliminating minor discrepancies.

270. *Committee on Colorimetry, Colorimeters and Color Standards. J. Optical Soc. of America,* July 1943, and 35, 13 (1945).

271. *A Practical Description of the Munsell System*—T. M. Cleland. Baltimore, Munsell Color Company, 1937. The first edition of this work, published by the Strathmore Paper Company in 1921 by an outstanding artist and illustrator, has been a scarce collector's item for many years.

272. *Colour Science*—Wilhelm Ostwald. Translated from the German by J. Scott Taylor. Vol. 1—"Colour Theory and Colour Standardization." Vol. 2—"Colour Measurements and Colour Harmony." London, Winsor and Newton, 1933. The Ostwald system was established by eminent German chemist Wilhelm Ostwald (1853–1932) (see number 46), a pioneer in colloid chemistry.

273. *The Ostwald Colour Album*—Wilhelm Ostwald. London, Winsor and Newton, 1933. Companion to the above.

274. *Color Harmony Manual*—Egbert Jacobson and Carl E. Foss. Chicago, Color Laboratories Division, Container Corporation of America, 1949. Includes the most comprehensive set of individual color chips pertaining to the Ostwald system. They are made on clear cellulose acetate for efficient comparison with wet or dry surfaces.

The following books also relate to the field of color notation:

275. *A Dictionary of Color.* 2nd edition—A. J. Maerz and M. R. Paul. New York, McGraw-Hill, 1950. Does not present any new system or color names but is the most extensive and authentic dictionary of color names used in English.

276. *A Guide to Color and Color Harmony*—Gladys and Gustave Plochere. Los Angeles, Fox Printing Company, 1948. The Plochere color system

has 1248 colors on 3-by-5-inch cards, showing nine basic pigments in mixtures with black and white. Numbers designate the colors, and the color names of paints and formulas.

277. *Atlas de los colores*—C. Vilalobos. Buenos Aires, Dominguez, 1947, sold in New York by Stechert-Hafner. A system with extensive color charts having a total of 7279 swatches. Reviewed in the Newsletter of the Intersociety Color Council, May 1949.

The following books deal with systems of color arrangement and control as applied to the artist's palette and picture:

278. *The Painter's Palette and How to Master It*—Bolton Brown. New York, Baker and Taylor, 1913.

279. *The Painter's Palette*—Denman Ross. Boston and New York, Houghton Mifflin, 1919.

280. *A Working System of Color*—Frederick Leroy Sargent. New York, Henry Holt, 1927.

281. *Modern Color*—C. G. Cutler and S. G. Pepper. Cambridge, Mass. Harvard University Press, 1933.

282. *Color Harmony, Its Theory and Practice*—Arthur B. Allen. London, Frederic Warne and Company, 1937.

283. *Theory of Colours*—Johann W. Goethe. Cambridge, Mass., M.I.T. Press, 1970 (paperback).

284. *The Art of Color*—Johannes Itten, New York, Van Nostrand Reinhold, 1973.

The following works on systematic color nomenclature differ form those listed above, which deal with precise or scientific identification. They represent efforts to standardize the nomenclature of hue designations as applied to everyday use, especially for the products of industry and the fashion trades.

285. *The ISCC-NBS Method of Designating Color and a Dictionary of Color Names*—Kenneth L. Kelly and Deane B. Judd. National Bureau of Standards Circular, 553, November 1, 1955. (ISCC stands for Intersociety Color Council.)

286. *The Descriptive Color Names Dictionary*—Edited by Helen D. Taylor, Lucille Knoche, and Walter C. Granville. Chicago, Container Corporation of America, 1950. Called a supplement to the Ostwald Color Harmony Manual, it lists the color names used for American merchandise by reference to 862 Ostwald notations.

NOTE: The ISCC-NBS system is described in detail and the Munsell system illustrated in color in the article on color in *Webster's Third New International Dictionary*, Springfield, Massachusetts, G. & C. Merriam Company, 1959. The article "Color" in the *Encyclopedia of Art*, New York, Philosophical Library, 1946, outlines color, color systems, and their history and development. The *Color Index* is listed on page 685, number 159.

LETTERING, CALLIGRAPHY, TYPOGRAPHY, AND ILLUMINATION

The study of lettering is of greatest concern to those engaged directly in the designing of books, posters, inscriptions, advertisements, etc. From the viewpoint of the general practice of art, the subject is of more occasional interest; in fact, the average artist who has not made a thorough study of the subject is quite often apt to have a very poor command of correct principles when occasion for the use of lettering arises.

The study may be approached from two distinct viewpoints—from that of the student of paleography and from that of the craftsman with the aim of practical application. A knowledge of the history and origin of the various basic letter forms is, of course, a necessary adjunct to a complete training in lettering from ancient Egypt to the present; a course in artists' lettering in construction; but the average designer of letters is more interested in the practical aspects of the subject. The following books are a few selections from a field in which a great number and variety of manuals are available:

287. *Lettering*—Thomas W. Stevens. New York, Prang Publishing Company, 1926. A standard textbook.

288. *Lettering for Students and Craftsmen*—Graily Hewitt. Philadelphia, Lippincott, 1930. An English manual of classic lettering.

289. *Writing and Illuminating and Lettering*. 15th edition—Edward Johnston. London, Sir I. Pitman, 1927. A complete manual of classical professional lettering includes architectural inscriptions.

290. *The Alphabet*—Frederic W. Goudy. New York, Mitchell Kennerly, 1922. Typographical alphabets.

291. *The Design of Lettering*—Egon Weiss. New York, Pencil Points Press, 1932. Principally concerned with architectural inscriptions.

292. *Lettering Today: A Survey and Practical Handbook*—John Brinkley. New York, Reinhold Publishing Corporation, 1961.

293. *Of the Just Shaping of Letters*—Albrecht Dürer. Translated from the Latin text of 1535 by R. T. Nichol. New York, Grolier Club, 1917. Paperback reprint, New York, Dover Publications, 1965.

294. *Italic Handwriting*—Tom Gourdie. New York, The Viking Press, 1955. Paperback reprint, New York, Pentalic Corporation, 1976.

295. *Anatomy of Lettering*—Russell Laker. London, Studio Books; New York, The Viking Press, new edition, 1960.

296. *The History and Technique of Lettering*—Alexander Nesbit. Paperback reprint, New York, Dover Publications, 1957. Historical account of lettering from ancient Egypt to the present; a course in artists' lettering in many alphabets.

297. *Lettering and Alphabets*—J. A. Cavanaugh. Paperback reprint, New York, Dover Publications, 1955.

298. *The Alphabet and Elements of Lettering*—Frederic Goudy. Berkeley,

University of California Press, 1942. Paperback reprint, New York, Dover Publications, 1963.

299. *De arte illuminandi; The Technique of Manuscript Illumination.* Translated from an anonymous fourteenth-century treatise by Daniel Varney Thompson. New Haven, Yale University Press; London, Oxford University Press, Humphrey Milford, 1933.

300. *The Art of Hand Lettering, Its Mastery & Practice*—Helm Wotzkow. New York, Watson-Guptill Publications, 1952. Paperback reprint, New York, Dover Publications, 1967. An excellent and complete work on lettering and calligraphy, tools, materials, and techniques.

301. *Calligraphy: The Art of Lettering with the Broad Pen*—Byron J. Macdonald. New York, Pentalic Corporation, 1970.

302. *Calligraphic Styles*—Tom Gourdie. New York, Pentalic Corporation, 1978.

DRAWING AND ANATOMY

(See also Drawing and Perspective, page 693.)

303. *Anatomical Diagrams for the Use of Art Students*—James M. Dunlop, with an introduction by John Cleland. New York, Macmillan, 1929. Employs a clear and practical method of instruction.

304. *Constructive Anatomy*—George B. Bridgman. Pelham, N.Y., Bridgman Publishers, 1919. A popular book on anatomy as applied to artistic figure drawing. The following three titles are by the same author.

305. *Bridgman's Life Drawing.* 1931.

306. *The Book of a Hundred Hands.* 1920.

307. *Heads, Features, Faces.* 1936.

308. *The Human Figure*—John H. Vanderpoel. Chicago, Inland Printer, 1930. Anatomy applied to figure drawing. Paperback reprint, New York, Dover Publications, 1958.

309. *Human Anatomy for Art Students*—Sir Alfred Fripp and Ralph Thompson. Philadelphia, Lippincott, n.d. A complete English textbook on anatomy and figure drawing.

310. *Animal Painting and Anatomy*—W. Frank Calderon. Philadelphia, Lippincott, n.d. A complete and well-illustrated English work. Paperback reprint, New York, Dover Publications, 1975.

311. *The Human Figure, Anatomy for Artists*—David K. Rubins. New York, The Viking Press, 1953. Paperback reprint, New York, Penguin Books, 1976.

312. *Technical Illustration*—Joseph C. Gibbey. Chicago, American Technical Society, 1962.

313. *Art and the Scientist*—Geoffrey Lapage. Bristol, England, John Wright and Sons, Ltd., 1961.

314. *The Art of Three-dimensional Design; How to Create Space Figures*—Louis Wolchonok. New York, Harper and Brothers, 1959.

315. *The Natural Way to Draw*—Kimon Nicolaides. Boston, Houghton Mifflin Company, 1941. A popular and original system of instruction and training in the fundamentals of creative drawing.

316. *Perspective Drawing Handbook*—Joseph D'Amelio. New York, Tudor Publishing Company, 1965. A clear, simple elementary guide to the application of perspective in drawing.

317. *The Act of Drawing*—Edward Laning. New York, McGraw-Hill Book Company, 1971. "Why we draw, how we draw, and what makes a master drawing."

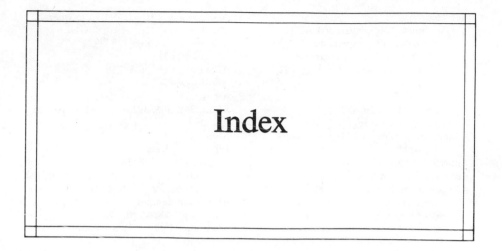

Index

Individual items mentioned in lists and tables and in the Bibliographies (Chapter 17) are not indexed here unless they also appear elsewhere in the text. See the entry for the general category under which an item you are seeking should appear, and turn to that reference; or consult the Contents, p. xv, for the Index of Lists and Tables. A glossary of miscellaneous terms appears on pages 626–31.